TRANSFORMING IMAGES

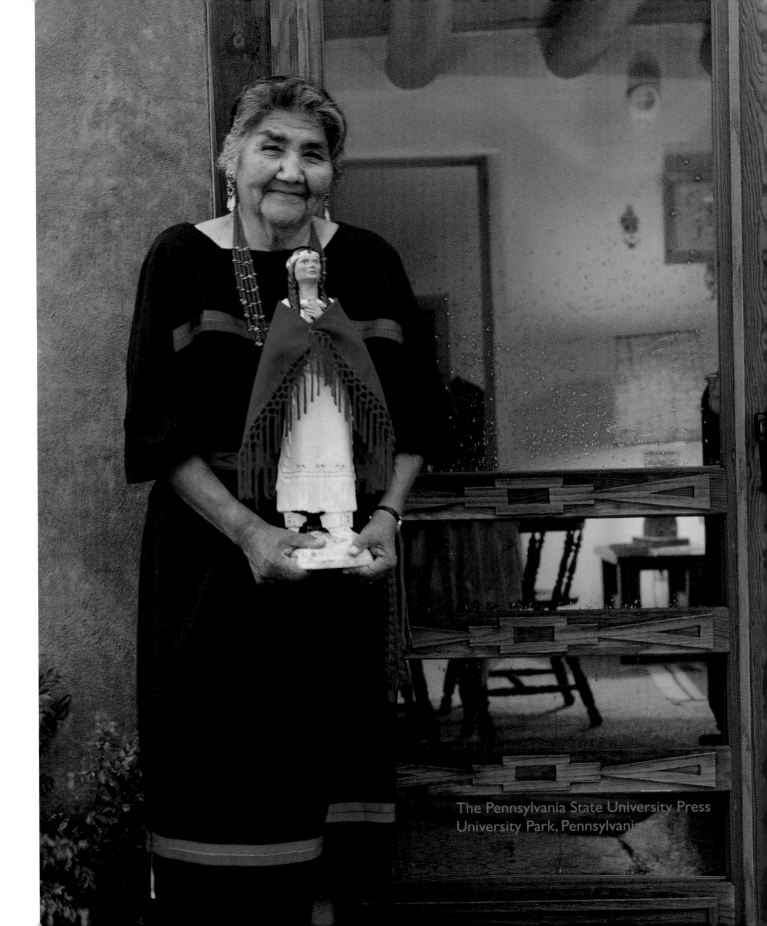

The Pennsylvania State University Press
University Park, Pennsylvania

TRANSFORMING
IMAGES

NEW MEXICAN *SANTOS* IN-BETWEEN WORLDS

Claire Farago and Donna Pierce

Marianne L. Stoller

Kelly Donahue-Wallace

José Antonio Esquibel

Robin Farwell Gavin

Paul Kraemer

Carmella Padilla

Thomas L. Riedel

Brenda Romero

Cordelia Thomas Snow

Charlene Villasenor-Black

Dinah Zeiger

with the assistance of Nancy Mann

✗ 61478777

Library of Congress Cataloging-in-Publication Data

Farago, Claire J.
 Transforming images : New Mexican santos in-between
worlds /
 Claire Farago and Donna Pierce.
 p. cm.
Includes bibliographical references and index.
ISBN 0-271-02690-1 (cloth : alk. paper)
1. Santos (Art)—New Mexico.
2. Folk art—New Mexico—Foreign influences.
3. Ethnicity—New Mexico.
4. Hybridity (Social sciences) and the arts.
I. Title: New Mexican santos in-between worlds.
II. Pierce, Donna, 1950– .
III. Title.

NK835 .N5F37 2006
704.9'48209789—dc22
2005026152

Design by Bessas & Ackerman
Printed in China through Asia Pacific Offset, Inc.
Published by The Pennsylvania State University Press,
University Park, PA 16802-1003

The Pennsylvania State University Press is a member of the
Association of American University Presses.

It is the policy of The Pennsylvania State University Press to
use acid-free paper. Publications on uncoated stock satisfy the
minimum requirements of American National Standard for
Information Sciences—Permanence of Paper for Printed
Library Materials, ANSI Z39.48–1992.

The publication of this book has been aided by a grant
from the Program for Cultural Cooperation Between
Spain's Ministry of Education, Culture, and Sports
and United States' Universities.

Publication of this book has been aided by a grant from the
Wyeth Foundation for American Art Publication Fund of the
College Art Association.

FRONTISPIECE: Juanita Martínez in her doorway, San Juan
Pueblo, holding an effigy of Kateri Tekawitha, a young
Christian Iroquois woman who died in 1680 in Kahnawake,
which is today a tourist-oriented village in upstate New York.
Kateri's tomb is both a tourist attraction and an important
pilgrimage site for Native and non-Native Catholics (Nicks,
"Indian Villages and Entertainments"). Kateri Tekawitha was
beatified by Pope John Paul II in 1980. When this photograph
was taken, Juanita Martínez and her parish priest had just
returned from a national conference urging that Kateri be the
first Native American saint officially recognized by the Church.
Permission for this photograph was arranged by John Reyna of
Taos Pueblo. Photo Ken Iwamasa.

JACQUES DERRIDA Teleology and hierarchy are prescribed in the envelope of the question.

—"The Parergon"

MICHEL DE CERTEAU History is "cannibalistic," and memory becomes the closed arena of conflict between two contradictory operations: forgetting, which is not something passive, a loss, but an action directed against the past; and the mnemic trace, the return of what was forgotten, in other words, an action by a past that is now forced to disguise itself.

—"Psychoanalysis and Its History"

BELL HOOKS . . . how often contemporary white scholars writing about black people assume positions of familiarity, as though their work were not coming into being in a cultural context of white supremacy, as though it were in no way shaped and informed by that context. And therefore as though no need exists for them to overtly articulate a response to this political reality as part of their critical enterprise.

—"Culture to Culture: Ethnography and
Cultural Studies as Critical Intervention"

HOMI BHABHA What is theoretically innovative, and politically crucial, is the need to think beyond narratives of originary and initial subjectivities and to focus on those moments or processes that are produced in the articulation of cultural differences. These "in-between" spaces provide the terrain for elaborating strategies of selfhood—singular or communal—that initiate new signs of identity, and innovative sites of collaboration, and contestation, in the act of defining the idea of society itself.

—"Introduction," *The Location of Culture*

CONTENTS

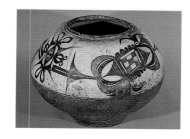

PART FOUR: INVENTING MODERN IDENTITIES

ILLUSTRATIONS

Frontispiece: Juanita Martínez in her doorway, San Juan Pueblo.

Introduction
Raton, New Mexico, trio of yard shrines with three bathtub *nichos,* including the Virgin Mary, the Virgin of Guadalupe, the Sacred Heart of Jesus, Saint Francis, and the Pieta, 1994. Photo Cara Jaye.

Chapter 1: Mediating Ethnicity and Culture

Chapter 2: Semiotics and Political Realities

Chapter 3: Active Reception of International Sources

10.b.2. Framed chest with *leos pardos* motifs, wood, dated 1823. Inscribed in three-inch-high letters carved across top of front panel: *Yo doy serbire a don Manuel Martin en todo ano de 1823* [I serve Don Manuel Martin in all things. Year 1823].

10.b.3. Bowl with serpent or *leos pardos* motif (?), unnamed red/brown ware, c. 1692–1750. Old Socorro Mission, El Paso, Texas.

10.b.4. Bandelier black-on-cream bowl, c. 1400–1550.

10.c.1. Zuni polychrome *olla* with "Rain Bird" design, c. 1825–40.

10.c.2. Cochiti polychrome storage jar, c. 1880.

10.c.3. Pueblo vase from Aby Warburg's collection, donated 1902 to Hamburg, Museum für Volkerkunde.

10.c.4. Zia polychrome storage jar, c. 1890–1900.

10.c.5. Emma M. Krumrine, *Illuminated Psalm,* inscribed in design "made for M. Schwartz, 1836"; watercolor, colored pencil, and graphite on paper.

10.d.1. Rafael Aragón, *Saint Achatius,* gesso and water-soluble paint on wood, mid-nineteenth century.

10.d.2. Ako polychrome jar, from Acoma or Zuni Pueblo, c. 1750–1800.

10.d.3.a–d. Mesa Verde black-on-white mugs, Anasazi vegetal paint tradition, Mesa Verde province, c. 1200–1300.

10.d.4. Quill Pen *Santero, Saint Peter Nolasco* (?), gesso and water-soluble paint on wood, mid-nineteenth century.

10.d.5. Follower of Quill Pen *Santero, Saint Stephen* (?), gesso and water-soluble paint on wood, c. 1871–80 (bark date 1871).

10.d.6. Follower of Quill Pen *Santero, Guardian Angel,* gesso and water-soluble paint on wood, c. 1871–80 (bark date 1871).

10.d.7. Follower of the Quill Pen *Santero, Female Saint,* gesso and water-soluble paint on wood, c. 1871–80 (bark date 1871).

10.d.8. Cleo Jurino, cosmological drawing made for Aby Warburg at the Palace Hotel, Santa Fe, on January 10, 1896, as noted on the drawing. Warburg's notations on the drawing identify Jurino as the priest of Chipeo Nanutsch, the guardian of the kiva at Cochiti Pueblo, and "painter of the wall paintings" there.

10.d.9. Santa Ana Polychrome storage jar, c. 1870–90.

10.d.10. Cochiti or Santo Domingo polychrome storage jar, Kiua polychrome ware, early–mid-nineteenth century.

10.d.11. Red Mesa black-on-white beaker, Anasazi mineral paint tradition, Chaco (?) province, c. A.D. 950–1050.

10.d.12. Quill Pen *Santero* (?), *Christ of Patience,* gesso and water-soluble paint on wood, mid-nineteenth century.

10.d.13. Hopi bowl.

10.d.14. Quill Pen *Santero* (?), *Christ of Patience,* gesso and water-soluble paint on wood, early nineteenth century.

10.e.1. Anonymous, *Virgin with Trinity* (?), gesso and water-soluble paint on milled wood board, late nineteenth century.

10.e.2. Blue curls; a member of the mint family found in Arizona, New Mexico, and southern California.

ACKNOWLEDGMENTS

What would the history of art look like if cultured interaction and exchange, and the conditions of reception, became our primary concerns? This collaboration came into being because its authors believed they could describe the cultural complexity of New Mexico without resorting to oppositional frameworks or relying on reductive categories like "Spanish" or "Pueblo" to ground their observations on politically sensitive issues in the areas of religion, art, and social identity. What began as a commitment to develop a new research program for understanding cultural exchange manifest in the material record, led Claire Farago from her theorectical proposal in *Reframing the Renaissance* (1995) to the present collaboration with a dozen experts in Southwestern material culture and Spanish Colonial art. For over a decade, this project unfolded in the classroom, in the field, at conferences, and in museums and archives, mostly as a grass roots effort, and almost entirely without funding. These circumstances have meant that work toward publication proceeded slowly, at the interstices of other commitments and deadlines; but on the other hand, these same circumstances enabled us to think deeply about our ethical responsibilities as academic scholars toward our subjects and our readers. We have resisted the temptation to conform to existing topics, subjects, and genres. Our shared aim at the end of this project is to provoke intelligent, thoughtful discussion; to foster shared interest and trust across existing cultural boundaries; and to increase appreciation for the role that art (in the best sense that this loaded word can take) plays in cultural interaction. And we are pleased to acknowledge the following institutional support for this project.

In 1991, Claire Farago was awarded a travel grant to New Mexico from her home institution, the University of Colorado at Boulder, to develop research for a study of New Mexican *santos* from a cross-cultural perspective. During this visit, Farago and Donna Pierce met and began discussions that eventually led to our present collaboration.

At the time, Pierce was involved in preparations for two companion exhibitions that opened in 1992 at the Palace of the Governors Museum in Santa Fe, "Another Mexico: Life on the Upper Rio Grande" and "Society Defined: People of Colonial New Mexico." Both exhibitions viewed the culture and art of New Mexico in an expanded way—by looking both in and out. The former exhibition placed it in the broader context of the rest of the contemporary world, and the latter delved into the broader ethnic composition of the culture of New Mexico itself. Extended conversations with her co-curators, Cordelia T. Snow and Diana De Santis, as well as with Director Thomas E. Chávez, greatly expanded Pierce's knowledge and thoughts on the topic of New Mexican society and culture and dovetailed with the plans for this book.

In 1991–92, Farago was awarded a research fellowship by the National Endowment for the Humanities for a residency at the John Carter Brown Library at Brown University in Providence, Rhode Island. She gratefully acknowledges the strong support of Director of the Library Norman Fiering and valuable conversations with other fellowship recipients, especially with Elizabeth Kuznesov, in the early stages of learning about New Mexico and the Spanish colonial world. She also benefited from contact with other scholars in Providence, including Nancy Armstrong, Mary Bergstein, Sheila ffolliot, Elizabeth Grossman, Shep Krech, Baruch Kirschbaum, Dian Kris, Len Tennenhouse, and Karen Nelson, Elizabeth Weed, and other members of the faculty seminar at the Pembroke Center. During the same year, she presented her ongoing research to knowledgeable audiences at

the John Carter Brown Library, the Art History Department at Brown University, the Rhode Island School of Design, and the International Society for the History of Rhetoric conference held at the National Gallery of Art, Washington, D.C., in 1991.

Many students from a wide variety of cultural backgrounds contributed their ideas since we began this project. They wrote papers, gave presentations, participated in countless classroom discussions, went on field trips, and organized an exhibition at the University of Colorado Museum, in the process learning about themselves and each other in ways that no conventional classroom can offer. Farago expresses many thanks to the Director of the University Museum Linda Cordell, then-Assistant Director Diane Clymer, and their staff, for the opportunity to organize an exhibition, entitled "Transforming Images: A Crosscultural Look at Santos," in 1997/1998; and especially to the participants in her seminars in 1992, 1994, 1996, and 1997, who contributed to the exhibition and this book, and to other graduate students who worked on related projects, whose ideas also contributed to her deepening understanding of the Southwest: Macy Allatt, Mary Jo Anderson, Bill Anthes, Pam Beverly, Diana Biles, Andrea Birkby, Nancy Bohm, Rebecca Briggs Moore, Nadi Carey, Hélène Casanova, Kathryn Charles, Luann DeMare, Eric Dickey, Zach Engel, Lindsey Gibson, Seth Goodman, Andy Granitto, Carlos Fresques, Jessie Friedman, David Griffit, Meredith Hansen, Barbara Hardesty, Augusta Holland, Cara Jaye, Marcela Juarez, Christina Johnson, Chris Jones, Karena Kimble, Wendy Levine, Merlin Madrid, Coate Manderson, Meredith McGee, Nicole McGruder, Melanie McHugh, Elissa Minor, Jill Mooney, Erin Moore, Michael Page, Carol Parenteau, Jeffrey Paterson, Thomas Riedel, Francesca Robledo, Sara Rockwell, Rayne Roper, Joanne Rubino, Graham Salzberg, Heidi Scolari, Nicole Seeds, David Shaw, Sam Tunheim, Rebecca Vaughan, Lydia Vierson, Shanna Waddell, Beth Warren-Turnage, Teresa Wilkins, Ken Yazzie, Melanie Yazzie, and Dinah Zeiger. Individual contributions by former students are acknowledged throughout the book.

During 1995–96, Pierce taught in the Department of Art and Art History at the University of New Mexico, where her lecture and seminar classes explored *santos* within the context of the greater Spanish colonial world. Insights and papers from students in these classes contributed to her thought process, with particular contributions from Kelly Donahue-Wallace, James Ivey, Felipe Mirabal, Robin Farwell Gavin, and Augusta Holland.

In 1996, Farago was awarded a Faculty Fellowship by Oregon State University in Corvallis, where she spent five productive months thinking and writing about *santos* in congenial surroundings. She warmly acknowledges the complementary interests of the other Fellows at the Center and, as this project is going to press, laments the untimely passing of its energetic, visionary director Peter Copek. In June 1997, a small grant from the Center for the American West at the University of Colorado and space generously donated by Thomas E. Chávez, Director of the Palace of the Governors, enabled the contributors to participate in a working conference at the History Library of the Palace of the Governors, Santa Fe.

During her work with various *santos* collections, Pierce had begun to feel that the cultural situation within colonial New Mexico was more complex than had previously been indicated by scholarship and that its cultural relationship to the world at large was more extensive. Pierce has had the privilege of hands-on work with several of the most extensive collections of *santos* in existence: first, as Curator of Spanish Colonial Collections at the Museum of International Folk Art in Santa Fe from 1983 to 1987; as Curator of Collections for the Spanish Colonial Arts Society, now the Museum of Spanish Colonial Art in Santa Fe, from 1988 to 2003; as Curator of Collections at El Rancho de las Golondrinas Museum in La Cienega, New Mexico, since 1995; and, most recently, as Curator of Spanish Colonial Art at the Denver Art Museum. Pierce has benefited greatly from conversations with colleagues at these institutions, including Keith Bakker, Robin Farwell Gavin, Helen Lucero, Joan

Tafoya, Judy Chiba Smith, Nora Fisher, Will Wroth, Sandy Osterman, Alan Vedder, Bill Field, Nancy Meem Wirth, Carmella Padilla, David Rasch, Timothy Standring, Judy Thompson, Margaret Young-Sanchez, Ann Daley, Anne Tennant, Teddy DeWalt, Julie Wilson, and Christine Romero Deal. Other persons who have contributed to the thought process include Pierce's coauthors on related projects, including Gabrielle Palmer, Marta Weigle, Felipe Mirabal, Robin Farwell Gavin, Cordelia T. Snow, Teresa Archuleta-Sagel, and Carmella Padilla.

Farago warmly thanks all the individuals, although they are not individually named, who provided assistance and shared their expertise at the Museum of International Folk Art in Santa Fe, the Taylor Museum in Colorado Springs, the Millicent Rogers Museum in Taos, the Laboratory of Anthropology in Santa Fe, the University Museum at the University of Colorado, the School of American Research in Santa Fe; the Art Gallery at New Mexico State University in Las Cruces; the Getty Research Institute in Los Angeles, and at public monuments at Mesa Verde, Chaco Canyon, Canyon de Chelly, Bandelier National Monument, Bernalillo National Monument; and at Santa Clara, Abó, and Quarai Pueblo National Parks.

In November 1998, Pierce was invited to present a paper on New Mexican santos at a conference on Spain and the Americas at the Casa de America in Madrid, Spain. She benefited from panel discussions and private conversations with colleagues Cristina Esteras Martín of the Universidad Complutense de Madrid, Concha García Sáiz of the Museo de América, and Manuel Gullón of the Fundación América and Colonel Francisco Frances-Vallero as well as Alfonso Pleguezuelo of the Universidad de Sevilla. She also acknowledges intellectual input from colleagues in Mexico, particularly Clara Bargellini and Rogelio Ruiz Gomar.

In 1998, Farago was Art Council Chair Visiting Professor at University of California at Los Angeles (UCLA), where she co-taught a seminar on the topic of cultural "hybridity" with Cecelia Klein and with her organized a conference on cultural hybridity central to issues in this book. She benefited from numerous classroom discussions and especially from exchanges at UCLA with Debashish Banjerii, Fred Bohrer, Robert Brown, Rebecca Hernández, Cecelia Klein, Dana Leibsohn, Santhi Mathur, Ruth Phillips, and Donald Preziosi. She is grateful for the opportunity to serve as discussant for a session on problems in Pre-Columbian studies organized by Cecelia Klein at the 1999 College Art Association conference in Los Angeles. The experience at UCLA was crucial in framing the theoretical concerns of this study. Over the years, Farago presented papers on New Mexican santos and related historiographical topics at many other universities and conferences, including Cornell University, Florida State University, Harvard University, New Mexico State University, Northwestern University, Oregon State University, Oxford University, Pomona College, the University of Colorado, the College Art Association, the Front Range Symposium in Colorado, the International Congress on Medieval Studies, the Renaissance Society of America, the Semiotic Society of America, the Sixteenth-Century Studies Conference, and the meeting of the International Congress of Art History in London in 2000. In 2000–2001, Farago participated in a faculty seminar on the subject of "Time," organized by the Center for the Humanities and Arts at the University of Colorado, where she developed many of the ideas presented in Chapter 10.

The University of Colorado supported the publication with a subvention to help defray the cost of illustrations. Here Farago thanks friends and colleagues who supported this research, including Ken Iwamasa, who helped to conceive the project, and traveled and photographed thousands of miles and places for this book. Sam Edgerton provided lively debate and encouragement through an extended email exchange while he was preparing *Theaters of Conversion*. For their insights and generosity, Farago also thanks Kirk Ambrose, Randy Ash, Gauvin Bailey, Keith Bakker, Jonathan Batkin, Homi Bhabha,

Suzanne Blier, Elizabeth Boone, Aline Brandauer, Kathleen Brandt, Marcus Burke, Charlie Cambridge, Thomas Chávez, Jeffrey Cox; Neil Cummings, Marysia Lewandowska and Basia; Tom Cummins, Anthony Cutler, Phil Deloria, Steven Epstein; Ronald and Elizabeth Feldman; Margaret Ferguson, Richard Ford, Larry Frank, Dore Gardner, Robin Farwell Gavin, George Gorse, Margaret Hardin, Francis Harlow, Andrée Hayum, Gary Hood, Evelyn Hu-Dehart, Eugenia Janis, Amelia Jones, Pamela Jones, Eloise Quiñones Keber, Jerry Kunkel, Yvonne Lange, Steve Lekson, Patricia Limerick, Charles Lovell, Billie Yandell, and the New Mexican State University Art Gallery staff; Wendy Madar, Salvatore Mancini, Nicholas Mann, Juanita Martinez; David Morgan, Marion Oettinger, Nat Owings, Sally Promey, and the "Visual Culture of American Religions" study group; Nan Newton and Dave Grusin; Zena Pearlstone, Matthew Rampley, Diane Reyna, Linda Seidel, Gail Tierney, Beeke Sell Tower; Tom, Susan, Eledge, Quinn, and Frieda Simons; David Simpson, Jaune Quick-to-See Smith, David Snow, Jonathan Spence, Thomas Steele, David Summers, Deward Walker, Pauline Moffitt Watts, Hayden White, Luther Wilson, Cathy Wright, and Richard Wright. As intellectual and emotional partner, Donald Preziosi deserves much more than an expression of gratitude: this book would simply not be the same without his profound support and encouragement during the past five years. And loving thanks also to daughter Mia, born in media res through no fault of her own.

Our editor at the University of Colorado Nancy Mann worked closely with all the authors to prepare this manuscript for publication. Her engagement with substantive issues and questions of organization has been crucial to the final product. Jean Charney, our word processor, integrated the complex document at an early stage; Katherine Eischeid was an able assistant at the very last stage of getting the manuscript to press. Generous individuals at various institutions facilitated the lengthy and often obscure process of obtaining photographs and copyright permissions. We are especially grateful to David McNeece and Diane Bird at the Museum of Indian Arts and Culture / Laboratory of Anthropology; Ree Mobley at the Museum of International Folk Art; Cate Feldman at the Museum of Spanish Colonial Art; Diane Block, Louise Stiver, and Fran Levine at the Palace of Governors, all in Santa Fe; Scott Cutler at the Centennial Museum in El Paso, Texas. After searching carefully for the right publishing house for this project, we were fortunate to find a perfect partner in the Pennsylvania State University Press. We warmly thank our editor Gloria Kury for undertaking this complex production because she believed in the project. Editorial assistant Stephanie Grace, copy editor Ann Farkas, book designer Jo Ellen Ackerman, and Cherene Holland, Jennifer Norton, Patricia Mitchell, and the rest of the production staff at Penn State University Press ably delivered the manuscript into print without sacrificing words to the images or vice versa.

The exceptional generosity of our two external readers Jeanette Peterson and Dana Leibsohn deserves a separate acknowledgment. We are profoundly grateful for their scrupulous engagement with this text. Of course, we alone are responsible for the remaining shortcomings. John Reyna of Taos Pueblo consulted with us throughout the development of the research. We have benefited from his knowledge and encouragement. Many thanks also to Charlene Villasenor-Black for contributing the short essay on Catholic Reformation representations of Saint Joseph that appears on page 164. We also express thanks to our eleven co-authors for contributing their time and research, for helping to conceptualize this joint endeavor, and for graciously enduring the long process of its production.

Claire Farago and Donna Pierce
March 17, 2004

INTRODUCTION:
Locating New Mexican *Santos* in-between Worlds

The very materiality of objects with which we deal presents historians of art with an
interpretive paradox absent in other historical inquiries, for works of art are both
lost and found, both present and past, at the same time.
—Michael Ann Holly, "Mourning and Method"

The concept of "style" has been one of the cornerstones not only of the modern
discipline of art history but also of related practices of social and cultural history
and theory such as archaeology, anthropology, and ethnography. In this vol-
ume, the writers argue the inadequacy of the belief that styles are specific or
essential to a person, people, place, or period, making powerfully clear the ideo-
logical and critical investments that the idea of style has had and still has in
maintaining social, political, cultural, and religious identities. While the subject
matter of this book is specific to religious practices in New Mexico between the
eighteenth and twentieth centuries, the implications of these investigations are
far reaching both historically and historiographically, and both methodologically
and theoretically.

A "historical" artifact of human manufacture—that is, a work of art in the
most generic sense of the word—is one of those peculiar objects of historical
inquiry that, in seeming defiance of time itself, are still with us today. In the
above epigraph, Michael Ann Holly articulates the conundrum at the core of the
art-historical enterprise: the very materiality of objects presents an interpretive
paradox absent in other historical enterprises, "for works of art are both lost and
found, both present and past, at the same time." Assumptions about their per-
manent or semipermanent quality are intrinsic to this conventional understand-
ing of works of art. Similarly, we understand works of art as objects whose
significance transcends the historical circumstances of their making. Precisely—

My thanks to Robert Zwijnenberg, coeditor of a volume of collected essays entitled *Com-
pelling Visuality: The Work of Art in and out of History,* for allowing me to use the same quota-
tion as we did at the beginning of our jointly authored introduction. A version of Holly's
essay also appears in that book.

paradoxically—it is the materiality of the object that is at once affected and unaffected by time.

This study deals with Catholic instruments of religious devotion produced in New Mexico from c. 1760 until the radical transformation of local artistic tradition in the twentieth century.[1] We argue that local artistic practice is indebted to many cultural traditions, and it addresses the pressing question raised by this reevaluation: why has the New Mexican tradition been understood exclusively in terms of its "Spanish" roots? Taken together, the writers in this volume make three key arguments. *First,* they make a case for bringing new theoretical perspectives and research strategies to bear on the New Mexican material and other colonial contexts. *Second,* and just as important, the essays in this volume demonstrate that the New Mexican materials provide an excellent case study for rethinking many of the most fundamental questions in art-historical and anthropological study, including questions about ethnicity and style, cultural appropriation, the ethics of scholarship, and the meanings that both practitioners and nonpractitioners assign to religious images. *Third,* the authors collectively argue that the New Mexican images had, and still have, importance to diverse audiences and makers. In making this argument, our collaborative study addresses a methodological problem of longstanding and widespread concern in the humanities: namely, how to account for relationships between "ethnicity" and culture, that is, between collective social identity and artistic production. One of the most demanding theoretical challenges posed by the study of cultural exchange is the self-reflexive one of paying attention to the history of the forms of thought that have been applied to the historical artifact, as well as to the history of the artifact itself. The present study, in keeping with an important trend in colonial studies worldwide, adopts a relativistic approach to the problem of reconstructing cultural continuity. In accepting partial recovery of dispossessed cultural traditions as a valid form of interpretation, we argue that the distinctive style of New Mexican Christian images is due to,

among other things, important continuities with the precontact artistic traditions of the Pueblo Indians and other indigenous societies.

The painstaking process of partial recovery involves identifying the continued presence and transformation of artistic conventions. The present study implicates historians in the same continuum of cultural events as their subject of study. As scholars supported by powerful institutions, we are not innocent bystanders to the history of cultural interaction in the colonial world. Yet previous generations of scholars were also sensitive to the problem of projecting their cultural values onto alien historical material. The difference between our current position and theirs is more tenuous than some contemporary cultural theorists might like to admit.

Interpretative aims may not have changed, but epistemological underpinnings have. One of our deepest-rooted forms of art-historical thought is the assumption that an artwork has a radical unity that reconciles (harmonizes, synthesizes) any surface contradictions. This radical unity purportedly stems from the conscious or unconscious intention of the author, and in turn accounts for the work's power to communicate to audiences. The conditions of production and use of art in colonial societies call into fundamental question the connections among artistic intention, unified meaning, and communicative power. There appears to be no way to resolve the meaning of the colonial images into a single, stable reading, any more than there appears to be a resolution to the complex agencies involved in their production and use. The kinds of semiotic equivocation and polysemy discussed in the present study revise longstanding anthropological notions of the "syncretism" of colonial culture.

Exactly when and by whom portraits of saints and other holy figures began to be made in New Mexico are open questions. The first European exploration of the region was led by Vásquez de Coronado, who found subsistence-level villages instead of the seven cities of gold he was seeking in 1539. The first settlers

arrived nearly fifty years later, in 1598—another group of adventurers, led by Juan de Oñate. By 1630, Franciscan missionaries filed the first report on the conversion process, but the regular clergy fought with landowners over rights to Indian labor to such an extent that, in 1680, the pueblos united to stage a well-organized revolt, ordering the destruction of all Christian images and forcing the settlers to retreat to El Paso. In 1692, Don Diego da Vargas recaptured Santa Fe, and abuses of the Indians continued, leading to a smaller revolt and further destruction of images in 1696, two years after the arrival of the first colonists who were prepared to survive by farming and providing for their own needs.[2] The earliest-named artist whose works survive is Bernardo Miera y Pacheco, born in Burgos, Spain, who was working in Santa Fe by around 1760.[3] But about most of the individuals who produced polychrome wood sculptures and paintings on wood panel before the end of the nineteenth century, we know next to nothing.[4] Of the perhaps 10,000 objects that are known to survive, only about twenty are signed or dated.[5] Typically, all that remains in the museum records is the name of the immediate donor or the dealer.[6] Perhaps continued combing of the archives will yield new information about artists and early owners, which can be matched with existing works of art.[7] It is, however, unlikely that information of this nature will ever be found for the majority of surviving objects.

These circumstances, while limiting in one sense, are liberating in another. For they mean that the most significant documents about New Mexican Christian art are the images themselves. It will be argued here that New Mexican Christian images of saints and other holy figures are not syntheses of separate cultural traditions. Rather, in the *santos* overlapping and even mutually exclusive meanings, like the positive and negative valences of the color "black," *coexist*—these images oscillate depending on the viewer's frame of reference. Nothing about these images resembles the model of the artist-embodied-in-his-work that is the backbone of art-historical interpretation. But how do we account for conflicting and overlapping meanings attached to one visual motif by different cultural traditions without grounding the analysis in the artist's inward state? Studying the New Mexican material has led us to consider cultural identity in a very basic way: how people manipulate whatever material culture is available in their environment to negotiate their relationship with the world. Artifacts and images function in concrete, lived situations. Their meanings are "performed" in the sense that the same object carries different connotations in different contexts, and sometimes carries different connotations in the same context for different people. Miscommunication, as much as real communication, allows different worldviews to coexist in the same place. The maker of the object, the patron if there is one, the distributor if there is one, its users, its later owners, and so on all have agency of some kind in the "aesthetic field," to give a name—Bourdieu's—to all the social actions linked to the objects we use to construct meaningful relationships with the world.

The prospect of disentangling these agencies is daunting: it's not surprising that most of the disentangling to date has taken place at the abstract level of theory. The distinctiveness of New Mexican *santos,* as these religious images are known in the scholarship today, consists not in their overt subjects (which conformed to Catholic Reformation tastes), but in elements that may appear to have been "merely decorative": graphically striking and frequently elaborate abstract design motifs and landscape references. Despite their anonymity, the images are, as a group, readily distinguished from local products anywhere else in the Spanish colonial world.[8] This distinctiveness suggests that we should inquire not so much about the individual identities of their makers as about the collective identity of the society that produced and used them.

Yet everything we know about that society suggests strongly that it did not have a single, homogeneous identity. The distinctiveness of New Mexican Christian art, then, raises questions central to postcolonial studies about the contributions of indigenous

people and their descendants to colonial culture, and the social construction of meaning among segmented audiences. The process of trying to account for cultural identity in a colonial society—particularly in sensitive areas such as religion and in circumstances where lack of direct evidence may tempt us to reason backward from contemporary practice—raises issues of power and interpretative privilege. Readers, perhaps even more than writers of historical texts, take for granted that chronology is a neutral ordering device, as "natural" as it seems in "Nature." But every historical study is necessarily a *selective* representation and therefore an artifice. By definition, an interpretation tries to make sense of the world. In this context, temporal succession cannot have the epistemological status of a "law of nature." As the historian Hayden White famously argued in his 1978 essay "The Fictions of Factual Representation," factual (re)presentation is grounded in the implicit claim that a chain of causes and effects was mere temporal succession and not narration.[9]

Chronology is a powerful and seductive rhetorical apparatus. And cultural exchange has not been symmetrical. In a recent critique of postcolonial writing subtitled "Toward a History of the Vanishing Present," Gayatri Chakravorti Spivak discusses the hegemonic effects of "historical" accounts of time. She formulates "the reader's perspective" as a conundrum, describing the (im)possible position of a native informant whose identity has *not* been shaped by what Spivak calls the Kantian/Hegelian/Marxian heritage:

The possibility of the native informant is, as I have already indicated, inscribed as evidence in the production of the scientific or disciplinary European knowledge of the culture of others: from field-work through ethnography into anthropology. That apparently benign subordination of "timing" (the lived) into "Time" (the graph of the Law) cannot of course be re-traced to a restorable origin, if origin there is to be found. But the resistant reader and teacher can at least (and persistently) attempt to undo that continuing subordination by the figuration of the name—"the native informant"—into a reader's perspective. Are we still condemned to circle around "Idea, Logos, and Form" or can the (ex)orbitant at least be invoked?[10]

Spivak's critique is directed partly against the anti-Eurocentrism of other postcolonial critics of European thought. No one will deny that, from first contact in 1539, Europeans attempted forcibly to impose their cultural beliefs in the American Southwest. The challenge before us is going beyond the old, tiresome, worn-out, and wearisome opposition between Eurocentrism and anti-Eurocentrism.[11] As multiple authors of a unified study, we faced the organizational problem that, notwithstanding critiques of history writing, without chronological structure, our data would tend to appear chaotic and, beyond this, we would not have dealt with "chronology" as the fictive construct that it is, masking ideology under the false sign of "natural" time. The study that follows articulates a response to political realities—defined broadly to include, for example, professional expectations still emanating from some quarters to treat chronology as the neutral ordering device sine qua non of historical studies—as part of the critical enterprise. In compiling the manuscript, we have decided to maintain a chronological presentation, while breaking up the narrative sequence with short "interleaf essays" and extended captions between and in the chapters. That is, we have made some use of "hypertext" strategies, without, we hope, mixing the ingredients to the point of confounding our readers.

As a preliminary point of departure, we do not wish to claim in this study that the significance specific icons held for one segment of their original audience was necessarily beyond the reach of other segments, but people undoubtedly attached varying importance to content derived from different cultural traditions and contexts. In the messy contingency of past-lived situations, moreover, a lot of the evidence does not survive, and what does survive is capable of multiple interpretations for this reason as well. In his 1940 study of Pueblo mission architecture, George Kubler formulated his classic view of a distinctive

"Spanish colonial" culture in terms of its survival rate: "from the first formulation of the style to the recent decades of architectural activity, New Mexico has maintained the status of a provincial area, isolated from the currents of change which were effective in Metropolitan centers of the Spanish world. The phenomenon of regional survivals of an older artistic tradition, altered only by progressive simplification and reduction, characterizes the arts of New Mexico."[12]

Kubler's statement that the regional variant ("survival") of a preexisting artistic tradition is altered only by "simplification and reduction" is based on the limited evidence he took into consideration. The present study in its entirety addresses the problem of "artistic tradition" in a heterogeneous society where distinct but fragmented, previously unrelated social groups are in sustained, intensive contact. The iconography and formal structure of the New Mexican *santos* demand to be investigated at a level of generality that encompasses native and imported pictorial traditions without bias. Without such a comparative analysis, can we accept as anything more than a Eurocentric assertion the statement that colonial art forms are versions of old European traditions, "simplified" and "reduced" by isolation?

Isolation is a relative phenomenon anyway. Certainly, New Mexico was politically and geographically removed from ecclesiastic centers of the Catholic Church in Rome and the West Indies. But New Mexico was not isolated economically or culturally. The research published in this volume by Donna Pierce, Kelly Donahue-Wallace, and Cordelia Thomas Snow documents New Mexico's links to a global network of commerce. The presence of imported goods from Mexico, Europe, and Asia—even though the quantities were limited—means that New Mexican artists had an extensive range of visual sources at their disposal. Furthermore, to varying degrees of refinement, basically the same material culture was available to everyone, regardless of lifestyle, social status, or economic circumstances. As is explored at greater length in the following chapters, the traditional view that locally made Catholic devotional art emerged in New Mexico in isolation from a cultural center ignores a significant, enduring Native American presence. It also underestimates the complex and heterogeneous conditions in which religious art circulated globally during the Spanish colonial period (1598–1821) and afterward. And it imposes an ethnocentric framework biased toward "culture" defined in European terms.[13] New Mexico was a cultural center in its own right before, during, and after Spanish colonialism.

From Reductive Categories to Social Realities

Santos is now the favored word for all New Mexican figural religious art made in the "traditional" style. *Santos* are usually painted on wood panel *(retablos)* or carved and painted in the round *(bultos)*. The modernist reduction of New Mexican Catholic visual culture to its Spanish roots is exemplified in these three Spanish terms—terms that, according to at least one prominent artist with deep New Mexico roots, are twentieth-century appellations not customarily used in Spanish-speaking households.[14] *Imagenes* occurs most frequently in Spanish historical documents, as it still refers to religious images today. The term *santo* is said to have been introduced into New Spain farther south during the early contact period, by missionaries who wanted to convey the difference between the proper religious veneration of images and idolatry: *santos* designated holy beings of lesser stature than the incarnation of god, or *teotl* in Nahuatl.[15] *Santos* designated the saints themselves. Today terms like *santos, bultos,* and *retablos* are used instead of *imagenes* to convey a sense of "cultural authenticity"—specifically, of "Hispanic New Mexican" cultural authenticity—in the predominantly English-speaking commercial art world.

The relationship between the contemporary art market and religious instruments of the past is far from straightforward, and the relationship between ethnic and cultural identity is in any case not transparent. The burden of this book is to establish a historical and critical perspective broad enough to take opposed

cultural attitudes into account without creating a new totalizing structure. A case-study approach is well suited to this labor because it allows reconsideration of a specific range of artifacts in detail. To date, the literature on New Mexican religious art has been limited to cataloguing works by style and subject; except in a handful of cases, artist and date have been assigned solely on this basis. This book addresses problems of style and attribution in the existing literature and suggests new approaches, but it is primarily concerned with the social functions of images, not the individual identities of makers.

For the sake of this study of social function, it is *absolutely essential* to think beyond reductive categories like "Spanish" and "Native American" to the social realities to which these terms (so inadequately) refer. Since colonial times, the ethnic identity of New Mexicans has been far more complex than present-day terminology suggests. The traditional definition of ethnicity is membership in a distinct, self-identified population that is largely biologically self-perpetuating. By this definition, eighteenth- and nineteenth-century New Mexico can be described as a colonial society segregated by lifestyle and language into three dominant social groups: Spanish-style towns, Indian pueblos, and the nomadic frontier. None of these sectors can be defined by lifestyle or genetic pool as a separate ethnic group, because they interacted socially and economically. Genealogical records indicate that by c. 1790 a large segment of the population—at least one-third of New Mexico's 30,000 inhabitants and probably more—was *mestizo*.[16]

One of the priorities of this entire undertaking has been to revise the assumption, too widely disseminated in the scholarship to attribute to individual writers, that the religious art of New Mexico was simply provincial "Spanish" art produced by "Spanish" artists. Standard explanations for the rise of local religious artistic production are demographic: we know that there were earlier images made locally that have not survived, but the later 1700s and early 1800s saw a dramatic increase in the settler population of Spanish colonial New Mexico. There were not enough priests to meet the needs of the expanding population, a shortage that made the availability of sacred images crucial. Lay Catholicism often depends on images to enact the basic tenets of faith through individual piety and communal religious dramatizations, rather than a system of worship organized institutionally around the sacraments administered by priests. "The folk of Spanish New Mexico," writes Will Wroth, a specialist in New Mexican religious art, "were obliged to take care of their own lives as best they could."[17]

From the mid-eighteenth century, in addition to importing religious art from Mexico, New Mexico produced its own altarpieces and individual devotional panels depicting Christ, the Virgin, and saints, made for both the colonists and the Pueblo missions, sometimes by the same artists.[18] Like their neighbors in the Christianized pueblos, the settlers were served by relatively very few priests. In these conditions, brotherhoods and sisterhoods, or *cofradías,* took care of community religious needs, just as they had on the Iberian Peninsula, where the majority of European settlers had ultimately originated. In the process, the local population produced substantial numbers of religious images. To the New Mexican communities that made them for their own domestic use, images of holy figures were part of what the contemporary historian Father Thomas Steele calls "a complete motivational system" along with scripture and religious stories, prayers, processions, and other ceremonies.[19]

The decline of local artistic production in the second half of the nineteenth century is usually attributed to both demographic and technological factors. This period saw enormous changes in New Mexican material culture, changes that were accelerated by the arrival of the national railroad system in 1879–85. Significant non-Catholic populations settled in the region after it became a U.S. possession in 1846. When anthropologists, museum professionals, academics, and artists began arriving in New Mexico in the latter part of the nineteenth century, new cultural attitudes formed toward the region's material culture. By 1900, the local

religious artistic production had been replaced for the most part by imported mass-produced prints (typically displayed in locally crafted tin frames) and plaster-cast sculptures.[20] The Hispanic arts revival initiated in the 1920s by the potter Frank Applegate, the writer Mary Austin, the collector Mabel Dodge Luhan, and other transplanted Easterners marks a dramatic change in the social function of New Mexican religious art. Instruments of religious practice were transformed into cultural artifacts for aesthetic contemplation outside the framework of Catholicism.

As a commercial network of dealers and buyers emerged, new labels such as colonial "Spanish" and native "Pueblo" were associated with the cultural productions of a complex society and its multicultural heritage. Art collectors expressed their educated appreciation for "folk art," museum collections were formed, and eventually the federal government mounted a cultural preservation program for New Mexico's Spanish religious art. To this day, a thriving New Mexican market in historical and contemporary religious images provides a diverse public with "art," while offerings at pilgrimage sites, roadside shrines, and yard displays are abundant reminders that visual material culture still serves the religious needs of lay Catholics in New Mexico.

Overview of the Volume

To address the question of how social identity and cultural production are mediated by factors such as artistic conventions, social structure, and economic exchange, we found it necessary to go beyond existing genres of writing and existing fields of study, which are limited by problematic assumptions that social groups are homogeneous by nature, and that cultural production can and should be classified into categories such as "art" and "artifact" best understood in isolation from one another. In closing this introduction and opening the rest of this book, I want to reemphasize what is at stake in studying the artistic production of heterogeneous societies. Behind the now-burgeoning academic

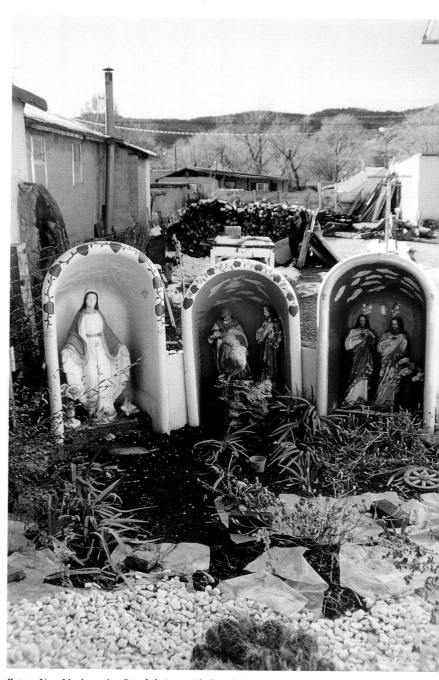

Raton, New Mexico, trio of yard shrines with three bathtub *nichos,* including the Virgin Mary, the Virgin of Guadalupe, the Sacred Heart of Jesus, Saint Francis, and the Pieta, 1994. Photo Cara Jaye.

enterprise of postcolonial studies is the commitment of an earlier generation of dissenting intellectuals who first articulated, and thereby validated, the divided forms of (non)identity that exile and diaspora bestow. Among the best known of these post–World War II era writers whose shared concerns arose from personal experience in different colonial settings are Albert Memmi, Frantz Fanon, and Césaire Aimé.[21] In *Torn Halves: Political Conflict in Literary and Cultural Theory,* Robert Young offers sober reflection for anyone who would celebrate the postcolonial subject position that these survivors of political oppression first articulated, either as a personal form of identity or as an academic subject of study. Young begins with the observation that academic institutions see "culture" as an object of study, yet there is not an actual object corresponding to it. The dialectical form of theoretical conflicts ensuing from this false premise, far from tearing academic institutions apart, constitutes their necessary structure. These "torn halves of an integral freedom" never add up because the dialectical structure of academic dissension reproduces the economy of capitalism itself. *If* there is a way out of the quandary posed by the constant flow of irreconcilable choices, Young argues, it is not to choose between them, but to practice them all at the same time.[22]

Writing in a way that allows irreconcilable choices to coexist is what this collaborative study offers in response to the interpretative challenge that material objects present. The relationship between "ethnicity" and cultural production is a vexed question for many reasons, one of which is that one category often slides into the other in historical interpretations. Obviously, culture is not genetic—as past scholars of New Mexican cultural history, notably George Kubler and E. Boyd, have relentlessly emphasized. Nevertheless, there is a relationship between the two, because both are determined by daily human contact, in households and communities. Yet this is the first study to document ethnic identities in the northernmost reach of the Spanish colonial empire in relationship to the region's material culture.

Two general conclusions emerge from our collaborative, multi-evidentiary investigation. First, while there is no necessarily direct relationship whatsoever between culture and "ethnicity," there is one between culture and material resources. The distinctive appearance of New Mexican *santos* is due, in other words, partly to the distribution of resources and the organization of labor. Yet, second, a strictly materialistic explanation is not fully satisfactory: the formal, symbolic, and ultimately noumenal traces in the visual realm appear to result from superimpositions (more than syntheses) of divergent cultural traditions. The implications of our findings, like the material evidence itself, differ according to who is observing. While there are significant overlaps and correlations, some real differences of opinion are also a matter of record.

This book is subdivided into four sections, dealing respectively with (1) questions of methodology, (2) the archival evidence, (3) the religious art itself, and (4) the history of the scholarship. In the opening theoretical section, entitled "Problems for Interpretation," Claire Farago introduces the specific historical circumstances that shaped social interaction in New Mexico during and after the colonial period, challenging lingering Darwinian assumptions in the contemporary scholarship. This chapter frames the history of New Mexico as a case study to investigate how the relationship between the ethnicity of a people and the culture they produce is mediated by many complex factors.

The second chapter follows this line of argumentation by developing criteria for interpreting the religious images produced in the region. Farago introduces visual evidence that many locally produced works of art are multiply indebted to two or more representational systems and iconographic traditions in ways that prevent any stable meaning from being assigned to the object. She argues that these circumstances allow different, even mutually exclusive "meanings" to reside in the same image or object, depending on the viewer's cultural orientation. In the third chapter, Donna Pierce explores the artistic sources available to New Mexico artists to reexamine

the historical transition from Baroque to Rococo in the material culture of the region. Pierce's newly assembled evidence suggests that, far from being uninterested in or incapable of understanding stylistic trends, as is usually assumed, local artists responsible for the production of religious images were attentive to the latest formal innovations. Out of choice, as well as economic and technological necessity, they imitated these sources selectively, combining imported appropriations with elements drawn from local sources, and executing them in locally available materials. In a short essay positioned as a transition or "interleaf" to the next section, Pierce continues her investigation of the social context in which *santos* circulated by suggesting that complex class issues were also involved in *santo* production. In some instances, an underlying political message adds yet another potential level of interpretation to the multilayered meanings present in New Mexican *santos*.

The second section of the study, entitled "Reconstructing Ethnicity from the Archives," was conceived by art historians with the help of experts in other fields, archaeologists and genealogical historians, who analyzed the raw data of archival documents such as census, birth, marriage, death, and tax records. Archival records document the activities of a population of diverse ethnic origins that interacted extensively, thus revising longstanding claims that the *santos* are the product of a segregated "Spanish" sector of the New Mexican population looking only to "Spanish" artistic sources. However, the archival data are far from straightforward. Inconsistent terminology and the accidents of document survival necessitate subtle interpretative tactics, as the fourth and fifth chapters about population records, written by José Esquibel and Paul Kraemer, respectively, demonstrate. In his study of the early years of the Resettlement period (1693–1720), José Esquibel focuses on the variety and internal consistency of *casta* designations preserved in the archival records and the context in which these designations appeared. It is important to emphasize that Esquibel does *not* assess the reliability

of these markers. That question is addressed, for eighteenth-century New Mexico, in Paul Kraemer's analysis of census records in the following chapter. Kraemer documents the instability of *casta* designations, thus underscoring the arbitrary nature of the terminology as well as the rapid emergence of a new social hierarchy in a dynamic, status-seeking social order differentiated primarily through visual markers of "caste" rather than any reliable measure of genetic relationship, and through class distinctions based on kinship groups, occupation, and ownership of land and property.

Evidence for the kinds of material culture the settlers of New Mexico brought with them and manufactured locally is preserved in archival records, in inventories and wills, and in the material record—wherever these survive the accidents of time. The following chapter, coauthored by Donna Pierce and Cordelia Thomas Snow, complements the findings of Esquibel and Kraemer by documenting an international circulation of goods available to all social sectors of the heterogeneous population during the same period. The sixth chapter concerns the material culture available to New Mexican residents during the seventeenth and eighteenth centuries. Pierce and Snow document the unexpected but indisputable presence of imported goods from Europe, Mexico, and Asia, most of which are no longer extant, as well as local imitations of them in cheaper materials that attest to similar tastes for the latest fashions across a wide social and economic spectrum.

On the basis of this solid historical distinction between markers of ethnicity and the circulation of material culture in a hierarchically organized society, the remaining chapters deal directly with Catholic devotional images imported to and produced in the region since the seventeenth century. In the next section, entitled "Christian Icons Between Theory and History," Chapter 7 is a previously unpublished essay written twenty-five years ago, which remained unpublished because it challenged the then prevailing opinion that all *santeros,* or makers of *santos,* were of

"Spanish" descent. Marianne Stoller counters previous explanations of the artistic identity of the *santeros* by assembling extensive material and archival evidence, which suggests that Indians, Christianized and probably Hispanicized, culturally or genetically or both, contributed to the artistic identity of New Mexican devotional art.

Chapters 8 and 9 deal with hide paintings, the earliest form in which religious images were locally produced. Although it has been common knowledge for quite some time that tanned hides were a major New Mexican export item, Donna Pierce publishes documentary evidence to prove that hides were tanned in the Indian tradition (brain-tanned), painted in New Mexico with images of saints, and, in a few cases, with secular scenes, and exported to Mexico in quantity as well as used locally. The documents also reveal that Indian artists in New Mexico participated in the production of these works of art from the earliest days of the colony into the mid-eighteenth century, that they were used in private homes as well as churches in New Mexico, and that they were owned by people of various ethnic backgrounds. This information published by Pierce complements Esquibel's important new archival findings, testifying to exchanges between the early settlers and Native Americans, and between generations of artisans. Esquibel documents that the son of the earliest-named artist working in New Mexico whose works survive, the Spanish-born and Mexican-trained Miera y Pacheco, worked with the earliest known native-born artist whose works are extant, the prolific Pedro Fresquís of Truchas, who is classified as *mestizo* in the records. In the following Interleaf, Pierce contributes a short essay on Pacheco. In Chapter 9, Kelly Donahue-Wallace considers how the eighteenth-century hide painters of New Mexico departed from their print sources, thus foiling the strategy of the Spanish crown and the Church of Rome to evangelize the faithful by allowing identical images of approved dogma to travel simultaneously to the most distant regions of the viceroyalty. From archival documents and survivals of visual material evidence, we are beginning to piece together the various ways in which artistic skills were transmitted to the northern frontier of New Spain. The latest evidence points to the existence of professional workshops throughout the colonial period involving artists recognized to be of diverse ethnic origins.

In Chapter 10, Claire Farago explores the radically open-ended semiotic conditions embedded in images made by artists with such culturally complex backgrounds, from the viewpoint of how these *santos* would have functioned for a heterogeneous public, primarily in outlying towns founded in the mid-eighteenth century where cultural interaction was intensive. The material evidence of the *santos* compared with other types of material culture produced or available in the region suggests that what is still routinely dismissed as decorative fantasy, the misunderstanding of a prototype, or the unavoidable reliance on crude materials and techniques is the visible measure of a new colonial identity. In an Interleaf essay Brenda Romero observes counterparts to the complex processes of intercultural exchange in the performing arts. She traces the dance ritual of the *matachines danza,* introduced by the Spanish in the sixteenth century with the intention of converting the Indians to Catholicism, to sources on both sides of the Atlantic, showing that New Mexican versions introduce elements that resemble the role of sacred clowns among the Pueblos.

The authors of this study try to acknowledge the formal complexity of New Mexico's religious images. The final section of the book, entitled "Inventing Modern Identities," is framed to address the question of why this complexity had not been acknowledged earlier. Chapter 11, by Farago, outlines a deep-seated point of tension between institutionalized Catholicism and lay practice by considering what caused the decline of *santo*-making in the second half of the nineteenth century. She argues that, in New Mexico, where "international" and "regional" systems of cultural production were not separate spheres of activity, anonymous mass-media prints acquired distinctive local characteristics that enabled lay Catholics to seek efficacious contact with the supernatural through

images. Continuing the same line of investigation, Thomas Riedel argues in Chapter 12 that the careers of two leading early twentieth-century New Mexican artists, Juan Sanchez and Patriciño Barela, demonstrate the rapid transformation of *santo*-making from its roots in religious worship to its secularization as collectible "primitive" art identified exclusively with "Spanish" culture. The "revitalization" of Hispanic craft production at this juncture was often indicative of Anglo taste for the exotic and unspoiled expression of an imaginary colonial subject. Despite the rich literature on the "Spanish" identity of individual *santeros*—the long-term result of the rapid transformations Riedel describes—the training of artists before the twentieth century is poorly documented. In Chapter 13, Robin Farwell Gavin reviews the existing system of stylistic attribution, including standing assumptions about artistic training on which this system is based, and introduces extensive visual evidence that many *santos* were copied from other New Mexican *santos*—a long-overdue acknowledgement that, in short, revises the whole system on which attributions are currently made. In Chapter 14, Dinah Zeiger reviews the pertinent literature on the reception of religious art as she reports on her informal survey of contemporary buyers of *santos*. Zeiger sums up her study in terms that resonate throughout the volume: "*Santos* are not closed, unmediated images; rather, they appeal across a spectrum of religious practice and belief because of their multivalent meanings. Nor are they static and fixed in time and place. On the contrary, they are endlessly adaptable to the changing needs of different beholders. They remain today, as they were in the past, useful objects."

Ultimately, cultural interaction is based on mutual trust and interest. Carmella Padilla, in a closing Interleaf essay, publishes the results of her interviews with Catholic members of Isleta, Laguna, Acoma, and Picurís Pueblos, which indicate a range of ways to adapt Catholicism to fit private spiritual lives.

As the historian Joe Sando, a native of Jemez Pueblo and director of the Institute for Pueblo Studies and Research in Albuquerque, emphasizes, the deeply intertwined history of the Hispanic and Pueblo cultures cannot be overlooked. Yet a number of contemporary Pueblo people object to non-Pueblo historians writing "histories" of their culture. These objections are rooted in a sorry record of Western imperialism, and also in a native system for maintaining and transmitting shared beliefs through enactments, ceremonies, and rituals.

Contemplating the current politics of cultural interaction in New Mexico, as academics and other professionals supported by private and state institutions, we have been challenged to account for contributions to New Mexican Catholic religious art of local, native, and non-European origin without reproducing the colonial power structure. This work represents a case study addressed to the question of the forms that scholarly practice might take if it took to heart the by-now familiar critique that the study of national cultures exists in (unacknowledged) collusion with imperialist politics.

In short, this study is concerned with the ability of symbols to mean different things to different people. In this sense, our interdisciplinary collaboration continues the project of the early twentieth-century Renaissance art historian Aby Warburg (1866–1929), whose life's work centered on the transformative power of visual symbols. In Chapter 15, the book concludes with an essay calling for intellectually responsible and ethical scholarly practices, paradoxically framed as a critical response to the celebratory, largely uncritical contemporary reception of Warburg's own outdated, problematic ideas about "primitive" Pueblo symbolism. We dedicate this study to the hope that future collaborations across social and disciplinary boundaries can present a greater diversity of perspectives on the significance of *santos* than we are currently able to offer in an academic setting.

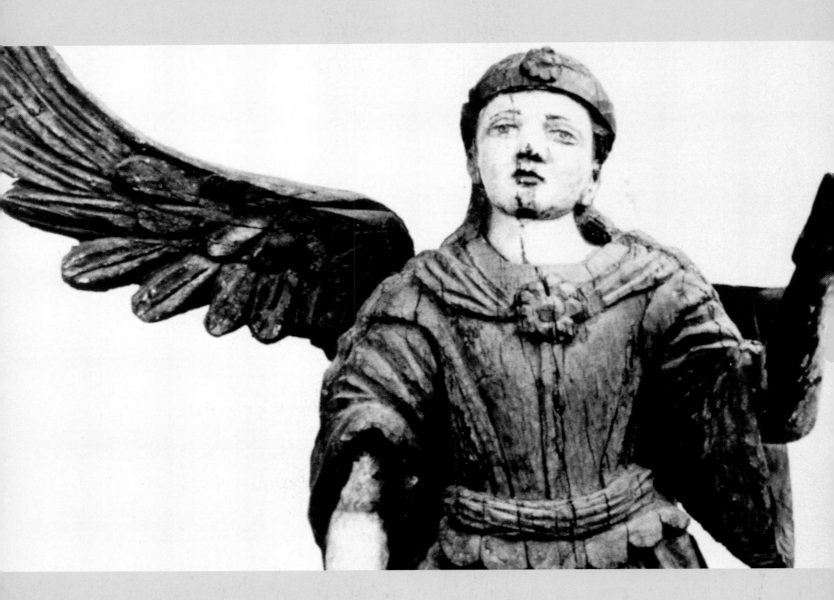

PROBLEMS FOR INTERPRETATION

MEDIATING ETHNICITY AND CULTURE
Framing New Mexico as a Case Study

1

CLAIRE FARAGO

How does the visual record document social processes? Even today, ethnicity can be studied only through cultural forms that express shared values "in a field of communication and social interaction," to use language developed by some processual anthropologists who study transcultural social behavior.[1] But such anthropological terms may simply mask the problem—and postpone the labor of analysis—insofar as they beg the principal question: what constitutes a "field of communication" *prior* to the cultural forms themselves? Wouldn't it be circular to argue that *santos* communicate the "same" meaning to all members of their heterogeneous collective audience? Part of the interpretative challenge is *naming* New Mexico's cultural identity: to begin, being "Spanish" in New Mexico is certainly not interchangeable with being "Spanish" elsewhere.

The methodological challenge that *santos* present is the possibility (or impossibility) of reconstructing their signifying power in terms that were meaningful to their original audiences. What happens when the pictorial systems of unrelated cultural traditions are conflated? Although previous scholars have assumed that the artists who made *santos* looked only to European sources, the burden of proof really lies in the opposite direction. There is no guarantee that an artist would not use motifs and pictorial conventions from a culture other than his own—on the contrary, this is what artists often do. Moreover, neither the artist nor the artist's audience necessarily attaches the same meaning to an appropriated motif or convention that it had for its previous audience in a different context. Nor can it be assumed that all viewers attach the same meaning to a motif, especially when it is inserted into a new representational system. Is the stylistic "hybridity" of such an artistic image *merely* formal, or do these works of art also communicate differently to different audiences? The conditions of reception are even more complex when the audience itself originates from a variety of cultural settings unrelated to one another. How do artistic images convey culturally shared meanings to a heterogeneous audience? And how much can be recovered from the surviving record of a society in which diverse artistic traditions have interacted for generations and even centuries?

Objections to the term "hybrid" because it is rooted in the nineteenth-century "science of race" have been rehearsed extensively in recent years, as have

1-1. Pam Gagner, photographer, Penitente Canyon, *Virgin of Sorrows,* 1995. Photo in the collection of Claire Farago.

A colossal image of the Virgin is painted high on a secluded canyon wall in the San Luis Valley, southern Colorado, site of *cofradia* processions associated with the reclusive Penitentes as recently as 1960. The merging of image and land continues in altered Christian form an ancient Native American tradition of rock art.

justifications for empowering the word now with different connotations.[2] Whether the term itself, or others like it, will endure or not is beside the point. What matters is our understanding of the conditions that "cultural hybridity" attempts to describe: in colonial societies where the authority of texts and other forms of artistic representation are destabilized by multiple viewing perspectives, "identity" itself is in the process of formation.

Ethnic Origins

A brief overview of the ethnic origins of New Mexico's population can suggest what is involved in reclaiming the many cultural traditions that contributed to the region's dynamic artistic identity. What we refer to collectively as the Pueblo Indians comprise seven distinct linguistic groups belonging to four different language families that have lived in the region since at least the thirteenth century.[3] Although the Pueblo Indians resisted outside intrusion from first contact with Europeans, the nineteen Pueblo towns that exist today are partly a product of colonialism. While there is considerable disagreement on how Pueblo identities have changed, there is no question that more than 100 settlements existed when Europeans first passed through the region in the mid-sixteenth century. Athabaskan and other, Plains Indians brought their own linguistic histories and material cultures into the region shortly before Europeans made contact in 1539, and perhaps earlier.

The colonists who began arriving in 1598 were also culturally and ethnically diverse: they came from Mexico City, Zacatecas, Nueva Galicia, the Iberian Peninsula, Africa, and elsewhere. It used to be assumed that a small core of twelve intermarried Spanish families who formed the local aristocracy were the "pure" Spaniards of New Mexico, but the genealogical records recently brought to light explode this view: in this volume, José Esquibel presents extensive new archival evidence that even the "pure Spanish" families were ethnically mixed when they arrived.[4] Sephardic Jews recently converted to Catholicism may also have been a significant, distinct cultural presence from the early colonial period, although, at this writing, their identity remains entangled with that of Eastern European Jews who immigrated as tradesmen during the U.S. territorial period (1848–1912).[5] After Mexico won its independence from Spain in 1821, and even more so after New Mexico became a U.S. territory, other Europeans and Anglo-Americans settled in significant numbers, adding further diversity to a heterogeneous population that had intermarried for 150 years.

The cultural identity of New Mexico is even more complex than the diverse ethnic origins of its population suggest. Although segregated by lifestyle, the inhabitants interacted intensively (in asymmetrical relationships of power, of course) on several levels: economically, through warfare, and via intermarriage. By 1629, twenty-six friars had built fifty churches with native labor and reportedly baptized 34,650 natives, the official report giving an optimistic figure larger than the entire estimated population.[6] Beginning around 1640, a protracted period of contestation between the regular clergy and the provincial arm of the viceregal government over their respective rights to exploit native labor resulted in a temporary alliance among Pueblos to throw off their Spanish oppressors. The Pueblo Revolt of 1680 was directed against the Franciscans and the *encomienda* system of forced labor. The revolt forced the settlers south to El Paso for fourteen years, until the Pueblo peoples, who had begun to quarrel among themselves, were suppressed by the Spanish military under the direction of Governor Diego de Vargas over a ten-year period of internal civil war.[7] Colonists returned in 1693, now including new ethnically and culturally diverse people recruited specifically for their agricultural expertise and artisanal skills, that is, the human resources necessary for the colony to be self-sustaining. The colonial era after the failure of the Pueblo Revolt is known as the Resettlement period.

When the Pueblos united in 1680 to force the colonists out, some Native American inhabitants fled

the turmoil by joining the *Dineh* (Navajos) in their heartland along the Pecos River in northwestern New Mexico, a region known to outsiders as Gobernador Canyon. Consequently, the *Dineh* heartland became the site of new, intensive interactions among distinct native cultures. In the 1750s, Utes attacked the region north of San Juan Pueblo, forcing Navajos south and west from their homeland and impelling them into conflict with the western Pueblos of Zuni, Acoma, Laguna, and Jémez. These protracted interactions produced unprecedented styles of pottery, which share many formal elements with the renewed production of Christian religious art during the Resettlement period (see Figs. 1.a.1., 1.a.2, 1.a.3. 1.a.4).

The Production of Religious Images

In the Resettlement period, the eastern Pueblos coexisted with new settlements of farmers and artisans, all intimately connected by their physical setting in the Rio Grande Valley (Fig. 1-2). Though segregated by lifestyle and language throughout the eighteenth and during a large part of the nineteenth century, the valley's inhabitants defended themselves against common enemies. The short-lived 1837 and 1847 Taos revolts against newly independent Mexico indicate the political solidarity of villagers and Pueblos acting jointly to oppose encroachment on their land.[8] These groups also intermarried to some extent, and exchanged goods and labor with one another, largely because of the tribute system imposed on the Pueblos by the provincial viceregal government. Pueblos supplied Hispanic households with textiles, pottery, baskets, food, and labor.[9] Thus native imagery, dynamic in itself, was part of everyone's daily environment and is therefore central to any study of New Mexican colonial art.

The traditional view of the *santos* neglects and oversimplifies the conditions of production and use that were imposed by their religious function in a colonial state. Whether Indian-authored or not, Spanish colonial religious art always involved negotiations between natives and colonizers, because it was used

as one of the principal instruments of conversion, in a society where conversion was the Church's paramount task. As a result, the images themselves are laden with contemporary European ideas, not only about religion, but also about the function of art and the nature of Indians. Following the last session of the Council of Trent in 1563, which issued a decree on the appearance and proper use of religious images (discussed further in Chap. 11), ecclesiastic art theorists endorsed scientific styles of naturalism to disseminate Christian doctrine to a "universal audience" at home. The Church of Rome exported the same ideas to European colonies overseas.

Longstanding custom, supported by literary theory, gave artists, like poets, both the right and the responsibility to interpret their assigned subjects. In the Tridentine period of Church reform after 1563, conflicts arose over the extent to which the license of artists interfered with the Church's desire to regulate the appearance of sacred images. The connections that ecclesiastics made among naturalism, universality, and orthodoxy are complex—and far from univocal—but their basic formulation about appropriate religious images can be simply stated: Sacred images that correspond exactly to Scripture and imitate the way that the world appears directly through the sense of sight were presumed to be universally comprehensible, regardless of their audiences' cultural, linguistic, or even cognitive differences. Thus they were considered—erroneously, as it turned out—to be an ideal way to disseminate Christian doctrine, especially to the illiterate.

The perennial problem with this religious theory of images is that art constructed on the European model of perception—that is, art that imitates the direct perception of nature by the sense of sight—was understood differently by colonial audiences who had only remote access to the European context of discussion. Nevertheless, the European system of optical naturalism—knowledge of perspective and anatomy, the modeling of volumes and depiction of lighting in general—constituted the basis for new cultural hierarchies established by those with the power to "write culture."

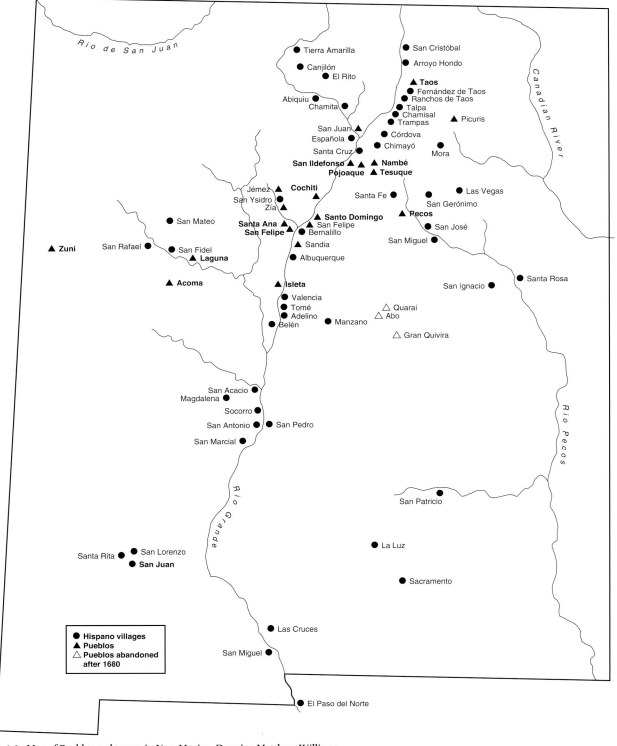

1-2. Map of Pueblos and towns in New Mexico. Drawing Matthew Williams.

From what is known about the friars and priests who oversaw the production of religious images in the Spanish colonies, they understood their salvific mission in Aristotelian terms, judging the mental capabilities of their converts and potential converts according to their forms of society and artistic products.[10] The earliest sixteenth-century discussions focused on the degree to which the Amerindians, unrecorded by any ancient authority, were rational creatures worthy of the name "human."[11] Some apologists for the Spanish crown regarded the indigenous populations of the American continent as examples of Aristotle's "natural slave," described in Books 1 and 3 of the *Politics* as lacking in the higher faculties of the human soul; others saw the American populations as "nature's children," who possessed reason only potentially and were therefore truly unrational.[12] Fray Bartolomé de Las Casas, the most famous sixteenth-century European apologist for Amerindians, compared the arts of the Old and New Worlds to prove the rationality of Amerindian peoples. (In 1537, Pope Paul III issued a bull declaring that the Indians were human beings whose rights must be respected.) Acutely aware of the danger of classifying outsiders as

The inhabitants of many pueblos joined forces with their traditional enemies in the Navajo (Dineh) heartland of Gobernador Canyon in northwestern New Mexico to escape Spanish domination after the reconquest of 1694. This exiled group produced unusual pottery forms with striking painted designs that document the interaction of many Indian subgroups now in even closer contact than they had been in the Rio Grande Valley. The unusual ceramic designs on vessels recovered from Gobernador Canyon are among the earliest pieces of historical Pueblo pottery that share formal characteristics with the rich border decorations characteristic of *santos* produced in northeastern New Mexico since the mid-eighteenth century.

By the beginning of the eighteenth century, Pueblo artists incorporated new motifs at a rapid pace, inspired by items of everyday colonial life, such as trade goods, as well as by ancient pottery designs, such as those connoting rain and weather patterns associated with prayer and fertility (Scothorn, "Pueblo Women, Colonial Settlement," 19–20). Often the motifs had multiple cultural sources, a feature they share with many *santos*. The undulating lines and star motifs in the nineteenth-century storage jar (Fig. 1.a.4) point to European influences, while the shape of the jar reflects a Spanish unit of measurement called a *fanega*. This jar held about half a bushel, or half a *fanega,* of goods, such as seed, paid in tribute to the Spanish settlers (Snow, "A Note on *Encomienda* Economics," 350). Boldly painted designs and new shapes, such as bread bowls, conformed to expectations of the Hispano settlers who bought them for daily use. Some motifs, such as the "Vallero star" seen on the Zuni Pueblo jar illustrated here, derive from Spanish sources traceable to Moorish decorative arts, but also suggest popular Pueblo motifs predating contact—in this case, a *hepakinne* or "sunflower" associated with fertility and the calendrical cycle (Scothorn, 21–22, citing Jonathan Batkin and Ruth Benzel, respectively). This may also be the symbol painted on an Ogapoge polychrome pot recovered from Gobernador Canyon (Fig. 1.a.1). On Gobernador, see Carlson, *Eighteenth-Century Navajo Fortresses;* Kidder, "Ruins of the Historic Period," 322–29.

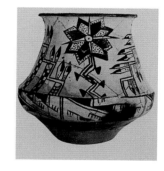

(clockwise from top right)
1.a.1. Ogapoge polychrome *olla* (water jar), eighteenth century. University of Colorado Museum (381), Boulder.

1.a.2. Puname polychrome *olla* (water jar), c. 1700–1750. University of Colorado Museum (382), Boulder.

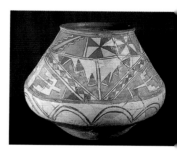

1.a.3. Zuni polychrome storage jar, c. 1850–1920. Museum of New Mexico, Museum of Indian Arts and Culture (16185/12). www.miaclab.org. Photo Blair Clark.

1.a.4. Santo Domingo or Cochiti storage jar, c. 1800–1850. Taylor Museum, Colorado Fine Arts Center, Frank Applegate Collection, gift of Alice Bemis Taylor, Colorado Springs.

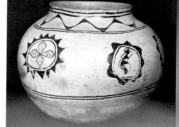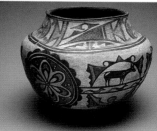

inferiors and believing that Amerindians possessed full potential for civility, Las Casas cited as evidence their skill in the mechanical arts, which, he argued, were, like the liberal arts, a function of the rational soul (*habitus est intellectus operativus*).[13]

Las Casas's arguments echoed ideas recorded by Italian art theorists who claimed that painting, sculpture, and architecture—traditionally numbered among the mechanical arts—deserved the same status as the more exalted liberal arts. Yet even as Las Casas defended the Amerindians' humanity, he helped to construct an inferior collective identity for the "New World." In his view, the Indians were merely *capable* of assimilating European culture (including Christian art and Christian social norms) under European guidance.[14] Moreover, his praise of Amerindians for their skill in the mechanical arts positioned their capabilities at a level inferior to that being argued for painters, sculptors, and architects in contemporary European debates on the status of the arts.[15]

Against this general background of Catholic Reformation culture, New Mexico offers a challenging case study for the recovery of indigenous contributions to colonial art, because the kinds of textual sources that have made it possible to document Nahua-Christian relations in central Mexico, for example, are completely lacking. The first question to ask is why there are no written records pertaining to New Mexico's colonial art. The answer is partly that Las Casas's efforts began during the first phase of evangelization, whereas the history of Christian art in New Mexico really begins with the *second* phase. During the first phase of evangelization, which began in 1523 with the arrival of twelve Franciscans at Tenochtitlan/Mexico City, Bernardino de Sahagún, Diego Duran, and other mendicants compiled extensive archives about native customs and beliefs with the assistance of learned native informants and native artists, ostensibly to enable the more profound assimilation of indigenous peoples into the universal Christian church.[16] Central to this effort was training clergy in the native languages—in particular Nahuatl, which

was the main language of commerce from Zacatecas in northern Mexico to Nicaragua. The existence of a dominant native language meant that during the first phase of evangelization Nahuatl became an instrument of empire to spread Christianity.[17]

In contrast, the Franciscans who missionized New Mexico lacked training in the native languages. Many reasons have been suggested for this situation, but the most significant is the Church of Rome's growing reservations about its success in converting native populations, expressed in a series of decisions to abandon religious instruction in the native languages. It is not the case, as Robert Ricard once argued, that the secular clergy abruptly forced the mendicant orders out of central New Spain in 1572.[18] The period of transition from regular to secular clergy was far more gradual, dependent largely on creole priests who slowly gained the upper hand in ecclesiastical matters. The mendicant orders were well entrenched throughout the seventeenth century, especially in rural areas. Moreover, 1572 also marked the entry into Mexico of the Jesuits, who reinvigorated the regular orders with new zeal and authority. The era of the primitive church—as the apostolic mission of the mendicant orders was called—effectively came to an end, not at the moment when a newly appointed archbishop first granted the secular clergy authority over the mendicant orders, but approximately two centuries later, in 1767, when the Jesuits were recalled from all Spanish dominions by Pope Clement IV, who dissolved the Order in 1773.[19]

In this gradual process of secularization, many factors came into play to differentiate the effects of colonization in various locations. In central Mesoamerica, significant social factors contributing to the local production and reception of material culture included a highly concentrated urban population in places such as Mexico City, the hierarchical social structure of the Aztec state, the imperial Aztec tribute system, an organized indigenous priesthood with a well-developed pantheon of anthropomorphized deities in many ways similar to the Catholic panoply

of saints and holy figures, and the existence of a widely disseminated pictorial writing system. In 1598, constrained to evangelize on the remote northern periphery of New Spain, the Franciscans undertook their first major effort of conversion since 1572. By contrast to the situation farther south in Mexico where the Franciscan expeditions originated, the colonizers encountered a sparsely settled, arid region supporting a subsistence lifestyle that was by nature and by cultural choice antagonistic to material displays of wealth and power. The region was inhabited by small groups of indigenous peoples, some sedentary and others nomadic, whose egalitarian social organization was very different from anything the colonizers could ever have known, who spoke hundreds of local dialects, and who maintained no uniform system of literary or visual artistic representation.[20]

If New Mexico had been missionized by the Franciscans in the *first* stage of evangelization, their ability to communicate with the natives might have been very different. Language training, ethnographic studies, and, above all, the preparation of devotional materials in the native languages might have been encouraged despite the obvious practical difficulties initiating very different cultural interactions. However, because New Mexico was missionized *after* the Catholic Reformation Church's decision to abandon training in the native languages, Church and state were severely limited in their capability to convey complex points of doctrine and law. It was difficult to assimilate native populations in these social and economic circumstances anyway, but the lack of language training placed greater pressure than ever on images to communicate.

For the Franciscans, who in any case placed a strong emphasis on the visual and the mystical (as opposed to the textual and the intellectual), these limitations were not as restrictive as they must have been to others. The earliest surviving Christian images in New Mexico, decorative fragments of murals in now-ruined early seventeenth-century mission churches, are similar to elements of surviving wall paintings that were executed at Pedro de Gante's Franciscan school in Mexico City and elsewhere on the basis of imported European engravings.[21] Yet it is important to bear in mind that the methods used at de Gante's school, for example, as depicted by his student Diego Valadés in 1579 (Fig. 1-3), would not have worked in New Mexico simply because the priests did not share a language with the majority of the population. Transposed to the circumstances in most Pueblo mission churches, this picture would have had to include a native interpreter to translate Fray Pedro's explication of the narrative scenes he is using to convey Christian doctrine and practice to his native audience.[22] On the northern frontier, the lack of a shared language discouraged attempts to illustrate complex doctrinal ideas that might have required verbal explanations. The Franciscans did not prepare prayers and other ritual materials for this region, as missionaries did elsewhere. Henry Kelly writes that the missionaries were ordered to instruct in the native dialects "in accordance with La Nueva Recopilación," but they ignored the royal law because of the bewildering number of dialects.[23]

Narrative scenes are almost nonexistent in New Mexican art. Instead, most surviving locally manufactured New Mexican colonial religious art portrays individual saints and other holy figures, in keeping with Catholic Reformation emphasis on exemplary visual material and specifically in tune with Franciscan mysticism, which interpreted Christianity as primarily a spiritual practice based on imitating the lives of Christ, Saint Francis, and other saints.[24] An image of a saint or other holy figure is a vehicle, that is to say an intercessor, between the human and divine realms. It appeals to the human imagination through the sense of sight to facilitate the purgation of the soul—the process generally referred to as religious *imitatio*. The depiction is a tool in the internal healing process (which reforms the soul, leads it to grace). The artist's personal style, and the ornamental borders and settings that help to set off the sacred image from its surroundings, engage the senses in the

artistic depictions are denotative and praiseworthy if they (a) are recognizable and (b) do not distract from their religious content. Ornamental borders, landscape settings, and other visual elements in religious images are incidental to the subject and should not compete for attention with it. It is this assumption that explains why so many writers conflated issues of religious decorum with issues of artistic quality judged in terms of European norms.

How the category of "visual" art is ideologically freighted is a complicated matter, however. The extent to which style—particular kinds of pictorial artifice—served the clarity and purpose of the depiction was a continuing matter of great importance before, during, and after the Catholic Reformation, as discussed in later chapters.[25] It would be a drastic oversimplification to assume that the colonists' religious attitudes were identical with those of institutionalized religion.[26] The historical record documents a wide range of responses to eighteenth- and nineteenth-century New Mexican *santos,* from some contemporary ecclesiastics who found them so defective that they ordered them destroyed, to early twentieth-century art collectors whose aesthetic pleasure, though genuine, nonetheless lacked historical and religious understanding.[27]

The other principal reason why New Mexico's Spanish colonial religious art is largely undocumented is that highly institutionalized forms of artistic instruction apparently did not develop in the region. After the era of San José de los Naturales, which closed at the death of its founder in 1572—a year that signals the waning of mural production—patronage shifted away from the mendicant orders toward the secular clergy. In Mexico and Peru, craft guilds, independent art academies, commercial workshops, and a brisk trade in imported academic paintings resulted in a legacy of colonial art including narrative subjects, iconic representations, richly articulated church interiors, portraits, and domestic furnishings.[28] Urban centers in central New Spain, moreover, continued to have other monastic schools of the manual arts and

1-3. Fray Diego Valadés, *Fray Pedro de Gante Preaching to the Indians,* engraving, from *Rhetorica Christiana,* Perugia, 1579, p. 111. The John Carter Brown Library at Brown University, Providence, Rhode Island.

process of attaining grace. The likeness of the image aids the beholder in recognizing another order of likeness, namely the formal identity of Christ (the visible God incarnate) with his invisible prototype.

According to any number of sixteenth- and seventeenth-century Catholic Reformation writers on art,

guilds. Itinerant artists (including indigenous artists), who were commissioned by private patrons, sold their work on the open market and continued to make *lienzos,* sculpture, *retablos,* and other liturgical furnishings. In New Mexico, while there may have been workshops at the village level, little is known about private patronage or artistic instruction and the transmission of artistic skills. New Mexico was remote from any urban center of artistic instruction. There is no evidence that the monastic education system the Franciscans established in 1523 at San José de los Naturales in Mexico City ever translated to the northern frontier. If these colonial forms of artistic training developed there, they left no trace in the archives.[29] Whatever continuities there were between craft production in central New Spain and its northernmost colony are likely to have resulted from the relocation of master craftsmen and the presence of traveling journeymen, as appears to have been the case in furniture production.[30] Corroborative evidence has recently been discovered in the form of archival records that indicate that a Santa Fe workshop under the direction of Governor Rosas employed Indian artists in Santa Fe as early as the 1630s, only three decades after the first settlers had arrived.[31] Rosas's workshop exported hide paintings to Puebla and farther south.[32] This new document, first published and discussed in the present volume by Donna Pierce, offers the earliest concrete proof to date that New Mexican artists were not exclusively Spanish.[33]

For a later period, emerging physical evidence indicates that leading artists sometimes worked together on the same altarpiece and even on the same panel, which suggests that a regional network of more or less "professional" *santeros* operated from the late eighteenth century on.[34] This does not preclude the presence of other image makers: as Robin Farwell Gavin points out in her contribution to this volume, the material record leaves no doubt that the European custom of replicating specific images was practiced widely, to serve religious needs. In any event, although ecclesiastics kept track of religious images displayed in mission churches and other sanctuaries where priests sometimes officiated, there is no evidence that the Church in general or the Franciscan order in particular regulated the manufacture or distribution of religious images until Archbishop Jean Lamy arrived in 1851.[35] Even then, increasing numbers of chromolithographs and other mass-media religious prints, paintings, and carvings of saints and other holy figures were produced in the private sector.

In the lay-dominated conditions of colonial and postcolonial New Mexico, not only the production but also the use of religious images was partly outside the control of the institutional Church. The employment of images in prayer, which Franciscan mystics since the thirteenth century had envisioned as an individual "spiritual practice" of *imitatio,* became a means of soliciting practical protection, often as a collective activity involving religious dramatizations, public processing of religious effigies to celebrate saints' days, and subgroup solidarity (in the *cofradías*). When New Mexico became a U.S. territory in 1848, the Church changed its reporting structure so that institutionalized Catholicism came under American control administered from Saint Louis. The first archbishop thereafter, the French-born Lamy, directed harsh efforts to rein in the lay communities. When he tried to oversee all confraternities, associating them with the Third Order Franciscans, persecuted groups became more secretive and even moved out of his jurisdiction to the San Luis Valley.[36] Currently, we are far from understanding the assimilative mechanisms produced in this historical process of sustained, coerced cultural exchange (see Fig. 2-1).

Negotiated Christianities Among the *Genízaros*

As a result of demographic shifts, martial conflict, and domestic trade, new cultural and religious identities were forged in eighteenth-century New Mexico. It is perhaps most accurate to talk about multiple negotiated Christianities. Regular and secular clergy contested each other's authority, as vexed exchanges in

the institutional records attest.[37] A second important arena of contested authority (although this is difficult to reconstruct from archival records alone) involved negotiations between clergy and lay Christian settlers, because Catholics always have direct access to the supernatural through sacred images alone, without the mediation of priests.[38] A third distinct arena of negotiation involved the Christianity practiced within the pueblos, which remain inaccessible to academic study today. Anthropologists argue against any profound assimilation of Catholicism into the Pueblo lifestyle, yet contemporary inhabitants of the pueblos include devout Catholics.[39]

One new ethnic subgroup that emerged in the mid-eighteenth century is particularly relevant to the present study. Throughout the eighteenth century, military campaigns were waged against nomadic Indians—Apaches, Navajos, Utes, and Comanches—who raided both Pueblo and Spanish-style villages. In the 1720s, when the nomadic Comanches replaced Apaches as raiders from the east, they also exchanged goods and captives annually (with the same settled communities they raided) at trade fairs held at Taos Pueblo. Captured Plains Indians of various backgrounds were sold and traded, many as children, by the Comanches to settler households as indentured servants. The term *genízaro* initially applied to these detribalized, Christianized Plains Indians, but it also came to be used for other exiled Indians, including Pueblo outcasts who left their traditional lifestyles as adults and brought extensive cultural knowledge with them.[40] Beginning in the 1750s, land grants were made on the perimeter of Hispanic settlements to *genízaros* from the barrios of Albuquerque and elsewhere who had fulfilled their terms of indenture. The main purpose of the *genízaro* land grants was to establish a defense system to protect the interior from Indian raids: *genízaros* had to provide militia service to defend their own communities and the province as a whole.[41] These settlers soon established themselves as an upwardly mobile social class consisting of farmers and artisans at Abiquiu, Carmel, San Miguel del Vado,

Belén, Tomé, and elsewhere. Some of these communities included sizable numbers of Pueblo residents.[42] *Genízaros* also lived in the Pueblos of Isleta, Santa Clara, Taos, San Juan, and elsewhere.[43]

In zones of intensive ethnic mixing like the *genízaro* villages, especially in the period from c. 1750 to 1860, people with limited knowledge of any given cultural tradition—but with a demonstrated capacity for negotiating between cultures—united against common danger. Penitential societies, the most widely practiced form of community-based devotion outside the pueblos, multiplied rapidly in the 1830s and 1840s, indicating that a culturally fragmented population was creating new, cohesive forms of social organization at the village level.[44] As these lay religious organizations simultaneously sought spiritual aid and gained mutual social protection, they created an increased demand for sacred images.

During the next decades, however, as Roxanne Ortiz argues in her study of land grants and water rights, the *genízaro* communities rapidly lost control over their own means of production as wealthier Mexican and Anglo-American speculators bought up their land and water rights, forcing the *genízaro* communities into a dependent status.[45] Meanwhile, trade with the eastern United States increased. In 1851, shortly after New Mexico became a U.S. territory, the new Archbishop of Santa Fe Jean Lamy and his French staff arrived and began encouraging the "Spanish" population to use imported prints—especially chromolithographs—in place of locally manufactured *retablos* and *bultos,* which the French priests considered too crude to venerate. All these developments contributed to an exceptionally complex and sudden economic transformation and a new discourse of cultural difference grounded in the process of capitalism. By about 1890, cultural experts—archaeologists and historians—were dividing the productions of New Mexico's colonial society into two categories, Native American and Spanish. These categories remain in place today, their constructed, hierarchical nature and European bias largely unacknowledged.

Are there any identifiably "New Mexican colonial" cultural products that predate the constructed dichotomy? The confluence of Indian and Spanish traditions in textile and furniture production, and in architecture, is recognized.[46] Stone tools and utilitarian pottery recovered from *genízaro* village sites are technologically identical to those produced by long-standing Pueblo methods.[47] Furthermore, Ross Frank presents convincing evidence that decorated Pueblo wares datable to c. 1780–1810 were influenced by the tastes of the *vecinos* (a term used in archival records to designate Hispano neighbors of the Pueblos), who controlled a prospering export trade in Pueblo ceramics to southern markets following the smallpox epidemic of 1780–81 and the Spanish-Comanche treaty alliance of 1785.[48] Frank argues that, as *genízaros* joined the dominant sector of the population and prospered economically, they took over areas of production in which the Pueblo Indians (definitively reduced by the epidemic) had previously dominated.[49]

Ross Frank is the only writer who has ever noted the visual affinities between this transitional, Europeanized Pueblo pottery and the religious art that New Mexico artists began to produce around 1780.[50] While it would drastically oversimplify a complex, hierarchical social network to suggest that all *santos* originated in socially and geographically marginal communities of mixed cultural and genetic roots, the economic boom beginning in the 1790s coincides with the most concentrated local production of Christian devotional art—a synchronicity that this study explores.

Although very little is known about Christianity within the pueblos during the historical period, it is doubtful that many *santos* accessible today originated in the context of a Pueblo lifestyle. The locally made Christian art of eighteenth- and nineteenth-century New Mexican villages is, on the other hand, an accessible product of the region's complex, heterogeneous colonial identity. Unlike transitional Pueblo pottery produced at the same time, pre-twentieth-century *santos* were never intended for commercial markets outside the immediate community. They were not produced by means of coercion, as (in Frank's view) Pueblo ceramics were. Rather, *santos* appear to be the self-expression of an upwardly mobile, ethnically complex class of settlers from highly diverse cultural backgrounds, living in the three urban centers of Santa Fe, Albuquerque, and Santa Cruz; in outlying villages; and on the frontier. These people withstood natural disasters, raiding Indians, land speculators, and manifold other human conditions that elicited pleas for health and salvation. The engaged spectators who initially used the *santos,* then, were probably not disturbed if their images diverged from the iconography or style that the Church of Rome sanctioned. And our own view, that local forms of knowledge on both sides of the Atlantic contributed to the imagery of New Mexican *santos,* would have seemed beside the point.

2 | THE SEMIOTICS OF IMAGES
AND POLITICAL REALITIES

CLAIRE FARAGO

To claim, as some have, that the Indians only "accepted" Christianity because it was
so thoroughly drubbed into them under Spanish occupation, is a demeaning ration-
ale. It implies in fact that the Indians were a servile people. Such an argument denies
the Indians yet another vital trait of universal human nature.
—Samuel Y. Edgerton, *Theaters of Conversion,* 3

The emergence of modern nation-states in the mid-nineteenth century coincides
with one of the most sustained periods of mass migration within the West and
colonial expansion in the East. New Mexican religious art of the Spanish colo-
nial and postcolonial eras, like the minority literature of British India in Homi
Bhabha's analysis, is "more hybrid in the articulation of cultural differences and
identifications than can be represented in any hierarchical or binary structuring
of social antagonism."[1] The production of New Mexican *santos* emerged during
the same period of rapid expansion of trade and participates in the same demo-
graphic shifts that Bhabha describes. Patterns of international trade that elude
any simple center-versus-periphery model inform Donna Pierce's historical dis-
cussion of style in the next chapter.

In this chapter I try to articulate significant theoretical implications that the
innovative New Mexican Catholic imagery raises for general theories of represen-
tation and for debates about cultural property and museological processes. How
can we interpret the visual traces of intersubjective religious experience under
such culturally complex conditions? And who are "we" to do the interpreting?

Current discussions of how "meaning" is shared are no longer concerned pri-
marily to explain referentiality, because it is now widely recognized that referen-
tiality constitutes only part of meaning's domain. What needs to be better
understood is *how* a sign means—meaning defined as a process. When semiotic
approaches are transposed to the study of visual signs, however, the terms of dis-
cussion often slip from culturally determined categories to presumedly universal
perceptual categories. But, of course, the Western tradition of writings about
perception, cognition, and "representation" is itself culturally specific, not univer-
sal. The Aristotelian analogy that art imitates nature—which has often been

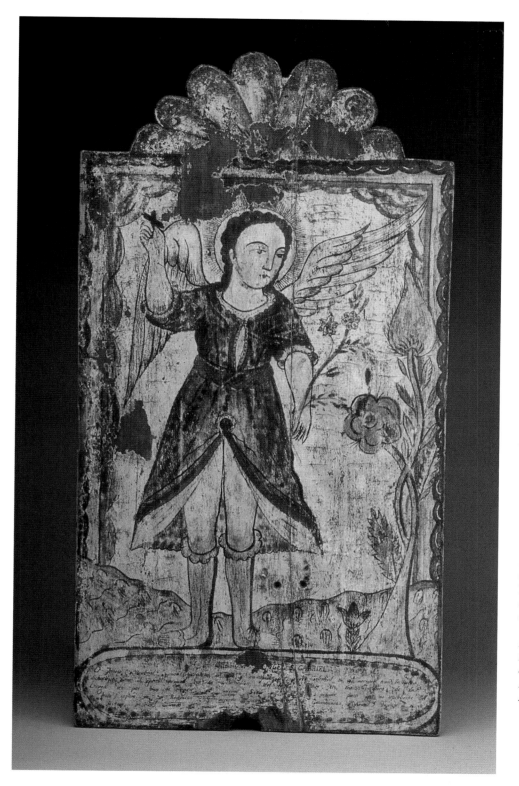

2-1. José Aragón, *The Archangel San Gabriel,* gesso and water-based paint on wood panel, signed José Aragón and dated 18 February 1825. Museum of International Folk Art (A.21.58-1), Santa Fe, New Mexico.

Inscribed ORACION AL ANGEL S. GABRIEL. *O glorioso S. Gabriel yamado por fortaleza de Dios y embajador del Padre celestial tu qe meresiste trair la nueva, dichosa para la genera humana; de la encarnacion del Hijo de Dios en las entrañas de la Virgen. Ven por bien de rogar al mismo Señor por un . . . pecador para que me aprobeche del fruta copiosa de su Redención y meresca gozar de aventuranza. Amen. Se pinto el 18 Febrero de 1825 y firme en este qe yse a mano de D. José Aragon* [Prayer to the Angel Saint Gabriel. Oh glorious Saint Gabriel, called by the power of God as ambassador of the heavenly Father, who was worthy to bring the glad news to mankind of the incarnation of the son of God in the womb of the Virgin; be good enough to pray to the same Lord for a . . . sinner that I may be granted the copious fruit of His redemption and deserve to taste blessedness. Amen. Painted the 18th of February of 1825 and signed in this (day) by the hand of don José Aragón]. Translation cited from Boyd, *Popular Arts of Spanish New Mexico,* p. 369. There is another version of the same composition with slight variations in costume and inscription, identified as The Guardian Angel and also dated 1825, in the Taylor Museum (n. 1556), Colorado Springs. In this inscription, the painting is described as being "exhibited in the painting and sculpture studio of Don José Aragón" (*muestrario . . . del pintureria en la esculteria de/D. José Aragon*). This is the only textual evidence to date of the existence of workshops in New Mexico. Another, smaller version of this subject is dated 1835, and there are eight other dated *retablos* by the artist ranging from 1820 to 1835, the majority of them also signed. See Boyd, *Popular Arts,* 366–75; and Wroth, *Christian Images in Hispanic New Mexico,* 105–14, with a family history compiled from interviews with a descendant. José Aragón was one of the few nineteenth-century *santeros* who signed and dated his work.

interpreted as meaning that art imitates the way we see nature—is apparent in the earliest assessments of devotional painting in New Mexico, recorded by Europeans who condemned what they saw on the basis of their familiarity with representational conventions in the European academic tradition. Implicitly negative judgments persist in the scholarship even today, in assessments such as "simple," "lacking in three-dimensional depth," and "archaic looking," and in allusions to the "simple spirituality of the rural folk."[2] This language not only ignores technological factors but assumes the metaphorical relationship between nature and art that underlies Western styles of optical naturalism. Artists and spectators versed in non-Western pictorial traditions do not view Western pictorial conventions so "naturally." This is not because they are "untrained" artists but because they have a different *social* construct of the visual sign. The following four chapters of this study present extensive material and textual documentation, much of it never published before, for the heterogeneous social makeup of the New Mexico population; the rest of this book explains the artistic identity that developed in the wake of this intensive, prolonged *social* interaction.

Unfortunately the assumption that culture is genetic still pervades the concept of "style" in the modern disciplines of art history, archaeology, anthropology, and ethnography. For example: extensive material evidence and detailed historical records should cause us to question the standing assumption that all *santos* were made by Hispanic artists who looked only to European sources. Although the identity of individual artists is unknown in all but a few cases, there were no separate genetic pools in the population, which was ethnically complex from the first days of European settlement, and a significant portion of which was *mestizo* by the end of the eighteenth century. And no matter who the artists were, other factors contributed to the appearance of religious art produced in colonial New Mexico.

The evidence set forth in this study suggests that different sectors of the heterogeneous New Mexican

audience understood one another's visual signs and pictorial systems to a certain extent, but attached different values to the images that circulated among them. To give a preliminary example of the kind of "shared" visual motif that this study explores, the prominent plant forms in José Aragon's San Gabriel (Fig. 2-1), as the Archangel is often called in New Mexico, may be simply a local variation on the lily that Gabriel usually presents to the Virgin in scenes of the Annunciation—even though this is not an Annunciation scene. To an audience unfamiliar with lilies, this substitution may have made the conventional iconography associated with Gabriel more meaningful. At the least, we can infer that the inclusion of a large and elaborate flower is meaningful on some level, even if the specific intention behind it is a mystery.

While its stylization suggests that the artist utilized a textile or ceramic pattern of European origin as his immediate model, San Gabriel's flower (almost as tall as the archangel himself) bears a notable resemblance in its botanical features to the local bellflower (*Awéé'chi'í*, "baby newborn" in Navajo; Latin *Campanula parryi*) (Fig. 2-2), traditionally used by Navajo women to encourage the birth of a baby girl.[3] Herbal remedies were important in a society where other forms of medicine were scarce or nonexistent—ethnobotanical information was, therefore, a likely subject for intercultural exchange and cross-cultural understanding. The possibility that the prominent flower has some significance related to the health of its patron is also suggested by the circumstance that icons, generally speaking, are images intended to heal the soul. The depiction of a flower influencing the birth of a child in an icon portraying the angel who announced the most important birth in all Christianity to the expectant mother makes a certain amount of sense.

Regardless of the viewer's immediate cultural orientation, this artistic innovation may have simultaneously held little value for some viewers and been significant for others (those who understood the bellflower's medicinal value). From an orthodox Catholic point of view, the iconographic innovation does not

significantly compromise the religious function of the saint's portrait. The flower constitutes at most a minor "misunderstanding." But if the plant may be connected with the traditional power of icons to elicit supernatural aid, the new pictorial element might have functioned as a supplement to the icon's orthodox Christian meaning, rather than a rejection of it.

The flowers in Aragón's San Gabriel are unusual and prominent, yet they have always been overlooked in the scholarship. Such visual elements that may appear merely "decorative" or "ornamental" from a European perspective may in fact be signifying elements derived from other cultural traditions—even when the style of rendering is not. We are operating only on a hypothesis in the case of Aragón's San Gabriel, but other cases—such as the sixteenth-century Garden murals at the Augustinian convent at Malinalco, Mexico, studied recently by Jeanette Peterson and Samuel Edgerton—demonstrate that native imagery can be incorporated into a European genre without disrupting its visual coherence.[4] According to Peterson, precisely those areas of the Garden murals that were considered "ornamental" by European standards were sites of cultural resistance. According to Edgerton, the localization of the flora and fauna in the same images had the full blessing of the priests under whom the native artists worked.[5]

This raises a second difficult question, in many cases unresolvable, concerning artistic intentionality. Is this "localized" colonial imagery *really* a form of resistance or are we witnessing welcome innovations that did not (in the missionaries' view) compromise Christian content?[6] Recent attempts to understand colonial art as a dialogue between European and native cultures stress the ability of native colonial artists and audiences to participate actively in cultural assimilation. The most challenging and disputed issue is not what survived or where, writes Peterson, but *how* and *why*.[7] And, in the case of New Mexican *santos,* where the evidence is largely limited to undocumented works of art, there is an additional theoretical challenge: can anyone's intentions be reconstructed from the surviving record?

2-2. Bellflower (*Awéé'chí'i,* "baby newborn" in Navajo; Latin *Campanula parryi*). After Mayes and Lacy, *Nanise: A Navajo Herbal,* p. 14.

The Parry bellflower is an erect, single-stemmed herbaceous perennial, reaching a height of 6–10 inches. The plant is sparsely leaved and bears one nodding, purplish-blue flower at the top. Its blue pollen was used in many Navajo ceremonials and is still used in the Blessing Way medicine.

Ways of Worldmaking with Objects

The theoretical challenge before us is to account for the ways in which New Mexican Christian icons—regardless of their artistic antecedents—constructed meaningful worlds for their original audiences. But how are we to define "meaning"? Technical art-historical scholarship focuses on establishing the identity of the artist, the date of the work's execution, and the subject matter or iconography of the image. Of course, this information constitutes "meaning" only

for the connoisseur, the collector, the academic, not for the worshiper, who attaches personal, religious significance to his or her patron saint. The problem of deciding whether or not a stylistic element means something to the beholder is aggravated when different cultural traditions collide. How do we account for the culturally determined predispositions of different spectators in front of the same objects and images, which might incorporate elements from previously unrelated artistic traditions, without falling back on discredited assumptions of cultural coherence or of individual free will?

Full recovery of the worshiper's "meaning" is in any case impossible, even if every bit of evidence survived, simply because the relationship between an individual worshiper and the religious instrument through which he or she engages the supernatural is a private one. In other words, what an image of a saint meant privately to an individual is beyond the scope of historical reconstruction. We do, however, know that the relationship among worshiper, work of art, and the supernatural is contractual: the icon, votive, or other material object functions as the outward manifestation or sign of agreement: "I Maria Lucero beseech Nuestra Señora de los Remedios to intercede on my behalf. If God grants my wish, I will dedicate X [prayers, a votive painting, a new statue, a pilgrimage, a promise] to Her." The visual sign is both the intercessor between the quotidian world of the worshiper and the divine realm, and the equivalent of the enduring signature on a contract or a handshake in a verbal agreement: it cements the deal and it is a constant reminder of the vow.

The visual sign does not necessarily "reveal" its meaning—the visual hides as much as it shows. A New Mexican *santo,* like any other icon, is valued by individual worshipers for its efficaciousness. The personal significance that an icon has for its owner or devotee is private, beyond the reach of historical recovery in most cases, and subject to change every time the saint intercedes on behalf of the devotee. The worshiper does not actually worship the images—the worshiper appeals to the saint *through* the image, as a mnemonic aid; but this distinction is not always clearly maintained. A particularly efficacious icon may even be ingested, like medicine, as if the curing powers of the saint were present in the material image.[8] When the saint does not do whatever might be asked of him or her, the icon may be "punished" by being turned to face the wall, or put in a drawer.[9] If the saint responds, on the other hand, his or her portrait may be adorned with new clothes if it is a statue, or offered flowers, candles, incense, food, and other thanks almost as if it were a person (Fig. 2-3). Christian icons in New Mexico, as elsewhere, have lives of their own, reputations, good days and bad days—not unlike the human beings they portray—and needless to say, these images acquire more "meaning" over time.

Perhaps it is as such transactions cumulate that we begin to transcend the unknowably personal and move into the more accessible realm of historical reception. Social historians of art have tended to approach "religious meaning" from the perspective of institutionalized religion, and the lay Catholicism of New Mexico is no exception.[10] Even the most innovative studies of Catholicism in New Mexico assume that ecclesiastical authority in Rome provided the standard measure of meaning in religious images, but this is far from true even for the "Old World." Catholicism is not exclusively an institutionalized religion; the "meaning" of the *santos* is determined not just by the Church hierarchy, but by the religious practices of "secular" Catholics—those believers who are "of the world" and who practice what William Christian, in his study of sixteenth-century Spain, calls "local religion."[11] Recovery of this practice can be pieced together from oral tradition, from material evidence, and—as Carlo Ginsburg famously demonstrated about a man who was persecuted for believing that the world was made from rotting cheese—by reading between the lines of documents such as court records maintained in times of religious persecution.[12] New Mexico had its own varying local forms of

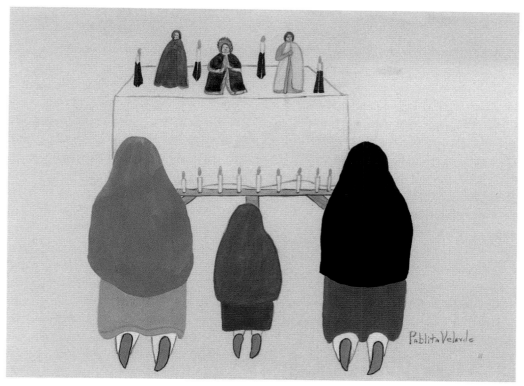

2-3. Pablita Velarde (Tse-Tsan), Santa Clara Pueblo, *Santa Clara Women Before the Altar,* watercolor, 1933. Dorothy Dunn Collection, Museum of Indian Arts and Culture/Laboratory of Anthropology, Museum of New Mexico (51455/13), Santa Fe. www.miaclab.org. Photo Blair Clark.

Catholicism: the subcultures of the Franciscans, of the Inquisition, and of immigrants from different parts of the Iberian Peninsula and the colonial Spanish empire. Pilgrimage studies attempt this kind of "recovery" of local religion. The *Penitentes'* annual observance of the Passion of Christ did involve a pilgrimage in the form of a dramatic reenactment. Otherwise, in New Mexico, aside from the presence of many devotional subjects associated with shrines farther south in what is now northern Mexico, which could have entered the region in a variety of ways, the surviving evidence does not suggest that pilgrimage—other than the processing of saints on feast days—was a dominant form of lay religious observance. Rather, the religious images that survive were associated primarily with individual domestic piety, family and community

chapels, urban churches, and a variety of other activities practiced by the *cofradías.*[13]

In the case of New Mexico, even recovery of *social* religious significance is problematic because of the unequal relationships of power in a colonial society. The imagery of the *santos* undoubtedly derives from European models.[14] Yet, as recent studies of colonial art almost everywhere else demonstrate, dispossessed cultural traditions often survive by assuming the pictorial language of the dominant culture.[15] Did this happen in New Mexico? How far can we recuperate such complex meanings from the historical record in the absence of direct textual documentation of patrons, artists, and concrete contexts of use? And—given the privacy issues around religious experience—how can we do so without perpetuating power inequalities?

Who Owns the Past?

Despite widespread acknowledgment of mass migrations and complex patterns of trade, the nineteenth-century legacy of nationalism still impinges today on New Mexican cultural studies, which are conducted in a highly politicized arena. Ongoing debates about the ownership of cultural property involve not only the physical remains of the past but also perceptions of the past. In New Mexico, the role of the critical historian is inscribed in a history of institutional repression of native belief systems and practices. What, responsible historians must ask in these circumstances, are the political consequences of our conclusions? As scholars supported by powerful state and private institutions, if we force access to knowledge that intentionally excludes outsiders, we reenact the historical role of the Church and state to police the actions of the community and impose the institution's normative values.

An important aspect of the longstanding debates over cultural property in New Mexico involves cultural difference over the right of individuals to obtain esoteric knowledge. Contemporary Western assumptions that knowledge should be accessible to everyone do not take into consideration Pueblo attitudes toward certain sacred forms of knowledge. According to Joseph Suina, who teaches at the University of New Mexico and is a resident member of Cochiti Pueblo, native esoteric traditions account for the unwillingness of contemporary Pueblo people to discuss their sacred beliefs with outsiders:

> Misinterpretation of Pueblo secrecy is partly due to differing views of knowledge held by different cultures. In the Anglo world, knowledge is highly regarded and its acquisition is rewarded in a variety of ways, including admiration of knowledge for its own sake.... But that is not the case in the Pueblo world. Like the Anglos, Pueblo Indians consider knowledge to be of high value. Some types of knowledge, however, are accessible only to the mature and responsible. This is particularly the case with esoteric information that requires a religious commitment.[16]

Many leading native scholars and community leaders are more extreme than Suina in their rejection of models that the academic mainstream considers progressive and revisionist.[17] A current dispute over the ownership of cultural property, involving the Hopi tribe and the Warburg Institute in London, is discussed in the Epilogue. The circumstances provide a poignant example of the way in which unexamined cultural differences lead to miscommunication and resentment. New Mexico presents the difficult situation that some of its potentially key participants in what Bhabha calls an "interstitial space" refuse the label of hybridity and reject the model of cultural pluralism.[18] Given this situation, how are we to assess and possibly recuperate Native American contributions to a complex, hybrid cultural practice that developed in eighteenth- and nineteenth-century New Mexican towns outside the pueblos? How should we respect the general unwillingness of the pan-Pueblo community—notwithstanding individual dissenters—to share knowledge and simultaneously refrain from reinscribing their resistance in some sort of romanticized discourse of idealized primitivism?[19]

To address this question, I first briefly situate the differences between Suina's and Bhabha's positions in the context of current discussions of native resistance taking place at a more general level, then move the discussion beyond oppositional frameworks into an "interstitial" conceptual space for conducting research on New Mexican *santos* in a manner that does not violate any community's right to privacy. Let me begin with the views of the anthropologist Richard White, who is highly critical of any postcolonial cultural identity grounded in the assumption that there exists a unified collective self. It is difficult to imagine Suina or most other Native Americans whose cultural heritage resides in the Southwest sympathizing with White's position, yet his criticism that "Indian people have themselves embraced a romantic vision of a sacred past" merits a response.[20]

Identity, White emphasizes, is a contestable and unstable notion: the false claims of earlier generations of scholars and curators are not necessarily corrected by replacing them with Indian voices. White favors

reconstructions of the Indian past that stress the conditions of cultural "porousness," by using materials that blur cultural boundaries. It is equally important, he maintains, to emphasize "the messiness of change" instead of creating a reverential picture of a lost and perfect past. The "museological process" itself—the compiling of exhibitions (and books, we add)—inevitably presents a past as it was discovered by scholars at a particular historical moment. What are displayed are often stolen goods or goods "confiscated by a foreign state engaged in cultural and religious repression and then conveyed to private collectors." Objects procured by these tangled means are conserved along with Indian craft items that were produced specifically for white tourist and collectors' markets, heavily influenced by the Arts and Crafts Movement of the late nineteenth century. Such items are far from being sacred in a traditional sense. The sacred and traditional world uncorrupted by cultural contact is but one imaginary response to our motley and messy world.

The museological enterprise, as White says, teaches "explicitly and implicitly, intentionally and unintentionally," that all life in America is hybrid and contingent. As realistic as White's portrayal of post-contact Native American material culture may be on some levels, it leaves out of the equation the right of any cultural group to a dynamic, self-described identity. Sensitivity to issues of self-representation accounts in part for the acceptance of Jackson Rushing as a non-Native American historian of Native American art among a wide spectrum of contemporary Native American artists.[21] A leading cultural anthropologist, Nicholas Thomas, also endorses a nativist position, precisely for its political effectiveness in promoting cultural pride and civil rights. Arguing that the same anthropological theories are heard differently when they are used by First World and by Third World peoples, Thomas describes the success of two recent traveling exhibitions of Maori culture. The exhibitions' "radical aesthetic decontextualization" excluded European influences of all kinds, yet the the-

oretical interest of this self-presentation lies precisely in its reproduction of anthropological systematizations.[22] Thomas is sympathetic to the transformation of such discourses to suit native positions; nativist consciousness, he argues, cannot be deemed undesirable merely because it is ahistorical and "uncritically reproduces colonialist stereotypes." Colonialist stereotypes and essential differences have different *meanings* at different times, and for different audiences. By promoting the legitimacy of Aboriginal culture at a time when it was not widely respected by the dominant population, the exhibition *Te Maori* involved "mobilization": it capitalized on white society's primitivism and created for the Maori a degree of prestige and power that did not exist before the 1980s.

In other words, in nativist discourse, essentialism plays a progressive role in forming a self-determined (or at least self-named) national identity that can be appreciated only in the *performative* realm. *Meaning,* as this study emphasizes throughout, is always, necessarily, determined by context. Thomas's recognition of the progressive role of native resistance is unusual among non-native anthropologists in cultural studies. Most of the advocacy comes from within the native communities themselves. Marie Mauze, editor of *Present Is Past: Some Uses of Tradition in Native Societies,* defends tradition as the expression of a conservatism "which is the touchstone of traditional societies," for tradition implies antiquity, continuity, and heritability.[23] Like Thomas, she advocates an approach that looks at the performative context in which a conceptual framework functions. Mauze refers to this context as the "conditions of instrumentality." What is at stake is the "instrumentalization of tradition as a conscious model in the construction of identity." Although Mauze endorses the contemporary quest for native identity in these terms, she also sees it as an unhappy symptom of a "possibly irremediable loss of meaning in a rather frightening world."[24]

Even this brief sketch of contemporary nativist arguments is enough to suggest concrete ramifications for academic investigative procedures. It is not

possible to move beyond the oppositional claims made in current debates over cultural property without considering the politics of knowledge production in mainstream scholarship. The categories and concepts used in arguments over ownership of intellectual property, including perceptions of the past, are inadequate to the task of revising ethnocentric accounts of history if they conceive of cultural artifacts within a Western, patriarchal conceptual framework. The initial step toward creating what Bhabha calls an "interstitial space" that actively accommodates nativist resistance, without romanticizing or otherwise appropriating it, is to make visible the broader conceptual framework in which the debates over cultural properties are conducted.

Dinosaurs and Dioramas

As an analogue for the methodological challenge before us, let me introduce a contemporary example of an artistically and culturally "hybrid," polysemic image. In 1994, when the artist Melanie Yazzie, who is Navajo, was a student in my graduate seminar on *santos,* she made a miniature diorama depicting one of her favorite childhood games (Fig. 2-4). Yazzie explained that when she was growing up on the reservation in Ganado, Arizona, she used to play a version of cowboys and Indians that the Indians always won: they imagined riding dinosaurs that overpowered the cowboys' horses in size, speed, ferocity, and intelligence. To this day, dinosaurs are her personal emblem.

It was relatively easy for an outsider (like me) to recognize appropriations, inversions, and substitutions of imagery that she drew from the contemporary popular culture that we share. The inverted narrative is legible in the diorama itself: the ubiquitous scene of cowboys and Indians brings back countless television shows and grade-B movies of the fifties, sixties, and even seventies, except that the Indians are winning. The inversion includes rather than excludes outsiders largely because it depends on humor in its

incongruous substitution of dinosaur for horse. Crucially important to this basic understanding of the narrative are the *means* by which the artist manipulates conventional popular symbolism to transform it into a unique statement—that is, the operations of inverting and substituting. In the humanist language of art appropriated from classical rhetoric, these operations make the image eloquent—in literary theory, they are figures with names such as *reflexion* and *metalepsis.*[25] It will be more useful to refer to them here in contemporary terms as semiotic operations.

In recent years, the word *semiotic* has been applied to the study of visual images in many different ways.[26] By about 1990, attempts to develop a theory of visual semiotics—in particular, a semiotics of art and architecture—ran into a brick wall, with no apparent way through the reductivist verbocentric models that transferred the categories of linguistic signification to visual practices. There is no insurmountable reason, however, that the semiotic analysis of verbal signs, which in general focuses on the socially constructed nature of signs, cannot serve as a useful frame of reference for understanding the signifying power of visual operations. Visual signs are easily transferred from one society to another—more easily than words—yet their meaning is also more readily mis- and reinterpreted. A widely held assumption of semiotic linguistic theory is that community agreement privileges some intersubjective meanings over others. The functional properties of any message derive from its use in a socially structured interaction—real communication, Bourdieu tells us, is possible only when we understand the artist's cues to hierarchies of power and status.

If the intersubjective codes are fragmented, or capable of different interpretations, however, then different viewers read the same image differently. That is, they have differential access to the images, depending on their cultural background, and they attach different priorities to the same imagery, depending on their orientation. The reception of images by different subgroups of a single, heterogeneous society is an excellent

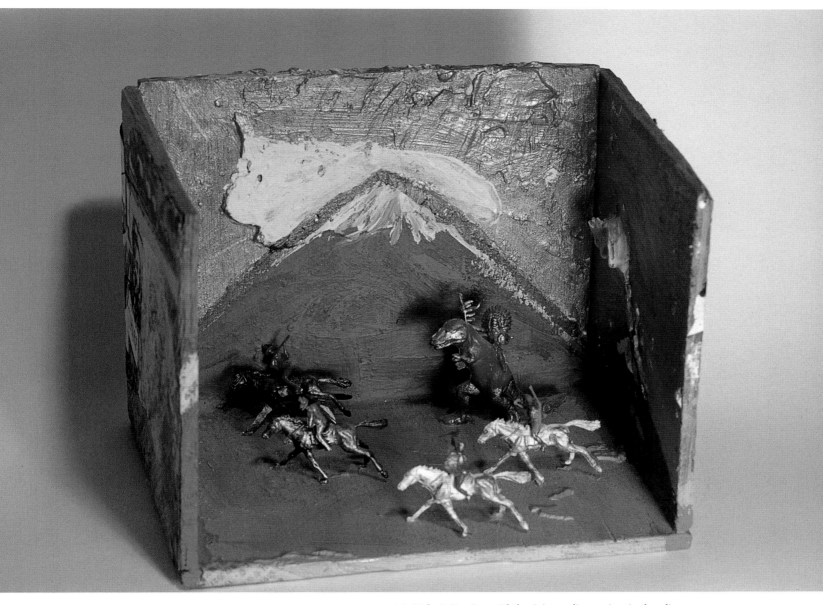

2-4. Melanie Yazzie, untitled, miniature diorama in mixed media,
1994. Collection Claire Farago.

test case for understanding the process of semiosis. The reception of images in these circumstances presents an ideal subject for investigating what semioticians (deriving their terminology from Freud's description of psychological processes) call condensation, the use of a single sign to refer to different and even unrelated and inconsistent meanings; and displacement, the substitution of one meaning for another.[27]

The two processes suggest *how* a plurality of viewing conditions always exists for a given image at the level of interpretation.

Semiotic operations, as defined throughout this study, are conceptual acts that operate through pictorial conventions to shape what viewers experience when they look at an image. If we did not understand how the artist redeploys conventional symbols, we could never understand when something unconventional is going on. A "good interpretation" of an object begins here, with an understanding of the cultural context in which the symbolism functions and the *mode* by which its meaning is generated. When Melanie Yazzie substituted a dinosaur for the Indian's horse, she opened up the interpretation of a conventional iconography to new possibilities that the artist cannot completely control. Her semiotic operations generated an open-ended range of meanings. It is not difficult to decide what role the dinosaur plays in her story: it is the hero, that much is clear. But why did the artist choose this symbol in particular?

Did Yazzie intend to refer to Native American myths about dinosaurs—and did she intend viewers to recognize the reference? The Navajo reservation in Ganado, Arizona, where she grew up, is in "dinosaur country," but a reading of this image in the context of Native American beliefs about dinosaurs demands specialized knowledge that is not accessible to outsiders. Did my position of authority in the professor/student relationship function analogously to the historical relationship between colonizer and colonized? And did Yazzie's playful narrative carry veiled native references to dinosaurs that she never shared with me? I turned to Vine Deloria's *Red Earth, White Lies,*

where the author, of Sioux heritage, argues that Indian myths about dinosaurs and other megafauna preserve a real cultural memory of lived experience on the American continent.[28] The core of Deloria's argument debunks the Bering Strait land-bridge theory, used to explain the arrival of humans on this continent only 13,000 years ago, as an unexamined leftover of cultural evolutionism. Deloria argues that the current scientific explanation for the populating of the American continent denies and discredits contrary scientific and cultural evidence for a much older human presence. Outrageous—and outrageously funny—as some of his claims are, Deloria's demand that Native American oral traditions deserve to be taken seriously critiques "science" driven by a racial paradigm whose unfounded assumptions are largely unrecognized by the scientists.

Deloria's account of native oral traditions is attested by interviews conducted with Sioux tribal elders at the turn of this century. The big bones found in the bluffs of Nebraska and Dakota were thought by the Sioux to be the remains of the *Unktehi,* giant monsters big enough to eat men.[29] These interviews shed new light on the significance of dinosaurs from a subordinate or marginalized position of power. Sioux myths and legends, observes W. J. T. Mitchell in his study of the dinosaur as a cultural icon, help to explain the curious tolerance shown by the Indians for faunal bone hunters: "dinosaur bones were not, like the relics in Indian burial mounds, sacred traces of the ancestors that it would be impious to disturb, but relics of enemies whose death had made Indian life possible."[30]

This testimony puts Melanie Yazzie's diorama in a slightly different light—further fueling my suspicion that her easy humor veils a second, more serious critique of institutional authority—but it cannot be used to reconstruct her conscious intentions (nor does it resolve my anxiety). To begin with, there are considerable differences among the views I have cited. And the correspondences among them are not enough to suggest a pan–Native American point of view about dinosaurs, or about anything else for that matter. On

the contrary, my point is that Melanie Yazzie's image invokes a range of cultural meanings that blur the boundaries between individual agency and a broader network of social relations.[31] The evidence just cited produces an open-ended chain of signification that extends from personal mythology to political processes and racially sensitive issues. Some of these associations may be shared by a Native American audience, broadly defined, but they are *not* shared by those who are unaware of Native American associations with dinosaurs. Yazzie's humor destabilizes cultural authority and elicits a certain emotional dissonance in certain viewers, perhaps not in others.

Semiotics of the Visual Sign

The doubleness of the images produced in New Mexico emerges from considering sources on both sides of the Atlantic. Pictorial mechanisms of substitution are interesting for their own sake, but in the present case they are also evidence of the destruction of existing symbolic orders and the emergence of a different, coercive colonial social system. The formal operations of substituting one motif for another that I try to describe below suggest a more general, transcultural process of appropriating visual motifs and putting them to new purposes. What became a strategy of survival and empowerment over an extended period involved many people whose views were partly the result of the visual symbols they shared and partly the result of social inequalities in the colonial and postcolonial world.

Once a visual symbol is appropriated from one conventional context and inserted into another one, meaning is destabilized. The appropriated figure may carry at least a trace of meaning from its former context into the new one, and the range of associations thus generated is difficult to arrest.[32] It matters less whether a certain meaning was intended by the artist than what range of meanings are located in that image by viewers.

When concrete symbols are appropriated for uses other than that for which they were intended, they can also destabilize existing social orders.[33] The

anthropologist Barbara Babcock, a specialist in Southwestern Native American studies, is interested in describing the strategies of destabilization themselves, at a general level, in theoretical terms. What she calls "symbolic inversion" refers to

any act of expressive behavior which inverts, contradicts, abrogates, or in some fashion presents an alternative to commonly held cultural codes, values, and norms, be they linguistic, literary or artistic, religious, or social and political. Although, perhaps because, inversion is so basic to symbolic processes, so crucial to expressive behavior, it has not, until recently, been analytically isolated except in its obvious and overt forms such as "rituals of rebellion," role reversal, and institutionalized clowning. Precisely because it is such a widely observed form of symbolic action and because the nature of symbols and of expressive behavior has become a focus of anthropological concern, symbolic inversion merits specific discussion.[34]

The concept of symbolic inversion was first formulated by Mikhail Bakhtin in writings on the ambivalence of all representation. For Bakhtin, the "carnivalesque" directly inverts the normal order of the world, just as normal social roles are inverted in actual Carnival celebrations preceding the Lenten season; and other writers have subsequently emphasized how participation in the "carnivalesque" blurs identity. This principle has been important for postcolonial theory, as the following section of this chapter elaborates further. Babcock correctly emphasizes that symbolic inversion plays with the classification system that constitutes its content *without* rejecting the formal structure itself. Thus, the relationship between a given taxonomy and its contents accounts for the ways in which new meanings are formed from old ones: symbolic inversion calls forth "enchantment with the form and veneration of the cosmic categories it embodies."[35]

Symbolic processes in general, and particularly inversion, coded in material objects, structure relationships between the body and space. David Morgan notes that material culture can also structure relationships between the body and space over time. The

material culture of religion—Protestantism is the subject of Morgan's research, but his findings are applicable to other contexts—provides forms of collective memory that play an important part in structuring and maintaining the symbolic universes in which we live.[36] Focusing on the daily environmental experience of individual subjects with such objects, Morgan sees his findings as challenging Kant's notion that aesthetic judgment is grounded in disinterestedness. Instead, Morgan argues, objects of religious contemplation testify to the sustained *interestedness* of viewers.

Morgan's theoretical model draws upon studies of identity by the University of Chicago sociologists Mihály Csikszentmihályi and Eugene Rochberg-Halton, who argue that people maintain their sense of self over time through artifacts in their daily environment, which in turn maintain traces of the past in the present and indicate future expectations.[37] For example: what the game of cowboys and Indians-riding-dinosaurs meant to Melanie Yazzie as a child changed considerably by the time she made it the subject of a graduate school art project. Yet continuities in the visual symbolism contributed to Yazzie's sense of her individual and cultural identity over time.

Toward an Intercultural Theory of Artistic Production and Reception

Polyvalent images present a theoretical challenge for general accounts of visual representation. The remainder of this chapter looks more closely at the nature of classification systems (Babcock's "cosmic categories") and their role in the process of semiosis, or signification. Pierre Bourdieu provides a useful point of departure for discussion because he emphasizes both the social role of art objects—that is, their symbolic value as material presences—and the importance of individual agency in a social network. Moreover, since his interpretative model is cited widely, his work provides common ground for what is currently an unfocused interdisciplinary effort to theorize objects. Bourdieu emphasizes that each individual is both a producer

and a reproducer of objective meaning. In Bourdieu's account, works always outrun the conscious intentions of their makers: "schemes of thought and expression" are not only the basis for intentional invention, they are also the basis for the "intentionless invention of regulated improvisation."[38] Thus human practice, though it exhibits a collective structure, is not rigidly predetermined. Bourdieu maintains that the only way to escape the crude model of style that views artistic practice as the product of obedience to "rule" is to play on the polysemous nature of the word *rule* itself: rules can refer to the social norm, to theoretical models, to schemes immanent in practice. The true medium of communication between two subjects, writes Bourdieu about immanent practice, is not discursive. The true medium of communication is the "immediate datum considered in its observable materiality."[39] Functional properties of the message, according to Bourdieu (and others), derive from its use in socially structured situations. Objectivity is secured by social consensus on the meaning of practices and thus of the world.

Bourdieu refers to the same phenomenon as embodied forms of cognition and collective memory. He coins the word "doxa" to describe the ways in which a traditional society makes cultural choices look "natural."[40] The *conventional* character of the social world can be recognized only when it loses its (culturally constructed) character as a *natural* phenomenon. And this happens only when groups come into conflict over "legitimacy."[41]

The notion of cultural schemes is familiar to art historians—above all, through E. H. Gombrich's notion that when artists "make" their representations, they "match" their own experience of the world with preexisting representations.[42] The originality—and strength—of Bourdieu's theory is his way of explaining agency without recourse to problematic psychologistic assumptions that we have direct access to the mentality of the maker. In reality, we have only the physical effects of mental operations: in the present case, anonymously executed religious images. The

weakness of Bourdieu's theory is its failure to account for disparities between artists and viewers, or among viewers, at the *collective* level. What causes some viewers to agree with one another and to disagree with others? And how are different opinions to be evaluated? Against a norm? Who decides what is normative? Gombrich's notion of schemes has been criticized for much the same reason. Because he assumes that "matching" nature is the artist's goal, his account of "schemes" is biased toward representational art and does not explain nonnaturalistic traditions of image making at all.[43] And even though Gombrich is sensitive to the manner in which cultural choices appear naturalized, he still assumes that his own account of schemes is the "correct" one. He never examines his own vested interest as a cultural authority.

What Bourdieu calls schemes immanent in practice include historical interpretations. The dialectic play between norms and immanent schemes enables the historian, according to Bourdieu's analysis, to construct a theory of the modes of generating practices: that is, a theory that can account for the capacity of members of a society to improvise—improvisation being to master the transformational schemes in a particular environment and come up with something new. Bourdieu wants to explain how observers comprehend cultural codes in a given cultural setting. He writes that mental structures are constructed through practice, that is, through interactions in and with a world of objects constructed according to the same structures.[44] The hybrid styles of artistic representation observable in so many New Mexican *santos* offer excellent examples of the outcome that Bourdieu describes as a process of introducing new meanings. Bourdieu's explanation sidesteps the problematic assumption of cause and effect, which implies that mental structures are precedent, which is nothing but an a priori (Platonic) idealist claim. Bourdieu specifically criticizes Panofsky's treatment of works of art as a discourse to be interpreted by means of a transcendent code.[45] Instead, he calls attention to the dialectic play between schemes immanent in practice, on the

one hand, and norms produced by reflection on practices, on the other hand, which, inevitably, introduce "new meanings by reference to alien structures."[46]

Bourdieu has also considered whether the artistic competence that the beholder brings to deciphering the work is (always) adequate. What happens if/when the competence of the originator and that of the beholder are not matched? In these "periods of rupture," Bourdieu writes, comprehension is illusory, based on a mistaken code.[47] For example, educated people dealing with foreign traditions are prone to ethnocentrism or class-centrism, when they believe that their way of perceiving is a fact of nature, rather than being one among many possible, culturally conditioned ways of perceiving, some of which are institutionally sanctioned, while others are not granted institutional authority.

By adopting this relativistic epistemological framework, however, Bourdieu assumes that he has dealt with the major problem in proposed accounts— namely, that the investigator's own socially constructed subjectivity remains outside the framework of evaluation. Although he has perhaps gone farther than any other theoretician to address the social effects and epistemological consequences of "mistaken codes" by insisting on the possibility that codes are "mistaken" and by insisting on the validity of "mistakes" that are not granted institutional authority, Bourdieu does not really come to terms with the complexities of a colonial society, and other heterogeneous, hierarchical sociocultural settings. In such settings, what may be viewed as "mistakes" from the perspective of the dominant cultural position take on new social functions as semiotic "shifters of meaning"—to use a linguistic and anthropological term that tries to describe resistance and other forms of reinterpretation neutrally, and simultaneously to classify a variety of effects in the same general terms.

In a more recent analysis of the socioeconomic role of artistic production in hybrid cultures, based on contemporary Central and South America, Néstor García Canclini supplies some of what Bourdieu and

Gombrich are missing.[48] Citing conflict between subgroups, García Canclini maintains that "hybridity" is the ongoing condition of all human cultures. He focuses on complex relations *within* social totalities, particularly the interactions of those who "suffer history and at the same time struggle in it," because these are the people who are continually working out the "intermediary steps": they have "no possibility for radically changing the course of the work" (i.e., history), yet they "manage the interstices with a measure of creativity and to their own benefit."[49]

Homi Bhabha, writing about the social effects of symbolic inversions in artistic representations, describes the condition that results when the distinction between minorities and majorities becomes blurred within a heterogeneous society. Bhabha (like García Canclini, and others such as Frantz Fanon, Trin Min-ha, and Gayatra Chakravorty Spivak) envisions an interstitial space that is constituted not as a "dialectic between the first and third person" (i.e., between "us" and "them"), but as "an effect of the ambivalent condition of their borderline proximity."[50] Bhabha's concept of ambivalence, developed by many postcolonial writers, suggests that the *process* of meaning formation, more than the meaning formed, is the legitimate object of investigation.

The nineteenth-century philosopher Charles S. Peirce introduced a semiotic concept of "meaning" as the translation of one sign into another, whether the latter is a component member of the same sign system or of another sign system.[51] A great advantage of Peirce's definition is that it allows any available resource to be transformed into a meaningful sign, including elements from other sign systems, the built environment, and the "natural" landscape.[52] Peirce's definition conveniently sidesteps the problem of cultural specificity that categories like "Spanish" or "Pueblo" raise. According to Peirce's definition, any "sign" can be appropriated from any context to any other, so it does not matter if a motif or visual sign is misunderstood relative to its place of origin—what matters is its signifying power in the new location.

At first take, this definition only defers the problem of interpretation. For if the "meaning" of a given sign is only a temporary position along a chain of signifiers, how do we ever decide what anything means? Yet what initially appears to be a weakness of Peirce's account turns out to be its greatest strength: Peirce understood that the chain of association—semiosis—is open-ended. What arrests "meaning" is context—as long as it lasts. The next problem is how to define the context of a sign in a way that recognizes change.

Linguists focus on the socially constructed nature of signs. Their discussions take place at the level of communication and interpretation, rather than taxonomy. What matters is that the verbal sign communicates with its audience. The conventional concept of a community of understanding leans heavily, however, on the problematic assumption of cultural coherence. The assumption that cultures are distinct entities with separate historical trajectories is Eurocentric, in the specific sense that political theorists like Samir Amin define the term in connection with European imperialism and the modern emergence of nation-states.[53] The concept of a unified culture does not take into account the actual, dynamic conditions of cultural continuity over time. Histories based on models of cultural coherence helped justify modern nation-states; they do not acknowledge the asymmetrical power relationships involved in the formation of those models or in the practice of colonialism abroad.

The Many Meanings of Things

As the foregoing discussion has begun to suggest, the reception of signs by a heterogeneous audience raises significant questions about intersubjectivity. Reception models treat aesthetic response only at the individual level. Does it necessarily follow that, just because the same sign means different things to different members of a heterogeneous society, "meaning" is determined only on an individual basis? The local variations on European iconography and style in New Mexican Catholic images (transformations that are

conventionally described in the existing scholarship as the "misunderstandings" and "simplifications" of provincial artists) suggest something different. The generation of new combinations from an existing body of visual signs can indicate shared understanding at the community level. And what determines community understanding is not genetics or preexisting cultural identities but, as García Canclini maintains, shared goals.

The goal of "secular" New Mexican Catholics was access to the divine through interactions with holy figures, visualized in effigies, paintings, statues, other static images, and religious dramas.[54] According to Peter Brown, tension between people and the institutionalized Church to control access to the supernatural has been an enduring conflict throughout the entire history of Catholicism.[55] Images are central to this history of struggle, but discussion of New Mexican religious art has imposed on the images a narrowly orthodox view of religion. For example, scholars have for generations noticed similarities between *santos* and contemporaneous Pueblo painting, in kivas (meeting rooms for the initiated) where masked *katsina* dancers are sometimes represented in life-size wall paintings. *Santos* and these paintings exhibit many formal and figurative similarities in the organization of the surface and handling of individual elements. Past discussions have assumed, however, that if *santos* or *katsinas* are indebted artistically to each other, their efficacy is compromised: either the *santos* are "idolatrous" because they are actually *katsinas* disguised as saints, or the *katsinas* are "polluted" by European contact because they look like Christian saints, or both.[56] Unfounded assumptions about the orthodoxy of Catholic images have contributed to an interpretative standoff on both sides of today's highly politicized regional academic activity in New Mexico. Regional scholars have avoided considering the *santos* from any other point of view than the orthodoxy of saints recognized by Rome. The possibility that other beatified or locally esteemed holy individuals might be included in the New Mexican repertory of images has not been raised in this literature, as it has elsewhere.[57]

A semiotic analysis of the concrete visual evidence suggests alternatives to such rigid binary logic. But semiotic analyses, too, have limited ability to recover socially constructed "meaning." Current semiotic approaches to material artifacts that are undocumented by other forms of evidence, such as the revisionist studies of Paleolithic cave art by André Leroi-Gourhan, recover general aspects of the rules of social organization rather than the specific interpretation of symbols. Dismissing explanations of cave paintings as "hunting magic," Leroi-Gourhan argues that the surviving evidence does not permit us to recover more than constructed systems of relationships—the *meaning* of these meaningful patterns is beyond our reach.[58] On the other hand, a semiotic analysis of constructed relationships (of differences, paired opposites, and so on) is invaluable for getting the images "off the walls," seeing in them the surviving evidence of a social practice rather than, ethnocentrically, reading into them the origin of the history of western painting—really beside the point from the perspective of the producers and intended users of cave paintings.

Semiotic studies of later artifacts recovered from other nonliterate contexts—including studies of symmetry in Pueblo pottery designs—have also focused on formal structures, rather than the culturally specific content that these structures must once have helped to convey.[59] The general problem with structuralist approaches, whether they are trained on linguistic, material, or some other kind of sign system, is that formal ordering principles carry cultural signatures, but these "signatures" do not translate directly into the referential context of culturally shared meanings and symbolism. Structural ethnoarchaeologists like Ian Hodder and Christopher Tilley, addressing precisely these considerations, argue that all aspects of material culture patterning must be understood as being produced according to sets of rules that communicate a shared understanding of the world that is

not directly visible.[60] Unfortunately, they have not been able to recuperate any actual worldviews in their semiotic field studies.

Two semiotic studies of material culture in New Mexico stand out as major contributions for their success in linking the visible with the invisible in a multi-evidentiary field of sign systems: Alfonso Ortiz' *Tewa World,* based on the author's experience as a cultural "insider" native to San Juan Pueblo, and Sylvia Rodriguez's more recent study of *matachines* dances held on certain occasions in a variety of Hispano towns and contemporary pueblos.[61] Ortiz' success lay in articulating like social patterns in different realms of culture: in the Tewa annual cycle of observances, in the social organization of the village into moieties, in kinship groups, and in a centralized administrative structure composed of "inside" and "outside" war chiefs. Ortiz was even able to extend his analysis to the organizational principles of *katsina* dress (masks and attire are the means for distinguishing one supernatural from another). The structure of differences in all areas of Tewa culture that Ortiz describes bears an uncanny resemblance to language, suggesting—beyond Ortiz' analysis—that the pictorial systems of the Southwest should be considered analogous to written forms of language, like Maya pictographs. Rodriguez, too, succeeds in getting beyond the general social patterns in relating *matachines* dance pageants to the culturally specific value system to which they refer. The greatest significance of her contribution, at least in the present context, is to distinguish subtleties between the two worlds of Pueblo and Hispano towns and, within these two general categories, to see further differences and correlate them with the extent of the town or village's cultural interaction/assimilation/integration across the same divide. The fact that distinctions between the cultural signatures of Europe and the Americas are still perceptible four hundred years after their initial contact is remarkable.

But how different the historian's overview is from the participant's partial perspective! Both Ortiz and Rodriguez emphasize that participants have a par-tial view of events. On the other hand, as trained cultural analysts, Rodriguez and Ortiz describe the same society in semiotic terms as an integrated structure (for example, the structure of the Tewa universe, in all three realms of ceremony, kinship groups, and administrative structure mentioned above, is describable as two dominant pairs of oppositions).[62] If the aim of interpretation is to recover what *santos* "meant" to their original makers and users, then perhaps structuralist semiotic analyses are inadequate for the same reason that the "meanings" that connoisseurs attach to these historical artifacts are often ahistorical: they do not tell the story from the viewpoints of the audiences for which they were made. If the forms of resistance that have been observed elsewhere in the colonial world are any indication, the long-term suppression of Native American religious beliefs in the Southwest and elsewhere means that we can expect to find native inclusions in areas of the Catholic image that are overlooked from an institutional perspective on Catholicism. Thinly or otherwise disguised survivals of native culture do not necessarily mean that missionaries and priests were oblivious or practiced a double standard, but only that the Roman Catholic Church negotiated differently in different locations, under varying circumstances.[63] In fact, the word "resistance" is really inadequate to describe the complex mediations among individual subjects, local communities, and the Church in most colonial societies.

Foucault's definition of the subject as an individual who is positioned and shaped by the symbolic order he or she inhabits has, as much as any semiotic theory, focused attention on the constructive role of symbols.[64] In structural linguistics, the means of expression (the signifier) and the concept (the signified) have no meaning outside their relation. Critics of structuralism like Foucault (though he never regarded himself as a structuralist or a poststructuralist) refine this account in one major respect: they insist that neither sign nor signified *preexists* the other.[65] At a crucial turning point in the reexamination of structuralism, Roland Barthes, like Foucault, recognized that the

coterminous, contextually determined relationship between signifier and signified multiplies meanings. Barthes focuses on what he called the "musicalization" of language in poetic texts, which "expose the inadequacy for literature of the model of 'communication' (addressor/addressee)."[66] In twentieth-century discussions of intersubjective meaning, poetic language, avant-garde texts, and dreams are the exceptions that prove the rule. These nondenotative sign systems displace and redistribute the relation of sign and meaning in such a way that the distinction between signifier and signified is blurred, complex, multivalent. In emphasizing artifice over mimesis, poetry demonstrates the artificiality and arbitrariness of denotative meaning. Denotation is a rhetorical strategy like every other artifice, no more and no less.

But need there really be two distinct orders of being, representation and the "meaning" of representation?[67] Jacques Lacan has argued that it is never possible to separate the domains of the conscious (conventionally identified with denotation) and the unconscious (conventionally identified with condensation and displacement). Through a combination of linguistic semiotic theory, psychoanalysis, and topology, he builds a poststructuralist semiotic account of the *un-unified* self. In Lacanian theory, the social production of the subject, and therefore the subject's ideological positions, are self-contradictory. On the one hand, the structure of the subject, constituted by oppositions between terms, is comprehensible only as a totality of relations. On the other hand, because the subject constantly undergoes transformations and substitutions at a subindividual level, the subject's self-understanding is always partial, experienced as it is in "real time." Thus, the Lacanian subject is produced, like "meaning" in the poststructuralist sign, continuously in its movement.

Theoreticians have tackled sign systems in many different realms. Yet the simultaneous condensation and displacement of meaning that Roman Jakobson first described in the early twentieth century is still the current way to account for sign systems—even for Barthes, who initiated the application of structural theory to nonverbal sign systems such as the "fashion system,"[68] the linguistic model (poetic texts, avant-garde texts) remained prototypical. Yet in the visual arts, as in dreams, denotation and connotation are inseparable: art historians have long recognized this in the historical formation of styles, which is the topic of the next chapter.[69]

THE ACTIVE RECEPTION OF INTERNATIONAL ARTISTIC SOURCES IN NEW MEXICO

DONNA PIERCE

Research on the history of New Mexico in the past ten years has indicated that the population was diverse and that intercultural contact as well as intermarriage between ethnic groups was more prevalent than has been previously assumed (see Chaps. 4 and 5). In addition, recent research has indicated that international trade was more frequent than had been suspected, making source material from various cultures from outside New Mexico (some of which will be discussed here; see Chap. 6) available for potential adaptation by local artists. In particular, it has not previously been acknowledged that Asian source material was available in New Mexico.

This case study traces a few formal stylistic elements originating in Europe, Asia, and Mexico as they were used in New Mexico, to see how some were adopted, others eschewed, and some manipulated by local artists in the process of developing the region's dynamic artistic identity. In discussing the reception and production of multicultural source materials for New Mexican *santos,* one cannot ignore European artistic styles. I would, however, like to address European motifs from the standpoint of the choices made by New Mexican artists, taking into account the previous transformation of these motifs in colonial Mexico.

New Mexican *santos* have often been compared to the Romanesque and Gothic religious art of medieval Europe.[1] Indeed, in their pared-down abstraction, they do have an overall feeling similar to that of the medieval art styles prevalent in Europe some five to eight hundred years earlier. More directly, however, the iconography and style of the New Mexican images can be traced to the Catholic Reformation style of the Baroque and, later, the Rococo era. Even the transition from Baroque to Rococo is reflected in New Mexican *santos,* a previously unnoticed point that documents the relatively international awareness of New Mexican artists and audiences.

These mainstream European styles, of course, are by no means the only wellsprings for New Mexican imagery, but given the history of the scholarship, they serve as a necessary starting point for new discussion. International Baroque and Rococo composition and decorative detail were filtered through the distinctive Catholicism of the Iberian Peninsula, particularly as it developed during the Catholic Reformation. The styles were altered yet again in colonial

Mexico, with an underlayer of imagery from local Mexican cultures and symbolism that drew from the local climate and geography as well as from Asian sources available there.[2] The already hybrid styles were then exported to New Mexico, where additional layers of regional form and perhaps content derived from already existing local traditions were developed.

In this chapter I analyze the pattern of transmission of motifs through Spain and Mexico and their retention or rejection in New Mexico. Their meanings—which can be multiple—are addressed elsewhere in this volume. The visual evidence suggests that, far from being provincials uninterested in or incapable of understanding international artistic trends, the local producers of and audience for religious images were attentive to the latest stylistic innovations and at times altered as well as borrowed motifs.

Misunderstandings of New Mexican *santero* art, and particularly of the artists' intentions, have resulted, in part, from lack of knowledge of coeval developments in the Baroque and Rococo art of colonial Mexico and from underestimating New Mexican artists' familiarity with that art. The modern political division between Mexico and New Mexico has influenced scholarship on the arts of New Mexico. Using geographical distance as a convenient excuse, many authors have written as if New Mexico had always been disconnected politically and culturally from the greater Spanish Catholic world.[3] Undoubtedly racial and political bias has played a role in this dismissal, particularly in the late nineteenth and early twentieth centuries. Recent research has indicated that colonial New Mexico, although geographically remote, maintained what was, by the standards of the times, constant contact with major urban centers in central Mexico.[4]

Failure to acknowledge the artistic connection to the greater Hispanic world as well as to Asian source material results partially from the lack of familiarity with Spanish Baroque and Mexican colonial art on the part of many authors.[5] In defense of early writers on New Mexico, it must be admitted that scholarship on these two areas, particularly in English, has been minimal until the past few decades, and that most early publications understandably focused on overviews of production in major centers and paid little attention to outlying areas or to decorative arts, which probably were especially accessible motif sources for New Mexican artists.[6] Also, much scholarship on Mexican colonial art has attempted either to link it to mainstream European art or to search for pre-Columbian roots, neglecting the hybridity and distinctively Mexican character of most colonial art.

Recent research has acknowledged that from the mid-seventeenth throughout the eighteenth century, both the arts and the literature of Mexico reflected the nationalistic fervor developing in the colony and soon to be expressed in the Independence movement. Art styles were sometimes intentionally divergent from mainstream European ones and were often consciously "Mexican" or "New World," particularly in the details and landscape backgrounds, at times even drawing upon Asian or pre-Hispanic sources for inspiration.[7] Occasionally idealized elements from Mexico's pre-Hispanic past were incorporated into imagery, and exclusively "Mexican" religious figures, such as the Mexican-born Franciscan saint Felipe de Jesús and the Virgin of Guadalupe, became increasingly popular among the creole as well as native populations.

With the taking of the Philippines in 1565, Spain opened direct commerce with Asia via Manila and Acapulco. All Asian goods destined for Spain were offloaded in Acapulco and transported overland across Mexico to Veracruz, where they were loaded onto galleons again for the Atlantic crossing. Many products from the Far East remained in Mexico, and local artists could look directly to Asian goods for inspiration as well as to chinoiserie objects from Europe. As a result, European Baroque and Rococo prototypes were dissected and reassembled in a different manner in colonial Mexico, with new details picked up directly from Asian or local decorative arts.

The *santero* artists of New Mexico made conscious and selective choices from all of this heritage as well as from other sources. Numerous motifs from

3-1. Church exterior, Las Trampas, New Mexico, begun 1760. Photo Donna Pierce.

3-2. Church exterior, Taxco, Mexico, c. 1750–70. Photo Donna Pierce.

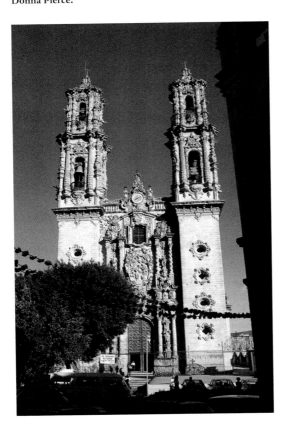

Mexican colonial Baroque are not used in New Mexico, and some of those that are used appear to transform in New Mexican art into slightly different, more locally relevant, motifs, or, at the very least, to be endowed with additional significance there.

The International Baroque style, born in Rome in the late sixteenth century at the conclusion of the Council of Trent, spread rapidly throughout Europe and to the New World. The new Catholic Reformation style was particularly long-lived in Mexico, where it held sway for at least two hundred years, developed a distinctive character, and, some would argue, still permeates Mexican art, particularly folk art, in the twentieth century. During the seventeenth century, artists in Mexico exaggerated certain elements of the European Baroque to create a distinctive early Mexican Baroque style. When the French Rococo style infiltrated European arts in the early eighteenth century, many artists in Mexico resisted full adoption of it, choosing rather to add individual Rococo motifs, along with elements from other sources, to a basic Baroque core, creating the hybrid style of the late Mexican Baroque era.[8]

As in the rest of colonial Mexico, the Baroque style was used in New Mexico in the decorative arts but also on a monumental scale in church architecture, one of the contexts within which *santero* art was used. For example, consider the church in the village of Las Trampas, licensed in 1760 (Fig. 3-1).[9] Incorporating many of the Baroque elements used in Mexican colonial churches, it represents a distinctive New Mexican version of the Baroque style. A comparison with the roughly contemporary late Baroque church of Taxco, Mexico, built in the 1750s, illustrates both the borrowings and the alterations (Fig. 3-2).[10] In both examples, projecting towers flank slightly recessed facades, but the Mexican church is built of cut and carved stone with a domed and vaulted roof. In New Mexico, where the local population had no tradition of building with cut stone, the church is constructed of sun-dried adobe bricks with a flat wooden ceiling, creating a locally appropriate architecture.

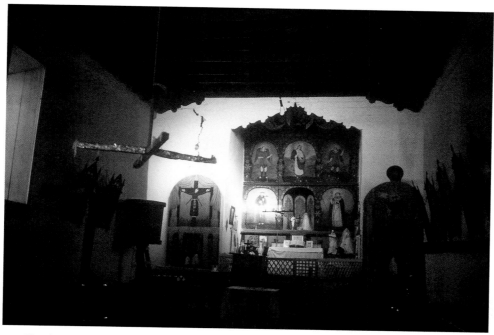

3-3. Church interior, Las Trampas, New Mexico, begun 1760. Photo Donna Pierce.

Both churches are cruciform in plan, with dramatic Baroque interior lighting concentrated in the transept and apse (Fig. 3-3). In Mexico, as in Europe, this lighting effect is achieved by the placement of a dome at the crossing of the transept arms; in New Mexico, the same theatrical effect is achieved by raising the roofline at the crossing and inserting a transverse clerestory window. Both methods create a burst of light in the most sacred section of the church, in contrast to the darker area of the main nave. In both churches, the use of an elevated choir loft above the main entrance further darkens the naves by preventing light from the main entrance from disseminating upward and, consequently, increases the contrast between light and dark areas. Another Baroque detail on the interior at Las Trampas is the fake arch created by placing carved wooden beams on top of one another and extending them to form a mixtilinear arch over the chancel.

In late Baroque fashion, the walls of both churches are lined with altar screens. In Mexico, those screens are architectonic structures of carved wood covered with gold leaf and incorporating the extensive use of polychromed sculpture along with oil-on-canvas paintings (Figs. 3-4, 3.a.1, and 3.a.2). In New Mexico, a distinctive altar-screen style evolved, incorporating some elements of Mexican Baroque and discarding others. Most New Mexican screens are flat wooden panels within squared beam structures (Figs. 3.a.3 and 3.a.4). Architectural elements, such as columns, entablatures, and their vegetal decoration, are painted rather than carved, as are most of the images of saints,

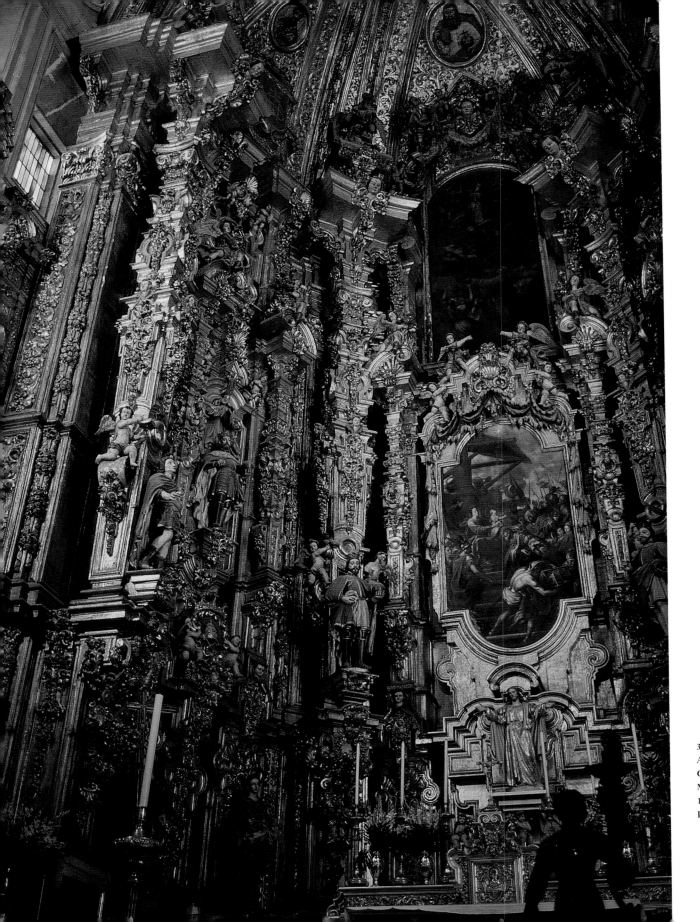

3-4. Jerónimo Balbás,
Altar of the Kings,
Cathedral of Mexico,
Mexico City,
1718–37. Photo
Donna Pierce.

After its use by Gianlorenzo Bernini in the baldachin of Saint Peter's in Rome (1624–33), the twisted Solomonic column was adopted in Spain and Mexico, where it was produced in carved and gilded wood. In New Mexico, the form was appropriated as well, but was reinterpreted in the polychromed wood format of local altar screens and eventually abstracted into a two-dimensional version with the twisted shaft indicated by parallel diagonal lines.

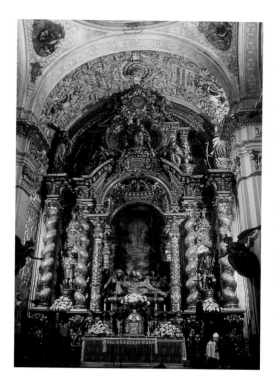

3.a.1. *(left)* Main altar, Church of La Caridad, Seville, Spain, c. 1650. Photo Donna Pierce.

3.a.2. *(right)* Main altar, Franciscan mission church, Ozumba, Mexico, 1730. Photo Donna Pierce.

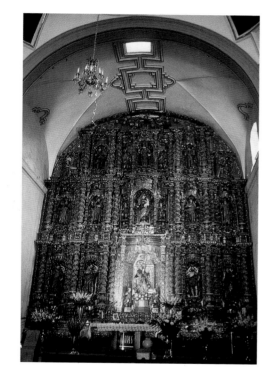

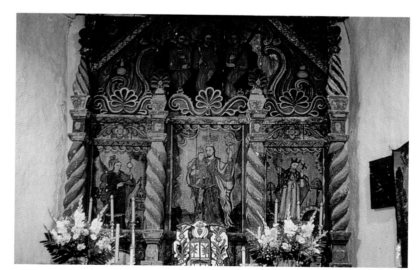

3.a.3. Laguna *Santero*, altar screen, before overpainting. Laguna Pueblo Mission Church, Laguna Pueblo, New Mexico, c. 1800–1809. Photo Donna Pierce.

3.a.4. Rafael Aragón, altar screen from Llano Quemado church, Llano Quemado, New Mexico, c. 1830. Museum of Spanish Colonial Art, collections of the Spanish Colonial Arts Society, on loan to the Palace of the Governors Museum, Santa Fe. Photo Jack Parsons.

which are painted directly on the flat panels *(retablos),* with only one or two niches containing three-dimensional statues of saints *(bultos).*

Two types of columns were used extensively in the altar screens of the Baroque styles of Spain and Mexico and also appear in *santero* art. The earlier of these, the Solomonic column, was first used on a monumental scale by Gianlorenzo Bernini in his baldachin (1624–1633) for the renovation of Saint Peter's in Rome. Use of this twisted-shaft column spread rapidly to Spain (Fig. 3.a.1) and was introduced to Mexico in 1648 in the Altar of the Kings, designed for the Cathedral of Puebla by the famous Spanish Baroque artist Juan Martínez Montañés. The Solomonic column became exceedingly popular throughout Mexico, including New Mexico, and remained so long after its use in Europe had waned.

Concurrently, dense foliate space filler became another leitmotif of the Mexican Baroque style. Bernini's columns had been covered with a gilded grapevine symbolic of the Eucharist. Most Solomonic columns in Spain and Mexico continued this decorative detail, but the foliage was not necessarily restricted to a grapevine, and the density was greatly increased, particularly in Mexico, where the motif often filled all areas of the altar screen not taken up by sculptures or paintings, in a rather unrestrained manner (Fig 3.a.2). In Europe, the classical format of altar screens, established in the fifteenth century, was revised in the seventeenth century. Although the twisting columns and busy foliage imply movement, during the early Baroque era in Mexico the overall structural format of the altar screens remained classical, with three to five vertical levels divided by horizontal entablatures, and three to five bays across.

Both the Solomonic column and the foliate filler appear in New Mexico but are executed in a different medium and in a distinctly new manner. The Solomonic column appears as fully carved, three-dimensional, and freestanding in a handful of altar screens, most notably those attributed to the Laguna *Santero* (Fig. 3.a.3) and his workshop, active in the 1790s and early 1800s.[11] In New Mexico, however, the columns are always brightly polychromed in contrasting colors, rather than being covered with gold leaf. Later *santeros* tended to simplify the Solomonic column, executing it in a two-dimensional manner with low-relief-carved diagonals on a flat board or merely painted diagonal stripes (Fig. 3.a.4). The unrestrained Mexican version of the foliate filler is used in New Mexico, but is executed two-dimensionally in polychrome paints on flat wooden panels rather than carved in low relief and gilded.

The second type of column used in Hispanic Baroque art was the *estípite,* with its distinctive bulged shaft—narrow at the top and bottom and wider in the middle. The column was used tentatively in Spain on altar screens by José Benito Churriguera just before 1700 and on a large and dominating scale a decade later, mostly in southern Spain, with the most famous example being the now-destroyed altar screen constructed by Jerónimo Balbás for the Sagrario of the Cathedral of Seville. The huge screen (80 x 40 ft.) was described as "four large estípites, pilasters, lots of angels prankishly tumbling about, and a cornice broken and interrupted in a thousand places with tortuous projections and recesses, the whole topped by a huge arch."[12]

The same Jerónimo Balbás from Seville was commissioned to construct a similar screen in the Cathedral of Mexico between 1718 and 1737 (Fig. 3-4).[13] Known as the Altar of the Kings, this mammoth structure introduced the new late Baroque style to Mexico, where it soon took on a decidedly Mexican character, particularly in northern Mexico. Even in Spain, this late Baroque style borrowed many details from the decorative arts, particularly from the popular French Rococo, Mannerist Revival, and chinoiserie decorative styles. In Mexico, Asian elements proliferated and New World motifs were added to the repertoire.

The new style spread rapidly throughout Mexico and very quickly distinguished itself from its prototypes in Spain at this time. As early as 1749, huge *estípite*-style altar screens were being executed in

carved stone on the facades of churches. Known as *retablo* facades, these exteriors were unknown in Spain. Furthermore, in a trend initiated in Mexico by Balbás and soon carried to extremes there, the architectonic qualities of the screens, especially the entablatures, on both interiors and exteriors began to be manipulated and broken up in a way that violated all the canons of classical architecture. In denial of its structural function as a column, the upper half of the *estípite* shaft was often broken down into geometric shapes as it narrowed toward the capital. Later, the columns were flattened into shallow pilasters, and imposing sculptural niches were inserted into the shaft, forming a distinctively New World derivative element known as an ornamental niche pilaster.[14]

Estípite-style altar screens were used in New Mexico in the late eighteenth and early nineteenth centuries, but were usually executed in the polychromed panels common there. The earliest extant *estípite*-style screen in New Mexico is carved of stone and dates from 1761, relatively soon after the completion of the Altar of the Kings in 1738, and may be one of the earliest examples in northern Mexico (see page 135, Fig. 2).[15] In New Mexico, the characteristic bulged silhouette is sometimes angular and sometimes curvilinear (page 136, Fig. 3; page 137, Fig. 4). Whereas in Mexico the upper half of the *estípite* column disintegrates into geometric forms, by the 1840s in New Mexico the whole *estípite* column is sometimes completely abstracted into a series of geometric shapes—often ovals and Xs set into squares and rectangles—but usually retains its distinctive outline, being wider in the middle and narrow at the top and bottom of the shaft (page 137, Fig. 4). In New Mexico, however, the breakdown of structural properties is confined to the *estípite* column itself. The classically accurate architectonic structure of the screens, with the standard format of two to three regular levels, is retained from the earlier Baroque style; the wildly broken up quality of the late Mexican Baroque altar screens is never adopted by the *santero* artists.

The altar screens and *retablo* facades of the late Baroque or Rococo style in Mexico are replete with a jungle of decorative motifs, some of which recur in the decorative arts of the era and, ultimately, in the *santero* art of New Mexico. I next discuss how New Mexican artists appropriate and manipulate several individual motifs and two stylistic trends of the Mexican Baroque style.

Scallop shells had been used in the early Baroque style but became even more prevalent and occasionally more prominent in the later Baroque, often projecting from the tops and sides of altar screens, as at Taxco. Oval forms became popular, frequently framing paintings or low-relief carvings, and often set into rectangles or squares in the upper half of *estípite* columns. The late Baroque style of colonial Mexico borrowed from both French Rococo and Asian sources several scrolled forms, including S-scrolls, C-scrolls, scrolled leaf forms, and asymmetrical scrolling compositions.

Borrowed from Mannerism and Asian art, asymmetry in general evolved as the late Baroque style progressed, particularly in the Bajío region and farther north in Mexico. Characteristic of the International Rococo style, asymmetry was used in both major and minor Mexican arts, often in scrolled framing devices and crests. Sometimes the asymmetry is obvious; at other times it is quite subtle. A second major tendency, also particularly pronounced in the Bajío area and farther north, was for the decorative motifs to increase in scale while the imagery shrank, so that ornament dwarfed representation, directly inverting the expected relationship between the image and its frame. In some examples, large, playful C-scrolls and scallop shells tower over diminutive saints, and giant leaf scrolls appear about to engulf their tiny figures.

These international elements became ubiquitous, especially in the decorative arts, including furniture, silver, ceramics, and textiles—all trade goods imported to New Mexico throughout the colonial period (see Chap. 6). Some of the motifs, particularly C-scrolls and leaf scrolls, were probably introduced to the art of Mexico and New Mexico directly from

3-5. Pedro Antonio Fresquís, altar screen crest with *Trinity*, c. 1790, pine, water-based paints. Denver Art Museum, gift by exchange Althea Revere.

imported Asian textiles and porcelains. Certainly, trade goods imported directly from Asia reinforced local taste for motifs like these.

Both luxurious Chinese silks and inexpensive printed cottons from East India were imported to Mexico on the Manila galleons in tremendous quantities, and many made their way to New Mexico, appearing in trade caravan inventories and wills and estate inventories there.[16] This means that through textiles some Asian motifs were available to almost everyone, regardless of economic means: wealthier individuals acquired the Chinese silks (Chap. 6, Fig. 6.b.2), while people of lower classes wore the East Indian printed cottons, known as *indianilla* (Chap. 6, Fig. 6.b.3). The same textile patterns were copied in locally produced textiles in Spain and Mexico and in the *colcha* embroideries of New Mexico (Chap. 6, Fig. 6.b.4).[17]

C-scrolls had been used extensively in Chinese Ming porcelains, which had been available in Mexico since the opening of Manila galleon trade in 1568.[18] And Chinese porcelain inspired designs of ceramic production in Spain and Mexico throughout the colonial period, reinforcing asymmetry and dwarfism as well as C-scrolls (Chap. 6, Fig. 6.a.4).[19] Chinese porcelains as

well as Spanish and Mexican ceramics were brought to New Mexico throughout the colonial period. Shards of Chinese porcelain have been recovered from many archaeological sites in New Mexico, including the first Spanish settlement at San Gabriel (1598–1610); and a Ming tea cup covered with C-scrolls and dating before 1680 was excavated from the Palace of the Governors in Santa Fe in 1974 (Chap. 6, Fig. 6.b.1).[20]

All types of religious art, including paintings, sculptures, engravings, altar screens, and church furniture, were imported during the colonial period to New Mexico, where they served as potential transmitters of Baroque and Rococo stylistic ideas. For example, an image of a late Baroque altar screen was painted in 1783 on a huge canvas by the well-known artist José de Alcíbar, of Mexico City, and brought to New Mexico to hang in the apse of the Santuario of Guadalupe in Santa Fe.[21] The painted screen contains many late Mexican Baroque motifs, including *estípite*-derived ornamental niche pilasters, asymmetrical oval paintings framed with elongated C-scrolls, and scrolling crests. Smaller paintings, sculptures, and engravings also were available in New Mexico as source material for local *santeros*.

New Mexican *santeros* responded to international source material by choosing to appropriate some elements and to discard others. The carved and gilded motifs of the late Mexican Baroque style were executed in polychrome pigments painted onto wooden board in New Mexico. Local artists incorporated late Baroque scroll forms on altar screens, but often in a distinctive manner, such as the large cut-out and projecting S-scrolls on the main altar screen at Córdova church, attributed to Rafael Aragón, or the ones at Truchas, attributed to Pedro Antonio Fresquís (page 136, Fig. 3). Local *santeros* frequently used large painted leaf scrolls, such as the ones by Fresquís flanking the orb on the altar screen crest now at the Denver Art Museum (Fig. 3-5). Also attributable to Fresquís is the tabernacle at Las Trampas church, which has C-scrolls on the interior in apparent emulation of Asian-inspired textile patterning. Late Baroque ovals

on *retablos* and altar screens, and at times projecting from the tops and sides of altar screens (Fig. 3-5).

Asymmetry was used deliberately in the decorative arts during this era, though modern scholars have mistakenly attributed asymmetry in New Mexican objects to a lack of skill on the part of the artist. An example of an item of personal adornment with an asymmetrical composition of scrolls is a woman's hair comb probably made in Mexico in the late eighteenth century and collected in New Mexico in the early twentieth century (Chap. 6, Fig. 6-3). Such personal objects could have served as prototypes for New Mexican artists. Chests made in New Mexico often have relief-carved fronts decorated with slightly asymmetrical compositions (Chap. 6, Fig. 6-10). Considering that symmetry can easily be achieved by tracing, such New Mexican compositions were likely intentional, in keeping with the concurrent trend in all areas of New Spain at that time.

3-6. Molleno, *Saint Anthony,* New Mexico, early nineteenth century. Museum of International Folk Art (A.71.31.41), Santa Fe, New Mexico. Photo Blair Clark.

3-7. Laguna *Santero, Saint Barbara,* New Mexico, late eighteenth–early nineteenth century. Museum of International Folk Art, Santa Fe, New Mexico.

set into rectangular forms were appropriated by most *santeros,* but are particularly common in the work of the Laguna *Santero,* Molleno, José Aragón, and Rafael Aragón. Molleno often chose to place his distinctive curled C-scrolls in the corners created by the inset ovals (Fig. 3-6). Many *santeros* appropriately used C-scrolls on the clothing of saints in *bultos* and *retablos,* inspired by clothing styles and textile patterns fashionable in the late eighteenth and early nineteenth centuries (Fig. 3-7). New Mexican artists also employed projecting and oversize scallops in the same locations as in late Baroque Mexican art—on crests of furniture,

3-8. Pedro Antonio Fresquís, *Crucifixion with Virgin of Sorrows*, late eighteenth–early nineteenth century. Museum of Spanish Colonial Art, Collections of the Spanish Colonial Arts Society, Santa Fe. Photo Jack Parsons.

New Mexican *santeros* also incorporated Late Baroque asymmetry in the compositions of some *retablos*, particularly those in the style of Fresquís, where, as we will see, compositions are rarely balanced bilaterally (Fig. 3-8). "Dwarfism" often accompanies such compositions, with large plant forms curving up one side and towering over the figures, just as they did in Mexican altar screens, especially in the Bajío area, as well as in the decorative arts, particularly Asian and Mexican ceramics (Chap. 6, Fig. 6.a.4; Chap. 10, Fig. 10.b.1).

New Mexican *santeros* not only used decorative motifs from Baroque art but also changed with the times, reflecting the transition from early Baroque to late Baroque in painting and sculpture. Painting of the early Baroque style in Spain and Mexico often used the tenebrist technique, with extremely dark backgrounds accented by areas of dramatically brilliant light (Chap. 6, Fig. 6-8).[22] Figures in both painting and sculpture usually had stocky body proportions and were dressed in rich, dark fabrics with a sense of weight and volume (Chap. 6, Figs. 6-6 and 6-8). The early *santeros* working in New Mexico in the late eighteenth century, such as Miera y Pacheco, the Eighteenth-Century Novice, and García, were still using a local variation of the early Baroque style that had been popular in Mexico until around 1730 (Figs. 3-9 and 3-10). In the work attributed to these artists, colors tend to be dark, body proportions robust, and drapery and clothing rich and heavy. Images in both painting and sculpture tend to be relatively large, ranging up to three or four feet in height.

In contrast, late Baroque painting and sculpture in Spain and Mexico is characterized by strong influence from the French Rococo style. Backgrounds are lighter, pastel colors common, flowers and cherubs ubiquitous, body proportions delicate, fabrics ethereal, and body positions off-balance and illogical (Chap. 6, Figs. 6-7 and 6-9). Overall scale is reduced as the images themselves become smaller. In New Mexico, late Baroque elements begin to appear around 1800 in the work of the Laguna *Santero* and his followers,

less grounded in space and appears to float in the ambiguous landscape. The composition is asymmetrical, with oversized plants that miniaturize the saint and scattered decorative elements that appear to be floating in the air.

In sculpture, compare the archangels by Miera y Pacheco and Rafael Aragón (Figs. 3-10 and 3-12). The Miera y Pacheco angel is depicted with robust body proportions, a solid stance, and the straightforward frontal body position of the early Baroque style (compare Chap. 6, Fig. 6-6). The clothing is carved to appear heavy, providing an illusion of weight and volume. In contrast, the angel by Aragón is executed in the late Baroque style (compare Chap. 6, Fig. 6-7) with extremely thin, elongated limbs and an off-bal-

3-9. Fray Andrés García, *Saint Jerome,* New Mexico, late eighteenth century. Museum of Spanish Colonial Art, Collections of the Spanish Colonial Arts Society, Santa Fe. Photo Jack Parsons.

3-10. Bernardo Miera y Pacheco, *Archangel Gabriel,* from Zuni Pueblo Church, New Mexico, before 1776. Destroyed in fire at the Smithsonian Institution in 1960s. Photograph from the collection of Donna Pierce.

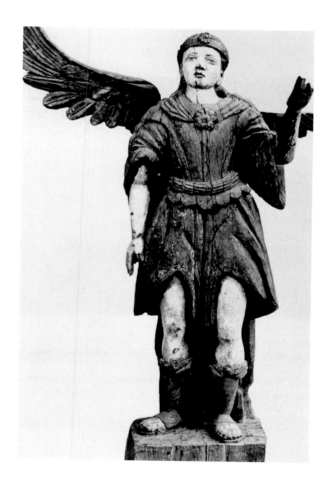

including Molleno, but are most fully appropriated and manipulated in the art of Fresquís and Rafael Aragón.

Two comparisons illustrate the transition in *santero* art from early to late Baroque style. In painting, the work attributed to García usually has dark colors in the background, with deep reds and greens predominant in the tradition of the early Baroque style (Fig. 3-9). Figures are solidly placed in the space of an interior or landscape setting, and compositions are usually symmetrical or at least balanced. In contrast, the image of Saint Colette by Fresquís has a light-toned background, and pastel colors are prevalent, particularly pinks and blues (Fig. 3-11). The figure is

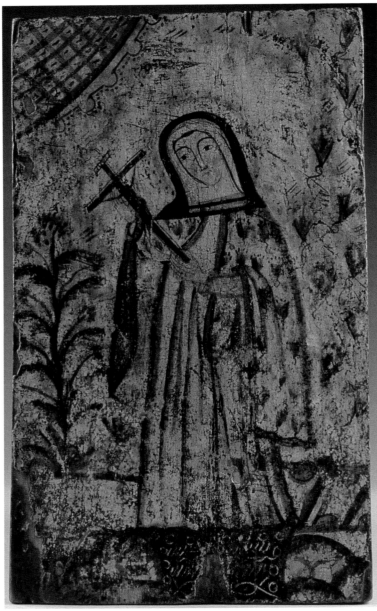

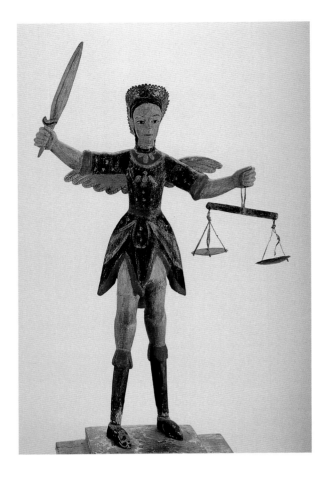

3-11. Pedro Antonio Fresquís, *Saint Colette,* New Mexico, late eighteenth–early nineteenth century. Museum of International Folk Art (A.9.54-70R), Santa Fe, New Mexico. Photo Blair Clark.

3-12. Rafael Aragón, *Saint Michael,* New Mexico, c. 1840. Collection Alyce and Larry Frank.

ance, twisting stance, with the right knee bent forward and the left leg set back. The upper body and shoulders turn to the figure's right, while the feet are pointed off to his left.

Similarly, images of saints and the Virgin in both painting and sculpture in this period in Spain and Mexico often imply movement by giving the figure a twisting body position. The formula is basically identical: the feet usually point toward the left, the right knee is bent in exaggerated contrapposto, and the upper body is turned toward the right, with the left shoulder noticeably higher than the right, creating a curve in the vertical axis of the sculpture. This curved and twisted position was used in New Mexico and adapted to many subjects, such as the Virgin of Sorrows by the Santo Niño *Santero* and the Virgin of

Guadalupe by Rafael Aragón (Fig. 3-13). In the latter the artist has further accentuated the curve by adding a framing device that actually leans in the opposite direction, creating an overlap and an asymmetrical composition. Rather than representing a miscalculation, this image probably reflects a conscious choice on the part of the artist and represents a New Mexican version of a late Baroque twisting Virgin.

The transition from early to late Baroque art in New Mexico indicates that local *santeros* were aware—but not slavishly so—of artistic trends in the greater Hispanic world. With apparent disregard for chronological stylistic evolution, they incorporated fashionable international elements into their own regional style selectively—for example, New Mexican artists eschewed the wildly violated, vertical format of late Baroque Mexican altar screens and instead retained the rigid classical structure of early Baroque altar screens, but in the same moment they adopted the *estípite* column from the later style. And at times, they devised unique methods for achieving Baroque effects of movement and lighting, such as Aragón's framing device to exaggerate the curve of the Virgin, or the transverse clerestory that creates a dramatic burst of light in the apse at Las Trampas and other New Mexican churches.

The Mexican baroque style, including the transition from the earlier to the later version of it, is only one of the international sources drawn upon by the *santero* artists of New Mexico. The regional artists made conscious and selective choices, incorporating a variety of motifs from international models including Asian and decorative arts, discarding others, and often mixing them at will. As discussed in later chapters of this volume, the result was a variant style that was relevant to the local environment and audience and is still today decidedly recognizable as a distinctive creation.

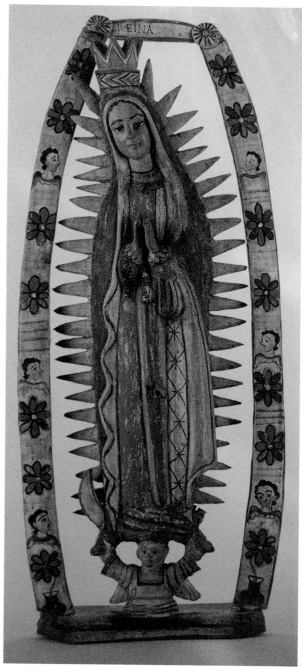

3-13. Rafael Aragón, *Virgin of Guadalupe*, New Mexico, c. 1840. Collection Alyce and Larry Frank.

POSSIBLE POLITICAL ALLUSIONS IN SOME NEW MEXICAN *SANTOS*

DONNA PIERCE

At least eight *retablos* in the style of Rafael Aragón or his workshop depict a saint generally identified as Saint Ferdinand (Figs. 1 and 2).[1] No *retablos* of San Fernando Rey survive by other *santeros* or as *bultos*. The Aragón *retablos* may contain subtle political statements, and a few may actually represent not the saint, but rather a political figure, King Ferdinand VII of

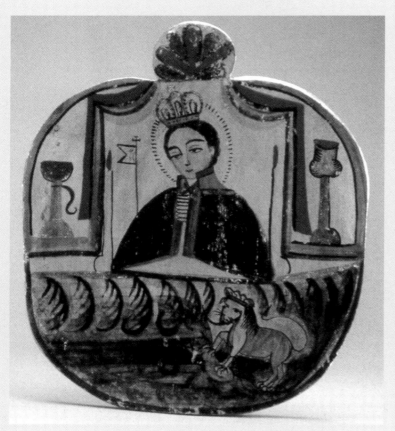

1. Rafael Aragón Workshop, *Saint Ferdinand* **or** *Ferdinand VII* **(?), gesso and water-soluble paint on wood, early nineteenth century. Museum of International Folk Art (A.9.54.20-R), Santa Fe, New Mexico. Photo Blair Clark.**

Spain. We will probably never know whether or not these images of Saint Ferdinand have underlying meanings reflecting the political sympaties of their owners (or artists). Nor will we be able to discern for certain whether some of these images are portraits of Ferdinand VII rather than religious images of his ancestor the saint, Ferdinand III, or a conflation of the two. But it is intriguing to consider the possibility of other layers of content in the art of the late colonial and early republican period of New Mexico.

Saint Ferdinand, or Ferdinand III, was king of Castile and León in Spain during the early thirteenth century and was instrumental in the struggle to reclaim large areas of Spain from Muslim occupation. Although he was not particularly popular in New Mexico, in the eighteenth century the Spanish settlement near the Indian Pueblo of Taos was named San Fernando de Taos in his honor.

The New Mexican *retablos* represent Saint Ferdinand in an unconventional manner. Rather than garbed as a medieval king, the standard iconographic representation, he is dressed in the military manner of Spain and its colonies from the early nineteenth century, or as E. Boyd has noted, "as a Mexican general" of the era.[2] Interestingly, the New Mexican figures are strikingly similar to images of Ferdinand VII that were widely circulated via engravings and were extremely popular as a motif in the neoclassical decorative arts of the early nineteenth century in Spain and the colonies (Figs. 3 and 4).

Ferdinand VII, named for his saintly ancestor, assumed the throne of Spain under unfortunate circumstances when his father, Charles IV, abdicated to him and fled the country as Napoleon's troops advanced across Spain in 1808. Ruling in exile during

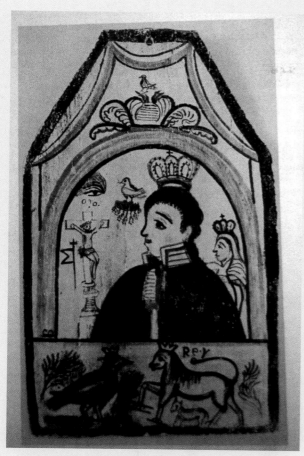

2. Rafael Aragón Workshop, *Saint Ferdinand* or *Ferdinand VII* (?), gesso and water-soluble paint on wood, early nineteenth century. Taylor Museum (TM 510), Colorado Springs Fine Arts Center, Colorado Springs.

the Napoleonic occupation of Spain, he returned to Madrid to assume the throne in 1814 and reigned until his death in 1833. Ferdinand's control in Spain was threatened briefly in 1820 by a liberal movement that coincided with the end of the Independence movement in Mexico. Meanwhile, in Mexico, Ferdinand was championed by Mexican conservatives led by Agustín Iturbide. Seizing control from 1820 to 1823, in 1821 this group enacted the Plan of Iguala calling for Mexico to become a constitutional monarchy under Ferdinand VII and intending for him or a relative to assume the

throne of Mexico. This hope was dashed in December 1823, when Iturbide's Mexican Empire was dissolved and the Republic of Mexico was founded.

During Ferdinand's entire reign, decorative arts bearing his image were widely circulated and used with pride by royalists in both Spain and the colonies. This was particularly true in Mexico during the Iturbide era. Almost always depicted in profile and most frequently surrounded by a neoclassical oval frame and classical symbols of power such as Roman fasces (reed bundles), swords, drums, laurel wreaths, and cannons, Ferdinand appears in ceramics, textiles, silverwork, leatherwork, engravings, jewelry, and clothing. For example, several majolica jars or pitchers made in Spain bear his image on the shoulder, and a pair of leather leggings made in Mexico depicts him with the inscription "Viva F(ernando) VII" underneath (Fig. 4).[3]

The *retablos* of New Mexico are remarkably similar in composition and detail to these images of Ferdinand VII. The face and hairstyle as well as the uniform match those of the nineteenth-century king, as do the oval frame and some of the symbolic paraphernalia. The use of this portrait composition in New Mexico may be an appropriation from some form of decorative art, applied to San Fernando Rey without any reference to content or to the political situation at hand. In two examples, the inscription "San Fernandes" is included, making it clear that these *retablos* represent the saint-king, but they may have another layer of meaning as well.[4]

In several of the images there is no halo surrounding the head of the figure, and most are devoid of Christian imagery. Several of the *retablos* include images of a lion facing off with, and in some cases vanquishing, a bird, probably an eagle (figs. 1 and 2). The lion, of course, is a traditional symbol of royalty; it had been associated with the kings of Spain since before Ferdinand and Isabel and remained so throughout the Bourbon monarchy from 1700 through Ferdinand VII. Although the eagle had been one of the symbols of the earlier Hapsburg dynasty of Spain, it

3. José Mariano Torreblanca, *Ferdinand VII, King of Spain*, Mexico, 1818, engraving. Photo from the collection of Donna Pierce.

4. Majolica pitcher with image of Ferdinand VII, Talavera de la Reina, Spain, early nineteenth century. Collection Alyce and Larry Frank.

was also the recognized symbol of Mexico, adopted from the Aztecs and used to the present. The animal-combat images in the *retablos* may represent the king of Spain as the lion and the "republic" of Mexico as the eagle.

One of the few images including references to Christianity depicts Ferdinand looking toward a small image of Christ on the Cross surrounded by an eye with the word *ojo* under it (presumably the eye of God), a bird (probably a dove of the Holy Spirit) and a woman wearing a crown (possibly the Virgin or the queen) (Fig. 2). None of the figures has a halo. The lion facing off with the eagle below has the word *Rey* written above it and a smaller animal (representing the Empire of Mexico?) beneath. These symbols imply the religious devotion of Ferdinand but may carry a second layer of meaning referring to the changing political situation in Spain and the colonies, where the monarchy was identified with Catholicism and the republics were identified with anticlericalism.

Spain itself spent most of the nineteenth century fluctuating between monarchy and attempts at republican government, with the end result being an awkward compromise between these institutions. Certainly in the colonies in the early nineteenth century there were many people, particularly of the middle and upper classes, who preferred the monarchy even if they did wish for a somewhat larger measure of self-control in local government. Most likely, royalist sympathizers existed in New Mexico, which never seems to have developed a strong bond to the Republic of Mexico and was much neglected by it. The expulsion of all Spanish-born persons by the Republic in 1826 was not favored by many New Mexicans, partially because it included most priests stationed in New Mexico.[5]

Aragón's *retablos* could be innocent conflations based on portraits taken from decorative arts. But the manipulation of tangential symbolism such as the eagle and lion implies a conscious choice on the part of the artist. Perhaps some of the *retablos* are actually portraits of Ferdinand VII, and others represent the saint-king but have a secondary allusion to his descendant, Ferdinand VII. As such, they may represent royalist sympathies on the part of either Aragón himself or his patrons or both, as well as hostility toward the Mexican government that had cut off financial support to the province and evicted all Spanish-born citizens, including most religious leaders. The images could even represent specific support for Iturbide's planned monarchy in Mexico. If they do, on some level, represent portraits of Ferdinand VII, they would be the only known portraits to have been produced in New Mexico as well as the only known examples of political expression in New Mexican arts.

PART TWO

RECONSTRUCTING ETHNICITY FROM THE ARCHIVES

4 | THE FORMATIVE ERA FOR NEW MEXICO'S COLONIAL POPULATION: 1693–1700

JOSÉ ANTONIO ESQUIBEL

There is a persistent and common misconception that the Hispano cultural traditions of New Mexico originated with the founding of New Mexico as a Spanish colony in 1598. The common perception is that these traditions, transplanted directly from Spain, were adapted and maintained by descendants of the original Spanish colonists over the next four hundred years.[1] But culture does not exist without people. If we are to gain an understanding of the formation and evolution of New Mexican cultural traditions, we must study patterns of migration to the region. The most active period of migration of Spanish citizens to New Mexico occurred between 1693 and 1695, as part of a great effort to achieve reconciliation between Spanish citizens and Pueblo Indians. The rift between these two groups of people centered on the Pueblo Indian Revolt of August 1680, a decisive event that altered the developmental course of New Mexico's seventeenth-century frontier society and cultural heritage. The Revolt marked the passing of one era and set the foundation for the next, shaping the New Mexico Hispano culture and heritage we know today. Consequently, the formative era of New Mexico's colonial society really took place *after* the restoration of the region to the Spanish crown, between December 1693 and 1720. In turn, this era can be divided into the period of restoration of the Spanish colony (1693–1700) and the period of stabilization and integration of the colony with the preexisting population (1701–20).

This chapter focuses on the origins of the people who reestablished the colony in frontier New Mexico during the crucial period of immigration between 1693 and 1700, as documented in muster rolls, census records, sacramental records, and other surviving firsthand testimony. Fortunately, these records are more consistent in their designations of ethnicity and geographical origins than are records of eighteenth-century New Mexico.[2] Individuals who provided sworn testaments before officials of the Inquisition and the military government often included their *casta* (proto-racial/ethnic) designation.[3] Although these designations were arbitrary—the underlying assumption that visual characteristics like skin color express genetically coded differences of character, temperament, or intelligence is simply untenable today—the sheer presence of so many different designations demonstrates that, at the end of the

seventeenth century, the New Mexico settler population was already diverse. Indeed, its multiple and compound diversity—geographic and ethnic, social and cultural—is key to the dynamic culture that emerged during and after the Resettlement period.

In the first three decades of the seventeenth century, the population of New Mexico's Spanish citizens remained small. The majority of the colonists who came with Juan de Oñate in 1598 left New Mexico in disappointment and poverty. By 1609, there were about sixty Spanish settlers remaining in New Mexico, and they most likely stayed in order to receive the privileges of the lower Spanish nobility as promised by the Spanish crown for those who remained more than five years in the colony.[4] The status of first settler provided an advantage in, though not a guarantee of, social and economic advancement. The social hierarchy of seventeenth-century New Mexico was based on the quasi-feudal social system of the *encomienda*. The upper-class citizens were the *encomendero* families, many of whom were part of the extended kinship group of first settlers. The heads of these households were granted authority to exact tribute from Indians placed in their care. The *encomendero* class were landowners and often maintained ranching *estancias,* relying on lower-class citizens—generally Indians, *mestizos, mulatos,* and Africans—for labor and the production of local goods. Thus the artisans in New Mexico before 1680—such as painters, blacksmiths, carpenters, weavers, and brick masons—were usually Mexican Indians or Pueblo Indians who had learned their trade skills from Spanish settlers and Franciscan friars.

Seventeenth-century New Mexico was marked by continual strife between civil government officials and their supporters and the Franciscan friars and their supporters, culminating in the erosion of New Mexico's political stability by the 1670s. This discord, coupled with the Pueblo Indians' growing resentment of the demands placed on them for labor, fostered intense discontent that was channeled by Pueblo Indian leaders into a well-planned uprising in August

1680, forcing the Spanish citizens to flee from their homes and settlements. The destination of the refugees was the settlement of El Paso del Río del Norte, which functioned as an important outpost along the royal road. However, having suffered great loss during the uprising, they were not able to sustain themselves there as well as they had in northern New Mexico. Over the course of the next twelve years their numbers dwindled with each passing year. The arrival of Don Diego de Vargas as governor of New Mexico in 1691 marked the beginning of the critical episode of New Mexico's restoration, which was underscored by the remarkable reconciliation between Pueblo Indians and Spanish citizens. Vargas's military and diplomatic skills measured up to the daunting task of regaining New Mexico and reestablishing Spanish government and culture. Toward this aim, Vargas requested permission to recruit additional settlers, since the remnants of the families that had fled New Mexico in 1680 were too few to repopulate and maintain the colony.

Besides the families of the pre-Pueblo Revolt period (1598–1680) who returned to New Mexico with Governor Vargas and his military troops, there were three additional colonizing groups that settled in New Mexico between December 1693 and April 1695. All four groups consisted of ethnically diverse people from as many as fifteen different regions of the Spanish realms on the Iberian Peninsula, in the "New World," and elsewhere in Europe, Africa, and the Philippine Islands. After converging in Santa Fe, the new and returning settlers initially focused on meeting their basic needs for shelter, food, and safety. Following the first difficult seven years, which included threats of another Pueblo Indian uprising (the last serious one was in June 1696), new communities were founded, beginning with Santa Cruz and Bernalillo in 1695. An era of economic stability, expansion of settlements, and growth of families and new kinship groups began.

The material presented in this chapter only *begins* to outline the ethnic complexities of New Mexico's Hispano population. Nonetheless, it is the most extensive analysis published to date of the archival evidence

for the mosaic of people of diverse backgrounds who converged in New Mexico between 1693 and 1695. By using archival records to document social interactions among a diverse population of settlers during the Resettlement period, this account serves a twofold purpose. It witnesses the hybrid ethnicity of the settler population as it began to be socially integrated; and it provides an unprecedented glimpse of the artisan skills that these transethnic kinship groups shared and transmitted from one generation to the next.

Reestablishing New Mexico's Spanish Society

From the first, the re-formation of Spanish society in New Mexico between 1693 and 1700 involved the crossing of social and economic boundaries. For the additional settlers who were recruited from various regions outside New Mexico, the privileges of *pobladores,* or frontier settlers, presented the opportunity for upward social mobility. People who did not belong to the privileged Spanish aristocracy did not easily get such opportunities, even though Spanish society had long allowed for legitimate upward mobility as a legacy of the centuries of reconquest on the Iberian Peninsula. There was a distinction between nobility by blood (descendance from royalty) and nobility of service. It was the latter that was conferred on the original settlers of New Mexico in 1598, as well as on those of the Vargas era in the 1690s.[5] In exchange for his commitment to remain as a settler, a man who had been a weaver by trade in Mexico City or Zacatecas, for example, would receive commissions and privileges as a frontier military captain and *alcalde mayor* (the Spanish crown's civil representative) of a jurisdiction in New Mexico.

A family's commitment to frontier settlement in service to the crown raised its social standing and guaranteed eligibility for such privileges as royal land grants and commissions of civil and military leadership. In addition, those with entrepreneurial inclinations found themselves involved in potentially profitable commercial trade. In the colonial era, even

mestizo settlers (people of Spanish and Indian parentage) and nonindentured Africans and mulattos (mostly people of Indian and African parentage, as opposed to *mulatos blancos,* people of Caucasian and African parentage) were given access to these opportunities for upward social mobility and other privileges denied them in their places of origin.

The majority of the re-settlers of New Mexico between 1693 and 1695 came with very few personal resources and were initially dependent on the Spanish government for their sustenance. Lands were granted to many settlers within the first two years of their arrival in New Mexico, together with grain and tools to farm the land. In May 1697, Governor Vargas was distributing livestock on behalf of the crown to the settlers. As late as 1712, settlers were again receiving farming tools, mainly shovels and hoes, from the government.[6] The government's active encouragement and support of a pastoral livelihood, along with the abolishment of the *encomienda* tributary system that existed in New Mexico before the Pueblo Indian Revolt of 1680, underscores the vivid distinction between the seventeenth-century development of New Mexico's Spanish culture and the remarkably different development in the decades following the restoration of New Mexico to the Spanish crown.

Restoring Broken Bonds

It is important to note that at the time of the Pueblo Indian Revolt in 1680 there was a segment of New Mexico's population that straddled the cultural boundaries between the Pueblo Indian communities and the Spanish communities. There were *mestizos,* people of Spanish and Indian parentage, living in Spanish communities with relatives among the Pueblo Indian population, and likewise there were *mestizos* among the Pueblo communities with relatives in Spanish communities.[7] With the Revolt, these family groups were torn by their community loyalties, and extended familial bonds were severed, at least temporarily.

Twelve years after the forced abandonment of the northern Rio Grande Valley, the region was restored to the Spanish crown. Critical to the success of Governor Diego de Vargas in securing New Mexico in 1692 and 1693 were his interpreters and Indian allies. In addition to being fluent in the languages of Keres, Towa, Tano, and Tewa, several interpreters had relatives among the Pueblo people. Among these figures were men such as

- Sargento Juan Ruiz de Cáceres, who had relatives among the Tewa Indians, particularly at San Juan Pueblo;
- Captain Francisco Lucero de Godoy, for whom the Towa language "was his mother tongue"; and
- Miguel Lújan, who had *comadres* and relatives among the Tewa and Tano Indians who occupied Santa Fe after the Revolt.[8]

Before entering Santa Fe in late December 1693, Vargas and his troops were challenged by Pueblo Indians who refused to evacuate the walled town. While the greater portion of Vargas's troops and settlers remained encamped outside Santa Fe, a few were allowed by the Tano- and Tewa-speaking Indians to enter and take up residence with their Indian relatives. For instance, there is mention of a woman named Gerónima Márquez, described as a settler from the hacienda of Tabalaopa north of Chihuahua, who was allowed into Santa Fe to stay with an aunt of hers, an Indian woman named Ángela. Likewise, Agustín Sáez sought shelter in town, where he found an Indian by the name of Juan Gañán, a son of Sáez's father, and thus his half-brother. Other settlers noted as having been able to take up residence in the walled town during the tense days before it was stormed by Vargas and his men were Juan Pacheco with his wife and children, a woman identified as Doña Bernardina, Diego Montoya with his wife, Andrés González and his wife, and the blind interpreter, Agustín de Salazar.[9] In sum, the restoration of New Mexico to the Spanish crown—violent though it was in other respects—was also underscored by reconciliations between family members who bridged cultural boundaries between Pueblo Indian society and Spanish society.

Migration and Convergence

As early as October 1692, Vargas was considering his plan for resettlement. Expatriated native New Mexico families living at El Paso were willing to return to the restored kingdom. However, rounding up the refugee citizens who had left New Mexico to settle elsewhere, and recruiting new settlers, was expected to be a daunting task, as Vargas said in a letter to the viceroy of Nueva España, Don Gaspar Sandoval de la Cerda, Conde de Galve: "It would be easier for the Inquisition to forgive the Jews than force the citizens to leave the places where they live and are well established."[10] Specifically requesting that craftsmen be recruited, Vargas initially suggested that this could be done by sifting through the jails of Mexico City, Querétaro, Zacatecas, Guadalajara, and Rosario, and that vagrants and vagabonds could come to work the mines in New Mexico. At the time, Vargas was not particularly discriminating about the quality or character of prospective new settlers. He later altered his judgment in this matter, choosing not to recruit vagrants and vagabonds or to recruit from jails.

However, the need for craftsmen remained a significant factor when settlers were recruited in Mexico City. Governor Vargas was of the firm opinion that New Mexico could not be maintained for the Spanish crown without such skilled colonists. In January 1693, he sent a lengthy letter to the viceroy in which he mentioned his intention to travel to Nueva Vizcaya (the modern Mexican states of Durango and Chihuahua) and Nueva Galicia (mainly the modern Mexican states of Jalisco, Nayarit, and Zacatecas) to recruit personally previous residents of New Mexico and new settlers.[11] Between April and June 1693, armed with a royal directive, he traveled to various mining towns of Nueva Vizcaya and Nueva Galicia in the attempt to collect the native New Mexico families who had left the deplorable conditions of El Paso for other communities that were safer and offered better means for supporting themselves.[12] But the threatened consequences of disobeying a royal directive were not enough to force the refugee citizens from the security

and comfort of their adopted communities. These families had no interest in returning to New Mexico.

Vargas's only recourse was to recruit new volunteers to settle the restored kingdom, but these recruitment efforts, too, were disappointing. In late June 1693, while at the city of Durango, Vargas wrote to the viceroy, "Thus, I am leaving, very unhappy to see that it has been made impossible to accept the settlers and other people who may offer to go to the kingdom of New Mexico, as well as the refugee settlers who have been living in the kingdom of New Biscay and various outposts."[13] Traveling through the towns of Zacatecas, Sombrerete, Fresnillo, and Durango, Vargas managed to entice some people with the privileges of *pobladores,* frontier settlers. In the end, a small band of fifty volunteer settlers, both families and young single men and women, traveled with Vargas to El Paso, arriving in mid-September 1693 and continuing on to the abandoned Pueblo of Socorro.[14] The new settlers resided at Socorro until the native New Mexican families and soldiers who left El Paso on October 4, 1693, joined them on the way to Santa Fe. All together, an estimated seventy families with about eight hundred people arrived at Santa Fe in mid-December 1693.[15]

Meanwhile, in February 1693, the viceroy had manifested his support of Governor Vargas by initiating the recruitment of families from Nueva España, mainly from Mexico City.[16] This carefully organized recruitment, funded at the expense of the royal treasury, generated the largest group of colonists to journey to New Mexico since 1598. The families of this colonizing expedition endured nine months of travel on the Camino Real before arriving at Santa Fe in mid-June 1694 as welcomed reinforcements.[17]

Between June 1694 and February 1695, a third recruitment effort was initiated under the leadership of Captain Juan Páez Hurtado at the command of Governor Vargas. Páez Hurtado traveled to the mining towns of Nueva Vizcaya and Nueva Galicia to recruit families of good character. This proved to be a challenge, particularly because of the inability, or reluctance, of royal treasury officials to provide Páez Hurtado with adequate funds to pay the travel expenses for new settlers.[18] Subverting the system, Páez Hurtado cleverly paid single men and women to pose as couples with children who were not their own in order to receive the cash allowance for travel to New Mexico.[19] Minus the small amount paid to the actors, Páez Hurtado thus acquired the additional funds needed to feed, clothe, and transport the newly recruited settlers, consisting mostly of family groups in addition to some single men and women. This group left Zacatecas in mid-February 1695 and arrived at Santa Fe in mid-April of the same year.

Over the span of sixteen months, from December 1693 through April 1695, four groups of colonizers—people of multiple social, ethnic, and geographic backgrounds—converged in New Mexico. Besides the native New Mexicans, the individuals and families in these groups were predominately from Nueva Vizcaya, Nueva Galicia, Nueva España, and Spain, but they represented in total as many as fifteen different regions and sixty-three different towns: former realms of modern-day Mexico—Nueva Vizcaya (Casas Grandes, Durango, Nombre de Dios, Parras, Real de San Felipe, Valle de San Bartolomé), Nueva Galicia (Fresnillo, Llerena, Puesto de Covadongo, Sombrerete, Villa de Jérez, Zacatecas), Nueva España (Acazingo, Aguas Calientes, Celaya, Cuatitlán, Fistla, Guajocingo, Guamantla, Guanajuato, Istlehuaca, Jimiquilpa, Los Lagos, Mexico City, Nochistlán, Orizaba, Pachuca, Panuco, Pátzcuaro, Puebla de los Ángeles, Querétaro, Salvatierra, San Luís de Potosí, San Miguel el Grande, Tacubaya, Tenango, Tlapujagua, Valladolid, Valle de Toluca, Xucimilco, Zamora), Nuevo León (Monterrey), Sinaloa, Sonora (San Juan Bautista); realms of Spain—Castilla (Berguega, Madrid), León (Santa María de la Nieva, Villa de León), Andalusia (Baeza, Cádiz, Carmona, Granada, Medina Sedonia, Osuna, Puerto de Santa María, Sevilla, Villafranca de los Palacios), Asturias (Asiera, Oviedo), Galicia (Mondoñedo), Murcia (Lorca), Aragón (Langón); and other countries and conti-

nents—Portugal (Bejar), Philippine Islands (Manila), France (Bayonne, La Rochelle, Paris), and Africa (Congo, Guinea).

According to the records, the colonizers were ethnically and culturally diverse, like those found in other areas of the Spanish Americas. The most privileged people were the *españoles peninsulares* (people native to the Spanish realms of the Iberian Peninsula), followed by the *españoles criollos* (Spaniards born in the New World). Also considered as *españoles* were the numerous *estrangeros,* foreigners from other European countries such as Portugal, France, and Flanders. Next followed the various *castas,* consisting of Indians and people of mixed racial background, mainly *castizos* (*español* and *mestizo), mestizos* (Indian and *español), mulatos* (mainly Indian and African, rather than the *español*-and-African combination referred to as *mulatos blancos), negros* (African), and various combinations of these. Individuals and families of all these "caste" combinations were part of the re-colonizing of New Mexico and became the founders of the frontier society from which evolved the cultural traditions of Hispano New Mexicans.

Thus the adjective "Spanish" is a misleading and limited term to describe the society and culture of colonial New Mexico. Although the mainstream elements of the society were of peninsular Spanish origin (i.e., in language, government, religion), modifications and adaptations based on regional circumstances in the Spanish colonies of the Americas created local differences between regions. The majority of colonists who arrived between 1693 and 1695 came with the intent of remaining permanently. Unlike their predecessors of almost a century earlier, they were not motivated by the promise of finding gold and silver, and they did not come seeking significant discoveries. In short, they came as *pobladores* (settlers), not *conquistadores* (conquerors). The permanence of these settlers is documented in the surviving ecclesiastical records of baptism, marriage, and burial as families and kinship groups increased in size with each generation.

The re-settlers of New Mexico—ancestors of twentieth-century Hispano New Mexicans—thus established cultural traditions unique to the region that were passed on and modified from one generation to the next. The following sections of this chapter take a closer look at the kinds of diversity recorded for each of the four groups of colonists who arrived between 1693 and 1695, beginning with the overview fortunately provided by the survival of a 1697 census of livestock recipients.

The 1697 Census of New Mexico's *Pobladores*

As was promised by royal officials, individuals and families who settled the restored kingdom of New Mexico were granted assistance in establishing themselves as permanent residents. In addition to receiving the privileges of the lower nobility of Spanish society, they were granted lands and given livestock. An accounting of livestock recipients was recorded in May 1697.[20] This exceptional record provides an every-name listing of families and individuals who were regarded as *pobladores.*

The census lists 317 households, three of which are duplicates, and thus the census accounts for 314 households. Subtracting the thirteen duplicate individuals, the census accounts for a total of 955 people. The first 238 entries of the census are of families, and the remaining entries, numbers 239 to 317, are of single individuals. Among the families listed, there are distinct groupings. In recording the settlers, an effort was made to distinguish those who had lived in New Mexico before the Pueblo Revolt (pre-Revolt families) from those who were recruited in other regions and who arrived in New Mexico in 1693 (Vargas Recruits), 1694 (Mexico City Recruits), and 1695 (Páez Hurtado Recruits).

At this early date of New Mexico's Spanish restoration, it appears that at least the officials who documented the settlers regarded each group differently, since the evidence reveals that they did not intermarry. An analysis of the census shows that among the 152 pre-Revolt families there were fifteen unions between female natives of New Mexico and

soldiers. Of these fifteen, only one represented a union of a colonist from a different group with a native New Mexican: a male New Mexican married a woman from Nueva Vizcaya.[21] Perhaps this is indicative of a preference in the first formative years of New Mexico's restoration for the people of the different groups to form and maintain bonds mainly within their own social groups. It was not until the children of this generation were grown that intermarriage among the various groups became more common.[22]

Many of the families listed—48.4 percent of the 314 households—belonged to the pre-Revolt group. The next largest group consisted of the families recruited at Mexico City, which made up 16.9 percent of all households listed. This group was followed by the families recruited in 1695 by Juan Páez Hurtado in Nueva Galicia, 7 percent of all households. The families recruited by Governor Vargas at Nueva Vizcaya and Nueva Galicia in 1693 included only 2.8 percent of all families listed. Nearly a quarter of the 314 households (24.9 percent) consisted of single individuals.

The census is a register of those people recognized by the Spanish government as frontier settlers. Missing from this register are servants, who were mainly Indians, Africans, and mulattos, and who lacked formal social identity as frontier settlers. Their role within the social context is not officially acknowledged in the census, mainly because of longstanding racial bias. Among the *pobladores,* social and family identities are only nominally evident from the census information. The first grouping of households consists mainly of pre-Revolt families, an ordering that speaks to the prominence of their social standing in New Mexico's redeveloping frontier society. The second grouping includes families recruited in Mexico City residing in Santa Fe, followed by those recruited in the areas of Zacatecas and Durango, and then by the families from Mexico City living in Santa Cruz de la Cañada. The final grouping consists of single people, including widowers, widows, unmarried adults, and orphans. Underscoring the characteristics of New Mexico's re-emerging frontier society, the clustering

of family groups by regions of origin emphasizes group mobilization and solidarity.

Because social roles and functions are not specified in the census, family identity is not clearly defined within the redeveloping social structure at this early period. However, the Spanish government clearly intended that the families should adopt a pastoral lifestyle, since the items distributed to each family at the time of the census included cows, sheep, and bulls. There was an expectation for these families to sustain themselves with help from the government. In time, many of these families and their descendants assimilated the pastoral lifestyle into their family and social identity.

Pre-Revolt Families

The pre-Revolt families listed in the 1697 census represent the descendants of those people who had settled in New Mexico between 1598 and August 1680 and include new families formed by soldiers who arrived at El Paso and married New Mexico natives between September 1680 and November 1693. As each successive governor of New Mexico sought to maintain the exiled citizens of New Mexico at El Paso del Norte and regain the lost kingdom, soldiers came, and some married into the pre-Revolt families. The few families formed by these men who appear in the 1697 census include the Arias de Quiros, López Gallardo, Medina, Tafoya, and Villalpando families.[23] Among the pre-Revolt settlers are a few Mexican Indian families who had lived in Santa Fe before the Revolt. Although it is difficult to account for all the Mexican Indian settlers, seven households are confirmed as such.[24]

The 152 returning pre-Revolt families comprised 213 heads of households, defined to include married couples (61), widows, and widowers. They can be categorized into four subgroups: (1) 49 heads of households descended from the original colonists of 1598 (23 percent); (2) 21 heads descended from the colonists who came to New Mexico as reinforcements

in December 1600 (9.8 percent); (3) 108 heads descended from men who arrived in New Mexico between 1601 and August 1680 (51 percent); and (4) 13 heads who were soldiers, of whom nine had come to New Mexico between August 1680 and November 1693. Each of these subgroups was diverse in geographic origins and ethnic backgrounds.

Kinship groups were a dominant social factor. Of the ten largest kinship groups among the pre-Revolt families, five were families established in New Mexico in 1598. The largest was the Martin Serrano clan, a *mestizo* family group with Spanish and Indian antecedents (perhaps Tigua, and possibly also Tano),[25] consisting of eighteen families and representing 12 percent of the pre-Revolt families. Next was the Varela de Losada/Varela Jaramillo clan, with eight families (5.3 percent). The Montoya clan consisted of seven families (4.7 percent). Next was the Griego clan, also a *mestizo* family, which consisted of six families (3.9 percent). Also consisting of six families each were the Lucero de Godoy clan, a family with Spanish and Indian antecedents, and the Romero clan.[26] Each of these family groups can be found more than once in the lineages of twentieth-century Hispano New Mexicans.

The families that settled New Mexico with Don Juan de Oñate in 1598 were not a homogeneous group. Their origins were not only in the Spanish Americas, primarily Nueva Galicia and Nueva España, but also in Spain and Portugal.[27] People of African background also came with Oñate's expedition, mainly as servants or slaves. From this group of original colonizers, there are only twenty-two families for which there is documented descendance to the present day, most prominently including the Archuleta, Bernal, Brito, Carvajal, Durán, Griego, Jaramillo (Varela Jaramillo), Márquez, Martín Serrano (Martínez), Morán, Romero, Valencia, and Varela/Barela (Varela de Losada).

The difficulties during the early years of the New Mexico colony fostered discouragement. Oñate persisted, and his request for additional colonists resulted in the recruitment of families that arrived at the Villa of San Gabriel in late December 1600.[28] This group consisted of sixty-five people, including several families and twenty-five servants. Of this group only six families are known to have descendants living in New Mexico today: the Baca, Cháves, Herrera, Lújan, Olguín, and Montoya.

The majority of the families of these two subgroups were among the most privileged in seventeenth-century New Mexico society. It was primarily members of these families who were granted *encomiendas* to oversee the care of local Indians in exchange for tribute goods and labor—a source of conflict contributing to the Pueblo Indian Revolt. *Encomenderos* also provided military service to the crown at the order of the governor.[29] Of thirty-eight identified *encomenderos* of seventeenth-century New Mexico, twenty-seven were members of, or related by marriage to, families from the two early groups of New Mexico colonizers.

The third subgroup consisted of families founded over the course of the eighty years between 1601 and August 1680 by men who came to New Mexico in various capacities, mainly as soldiers in the company of arriving governors or as wagon escorts, but also as merchants or aides to governors. Between 1601 and 1680 very few people migrated to New Mexico as family groups, but as many as fifty-five families with descendants living today were founded in this period of New Mexico's history, including the Anaya, Apodaca, Candelaria, Cedillo, Cisneros, Domínguez, Fresquís/Fresques, Gallegos, García de Noriega, Gómez, González, Gutiérrez, Hurtado, Leyba, Lucero de Godoy, Madrid, Maes, Manzanares, Mestas, Mondragón, Montaño, Naranjo, Nieto, Pacheco, Padilla, Perea, Sáes, Salazar, Serna, Tapia, Torres, Trujillo, and Zamora.

The people and families of these three subgroups formed the Spanish society of New Mexico in the seventeenth century, a society based primarily on hierarchies—social, political, religious, military, and economic. At the apex of New Mexico's seventeenth-century society were the *encomenderos* and their fami-

lies. *Encomiendas* were granted by the crown and could be held in perpetuity; thus the titles, privileges, and obligations of the *encomienda* could be passed on to each subsequent generation. Families of this group that appear in the 1697 census of New Mexico settlers include the Anaya Almazán, Carvajal, Chávez, Griego, Herrera, Martín Serrano, Mondragón, Montoya, Tapia, and Trujillo, all with descendants living today in New Mexico.

Interestingly, five of these family groups—the Anaya Almazán, de la Cruz, Griego, Martín Serrano, and Montoya—are known to have had Indian antecedents and were regarded as *mestizos* and *castizos* over the course of several generations. In turn, these families were related by marriage to the González Bernal, López Sambrano, Lucero de Godoy, Moraga, and Martín Barba families.[30]

Documentary evidence confirms that the Anaya Almazán and de la Cruz families were of Spanish and Mexican Indian ancestry. For example, Beatriz de los Ángeles, wife of Juan de la Cruz (native of Cataluña in Spain) and mother of the *encomendero* Pedro de la Cruz, a *mestizo,* was a Mexican Indian woman described as *india ladina mexicana* of whom it is said *que se le trata como española* ("that she is treated as a Spanish woman").[31] A daughter of this woman was the wife of the *encomendero* Juan Griego, himself identified as *mestizo.*[32] The mother-in-law of Francisco de Anaya Almazán, an *encomendero* identified as *español,* was María de Villafuerte, who was also a Mexican Indian and was originally from the Pueblo of Guatitlan in Nueva España.[33] She and Beatriz de los Ángeles, also a native of Nueva España, were described as *muy ladinas y españoladas mujeres de dos soldados españoles.*[34] This description indicates that these women, both among the common ancestors of Hispano New Mexicans, were very much acculturated, so much so that they were regarded and treated as if they were *españolas.* Accordingly—but contrary to the general presumption of discrimination based on "racial" mixture—their offspring were accepted as members of the *encomendero* class.

In descending order, the next group in New Mexico's seventeenth-century social hierarchy functioned as ranchers and merchants and held important civil positions. Many were landowners with servants, and most served as soldiers, since New Mexico was also a frontier militia society. These men held the ranks of *alférez, capitán, sargento mayor, ayudante,* and *maese de campo.* As with the *encomendero* class, this group was not exclusively *español* and included people classified as *mestizos* and *mulatos.* The prominent families of this group who were regarded as *castas* and who have descendants living today include Apodaca (*mestizo*), Domínguez (*mestizo*), López de Gracia (*mestizo*), González Bernal (*castizo*), López Sambrano (*mestizo*), Lucero de Godoy (*castizo*), Moraga (*castizo*), Nieto (*mulato*), and Valencia (*mestizo*).[35] Families of this social class that appear in the 1697 census of New Mexico settlers include the Apodaca, Baca, Cedillo, Domínguez, Durán, Fresquís, García de Noriega, González Bas, Gutiérrez, Hurtado, Lucero de Godoy, Manazanares, Márquez, Olguín, Pacheco, Serna, Sisneros, Valencia, and Varela.

There is very little information available about the Mexican Indian citizens of New Mexico. The two Mexican Indian women mentioned above were members of the *encomendero* social class. Mexican Indian men appear in seventeenth-century records as tradesmen and laborers, such as Francisco "Pancho" Balón (d. c. 1628), a blacksmith in Santa Fe, and Juan Chamizo, a mason in Santa Fe as early as 1662 who fled to El Paso del Norte with his family at the time of the Pueblo Revolt in 1680.[36] There is even less information available concerning *mestizos,* free *mulatos,* and free *negros* of lesser social standing.

The Pueblo Indian people also had their own well-established social hierarchies, as documented primarily by twentieth-century anthropologists relying on direct observation and oral history outside the present scope of study.[37] During and after the colonial era, the Pueblo Indians and other, primarily nomadic groups were exploited as laborers to the profit of governors, friars, *encomenderos,* merchants, and ranchers.

Under Spanish law, however, Indians had access to legal recourse to address injustices. The archival record of Indians bringing suit against officials of the viceregal government provides illuminating information about these injustices and also documents the trade skills of the New Mexico Indians of the seventeenth century.[38] Petitions filed in 1662 against Governor Don Diego López de Mendizábal by Antonio González, Protector of Indians, name

- Ana Velasco, Indian woman, demanding compensation for eleven months of services for Governor Mendizábal.
- 10 Indian painters (yndios pintores) requesting compensation for two years of work.[39]
- Francisca Tadeo, Humano Indian, demanding 74 pesos for her husband, who provided 10 months of services for Governor Mendizábal as a cart driver and carpenter (carretero y carpintero) and died while in the governor's service.
- Juan Chamizo, a master mason (albañil maestro) requesting an additional 16 pesos for reparation work on the Casas Reales. (This appears to be the same person identified in 1680 as Juan Chamizo, a Mexican Indian who escaped the Pueblo Revolt with twenty persons in his family, including his wife, children, grandchildren, and servants.)[40]
- 60 Indians of Quarác, demanding compensation for 17 days of work gathering bushels of piñon.
- the Indians of Pecos, demanding 100 pesos for 100 parchments.
- Antonio de la Serna, shoemaker (zapatero), demanding 35 pesos.
- the natives of the six pueblos of San Juan, Santa Clara, Jacona, Pojoaque, Nambé, and Cuyamungue, demanding 60 pesos for making woolen socks.
- Juan, blacksmith by occupation, for making knives, latches, shackles, and 200 keys.
- the natives of Tesuque, demanding compensation for 14 bushels of piñon.
- Francisco Quasin, leather jacket maker (coletero), demanding 19 pesos and 2 reales.
- an Indian woman named Juana from the Pueblo of San Felipe, demanding 2 pesos for making 16 pairs of socks.
- 10 Tewa Indians, demanding 28 pesos for making leather jackets and other items.

- the carpenters (carpinteros) of Sandia, Alameda, and Isleta, demanding 300 pesos for thirty wagons and carts (carros y carretas).
- the Indians of the Pueblo de la Cienega, demanding 12 pesos for making socks.

The lawsuits filed in a single year by a single advocate are sufficient to demonstrate that Indian skills and labors contributed to the material culture of New Mexico and to the economic system. Moreover, many of these items could be and were traded outside New Mexico. Indians produced items of everyday use from piñon nuts to socks to paintings. The archival record reveals that the identified Indian pintores were painting elkhides, one per day, although the record unfortunately does not indicate what was painted on them. In 1665, Don Pedro Manso mentioned that he had instructed the Indian painter Francisco Pachete to ask for a Bible from which Pachete could copy some of the medallions, as he had copied others in the past. This is a clear reference to the common practice of producing works of art by copying images from printed sources and a direct reference to the fact that Indians were trained to copy images.[41] Further documentary evidence for cross-cultural mingling of customs, still awaiting study, is found in Inquisition records, such as the investigations of women, including españolas, mestizas, and mulatas, accused of witchcraft.[42] Recipes for potions with powers to influence people, mainly men, were supposedly shared among women of diverse "racial" backgrounds, according to Inquisition records that exist as early as 1606 at the settlement of San Gabriel in New Mexico.[43]

By the 1670s, New Mexico settler society was defining a cultural direction supported by Indian skills and labor. However, with the revolt of the Pueblos in August 1680, these colonial power relations changed irrevocably. Two critical consequences resulted from the Revolt. The first was the immediate elimination of the encomendero system in New Mexico—although, needless to say, the social effects of this change were complex and far more gradual. The other was the

migration of a significant number of people from regions beyond New Mexico when the kingdom was restored to the Spanish crown. The concluding discussion considers the effects of these migrations further.

Vargas Recruits of 1693

A little-known New Mexico colonizing expedition that has received insufficient recognition by scholars was organized under the authority of Don Diego de Vargas. From March through June 1693, Vargas visited several towns in Nueva Galicia and Nueva Vizcaya in his attempt to collect the native New Mexico families that had left El Paso del Norte. He managed to entice only one former New Mexico family to return with him. He also solicited for new volunteer settlers willing to go to New Mexico. Writing to the viceroy in June 1693, Vargas mentioned having recruited 100 soldiers and 50 settlers, mainly from the towns of Zacatecas, Sombrerete, and Durango.[44] As he proceeded northward he enlisted at least five more people, for a total of 55 new settlers by September 1693. Arriving at El Paso del Norte by mid-September, Vargas ordered the new settlers to continue northward under the command of Captain Roque de Madrid with instructions to establish themselves at the abandoned Pueblo of Socorro.[45] There they would wait until Vargas and the old New Mexico families joined them. This small group of settlers re-blazed the tracks of El Camino Real de Tierra Adentro and spent at least two months at the Pueblo of Socorro, one of Spain's most remote frontier territory outposts.

The Socorro group consisted of 14 families and 11 single people.[46] Fifty-five people who were part of this group can be accounted for from various sources, and a total of 46 were identified by "racial" status. There were 9 adult *españoles,* 6 *mulatos,* 4 *negros,* 4 *moriscos,* 2 *mestizos,* 2 *coyotes,* and 1 Tarascan Indian.[47] Of the children, 16 were of mixed African ancestry, 2 of *morisco* background, and 2 Tarascan Indians. Widowed women headed 9 families with children, including probably 32 people, or 59 percent of this colonizing group. There were only 3 married couples, 2 with children, totaling 8 people. The rest of the expedition consisted of at least 14 single men, most of whom served as muleteers, and 1 single woman, a Tarascan Indian who served as a cook for the muleteers.[48]

The families of this group are identified in the 1697 census of livestock recipients under the title *las familias que viven en esta villa de Santa Fe de Sombrerete y Zacatecas* ("the families from Sombrerete and Zacatecas that live in this town of Santa Fe") and are listed as families numbered 136 to 143.[49] The remaining members of this colonizing group are listed among the single people. Most members of this expedition, although accorded the rights of *pobladores,* did not do as well socially in New Mexico as did the pre-Revolt families. Few attained important civil and military positions. Exceptional families of this colonizing group that achieved social prominence include the Abeyta *(español),* Benavides *(español),* Fernández Valerio *(morisco),* Palomino Rendón *(español),* Velásquez *(mulato),* and another Velasco/Velásquez family *(mestizo).*

It is relatively difficult to uncover the contribution of this colonizing group to the re-formation of New Mexico's Spanish society. It is worthwhile to note that one member of this group, Diego de Velasco, a.k.a. Velásquez, identified as *mestizo* and a native of the city of Durango in Nueva Vizcaya, was a master carpenter. In 1710, he participated in and supervised the reconstruction of the San Miguel Chapel in Santa Fe. He also worked on the construction of the new parish church in Santa Fe. As late as 1746, as a resident of the jurisdiction of Santa Cruz, Velasco/Velásquez was still recognized as a *maestro carpintero* (master carpenter).[50] As such, he would likely have taught many apprentices, although no documentary evidence confirms this speculation.

Mexico City Recruits of 1694

The characteristics of the families who enlisted as colonists for New Mexico at Mexico City can be understood from the decree of the viceroy. Read in all

the customary places in Mexico City, the proclamation stated that transportation would be provided for families and that they would be accorded the honors and privileges of colonizers and would be granted lands. The chance to obtain the honors and privileges of the lower Spanish nobility was perhaps the single most influential reason that many of the families enlisted as colonists, uprooted themselves from their familiar urban environment, and sought to settle a distant and dangerous frontier. Viceregal stipulations insured that only *españoles,* "legitimately married and of good character," were recruited (i.e., racially mixed families of lower social status were excluded).[51] At the same time, the enticements offered no gain to aristocrats. Rather, the men who enlisted with their families as colonists for New Mexico were tailors, painters, weavers, carpenters, cabinetmakers, cutlers, millers, stonemasons, brick masons, shoemakers, barbers, and blacksmiths.[52] Although these were respected and honorable trades, under "normal" circumstances they did not include the privilege to acquire land and gain higher social status.

In order to be accepted as a colonizing family, couples were also required to prove they were legitimately married in the Catholic faith. Local church records were consulted, or official certificates of marriage were obtained as proof. Fray Francisco Farfán, procurator of the custody of New Mexico and the main organizer of the 1694 colonizing expedition, adamantly insisted that no unmarried men be allowed to go: "Also, in attention to the fact that these families are composed precisely of married couples and are taking along some unmarried daughters, it should neither be permitted nor agreed that any single man, even under pretext of being a kinsman, be allowed to go, live, or mix with these families."[53] Several single men made contact with Farfán, registered as colonists, and then actively sought brides willing to leave Mexico City and settle on the far northern frontier. In fact, as many as thirteen enlisted couples—about 11 percent of the colonists—were married between May 17, 1693 and September 8, 1693.[54]

After many delays, the colonizing expedition to New Mexico was finally ready to begin its northward journey in early September. Sixty-eight families, comprising 235 individuals, left Mexico City under the guidance of Farfán.[55] The route north to New Mexico followed El Camino Real de Tierra Adentro to Querétaro, Zacatecas, Cuencamé, the outpost of El Gallo, Parral, El Paso del Norte, and finally Santa Fe. The caravan traveled slowly; the anticipated three-month journey became a nine-month ordeal. Nonetheless, in the early morning hours of June 23, 1694, sixty-two families and four single men, totaling 217 people, entered the Villa de Santa Fe as welcomed reinforcements for re-colonizing New Mexico. Of these colonists, 92.3 percent were natives of the Spanish colonial provinces, specifically, Nueva España, Nueva Galicia, Nueva Vizcaya, and New Mexico. Those born in Nueva España comprised 76.2 percent of the colonists, with 61.3 percent originating from Mexico City.[56] Natives of Europe, principally Spain and France, represented only 7.7 percent of the colonists. All but two individuals were considered *españoles.* Juan de Gamboa was identified as *castizo.*[57] He and his family fled the expedition at Zacatecas and did not arrive in New Mexico. Micaela de Medina, wife of Simón de Molina, was identified as *castiza.*[58] This family completed the journey to New Mexico. One of the main reasons for the success of this colonizing expedition, resulting from the careful recruitment by royal officials, was the existence of kinship relations among the various families. In all, there were nine distinct kinship groups, involving twenty-eight of the sixty-two families, and comprising 116 individuals.[59]

The families of this colonizing expedition left their familiar urban environments and the cultural centers of nonfrontier Spanish society on the promise of social and economic privileges and land acquisition. On the rugged and hostile frontier, their lives and lifestyle changed considerably. Nevertheless, this particular group of colonists, educated and highly skilled, was integrated quickly into the higher echelons of

New Mexico society. The men and their sons came to occupy important civil and military positions. The families of this expedition with surnames that are still familiar in New Mexico today include Aragón, Atencio, Bustos, Cárdenas, Casados, García Jurado, Jaramillo Negrete, Jirón de Tejeda, Mascareñas, Molina, Moya, Ortiz, Quintana, Rodríguez, Sandoval Martínez, Sena, Silva, Valdés, and Vallejo. These families became the new elite of New Mexico society, and many were able to establish themselves among the pre-Revolt oligarchy, by intermarriage and by the acquisition and successful management of land, servants, and livestock. The bonds created by the long, difficult journey north were strengthened in New Mexico through matrimonial alliances and through the special relationship between godparents, referred to as relations of *compadrazgo*. As a result, the existing kinship groups became larger and more complex as new kinship affinities were formed over the next two decades.

Less than a year after the arrival of the colonists from Mexico City, plans to establish the first new Spanish town in New Mexico were coming to fruition. On April 21, 1695, the families from Mexico City departed from Santa Fe and completed a short journey to the north. Arriving on the following day at the evacuated Pueblo of San Lazaro, they christened the site *La Villa Nueva de Santa Cruz de Españoles Mexicanos del Rey Señor Carlos Segundo.*[60] This town would be more commonly referred to as Santa Cruz de la Cañada, or simply Santa Cruz or La Cañada. Over the course of the next two years, some of the Mexico City colonists returned to live at Santa Fe. This is evident in the 1697 cattle distribution census section identified as *familias mexicanas que viven en esta villa de Santa Fe* ("families of Mexico that live in this town of Santa Fe"), which lists seventeen households.[61] A second grouping of the Mexico City colonists, later in the list, consists of thirty-four households. Presumably, these thirty-four families were residing at Santa Cruz. In all, the 1697 census accounts for fifty-one families of the sixty-eight families who were recruited

at Mexico City. These families transported the culture of Nueva España, particularly that of Mexico City, to New Mexico. Many of the individuals were educated and highly skilled. For instance, the colonist Juan de Paz Bustillos (a.k.a. Juan de Bustos) was teaching school at Santa Fe as early as 1700.[62] He was still living at Santa Fe in 1721. Miguel de Quintana, a founder and a longtime resident of Santa Cruz, wrote poetry and pastoral plays.[63] His writings reveal the influences of the spiritual and intellectual milieu of Mexico City in the latter part of the seventeenth century. The seven Góngora siblings who accompanied their widowed mother to New Mexico were great-grandchildren of one of Mexico City's gifted literary masters, Bartolomé de Góngora (b. c. 1578, Éjica, Andalusia, Spain–d. 1659, Mexico City), an extremely well-read individual who drew from varied sources including the Bible, the classics (Ovid, Seneca, Aristotle, Virgil, and Horace), the early Church Fathers, Christian ascetics (Saint Teresa, Fray Domingo de Baltanáns), Spanish histories, biographies, and New World epics and histories.[64] His great-grandson, Cristóbal de Góngora, served in New Mexico as a lawyer representing clients in a variety of judicial cases. Colonizer José Bernardo de Mascareñas was the son of *Bachiller* (i.e., university graduate) Don Felipe de Mascareñas.[65]

The social and cultural influences introduced to New Mexico's frontier society by the individuals of this unique colonizing expedition have not been fully recognized or studied. Such a study is likely to unveil influential contributions in the areas of social customs, religious traditions and expressions of faith, commerce, trade skills, education, and very probably art, music, medicine, and oral folklore. The ultimate success of this particular group of colonists was its sheer number of descendants, who spread northward over the course of the eighteenth century into Quemado, Las Trampas, Santa Barbara, El Llano, San Rafael del Guigue, Embudo, El Rito, Taos, San Pedro de Chama, and Abiquiu, and southward to Bernalillo, Albuquerque, Belen, and Tomé.

Páez Hurtado Recruits of 1695

The individuals and families who arrived at Santa Fe in April 1695 under the leadership of Captain Juan Páez Hurtado represent the last colonizing group to come to New Mexico in the colonial era. Recruited in the several towns in Nueva Galicia, these settlers came originally from a variety of places, including Nueva España (8), Nuevo León (2), Sonora (1), Portugal (1), and Spain (1), but the majority were natives of the towns of Sombrerete and Zacatecas in Nueva Galicia.[66] Accounting for all the people of this colonizing group has been challenging because of the fraud involved in their recruitment.[67] A detailed study of this group has accounted for approximately 150 individuals. There were twenty-five families with thirty-nine heads of households and ninety children. In addition, there were twenty-one single people, sixteen men and five women, ranging in age from 16 to 31. Twenty-two of the twenty-five households are listed in the 1697 census of *pobladores* as receiving livestock.[68] As with the other groups, these families are listed in a cluster and are identified as *familias de Zacatecas que viven en esta villa* ("families of Zacatecas that live in this town"). Only eleven of the twenty-one single individuals appear on this same list of *pobladores*.[69] The notable family names found in the census and still familiar in New Mexico today include Arellano, Armijo, Espinosa, Lobato, Montes Vigil, Olivas, Rivera, Rodarte, Sierra, and Tenorio. (See Chap. 5 for details on the racial diversity of this group of settlers.)

Little more than a handful of the families of this group were notably successful in integrating themselves into the re-forming frontier society of New Mexico. Among the most prosperous were the Armijo *(mestizo),* Lobato *(español),* Rivera *(español),* Tenorio *(español),* and Vigil *(mestizo)* families.[70] The Armijo were an exceptional family. From as early as 1695, Antonio Durán de Armijo, born c. 1677 at Zacatecas, was a practitioner of medicine.[71] As a "Master Barber," he continued to practice medicine until his death at Santa Fe in 1753. Two brothers, José and Vicente, worked to restore the old San Miguel Chapel at Santa Fe in 1710.[72] Over the course of the eighteenth century, members of the Armijo family married into pre-Revolt families such as the Apodaca, Baca, Cháves, Lucero de Godoy, Montoya, and Romero.[73] The success of the Lobato, Rivera, Tenorio, and Vigil families was based mainly on a combination of land acquisition, military service, and strategic matrimonial alliances with members of prominent pre-Revolt families and families recruited at Mexico City.

Formation of Hispano Society in New Mexico

The material presented in this chapter only begins to outline the complexities of the formation of New Mexico Hispano society, when people of diverse backgrounds converged between December 1693 and April 1695. The children who came to New Mexico with their parents as settlers were reared with the values and cultural traditions of their families of origin, reinforced by the initial tendency of families to form relationships within their own colonizing group. For the first seven years following 1693, the adults were concerned with basic survival and with establishing themselves within New Mexico's new, emerging social order. The social positions that they established during this formative period would significantly affect their children's social, economic, and political standing. Between 1700 and 1720, many children of the restoration era reached adulthood and began to marry. During this period, unions of family members from the different colonizing groups occurred more frequently. The offspring of these couples were raised with influences from the diverse backgrounds of their parents. Thus, geographically and ethnically diverse cultures created a distinct frontier society—a mosaic of people who established cultural legacies for their descendants. The first two decades of the eighteenth century initiated a sustained period of stabilization and integration for New Mexico's Spanish settlements. For the colonists, the last serious threat of a Pueblo Indian revolt occurred in June 1696; from 1700 to 1720, families became sufficiently established to

sustain themselves without continual assistance from royal authorities. From this period until the late nineteenth century, Indian attacks and counterattacks were a regular feature of daily life. Nonetheless, descendants of the re-colonizers increased, intermarried with one another and with the native inhabitants, founded new settlements, and actively transmitted the cultural traditions of previous generations, infusing their own innovations with each passing generation. In the course of the eighteenth century, a stream of immigrants from various geographic regions in Europe and the Americas contributed further to the active development, as well as the preservation, of tradition and custom. Furthermore, the presence and influence of the *genízaro* (detribalized Indian) segment of New Mexico's society were additional contributing factors by the mid-eighteenth century. One manifestation of Spanish piety in New Mexico was adopting orphaned Indian children who were traded by nomadic Indian groups. The settlers cultivated Spanish identity and communal ties among the *genízaros* they raised. In the mid-1700s groups of *genízaro* families founded the settlements of Belen, Carnuel, and Abiquiu. *Genízaro* descendants came to regard themselves as "Spanish" and made contributions, often overlooked, to New Mexico's cultural heritage.

The formation of Hispano society in New Mexico involved a complex process of cultural memory and amnesia. Fortunately, cultural memory is embedded in the preserved archival documents of New Mexico's colonial period, such as censuses, government records, wills, military records, land grant records, civil suits, and sacramental records. Information collected from these various sources illuminates New Mexico's frontier society as it developed and was sustained by frontier families from the 1690s onward. Woven into the content of the archival documents are threads of family memory that inform us about family constitution, social and familial relations, and family identity, each of which was influenced by and preserved within the context of social conditions and occupation.

Families were the vessels of culture, transmitting the customs and traditions of the *Nuevoméjicano* heritage. The best-documented case of the transmission of an artisan trade skill and family identity from the late seventeenth century into the twentieth century is found in the Sena family.[74] Bernardino de Sena (b. c. 1685, Mexico City–d. 1765, Santa Fe, New Mexico) came to New Mexico with his foster parents from Mexico City in 1694. In 1705 he married Tomasa Martín González, a daughter of Hernán Martín Serrano, a *mestizo* Spanish-Tano Indian *encomendero* of seventeenth-century New Mexico. This matrimonial alliance with a pre-Revolt New Mexican family secured Sena's social status among the elite families of Santa Fe and facilitated his access to important civil positions and opportunities for acquiring additional land. He also learned the blacksmith trade and operated a blacksmith shop in Santa Fe. In 1758 Sena bequeathed his blacksmith shop to his only son, Tomás Sena. The blacksmith skills and trade were diligently passed from one generation to the next in several branches of the Sena family. A compilation of information from genealogical and historical records accounts for as many as twenty-three Sena blacksmiths within seven generations from the late 1600s to 1900. The pattern of skills transmission in the Sena family was patrilineal, with no evidence that sons of Sena women were blacksmiths. Within the frontier society of New Mexico the Sena family identity was well defined, consolidated through a particular trade, and transmitted over many generations.

Throughout the course of the eighteenth century individual men settled and married in New Mexico. These men came from places farther south such as San Juan del Río, Chihuahua, Zacatecas, Querétaro, Guadalajara, Toluca, Puebla de los Ángeles, and Mexico City, as well as from Spain—Castilla-León, Castilla La Mancha, Burgos, Aragón—and Canada.[75] Of particular importance was the significant contribution to the expression of devotional art in New Mexico made by Don Bernardo Miera y Pacheco, a native of Valle de

Cariendo (near Burgos), Spain, and a talented painter and sculptor.[76] Miera y Pacheco married into the prominent Domínguez de Mendoza family, a pre-Revolt family at El Paso, and he settled in Santa Fe by 1756. He made devotional art for several pueblo churches as well as for the military chapel in Santa Fe and was apparently an influential force in the early nineteenth-century *santero* art that developed out of Santa Fe.

The *santero* Pedro Fresquís of Truchas was identified as *mestizo,* and was very likely a descendant of *genízaros,* if not Pueblo Indians.[77] Although nothing is known about his training as a painter and sculptor, there is a social connection between Fresquís and the Miera y Pacecho family. In 1824, Pedro Fresquís was a principal witness in the premarriage investigation proceedings for Joaquín Miera of Las Truchas.[78] Miera was a son of the painter Manuel Miera y Pacheco and a grandson of Bernardo Miera y Pacheco. Fresquís attested to his personal knowledge of Joaquín Miera's family background and stated that he knew Miera's father and grandfather. This indicates an association with Bernardo Miera y Pacheco before his death in 1785 and an association with Manuel Miera y Pacheco, who resided in the jurisdiction of Santa Cruz de la Cañada from 1789 to his death in 1800. The social context in which Fresquís knew the Miera family was very likely related to the production of devotional art. If so, Fresquís may have assisted Bernardo Miera y Pacheco and collaborated with Manuel Miera y Pacheco. What influence the Miera family had on Fresquís is not known, nor has it been studied, but Fresquís influenced the generation of painters and sculptors that followed him.

Although New Mexico was a distant frontier realm in New Spain, it was a cultural center in its own right. Many writers have skewed our understanding of frontier societies by comparing them with cosmopolitan urban centers, focusing on stark differences to highlight the perceived shortcomings of "isolation." Another factor influencing the misconceptions of Hispano New Mexican cultural development is the relative scarcity of historical records, particularly relating to the seventeenth century. Yet the existing historical documents have not been thoroughly studied from the perspective of cultural and familial memory. Consequently, memories about New Mexico's historical and cultural past have been generated from limited details. The information presented in this chapter aims to dispel earlier misconceptions about New Mexico's "backwardness" by documenting the remarkable number of different geographic regions that contributed to its "Spanish" society. That is to say, under the canopy provided by the Spanish language, the Spanish civil and military government, and Spanish Catholicism, the re-settlers of New Mexico transplanted "Old World" culture, adapting folktales, music, colloquialism, artisan skills, and other cultural practices to their new location—often by way of previous stops in the colonial world. In this dynamic process of cultural transmission, differences were blended, but they sometimes also collided; customs were preserved, transformed, discarded, or forgotten. As each successive generation passed on its reinterpreted traditions to descendants, the rich and dynamic cultural heritage of New Mexico emerged. What exactly emerged is a subject for the following chapters of this volume.

5 | THE DYNAMIC ETHNICITY OF THE PEOPLE OF SPANISH COLONIAL NEW MEXICO IN THE EIGHTEENTH CENTURY

PAUL KRAEMER

As a means of demarcating groups of people, "ethnicity" is an ambiguous concept. Traditional definitions of ethnicity include multiple components (race, national origin, language, culture, not to mention political constructions) that may or may not be independent variables.[1] Users of the word very rarely specify which of these components are intended in a particular context. Indeed, even individual articles frequently use the word to mean mostly *race* in one connection, then to mean *culture* or *language* some paragraphs later. The problem is compounded by the fact that ethnicity can be either claimed or ascribed, and in either case can reflect erroneous assumptions.[2] These considerations lead one to conclude that ethnic classifications of groups of people are *always* dynamic (i.e., change with time). However, by any standard, the ethnicity of Spanish colonial New Mexico (1598–1821) was unusually unstable and complex. In this chapter I focus on numbers of people and their geographic distributions; I discuss highly visible historical events and well-known persons primarily as temporal benchmarks to track the ever-changing population of New Mexico during the colonial period.

The Beginning of Spanish Colonial New Mexico

The initial settlements of Spanish-speaking people in New Mexico, under Don Juan de Oñate in 1598 and 1600, included more than 500 people, although more than half deserted the colony in 1601. Muster rolls and inspections of the original groups give considerable information on the ethnicity of those involved. About two-thirds of the adult men had been born in Spain; they reflected a wide range of Spanish ethnic groups including Catalans, Basques, Galicians, Portuguese, Canary Islanders, *Conversos* derived from Sephardic Jews, and Castilians of various subgroups. Physical descriptions of these Spaniards also suggest considerable genetic diversity: of the seventy-three whose beard colors were described, sixteen had red beards, thirty-one chestnut color, eighteen black, and eight gray. Five men were described as blue-eyed and twelve as having dark complexions.[3]

Thus, the racial, linguistic, and cultural differences between various peoples all nominally called Spanish or *peninsulares* contributed to the ethnic diversity of New Mexico from the very beginning. They would continue to contribute such

diversity throughout the colonial period. For instance, Basques (who included Oñate himself) maintained some degree of ethnic identity throughout the northern frontier of New Spain and continued to be prominent in many areas. A more problematical example is the question of to what extent "crypto-Jews," derived from Spanish *Conversos,* contributed to the ethnic mix in New Mexico.[4]

Among the other third of the settlers, people native to central New Spain (the Mexico City–Puebla area) predominated. In many cases, it is not clear whether these people had *peninsulares* parents, in which case they would have been considered *criollos* in New Spain, or whether they were of Indian or mixed ancestry. People native to Zacatecas (Oñate's home town) and other northern towns were also frequent. In addition, about 10 percent of the people of the initial settlers were servants, mostly Indians from New Spain but also three Negroes and two *mulatos.* Two other *mulato* individuals carried with them interesting affidavits that indicated that both were free persons. One, Isabel Olvera, carried testimony from several witnesses that both of her parents, a Negro father and an Indian mother, were free and that she had always been free and unmarried. The other, Mateo Montero, was branded on the face as a slave and had been freed by his master (also named Mateo Montero) on condition that he go on the expedition of 1600.[5]

Thus, by the end of the sixteenth century, approximately five hundred people of mixed ethnicity had come from New Spain and settled among somewhere between 25,000 and 60,000 Pueblo Indians, who themselves included people of diverse language groups. Numerous other Indian groups had been noted by Oñate during his exploratory trips, but apparently only the eastern Athabaskan people (called Vaqueros) and Jumanos had significant interactions with the Pueblos at this time. The people from New Spain included nine Franciscans and about 160 soldier-settlers. Forty-two of the soldier-settlers had brought wives and families.[6]

Development of the *Casta* System

The Oñate settlers were members of a colonial society that had been rapidly evolving in New Spain since the conquest in 1521. Radical demographic changes during this period made it impossible for New Spain to become in any sense a replica of Spain. For one thing, unmarried women who were *peninsularas* were rare throughout the colonial period. Hence, the creation of an authentic *criollo* aristocracy was prevented, and the number of *mestizos* (resulting from the nearly universal unions of Spanish men and Indian women) rose continuously.[7] While the elite people often referred to themselves as *criollos,* this was mostly a political statement and often had little to do with their actual racial background. At the same time, the Indian population during this century suffered disastrous death rates from Old World epidemic diseases. This also markedly increased the proportion of the population that was *mestizo.* Furthermore, the deaths of Indians, who did much of the manual work in the colony, vastly increased the importation of African slaves to take over their socioeconomic role in the labor force. What had started as a colony with a few thousand Spaniards, a handful of Blacks, and 25 million or more Indians became, in the seventeenth century, a largely *mulato-mestizo* society with a total population of about 3 million people (it is estimated that 90 percent of the Indians in New Spain died in the first hundred years).[8] Socially and politically, all of this demographic shift was intolerable for both the civil and the ecclesiastical authorities. It was made even worse by the custom of giving servants and slaves the Spanish family's surname (as in the case of the freed slave Mateo Montero). In order to ensure that wealth and power were secure and could be securely transferred to the next generation, a number of interesting stratagems were employed. For instance, laws were passed that required people to dress according to their ethnic category. Presumably the rationale was that the authorities had a right to know with whom they were dealing. Another strategy with wide-ranging implications was the institutionalization of ethnic categories, called the *casta* system.[9]

The *casta* system appears to have been a typical sixteenth-century Spanish contrivance. Spain had been a stratified society for some time and had perceived a vital need to categorize people as a consequence of the Inquisition and the forced conversions to Christianity of Jews and Muslims.[10] Developing the concept of "pure blood" *(limpieza de sangre)* involved enacting legal procedures for persons to demonstrate their fitness for high office or the priesthood. In New Spain the problem was more complicated. By the end of the sixteenth century, people were legally categorized into three basic categories (Spanish, Indian, and African) as well as the first-generation crosses of these three: Spanish and Indian yielded *mestizo;* Spanish and African yielded *mulato;* Indian and African yielded *zambo* or *zambaigo.* Later, all manner of secondary and tertiary crosses were given specific names, and the system became very complex and, to an extent, irrational, subjective, and subject to local variations. One writer listed fifty-three *casta* categories. Generically, people perceived to be of mixed race were referred to as *castas* regardless of the particular races involved.[11]

By the early eighteenth century, under the beginnings of the Bourbon reforms, it was perceived that the *casta* system in New Spain needed a more rational and defined basis. Authorities in Spain demanded that both civil and ecclesiastical authorities in the New World explain what they were doing about defining the boundary conditions of social stratification. In order to defend the concept of a legitimate creole elite, this demand was met, in part, by the sponsorship of an amazing, and perhaps unique, genre of art, the *Casta* paintings.[12]

Throughout the late seventeenth and eighteenth centuries, hundreds of paintings were executed by artists in New Spain, each one depicting an interracial couple with their small child, and inscribed at the top or bottom to explain the racial mixture depicted. The paintings were done in sets, most commonly of sixteen paintings; more than fifty groups have been cataloged and analyzed. Stylistically they range from fairly primitive portrayals (such as the set published by

Pedro Alonso O'Crouley)[13] to the masterful works of Miguel Cabrera and other artists highly trained in European painting styles. Interestingly, *casta* paintings do not overtly denigrate the racial mixtures portrayed. Earlier, the famous poet Sor Juana Inés de la Cruz (1648–95) had portrayed *mestizos* and *mulatos* as picturesque or even ludicrous. But the *casta* paintings, seemingly under the guise of scientific classification, portrayed the different *castas* without any hint of social conflict and with meticulous depiction of their clothes and occupations. The paintings were commissioned by members of the *criollo* and *español* population—including viceroys, archbishops, and other wealthy people—and were shipped to influential people in Spain. Their purpose was clearly political, that is, to legitimate a ruling *criollo* aristocracy in New Spain that would have some degree of independence from the mother country. This effort clearly failed; nevertheless, the paintings yield a vivid record of the *casta* system, whose basic features influenced the entire Spanish empire in the New World.[14]

Despite the seemingly benign nature of the *casta* paintings, the system was rigorously anti-Black. People with known African ancestors were indelibly stigmatized both by the boundary theories of the *casta* system and by many practical aspects of the colonial society. In the structure of the *casta* system, mixtures involving Indian blood were perceived as "redeemable": *español* and *indio* yielded *mestizo; español* and *mestizo* yielded *castizo;* and *español* and *castizo* yielded *español.* Thus, within two generations, interracial unions between the highest social strata and an Indian were redeemed. Not so for *mulatos.* In that case, special terms were invented to indicate some African blood even after many generations of crosses involving only "higher" *castas (español* and *negro* yielded *mulato; español* and *mulato* yielded *morisco; español* and *morisco* yielded *salta atrás; español* and *salta atrás* yielded *tente en el aire;* and so on).[15] In other words, the stigma of having been brought to New Spain in the first place as slaves, often in chains and branded like cattle, was perceived to have caused permanent

genetic debasement for the slaves' descendants. Spanish colonial America never seemed to resolve this problem. While the *mestizaje* process was clearly a melding of European, Indian, and African ethnicities, only the European and Indian elements became celebrated as a "forging of the cosmic race" and the pride of most Mexicans ("the Spaniard is my father and the Indian my mother").[16]

The *casta* system also attempted to maintain an elite "Creole" aristocracy. Since the number of marriageable *peninsularas* females was always minuscule, there could never really be very many *criollos* (both parental lineages pure Spanish). The only way that *española* women could be obtained was by carefully planned unions of powerful families with *castizas* in the early formative days of New Spain. In other words, the legal "whitening" process had to be an important consideration in the economic and political stratification of the people of New Spain and tended to be a demographic bottleneck preventing the accumulation of people with elite status. Conversely, the legal system also assured that Blacks remained at the very bottom of the social hierarchy, and, since partly Black *castas* were not readily upgraded by further miscegenation, they tended to increase rapidly in number in some areas.[17]

The Northern Expansion of New Spain

By the 1650s, there were in New Spain about 185,000 people classified as European or *criollo,* 110,000 *mestizos,* 155,000 Blacks and *mulatos,* and 1.3 million Indians.[18] However, there were important geographic variations in the demography and in the conditions under which the various groups lived. For the New Mexico story, the most important of these variations involve Mexico City and the northern frontier.[19]

In the seventeenth century, Mexico City itself as well as the southern rural regions had disproportionate numbers of Blacks and *mulatos,* while most Indians tended to live in small rural settlements. Many areas had dense populations of unmixed *negros* and Indians on rural estates and in urban *barrios*. A relatively high proportion of the nonelite classes achieved some level of status in the trades and craft industries. While most people were very poor, they belonged to a highly organized society and cannot be considered marginalized. By contrast, northern New Spain, which provided many settlers to New Mexico throughout the colonial period, had a distinct demographic profile consistent with its frontier-mining role (silver had been discovered at Zacatecas in 1546) and with the reputed tendency of frontier societies to harbor large numbers of marginalized people. The area from Zacatecas to Santa Bárbara (founded 1567) included Somberete, Nombre de Dios, Durango, Parral, Valle de San Bartolomé (now Allende), and other places along the Camino Real to New Mexico. Not counting Zacatecas itself, the area (mostly in Nueva Vizcaya) was sparsely populated throughout the seventeenth century. While the area north of Zacatecas had been settled by "Spanish" silver-mining people for some years, additional adventurers of all descriptions flooded into the area after news of the Pueblo country was brought back by Fray Agustín Rodríguez in 1582 (other *entradas* having apparently been forgotten). Santa Bárbara became the magnet for this flow and the future center of an ethnically mixed area that provided many settlers to New Mexico. Counting *españoles y castas* only, Santa Bárbara is said to have had 30 families in 1576, Parral 300 families in 1632, Durango 65–90 families in 1604, and all of Nueva Vizcaya 2,500 people in 1693. The Durango families had about eighty *negro* and *mulato* servants.[20] About half the people in the Parral–Valle de San Bartolomé area were free *castas,* of whom more than half were *negros* and *mulatos.* In addition to the free *castas,* 7 to 15 percent were *negro* and *mulato* slaves. A recent detailed study of the Parral and Valle de San Bartolomé baptismal records showed very high rates of illegitimacy and abandonment of *casta* and *esclavo* infants[21] and tended to confirm the common idea that an important factor in the *mestizaje* process was extramarital relationships between *español* men and non-*española* women.[22]

From a geographical point of view, Oñate's settlement in New Mexico appears to have been a premature salient (i.e., noncontiguous by hundreds of leagues of uncontrolled territory) of this general northward expansion. Indeed, the Oñate and Ibarra families, both of Basque origin, were founders of Zacatecas as well as primary colonizers of the northern regions. Oñate's people shared the social characteristics of this expansion, which coupled the mining industry with warfare against the Chichimeca Indians and slave raiding.[23] But Oñate's men included an atypically high proportion (71 percent) of *peninsulares,* perhaps because his recruitment centered at Zacatecas and Mexico City and emphasized all of his political and family contacts, his record of success in finding silver deposits, and the conditions in his contract that guaranteed future "rights of first settlers" and *hidalgo* status to the settlers.[24] Whatever the reasons, the high proportion of *peninsulares* in the Oñate settlements was anomalous in terms of the later settlement patterns of colonial New Mexico. While *peninsulares* and other Europeans continued to trickle in throughout the colonial period, they represented only 20 percent of the adult male settlers in the remainder of the seventeenth century and 38 percent in the eighteenth century (the latter number includes the Vargas recruitments).[25] In addition, during the desertions of 1601, Oñate lost more than half of his settlers.[26] Although the exact numbers are not readily accessible, Chávez summarizes this period as follows: "Of more than two hundred names found in the Oñate lists, less than forty established themselves permanently in the new land." Of these, as of the whole number, about 70 percent were *peninsulares*—but twenty-eight men do not constitute a huge impact on the actual ethnicity of New Mexico.[27]

Seventeenth-Century New Mexico

Recovery from the large-scale desertions of the Oñate settlers was quite slow, in part because viceregal authorities were unsure about whether the enterprise in New Mexico should be continued or abandoned.[28] But finally, with the selection of a permanent capital at Santa Fe (sometime between 1607 and 1610)[29] and the establishment of the mission supply service, formalized in 1631, the colony became committed to continued existence.[30] The caravans, coming once every two to four years, including ten dispatches between 1603 and 1631, made a small but steady addition of men (but few women) to the Hispanic population before the Pueblo Revolt in 1680. Chávez, in his "Origins of New Mexico Families," names seventy people who settled in New Mexico during the pre-Revolt period who came with these wagon trains—escort soldiers, convicts, people in the retinues of new governors, and occasional well-to-do speculators or miners, as well as people who were socially marginalized. Nevertheless, by 1680 nearly 90 percent of the people who were counted after the Pueblo Revolt claimed that they had been born in New Mexico.[31]

According to Benavides, by the 1630s, Santa Fe, the only organized Hispanic community, had about one thousand people, of whom more than seven hundred were *castas* and Indian servants and their families.[32] Only about fifty were men counted as capable of bearing arms and were considered *vecinos,* that is, established citizens. The *vecinos* were of two categories: those who had been awarded rights to tribute from particular Pueblos, the *encomenderos,* and those without such rights, the *moradores.*[33] However, determining how many "elite" families there were, using this distinction, is not straightforward. Although the number of *encomiendas* was limited by law to thirty-five (there were forty-three Pueblos at this time), there were many split *encomiendas* as well as shifts in ownership. About thirty-six men have been identified as *encomenderos* in the seventeenth century, and these include a number of clusters involving the same family. Not surprisingly, twenty of the thirty-six were members of families who settled in the Oñate period.[34]

The numerous servants that Benavides noted in the Santa Fe population of 1630 included some Mexican Indians who lived independently of any particular

Hispanic family. They were clustered in the *barrio* of Analco (Nahua for "across the river"), had their own cornfields, and eventually (sometime between 1636 and 1650) had their own church, San Miguel, now known as "the oldest church." Tradition (but meager evidence) holds that these people were Tlaxcalan Indians derived from the Nahua-speaking people of central New Spain, who were important allies of the Spanish during the conquest and throughout the sixteenth century. In 1591, 400 families of Tlaxcalans, numbering about a thousand people, founded six colonies in Chichimeca country in order to help resolve the chronic warfare in the north. In return, the viceregal government guaranteed the Tlaxcalans numerous perpetual rights and privileges. The colonies, especially the one nearest New Mexico at Saltillo, were very successful, grew rapidly, and conserved their ethnic identity for many years. Indeed, several of the original six colonies spawned new colonies in Nuevo León, Coahuila, and Nueva Vizcaya. While there appears to be no evidence of a formal colonization effort in New Mexico, the traditional inference is that the Mexican Indians of Analco in the seventeenth century were these ethnic Tlaxcalans from these migrations initiated in 1591. During and after the Pueblo Revolt, these Mexican Indians were still identifiable; Vargas found them in 1693 living as a group of nineteen families in the San Lorenzo area of El Paso, where they stayed during the reconquest. Only one family, that of Juan León de Brito, returned and claimed property in the Analco barrio. During the eighteenth century, as we shall see, Analco was repopulated with *genízaros,* detribalized Indians.[35]

In addition to the Santa Fe people, a large subset of the Hispanic community dispersed early in the seventeenth century across the entire land of the Pueblos, from Senecú in the south to Taos in the north, and from the Hopi villages in the west to Pecos and the Galisteo villages in the east. Indeed, this area was considerably larger than the area controlled at any time in the colonial period after the Pueblo Revolt. By 1641, there were

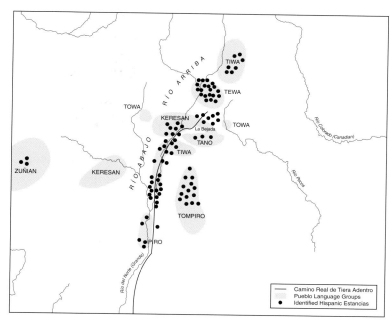

5-1. Geographic distribution of seventeenth-century pueblos and Hispanic *estancias*. Data compiled from Hackett, *Historical Documents,* 106–15; Hackett, *Revolt* 1:125; and Kraemer, "Haciendas," 4–8. Map by Paul Kraemer, redrawn by Matthew Williams.

more than forty rural *estancias,* usually placed adjacent to pueblos, and often initiated by the Hispanic person having *encomienda* rights over a particular pueblo. By 1675, more than one hundred such Hispanic *estancias* had been started (see Fig. 5-1). The dispersal pattern was determined by the selection of arable, irrigatible land that could be legally construed as not belonging to a pueblo. Some of the most ambitious of these ventures belonged to men with important military positions rather than to *encomenderos.* Many of the Hispanic families had dispersed well beyond any frequent contact with even nominal *españoles* save a few priests. This diaspora, so to speak, was very much against the regulations of the time, and was to cause considerable practical problems. Writing after the rebellion, Father Francisco de Ayeta told the viceroy that "prior to this disaster it did not seem that this Kingdom had sufficient forces, the reason being that those who perished as well as those who are retreating were so scattered and at such great distances from one another on small ranches, that they could not

help each other and it was a great matter to be able to get together thirty men." In other words, close physical contact between a significant portion of the Hispanic community and the Pueblo peoples became the reality of daily life in the seventeenth century.[36]

Even in the absence of any census or *casta* records for much of the seventeenth century, the above demographic facts make it likely that a great deal of reciprocal accommodation, acculturation, and miscegenation occurred. The opprobrious comments of some of the clergy probably had some basis in fact. In 1631, Father Estévan Perea characterized New Mexican colonists as a group of *"mestizos, mulattos,* and *zambohijos."* In 1661, Father Alonso Posada commented that "New Mexico did not have more than a hundred *vecinos* and among this number were *mulatos, mestizos,* and all who have any Spanish blood, even though it is slight."[37] Being a *casta,* even an illiterate one, did not preclude prominence and holding office. Several *alcaldes mayores* and military captains were known to be *mulatos* or *mestizos.*[38]

By far the most important extant demographic documents of the seventeenth century are the muster rolls taken in the El Paso area following the Pueblo Revolt in 1680. They reflect the Hispanic population that had accumulated and had to a large extent acquired an ambiguous ethnicity throughout the years since the Oñate settlements. The Pueblo Revolt can be viewed as a definitive re-establishment of ethnic boundary conditions. The people who stayed (some of whom were settlers) elected to perceive themselves as "Indian." This included some Pueblo people whose participation in the Revolt was minimal. It also included numerous *castas,* some of whom were actually leaders of the Revolt. The people who were killed or expelled became "Spanish," although the refugees included all kinds of *castas* and even entire pueblos that retreated with the "Spanish." That these two groups of people, those who stayed and those who left, were ethnically not completely distinct was shown later during the Vargas reconquest in 1693. At that time it became clear that some of the returning people outside the

walls of Santa Fe had relatives among the defenders inside. As Christmas 1693 approached and the weather became severe, some of the *entrada* people in Vargas's camp even joined their relatives inside the walls.[39]

While the muster rolls of 1680 and 1681 contain very few *casta* designations, they nevertheless represent the only available systematic censuses of this period. They identify by name, and much more besides, the majority of all of the Hispanic people of pre-Revolt New Mexico. This information can be used to approach the question of whether the people with the most power and wealth were all *criollos* or *españoles.* One inference derived from the muster rolls concerns the military structure of this frontier society: the 163 households of the 1680 muster included 208 adult males who could bear arms; of these, 65 had officer rank, and this large group usually had other titles and offices as well. Later, when Governor Otermín was assembling forces to attempt a reconquest in 1681, of 146 soldiers, no fewer than 38 were officers. Top-heavy military hierarchies are, of course, characteristic of colonialism because they are adapted to the management of large numbers of native subjects.

The muster roll of 1680 also includes evidence that the agricultural economy was not merely a combination of subsistence family farming and collecting *encomienda* tributes. The Hispanic households totaled 2,010 people. Of these people, who were all considered part of the "Spanish" community, more than one-third (739) were actually servants, most of whom were at least part Indian, including Mexican Indians (some of whom were from the community of Analco), Apache captives, and probably Pueblo Indian employees of some Hispanic families. But these servants were by no means evenly distributed among the Hispanic families: 60 percent of the families had no servants, and most of the others had one or a few. However, seventeen families reported on the eve of the rebellion that they had more than 10 servants each. This elite subset had, in fact, a total of 401 servants, more than half of all the servants of the colony. These same families also often had unusually large

nonservant components in their households. For instance, the two Domínguez brothers' combined households equaled 139 people. Tomé Domínguez, whose place was at the site of present-day Tomé, New Mexico, reported 55 family members and 41 servants, while his brother Juan, who maintained a farm established by their father at Atrisco, reported 10 family members and 33 servants. A similar pattern is evident in the records for other families of this elite class. Thus, the dry numerical data evoke the image of the patriarchal "big house" of old Mexico, that is to say a hacienda, which Simpson has characterized "by its swarms of cousins, compadres, huge families, in-laws, vaqueros, priests, retainers, serfs, and hangers-on." In general, the data support several propositions. (1) Seventeenth-century Hispanic New Mexicans included a small group of ten to fifteen dominant families. (2) The dominance of these families can be correlated with a large number of characteristics: descendance from "first" families who stayed in 1601, possession of a hereditary *encomienda,* high military rank, number of servants, literacy, and owning a residence in Santa Fe (in addition to a rural *estancia*). (3) None of these characteristics was essential, and, in particular, few of the elite could claim pure *español* background.[40]

History, of course, tends to highlight some people and make others invisible. Many historians suspect that in the Revolt period at least several hundred people bypassed or otherwise were not included in the muster rolls. If this is true, a reasonable estimate for the total population in New Mexico under Hispanic control before the Revolt is 2,800 "Hispanics" and 20,000 Pueblo people living in about forty-three Pueblos.[41] It would be many years before these modest numbers would be attained again.

The Resettlement of Hispanic People in New Mexico

The recolonization of New Mexico under Vargas included the immigration of three groups of people. First, there were the settlers who came with the Var-

gas colonizing *entrada* that left El Paso in October 1693. Vargas had earlier made a house-by-house census of the El Paso communities and found that more than half of the people of the muster rolls of 1680–81 had gone back to New Spain and were no longer available. These included some of the "important" people, such as the Domínguez brothers, one branch of the Chávez clan, and many others.

This house-by-house census was quite detailed and is worth examining. In early 1680, El Paso had had a small colony of Hispanic settlers and an ambitious mission to the Manso and other Indian tribes. The sudden acquisition of about 2,000 Hispanic refugees, plus Indians from the Pueblos of Isleta, Socorro, and Senecú, created immediate problems, not the least of which was to prevent the dispersal of the New Mexicans. Twelve years later, not counting the southern Pueblo people in their new communities, Vargas could find only 1,044 people (295 adults and 749 children in 131 households). Interestingly, the Mexican Indians from the Analco area of Santa Fe were there as a small community of 85 people in 19 households.[42]

Vargas took about eight hundred people, mostly from pre-Revolt New Mexican families but also including some recruited locally, who joined the recolonizing effort. In addition, Vargas had recruited almost one hundred soldiers, some with families, from other presidios of northern New Spain. In sum, Vargas arrived at Santa Fe before Christmas 1693 with well over eight hundred people, some of the soldiers arriving a little later.[43]

In the meantime, another group was being recruited in the Mexico City–Puebla area by Fray Francisco Farfán and Capt. Cristóbal Velasco. According to Kessell, these people were largely of the artisan class, and almost all were considered *españoles,* although Bustamante suggests that about 40 percent of these families were actually *castas.* At any rate, fifty-six families with a total of 219 people received expenses from the crown. The heads of these families included a wide range of occupations: miners, masons, millers, weavers, tailors, cartwrights, a cop-

persmith, a chandler, a cutler, a musician, two painters (Tomás and Nicolás Girón, suspected to have been involved in the Segesser paintings (discussed and illustrated in Chap. 8, this volume), and even a "gentleman" who received no pay. Also included were three French convicts whose faces had been branded with stripes; they were captured remnants of the LaSalle expedition: Pedro Munier, Santiago Gurulé, and Juan Archibeque. The entire group arrived at Santa Fe in spring 1694, most of them founding the Villa de Santa Cruz in April 1695 and thus making room in Santa Fe for the next group.[44]

The third group, recruited in the Zacatecas area by Juan Páez Hurtado in 1695, was assembled under quite different conditions than the Velasco-Farfán colonists. Apparently Páez Hurtado, who was Vargas's closest associate, was completely unsupervised in his recruitment and was able to charge the viceregal authorities for successful feeding and delivery (or even fictitious delivery) of any person he could find. Consequently, the muster roll widely cited in earlier works is now thought to have been padded and shuffled in terms of family groups. Recent analyses of this expedition support the conclusion that on May 9, 1695, about 139 people (25 families plus 21 single people) arrived in Santa Fe under the leadership of Juan Páez Hurtado. Most of these people received *casta* designations in the muster roll: about 20 percent were *españoles* including several *peninsulares;* 35 percent were *mestizo,* 28 percent were *mulato,* and a scattering of people were designated *coyote* (an alternative term for *mestizo* in New Mexico), *castizo,* or *lobo* (Indian and African in New Mexico).[45]

Thus, adding the three groups, the reconquest and resettlement of New Mexico initially involved about 1,200 people, united for the moment as the Hispanic community, linguistically Spanish and under Spanish institutions, but racially and culturally diverse.

Ethnic Melding Among the Indian Communities

The Pueblo Revolt, generally referred to as a single event that took place in 1680, might better be thought of as a twenty-three-year period of reciprocal violence between the Hispanic community and the Pueblos. That is, it extended from its beginning in 1680, through the several sorties of the 1680s and the Vargas-led wars of 1693 and 1696, to the last gasp of Pueblo resistance at Zuni in 1703.[46] Even before the Revolt started, many pueblos had been abandoned, and the Pueblo population had long been contracting because of epidemic diseases and pressure from other Indian groups. By 1706, only nineteen pueblos with about 9,000 people were reported (not counting the Hopis, over whom the Hispanic community never regained control after the Pueblo Revolt), a far cry from the forty-three pueblos and 20,000 people reported before the Revolt.[47] While epidemic diseases and other biological factors undoubtedly played some role in this loss,[48] many individual Pueblo people survived but became refugees during the reconquest. In two cases, groups of refugees achieved historical visibility because they were brought back to the Rio Grande Pueblos by the Hispanic community. Picurís people abandoned their homes in 1696 and went to live with the Cuartelejo Apaches in present-day Kansas, where they were promptly enslaved. Many were brought back by an expedition led by Juan Ulibarrí in 1706.[49] The other case involved Tewa and Tano people who also left their pueblos in 1696 and were afforded refuge by the Hopis. Four hundred forty-one of them were brought back to the Rio Grande area in 1742 by Fray Carlos Delgado.[50]

Many other shifts and mixtures took place during this Revolt period. One of the most interesting involved fairly large numbers of Pueblo refugees who moved in with the Navajos in their homeland, the Dinetah, in the Gobernador region of northwestern New Mexico. Pueblo people from a number of pueblos were involved, including Tewa, Jémez, Keresan, Zuni, and even some Hopi refugees from Awatovi, the latter having been destroyed by other Hopi villages in 1700. All of these people joined the Diné over a period (perhaps starting considerably before 1680) and had a profound impact on all components of

Navajo ethnicity save language. The Pueblo-Athabaskan genetic mixing was evidently extensive, since many Navajo clans are known to have derived partially from Pueblo people. For instance, the Coyote Pass clan was based on Jémez Pueblo women marrying Navajo men. The cultural additions included pottery styles, many ceremonial traits and materials, the building of Pueblo-style houses called *pueblitos,* and even European traits brought in by the Pueblos. In particular, Pueblo weavers (men) taught Navajo women how to weave. Pueblo weaving methods had already been partially "Hispanicized" by that time. Some of the cultural additions, such as the building of *pueblitos,* were evanescent, while others permanently differentiated Navajos from other Southern Athabaskans (before the Revolt, they were all called Apaches).[51]

The Census of 1750

Population growth in the resettled colony was almost negligible for the first half of the eighteenth century. Figure 5-2 shows that it required almost all of this time for the Hispanic community to regain the population size achieved in the seventeenth century, while the Pueblo population remained thousands of people short of its former size.[52] In the second half of the eighteenth century, the growth rate of the Hispanic community radically increased while the Pueblo population remained virtually the same. Figure 5-2 also shows that the pronounced change in growth rate of the Hispanic population occurred just after the mid-century. Thus the 1750 census, which was the first systematic census of the Spanish colonial period, can shed light on the demography just before this shift and can be used as a benchmark against which to measure later demographic trends.[53]

The 1750 census has received much less scholarly attention than the census of 1790. To be sure, it has much less information about some categories, particularly the occupations of the Hispanic people. But the 1750 census covers the Pueblos more completely and

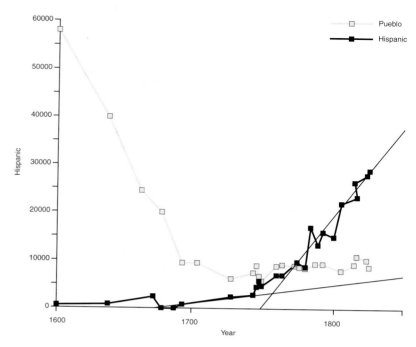

5-2. New Mexico population, 1600–1821. Data compiled from Frank, "From Settler to Citizen," 413–23; Hackett, *Historical Documents,* 396–407; La Fora, *Frontiers of New Spain,* 81–92; Cutter, "Anonymous Statistical Report," 347–52; Jones, *Los Paisanos,* 123. Graph by Paul Kraemer, redrawn by Matthew Williams.

is consistent with the survey of Pueblos made by Father Menchero in 1744. Even the limited ethnicity data, when used in conjunction with those of the 1790 census, allow some unique insights into the dynamic nature of ethnicity in New Mexico.[54]

The 1750 census was relatively complete, with the following exceptions. Most of the settlements shown on a map for 1773 were covered person-by-person (Fig. 5-3). The map also illustrates the significant geographical contraction that the Hispanic-Pueblo colony had undergone since the pre-Revolt period.[55] Two settlements missing from the 1750 census can be estimated through other data. Abiquiu, first settled in the 1730s by Hispanic people, was under such aggressive assaults by Utes and Comanches (who came from the same linguistic stock and were allies until 1749) that the area was aban-

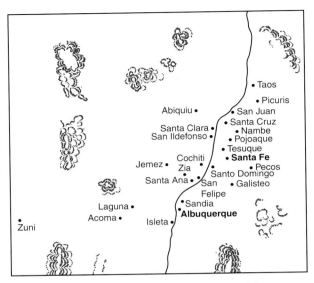

5-3. **Hispanic and pueblo settlements in 1773. Adapted from Simmons,** *Indian and Mission Affairs,* **11. Map by Paul Kraemer, redrawn by Matthew Williams.**

doned in 1747 and not reoccupied until 1754. Many of the people who retreated from the Chama Valley during this period may have been included in the Santa Cruz population.[56] Sandía Pueblo was also not covered even though it had recently been resettled by Father Menchero with 352 refugee people.[57] Zía Pueblo was mentioned but not counted, while Pojoaque Pueblo was not mentioned although it had been resettled by an unknown number of Tewas in 1707. While the map shows only four Hispanic settlements, the census named sixteen Hispanic communities, making a clear distinction between Pueblo Indians and Hispanic people who lived near or in pueblos. The census totaled 7,291 Pueblo people living in eighteen pueblos and 5,914 Hispanic people in sixteen communities for a total population of 13,205.

Figure 5-4 is a detailed diagram of the census data for each settlement, converted to circles with areas proportional to the number of people, and colored red (Pueblo) or green (Hispanic) to indicate the ethnic boundary conditions that were re-established by the Pueblo Revolt. Hispanic Albuquerque had 1,337 peo-

ple, about the same number as Santa Cruz, while Santa Fe was slightly larger, with 1,681 people. The pueblos had generally only a few hundred, the largest being Acoma with 956. The diagram shows that the two main ethnic categories were interspersed, suggesting the existence of an interactive Hispanic-Pueblo complex.

The diagram also includes approximate locations for some of the nomadic Indian groups: Apaches, Utes, Comanches, and Navajos. Beyond these were others: Jumanos, Pawnees, Kiowas, and, even farther away, the ever-looming specter of the French. Thus, the diagram illustrates a common perception of the nature of New Mexico in this period: that after the Vargas resettlement, the intermingled Pueblo and

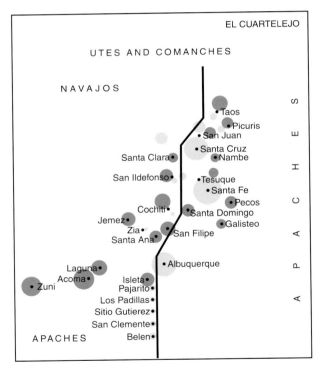

5-4. **Diagrammatic representation of Hispanic (light gray) and pueblo (dark gray) settlements. Circles are proportional to population according to the census of 1750. Data compiled from Hackett,** *Historical Documents,* **402–6; Olmsted,** *Spanish and Mexican Censuses,* **1–97; Rios-Bustamante, "New Mexico," 357–89. Map by Paul Kraemer, redrawn by Matthew Williams.**

Spanish populations had reached an improved accommodation to each other, but were now jointly surrounded by intractable enemies. Considerable data support such a paradigm.[58] However, one of the conclusions argued in this chapter is that it is an inadequate model for describing the ethnic melding of this period. For one thing, none of the groups mentioned so far was monolithic. Apaches consisted of many autonomous bands with widely diverse relationships with other Indian and Hispanic groups. The different portions of the Navajo nation had different perspectives on the value of the Pueblo intrusion into their culture. One band of Comanches appeared to be trying to exterminate Pecos Pueblo, while another band was very interested in the Taos trade fairs.[59] All kinds of relationships (slaving, raiding, or trading) appeared to affect acculturation and ethnic melding.

The 1750 census also shows that the sharp ethnic boundaries implied by the red and green circles of Figure 5-4 had been greatly blurred since their presumed re-establishment at the time of the Pueblo Revolt. The 1750 census included *casta* designations, but only for Albuquerque. Nevertheless, these were very informative because they were the first such systematic designations in colonial New Mexico, and because seven-eighths of all adults in Albuquerque received *casta* designations. The designations were signed by Father José Yrigoian, but nothing is stated as to how far they were influenced by the subjects. Father Yrigoian (1698–1781?), a native of Puebla, was an experienced Franciscan in 1750, having professed in 1716 and served in New Mexico since 1725. Like most eighteenth-century New Mexico Franciscans, he was rotated through different mission posts, serving a year or more at each, then being sent to another post. In this way he became familiar with the entire colony over his years of service. By 1750, he had served at Galisteo, Tesuque, San Felipe, Isleta, Picurís, Nambé, Pecos, San Ildefonso, Santa Clara, Santa Cruz, Acoma, Zía, Jémez, Cochití, and Albuquerque. He had served many times at Albuquerque between 1728 and 1751 and almost continuously in Albuquerque between 1735 and the time of the

5-5. *Casta* designations of 504 adults in Albuquerque, 1750. Olmsted, *Spanish and Mexican Censuses*, 1–97. Diagram by Paul Kraemer, redrawn by Matthew Williams.

1750 census. Some personal aspects of his career are of interest: he was part of the mission of Father Carlos Delgado to bring back the refugees from the Hopi Pueblos in 1744. He had earlier become interested in these people when, at Ojo Caliente in 1739, he baptized seventeen men and twenty women with Christian names (all of the men were baptized Cristóbal and all the women were named Bárbara). Perhaps these were the first of a category of people known as *genízaros* who are discussed below.[60]

At midcentury, Albuquerque was a dispersed community, including numerous farms extending along the Rio Grande for many miles. Father Yrigoian's designations for the adults of Albuquerque in 1750 are illustrated in Figure 5-5. Only a third of the adults were classified as *español,* and almost a third were classified as Indian. While all of the latter were no doubt baptized, apparently few had learned their Catholic catechism: in his summary, Father Yrigoian did not consider them *gente de razón.* This would probably be of importance if these families were to attain *vecino* status later. However, Father Yrigoian did not use the term *genízaro* (detribalized Indian) for these people, most of whom were servants of Hispanic families.

42%

29%

18%

11%

5-6. Endogamous and exogamous marriages, one or both partners being *Español*, 1750. Olmsted, *Spanish and Mexican Censuses*, 1–97. Diagram by Paul Kraemer, redrawn by Matthew Williams.

The 14 percent *mulato* class was considerably larger than in later censuses and is more consistent with what we know about the settlers who were brought to Santa Fe by Juan Páez Hurtado in 1695. However, the major families who founded Albuquerque in 1706 were seventeenth-century people returning to pre-Revolt holdings. These included two prominent *mulato* families.[61] Father Yrigoian did not often use the designation *mestizo;* instead, he frequently used the term *coyote,* apparently with a similar meaning.[62]

The 1750 census also allows us to look at spouse selection as a function of *casta* designation for Albuquerque. Figure 5-6 considers the case of 116 marriages in which one or both spouses were *español,* while Figure 5-7 illustrates 41 marriages in which one or both were *mulato.* Both cases show a high frequency of exogamous marriages. Indeed, Figure 5-6 is conservative in the sense that many of the 'SP X ?' category probably involved an *indio* or *casta* partner. In general, the data suggest that the *casta* system was not very restrictive in limiting interracial marriages in Albuquerque at this time.

There is some reason to believe that the pattern of *casta* designations for Albuquerque was not unusual compared to patterns of other Hispanic communities in 1750. For one thing, as has already been mentioned, the ethnic diversity of the Páez Hurtado colonists, who settled Santa Fe, was similar to that of Albuquerque residents. Assuming that many servants were *castas,* in the Hispanic settlements outside Albuquerque the number of people called servants within Hispanic families averaged about 15 percent of the population, ranging from 10 percent in Santa Cruz to more than 25 percent in those Hispanic settlements that encroached on the Pueblos of San Juan, San Ildefonso, and Santa Clara. At Taos, the Hispanic settlement of 138 people included 55 *coyotes* and 26 *genízaros.*

The 1750 census appears to be the best census of the pueblos in the eighteenth century; the census of 1790 included data on only five pueblos. The pueblos in 1750 were more homogeneous than the Hispanic settlements. Most contained almost all Pueblo surnames, which the census takers, often priests, dutifully and methodically tried to spell phonetically. It was illegal for Hispanic settlers to live in the pueblos, a point periodically re-emphasized by the governors.[63] Nevertheless, Hispanic settlers did live in some of the pueblos, and this contributed to the increase in Pueblo people with Spanish surnames. As Figure 5-8 shows, a number of pueblos had a significant number of people with

5-7. **Endogamous and exogamous marriages, one or both partners being** *Mulato,* 1750. Olmsted, *Spanish and Mexican Censuses,* 1–97. Diagram by Paul Kraemer, redrawn by Matthew Williams.

Spanish surnames. It was particularly striking that at Taos, there were numerous Spanish surnames as well as Tano and Apache residents of the Pueblo proper, not counting the very diverse Hispanic community nearby. As Taos was the site of the most important trade fairs of this period, the Taos area must have been a very dynamic, diverse, and exciting place in 1750, even before the influx of French trappers.[64]

In a general way we know that the Pueblos had not done well demographically ever since contact, as Figure 5-2 shows. The 1750 census opens a window on one aspect of this question, because it identified widows in both the Hispanic and the Pueblo settlements. Obviously, an excess number of widows in a population reflects a greater number of deaths of adult males versus adult females, which could simply mean that the women, on average, lived longer than the men for biological reasons. However, an accumulation of young widows can suggest much more, since widowhood in young Pueblo women was generally a temporary state.[65] Figure 5-9 tabulates the accumulation of widows recorded in 1750 in the various settlements, that is, widows / 1,000 people, a prevalence number, not an incidence or rate number. (Of course, the prevalence of widows, in a general sense, reflects a large number of

demographic rates.) The averages for Pueblo and Hispanic settlements, shown in the first two lines, are single-number summaries of this complexity. However, some pueblos had significant increases over these averages, and it was noted that these increases were mostly women who were young or had small children. As is shown, Pecos Pueblo in 1750 had an enormous preva-

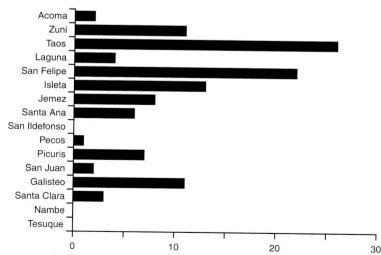

5-8. **Percentage of pueblo households, listed by pueblos, with Spanish surnames, 1750. Olmsted,** *Spanish and Mexican Censuses,* 1–97. Graph by Paul Kraemer, redrawn by Matthew Williams.

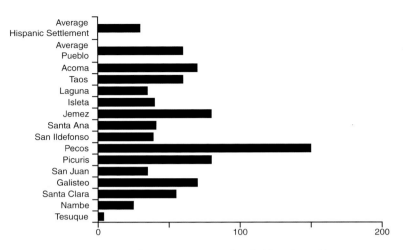

5-9. Prevalence (per 1,000 people) of widows in pueblos, 1750. Olmsted, *Spanish and Mexican Censuses*, 1–97. Graph by Paul Kraemer, redrawn by Matthew Williams.

Table I: Estimated Total Population of New Mexico in 1750

1750 census	13,200
Sandia, Zia, Pojoaque	900
Hopi villages	10,900
Navajos	3,000
Comanches & Utes	1,500
Apaches	1,500
Total	31,000

Sources: Hackett, *Historical Documents*, 3:399, 402–6, 414, 464; Olmsted, *Spanish and Mexican Censuses*, 1–97; Rios-Bustamante, "New Mexico," 357–89; Simmons, *Indian and Mission Affairs*, 11; Twitchell, *SANM II*, 233–34; Swadesh, *Los Primeros Pobladores*, 33–41; Poling-Kempes, *Valley*, 31–52; Noyes, *Los Comanches*, 25; Worcester, "Navajo," 114.

lence of widows, consistent with the historical record of Comanche attacks in the years immediately preceding 1750.[66] Indeed, what is shown in Figure 5-9 can be considered diagnostic of demographic collapse. Widowhood for these Pecos Pueblo women involved not only the death of their own spouses, but also the increasing scarcity of appropriate males for remarriage. On average, they would remain widows longer, and their numbers would accumulate. In fact, demographic collapse is exactly what happened after this period, the last survivors leaving Pecos Pueblo in 1837. A similar situation at Galisteo Pueblo likewise led to demographic collapse and abandonment in 1794. The other pueblos that showed high prevalence of widows were characteristically those that were most exposed to attack by nomadic Indians.[67]

To summarize: the demographic data indicate that in 1750, New Mexico was a single complex society in which numerous groups and subgroups were all interactive in various ways. This theme is developed further in the next section, but for now it can be emphasized that, putting all of the known or estimated numbers together, as Table 1 shows, this was a very small society of about 31,000 people, spread over a very large geographical area.[68]

Growth of the Hispanic Population and the Slave Trade

It should be fairly easy to explain the numerical stagnation of the Pueblo population in the eighteenth century as illustrated in Figure 5-2. About a dozen pueblos disappeared around the time of the Revolt. These included Piro, Tompiro, Southern Tiwa, and Tewa villages. Virulent Comanche assaults contributed to the demise of Pecos and Galisteo Pueblos, and in general the pueblos with the greatest frontier exposure lost many lives. Epidemic diseases played a role; there were numerous epidemics of smallpox and measles in the eighteenth century. In particular, the smallpox epidemic of 1780–81 killed thousands of Indians but only hundreds of Hispanics.[69]

In addition, an area that clearly needs further investigation is the question of how many Pueblo people left the pueblos during this period, becoming de facto *genízaros*. The high percentage of the Albuquerque people being designated *indios* raises the question of how many of them derived from Pueblo people. For instance, the small Hispanic communities of Los Padillas, Pajarito, and Belén apparently attracted people from Isleta Pueblo, suggesting that some emigration of individuals occurred. In general, the aggregated *genízaros*

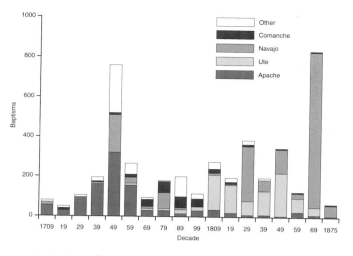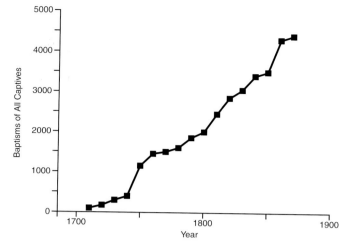

5-10. Baptisms of Indians: A, by tribe of origin, for each decade; B, cumulative summary. Data from Brugge, *Navajos in the Church Records.* Graphs by Paul Kraemer, redrawn by Matthew Williams.

who were settled in towns such as Abiquiu, Belén, and the Tomé area were more historically visible and were known to be mostly non-Pueblo; how many others there were and their origins are not clear.[70]

The marked change in the growth rate of the Hispanic population in the second half of the eighteenth century is not nearly so easy to explain. Apparently the change was internal, because the immigration of new Hispanic families was very similar for the two fifty-year periods and there appears to be no evidence for any burst of immigration.[71] We have already mentioned the possibility of additions to the Hispanic communities from the Pueblos. It has also been convincingly shown that there was a great deal more economic activity in the latter part of the century, but the causal relationships, in the context of population growth, are not easy to resolve.[72] Possibly, reduced hostilities with Comanche and Ute tribes made some contribution to growth. However, quantitative analysis of the slave trade appears to provide an adequate explanation for much of this population growth.

Almost all of the various kinds of people mentioned above raided one another for slaves whenever opportunity allowed. Some were brought to the trade fairs by nomadic Indians or by Hispanic slavers. While the biggest fairs were those at Taos, slave sales were common in many places along the Rio Grande corridor. Many of the captives were women and children, who were generally sold as domestic servants for New Mexico families. Many of the men, especially if a governor could gain ownership, were shipped to New Spain to work in the mines. In either case, few captives ever saw their native villages again.[73]

Captives were added to the population of New Mexico under conditions specified by Spanish law. Masters had to constrain them to become Catholics, and they were therefore baptized, often identified thereafter with their masters' surnames. In addition, hereditary slavery was illegal, and all children had to be emancipated as they became adults. Under these conditions, the captives and especially the children became detribalized, that is, *genízaros,* and thus added people of a highly prolific age group to the Hispanic community.[74] David Brugge's analysis of the baptismal records gives critical quantitative data on the demographic impact of the slave trade on New Mexico. A summary of these data is illustrated in Figure 5-10A together with a cumulative transformation of the same data in Figure 5-10B. The long period in the first half of the eighteenth century, when most of the captives

were Apache and almost none were Navajo, coincided with the period when the Navajos were at peace with the Hispanic settlements.[75] Later, Navajos and Utes became the most frequent source of captives. Many of the captives identified as of Apache origin were probably themselves captives of the Apaches with Pawnee or Kiowa origin. It seems clear that, at least in genetic terms, the slave trade added a heterogeneous mixture of Native Americans to the Hispanic community.[76]

The quantitative aspects are even more remarkable. Figure 5-10B shows that by 1750, when the entire Hispanic community totaled 5,914 people, the slave trade had already added almost 1,000 people, and many of these had already joined the *genízaro* ranks and had progeny of their own. By the end of the colonial period in 1821, more than 2,000 *captivos* had been added, and several historians have concluded that by this time New Mexico was at least one-third *genízaro* in origin.[77]

The Atrophy and Demise of the *Casta* System

The enormous flow of Indian slaves and servants into the Hispanic communities, and the subsequent emancipation of most of them as *genízaros,* resulted in a serious social problem. In general, these people were without lands or other means of subsistence and roamed about the province as socially marginalized people, loosely attached to Hispanic settlements and Pueblo villages.[78] Their ever-increasing numbers forced the governors to set aside land so that they could be aggregated in a manner that would allow them to become useful, beginning in 1740 with a settlement in the Belén area. By 1776, the three main *genízaro* towns were Abiquiu, Analco (in Santa Fe), and Los Jarales de Belén. In the 1790s, additional settlements were initiated by Governor Chacón in the Pecos River Valley at San Miguel and San José.[79] While Father Domínguez thought poorly of these people ("the Indians of Abiquiu . . . are weak, gamblers, liars, cheats, and petty thieves"), others thought highly of their courage and usefulness in providing a buffer against nomadic Indians. In fact, organized

genízaro troops were used to fight Apaches in at least the period between 1777 and 1809.[80]

It is probable, however, that only a small portion of the *genízaro* population of the late colonial period became historically visible as residents of *genízaro* towns or as protectors of the province. Incidental reports find them scattered among most of the pueblos, the Hispanic villages, and the frontier areas such as the Chama Valley and the Río Puerco area.[81] Indeed, the main thing that caused the *genízaro* population size to stabilize in the face of the ever-increasing numbers of *captivos* shown in Figure 5-10B is the fact that they were gradually assimilated into the Hispanic community. By marriage or some degree of economic success, the transition from *genízaro* to *vecino* occurred almost routinely in the late colonial period. It seems doubtful whether the *genízaro* status ever lasted more than a few generations for any particular family lineage.[82] As a consequence, the *casta* designations became ever more imprecise and variable, as was evident at San Miguel del Vado in the early nineteenth century. In the latter instance, claims that the settlement was mostly *genízaro,* which was only a quarter-truth, were fostered to win concessions from Church and state.[83]

The *casta* system was not a trivial boundary condition for those affected by its rules. For example, Governor Mendinueta issued an edict in 1768 that made the punishment for stealing garden produce twenty-five lashes at the pillory if the thief was a *casta,* but only being tied to the pillory with the stolen produce hung around the neck if the thief was *español.* Nevertheless, the *casta* designations were becoming increasingly flexible and subjective as time went on.[84]

Some of the best evidence for this evolution comes from comparative study of the censuses of 1750 and 1790, particularly the data from Albuquerque, where *casta* designations were made for both censuses. These designations for 504 adults in 1750 (Fig. 5-5) can be compared with those for the 479 adults of the same area in 1790. Two changes are noticeable. First, the *mulato* designation had almost completely disappeared in the 1790 census (from 14

percent to 0.5 percent), yet the families that were mostly *mulato* in 1750 were still there in 1790, now mostly with "higher" *casta* designations. In particular, two of the founding families of Albuquerque together had 18 *mulato* individuals and 4 adults classed as *indios* in the 1750 census. By 1790, families with the same two surnames included no *mulatos*, 5 *genízaros*, 2 *indios*, 1 *coyote*, 17 *mestizos*, and 24 people designated *españoles*. In two instances, young women of these families were designated *mulatas* in 1750, then listed again in 1790 as elderly *españolas* widows.

Second, in 1790 there was also a general shift of the adults to "higher" *casta* designations at the expense of the percentage of adults previously classed as *indios* or *coyotes*. This resulted in 85 percent of all adults being designated either *español* or *mestizo*. This "whitening process" is commonly believed to be an important component of acculturation and *mestizaje* processes.[85]

In addition to the censuses, the marriage records of the Archdiocese of Santa Fe *(Diligencias Matrimoniales,* or prenuptial investigations ["DMs"]) provide limited data on the *casta* system in New Mexico. A problem with these records is that most of them between 1731 and 1760 are missing. Nevertheless, some paradoxical trends emerge. On the one hand, no *casta* designations are given for most of the people covered. On the other hand, when a designation is made, most frequently the designation is *español.* Many of those with no designation were the brides, who often did not identify their parents. An important purpose of the DMs was to determine whether there were any impediments, such as consanguinity, that should prevent the marriage. Thus it appears that without committing family relationships or *casta* designations to the public records, in many cases the priest was satisfied on an informal basis that no serious impediment existed. This follows from the numerous other examples where a consanguinity problem required a dispensation. As late as 1837, a couple claimed that "both parties are related on either side to families of their peers, who have preserved their pure lines . . . in honor and mutual love, and not

mixing with the lower castes." Their appeal for a dispensation was on the basis of *augustia loci,* that is, a dearth of people with pure blood lines. Fray Angélico Chávez commented in a marginal note that such a situation was common in the DMs of the "upper classes." No doubt these are the same families that John Kessell recently referred to: "By the end of the seventeenth century, 15 or 20 families ruled Santa Fe in near-European luxury." At any rate, the DMs throughout the colonial period in New Mexico support the notion that the *casta* system was increasingly ignored and designations ever more erratically applied as time went on. In the early eighteenth century (until 1733), only 7 percent of the DM applicants claimed *español* status. Between 1760 and 1800, 47 percent claimed *español* status even though the evidence as stated above suggests that the population was, if anything, changing in the other direction. In 1821, when Mexico won its independence from Spain, the legal basis for the *casta* system was eliminated.[86]

A Single Interactive Society

In sum, it seems clear that in late colonial New Mexico, ethnic boundaries in this population of diverse origins were weak and permeable. A large majority of the entire population was ethnically hybrid, and this complexity involved not only the Hispanic community but also Pueblo and nomadic elements. Only two bastions of ethnic boundary conservation remained. The first, already mentioned above, was the small, inbred group of Hispanic *ricos* who, in order to retain their wealth and power, married carefully, developed mechanisms for the conservation of capital (such as the *partido* system for managing livestock), and learned to utilize capital resources outside the province.[87]

The other important defensive group was the core theocratic elements of the Pueblos. They were highly skilled in defending Pueblo languages and cultural structures and were able to control deviant behavior within the Pueblo by means of their war captains and secret societies such as the "clowns" (the latter are

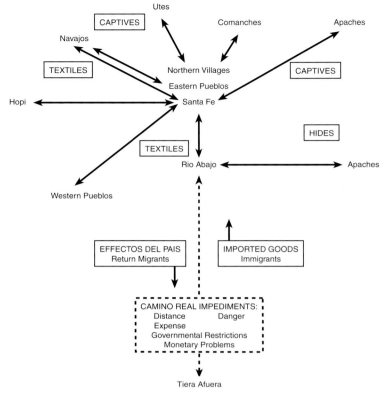

5-11. A diagram of interactions that tended to engender dynamic ethnicity in colonial New Mexico. Diagram by Paul Kraemer, redrawn by Matthew Williams.

referred to by Dozier as the "gestapo" of the Pueblos). Clearly an oligarchy, the Pueblo caciques, as they are commonly known, were obviously successful in conserving Pueblo cultures to the present day. What is still unclear is whether this internal control cost them substantial population losses, via the emigration of Pueblo people to Hispanic or *genízaro* settlements.[88]

Both of these bastions of ethnic conservation were powerful and historically visible. In demographic terms, however, they may have represented only a small portion of either Pueblo or Hispanic populations. In addition, both interacted in numerous ways. These considerations suggest that it is possible to create a more defensible paradigm for the ethnicity of New Mexico than the one illustrated in Figure 5-4.

Such a paradigm (diagrammed in Fig. 5-11) could have a geographical basis; that is, the society would be defined as a geographical area in which all of the different kinds of people interacted continuously through trade, miscegenation, and cultural exchange. In both love and war, proximity is everything. Exclusion from the society would have been entirely a function of being too far away to have many interactions.

Under the constraint of distance, the ethnicity of New Mexico became independent from that of New Spain because there were far more interactions within New Mexico than along the long, dangerous, expensive, monetarily problematic (because of variable value for the peso), and governmentally restricted Camino Real. Those historians dedicated to emphasizing the importance of the Camino Real can justifiably claim that the road was vital to maintaining the colony. The reciprocal interpretation is that the Camino Real barely achieved that goal, was mostly of importance to the tiny Hispanic *rico* class of people, and failed to preserve a Spanish ethnicity or a *criollo* culture. Instead, largely because of its remoteness, New Mexico during the eighteenth and early nineteenth centuries developed a uniquely mixed society that started with Spanish, Indian, and African elements from New Spain, but then acquired major components from Pueblo and nomadic Indians of New Mexico. The roles of the latter components have probably been insufficiently recognized. In any case, as already emphasized, New Mexicans in general had a nebulous ethnicity, nameless and therefore historically invisible. Oakah Jones simply calls them *los paisanos* and has to postpone the question of exactly who is a *paisano*. It is this group of people, who numerically were probably in the majority in the eighteenth and early nineteenth centuries, from whom derive many of the uniquely New Mexican cultural and historical characteristics. Manifestations of these characteristics include the populist insurrections of 1837 and 1847, the development of the Penitente brotherhood, the establishment of the *santero* traditions in art, and many others. Who were these people? We have tried to describe some aspects of their ethnicity, but much is still unknown.[89]

POSSIBLE APPROACHES FOR FUTURE RESEARCH BASED ON THE HUMAN GENOME PROJECT

PAUL KRAEMER

What was the "ethnicity" of the *santeros?* While the cultural aspects of the colonial New Mexican ethnicity are of mind-boggling complexity, it is possible that some of the genetic aspects are now becoming approachable. Genetic tools have been used for many years to trace the histories of human populations, the "peopling of the Americas," and the expansion of farming from the Middle East. Various types of genetic characters have been used in these studies, including blood group substances, mitochondrial DNA, enzyme variations (polymorphisms), and others. Indeed, any character that is inherited according to strict genetic laws shows variation from one individual to another and can in principle be used to trace the origins of an individual's ancestors. However, this is true only if enough data from enough people can be obtained. Some years ago, for instance, a population history of the Iberian Peninsula was reconstructed by generating maps of the present-day gene frequencies of as many blood groups, enzyme variants, and so on as were available. In this way it was shown that the present-day gene frequencies correspond geographically to linguistic and archaeological data about the earliest presence of the Basques and their relationship to subsequent immigrations of Neolithic peoples.[1]

Studies such as these are capable of only the most general conclusions and cannot resolve the complex ethnicity that we have been describing for New Mexico. In the last few years, however, the international Human Genome Project has obtained the type and quantity of data that could be used for such ethnohistorical research. Humans have about 3 billion nucleotides (of four types) arranged in a linear order that constitutes the genetic instructions as well as serving other functions. The first goal of the Human Genome Project was to determine the entire sequence of these 3 billion nucleotides, a job that is essentially complete. Several kinds of variations distinguish one individual from another. One kind is becoming recognized as being particularly useful for ethnohistorical questions: a small fraction of 1 percent of the nucleotides in the human genome varies from one person to the next. Most of these "single nucleotide polymorphisms" (SNPs) are harmless variations that have slowly accumulated and have been silently transmitted throughout the history of humankind. There are at least three reasons for the emergence of SNPs as the best candidate for ethnohistorical research. First, although SNPs constitute only a tiny fraction of the genome, that tiny fraction is about 10 million potential places to look for variation between one person and another. Second, since the primary goal of the Human Genome Project is searching for disease genes and understanding disease susceptibilities, all the SNPs will have to be identified anyway to ensure the validity of this work. Although this point has been recognized for some years, only recently have the funding agencies and international advisory bodies publicly accepted this need, a situation in which ethnohistorical research will be an incidental beneficiary. Third, technological developments are making it possible to do the enormous amount of sequencing required for identifying the numerous sites that vary in the human population. A recent report indicates that 4 million SNPs have already been identified. In addition, methods are being refined for quickly and accurately doing massive numbers of assays on DNA samples from large numbers of people.[2]

In view of the objections often raised to such testing, it should be pointed out that there is no known biological disadvantage to interracial breeding. Quite

the contrary is true—that is, genetic problems result from inbreeding. It is a well-established principle of genetics that when mating selection is confined to small, isolated populations, genetic drift and the emergence of deleterious recessive genes are enhanced. The New Mexican *ricos'* frequent use of dispensations to allow marriages between consanguineous couples hints that these people were at risk of genetic problems. But apparently such problems have only rarely been recorded, and this suggests that the *ricos* had failed to keep their lines as "pure" as they claimed. Indeed, we may speculate that the genetic diversity of the general population of colonial New Mexico was highly beneficial from a biological viewpoint. These conjectures encourage further study.

It is to be hoped that modern genetic methods will be applied within the next few years to specific questions raised here. For example, how much genetic exchange took place between Pueblo and Navajo peoples or between nomadic tribes and Pueblo and Hispanic villagers, and how can we quantify the *genízaro* heritage remaining in people of Abiquiu, Ojo Caliente, and other places? Gender-specific polymorphisms (such as mitochondrial DNA markers and SNPs that map to the Y-chromosome) would enable us to determine whether any significant numbers of *peninsularas* women ever came to the New World.

The case for significant cultural mixing in frontier New Mexico does not, of course, depend upon evidence of genetic mixing. Nevertheless, such evidence—were it politically possible to get, in the present climate of public opinion—would clearly bear on our question: who were the *santeros?* For proof of widespread genetic mixing, in a small, originally diverse human population dispersed over a very large area, would surely create at least some presumption that the people involved were intimately exposed to one another's ways of living.

6 | HYBRID HOUSEHOLDS
A Cross Section of New Mexican Material Culture

DONNA PIERCE

AND CORDELIA THOMAS SNOW

Cultural exchange between the settlers and the indigenous population occurred from the beginning of contact and increased significantly with Spanish settlement in New Mexico and the resulting daily interactions, trade, and forced tribute. The material culture of the colonial period reflects not only the interdependence between Spanish and Pueblo peoples, but also the introduction of objects produced by various Plains tribes as well as from other areas of Mexico, Europe, and Asia. In this chapter, we summarize the evidence published to date and present new documentary information that, combined with the archaeological record, indicates that the households of people in New Mexico in the colonial period were microcosms of cultural exchange. Items of material culture were imported from areas as distant as Spain and East Asia. Objects produced in the Pueblos, particularly ceramics, furniture, weavings, and hide products, were incorporated into households of the settlers from Mexico and Spain. At the same time, Christian religious images and imported items were owned by Pueblo Indians.

When the first settlers led by Juan de Oñate entered New Mexico, they moved into the Pueblo of San Juan de los Caballeros, living side by side with the Indians of that pueblo.[1] After several months, they moved to an abandoned pueblo across the river, which they remodeled and named San Gabriel. Several hundred years later, portions of San Gabriel were excavated, and it is clear from the artifacts recovered that daily life from the beginnings of the colonial period in New Mexico reflected cultural exchange.[2] Archaeological artifacts, coupled with inventories of goods brought by the settlers, indicate that the material culture brought to New Mexico with the settlers did not differ from that in Mexico and Spain and reflects the times. Chinese porcelains, fencing swords, clothing of Chinese silk and lace, beds, satin bedspreads embroidered in gold, silver dishes and saltcellars, brass candlesticks, imported glassware, Spanish lusterware ceramics, silver rosaries, even a headdress of pearls were taken to San Gabriel.[3]

Portions of this chapter have been adapted from an unpublished manuscript by Donna Pierce and Cordelia Thomas Snow for the 1992 exhibition "Another Mexico: Spanish Life on the Upper Rio Grande," at the Palace of the Governors Museum, Santa Fe, New Mexico.

6-1. Baltasar Echave Ibia, *Portrait of a Woman,* Mexico, c. 1650. Museo Nacional del Arte, Mexico City. The buttons on this woman's dress are similar to ones excavated in New Mexico, and the ruff is similar to ones described in inventories of settlers' personal belongings.

These imported goods were then combined in the colonial households with objects of material culture produced by the Pueblo and Plains Indians, such as brain-tanned buckskin curtains and doorcoverings, locally woven cotton fabrics, turkey-feather blankets, and Pueblo-produced ceramics. A number of items are listed in the Oñate expedition inventories as intended for trade to Native Americans, indicating that some Pueblo households would have begun to incorporate objects of European, Mexican, and even Asian manufacture from the early days of the colony.

In December 1600 reinforcements arrived at San Gabriel. Among the new colonists was Doña Fran-cisca Galindo, the wife of Captain Antonio Conde de Herrera. According to the expedition inventory, Doña Francisca's wardrobe included nine dresses of velvet, satin, and silk taffeta trimmed with lace cuffs and ruffs and fastened with gold clasps and buttons.[4] Her husband brought seven suits of wool, silk, and silk taffeta. Several gilt brass buttons were recovered from the excavations at San Gabriel; contemporary portraits from Europe and Mexico show both men and women wearing identical gilt buttons as well as lace cuffs and collar ruffs (Fig. 6-1). The couple's household goods included a bed, eight chairs, a table from Michoacán (an area of Mexico known since pre-Columbian times for the native production of painted and lacquered furniture and utensils), a washtub, silver tableware, a crimson taffeta bedspread trimmed with lace, eight bedsheets, and bolsters and pillows embroidered in multicolored silk, among other items.

Glass and ivory beads recovered in excavations at San Gabriel may have been used in rosaries or personal jewelry, or brought for trade with Pueblo and Plains Indians. An excavated bone plaque with a depiction of a medieval European town may have decorated a jewelry box or gun stock. Oñate listed nineteen and one-half dozen hawk's bells among his personal provisions specifically to be used for trade with Native Americans; a hawk bell was recovered in the excavations. Portions of mortars excavated at San Gabriel were used for grinding spices, herbs, and medicines, while excavated tub weights were used with scales to measure powder, pigments, and, it was hoped, valuable minerals. These imported goods, typical of life in Mexico City or Zacatecas in the late sixteenth century, were juxtaposed in the colonial households with objects of material culture from the local Pueblo and Plains Indians.

In 1609–10, the new governor, Pedro de Peralta, moved the capitol of New Mexico from San Gabriel to the site of present-day Santa Fe. The Villa of Santa Fe in New Mexico was built around a plaza with a parish church on one side and the *casas reales,* or royal buildings, on the others. The remaining section of those

buildings is now known as the Palace of the Governors. Throughout the first three-quarters of the seventeenth century, the *casas reales* were home to the governor of New Mexico, his family, and his servants, as well as to some other government officials and their respective families and servants.

Items recovered from twentieth-century excavations in the Palace of the Governors proved to be a microcosm of domestic life in New Mexico during the seventeenth century.[5] Among the items recovered was a woman's drop earring made of glass and covered with gold leaf. Similar drop earrings and hair ornaments can be found in portraits of European and Mexican women of the time. Buttons covered with thread wrapped with silver wire were also found. Metal straight pins, needles, and remnants of gold and silver galloon indicate that clothing was made or repaired on the premises. Other objects recovered reflect the minutiae of everyday life, including turned ivory fragments that may be pieces of a miniature chess set or decorative finials from a piece of furniture. In addition there were an ivory handle from a cane or dagger, bone handles, an ivory lice comb, a *chispa* (strike-a-light) flint, a copper escutcheon or plaque, an ox-goad, pieces of glass, and sealing wax.

The excavations yielded a large quantity of ceramic shards. Olive jars made in Spain and Mexico were the cardboard boxes of the time and were used to transport everything from olives to wines. Other imported ceramics included majolica, a soft-paste ware with a lead-tin glaze. Several shards appear to have been made in Spain, including one from a vessel decorated with a design in gold leaf. Other types of majolica were made in Mexico. One style was decorated with designs copied from Spanish lace used on women's clothing (see Fig. 6.a.1). Known as Puebla Polychrome, this type of majolica is found only in archaeological sites in New Mexico that predate 1680 (see Fig. 6.a.2). The semicircular lace patterns from Puebla Polychrome were appropriated by Tewa Indian potters in New Mexico and appear on examples excavated in the Palace of the Governors and

In the seventeenth century, lace patterns used on clothing were reproduced in majolica ceramic decoration in Spain and Mexico. Mexican majolica with these patterns, known as Puebla Polychrome style, was imported to New Mexico by Spanish settlers. Local Pueblo Indian potters appropriated these painted patterns for their own earthenware ceramics. At the same time, Chinese porcelains were imported to New Mexico, and the soup-plate form, previously unknown in Pueblo ceramics, was also adopted by Indian potters.

6.a.1. Anonymous, Portrait of a Lady, Mexico, mid-seventeenth century. Present whereabouts unknown. Photo Donna Pierce.

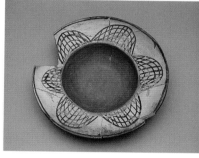

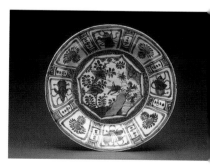

6.a.2. Majolica cup, Puebla Polychrome style, Puebla, Mexico, mid-seventeenth century. Museum of Indian Arts and Culture, Museum of New Mexico, gift of Florence Lister. This cup was excavated at Pecos Pueblo in New Mexico.

6.a.3. Earthenware soup plate, Tewa Indians, New Mexico, seventeenth century. Laboratory of Anthropology, Museum of New Mexico (1955/11), Santa Fe. www.miaclab.org. Photo Blair Clark.

6.a.4. Porcelain soup plate, China, Ming Dynasty (1368–1644). Museum of International Folk Art, Santa Fe, New Mexico.

other locations, documenting Spanish household use of native ceramics (see Fig. 6.a.3).

Other types of seventeenth-century Mexican majolicas recovered from the Palace included shards of the types referred to by archaeologists as Abó, Aucilla, Castillo, and Puaray Polychromes. Still other types of majolica excavated from the Palace have designs copied from contemporary Chinese porcelains. One type of Puebla Blue-on-White recovered from excavations at both the Palace of the Governors and various missions has banded designs that were copied from Chinese *kraakporselein,* or export porcelains (see Fig. 6.a.4). Developed in China specifically for the export market and imported into Europe by the Portuguese on their swift carrack *(kraak)* ships, *kraakporseleins* were given this name by Dutch pirates when they hijacked several Portuguese carrack ships full of porcelains in 1602 and 1603.

In 1567 Spanish merchants opened trade with Asia by sailing across the Pacific Ocean to Manila.[6] Within a short time, trade goods such as spices, fabrics, silks, ivory, and Chinese porcelains poured into Mexico and from there throughout the Americas and on to Europe. Porcelain and other Chinese goods were obtained in Manila and shipped across the Pacific Ocean by galleons to Acapulco, where they were off-loaded and hauled to Mexico City by mules. The goods were either sold in Mexico City to those who could afford them (Chinese porcelain was said to be worth its weight in silver), or hauled to Vera Cruz to await transportation to Spain. However, until the mid-eighteenth century, Chinese porcelain was far more common in Mexico than in Europe.[7] Cups and plates of Chinese porcelain purchased by private individuals in Mexico City were subsequently transported north for use in the missions and domestic sites in New Mexico.

Only a few decades after the China trade began in 1567, some of New Mexico's first colonists included among their possessions cups of Chinese porcelain. Several shards of Chinese porcelain were recovered from excavations in the 1960s at San Gabriel. These fragments are interesting not only for the long distance the original objects traveled, but because of their age and the fact that they were brought to New Mexico such a short time after the opening of trade with Asia. Some of the cups from which the shards came were heirloom pieces at the time they were brought to New Mexico. Decorated in blue and red enamels, some of the vessels had been made between 1522 and 1566 during the Chia Ching dynasty, the others between 1573 and 1620 during the reign of Wanli.[8]

In addition to the shards of Chinese porcelain recovered from San Gabriel, porcelain shards were recovered from excavations in the Palace of the Governors (see Fig. 6.b.1). At least one vessel decorated in blue on white was dated as having been made between 1522 and 1566. Other shards from a cup or small bowl decorated with gold leaf on a cobalt-blue background were made before 1644, the end of the Ming dynasty.

Even though Santa Fe was located on the farthest reaches of northern New Spain, thousands of miles from Mexico City, Spanish colonists of New Mexico drank hot chocolate in porcelain cups imported from China. Spaniards had adopted the custom of drinking chocolate, a product native to the Americas, from the Indians of central Mexico in the early colonial period. In a document from 1660, a Pueblo servant working in the Palace of the Governors described serving chocolate to the governor and his wife at three o'clock in the afternoon.[9] Governor Don Diego de Vargas described negotiating with Indian leaders over cups of hot chocolate, and his will, and an estate inventory taken in 1704, listed numerous pounds of chocolate in his possession.

The Pueblo Indians continued their long tradition of making pottery after the Spanish came to New Mexico. However, within a matter of years, possibly for Spanish patrons, Pueblo potters began to imitate not only the shape of the vessels imported by the Spanish, but also their decorative style. Soup plates, footed cups, goblets, and candlesticks of Pueblo-manufactured ceramics all became popular, while other vessels

exhibited designs made in imitation of the Spanish-lace design found on Puebla Polychrome majolica from Mexico (Figs. 6.a.2 and 6.a.3). Although handled mugs had been made by several groups in the Southwest before Spanish exploration and settlement, handled cups and jars proliferated after 1598. During the colonial period, Spanish settlers used Indian ceramics in their homes along with imported majolica ceramics from Mexico and Spain and porcelains from China.

In addition to shards of locally manufactured pottery and imported ceramics, the pits beneath the floors of the Palace contained quantities of faunal and vegetal remains that reflected the diet of both the Spanish and the Indian occupants of the *casas reales.* Butchered bones of Spanish-introduced sheep, goats, cattle, and pigs, as well as native bison, deer, antelope, trout, catfish, and other fish, were thrown into the trash pits, along with native corn cobs, beans, bits of squash rinds and gourds, kernels of European wheat and barley, and peach and apricot pits. Excavations at Indian pueblos indicate the same mixture of native and introduced foods.

Aside from archaeological evidence, few documentary sources list or mention personal or household goods owned by seventeenth-century colonists in New Mexico. One exception is the inventory of the household and personal possessions of Francisco Gómez Robledo, taken when he was arrested on May 4, 1662, and sent to Mexico City to stand trial before the Inquisition.[10] Gómez Robledo was later exonerated of all charges and returned to spend the rest of his life in New Mexico. The inventory was made of Gómez Robledo's "house that is located on the corner of the royal plaza of this villa (Santa Fe) that has a *sala* (living room), three rooms, and an (interior) patio with its kitchen door at the rear."

The inventoried goods in Gómez Robledo's home included a hybrid assortment of material culture such as Spanish weapons and armor accompanied by a few articles of buckskin armor obviously made locally from the distinctive brain-tanned leather of the Pueblo and Plains Indians (see Chap. 8). Horse

gear includes both Spanish- and Muslim-style saddles as well as horse armor probably made from Indian-tanned buckskin. Clothing includes articles clearly imported, such as shoes from Córdova, Spain, and taffeta cloth from Castile, Spain, along with two leather raincoats probably made locally. Household furnishings include a Spanish writing chest with nine drawers and lock and key, along with locally woven and painted *mantas,* or textiles, usually produced in the Pueblos, for use as curtains for the doors.

From the period after the reconquest (1693) to American occupation (1846), there are several hundred extant wills and estate inventories from New Mexico.[11] The documents represent a cross section of New Mexicans, from obviously wealthy individuals such as José Reano de Tagle and Juana Luján to much poorer individuals. The wills include, among others, persons listed in the documents as *españoles, mestizos,* coyotes, and *indios;* men and women; blacksmiths, weavers, soldiers, ranchers, and traders.

An analysis of the wills illustrates the hybrid lifestyles in the material culture of eighteenth-century New Mexico. Most households contained locally produced goods in addition to imported items. For example, in 1814 Manuel Delgado of Santa Fe owned thirteen suits of velvet, cashmere, and silk, in addition to two locally made three-piece suits of buckskin, consisting of a quilted vest, a jacket, and pants, a type of clothing adopted by settlers from the Native Americans in the early seventeenth century. We examine here the wills of a woman born in New Mexico of Spanish parents, several generations of an extended family listed as *mestizos* from Zacatecas, and a woman listed variously as a *coyota* (one-quarter Spanish) and as an *india* from Zia Pueblo. This brief sampling does not support broad generalizations, but it does provide an insight into the conflation of cultures in daily life.

Settlers who returned to New Mexico after the Pueblo Revolt often requested the return of their original family land grants. One such individual was Juana Luján, daughter of Matías Luján and Francisca Romero, who had settled near San Ildefonso Pueblo

6-2. Miguel Cabrera (1695–1768), *Portrait of Doña María de la Luz Padilla y (Gómez de) Cervantes,* Mexico, c. 1760, oil on canvas. Brooklyn Museum, Museum Collection Fund and the Dick S. Ramsey Fund, 52.166.4.

be buried in it. Despite this closeness, when she encroached on San Ildefonso lands the Pueblo filed a formal complaint in court and in 1786 won restitution of its lands from her heirs. Although she never married, her children married into prominent settler families. After her death in 1762, her will was probated in the district of Santa Cruz, the most important town between Santa Fe and Taos, and the estate inventory includes the dowry list of her daughter.[13]

The Luján inventory lists clothing including a jacket and skirt of embroidered brown brocade with silver-embroidered edging, and a black satin skirt with silver edging, among others. Two Brittany linen blouses, one embroidered in black silk thread and the other pleated and trimmed with sequins, are also listed. These articles of clothing could have been imported ready-made from Mexico or made by tailors in New Mexico from imported fabrics. Other items of clothing and accessories in the Luján inventory include two painted ivory fans and a silk shawl with silver trim, all from China; scalloped lace gloves; three pairs of silver shoe buckles; one pair of heeled shoes; twelve pairs of slippers; silk stockings; two hats with plumes; four petticoats (some embroidered); and two capes. Similar examples of clothing and accessories appear in contemporaneous portraits from central Mexico (Fig. 6-2).

Articles of jewelry listed in the Luján inventory include silver finger rings, necklaces, rosaries, medallions, lockets, and reliquaries (one with a wax image of the Lamb of God); a silver-gilt brooch cross with gemstones; a necklace of pearls and coral beads with a reliquary locket in the middle; rosaries and bracelets of coral and green glass beads; three pairs of drop earrings of gold or silver with pearls, corals, or crystals; two silver jewelry boxes; and one silver hair ornament, possibly similar to the one illustrated here (Fig. 6-3). Luján owned silver tableware, numerous items of Chinese porcelain and Mexican majolica "from Puebla," bronze mortars, and chests imported from Michoacán, Mexico (Fig. 6-4).

Catalina Durán, the widow of José de Armijo, had arrived in Santa Fe with her sons Antonio, Marcos, and

before the Pueblo Revolt.[12] The Luján family survived the Revolt and joined the other fleeing exiles in their long walk to El Paso. Juana returned to New Mexico after 1693. Socially prominent, Juana resided at a rancho of twenty-four rooms called San Antonio, which lay partially within the bounds of San Ildefonso Pueblo in the area of her parents' previous home. In addition Juana owned a rancho with two rooms, a garden, and planting lands at Santa Cruz de la Cañada.

Juana and her family had a strong, lifelong association with the nearby Pueblo of San Ildefonso. She employed several people from there, stood as godparent at the baptism of many local children, lent religious images to the Pueblo mission church, and requested to

Vicente in 1695 with the Juan Páez Hurtado recruits (see Chaps. 4 and 5).[14] Listed in the muster roll as *mestizos,* the family gave Zacatecas as their place of birth. Although Catalina died penniless at age ninety-five in 1752, her sons had amassed impressive estates. When Vicente died in 1743, nine years before his mother, he owned a house in Santa Fe of five rooms plus a *sala grande* or grand parlor. His will included thirty large locally produced chamois skins, fifteen buffalo skins, two wall tapestries made of four tanned buckskins each, and "two more that will be brought by the Indian Ignacio of Santa Clara." Among other food products, Vicente also had three *ristras* (strings) of chile and a barrel of twenty-five-year-old wine.

When Catalina's other son, Antonio Durán de Armijo, died in Taos in 1748, his possessions were left to his daughter, María Gertrudis, then a minor. María Gertrudis's inheritance included a two-story house of eight rooms with a portal and a balcony, a variety of silk, velvet, and linen clothing imported from Spain and Mexico, costly embroidered laces and ribbons, two pairs of silver shoe buckles, four cups of Chinese porcelain, and a piece of Mexican majolica (Fig. 6-5). The clothing was probably similar to examples illustrated in paintings from the same period from central Mexico (Fig. 6-2 and Figs. 6.b.2 and 6.b.3). The estate also included ten religious images—"a large one of Our Lady, two medium-sized ones of Saint Dominic and Saint Vincent, and the others, small ones of various Saints" (Figs. 6-6 and 6-7). Antonio Durán de Armijo owned a wooden wardrobe in addition to two tables, "one large one with a drawer, and another small one." He also had "one small looking glass."

Clothing listed in Antonio Durán de Armijo's estate included six *varas* of embroidered ribbon from Spain, ten *varas* of red China silk, one short coat of blue Castillian cloth with buttonholes worked in silver, and one hat band of silk ribbon. Durán de Armijo owned "one reliquary, plated in gold, one rosary of small silver beads with a silver cross, some coral bracelets which weigh two ounces, some pearl earrings, and a silver toothpick." Durán de Armijo also had seven pewter

6-3. Hair comb, Mexico, late eighteenth century, silver-washed brass, collected in New Mexico. Museum of Spanish Colonial Art, collection of the Spanish Colonial Arts Society, Santa Fe. Photo Jack Parsons.

6-4. Writing chest, Mexico, probably Michoacán, eighteenth century. Museum of Spanish Colonial Art, collections of the Spanish Colonial Arts Society, Santa Fe, gift of Mrs. H. M. Greene. Photo Jack Parsons.

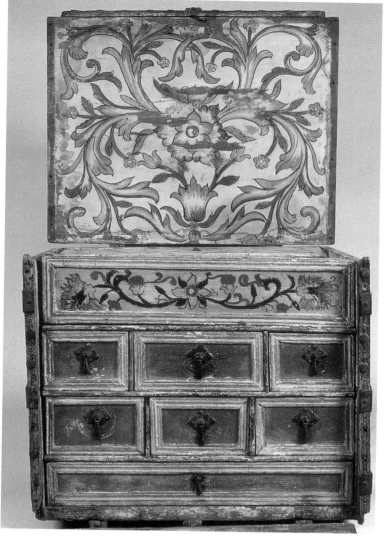

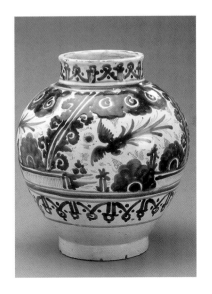

6-5. Majolica vase, Puebla, Mexico, eighteenth century. Museum of International Folk Art, Santa Fe, New Mexico.

6-6. Anonymous, Mexican, *Saint Francis of Assisi,* probably made in Puebla, mid-seventeenth century, polychromed and gilded wood. Denver Art Museum, bequest of Robert J. Stroessner.

6-7. Anonymous, *Saint Michael,* Mexico, probably Querétaro, late eighteenth century, polychromed and gilded wood. Museum of Spanish Colonial Art, collections of the Spanish Colonial Arts Society, Santa Fe, bequest of Alan and Ann Vedder. Photo Jack Parsons.

plates, two copper spoons, a bronze weight with scales, a copper jug, two copper *ollas,* and two large copper kettles, as well as four small lacquered cups from Michoacán, the area of Mexico known since pre-Columbian times for the native production of painted and lacquered furniture and gourd utensils.

A blacksmith by trade, he owned the appropriate tools: fourteen files of various types, eight punches, a variety of chisels, burins, pinchers, nippers, an adze, an ax, bellows, tongs, hammers, anvils, cold chisels, and augers with drills, together with one *arroba* (twenty-five pounds) of iron plus eleven pounds of "old (or salvage) iron." His inventory also listed "a good shot gun trimmed in silver, one short sword, one leather shield *(adarga)* painted in oils, and another

not painted." The leather shields were probably locally made.

In sum, for a *mestizo* tradesman who had arrived in New Mexico as a youth, Antonio Durán y Armijo had accumulated a substantial estate. When his daughter, María Gertrudis Armijo, died in Taos in 1776, the effects of her estate included "twelve canvas paintings, as well as twelve more, that total twenty-four in all" (Figs. 6-8 and 6-9). Her estate also included one dozen silver spoons, a half-dozen Chinese porcelain cups for chocolate, half a dozen Chinese bowls, and two chests with locks and keys from the Michoacán area of Mexico (known for painted furniture), in addition to several pieces of property (Fig. 6-4). Clothing belonging to María Gertrudis Armijo consisted of a silk underpetticoat and another of "fancy spotted silk," a fine scarf and head covering, and two "kimonos," possibly from Asia.[15] Her jewelry included a gold and coral brooch valued at thirty pesos.

In 1753 Juana Galbana, a native of Zia Pueblo sometimes referred to in documents as an Indian woman, at other times as a *coyota,* owned "two spacious dwelling houses, ditches, plowed lands for planting, and another dwelling house at the entrance of the Pueblo of Zia containing various rooms." She also had two silver reliquaries, one brass crucifix, and nine different pictures of saints on elkskin, including one of the Infant Jesus (Chap. 9, Fig. 9-1). Juana Galbana's estate included three copper drinking cups, a copper kettle, three "metal" plates, and a basin. Her clothing and jewelry of value consisted of one red wool cape, one silk taffeta cape, one black and white shawl, one pair of shoes, three more shawls, two of them painted and one embroidered (see Fig. 6.b.3), a pair of coral bracelets, and another of jet.

Although the majority of itemized goods in household inventories are the more valuable imported materials, locally made items occasionally appear, such as the paintings on hide listed above. The use of brain-tanned hide, or buckskin, clothing had been adopted from the Native Americans by the Spanish settlers in the seventeenth century, particularly for

Prevalent in Asian art, scrolls in the shape of the letter C were appropriated in the decorative arts of Europe and the Americas, including New Mexico, in the seventeenth and eighteenth centuries. The motif was spread through the importation of Chinese porcelains and silk textiles such as those seen in Mexican portraits as well as through inexpensive printed cotton fabrics, known as *indianilla,* from East India, seen in the skirt of the young girl in Miguel Cabrera's *casta* painting reproduced here. In New Mexico, the C-scroll motif was copied in locally produced embroideries as well as on *retablos, bultos,* and altar screens (see Chap. 3, Figs. 3-5, 3-6, 3-7, and page 136, Fig. 3).

6.b.1. Shards of porcelain cup, Ming Dynasty (1368–1644), China. These shards from a cup were excavated from the Palace of the Governors in Santa Fe in 1974. Photo Blair Clark.

6.b.2. Miguel Cabrera (1695–1768), portrait of Don Juan Joachin Gutiérrez Altamirano Velasco, Mexico, c. 1752, oil on canvas. Brooklyn Museum, Museum Collection Fund and the Dick S. Ramsey Fund.

6.b.3. Miguel Cabrera, *casta* painting of Negro man, Indian woman, and their mulatto daughter, 1765. Madrid, Museo de América.

6.b.4. Colcha embroidered bedspread, northern New Mexico/southern Colorado, late eighteenth–early nineteenth century. Museum of Spanish Colonial Art, collections of the Spanish Colonial Arts Society, Santa Fe, gift of Mary Cabot Wheelwright. Photo Jack Parsons.

6-8. Sebastián López de Arteaga, *The Incredulity of Saint Thomas*, Mexico City, c. 1643–50, oil on canvas. Museo Nacional del Arte, Mexico City.

6-9. Sebastián Salcedo, *Saint Joseph with the Christ Child,* Mexico City, c. 1779–83, oil on copper. Museum of Spanish Colonial Art, collections of the Spanish Colonial Arts Society, Santa Fe. Photo Jack Parsons.

6-10. Carved and painted chest, New Mexico, late eighteenth century. Museum of Spanish Colonial Art, collections of the Spanish Colonial Arts Society, Santa Fe, gift of Mr. and Mrs. John Gaw Meem in memory of E. Boyd. Photo Jack Parsons.

outdoor wear and horseback riding, and hide garments appear in inventories, such as the two three-piece buckskin suits owned by Manuel Delgado (see Chap. 8). In some inventories, other Native American products are itemized from time to time. For example, the Spaniard José Reano de Tagle of Santa Fe in 1743 owned "five Navajo baskets and one large Navajo basket," and Lugarda Quintana of Santa Cruz had "one new Indian basket" in 1749. Almost a century later, María Micaela Baca of Santa Fe had "four new Indian baskets" when she died in 1832. In 1814 Manuel Delgado of Santa Fe had a "Navajo serape." Other local weavings such as *jerga* (rough-weave twill cloth) appear often in the inventories and were produced by both Pueblo and Spanish weavers.

Although usually not itemized in estate inventories, locally made Pueblo ceramics appear in archaeological excavations of eighteenth-century Spanish homesites in New Mexico along with imported ceramics from Mexico and China.[16] Still produced at Taos and Picurís Pueblos, micaceous pottery was used by both Spanish settlers and Pueblo Indians. Micaceous pottery was apparently made also by *genízaro* (Christianized, non-Pueblo) Indians and some Hispanic potters as well at the end of the colonial

period.[17] Other types of Pueblo ceramics found in eighteenth- and nineteenth-century Spanish homesites are Ogapoge and Powhoge Polychrome pottery.

Other inventories and wills listed chests (Fig. 6-10) and furniture "made in this country," without further identification, as in the last will of Manuel Durán y Armijo, which listed "three wooden chests, made in this country, with their iron locks." While Gertrudis Martín had a "native chest," in 1770 Mónica Tomasa Martín, a creole woman from Taos, owned a locally made trunk, a bedstead with railing, and a table and bench. Pecos Pueblo had become well known in the seventeenth century for the manufacture of fine furniture and retained its reputation for carpentry throughout the colonial period.[18] The creole Diego Manuel Baca of Santa Fe noted in his will in 1727 that Juan Gabriel, an Indian of Pecos Pueblo, apparently a carpenter, owed him one double door, three single doors, and five windows, in addition to a large table, two wooden seats with a back [presumably, benches], and four elbow chairs. In 1752 a creole citizen of Santa Fe, María Diega Garduño, listed two bedsteads from Pecos, one with railings. A Spanish-born citizen of Santa Fe, Juan Montes Vigil, in 1762 owned "twelve chairs from Pecos."

Even a cursory look at the documentary and archaeological record indicates that people of all economic and social classes in New Mexico had hybrid households with a mixture of imported and local material culture. The distinction appears to have been in quantity. For example, both Juana Galbana from Zia Pueblo and Vicente Armijo, a *mestizo* immigrant from Zacatecas, had locally made paintings on buckskin in their homes. Galbana owned imported silk and embroidered clothing as well as coral and jet jewelry, although not in the quantities listed in the estates of Juana Luján and María Gertrudis Armijo. All households, regardless of social standing, show archaeological evidence of the use of Pueblo-produced goods, particularly ceramics. Conversely, Mexican majolica and Chinese porcelains are usually found in Pueblo excavations, though not in the quantity seen in settler

households. This is not to imply that access to goods was equal, but rather to point out that all people in New Mexico were functioning in a climate, even within their own households, of constant cultural exchange. New Mexican artists enjoyed a multicultural variety of source materials to appropriate or reject in the creation of a locally relevant art form.

WILLS AND INVENTORIES CONSULTED

The following wills and inventories were consulted. All can be found in the Spanish and Mexican Archives of New Mexico.

SANM I, 83, will of Diego Manuel Baca, Santa Fe, March 23, 1727.

SANM I, 964, inventory of the estate of José de Reano de Tagle, Santa Fe, April 16, 1743.

SANM I, 26, will of Vicente de Armijo [son of Catalina Durán], Santa Fe, November 15, 1743.

SANM I, 240, inventory of the estate of Antonio Durán de Armijo [oldest son of Catalina Durán, brother of Vicente, father of María Gertrudis Durán de Armijo], San Gerónimo de Taos, August 1, 1748.

SANM I, 968, will of Lugarda Quintana, Santa Cruz de la Cañada, May 12, 1749.

SANM I, 351, inventory of the estate of María Diega Garduño, Santa Fe, May 20, 1752.

SANM I, 193, inventory of the estate of Juana Galbana, Zia Pueblo, May 7, 1753.

SANM I, 1055, will of Juan Montes Vigil [father-in-law of Gertrudis Armijo], Santa Fe, April 30, 1762.

SANM II, 556, inventory of the estate of Juana Luján, Santa Cruz de la Cañada, July 15–August 22, 1762.

SANM I, 559, inventory of the estate of Gertrudis Martín, Santa Cruz de la Cañada, August 9, 1762.

SANM I, 246, will and deposition of the estate of Manuel Durán de Armijo [son of Vicente], Bernalillo (San Felipe de Albuquerque), February 12, 1765.

SANM I, 590, division of the property of Mónica Tomasa Martín, Taos, May 20, 1770.

SANM I, 48, inventory of the estate of Gertrudis Armijo, Taos, March 26, 1776.

SANM I, 1060, inventory of the estate of Manuel Vigil [husband of Gertrudis Armijo], Taos and Santa Fe, October 13, 1780.

SANM I, 252, inventory of the estate of Manuel Delgado, Santa Fe, September 14, 1815.

SANM, 144 and 146, will and distribution of the estate of María Micaela Baca, Santa Fe, May 14, 1832.

CHRISTIAN ICONS BETWEEN THEORY AND HISTORY

INTRODUCTION TO CHAPTER 7

DONNA PIERCE AND CLAIRE FARAGO

Mestizo is a term that's never been widely used in the South-west, whereas of course it is a cultural component of true Mexico. "*Mestizo?*" people would say, "[we]'re Spanish American." There's a wonderful quote that I used in something or the other from a man I interviewed. He said, "I'm a Spanish American. My grandmother was a Navajo Indian; that makes me an American. My great-grandfather was from Spain; that makes me Spanish." It wasn't [considered] benign, that Indian heritage.
—Marianne Stoller, 1997,
recalling her research experience in the San Luis Valley

Long before its publication here, Marianne Stoller's 1979 study of *santos* was known to specialists in the field through a typescript on deposit at the Museum of International Folk Art Library in Santa Fe. Circulation of the manuscript was restricted, and nothing in the published literature was even remotely similar to Stoller's research on the ethnicity of the *santeros* and the artistic identity of their work. When the present project was still in its formative stages, we contacted Dr. Stoller, by then Professor Emerita in the Department of Anthropology at Colorado College, Colorado Springs, to ask whether she had any plans to publish the article, and the present collaboration was born.

In 1997, Stoller explained in the following terms the circumstances that originally led her to undertake the study and later caused her to defer publication. In 1946, Congress created the U.S. Court of Indian Claims to settle suits brought by Native American tribes against the U.S. government for lands that had been appropriated by the United States. These circumstances provided fortuitous funding for many historians and anthropologists, including Stoller, who initially interviewed residents of Hispano villages in connection with her land-grant research. The Civil Rights Movement arrived in New Mexico and south-

ern Colorado in the late sixties and seventies, about a decade later than in Texas and California, and played out over different class issues, primarily involving longstanding battles over land grants and water rights. In the highly charged political atmosphere of that period, public demonstrations were frequently set off by specific events, like the courthouse raid at Tierra Amarilla, which resulted from land-grant issues that had smoldered since the United States created the Office of Surveyor General in 1854. With civil rights, activism came for the first time in a region that had strongly romanticized Indians for over a century, bringing national recognition for the poor, but *landed,* Hispano people and the Spanish cultural heritage with which they strongly identified. The term *mestizo* itself was not invoked, and, as Stoller explains in the words quoted above, cultural pride implied significant class distinctions from the *indigena* affiliation of Mexican migrant workers.

Stoller, who grew up in the region and was becoming even better acquainted with its complex legal and social history through her paid work, was led to write against the contentious grain of contemporary identity politics. Convinced that current patterns of behavior could shed light on past events at the village level from the eighteenth to the mid-nineteenth century, she began her study of New Mexican *santos* under the auspices of the Colorado Commission on the Status of Women to revive "folk art" in the San Luis Valley of southern Colorado. Although Stoller's preliminary findings were well received at the 1976 conference of the newly established American Society for Ethnohistory in Albuquerque, her vanguard cross-cultural approach proved so threatening to some that she eventually deferred to privately exerted pressure not to publish the following article.

7 | THE EARLY *SANTEROS* OF NEW MEXICO:
A Problem in Ethnic Identity and Artistic Tradition

MARIANNE L. STOLLER

Some early publications attributed the carved images *(bultos)* and painted panels *(reredos* and *retablos)* of late eighteenth-century and nineteenth-century Southwestern Catholic mission churches and village chapels to the Pueblo Indians. Most scholars of these arts, however, have identified the *santeros* (saint-makers) as Spanish colonists. But their arguments often fail to distinguish between artistic tradition and ethnic identity, or to take into account the Pueblos' tendency to compartmentalize native and Christian religious practice and how this compartmentalization might have affected Pueblo participation in Christian religious art. Parallels in the uses of art in religious chambers, techniques and materials, and some aspects of art style, together with the historical data concerning ethnic identity, reveal that an equally strong argument can be advanced for some of the early *santeros* being Indians—albeit increasingly Hispanicized Indians. In ethnohistorical perspective, the artistic tradition they developed is an illuminating example of Hispanic-Indian acculturative processes. In this chapter I first review the literature pertaining to the ethnic identity and artistic tradition of the *santeros*. Then I discuss the nature and processes of Spanish-Indian acculturation in general; the evidence of correspondence in techniques, materials, and style between the religious art of the Pueblos and that of the *santeros;* and the evidence on the identity of the early *santeros*. An assessment and interpretation of these data conclude the study.

A version of this chapter was presented at the annual meetings of the American Society of Ethnohistory, Albuquerque, 1976. Ruben E. Reina and Edward M. O'Flaherty, S.J., stimulated my understanding of Hispanic religious colonization in the New World. Myra Ellen Jenkins kindly gave me access to the E. Boyd collection in the New Mexico State Records Center and Archives, and James Purdy helped me search in these papers. Frances Leon Swadesh, Father Benedito Cuesta, and JoAnn Orsborn heard my ideas take form; I am grateful for their critical scrutiny, but alone take responsibility for the views expressed here. Every researcher on the *santeros* and their art owes an enormous debt to the late E. Boyd; to readers who may think I have contradicted her, I would ask them to reread both her words and mine.

The Art and Its Literature

The art of the *santeros* consists primarily of Christian icons; those painted on flat slabs of wood are called *retablos* and were often assembled into large *reredos* or altar screens mounted on the rear chancel wall or in the transepts of churches.[1] Those carved in the round and painted are called *bultos*. These religious images were (and still are in some places) used to decorate public churches, private chapels, chapter houses or *moradas* of the *cofradía* or fraternal organization familiarly known as the Penitentes, and small altars in family homes. The art flourished for a century, more or less, appearing, as best can be determined through tree-ring dating and scanty written records, toward the end of the last half of the eighteenth century and almost disappearing by the last quarter of the nineteenth century.[2]

Shalkop, echoing the opinion of other scholars as well as stating his own, called the work of the *santeros* "the only *non-Indian* religious art native to" this country (italics mine).[3] The subject matter of this art is unquestionably non-Indian, consisting of *santos,* saints or holy persons or symbols, from the Hispanic Catholic hierarchy of sacred personages, and their attributes. The style of these creations is less clearly a product of the Hispanic Catholic tradition, as scholars have acknowledged in stressing their uniqueness. Techniques and materials used in the production of *santos* are, for the most part, definitely not those of the Hispanic Catholic artistic tradition as it was brought to the New World in the sixteenth century and as it continued to develop in Mesoamerica. And the identity of the creators of this art—the *santeros*—has been the subject of controversy.

The first scholarly publication on the art of the *santeros* was an illustrated article appearing in *Hispanic Notes and Monographics,* published by the Hispanic Society of America in 1926 and titled "Ten Panels Probably Executed by the Indians of New Mexico."[4] Some other scholars continued to attribute the *santos* to Indians—notably Cheney and Candler[5] in one article and Pach[6] in another in *Parnassus,* both in 1935, and Spinden (one of the first scholar-collectors of *santos*) in the *Brooklyn*

Museum Bulletin in 1940.[7] As late as 1945, *New Mexico,* a volume of the American Guide Series assembled under the Work Projects Administration (W.P.A.) in the 1930s, claimed the *santos* to be the work of Indians.[8] But most of these publications were later discredited as based on inadequate information, and by the mid-1990s most scholars saw the *santeros* as Hispano people.[9]

Wilder and Breitenbach, in *Santos: Religious Folk Art of New Mexico,* were so thoroughly committed to interpreting the *santos* as a development from European Catholic religious art tradition that they referred to the *santeros* throughout as "colonials" or "settlers."[10] George Kubler's excellent research on both the architecture and the art of New Mexico has been directed almost exclusively toward demonstrating the simplification and reduction of Old World prototypes and traditions in a colonial frontier area. Kubler's 1964 essay on *santos* envisaged them as the "end of the line" of religious arts arising from and reverting to Byzantine and medieval European traditions.[11] A younger scholar, Christine Mather, wrote in the same vein in 1976: "All of the elements of style in the folk art of New Mexico are dependent upon previous artistic styles, primarily derived from Spain."[12]

Wilder, in 1950, posed the crux of the problem this chapter attempts to address, but he summarily solved it by denying it:

The story of the founding of New Mexico and its growth as a Spanish frontier settlement is the story of the Catholic Church and its successes in the conversion of the Indian. With the religious folk art of the area, however, the Indian is not concerned. His arts, well known and respected throughout the centuries, show little Christian influence. ... the Indian, despite his conversion to Christianity, continued his pagan rites and rarely undertook the representation of Christian symbols. However, his immediate neighbor, the Spanish colonist, was invariably a devout Catholic.[13]

José E. Espinosa seconded Wilder, with a vengeance:

It has been stated and restated by writers of articles in popular magazines that New Mexican *santos* are the product of Indian

craftsmanship. The New Mexican Indian, quite at variance with the proclivities of the Mexican Indian, was never attracted to the making of Christian images. In the few instances where Christian symbols are found in Indian art ... it is clear from their disposition that the decorative element was the point of attraction, and certainly not the abstractions of Christian symbolism. This absence of New Mexican Indian interest in the making of Christian sacred images is merely another reflection of his unwillingness to accept Christian religious practices in general, an attitude which he has consistently maintained since his earliest contacts with the Franciscan missionaries.[14]

Espinosa agreed with Kubler's opinions on stylistic origins: "It cannot be stated too often that there is little originality in New Mexican *santos*, for their every reflection, technical and artistic, issues from some facet of European or Mexican religious art."[15]

The greatest scholar on Spanish colonial arts in New Mexico, the late E. Boyd, in her fine review article "The Literature of the Santos," sounded a sensible word of warning about confusing ethnic identity and artistic tradition, but in so doing managed to dismiss the question of whether ethnic identity had any significance in the development of the *santeros*' art:

Since the coming of the earlier [Anglo] explorers confusion has persisted as to the identity of the *santeros*, who were carelessly described as Mexican or Indian, and their works as Spanish, Mexican, or Indian. ... The attribution of this art to Indians came from the fact that Indians and Spanish did interbreed. The fact that artistic style is not a hereditary characteristic was overlooked. Style is determined by environment; the influence of a Christian culture, not the ritual of the kiva, produced the *santero*, no matter if he was of European or mixed blood.[16]

All of the authors quoted who wrote since this important article was published—and a number of others could be cited—ignored Boyd's warning that style and ethnicity are separate subjects. Nevertheless, Boyd was consistently concerned with the *santeros*' individual or personal identity. Her years of painstaking research through archives, in oral history, and

with collections of *santos* resulted in the identification by name of several *santeros*, for example, Pedro Antonio Fresquís, Molleno, Juan Ramón Velásquez, and José Benito Ortega. Others, whose names were already known—José Aragon and José Raphael Aragon—she identified more precisely, adding significantly to our knowledge of their lives. For Pedro Antonio Fresquís and José Aragon she was able to establish at least partial genealogies.[17] Still others she identified on the basis of individual stylistic characteristics: the Laguna *Santero*, the Santo Niño *Santero*, and so on. Nowhere, in all her writings that I have examined, is there ever a suggestion that the works of *santeros* were other than Spanish in artistic tradition and cultural heritage.

The failure to distinguish among artistic tradition, individual identity, and ethnic identity has led some writers to overgeneralizations and misstatements of fact. Wroth wrote in his lead paragraph: "The late 18th century witnessed the development of an indigenous Hispanic folk art in the isolated mountain villages of northern New Mexico. Local artisans began carving and painting images of saints, known as Santos, to fill a void left by the weakening influence and gradual withdrawal of Spanish ecclesiastical authorities."[18] The evidence, however, indicates that the earliest appearances of *santos* are in the chapel of San Miguel, built to serve the Indian barrio of Santa Fe, where the *reredos* is inscribed 1798, and in two Pueblo mission churches in the Rio Abajo: San José at Laguna and San Estéban at Acoma, dated between 1800 and 1809.[19]

It must constantly be kept in mind that the church's (and indeed, the crown's) priority in the colonization of the Southwest was very clear and never wavered throughout the colonial period: to convert the Indians. Except for the three villas of the colony, Santa Fe, Santa Cruz de la Cañada, and Albuquerque, there were no ecclesiastical authorities assigned to the Hispanic settlements until the third decade of the nineteenth century. Priests were assigned to the Indian missions, where they also, incidentally, served adjacent Spanish settlements that, when they had a

church, were at best *visitas* of the mission (e.g., see Domínguez[20] on the church at Las Trampas and its relationship to the mission at Picurís Pueblo). When, in the mid- and late 1700s, the *genízaro* (Hispanicized Indian) villages of Abiquíu and San Miguel del Vado were separated as *visitas* of the closest Pueblos, they received priests in preference to the adjacent Spanish settlements of Santa Rosa de Lima and Pecos.[21]

Why writers refuse to take into account this very explicit religious effort by the Spanish, and thereby discount the possible effect it had on the Indians, must remain something of a mystery unless and until artistic tradition and ethnic identity—blood and paint—are kept separate. The author of a recent major study of *santos* simply declares, "The statement that the nineteenth-century New Mexican santos were fashioned by Indians has been disproved time and again. . . . Santos do indeed come from a culture vastly different from the European-American tradition, so different that the careless popularizers compulsively see an origin for them in a people without European roots."[22] His thesis, that the artistic tradition was very strongly shaped by local cultural developments in New Mexico, is in import not so very different from mine, but he obviously arrives at it from an opposite direction.

Does it make any difference whether the *santeros* were Indian or Spanish? After all, it might be argued, both the uses to which the art was put and its subject matter are clearly derived from the invading Hispanic culture, and the artistic style is largely traceable to religious art traditions that are European in general and Hispanic in particular. Isn't that what is important? The name of the artisan may be an interesting bit of information pertinent to local history, but, as Mills suggested, the questions "whodunit" and "whoisit" are not primarily the concern of the anthropologist.[23]

Mills notwithstanding, the ethnic identity and cultural affiliation of the *santeros* may yield concrete if circumstantial evidence about, and some insight into, the processes of Spanish-Pueblo acculturation and interaction in the middle and upper Rio Grande Valley. Special attention is given here to the Eastern Pueblos' adoption of Catholicism and to the late eighteenth and early nineteenth centuries, but most of the points made are still applicable today. And the mechanisms of peaceful cultural coexistence are not a trivial subject.

Spanish-Pueblo Acculturation

When the Spanish reconquered northern New Mexico in the 1690s, after the Pueblo Revolt, it was obviously with a very different attitude toward the Pueblos, an attitude that can perhaps be best characterized by the word *respect*. Colonial institutions such as the *encomienda* and *reducciones* systems were abandoned, and many safeguards were instituted to protect the rights of the Pueblos (to their lands, for example) and prevent exploitation by either civil or religious authorities.[24] If there was no well-formulated official colonial policy, there came to be one developed locally by trial and error, growing out of daily interaction between ordinary people of sincere good will on both sides, and occasioned in part by the mutual recognition of interdependence (most conspicuously for defense against the raiding nomadic tribes).

In the beginning, this policy of tolerance and respect must have proceeded warily and gingerly, interrupted intermittently by situations of ill will.[25] It was a policy developed not out of casual or totally informal daily intercourse, but—apparently—out of a grappling between members of the two cultures to establish quasi-formal channels and institutions for interaction. By the end of the eighteenth century, relationships between Hispanos and Pueblos, though they lacked formal codification, approached the status of institutionalized patterns that regulated the means and methods, the times and places, for interactions between these two groups. One example of a systematic pattern, recorded in eighteenth-century church archives, is the Spanish custom of *compadrazgo,* wherein Hispano godparents were sought for Indian

children, thus establishing a fictive kin relationship that produced a set of privileges and obligations, not only of a religious nature but also—and maybe more important—of a social and economic nature. There appear to be no official directives, and the records themselves do not say who sought *compadres*—presumably the priest would have been most concerned. Quite likely, people involved on both sides of the relationship perceived it as not only a way to establish a connection between families but, more significantly, a way to regulate that connection. Pottery production provides a less formal example of a systematized channel of social and economic communication: the evidence strongly indicates that the Spanish settlers relied on Pueblo potters to supply the bulk of their domestic needs well into the nineteenth century, and Snow suggests that the pottery trade may have been symbolic of ethnicity.[26]

The evolving pattern of religious adjustment between Hispanos and Pueblos becomes evident when one compares the remains of the seventeenth-century missions with those established after the reconquest, most of which still stand in the Eastern pueblos today. First, the postrebellion churches and their attendant *conventos* were appreciably reduced in scale and grandeur—Pecos provides the most vivid example—because the ecclesiastical colony was not so well supplied and funded as it had been in the 1600s. The Pueblo population had been reduced by disease, warfare, and migration; and the priests could no longer highhandedly commandeer Pueblo labor and resources but had, rather, to "persuade" their converts to contribute. Second, churches were no longer located over or near kivas, as, throughout Hispanic Mesoamerica, churches had been built on top of Indian ceremonial structures (Mitla is an excellent visual example), and as had been true of the seventeenth-century ruins at Gran Quivira, San Bernardo at Awatovi, Quarai, Abó, and Pecos.[27] Third, the churches were usually located outside the Pueblo plaza, an area of sacred land in Pueblo religion. At the five pre-Revolt sites mentioned above, the churches were inside or abutting the plazas: as with

the kivas, the Franciscans had attempted to pre-empt sacred space. The present churches at, for example, Picurís, Nambé, Santa Clara, Cochiti, San Felipe, Laguna, and San Ildefonso (perhaps visually the best example, for a wall is still maintained between the plaza and the churchyard), are all located outside the plaza. Those that are inside help prove the "rule." At Taos, where the church was rebuilt on the plaza after the 1847 rebellion, when Hispanos and Pueblos made common cause against the invading Anglos, the remains of the old church, definitely placed outside the plaza, have never been removed by the people of Taos and stand today as a graphic symbol—one is tempted to conjecture—of an adjustment to an earlier invader. Isleta, where the church also faces inward on the plaza, is another exception; but Isleta historically allied itself more closely with the Spanish than any other pueblo, even joining the colonists in the Revolt and reconquest.

Ortiz has presented in *The Tewa World* a beautiful explication of the Pueblo use of space as a symbolic expression of both metaphysics and social relationships.[28] Scully has attempted to demonstrate that Pueblo use of architectural space is also a system of symbolic expressions.[29] Certainly, it can be no accident that when the Pueblos accepted Catholicism they gave it a spatial location that graphically illustrates both the nature of their religious loyalty and their social acceptance of their Spanish fellow parishioners.

In short, during the eighteenth century, settlers and Indians developed a certain amount of interdependence—an exchange of goods, services, and ideas, along and within certain regularized conduits of contact—whose affective quality was respect composed of quasi-formal reserve and warmth. At least at the end of the eighteenth century, they had achieved a certain comfort with each other, by rather carefully guarding the ethnic identity and cultural integrity of each party.

Ethnic identity, in other words, is here presented as a principle and a historical process of cultural adjustment, not an invention of modern politicians and social scientists. Further proof of the Hispano and

Pueblo concern with maintaining separate identities comes from the ways in which they categorized and treated individuals who crossed cultural boundaries. In-marrying Spaniards were permitted in many instances to live in the pueblo, and their children at least were accorded full cultural membership (this was apparently easiest for an in-marrying male among the matrilineal and matrilocal pueblos, but there are also examples among the bilateral Tewa). More commonly, one suspects—but this is difficult to document—mixed couples were allotted or at least permitted to occupy lands outside but closely adjacent to the pueblo. This process may account for some of the so-called encroachments on Pueblo land grants. In turn, Pueblo individuals who had become too Hispanicized, either through marriage, voluntary acculturation, or the Spanish servant system, were cast into or removed themselves into Hispano villages or settlements created for the class of people called *genízaros*.[30] Church and census records are replete with a variety of ethnic terms whose exact meaning seems to have varied with the recorder but whose use has usually been interpreted as a piece of Spanish conceptual culture: the proclivity to base class on caste. I contend that the Pueblos, by either invention or adoption, used a similar system, in action if not in words, to separate "own" from "other."

Spicer (1954 and 1962)[31] has characterized the process of Rio Grande Pueblo acculturation to the Spanish as one of "compartmentalization": the selective acceptance of traits and trait complexes that, however, remained peripheral to the Eastern Pueblos' major interests, and the rejection of traits that would have altered the main orientations of their culture.[32] Spicer sees this process operating nowhere so clearly as in the sphere of religion:

[F]or over three hundred years they maintained churches in their villages and listened to and were baptized by official representatives of the Catholic Church. In assimilating the offerings of the latter to their own religion and continuing to accept, and pay for, their services, the Pueblos maintained a

sort of compartmentalization of religions. Keeping their own organization and viewpoint quite separate from that of the Catholic Church, they nevertheless accepted and sharply defined functions of the latter in their lives.[33]

Dozier, a member of Santa Clara Pueblo, adds confirmation and detail:

Pueblo Indians affirm that they are good Catholics and also feel that they are conscientious and zealous practitioners of their own native Pueblo religion. This paradoxical situation apparently presents no conflict to the individual Pueblo Indian. He serves each religious tradition separately and, to his manner of thinking, fully and adequately. For example, Pueblo Indians attend mass and other church services in their pueblo. Many families also conduct Catholic prayers in their homes. They prize pictures of Jesus and Catholic saints, and many of them are owners of Catholic *santos*. However, the reverence paid to Catholic saints and observance of Catholic ritual is separate and distinct from that accorded their own native practices. As further evidence of compartmentalization, it may be pointed out that Catholic prayers are said only in Spanish and holy water is restricted to use at mass or in relation to celebrations honoring Catholic saints.[34]

This compartmentalization is sharply different from the fusion (to use Spicer's term) or syncretism more typical of Mesoamerica.[35] While there are excellent studies of folk Catholicism covering both ideology and sociocultural roles for various Indian communities in Mesoamerica—Bunzel on Chichicastengo and Reina on Chinautla,[36] for example—there is a singular lack of such studies for the Pueblos; Elsie Clews Parsons's work is the only exception.[37] Perhaps it was the expectation of fusion that led Wilder and Espinosa to deny so vehemently any Pueblo involvement in *santero* art. They may not have been aware that the Pueblos, ethnographically quite different from other colonized Indians, added Catholicism to their cultural repertoire via highly distinctive processes.

It would naturally follow from this system of compartmentalization that the Pueblos would care-

fully keep separate the icons of their two religions. It is not that the Pueblos didn't "really" accept the symbols of Catholicism. Indeed, the Pueblos have a better "track record" of maintaining their *santos* than do Hispano villagers; they have been markedly more reluctant to have these objects alienated from their possession into museum and private collections, and they often show extraordinary effort and devotion in preserving and caring for the images. More *santos* can be seen today in Pueblo churches and homes than in Hispano ones, and the Feast Day dances in all of the Rio Grande Pueblos feature careful ritual display of their patron saint, almost always an old *santo*. The Pueblo of San Ildefonso is still making public appeals trying to locate three *bultos* stolen from its church in 1972, when there was a rash of such thefts from the churches and *moradas* of northern New Mexico. To deny Pueblo reverence for Catholic visual imagery is to fly in the face of many longstanding proofs to the contrary; but to expect to find Catholic symbols fused with Pueblo ones is to misunderstand the processes by which the Pueblos accepted the new religion. The Catholic imagery of *santero* art certainly does not rule out Indian creators.

Techniques and Materials in the Religious Arts

Both Spanish and Pueblo cultures decorated their religious chambers with graphic art. This goes without saying for the Spanish Christian tradition. At Awatovi, Coronado State Monument (Kuaua), and Pottery Mound, kiva murals were especially well preserved, first by nature and then by the excavators, and have been well studied and published.[38] A number of other sites where serendipity and science have not collaborated so well offer similar evidence—in Bandelier National Monument, for example.[39] It is important to note that the majority of these Pueblo IV sites—that is, dating from the last couple of centuries preceding the *entrada* of the Spanish into the Southwest—are in the Eastern Pueblo area, in the Rio Grande drainage. The centuries-old Catholic tradition of decorating

churches and using art to communicate religious ideas and inspire religious contemplation must have been something the Pueblos not only immediately understood but also appreciated.

Certain techniques and materials of Pueblo IV kiva paintings should be emphasized: (1) They were overpainted, time and time again, probably because it was ritually necessary to make statements about the nature of a particular ceremony that was cyclically renewed. Thin layers of plaster intervened before each new painted expression;[40] at Kuaua, in Kiva III, eighty-five plaster layers were determined, with most, but not all, having painted layers intervening.[41] (2) The plaster, or ground, for the paintings was a slip of adobe (clayey soil) containing white coloring matter—usually gypsum. The plaster was allowed to dry before paints were applied (the fresco secco technique of mural painting). A mordant or binder was rarely included in the plaster, so the paint was somewhat fugitive. (3) Paint pigments were of natural substances, mostly mineral with some organic vegetal pigments (the latter faded more readily with time and therefore have proved elusive under laboratory analysis).

Smith's report on Awatovi and Kawaika-a[42] contains the fullest analysis of the pigments; all were available locally to the prehistoric Hopi with the possible exception of cinnabar for vermillion (and it is not certain that cinnabar was really present). The raw materials were undoubtedly ground with a *mano* and *metate* (stone mortar and pestle) and mixed with a binding medium of water and/or vegetable oil extracted by chewing a variety of seeds. According to Smith;[43] Hibben reports animal grease used at Pottery Mound.[44] Yucca juice and *piñon* gum may have been employed, since they are known from ethnographic accounts of Pueblo paint preparation techniques, and Smith also reports the use of the white of eagle eggs to achieve a sheen or gloss, as well as yucca "syrup," over the painted surfaces.[45] Colors reported for Awatovi and Kawaika-a are black, white, gray, green, yellow, red, pink, orange, vermillion, brown, purple, and maroon;[46] Kuaua painters seemingly had a more

restricted palette,[47] with variations on primary colors, such as pink, not reported; and Hibben lists an expanded palette for Pottery Mound, with more variations from the primary ones.[48]

The *santos* show a number of close similarities at each point, and also some differences.

1. The custom of overpainting church decorations is frustratingly familiar to museum curators.[49] At San Estéban at Acoma, for example, the *reredos* has been overpainted so many times that the original is no longer recoverable;[50] recently it was again renewed with acrylic paints![51] The need to renew is a practical one—the paints wear off with time—but the occasion of renewal is often some special, sometimes recurrent, celebration such as an anniversary of the church.

2. The ground or priming coat for the paint for *santos* is called *yeso,* also called *jaspé,* a substance whose components have been analyzed by Gettens and Turner as gypsum mixed with water and, as best they could determine, an animal glue for binder.[52] They note that this is precisely the gesso used for centuries by European painters, but it is also that used by the prehistoric Pueblos except for the binding material. Montgomery points out that binders for the materials used in the churches were really necessary only when preservation of the material (whether plaster or wood) and its decorations was a consideration.[53] Franciscans and Pueblos differed in their perceptions of this need; hence the introduction of a binder for gesso by the Spanish. Pigments containing binders were, in fact, only rarely used in Franciscan Awatobi.[54] But *santos* are made of wood, not plaster, and thus the Spanish thought they required a binding and sizing agent—the glue. Whether or not the precontact Pueblos used such an agent in painting on wood is not known; if so, a water-soluble gum-resin would be most likely, since they did not have such ready access to animal products until the Spanish introduction of domestic animals. Colton reports that the Hopi *katsina*-maker used "a layer of kaolin" as an undercoat, with no binder, so it peels off fairly easily although native paints adhere quite well.[55]

3. Paint pigments used by the *santero* were temperas, or dissolved in water; their binding media defied Gettens and Turner's analysis,[56] but the possibilities they suggest are animal glue, egg white, milk, and water-soluble gums. Gilbert Espinosa said: "The New Mexican *santero* worked exclusively with earth and vegetable colors. . . . He learned his vegetable and earth colors no doubt from the Indian. . . . The earth colors, oxides and ocher, were mixed with egg yolk, one part to ten of color and water mixed to thin. This was applied as tempera paint. When dry it was given a coating of egg white to waterproof it."[57] Gettens and Turner question the use of egg yolk.[58]

Of the range of colors there is more to be said. Although Gettens and Turner state that the "palette of the *santero* was not so limited as the Indian palette," they were unaware at the time of the kiva mural finds at Kuaua and Pottery Mound.[59] From the variety of colors listed, and those I have seen, it appears that the muralists commanded as many hues as any of the *santeros,* or more. It is interesting to note that the variety of colors used by the *santeros* seems to have decreased with time: the early *santeros,* such as the Laguna *Santero,* seem to have had a more varied palette than José Raphael Aragón.

Gettens and Turner's analysis of the *santeros'* pigments shows them to be mostly the same as those used by the Pueblo muralists, but with some notable exceptions.[60] The *santeros'* blues were either indigo (most frequent), imported from Mexico, or Prussian blue, probably from Europe via Mexico, except for the blue analyzed from the altar screen of San José at Laguna. This was azurite, the same blue as that found at Awatovi, and, as they point out, this *reredos* is probably earlier than any of their other specimens (which were all small *retablos).* The most common red pigment was vermillion from cinnabar, and this most likely was imported from Mexico, as was the much less frequent cochineal; hematite, the usual red of the Pueblo painter, was found on only one *retablo,* and red lead on another. White was usually that of the background gesso, but Gettens and Turner did find a white lead paint together with the red lead; they considered

these to be imported. However, lead oxide glazes for painting pottery are known from Pueblo IV times and into the historic period, though apparently none was being made as late as the late 1700s;[61] whether the lead paints on pottery and those on the *retablo* are chemically similar is not known. Gettens and Turner also analyzed color chips from the remains of wall paintings behind the wooden *reredos,* which, presumably, were earlier in time; there they found that all of the colors were those known to have been native to the Pueblos, with the addition of indigo. The presence of murals in San Miguel in Santa Fe and the chapel at Las Trampas (newly built when Domínguez saw it in 1776) demonstrates that the practice was common and not confined to Pueblo missions alone. However, when wooden altar screens came into widespread use in the next century, the Spanish seem to have completely abandoned the use of wall murals, although the Pueblos continue it today (e.g., the churches at Taos, Santo Domingo, and Laguna).

The introduction of a binding substance, animal glue, into the whitewash seems to have been occasioned by the change from plaster to pine. Exactly why this change in material came about is not known, but perhaps the best possibility is that wood was substituted for the painted animal hides that were apparently very commonly used for church decoration through the first three-quarters of the 1700s. These, along with locally made statues, drew comments of disapproval from the ecclesiastical visitor Domínguez in 1776,[62] and they were roundly condemned and ordered destroyed by de Guevara on his official visit in 1817.[63] José Espinosa has conveniently summarized the reports of animal-skin paintings in three church inventories;[64] their incidence falls from 112 in 1776 to 16 in 1796 and 3 in 1806, a dramatic decline, and the dates correlate nicely with the beginnings of the extensive use of wood panels for detachable ornaments, a practice that appears to have been introduced by the Spanish.[65] While the wooden *reredos* apparently replaced both wall paintings (as at Laguna) and tanned skins above the altar, the painted skins were still used

for altar canopies or dust guards over the altar, as at Laguna and Acoma, and the tradition of painted frescoes on chancel side walls and those of the nave continues in the Pueblos to this day (for example, in San José at Laguna, the reconstructed mission church at Zuni, and the churches at San Felipe and Taos).

There appears to be no technical analysis of pigments from surviving skin paintings. Boyd identifies them as indigo imported from Mexico and "vegetal dyes used by Indians."[66] It seems unlikely that a binder or sizing was considered necessary because the tanned buffalo, elk-, and deerskins would naturally retain the applied pigments. Boyd feels very strongly, as do other authorities, that the Franciscan priests themselves were the artists of most of these paintings: a certain degree of sophistication in composition, and in the rendering of anatomy and use of perspective, argues for some training in drawing.[67] Her arguments are excellent, but there still remain alternative explanations—that the priests passed these drawing skills on to their Indian pupils, and/or that only the paintings done by priests, either because they were more sophisticated or because there was a particular emotional attachment to them, were preserved from the bannings and burnings and reductions to other uses. Certainly, the basic idea of paint on skins wasn't new to the Pueblos (these are the materials of *katsina* masks, shields, and so on). Boyd does attribute a few skin paintings to one of the early native *santeros,* Molleno;[68] these must have represented the end of the skin-painting tradition. Another *santero,* probably the first to whom this term can accurately be applied, the Laguna *Santero,* also painted on skins, if Boyd is correct in identifying the hide altar canopies at both Laguna and Acoma as his work.[69]

It would be nice if there were more evidence from the churches of the 1600s to provide a more graphically complete chronological sequence of decorative materials and techniques from the prehistoric kiva murals to the classic *Santero* period. Most of the pre-rebellion churches were destroyed during the Pueblo Revolt, and those that remained because they

had been abandoned earlier—the ruins at San José de Jémez and the Salinas Pueblos—were too weathered by the time archaeologists got to them to provide other than traces of paint remaining on their interior walls.[70] Only from the remains of the seventeenth-century Spanish buildings at Awatovi is there sufficient information, and there the paint pigments are virtually identical to those of the prehistoric murals from the same site,[71] although there was some variation in the incidence of local materials used for black, blue, and green.

The Eastern Pueblo policy of compartmentalizing religions meant that traditional rites and kivas were kept secret. Consequently, there appear to be no extant records of kiva decorations during the eighteenth century or up until the middle of the nineteenth century, when a few Anglos were permitted in and described paintings.[72] Kiva painting is known to continue today.

Style

Most of the scholarly energy devoted to the study of the *santos* has been concerned with questions of style and artistic tradition, and its results have been to place this art firmly in the Hispanic Christian tradition as far as subject matter is concerned. In the 1950s, Boyd published a series of short papers[73] tracing representation after representation to Spanish and Mexican prototypes, and this research is nicely summarized in her final major work, complete with excellent photographs that clearly demonstrate indisputable similarities and continuities.[74]

Various theories have been offered to account for the development of the *santeros'* style, that is, to explain the ways in which their works differ from the obvious prototypes. For, as Kubler remarks, "The Santos of New Mexico are unmistakable; no one who has looked at them attentively will confuse them with any other rural Latin American or European expression."[75] Most of these theories (although they may have been reached independently) are variations on

the one advanced by Kubler: that the survival of earlier forms combined with processes of simplification and reduction that were due to a lack of academic sophistication and artistic training on the part of the *santeros* produced a return to earlier stages in the history of Christian art—Byzantine and medieval. "New Mexico after 1750 and until about 1900 was not only the end of the geographic line but it was also the last recipient of the accumulated traditions of Christian imagery. Such a terminal position in space and in time deserves our close attention, for it seems to mark the end of a world of religious expression that opened with the Middle Ages more than a thousand years ago."[76] Such a theory smacks of the old "ontogeny recapitulates phylogeny" and even age-area theory arguments.

One might wish that art historians would devote a little attention to studying the stylistic similarities—or demonstrating the dissimilarities—between Pueblo kiva paintings and religious sculptures and those of the *santeros*. For, when subject matter is discounted, there are certain similarities, especially in painting: representationalism but with a pictographic rather than pictorial quality, conventionalization and stylization rather than realism and naturalism, preference for frontal views (at Kuaua), lack of attention to both hands and feet,[77] the outlining of figures with a dark line or contrasting color, the lack of landscape or situational context for the figures but the associated presence of symbols (or attributes) requisite to convey meaning in a spiritual context, lack of shading of figures, attention to costuming, and two-dimensionality, with figures and motifs on one plane.[78] The failure to use perspective (or the *santeros'* fumbling attempts at it) has bothered virtually every writer on the *santos*. The perceived necessity to explain two-dimensionality comes from assuming European prototypes, where, of course, perspective had been used in painting for several centuries. Steele has built a fascinating psychological theory, which he calls "Santo Space," out of this problem,[79] and it is apparently the single most important feature that causes art historians to see the

santos as reversions to pre-Renaissance representations and style.

It is very possible that these similarities in style between Pueblo and *santero* religious representations are so general as to have no explanatory value in this specific context—or it may be that the similarities are purely coincidental. It would be useful, however, to have a comparative study of style, disregarding subject matter, instead of out-of-hand dismissals of the possibility of resemblances and connections to Pueblo murals. It might be that the *santos* aren't such "an extraordinary anachronism—a final, unexpected flowering of medieval Christian imagery, separated from its roots by half a world and a thousand years."[80]

Further Considerations: On the Patronage of Church Decoration

It was expectable, given the scanty and tortuous supply system from Mexico to this New Mexican frontier, that the Spanish colonists would rely on local materials whenever possible. Granted, they could have discovered the sources of pigments for themselves, but since that knowledge already existed it seems logical to suppose that they relied on the Indians to supply the material and also, most likely, to prepare it and apply it when a church was being decorated.[81] In fact, Domínguez says so, at Acoma: "The whole area [of the high altar] that I have been describing, up to the top, has arches painted with colored earth, executed by Indians. The same is true of the saints at the sides which follow here."[82]

It is extremely unlikely that all of the artistic embellishments that we know from the eighteenth-century churches, as well as those from the seventeenth century, were the work of the priests.[83] A few, such as Fray Andrés García, were artists; but, as Boyd noted, friars who found time for the arts were "remarked upon, not always favorably, in the reports of Visitors from Provincial Headquarters."[84] Domínguez is particularly acerbic about them when the products do not measure up to his standards:

"Father García made the image [of Our Lady of the Rosary] and perhaps for the shame of her being so badly made they left the varnish on her face very red."[85] García made other images, too, both *bultos* and *retablos,* using tempera paints and gesso, and Domínguez didn't like any of them.[86] Nevertheless, it seems very likely that Fray García's artistic efforts were a major source of inspiration to the developing local *santeros.* By and large, however, the priests had too many other duties to spend so much time on the actual work themselves, although they probably supervised it carefully. And probably, most of the workers they supervised were Indians. It was a major tenet in Franciscan missionary policy, known and documented well from the New World beginnings of the efforts in Mexico,[87] to train the Indians as artisans, in the "mechanical arts" and the trades. The priests would accordingly have been far more intent on sharing their artistic knowledge with their Indian converts than with Spanish settlers.

Boyd and others have repeatedly pointed out that the religious paintings in the mission churches (and it must be re-emphasized that the vast majority of the churches in eighteenth-century New Mexico were in Indian pueblos, not in Hispano settlements) were meant to serve instructional purposes (i.e., were religious propaganda in the true sense of the word). It is simply illogical to assume that the priests would not have encouraged the Indians—who were anyway their available labor force—to participate in the execution of this religious art. It seems likely that the priests' own work was meant to serve as models for Pueblo apprentices to copy, just as the few imported oil paintings, prints, and engravings did.

Such a situation would not rule out Spanish artists like Captain Bernardo Miera y Pacheco (of whose work, incidentally, Domínguez[88] also disapproved) and later José Aragón. It was probably more common, however, for the colonists to commission a work to be made as a gift of piety for a church (e.g., Antonio José Ortiz for San Miguel in Santa Fe);[89] unfortunately, the artisans were usually not men-

tioned by name, while the donors were. It may also have been the practice occasionally for the Spanish to import artisans from Mexico for a special job, as was done for the carving of the famous stone *reredos* for the military chapel of Our Lady of Light in Santa Fe around 1760.[90] Possibly local citizens, Pueblo, *genízaro,* or Hispano, worked as helpers to such artisans and thus gained some basic skills.

New Mexico had been a Custody of the Franciscan Order from the beginning of colonization. Although it had been attached to the Diocese of Durango since 1729, the power struggles between the expanding secular ecclesiastical structure in Mexico and the Orders did not officially affect New Mexico until 1797, when the villa churches at Santa Fe, Santa Cruz, Albuquerque, and El Paso were secularized.[91] Domínguez reported 22 friars when he visited in 1770; treasury records show some 30 in 1788; Pino, in his famous report to the Spanish Cortes in 1812, stated that there were 22 Franciscan friars and 2 secular priests; and when Don Juan Bautista Ladrón del Niño de Guevara visited between 1817 and 1820, he reported 23 friars, 4 secular priests, and an assistant.[92] Contrary to oft-repeated statements that priests were withdrawn from the area in the late eighteenth and early nineteenth centuries (see Wroth, quoted above), the numbers then actually held quite steady and even increased slightly. What did happen was that as the Franciscans grew too old or infirm to serve they were replaced by secular priests, and the Hispano population over the turn of the century was growing and expanding its settlements.[93] Deprived of the crown subsidy that had supported the Franciscan missionaries, and confronted with an increasing number of people to serve, the priests must have been stretched very thin indeed, and the decoration of churches came more under the control of the people, whether Hispano or Pueblo, with less guidance by the priests.

Also, there were now more churches to decorate. Very few churches were built in Spanish settlements before 1800; most were constructed after that date (e.g., two of the most famous, San Francisco at Ran-chos de Taos and the Santuario at El Potrero, Chimayo), as the number of settlements increased and the dominance of the Pueblo missions gradually receded in the second quarter of the nineteenth century.

It is this niche that the native *santeros* filled. Assuming, as has been suggested, that the Franciscans trained a few Indians in the execution of Christian art works, their expressions would tend to become more distinctive as they adapted to the new medium, wood, and as priestly surveillance and guidance were relaxed because of the economic and political events in the 1790s. This is the time when the first *reredos* appear, made by what most authorities consider to have been local, Hispanic *santeros.*

The Identity of the Early *Santeros*

The earliest native *santeros* who produced major, stylistically distinctive surviving work appear to be the Laguna *Santero,* Pedro Antonio Fresquís, and Molleno.[94] What do we know about them as people and about their ethnic identities?

Despite Boyd's diligent researches, the Laguna *Santero* remains otherwise nameless. His title derives from the altar screen at San José in Laguna Pueblo, which many consider the finest piece of *santero* art (Fig. 7-1). Close study of this screen permitted Boyd (and others) to identify the other major pieces of his work already mentioned. His primary contribution to the San Miguel altar screen, and also apparently the one at Santa Ana, was architectural framing and the painting of ornaments and decorative devices; the paintings of religious images are either imported canvases done in Mexico or Spain or pictures painted locally by the Spanish settler Bernardo Miera y Pacheco in oils (Fig. 7-2).[95] Apparently, such paintings were lacking at Laguna, thought to be his next work after San Miguel, and so he supplied them. With the exception of the *reredos* in San Miguel, all of his other screens appear in pueblo churches and all in an area surrounding Laguna.

One can only conjecture that the Laguna *Santero*

CHRISTIAN ICONS BETWEEN THEORY AND HISTORY

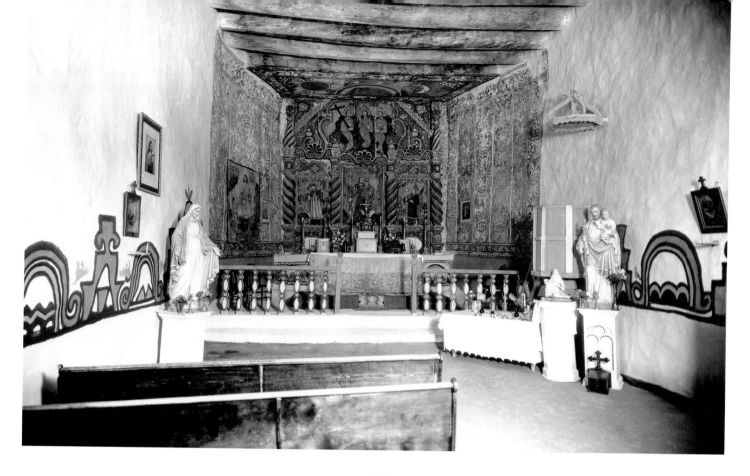

7-1. Laguna *Santero*, altar screen, gesso and water-based paint on wood, plastered side walls, and leather ceiling canopy, San José de la Gracia Mission Church, Laguna Pueblo, dated 1780 or 1800? according to an inscription in plastered area in upper region behind the altar screen: *Se pintó este coral y se yso a costa del alcalde mallor dn José Manuel Aragon este año de 780[?].* [This coral (colateral, an object against the wall) was painted and made at the expense of the Alcalde Mayor Don José Manuel Aragon, this year of (1)780 or 180(?).] Transcription and translation cited from Boyd, *Popular Arts*, p. 157. Photograph T. Harmon Parkhurst, c. 1935. Photo courtesy Museum of New Mexico, neg. no. 4870.

7-2. Laguna *Santero* (?) and anonymous Mexican artists, altar screen, floral elements in gesso and water-based paint on wood, inset with panels in oil on canvas, and polychromed wood statue of San Miguel, before 1709. San Miguel Chapel, Santa Fe. Altar screen commissioned by José Antonio Ortis and dated 1798, according to two painted cartouches (reproduced in Boyd, *Popular Arts*, p. 61, figs. 44 and 45).

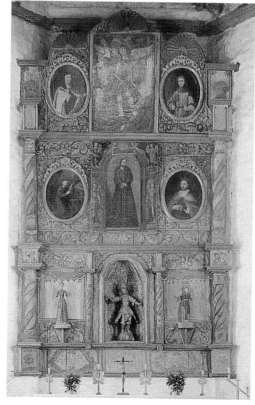

may have been a member of that Pueblo or a member of another tribe adopted into it or into a Spanish family in one of the adjacent plazas. Perhaps he was trained by Franciscan "F," the priest identified by Boyd as the painter of the patron saint of Laguna's church, a skin painting present in the church since the mid-1700s. The name of the donor of the *reredos* is inscribed on the back of it: Don José Manuel Aragon, a Spaniard living at Laguna who was *alcalde* and war captain for Laguna and Acoma and the intervening Spanish settlements between 1792 and 1813 (see note 51, this chapter)—but the name of the painter is not.

Examination of the Books of Baptism of Laguna Pueblo for the years 1720–76 showed that it was not generally customary for the priests to assign any patronyms to the Indians, although in the 1760s there were two priests (Fr. Oronzoro and Fr. Padilla) who attempted phonetic spellings of Indian names.[96] Ethnic identity is not always noted—this varies with the priest—but only *Españoles, genízaro,* and *Collotes* are given last names. These records periodically show baptisms of groups of Indians from other tribes (Hopi, Navajo, Apache, Jumanos);[97] they seem to have been baptized en masse, sometimes with all the girls assigned one Christian name and all the boys another (Maria and Antonio were extremely frequent). Sometimes they were assigned Spanish godparents, a *Padrino* or *Madrina* sponsoring three or four Indians at a time. Under such circumstances, it is very unlikely that a baptismal name meant anything on a societal level or that a personal identity would get preserved. Also it is obviously impossible to trace genealogies. If the early *santeros* were Indians, we should not be surprised if they are anonymous.[98]

Careful research through the Archdiocese records enabled Boyd to establish a partial genealogy of the Fresquís family, all of whom are descendants of a Flemish miner, Jan Friszh, who came to New Mexico with Fray Benavides in 1625, and whose grandchildren escaped the Revolt and returned with Vargas in 1693, settling in Santa Cruz, where Pedro Antonio was born probably three generations later in 1749.[99]

He died in 1831 and is buried in the churchyard of the Santuario in Chimayo. One fact about him that Boyd does not supply is that his ethnic identity is listed in the Spanish census of 1790 as *mestizo,* as is that of his wife, Antonia Micaela Medina, and his occupation as farmer.[100] Of the Fresquís (and Fresquíz) listed in that census from the Santa Cruz jurisdiction, one other is listed as *mestizo* and the remainder as Spanish; one Indian Fresquís appears at Isleta Pueblo—and it is noted that this family was originally from the Pueblo of Senecú.[101] According to Olmsted, the term *mestizo* as used in eighteenth-century New Mexico was generally understood to refer to a person of mixed Spanish and Mexican Indian ancestry.[102] Since the Fresquís family had been long established in New Mexico, the Indian mixture in Pedro Antonio's case may possibly have been local instead of from Mexico. If this is the case, he and his wife would probably have had relatives in the pueblos and thus a close affiliation to activities there. There is a gap in the Fresquís genealogy because the early records of marriage and baptisms are missing from Santa Cruz, so while Pedro Antonio's parents are listed at his baptism, the names of his grandparents are not known. His parents do not appear in the 1790 census, so their ethnic designations, along with those of the grandparents, are not known.

Before Boyd's chance discovery of a document identifying Fresquís,[103] he had been termed the Calligraphic *Santero* after certain stylistic characteristics; it is now recognized that the letters PF, in the form of a brand mark that appears on three of his surviving *retablos,* were, in fact, his monogram (Fig. 7-3).[104] Most of Fresquís' work appears in churches in Hispano villages, but Boyd attributes the early nineteenth-century *reredos* at Nambé Pueblo to him.[105] He is also represented in the "Ten Panels Probably Executed by the Indians of New Mexico" collection of the Hispanic Society of America.

Also represented in the "Ten Panels" is the third *santero,* Molleno, whose identity likewise offers mysteries. Boyd's sleuthing[106] turned up the name on the

back of one of his panels, and "local folksay" gave the name as Molino, Monero, Manilla, or Monillo; before these pieces of information were uncovered, he was referred to as the Chile Painter because red space fillers in many of his panels resembled ripe chile peppers (Fig. 7-4). As Boyd points out, there is no such Spanish patronym as Molleno, but she suggests that there were Spanish citizens and Franciscan priests named Moreno in New Mexico in the eighteenth century, who "might have served as god parents to a boy born 'de padre no conocido'" and might have given him their name.[107] This phrase, while used to indicate an illegitimate birth, was also frequently used by the priests when baptizing Indian captives. But Boyd's statement notwithstanding, the Spanish custom of carrying both the mother's and father's name meant that there was no frantic search for a patronym, and it was in fact not uncommon for people to carry a matronym only, and without disabling social disapproval. In any case, both Boyd's research and that of the present writer have so far failed to uncover any more clues to this *santero*'s identity. Common names, such as Montoya (often spelled Montolla in the eighteenth century), can be omitted on the grounds that they would not have been mistaken for some other sound pattern. Spanish phonetic shifts indicate that either Moreno or Molina (sometimes Molino) are the most likely names.

It is interesting to note that possible variants of the name, as these are recorded in the censuses of 1790, 1823, and 1845,[108] are identified more frequently as Indian than as Spanish, and most show up in the Rio Abajo plazas or pueblos south of Albuquerque (this, however, may be a function of the surviving census records, which are incomplete). Most of the Molina surnames are designated Spanish, although one is *mestizo* and one *genízaro*. The only Moreno who appears in the 1790 census is listed as an Indian (but living in a plaza outside the Pueblo of Isleta); oddly enough his wife, also an Indian, is a Fresquíz!

Most authorities see enough resemblances in style between the Laguna *Santero* and Molleno to suggest

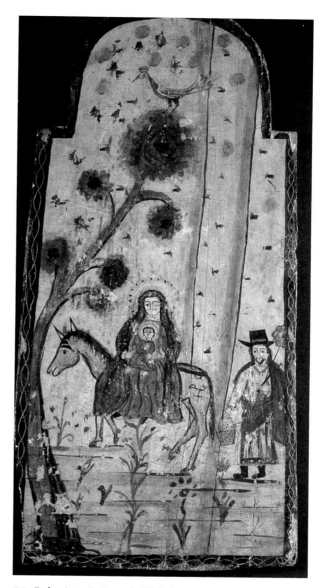

7-3. Pedro Antonio Fresquís, *Flight into Egypt,* gesso and water-based paint on wood panel, late eighteenth–early nineteenth century. Spanish Colonial Arts Society, Santa Fe, formerly collection of Cady Wells, gift of Eleanor Bedell. Photo Jack Parsons. The letters "PF" are inscribed on the hindquarters of the donkey.

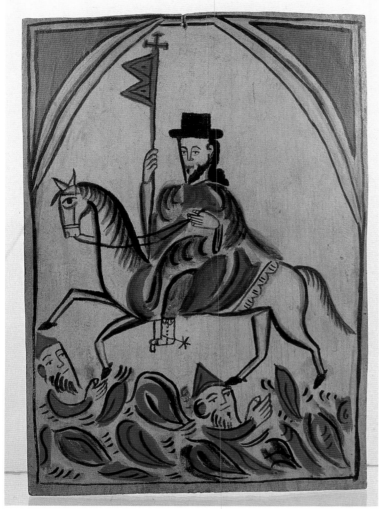

7-4. Molleno, *Saint James the Moorslayer,* gesso and water-based paint on wood panel, early nineteenth century. Collection of the Museum of Spanish Colonial Art, Spanish Colonial Arts Society, Santa Fe, bequest of Norma Fiske Day. Photo Jack Parsons.

chos de Taos appealed for their new church in 1815.[110] Pereyro was at Laguna and Acoma between 1798 and 1803[111] and served at Sandia Pueblo from 1803 to 1807 before being moved north and, as *Custos* (prelate), serving at Santa Clara, Nambé, San Ildefonso, and Pojoaque between 1807 and 1810.[112] Pereyro, as Boyd says, "had a long record of undertaking ornamentation of his various missions and churches."[113] He even transferred church furniture about, according to an entry dated June 15, 1811, in the Sandia Book of Baptism, which noted that books (for recording baptisms and so on) were given to the mission "in exchange for an altar stone which Custos Pereyro gave to Don Antonio Ortiz"[114]—the donor of the aforementioned *reredos* at both San Miguel and Rosario Chapels in Santa Fe. Pereyro's efforts, however, did not please the 1818 ecclesiastical visitor de Guevara, who, for this and other reasons, recommended that Pereyro be sent back to Mexico.[115] We can conjecture that Molleno may have been an apprentice to the Laguna *Santero* when the latter was working on the Laguna, Acoma, or Santa Ana altar screens, and that Pereyro, who was at Laguna and Acoma at the relevant time, knew him and his talents and later summoned him to the north to work in the rash of new chapels being built in Hispano settlements.

Shifting Ethnicities

As *santeros* such as Fresquís and Molleno moved into work in the Hispano villages, perhaps youths there, such as the new immigrant from Spain José Aragón, and José Raphael Aragón, served as their apprentices—and thus the *santero* tradition was passed into *Hispano* hands.

It can probably be assumed—and their works certainly suggest—that Indian youths working so much in the mission churches and so closely with the ideas and imagery of Catholicism achieved a state of Christian devotion such as to please greatly their Franciscan tutors and the Spanish gentry. Such a commitment might have been viewed with displeasure by Pueblo

that the latter may have been a student or apprentice to the former.[109] Molleno's earliest major work seems to have been at Ranchos de Taos, followed by Chimayó, and then various other projects around those two areas. He has been linked with Fray José Benito Pereyro, who was the priest at Taos from July 1810 to May 1818, and for whose services the settlers of Ran-

religious leaders, who could see it as a potentially dangerous break in their religious compartments, and the individual might even be encouraged to leave the pueblo and to affiliate more strongly with Hispanic culture—to become a *genízaro,* in short. If the youth had been in the first place a non-Pueblo Indian—an individual taken in from some of the previously mentioned tribes—this process would have been all the simpler and easier. Incorporation into a Hispanic community presented no particular difficulties, and during the 1800s official ethnic identities changed within a generation, as we know from Swadesh's study of Spanish-Indian relations on the upper Chama River and from the histories of two *genízaro* villages, Abiquiu and San Miguel del Vado.[116] A person with the skills and talents of a saint-maker would probably have been warmly welcomed by the profoundly Catholic Hispanos, and he would easily "disappear ethnically" into their society. Thus would each ethnic group have given to the other through their carefully wrought systems of communication and mutual help, respectfully maintaining their cultural integrity while sharing and shaping an artistic tradition.

Interpretations from Ethnohistory

Like most ethnohistory, this interpretation relies as much on other kinds of cultural data as it does on written records; and it involves quite a lot of supposition and reconstruction. The evidence assembled is not conclusive, one way or the other. Nevertheless, a persuasive argument can be advanced that some of the early *santeros* may have been Indians or Hispanicized Indians. This argument is based on similarities in techniques and materials between *santos* and Indian religious art, on the nature of the Catholic religious enterprise in the area and the Pueblos' mode of acceptance of this new religion, and on what is known about the identity—or the reasons for the obscurity—of the early *santeros.*

Equally important, this examination shows that some of the arguments and assumptions made by previous writers who maintained that the *santeros* couldn't have been Indians rest on equally infirm ground. The question, in short, must remain open.

Religion was the most critical, sensitive, and delicate aspect of Spanish-Pueblo relationships. Spicer has characterized the Pueblos' religious acculturation as compartmentalization.[117] The art of the *santeros* provides an example of a tacit system by which compartment boundaries were both maintained and transcended, resulting in the creation of a distinctive and beautiful artistic expression that is a tribute to the genius of both ethnic groups in learning to live together.

Addendum

When this paper was written in 1976 the revival of Hispanic arts of New Mexico, and particularly the arts of the *santeros,* was just beginning. It has since flourished. In the 1980s I did some research on contemporary women artists and was surprised to find a number of Hispanic women engaged in the production of the religious arts, either by themselves or in conjunction with male partners.[118] This led me to the conjecture that some of the *santeros* of the past may actually have been *santeras.* In the historical records, women's voices are almost as silent as those of Native Americans.

Also since this paper was written, a number of scholars, referenced in Gavin's and Snow's notes (see Chaps. 6 and 13), have made major contributions to the study of *santos* and *santeros.* Perhaps this paper, long available unpublished to these scholars and often cited by them, inspired some of the research on the identity of the early *santeros.* Despite this later research, I remain convinced that my thesis still has validity, and it gives me great pleasure to see the present volume, the first to consider seriously these ideas. My sincere thanks to Claire Farago and Donna Pierce.

THE LIFE OF AN ARTIST:
The Case of Captain Bernardo Miera y Pacheco

DONNA PIERCE

The identity, much less the biography, of most New Mexican *santeros* is unknown. There are two notable exceptions: Captain Bernardo Miera y Pacheco (1714–85) and Rafael Aragón (c. 1795–1862). Since much more is known about the former, I look at his biography as a case study here. Although artists are mentioned in documents as early as the beginning of the 1600s, no extant works of art can be associated with them. Miera y Pacheco is the earliest New Mexican artist identified by name whose surviving works of art can be connected to him.

Born near Burgos, Spain, in 1714, Miera y Pacheco was living in El Paso del Norte, Mexico (present-day Ciudad Juárez), by 1743 and apparently moved to Santa Fe, New Mexico, with the newly appointed governor, Francisco Antonio Marín del Valle, in 1751.[1] He is listed in New Mexico documents of the period as an artist as well as a rancher-farmer, soldier, mathematician, and cartographer. He made numerous official maps of New Mexico and the surrounding area under two governors, and, as official cartographer, he accompanied the Domínguez-Escalante expedition into southern Utah in 1776.

Fray Francisco Atanasio Domínguez, in his account of the expedition and his official visitation record of New Mexico, frequently mentions Miera y Pacheco as an artist—often disparagingly—and credits to him a statue of Saint Phillip in the San Felipe Pueblo church.[2] Other sculptures and paintings have been attributed to Miera y Pacheco on the basis of stylistic comparisons to the Saint Phillip statue and to the paintings and inscriptions included on his maps.[3] The remaining sculptures and columns of a wooden altar screen from Zuni Pueblo church—described as "new" by Domínguez in 1776—have also been attributed to

Miera y Pacheco (Chap. 3, Fig. 3-10).[4] From this list, it is apparent that he was commissioned to create artwork for churches in numerous Indian pueblos. During construction, he probably hired and trained assistants from the local pueblo population.

If not the first to do so, Miera y Pacheco was certainly one of the first immigrant artists to introduce elements of the international baroque style to New Mexico, where he adapted the style to suit local tastes and materials, as is evidenced by his surviving work (Chap. 3, Fig. 3-10). All of his pieces reflect the stocky body proportions, heavy drapery, and dark colors typical of the late seventeenth- and early eighteenth-century baroque style of Spain and Mexico (compare Chap. 6, Figs. 6-6 and 6-8). A distinctive affectation in the human figures carved by Miera y Pacheco is a short, somewhat truncated neck. Some of these figures have their heads inclined back or to the side at awkward angles in what is probably an attempt at intentional foreshortening for viewing from below—a standard technique in the manufacture of statues for inclusion in baroque altar screens. On occasion, the saints painted or carved by Miera y Pacheco gaze heavenward in a distinct manifestation of the pose employed by Spanish baroque sculptors such as Pedro de Mena, popularized in paintings by Bartolomé Murillo, and disseminated throughout the Spanish world by popular imagery and prints.

In New Mexico, Miera y Pacheco's work was altered from that of Mexico and Spain through the adoption of at least one technique from the Pueblo Indians. He learned from the Indians of Zuni of a local mineral (azurite) that could be made into a blue paint.[5] Miera y Pacheco was so taken with the qualities of this paint, now known as Zuni blue, that he advocated its

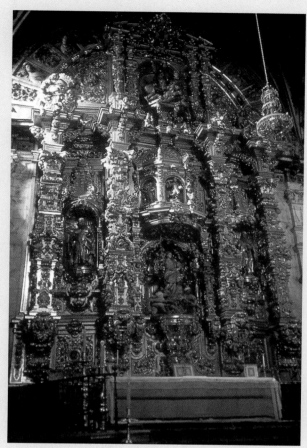

1. José Valdán, altar screen, Chapel of Santa Tecla, Cathedral of Burgos, Burgos, Spain, 1731–35. Photo Donna Pierce.

exportation to Mexico for profit by the government. It is clear from documents that Miera y Pacheco used the Pueblo-style blue paint himself in conjunction with imported oil paints, and the paint has recently been identified through chemical testing on at least one of his pieces.[6] Indeed, later *santeros* often used imported pigments such as cinnabar and indigo alongside paints made from local vegetal and mineral materials similar to those used by the Pueblo Indians.[7]

Miera y Pacheco may have been the first artist to use the late baroque *estípite* column in New Mexico. A large altar screen and matching altar frontal were carved from local stone and painted in bright colors for the main altar of a new military chapel, or *cas-*

trense, in 1761 (Fig. 2).[8] Funded by Governor Marín del Valle and dedicated to Our Lady of Light, the altar screen for the chapel was previously thought to have been executed by Mexican craftsmen brought to New Mexico from Zacatecas, Mexico.[9] Recent research has revealed that it was more likely designed and executed by Miera y Pacheco, who was secretary of the confraternity of Our Lady of Light at the time.[10] A comparison of the Santa Fe Castrense screen to the body of work attributed to Miera y Pacheco reveals strong stylistic similarities. Furthermore, the types of columns, decorative details, and structural elements bear some interesting similarities to two altar screens constructed in Burgos when Miera y Pacheco was living there.

In Burgos during the time of Miera y Pacheco's childhood and early adulthood, two major altar-screen projects were executed—both incorporating the new *estípite* columns with their distinctive profile: wide in

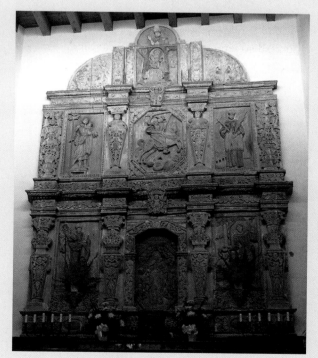

2. Bernardo Miera y Pacheco, altar screen from La Castrense military chapel, 1761, now in the Church of Cristo Rey, Santa Fe. Photo Donna Pierce.

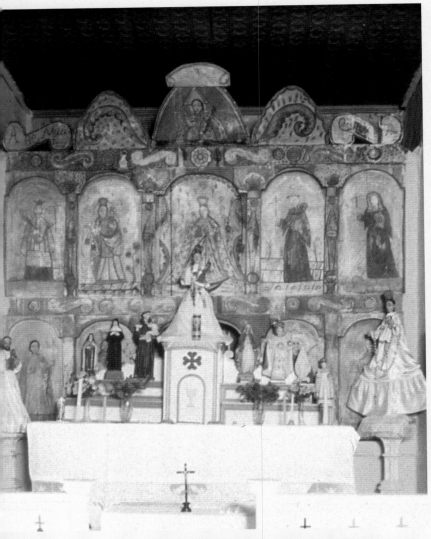

3. **Pedro Antonio Fresquís, altar screen, early nineteenth century, Church of Our Lady of the Rosary, Las Truchas, New Mexico. Photo Blair Clark.**

the middle of the shaft and narrow at the base and capital.[11] When Miera y Pacheco was around eleven years old in 1725, a major altar with four large *estípites* was begun for the main altar of the Jesuit church of La Compañía; the altar for the new chapel of Santa Tecla in the Cathedral of Burgos was initiated in 1731, when he was about seventeen years old, and completed by 1735 (Fig. 1). Both altar screens are similar in structure and design and are attributed to the same architect living in Burgos at the time, José Valdán.

As a teenager and young adult in the Burgos area, Miera y Pacheco was undoubtedly familiar with at least one and probably both of these high-profile commissions. He could conceivably even have apprenticed on the Santa Tecla screen, which was paid for by the Archbishop of Burgos, Don Manuel de Samaniego y Jaca. It was inaugurated with much pomp and circumstance in 1736 by a week-long series of elaborate processions, festivals, and high masses. It has been referred to as "the richest Baroque altar screen of Burgos" and "one of the best of its type in all of Spain."

Both altar screens in Burgos bear some interesting structural similarities to the Castrense screen: three levels and three bays; an arched crown piece with two smaller inset columns; four framing *estípite* columns; flat spaces filled with relief-carved floral motifs. Furthermore, the Santa Tecla screen has a prominent upper central image of Saint James (Santiago) on horseback, as does the Castrense one. The remains of the Zuni altar screen indicate that it also shared these characteristics with the exception of the image of Santiago and with the additional similarity of having large *estípite* columns that spanned both lower levels, as do both screens in Burgos.

To date, it is not known when Miera y Pacheco left Burgos, but presumably it was in the late 1730s, when he was in his early twenties. In Mexico at that time, the most prominent large-scale work of art was the new Altar of the Kings in the Mexico City Cathedral, built between 1718 and 1737—the very piece that introduced the late Baroque *estípite* style to Mexico (Chap. 3, Fig. 3-4).[12] Miera y Pacheco was undoubt-

edly aware of the new Altar of the Kings as he passed through Mexico City between Burgos and El Paso, where he arrived by 1743.

Throughout the 1750s and 1760s, altar screens in the new *estípite* style were being constructed all over central Mexico in imitation of the Altar of the Kings. And like the Altar of the Kings, most of these screens did not have arched crown pieces, but rather pointed ones. Use of the arched attic in New Mexico may reflect Miera y Pacheco's memory of the new screens in his hometown of Burgos. Furthermore, the Castrense altar screen has much more in common structurally with the Burgos examples than the Mexican versions, which tended to be more vertical in emphasis and less restricted by the triple bay and level format.

Although little research has been done to date on the late baroque altar screens of the northern provinces of Mexico such as San Luis Potosí, Zacatecas, and Chihuahua, most extant ones appear to date from the late 1760s and 1770s.[13] Judging from published information, the only other examples to survive that can be securely dated to the 1760s in the north are the altar screens of the Christ of Mapimí in Cuencamé, dated 1765, and those of Santo Domingo church in Zacatecas, dated between 1765 and 1770. As a result, the 1761 Castrense screen is possibly the first *estípite*-style altar screen constructed north of the Valley of Mexico area, and certainly the earliest to survive to the present.

Miera y Pacheco's life serves as an indication of the cultural interaction taking place in colonial New Mexico. Commissioned to make art for Pueblo mission churches, Miera y Pacheco would have lived in the pueblo temporarily during construction and would probably have hired and trained assistants from the pueblo population. From the Indians of Zuni Pueblo, he learned to make azurite blue paint that he prized. During construction of the Castrense and Zuni screens, he introduced the *estípite* style to New Mexico. However, Miera y Pacheco altered the *estípite* column in New Mexico from the carved and gilded

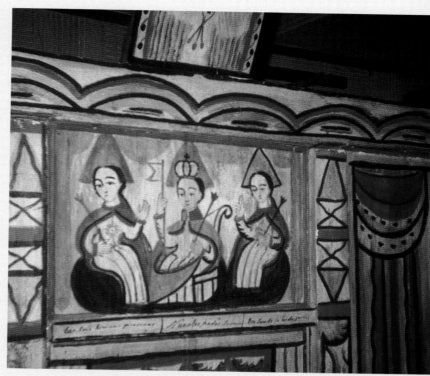

4. Rafael Aragón, detail, altar screen from Durán Chapel, Talpa, New Mexico, early nineteenth century. Taylor Museum, Colorado Springs Fine Arts Center, Colorado Springs.

version of Spain and Mexico to a polychromed wood (Zuni) or stone (Castrense) variation in New Mexico. Although still executed three-dimensionally by Miera y Pacheco, the *estípite* column was altered further by other New Mexican artists, such as Fresquís and Rafael Aragón, to an abstracted, two-dimensional form retaining only the geometric outline of the original in an example of form being chosen over function (Figs. 3 and 4). As a long-lived example of cultural exchange and the appropriation and alteration of outside forms, the New Mexican variation on the *estípite* column was used on altar screens for churches in both Spanish villages and Indian pueblos into the mid-nineteenth century.

DONNA PIERCE

Although painting on leather was a time-honored tradition in Spain, introduced during the Muslim occupation by at least the twelfth century, the production of brain-tanned leather resulting in buckskin or chamois was unknown in Europe. In the American Southwest, the Spaniards assimilated Native American brain-tanned leathers for all manner of uses, including as supports for paintings, and, as this chapter documents, exported them to Mexico. Documentary evidence indicates that Native American artists produced paintings on hide depicting European Christian images during the first decades of the colony, making them the earliest documented form of bicultural art in New Mexico.

During the early colonial period in New Mexico, sculptures and oil paintings were imported in limited numbers from Mexico or Spain for use in churches and homes.[1] The Spanish and Mexican tradition of painting on walls was continued in New Mexico, although little has survived.[2] At least sixty-nine paintings on hide have been collected in New Mexico in the twentieth century.[3] In the literature on the art of New Mexico from the colonial period, scholars have been divided over whether the paintings on hide were executed in New Mexico or made in Mexico and imported to the province.[4]

Although it has been common knowledge for quite some time that tanned hides were a major New Mexican export item, no documentary evidence has yet been cited to prove that hides were painted in New Mexico or that painted hides were exported from New Mexico to Mexico. Documents from the seventeenth and eighteenth centuries, however, are replete with such references.

In New Mexico, some hides were apparently processed locally, particularly elk and deer, while others were acquired in trade from the Plains Indians, who had readier access to herds of American bison and antelope.[5] Hides were dressed by scraping the rawhide and curing it with a mixture of fat and brains from the animal. The hides were then dried, worked for pliability, and smoked for water resistance. The Plains Indians produced a wide variety of hides. They left the

This chapter is partially based on a chapter in an unpublished manuscript on the Segesser paintings prepared for the Palace of the Governors Museum, Santa Fe.

hair on bison hides to be used as winter robes or bedding; others were scraped thin and tanned to the consistency of velvet. The latter, known in Spanish as *gamuzas,* were a type of chamois or buckskin made from the hide of various animals. The *gamuza,* or buckskin, was so highly valued by Native Americans and Spaniards alike that it became a standard unit of trade in the seventeenth century. At the time, a buckskin of average size and quality was worth one peso. In the eighteenth century, Indians and Spaniards both often paid alms to the church in buckskins.[6] For painting hides, the Native American tradition of painting directly onto the hides without a gesso primer was apparently continued, with the result that the paint saturates the hide like a stain, rather than forming a painted surface.

In the colonial period, Spaniards adopted the use of buckskin clothing from the Native American cultures. Even important Spanish officials wore buckskin clothing: Governor Bernardo López de Mendizábal (1659–61) had several pieces of buckskin clothing among his personal effects when he was tried by the Inquisition in 1663, as did Francisco Gómez Robledo, a leading Spanish citizen of Santa Fe, in 1660.[7] According to Fray Alonso de Benavides (1630), the Spaniards also used Indian-tanned hides for "bags, tents, cuirasses, shoes, and everything that is needed."[8] Hides were also used as curtains, door coverings, tablecloths, canopies, carpets, cushions, furniture upholstery, and wall hangings.

In the early decades of the colony, several Spanish governors of New Mexico established extensive export industries based on salable products available in the area: salt, *piñon* nuts, knitted woolen clothing, woven blankets, and tanned hides. Hides were used extensively in the mining operations in northern Mexico and were a profitable commodity.[9] It is likely that not only the governors of New Mexico, but also many citizens entered into this trade with the silver frontier of Mexico. As early as the 1620s, Governor Juan de Eulate (1618–25) was shipping merchandise to New Spain for personal profit.[10] In 1624 and 1626 he sent wagons loaded with trade goods to New Spain; his inventories probably included hides, since the friars accused him of favoring certain Indians "because they bring him hides."[11]

Certainly by the tenure of Governor Luis de Rosas (1637–41), hides had become a major export item, and many of these are identified specifically as "painted" hides.[12] Rosas apparently used his term of office to engage in a full-scale trading operation. According to his enemies, he operated a sweatshop in Santa Fe, where Indians, both Christianized and unconverted captives, were forced to labor for long hours under conditions of virtual servitude, weaving textiles and painting hides for export. Reportedly, Rosas himself could often be found at the workshop "surrounded by Indian painters, with his face and hands so covered with carbon that he could be distinguished from the Indians (only) by his clothing."[13] Since carbon was used to outline the designs to be painted, Rosas may have been something of an artist himself and certainly had a hands-on approach to his business venture. The documents state that he usually had at least thirty Indians painting textiles and hides, several of whom are identified as Mexican Indians.

A shipping invoice from 1638 records the inventory of one of Rosas's trade caravans sent to the mining town of Parral in northern Mexico. Listed on the invoice are 122 painted buffalo hides, 203 plain hides, 50 wall hangings (probably hide), 474 painted blankets, *36 fanegas* of *piñon* nuts, 12 baskets, and miscellaneous articles of clothing and cushions, some made from hides.[14] A few years later, in 1641, the inventory of a dry goods store in Parral lists "two small textiles from New Mexico with the Virgin and Saint Nicholas painted on them," possibly from the Rosas workshop. Also listed in the store inventory is a "buckskin jacket from New Mexico," another trade item exported from New Mexico in quantity (seventy-nine jackets of various types) by Rosas in 1638.[15]

The importance of plain and painted hides in New Mexico as tribute and export items continued through at least the 1660s. Governor López de Men-

dizábal maintained a store in the Palace of the Governors where he sold imported sugar, chocolate, clothing, textiles, hardware, and other goods from Mexico.[16] He also accumulated large quantities of locally produced goods for export to Mexico, including painted hides.[17] On at least three occasions during his term of office, López de Mendizábal sent New Mexican goods to Parral and Sonora for sale. One shipment to Parral in 1660 included 1,350 deerskins, many painted; numerous buffalo skins; and miscellaneous leather clothing, including jackets, shirts, and breeches, among other goods.

Also in 1660, a number of Pueblo Indians presented petitions alleging that López de Mendizábal had failed to pay them for services rendered or goods produced, including washing, tanning, and painting of hides.[18] The pueblos of Jémez and Santa Ana petitioned for payment for washing 500 and 80 hides, respectively. The Indians of Pecos requested payment for making "100 fine hides for painting or writing and seven hide tents." An individual Indian claimed balance due for making 38 doublets, 10 jackets, and 49 pairs of shoes, all of buckskin. In many cases in these documents, the painted hides are referred to as *reposteros,* the Spanish word for large-scale hangings for walls or doors.

López de Mendizábal was arrested in 1661 and sent to Mexico City to stand trial. His personal property, which was confiscated, included a large quantity of hides.[19] When he arrived at the jail of the Holy Office of the Inquisition in Mexico City, his personal effects included various items of personal clothing made of buckskin *(gamuza).*[20] During his trial, López de Mendizábal testified that the Franciscan friars in New Mexico were operating workshops where Indians made goods, including painted hides, for sale in Sonora and Parral.[21] Also during the trial, he defended a painting of Saint Michael he had commissioned: "As a matter of special devotion, he had an Indian paint it and ordered Manuel de Noriega to assist him. As there was no [model to] copy available, and [no guide other than] the idea of the Indian, it was possible that, as the

work of such a hand, and on such material as a piece of leather, the figure could come out rather imperfect."[22] Tribute and trade inventories from the period also list painted hides by the dozens.[23] López de Mendizábal's successor, Diego de Peñalosa, was also eventually tried by the Inquisition. He arrived in Mexico City with a large quantity of New Mexican goods, including hides.[24]

As we have seen, the surviving documents indicate that painted hides were produced in New Mexico in large quantities for export to Mexico. It is safe to assume that painted hides were also used locally, although documentation for such use in the seventeenth century is scant. Although it has always been assumed that painted hides were used in the churches of New Mexico during the seventeenth century, as they were in the eighteenth century, no such documentation exists for the earlier period. To date, the only references to the subject matter depicted on hide or textile paintings in the seventeenth century are the images of the Virgin and Saint Nicholas in the Parral store inventory and the Saint Michael commissioned by López de Mendizábal, already cited. In these cases the subject matter is religious. Presumably secular and purely decorative images were also produced. Fortunately, documentation for use of hide paintings in the eighteenth century is more extensive.

The hide industry came to an abrupt halt in 1680 with the Pueblo Revolt, and none of the extant hide paintings can be documented to predate that event. The traditions of painting and trading hides were apparently revived soon after the reconquest of New Mexico in 1692–93. As early as 1697, three painted hides were listed in an inventory of the church of Santa Ana by Governor Diego de Vargas.[25] Two of these paintings, an altar canopy and a carpet, may have survived the Revolt. However, the third is specifically noted as "another painted hide—new," indicating that the hide-painting industry had already been reactivated in New Mexico.

The tradition of exporting painted hides from New Mexico to other areas of Mexico was also

revived after Spanish resettlement. One of the most successful traders in Santa Fe in the early eighteenth century was the retired soldier and French expatriate Juan de Archibeque, who apparently made trading trips to Sonora and Mexico City, where he exchanged New Mexican products for items to resell in New Mexico. The estate inventory of his goods after his death in 1720 lists "eleven painted deerskins."[26] The painted skins along with other New Mexican-produced goods, including wool stockings, unpainted hides, and buckskin jackets, were in the possession of Archibeque's 24-year-old son, Miguel, who was on his way to Sonora to sell the goods at the time of his father's death.

During the eighteenth century, hide paintings represent a point of significant interaction between the diverse ethnic groups in New Mexico and so may be seen as embodying the specific circumstances of this remote community.[27] Wills of hide dealers suggest that the diverse ethnic groups of the area worked together to exploit this valuable resource. The professional relationship between Hispanic trader and native supplier was, according to the wills, equitable and based on a fee-for-service system. The conversion of the raw goods into products for sale in the South was an economic venture that the entire community could participate in, across ethnic lines.

Although documents indicate that in the seventeenth century most hides were painted by Indian artists, in the eighteenth century *mestizo* and Spanish artists seem to have participated in the production of painted hides as well. The earliest datable paintings on hide are two large wall tapestries depicting battle scenes, known as Segesser I and II. These were shipped to Switzerland from Sonora in 1758 by a Jesuit priest, Father Phillip von Segesser, who noted that they were from New Mexico and "done in the style of that country [New Mexico]"[28] (Figs. 8-1 and 8-2). Fray Angélico Chávez has recently proposed that these paintings, the only ones known to survive with secular subject matter, were produced in the workshop of the Girón de Tejeda family, *mestizo* artists

who had immigrated to New Mexico from central Mexico shortly after resettlement.[29] Father Thomas Steele discovered an inventory from 1715 indicating that another *mestizo* from Mexico, Francisco Xavier Romero, also painted hides.[30] Kelly Donahue-Wallace has located the 1763 will of the hide dealer Manuel García Parijas, which lists among his debtors Fray Andrés García, suggesting that this Spanish friar, known for his *retablos* and *bultos,* may have also painted hides.[31]

Church inventories and private wills made during the colonial era suggest that hides were acceptable vehicles for sacred images for all members of the community until the nineteenth century. When Fray Francisco Atanasio Domínguez made an official visit to New Mexico to inspect the missions in 1776, his inventory described hide paintings hung throughout the naves and sanctuaries of mission and parish churches.[32] According to this and other documents, hides were no more or less prevalent in predominantly Indian churches than they were in Spanish or mixed parishes. For example, in 1776 the parish church in Santa Fe, a multiethnic community with Hispanic, *mestizo,* and native parishioners, had nine hide paintings, and the mission church at the Pueblo of San Ildefonso also had nine, while the Pueblo of Santa Ana had none.[33]

According to estate inventories and wills, painted hides were used in the homes of New Mexican residents of various ethnic backgrounds in the eighteenth century (see also Chap. 6). When Vicente Armijo, a *mestizo* from Santa Fe, died in 1743, he owned two large wall tapestries composed of four hides each.[34] He had apparently commissioned two more from "the Indian Ignacio of Santa Clara," indicating that painted hides were being produced at some of the pueblos. Unfortunately, the subject matter of these hide paintings is not mentioned. The 1762 estate inventory of Juana Luján, a creole woman from the Santa Cruz area, lists "four painted elkhides and three large (paintings of) saints on elkhide."[35] This citation seems to differentiate between the images of saints

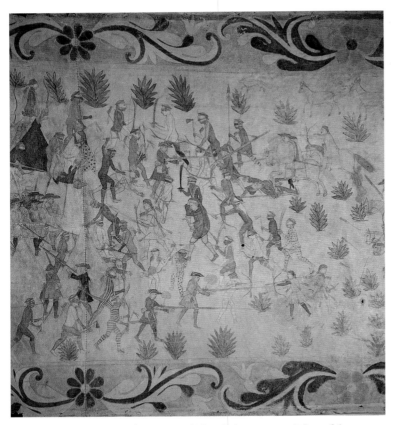

8-1. Detail, Segesser II hide painting, 1720–58, Palace of the Governors, Santa Fe. Photo Blair Clark. Photo courtesy Museum of New Mexico, neg. no. 149804.

Opposite: 8-2. Detail, Segesser I hide painting, 1709–58, Palace of the Governors, Santa Fe. Photo Blair Clark. Photo courtesy Museum of New Mexico, neg. no. 179800.

and the other painted hides, implying that the others were secular in subject matter.

Most hide paintings mentioned in the wills and estate inventories appear to be individual images of saints. In 1734 María Luján of Santa Cruz left hide paintings depicting Saint Peter and Saint Isidore to her heirs.[36] The estate of Pedro Chávez of Atrisco in 1735 included paintings on elkskin of the Crucified Christ and Saint James (Santiago).[37] Juana Galbana, a native of Zia Pueblo, owned an elkskin painting of the Infant Jesus as well as eight other paintings on hide that were

divided among her heirs after her death in 1753.[38]

In 1766 the creole Captain Joseph Baca of San Isidro de Pajarito near Isleta Pueblo left an image of the Holy Christ painted on buckskin to his daughter.[39] Monica Tomasa Martín of Taos owned "four framed paintings [probably on canvas] of Our Lady of Sorrows, Saint John, Our Lady of Bethlehem, and Our Lady of Guadalupe, and eleven fine hide [paintings]" when she died in 1771.[40] As late as 1839, Manuel Sánchez of Santa Fe willed to his heirs "one statue of Christ, twenty-four holy paintings on hide, and one statue of the Infant [Jesus]."[41] Many other religious paintings are listed in wills and estate inventories without identification of their support material; probably some of these were painted on hide.[42]

During his tour of the area in 1776, Domínguez recorded dozens of hide paintings hanging in the churches of New Mexico. Domínguez listed most as "already very old" and others as "almost new," implying that the tradition had continued up to at least that time but was probably in decline.[43] He described them as "paintings of saints on buffalo skins in the local style," indicating they were produced in New Mexico.[44] The only other datable extant hide paintings are the two large altar canopies that survive in situ in the mission churches of Laguna and Acoma Pueblos (Fig. 8-3). The altar screens of these churches were executed around 1800 by an anonymous artist known as the Laguna *Santero*.[45] The canopies are painted with decorative motifs in the same style as the altar screens, indicating they were made at that time.[46]

The turning point for the hide-painting tradition in New Mexico, as well as for other local art forms, was the official visitation of the representative of the Bishop of Durango, Don Juan Bautista de Guevara, in 1817–20. Guevara's instructions contain specific condemnations of paintings on hide and orders for their removal from the churches. For example, at the parish church of Santa Fe, he ordered that "the painting of Saint Barbara on elkskin must be removed and done away with completely as it is improper as an object of veneration and devotion of the altars."[47] Since Gue-

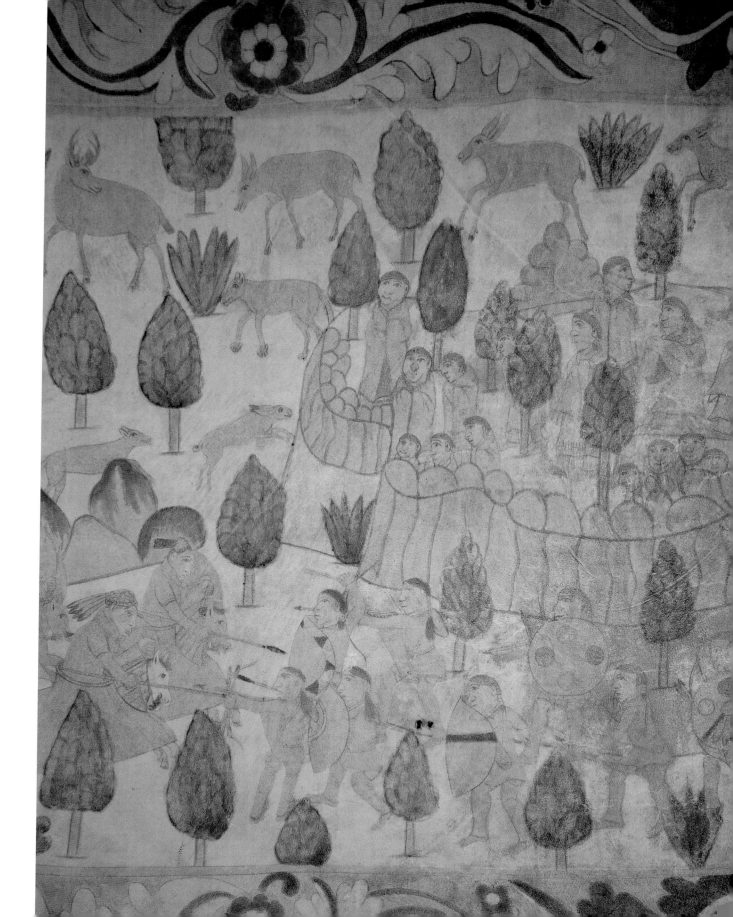

8-3. Altar canopy, Laguna Pueblo Church, c. 1800, repainted. Photo Robin Farwell Gavin.

vara did not explain further, it is unclear whether he objected to hide as an inappropriate support for religious imagery, or to the probably faded or tattered condition of the images by that time, or to what he considered inadequate artistic execution. Indeed, he may have objected not to hide paintings per se, but rather to the older Baroque style in general, an early nineteenth-century distaste influenced by neoclassicism, which resulted in the destruction of much ecclesiastical and civic art in many areas of Europe and the Americas, including New Mexico.

Indeed, later visitations by Mexican ecclesiastical officials from the Diocese of Durango, including those of Fernández de San Vicente (1826) and Bishop José Antonio Zurbiría (1833), echoed Guevara's condemnation of the paintings on hide.[48] In 1851, after the American occupation of New Mexico, French Bishop Jean Baptiste Lamy took over as the head of the Church and appears to have continued the official position of disfavor toward locally produced religious images begun thirty years earlier by his Mexican predecessors. Some of the hide paintings removed from

churches were preserved in Pueblo kivas, Penitente *moradas,* and private homes.

At least one artist of early nineteenth-century New Mexico continued to paint religious images on hide, but they were usually primed with a layer of gesso in the European tradition of oil-on-canvas or local water-based-paints-on-panel paintings *(retablos).* Several large images on hide are attributed to Molleno.[49] Whether he executed these images before or after Guevara's proscriptions is unknown, but they are done in the artist's mature style, indicating the latter. After Molleno, the hide-painting tradition in New Mexico appears to have died out by about 1850.

In a tradition begun at least two hundred years earlier, hide paintings depict Spanish Catholic imagery executed with and on traditional native materials by Indian, *mestizo,* and Spanish artists, reflecting cultural interaction and cross-fertilization of artistic ideas in New Mexico. The next chapter explores one of the ways artistic ideas were transmitted and transformed as local artists chose and altered elements from imported engravings and adapted them to use on hide paintings.

9 | HIDE PAINTINGS, PRINT SOURCES, AND THE EARLY EXPRESSION OF A NEW MEXICAN COLONIAL IDENTITY

KELLY DONAHUE-WALLACE

In this chapter I demonstrate that while individuals and institutions in Europe and colonial Mexico deployed religious woodcuts and engravings in support of their interests, the New Mexican paintings on animal hide based upon these works selected, altered, and departed from their Mexican and European print sources to express a local New Mexican style conflating European, central Mexican, and indigenous formal and iconographic vocabularies.

Prints as Sources

Art historians have long acknowledged the European print's contribution to Latin American viceregal culture. Surveys of colonial art routinely cite the early mendicant chroniclers who praised native imitation of imported woodcuts. Scholars have matched monastic sculptural and fresco programs to European imprints from Albrecht Dürer's woodcut series to illustrations in French Bibles and Italian architectural treatises. Likewise, published research conducted in the past century has related colonial paintings on canvas to imported printed models by European Old Masters. It has, in fact, become almost a requirement of scholarly writing to make reference to Latin American artists' reliance on imported prints.

Such references have reflected the changing critical fortunes of colonial art in general. Scholars seeking to validate Latin American art by establishing its affinity with contemporary European production matched Mexican or Peruvian paintings with Flemish or Italian engravings to demonstrate the colonial artists' stylish modernity. As Santiago Sebastián wrote upon "discovering" the correspondence between a painting by the Mexican artist Simón Pereyns (active 1566–c. 1600) and an engraving after Raphael, "The concrete relationship to a model by an artist as

Portions of this chapter were adapted from the author's "The Print Sources of New Mexican Colonial Hide Paintings," *Anales del Instituto de Investigaciones Estéticas* 68 (1996): 43–73, and from her unpublished manuscript, "An Odyssey of Images: The Flemish, Spanish, and New Spanish Print Sources of New Mexican Colonial Hide Paintings." The author would like to thank Dr. O. J. Rothrock, Dr. John Kessell, and Dr. Donna Pierce for their invaluable assistance.

famous as Raphael is the best argument we possess to demonstrate how saturated Pereyns was in the esthetic of his age."[1] By the same token, critics who saw colonial art as merely derivative of European forms blamed an excessive reliance on print sources. Martin Soria, for example, wrote in his survey of Spanish, Portuguese, and Luso- and Hispanic-American art that "colonial painting usually lacks originality and slavishly follows prints from Antwerp and Rome," though he did concede that local artists contributed their own color.[2] On the other hand, an anachronistic use of print sources has recently come to be valued as one of the unique qualities of viceregal art. This is particularly true in writings on Mexico, for example, where some scholars explain a sustained preference for elegant, elongated figures as a Mannerist aesthetic born of the use of sixteenth-century prints well after tastes in Europe had changed.[3] Similarly, most scholarship notes the role of prints by Peter Paul Rubens in the development of a unique Mexican Baroque style. Thus, depending upon whether the art is understood as properly European, slavishly derivative, or wholly unique, the print has emerged as an accomplice.

The print has a similarly ambivalent role in New Mexican colonial art historiography. Although most scholars explain the anachronism of New Mexico's late-eighteenth- and nineteenth-century *santero* style as the inevitable consequence of an inward-focused arts community, some attribute the look of the earliest work to the artists' print sources. But without investigating the Mexican and European prints that circulated in New Mexico, the authors assume that local painters and sculptors employed only stylized woodcuts and engravings lacking perspectival space or chiaroscuro.[4] For these authors the print sources became an example of New Mexico's cultural isolation, untouched even in this medium by current trends in Europe and Latin America, permitting the artists to eschew individual stylistic explorations in favor of higher, more spiritual ends.[5]

Recent scholarship, however, has begun to displace the print source from its central privileged or vil-

ified role in Latin American colonial art. Carolyn S. Dean's analysis of the contribution of Spanish engravings to a series of Peruvian paintings, for example, presents the paper images as one part of a complex process of artistic creation, stating "If our inquiry goes beyond the identification of European source material . . . and considers how the colonial product engaged its culturally diverse audiences, we soon recognize the colonial artist and patron as profoundly creative rather than merely imitative."[6] Gauvin Bailey has similarly destabilized the relationship between colonial artist and imported print, rejecting the possibility that alterations to the engraved model constituted mistakes and exploring the intellectual, artistic, and social contexts within which the European prints operated.[7] In this chapter I likewise realign the connection between prints and painters to privilege the artists' agency. I further offer an expanded discussion of the significance of European and Mexican prints in colonial culture in order to comprehend the relationship of prints and artists, revealing that altering printed information was a more significant act than has previously been imagined.

Prints in Viceregal Mexico

To understand the role of prints as sources of inspiration, it is necessary to consider the prints themselves and the perception of woodcuts and engravings in colonial Mexican culture. Vast numbers of prints circulated in the viceroyalty, some imported from Europe, but most produced in Mexico City and Puebla. The local works included complex engravings executed with refined technique and illusionistically rendered woodcuts, nearly all reflecting the eras' dominant styles. Despite their cheap and ephemeral nature, the prints' multiplicity, mobility, and broad accessibility meant that their imagery loomed large in the popular imagination, being the most intimate and direct contact Mexicans had with sacred and secular images. The presumed control over the press exercised by secular and ecclesiastical officials gave the

works enormous power by appearing to make print-edness itself a guarantee of truth. The Mexican Inquisition, for example, wrote in 1773 that the people "believe to be just and holy all that is printed,"[8] demonstrating that the active printing programs of Church and state led to the widespread perception that prints represented sacred and civic authority. Consequently, institutions and individuals—sometimes including dissidents—commissioned and disseminated prints to serve their interests, from official portraits and saints' likenesses to "statue portraits" produced as parish fundraisers, and even an image of an Indian Virgin Mary associated with a native uprising.[9] Taken as a group, these prints presented a colonial artistic identity that combined European and New World form and iconography. The viceregal court, the Catholic Church, and the urban elite collectively created and disseminated this local style to the Mexican people in single-leaf prints and book illustrations.

The movement of Mexican and imported European printed images to outlying settlements, including New Mexico, has yet to be examined. The few known documents refer primarily to the importation of European prints through Veracruz and take the form of inventories created to aid inquisitorial inspectors; others discuss the supply of woodcuts and engravings to members of religious orders as they embarked upon new missions.[10] Archival references to private distribution of prints are similarly sporadic. Newly discovered documents reveal that individuals paid for large editions of relief and intaglio prints to be sent to relatives, friends, and colleagues throughout the viceroyalty.[11] Mexican and imported European prints also moved through the hands of individuals and merchants, who pasted them into books, packed them in luggage, framed them, and sold them at trade fairs.

Unfortunately, the archival record has yet to reveal information specifically relating to the importation of European and Mexican prints into New Mexico during the colonial era. Most of the single-leaf religious images and many of the illustrated books probably arrived with the goods purchased by pilgrims, settlers, and traders.[12] Official supply caravans sponsored by the crown and, later, the Franciscan order to resupply the distant missions were also a likely source for the woodcuts and engravings.[13] Included in these caravans were the goods sent by the *procurador general* of the Franciscan order to outfit new missionaries and to replenish the liturgical books and painted, sculpted, and printed images needed for their evangelical efforts.

Without specifying exactly how the images arrived, the evidence from inventories of church and domestic collections tells of a great number of woodcuts and engravings circulating in the region. In 1776, Fray Francisco Atanasio Domínguez counted seventy-two prints in thirty-one New Mexican churches. These were of various subjects and sizes and joined sculptures and paintings in the decorative programs of mission and parish churches alike.[14] Later inventories made by *visitadores* from Durango counted even greater numbers of *estampas de papel*.[15] Domínguez also listed hundreds of European and Mexican books at the missions and in the main library at Santo Domingo Pueblo. Many of these bore woodcuts or engravings, either as single images or as full illustrative programs. Illustrated texts appeared as well in private inventories, including the remarkable example of an emblem book by the Spanish author Diego de Saavedra Fajardo in the library of Diego de Vargas.[16] Likewise, woodcuts and engravings appeared in personal art collections. For example, the will of Juana Luján from Santa Cruz de la Cañada described four prints hanging in her home.[17] Her neighbor Gertrudis Martín had ten prints arranged around a domestic shrine, while Antonio Durán de Armijo of Taos listed ten engravings of various saints in his will.[18] Of special interest for the present study are the two inventories made in 1715–16 and 1728 of the possessions of Francisco Xavier Romero. A hide painter and shoemaker from Santa Cruz, Romero owned dozens of prints.[19]

It stands to reason that although the woodcuts and engravings that reached the periphery of the viceroyalty represented a mixture of European and

Mexican works bearing both official and unofficial images and ideas, they nevertheless represented a kind of cultural primer to colonists with limited contact with centers of power. That is, the prints, with their stylistically hybrid images and associated air of secular and sacred authority—and even their multinational provenances—embodied the values and circumstances of colonial Mexican society. The question becomes, therefore, how this cultural primer was received on the periphery, specifically by the artists who painted the animal hides. Certainly studies of New Mexican colonial art, under the mistaken assumption that the imported woodcuts and engravings were rustic and simple, repeatedly claim that locals digested the prints wholesale and copied what they saw.[20] But visual evidence suggests that the Spanish, *mestizo,* and native residents of distant settlements like New Mexico applied these cultural messages from "the center" only when it served their interests to do so. When it came to their art, these colonists selectively applied printed models alongside local imagery and ideas in a balance appropriate to the nature of the context and the commission, as the corpus of New Mexican religious paintings on animal hides demonstrates.

New Mexican Colonial Hide Paintings

As is discussed in Donna Pierce's preceding chapter in this volume, New Mexico's extant religious and secular paintings on animal hides postdate the 1692 reconquest, marking the renewal of Western painting in the restored colony. At the same moment, the Mexican printmaking industry experienced substantial growth, while imported European works continued to cross the Atlantic. Consequently, and especially in light of traditional guild training methods, it is not surprising to find New Mexican colonial painters employing prints as sources of inspiration.

Although little information has emerged regarding shop practices in New Mexico, it has been assumed that prints played a decisive role in the training of young artists. The accepted practice on both

sides of the Atlantic was for apprentices to enter the workshop of guild-examined maestros, where they learned from oral instruction, copying prints and paintings, mixing pigments, preparing canvases, and eventually contributing to lesser portions of the master's work. Since aspiring frontier painters in the eighteenth century probably had few masters with whom to study, it is generally believed that the balance of training in contemporary stylistic principles and content shifted toward the study of prints.[21] This begs the question of how influential print sources—the images traditionally held responsible for the style and content of New Mexican colonial painting—truly were in the hide painters' creative efforts.

It is clear from the extant hides and known documentation that New Mexican artists employed prints for their content and iconography. Since unorthodox sacred art faced removal by episcopal or Inquisition authorities, painters in the Americas, like their contemporaries in Europe, relied upon prints and writings outlining the correct treatment of sacred themes. Among the texts available to New Mexican artists were the published proceedings of the three sixteenth-century religious councils celebrated in Mexico and the decrees of the Council of Trent.[22] These treatises explained the Church's position on art, but since they spoke only in general terms, local hide painters likely looked to prints to ensure dogmatic compliance. In fact, as Church officials removed hide paintings from New Mexican churches in the early nineteenth century, they did so for aesthetic and material reasons, not thematic errors.[23] In other words, the paintings were presumably correct in their content thanks to their print sources. This may be considered confirmation that the New Mexican artists attributed to their prints the same aura of officialdom and thematic authority documented elsewhere in colonial Mexico.

But what stylistic authority did the prints wield? How did New Mexican hide painters appreciate the Baroque forms imported to the region from Europe and central Mexico? It is here that local painters departed in differing degrees from prevailing styles in

the rest of the viceroyalty and Europe. The Wavy Hem Painter (formerly known as Franciscan F) painted long, elegant figures with proportions typical of the persistent Mannerist aesthetic in contemporary Mexican painting. Among his contemporaries, this artist stands out for choosing complicated compositions with multiple figures, and for his interest in rendering figures in space. Works by the Mountain/Tree Painter and the Dashed Sky Painter, on the other hand, are more stylized. The former preferred flattened figures posed in composite three-quarter and frontal views, and the latter negated space by placing his heavily outlined figures before patterns of short lines and abstracted floral decorations. The last-known hide painter, the nineteenth-century *santero* known as Molleno, worked in the abstracted style of contemporary *retablo* painters, employing highly stylized figures and rejecting three-dimensional illusionism.

How much, therefore, could European and Mexican Baroque prints have influenced these artists? Was it simply a matter of one artist comprehending contemporary European and Mexican styles more than the others? I argue that it is unproductive to look at the hide paintings as "rustic improvisations" by artists attempting—most frequently in vain—to copy the style of imported prints.[24] Nor do references to provincial renderings of academic styles seem appropriate. These descriptions assume a standard for art production based on European and urban Mexican values, a standard that most of the artists of New Mexico apparently did not set for themselves. Only the battle scenes in the hide painting known as *Segesser II* and a few paintings by the Wavy Hem Painter reflect the contemporary Mexican and European taste for complex narratives and allegories, idealized naturalism, and elegant figures in agitated drapery.[25] The rest of the surviving hides are characterized by two-dimensionality, earthbound compositions, and iconic clarity. Where, then, is the print source's influence?

Rather than lay blame or question the artists' skills, it is instead more productive to envision a

dynamic relationship between artist and print source, with the former acting not as a copyist mimicking the images sent from abroad, but as a creative individual who approached these imported works selectively, appropriating only that which he felt relevant to his circumstances. In other words, the stylistically hybrid cultural primer was, in turn, hybridized further again and again in this iconographically neutral, though socially potent, area of style. Consequently, the New Mexican hide painters' works incorporated some of the formal qualities received from the study of imported prints and paintings, but added these elements to a cornucopia of local circumstances: the didactic needs of the friars; the native visual traditions of two-dimensionality and symbolic representations; the use of the hide paintings in local churches and domestic shrines; and, perhaps, a certain degree of timidity on the part of the self-taught painters. While we have historically understood the hide paintings and their perceived adherence to print sources as a makeshift solution to a lack of academic art or as a last, futile attempt to re-create European and Mexican forms before New Mexican *santeros* turned inward, it seems that the hides may be understood as an experimental territory in which local artists developed a vernacular tradition incorporating native and Hispanic influences. In this way, the eighteenth-century hide paintings participated in, and perhaps established, the visual language that would characterize the later *santero* style.

The comparison of several hide paintings with their print sources illustrates how New Mexican artists produced works with formal qualities different from those popular in Mexico City, peninsular Spain, or the rest of Europe and reflected a local preference for stylized forms. Even the Wavy Hem Painter, who chose to reproduce many of the formal qualities of the prints he used as sources, made significant alterations to his models. For example, his painting of the *Infant Savior Standing on the Serpent with the Globe* (Fig. 9-1) recreates much of the intrinsic aesthetic experience of the single-leaf engraving by Pieter de Jode II based on

9-1. Wavy Hem Painter, *Infant Savior Standing on the Serpent with the Globe*, eighteenth century, hide painting. Museum of Spanish Colonial Art, collections of the Spanish Colonial Arts Society, Santa Fe. Photo by the author.

a painting by the Flemish Baroque artist Anthony van Dyck (Fig. 9-2). Though the faded condition of the hide obscures much of the painter's intentions, it is clear that the hide painter abstracted the rays of light in the upper left corner into five parallel diagonal stripes alternating red and white. That this was a conscious choice, and not an error arising from inadequate training, is demonstrated by the naturalistic shafts of light in the center of the painting. The meaning of this alteration has yet to be determined, but similar bands of color appeared in later *retablos* and hide paintings by the Laguna *Santero,* Molleno, the Arroyo Hondo Painter, and Rafael Aragón and were used to close off the upper portion of their compositions. This may indicate that the Wavy Hem Painter was responding to, or even establishing, a convention for New Mexican painting. At the very least, it demonstrates a willingness to ignore the authority of the imported print in favor of more local concerns.

What seems to be a preference for limiting the three-dimensionality of European and Mexican models appears again in the work of the Wavy Hem

Painter in the hide entitled *Christ Washing the Feet of the Disciples* (Fig. 9-3).[26] The engraving that inspired the hide painter and his patron came from Antwerp and was the result of collaboration between the Italian artist Bernardo Passeri and the Flemish printmaker Jan Wiericx (Fig. 9-4).[27] Unlike these two artists, the New Mexican hide painter had little concern for the ambient space surrounding the figures of this complex narrative and omitted the iconographically insignificant vaults looming above the figures in the print. He likewise reduced the distance between the viewer and the holy persons, especially the kneeling Christ. The effect of these alterations is a painting that focuses more directly upon the sacred events, providing an unremitting vision of Christ's humility on a monumental scale; the artist manipulated form to enhance the meaning and experience of his painting.

9-2. Pieter de Jode II, after Anthony van Dyck, *Infant Savior Standing on the Serpent with the Globe,* 1661, engraving. British Museum. Courtesy of the British Museum.

9-3. Wavy Hem Painter, *Christ Washing the Feet of the Disciples,* **eighteenth century, hide painting. Millicent Rogers Museum, Taos, New Mexico. Photograph courtesy of the Center for Southwest Research, Zimmerman Library, University of New Mexico, and the Millicent Rogers Museum.**

He made a similar alteration in the hide known as *Crucifixion with Cup-Bearing Angel* (Fig. 9-5) in the collection of the Spanish Colonial Arts Society, based on an engraving designed by Peter Paul Rubens (Fig. 9-6). The print appeared in various editions of the Missale Romanum published by the Plantin-Moretus firm of Antwerp in the seventeenth and eighteenth centuries. In this case, the Wavy Hem Painter chose to reduce the size of the angel collecting Christ's blood. His reasons for doing so remain unclear. Perhaps he did not feel Rubens's Eucharistic defense appropriate or sought to present the scene in hieratic scale with Christ as the largest, and most important, figure. While it would be helpful to know the artist's

motives, they are largely irrelevant for the purposes of this study. The central concern here is simply that the hide painter did depart from his model, whatever his reasons, presumably to transform the foreign image into one more applicable to his community. Even the authority of an illustration in the Roman Missal did not dissuade the artist from exercising his own creative powers.

A second painting of the same subject (Fig. 9-7), possibly by the Mountain/Tree Painter, further disproves the perceived subservience of hide painters to their print sources.[28] In this case, the crucified Christ is not dead, as he is in the Rubens engraving and the hide by the Wavy Hem Painter. Instead, he is fully

9-4. Jan Wiericx, *Christ Washing the Feet of the Disciples*, 1596, engraving. Jerónimo Nadal from *Evangelicae historiae imagines*. Courtesy of the Getty Center of the History of Art and Humanities Resource Collections.

9-5. Wavy Hem Painter, *Crucifixion with Cup-Bearing Angel*, eighteenth century, hide painting. Museum of International Folk Art, Santa Fe, New Mexico. Photo Blair Clark.

alive and looking down at his mother. As with the previous example, the recovery of the artist's motives is not absolutely necessary, though it likely referred to subtle doctrinal differences between descriptions of Christ's Passion. Instead, we should recognize the painter's use of the print source as a point of reference. Despite the aura of authority surrounding the Flemish print as not only an image from Europe but also an official imprint of the Catholic Church, the artist on the periphery of the viceroyalty accepted only that which he found relevant to his circumstances. To put it another way, the hide painter's creativity and inspiration preceded the arrival of the print source, which he incorporated as he saw fit. His departures therefore need not be considered mistakes by a provincial artist attempting to mimic the print, but purposeful acts, whatever his motives.

The hide painters' translation of the foreign images into a New Mexican vernacular by altering iconographically neutral aspects of their sources' compositions is further demonstrated by three additional examples. The first is the hide painting of *Our Lady of Begoña* (Fig. 9-8), representing a miraculous sculpture of the Virgin of the Rosary from Bilbao in the Basque province of Vizcaya. The painting has been matched with reasonable certainty to a 1714 engraving by Spanish printmaker José Antonio Rementería (Fig. 9-9). The hide painter remained true to the iconography of the sacred image, retaining the crowned figures of Virgin and Child, the rosary, the flower-bearing angels, and the inscriptions identifying the advocation. He did not, however, choose to present the Virgin in the setting described by the Spanish printmaker. Instead of the classicizing coffered arch and piers, the hide painter placed the Virgin of Begoña below an arch decorated with meandering vegetal motifs and supported by highly ornate columns with swelling shafts. Likewise he altered the tall silver pedestal, removing the grotesques and permitting the figure to hover directly above the crescent moon and its angel. These changes have the effect of de-emphasizing the Spanishness of the image by stripping it of its tempo-

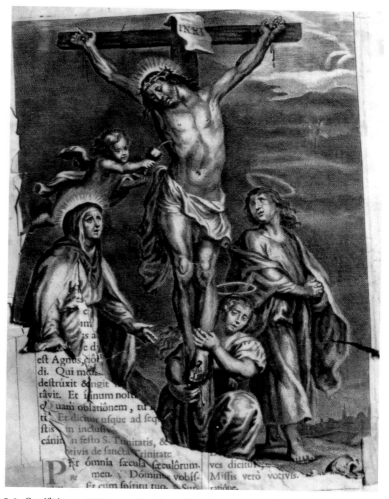

9-6. *Crucifixion*, c. 1687, engraving. From *Missale romanum*, Officina Plantiniana/Moretus, Archdiocese of Santa Fe, New Mexico, on loan to the Museum of International Folk Art, Santa Fe, New Mexico.

ral, geographic specificity. The artist created a setting that did not refer directly to the Basque shrine housing the miraculous sculpture, or to the silver pedestal that held aloft its sculpted figure. Instead, he invented a setting that was more familiar to the New Mexican viewers who knew Mexican Mannerist and Baroque architectural ornament from altar screens, paintings, and prints. In the same way, by removing the pedestal, the painter took away the sculpted image's physical contact with a specific location, thereby

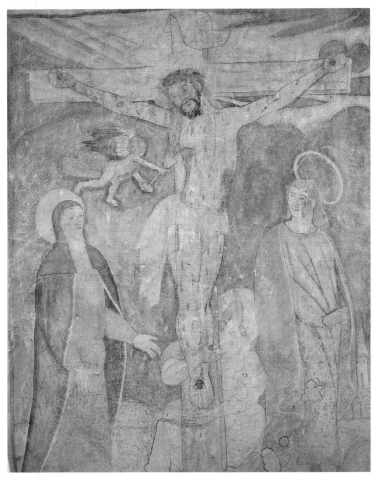

9-7. Mountain/Tree Painter, *Crucifixion with Cup-Bearing Angel,* eighteenth century, hide painting, Museum of Spanish Colonial Art, Santa Fe, New Mexico. Photo by Jack Parsons.

returning the viewer's attention to the miracle of the Virgin's appearance. Furthermore, the hide painter retained the inscription identifying the Virgin of Begoña to ensure proper identification, but omitted the reference to her role as patroness of Bilbao in the loyal *señorío* of Vizcaya.[29] The effect was to confirm the ancestral devotion of his perhaps Basque patron, but to remove the cult from its Spanish context and focus the viewer's experience upon the spiritual event, not the physical result.

The hide painting of *Our Lady of Solitude* (Fig. 9-10) represents a different strategy for adapting the sacred figure's setting to local needs. Instead of merely altering the setting found in the various Spanish and Mexican prints of this Spanish devotion, the anonymous hide painter chose a more radical course that can be clarified by comparing the hide painting with an engraving by Pedro Villafranca Malagón of the Madrid altar of this devotional image (Fig. 9-11). The Spanish engraving is a typical "statue portrait" composition, placing the sculpture on its highly ornate pedestal on an equally ornate altar. Other Spanish and

9-8. Anonymous, *Our Lady of Begoña,* eighteenth century, engraving. Collection of the Archdiocese of Santa Fe, photograph on file at the Museum of International Folk Art (photo Bernard López).

9-9. José Antonio Rementería, *Our Lady of Begoña,* 1717. Biblioteca Nacional, Madrid. Courtesy of the Biblioteca Nacional, Madrid.

9-10. Anonymous, *Our Lady of Solitude,* eighteenth century. Museum of International Folk Art, Santa Fe, New Mexico.

9-11. Pedro Villafranca Malagón, *Our Lady of Solitude,* seventeenth century. Biblioteca Nacional, Madrid. Courtesy of the Biblioteca Nacional, Madrid.

Mexican prints do likewise, with some Mexican images replacing the Spanish altar with the accoutrements of the Mexican shrines in her honor. The New Mexican hide painter, on the other hand, stripped the image of all references to specific sites, including all identifying inscriptions. Instead he presented the Virgin of Solitude with only a mandorla, a nun's habit, and a rosary—enough information to identify the advocation, but without messages referring to a particular setting and therefore perhaps confusing to viewers living elsewhere. The effect was to present this cult image in a manner that allowed parishioners to create a local devotion and to build up

their own altar to her image. In other words, by judiciously pruning information found in the print source, the hide painter presented an image that was wholly applicable to his community and one that, in keeping with the nascent vernacular tradition of direct communication of sacred themes, allowed his viewers undistracted access to the sorrowing Virgin.

The most extreme example of altering a setting found in a print source in order to communicate local ideas is the hide painting of *Our Lady of the Assumption of Santa María de la Redonda* (Fig. 9-12). The reproduction of a print of this cult image, much like the Begoña, may have reflected the desire to express ancestral devotions—in this case Mexican rather than Basque—in a new home. One engraving that closely matches the painting is another typical "statue portrait" by an anonymous Mexican engraver (Fig. 9-13). Instead of subtly changing the architectural elements or removing the sacred image from the context presented in the print, the hide painter fashioned a setting that reflected the hybridized social and cultural context of eighteenth-century New Mexico. The figure in the painting appears beneath an arch with hanging stepped-pyramidal forms. The arch is supported by cantilevered steps that are repeated farther down the jambs.[30] The jambs themselves bear decoration reminiscent of indigenous Pueblo cloud forms and are topped by pots that combine ornamental vocabularies of *talavera poblana* and local Pueblo imagery. The vertical members also bear small S-scrolls common in eighteenth-century late Baroque art, and they are interrupted midway down by balustered columns decorated with vegetal designs. To further alter the scene, the urns of flowers from the Mexican altar have been removed, and two angels holding symbols of the Virgin have been added to the composition. It seems, therefore, that with his invented setting, the hide painter referenced the multiethnic atmosphere of colonial New Mexico. As other authors in the volume demonstrate, this region was not filled with segregated Spanish, *mestizo,* and native communities, but the different cultures instead had multiple points of artistic and social intercourse. In other words,

9-12. Anonymous, *Our Lady of the Assumption of Santa María la Redonda* (damaged), eighteenth century. Museum of International Folk Art, Santa Fe, New Mexico, Fred Harvey Collection of the International Folk Art Foundation.

9-13. Anonymous, *Our Lady of the Assumption of Santa María la Redonda*, c. 1700. Reprinted from *Artes de México*.

this painter employed a type of visual bilingualism to present the advocation not as a Mexican Virgin of the Assumption, but as a Virgin of the Assumption reflecting the New Mexican environment. When it is recalled that hide paintings hung in native mission churches, Spanish parishes, and *mestizo* homes, the hide painter's inventive setting seems wholly appropriate. Obviously New Mexicans thought so as well, since some of the same elements from this hybridized New Mexican vernacular would appear again in later *santero* paintings. The hide painter's relationship to the print source is shown again to be dynamic, not servile, as the artist respected iconographically potent elements while consciously departing from the composition of the foreign print to create a socially potent image.

Images for a Colonial Audience

Many scholars of Latin American viceregal art have turned away from formal discussions of style to questions of cultural history, but important questions remain unaddressed about the ways in which images communicated with their colonial audiences, especially in socially heterogeneous settings. How did the independent styles of colonial societies form? What was the mixture of ideas from the metropolis and from the

colony? What meaning can be ascribed to the contributions of the local population to art produced during a colonial period? As yet, no single paradigm has been found that would answer these questions universally for the arts of colonized peoples. Perhaps no paradigm should be sought. Complicating the matter is the fact that the colonial experience differed around the world and even within a single colonized territory.

The culture of New Mexico that took shape during the first one hundred and fifty years of the colonial era was decisive for the *santeros* who worked in the late-eighteenth, nineteenth, and twentieth centuries and who are the focus of other chapters in this book. The period between the reconquest of 1692–93 and the last quarter of the eighteenth century was a time of cultural experimentation, formation, and self-expression. It was during this time that ideas behind the production of the *santos* coalesced, drawn from a hybrid environment of European, Mexican, and native values. Rather than representing only the imposition of Spanish constructs of reality or the resistance of indigenous forms to cultural annihilation, the *santero* culture that emerged during the eighteenth century represented hybridity, as locals of diverse ethnicities created a variety of forms with which to express themselves and their faith.

Part of the negotiation involved in creating a New Mexican colonial identity between 1693 and 1775 or so involved receiving, reinterpreting, and/or rejecting messages of cultural norms sent out from the colonizing center to the periphery. Through

woodcuts and engravings produced for ecclesiastical and governmental institutions or by the initiative of private citizens, the residents of the northern frontier could appreciate social, political, religious, and artistic standards and practices of the broader colonial society. Understanding the potent associations between prints and sacred and secular authorities makes all the more remarkable the fact that New Mexicans took only what they needed from the prints and even this they adapted and altered. While historians are increasingly permitting colonial artists to step out from behind the prints identified as their sources, knowing the authority attached to those woodcuts and engravings makes the painters' departures from imported models ever more significant. In the cases examined here of eighteenth-century hide paintings of saints and other holy figures produced in New Mexico, the changes consistently involve alteration of the setting. By stripping the source image of its temporal and geographic specificity, artists apparently ensured viewers access to the advocation without the distraction of an unfamiliar setting depicted in an unfamiliar style. Because there is so little surviving documentation, I have consciously refrained from hypothesizing what specific meaning these formal and iconographic changes might have held for their original viewers. Through a close formal description of the visual images themselves, I have emphasized instead the artists' visual bilingualism, which simultaneously reflects and is reflected in the multicultural environment in which these images once circulated.

CLAIRE FARAGO

The most significant documents about the artistic identity of the *santeros* are visual. It has recently been claimed, notably by Marion Oettinger and Marcus Burke, among the first art historians to examine the previously neglected Iberian material, that stunning parallels exist between peninsular popular art and its counterparts in the Spanish Americas—with the significant caveat that "no structural stylistic connections" exist. Given the complexity of parallels and multiple possible sources of imagery, these scholars urge—along with Marianne Stoller, whose 1976 study is finally published as Chapter 7 in this book—a closer analysis of these "stylistic components" in order to understand both their uniqueness and their resemblances, cast in terms of religious syncretism.[1] Burke and Oettinger use the term "syncretism" to describe the polysemy and multivalence of religious symbolism manifest in the formal features of constructed images and the collective practices associated with them. Other terms have recently been proposed to describe more-than-formal survivals. Cecelia Klein refers to the use of Christian iconography for native purposes as "visual bilingualism," and James Lockhart has called the same process "double mistaken identity," where positive associations within an enduring native system of values would have had little relevance to prevailing Christian symbolism.[2] A more serious case against the term "syncretism" stems not from taxonomic considerations, however, but from epistemological ones with broad social consequences. To begin, the distinction between merely formal survivals and substantive ones is not always easy to determine. Since each case is a matter for investigation, shouldn't the terminology take this situation into account? Beyond this (and getting beyond the distinction between merely formal and substantive survival is not easy, as the following discussion elaborates), can the incommensurability of cultural differences be preserved in any descriptive procedure that imposes a frame of reference from the perspective of the dominant culture?[3]

In discussing style, art historians no longer rely blindly on ordering concepts such as "national culture" that have typically treated all forms of cultural produc-

The title of this chapter borrows a phrase from Néstor García Canclini, *Hybrid Culture;* see Chap. 11, note 55.

tion as commensurable (and therefore interchangeable) manifestations of ethnic identity. But where do we go from here? What function does the concept of "style" serve in disciplinary discussions, and for whom? Images are, of course, not transparent codes but complex semiotic systems. The difficulty of distinguishing between meaningful and meaningless aspects of style in hybrid works of art was first articulated in the discipline of art history by George Kubler, in his writing about colonial art. In 1961, Kubler maintained that, owing to the success of religious authorities in extirpating native observances, most survivals of pre-Columbian motifs in Central and South America are merely formal survivals, not thematic ones. Although he granted that significant residues of indigenous culture existed in foodways, objects of utility, economic behavior, and what Kubler called the "superstitious rites of rural proletariat populations," in the area of art, he believed, pre-Columbian survivals and convergences with European traditions functioned independently of symbolic content. Kubler considered most formal survivals to be "extinct beyond recall," the ornamental end products of frequent copying that reinforced the power of the colonial state.[4] Although Kubler's approach to hybrid visual culture is more complex than the following short discussion can suggest—he also described categories of thematic survivals that foreshadow current studies[5]—his insistence that ornamental art is devoid of thematic content has been eclipsed by approaches that focus on the complex processes of indigenous resistance and participation. Across a broad spectrum of art-historical inquiry today, the indigenous contribution to colonial culture is being recovered, partially and provisionally.

In stressing the disjunction of form and content in ornamental art, Kubler also implicated racial issues on a fundamental level that have since largely disappeared from view. This forgotten chapter in the history of art history's engagement with racial theory is worth recuperating, however, because lingering assumptions continue to impose on contemporary theoretical challenges, as the present study emphasizes at many points. To understand the intergenera-

tional history of the pertinent issues Kubler addressed, it is most productive here to proceed in reverse chronological order, from terms of discussion that are still understood and debated in the present, to the questions from which these alternatives evolved, which have often been lost to view. The following brief history of the discipline's engagement with racial thinking takes Kubler back one generation, to his teacher Focillon, and touches upon the source of Focillon's concerns in the writings of Aloïs Riegl, which are still relevant to present discussions of style.

The main inspiration that Kubler acknowledged for his theoretical views was in the writings of the architectural historian Henri Focillon, whose 1934 publication *The Life of Forms in Art* was translated into English by Kubler himself in 1942.[6] Focillon, like Kubler, distanced himself from racial theories of style. A work of art, Focillon writes in *The Life of Forms,* exists only insofar as it is form, and form signifies only itself, despite the temptation to confuse form with image and sign, that is, with representation or with the signification of an object. A distinct echo of the terms of Focillon's discussion is audible in contemporary discussions of style, such as the theoretical work of Whitney Davis discussed below. And Focillon's text in its turn echoes the voice of Alois Riegl, whose *Stilfragen (Problems of Style)* is a groundbreaking study of ornament.[7] The fundamental content of form, writes Focillon echoing Riegl, is a formal one: its meaning is entirely its own, a personal and specific value that must not be confused with the attributes we impose upon it. Form has a mobile life in a changing world, and style is the principle that coordinates and stabilizes the endless metamorphoses of form. What then constitutes a style? Its formal elements, which have a certain index value and make up its repertory, or vocabulary, and its system of relationships, or syntax. And forms, above all in the realm of ornament, evolve according to their own internal logic, originating in "spiritual families of the mind" that "cut across the best defined 'races.'"

Focillon's attempt to extricate himself from racial theories of culture is as clear in this statement as his

lingering debt. He meant the concept of "spiritual families of the mind" as an explicit corrective to racial theories of collective identity: he stated that forms exist in a highly concrete world diversified not in terms of race, environment, or time, but in terms of a "certain kind of spiritual ethnography." Like Riegl, he was highly critical of the application of social Darwinism to art history.[8] But maintaining an evolutionary scheme for the explanation of stylistic change—as Focillon and Riegl both did—implies a theory of cultural evolutionism. The notion of an evolution of style is encapsulated in his phrase "the life of forms."

Kubler praised Focillon's theory that form is situated in the work of art according to "spiritual families of mind" when he insisted that the *tequitqui* style of Mexican architecture incorporated only formal residues of pre-Columbian culture that had an affinity with certain medieval European counterparts like the Plateresque style. Given current efforts to rid the discipline of any racial undertones inherited from nineteenth-century theories of cultural evolutionism, it is important to note that Kubler's argument was sensitive to the issue of race when he insisted that the terms *mestizo* and *mestizaje,* which had been adopted by some of his contemporaries like Alfred Neumeyer, Miguel Léon-Portilla, and others to designate the process of acculturation in the visual realm, were in fact inappropriate because they conflated cultural production with racial content: the transmission of cultural traditions is not a genetic trait.[9] To designate formal survivals, Kubler preferred the terms *criollo,* planiform, folk art, or (for Mexican monuments) *tequitqui,* derived from the Nahuatl word for *tribute,* a formal and linguistic equivalent of the Arabic term *mudéjar.*

But we are still stuck with the same, difficult problem of differentiating among the meaningful, meaningless, and indexical aspects of style. "Style," the English translation of the Latin rhetorical term *elocutio,* is the final stage in composing a speech or text, when the content is embellished with figurative language. In the professional discourse of art history, style has served primarily as an index of the maker. Whitney Davis formulates the following succinct explanation of the interpretive challenge that visual style currently presents.[10] Some, but not all, aspects of style are meaningful as signs and symbols. Those aspects of style that do not have inherent meaning may, or may not, still have indexical status (in the sense that C. S. Peirce developed in the nineteenth century for language). The indexical status of style enabled art historians like Berenson and Beazley to attribute thousands of separate works of early Italian painting and Greek painted pottery to individual masters on the basis of their formal features (Peirce's concept of the indexical sign is discussed in Chap. 2 of the present study.) However—and here is the crux of the problem—what constitutes an aspect of culturally shared meaning and what is not culturally shared are often morphologically indistinguishable in a formal analysis. There is no doubt that situating hybrid objects in their cultural context will be the prevailing approach for some time to come. How will we deal with the historically and culturally defined category of "ornament"? Many cultural historians are avoiding the issue altogether by restricting their analyses to thematic elements—but that method is dangerously circular because it is not easy to distinguish between inherently meaningful and meaningless elements of style, especially when analyzing unfamiliar artistic traditions.

Multitasking Motifs

Suppose, for the sake of argument, that the primary cultural conditioning of some New Mexican *santeros* and their audiences derived from Pueblo lifestyles. Certainly the culturally determined conditions of their perception would have been very different from those of viewers familiar primarily with European representational practices. To an audience attuned to the visual culture of the Pueblo world, for example, the tilted floor in an anonymous *retablo* from the first half of the nineteenth century, depicting Santo Niño de Atocha (Fig. 10-1), might not appear to be a "misunderstanding" of perspective. The image of the seated saint seems to hover above the floor, which loses

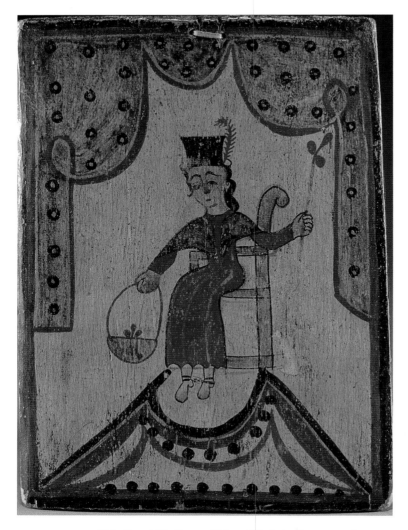

10-1. Santo Niño *Santero, El Santo Niño de Atocha,* gesso and water-based paint on wood. Museum of International Folk Art (A.9.54-70R), Santa Fe, New Mexico. Photo Blair Clark.

10-2. Detail, side chair, late eighteenth–early nineteenth century, pine, probably Cochiti Pueblo, New Mexico. Museum of Spanish Colonial Art, collections of the Spanish Colonial Arts Society, Santa Fe, bequest of Alan and Ann Vedder. Photo Jack Parsons.

Opposite: 10-3. Arroyo Hondo Carver (active c. 1830–50), *Saint Joseph* or *Saint Bonaventure,* gesso and water-based paint on wood. Taylor Museum (TM 1238), Colorado Springs Fine Arts Center, Colorado Springs.

almost all reference to an actual tiled floor. A fore-shortened floor rendered in centralized perspective might be better described from the viewpoint of Pueblo pictorial conventions as an abstract, trapezoidal shape drawn on a planar surface.

Many such "misinterpretations" of European pictorial conventions can be redescribed in neutral terms as the conflation of two different sets of perceptual conditions. But are we in the presence of "visual stratagems for cultural survival"—as the pre-Columbianist Cecelia Klein describes coerced colonial art—or only meaningless vestiges of dispossessed cultural identity, as Kubler claimed for the vast bulk of the same body of material? And if the stylistic survivals and transformations *were* freighted with symbolic significance for their initial beholders, how can we describe these active aspects of reception without resorting to untenable theories of cultural evolutionism or normative standards of artistic excellence?

Shared individual motifs are the easiest to spot, but, viewed in isolation, they offer only extremely circumstantial evidence of cross-cultural contact. Donna Pierce notes that even some of the most distinctive designs have multiple ancestry. For example, the cloud-terrace pattern (Fig. 10-2) on an eighteenth-century chair rail has Islamic as well as Native American

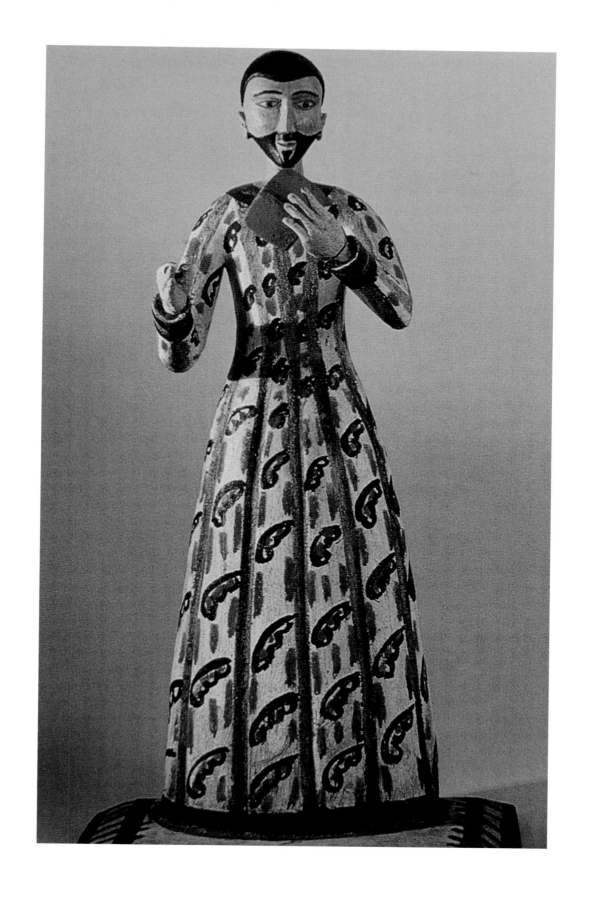

New Mexican *santeros* produced numerous *retablos, bultos,* and hide paintings of Saint Joseph, the humble carpenter, earthly spouse of the Virgin Mary and foster father of Jesus. After centuries of neglect, early modern Spanish theologians actively promoted his cult. In 1555, the first Provincial Mexican Council of the Catholic Church elevated Joseph to the position of patron of New Spain and of the conversion in the New World, a position he held until 1737, when the Virgin of Guadalupe became his co-patroness. Missionary friars presented Saint Joseph as a model convert to Native American neophytes. In New Mexico, as in the rest of the Spanish empire, Joseph always appeared as a young, bearded, and handsome man, following guidelines established by Catholic Reformation writers and Spanish Inquisition censors in the late sixteenth century. This image contrasted with the old graybeard Joseph of the Middle Ages and was intended to characterize him as an effective husband and father. By far the most frequent image represents the young saint standing, his flowered staff in hand, holding the Christ Child in his arms.

The main altar of the mission church of San José at Laguna Pueblo displays a quintessential New Mexican example of Josephine imagery, and numerous imitations of the same pose and iconography survive in the form of small devotional panels intended for domestic settings and community chapels. Joseph's two major attributes—the Christ Child and the flowering staff—identify his important roles as foster father to Jesus and earthly husband to Mary. Saint Joseph's pose is also meaningful in its similarity to images of the Virgin holding the Christ Child, thereby suggesting the strength of Joseph's love for his foster son. Joseph's flowering staff emblematizes his role as the husband of Mary. The symbol first appeared in medieval apocryphal legends, where it signified the choice of Joseph as Mary's husband. Numerous sermons proclaimed that the flowering staff signaled Joseph's status as the chosen spouse. According to Francisco Pacheco, the most widely read seventeenth-century Spanish art theorist, the flowers represented his virginity. Not surprisingly, the church hailed Saint Joseph as the special protector of families, marriage, fathers, and husbands. The *retablo* by the anonymous A. J. *Santero* illustrated here is "localized" in its striking use of pinks, purples, and oranges, its strong graphic patterning, and its variation in the type of flower in Joseph's staff.

—Charlene Villasenor-Black

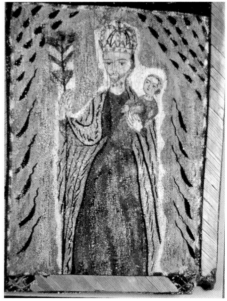

10.a.1. Laguna *Santero, Saint Joseph and Child,* detail, altar screen, c. 1800–1809. Laguna Pueblo Mission Church, Laguna Pueblo.

10.a.2. A. J. *Santero, Saint Joseph and Child,* gesso and water-soluble paint on wood, 1820s (?). Taylor Museum (TM 532), Colorado Springs Fine Arts Center, Colorado Springs.

prototypes.[11] This particular chair can be connected with Cochiti Pueblo on account of its gouge-carving technique, but most New Mexican religious art now in the public domain gives no definite clues to its artistic identity or provenance. In the absence of external documentation there is, however, material evidence to suggest that hybrid artistic traditions developed in colonial New Mexico. For example, rainclouds, associated with the gifts of the ancestral *katsina* among the Hopi and other Pueblo peoples, seem to be inserted into several representations identifiable either as Saint Joseph or Saint Bonaventure (Fig. 10-3). The unusual motif on the saint's robe suggests Hopi stylized depictions of rainclouds (Fig. 10-4). In this connection, it is worth mentioning that, according to the Hopi and other Pueblo peoples, the cloud *katsinas* or Cloud People are the spirits of humans who lived good lives and serve the living after death by bringing rain and life. The *katsinas'* role as guiding spirits who accompany individuals for life in turn suggests general associations with saints as intercessors and, in a Franciscan stronghold like New Mexico, suggests strong associations specifically with the medieval Saint Bonaventure, whose paternal role in the Franciscan Order was considered especially important during and after the Catholic Reformation.[12] As tempting as the associations with Hopi culture are, however, it is equally possible that the "raincloud" motif derives from oriental or orientalizing textile patterns available in the region, as Donna Pierce discusses in Chapter 3. The figure's gestures and attributes allow either "meaning"—or both, perhaps unblended, perhaps not. (See Figs. 10.a.1 and 10.a.2.)

Viewed in isolation, appropriated motifs may be no more than novel representations of familiar subject matter. A Saint Damascus (Fig. 10-5) attributed to the earliest known New Mexican-born *santero,* Pedro Antonio Fresquís (1749–1831), presents a more complex case for the analysis of artistic hybridity. As the only known treatment of the subject in New Mexican art, this saint's image may have been ordered by a patron for specific reasons we cannot reconstruct on

10-4. Drawing based on painted stone slabs with cloud and rain motifs, Walpi Pueblo, Hopi, northeastern Arizona, c. 1300–1600. After Jesse Fewkes, "A Theatrical Performance at Walpi," *Washington Academy of Science, Proceedings 2,* **pl. 65.**

the basis of surviving evidence. There are, however, internal clues about the audience of this image. Like the *bulto* of Saint Joseph/Bonaventure discussed above (Fig. 10-3), this *retablo* incorporates motifs that have multiple cultural origins. It depicts landscape according to a widely used Pueblo convention for drawing mountains that predates European contact (Fig. 10-6)—though this is also a medieval European convention. Likewise the "scallop" motif, like the Pueblo raincloud/orientalizing C-scroll, suggests that what we might call visual homologies encouraged artists to appropriate and reinterpret the pictorial vocabulary of foreign artistic traditions. The entire image is in fact an assemblage of motifs borrowed from different sources, several of which have multiple identities. The stylized tree on the left appears to be derived from a Puebla majolica imitation of Chinese export ware, similar to the example illustrated here (Fig. 10-7) that was available in New Mexico.[13] The slender plant on the right is probably a young cornstalk, a subject that is depicted in several pre-Hispanic kiva murals, though the naturalistic style of representation here suggests knowledge of European sources.

The formal organization of the image is particu-

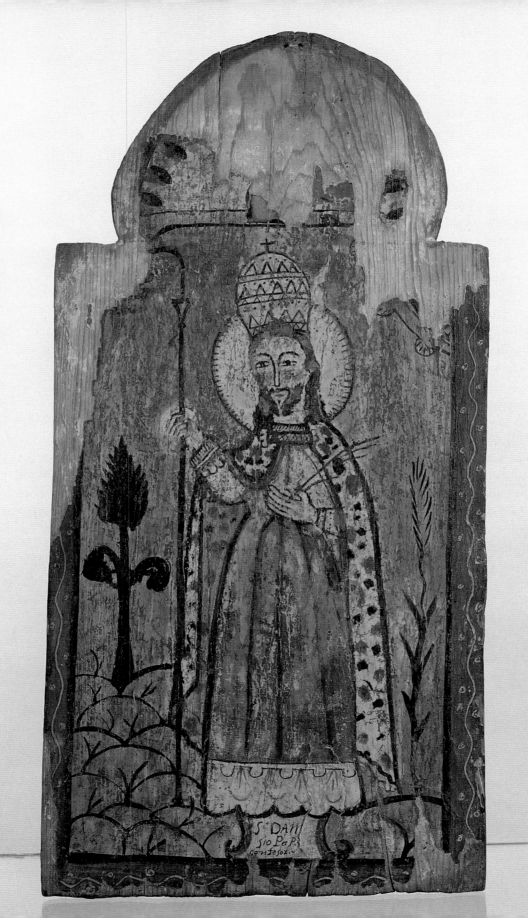

larly open-ended, semiotically speaking. The way in which the artist inserted the figure of Saint Damascus on a pedestal into a landscape setting poses a quandary for the contemporary viewer: does the *retablo* literally depict a *santo* in a shrine, or is this the "real" saint standing in a landscape? It is probable that Fresquís, the artist, depended for the figure on a Mexican "statue portrait" engraving, such as the commemorative prints collected and reissued in Francisco de Florencia's *Origen de los dos célebres santuarios de la Nueva Galicia* (1757), discussed by Kelly Donahue-Wallace in Chapter 9 of this volume.[14] In its transformed setting in the Fresquís *retablo,* however, the saint is no longer associated with a specific shrine. From our present-day remove, it is not possible to decide which reading is "correct." If the former, why have landscape conventions replaced architectural details? If the latter, why did the artist not disguise the sculptural source of his borrowing when he placed the figure into a landscape setting? Perhaps, as Donahue-Wallace suggests, eliminating the reference to a specific shrine provided a way to adapt an existing cult image to a new, local setting—and that's what really mattered to the intended viewers of the image at the time the icon was made.

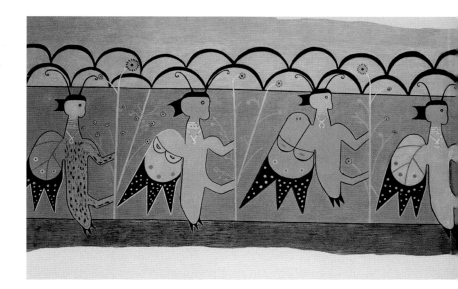

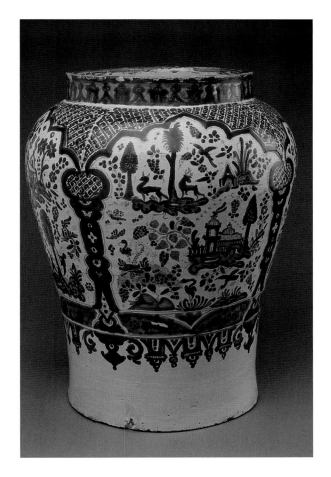

Opposite: 10-5. Pedro Antonio Fresquís, *Saint Damascus, Pope and Confessor,* gesso and water-based paint on wood, late eighteenth–early nineteenth century. Museum of Spanish Colonial Art, collections of the Spanish Colonial Arts Society, Santa Fe. Photo Jack Parsons. Saint identified by inscription on base of statue depicted in the *retablo.*

10-6. Frieze from Pottery Mound, diagram from Hibben, *Kiva Art of the Anasazi at Pottery Mound.* Reproduced with permission of K. C. Publications.

10-7. Puebla, Mexico, vase, earthenware with tin glaze, eighteenth century. Museum of International Folk Art (A.69.45.9), Santa Fe, New Mexico. Photo Blair Clark.

Bricolage Compositions

A *retablo* attributed to Pedro Antonio Fresquís representing Our Lady of Mount Carmel exhibits several motifs in common with a ceremonial bowl from Tesuque Pueblo, c. 1890 (Figs. 10-8, 10-9, 10.b.1, 10.b.2, 10.b.3, and 10.b.4). The Spanish iconography of Our Lady of Mount Carmel represents her as a miraculous image appearing on a holy veil held aloft by cherubs while burning souls appear below.[15] Here she is not accompanied by all of her customary attributes, and the landscape setting is not traditional for this subject. The stylized mountains offer another clear example of a design rooted in both cultures, but it is difficult to imagine that the artist did not borrow directly from Pueblo imagery. The heraldic lion on the ceremonial bowl is of European origin (the lion depicted with its face turned toward the viewer, known as a *leos pardos* in heraldic language, reappears on imported ceramics and an early nineteenth-century New Mexican framed chest)—but as Teresa Gisbert has documented, the cultural ancestry of the visual motif includes Mesoamerican precedents.[16]

Building a composition from available parts in this manner compromises the illusionism of the image, but at the same time it introduces new principles of organization. Who could have been the audience for such obviously aggregate images, lacking formal unity or resolution? The unprecedented aesthetic effect of these images is due to the ways in which motifs and stylistic conventions from different pictorial traditions are combined. Does such pictorial hybridity—and the cases of the Saint Damascus and Our Lady of Mount Carmel could be multiplied a thousandfold—document a new social group in the process of formation? In other words, are we, at our present-day remove, witnessing in these religious instruments of devotion the formation of a new collective cultural entity on the (still warm) ashes of many older ones?

If the hybrid pictorial motifs and conventions of New Mexican art of the colonial era were catalogued, a prominent place would be reserved for landscape

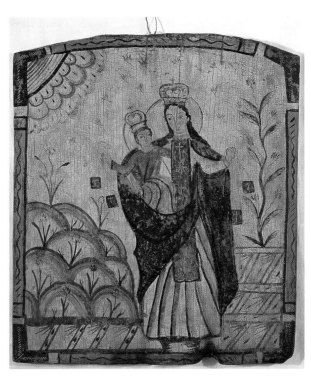

10-8. Pedro Antonio Fresquís, *Our Lady of Mount Carmel,* gesso and water-based paint on wood panel, late eighteenth–early nineteenth century. Collection Alyce and Larry Frank.

10-9. Tesuque Pueblo, pseudo(?)-ceremonial bowl, black-on-white ware, c. 1890. Museum of Indian Arts and Culture/Laboratory of Anthropology, Museum of New Mexico (7958/12), Santa Fe. Photo Blair Clark.

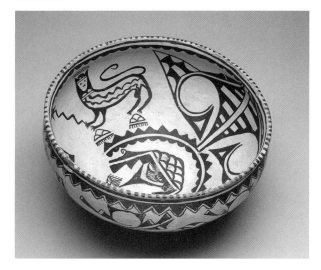

elements that appear frequently on both *santos* and Pueblo pottery of the same period.[17] In addition to individual bicultural motifs, the two objects just discussed—the Our Lady of Mount Carmel and the Tesuque ceremonial bowl—share a similar looseness of movement in the freehand drawing that is entirely absent in European print sources. These stylistic affinities are emphasized by similar patterning devices: the framing scallops, frequently encountered in Rococo ornament, are not found in pre-Hispanic Pueblo pottery; but the wavy lines, diagonal hatching, and thin, banded borders are.

Such formal affinities of iconography and graphology (meaning the handling of drawn lines) can be described more comprehensively in terms of the overall organization of the visual register. In a polychromed water jar with a bird design from Zia Pueblo, for example, the lower band behaves like a ground line so that bird and vegetation seem to coexist in a virtual space as a quasi-optical image (see page 170, Figs. 10.c.1, 10.c.2, 10.c.3, 10.c.4, 10.c.5). But the pictorial organization of the *retablo*—the use of ground line, loosely organized optical space, stylization of the vegetation, scattered figures of various scales arranged in relationship to the principal figure rather than ordered to an optical viewpoint—is also closely related to Pueblo ceramic designs of the same period.

The material culture of New Mexico offers many examples, in various media, of various kinds of artistic hybridity. While the motifs deserve further study on their own terms—many are neither Spanish nor Pueblo—we should also look at the formal organization of the hybrid image as a whole. If the entire pot or *retablo* is considered to be the "visual sign," then it certainly documents a process of mutual cultural exchange.

Fateful Symmetries

To redeploy the structuralist language that Dorothy Washburn developed to describe Pueblo ceramic designs, communities use "distinctive symmetries" to

When artists appropriate motifs from unfamiliar cultural contexts, it is often difficult to assess how they resonate in their new setting, but the presence of visual homologies suggests that the appropriations take on the meaning assigned by the borrowing culture. Yet such assimilations also destabilize the ability of the visual sign to communicate unambiguously with its audience. Heraldic lions of European derivation are carved on the Martín chest, dated 1823. The complex hybridity of New Mexican imagery is exemplified in this motif. A distant variant of the heraldic motif is found on a jar recovered from Old Socorro Mission, El Paso, Texas, which was founded by Franciscan missionaries with Pueblo Indians and other refugees who fled from the 1680 revolt. The crown and elongated body painted on this jar recall depictions of sacred snakes associated with rain on Pueblo vessels predating European contact.

10.b.1. **Ceramic dish with heraldic lion motif, Mexico, late eighteenth century. Museum of International Folk Art (A.55.86.116), Santa Fe, New Mexico. Photo Paul Smutko.**

10.b.3. **Bowl with serpent or *leos pardos* motif (?), unnamed red/brown ware, c. 1692–1750. Old Socorro Mission, El Paso, Texas. Collection Joe and Ofelia Ledesma, El Paso, Texas. Thanks to David Snow for this example.**

10.b.4. **Bandelier black-on-cream bowl, c. 1400–1550. Museum of Indian Arts and Culture/Laboratory of Anthropology, Museum of New Mexico (21604/11), Santa Fe. www.miaclab.org. Photo Blair Clark.**

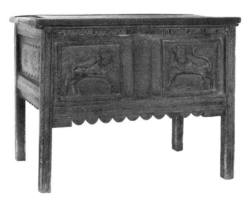

10.b.2. **Framed chest with *leos pardos* motifs, wood, dated 1823. Inscribed in three-inch-high letters carved across top of front panel: *Yo doy serbire a don Manuel Martin en todo ano de 1823* [I serve Don Manuel Martin in all things. Year 1823]. The Harwood Museum of Art, University of New Mexico.**

compose "homogeneously structured designs," so that "the symmetry classes are, in effect, group 'name tags.' Designs with similar symmetries will be indicative of groups which are situated in close proximity and/or are in close contact."[18] A late nineteenth-century Our Lady of Sorrows (Fig. 10-10) attributed to the Arroyo Hondo Carver exhibits this sort of visual affinity with a decorated pot from Gobernador Canyon (Fig. 10-11), especially in the wavy line separating two areas of contrasting color. Beyond shared motifs, patterns, and even quality of line, the *bulto* and the jar from Gobernador Canyon exhibit *structural*

similarities—ways in which the surface is organized, subdivided by banding and framing; ways in which the individual elements are handled, generated, modified, combined, and transformed by operations of mirroring, rotation, inversion, repetition. Because it analyzes figuration at a level of semiotic generality that encompasses both European and Native American pictorial conventions, Washburn's descriptive language can be productively adapted to the present case.

What can be made of connections existing at this formal level of organization between Pueblo pottery and Spanish *santos*? An early to mid-nineteenth-century

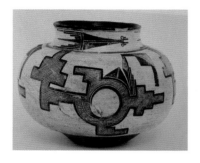

10.c.1. Zuni polychrome *olla* with "Rain Bird" design, c. 1825–40. Taylor Museum (TM 1987.7), Colorado Springs Fine Arts Center, Colorado Springs, Debutante Ball Committee Purchase Fund.

10.c.2. Cochiti polychrome storage jar, c. 1880. Collection Alyce and Larry Frank.

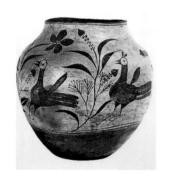

10.c.3. Pueblo vase from Aby Warburg's collection, donated 1902 to Hamburg, Museum für Volkerkunde (B 6098). The shape of this jar and its naturalistic rendering of an animal suggest the pseudo-ceremonial forms produced for the tourist market, such as the jars from Cochiti and Zia Pueblos illustrated here.

10.c.4. Zia polychrome storage jar, c. 1890–1900. Taylor Museum (TM 4376), Colorado Springs Fine Arts Center, Colorado Springs. Frank Applegate Collection, gift of Elizabeth Sage Hare.

When pictorial conventions change, the same content may be carried in altered form, as these examples of Pueblo pottery suggest. They also suggest that continuing resonance of visual symbols is not necessarily due to an individual artist's conscious choice. Harry Mera has studied the abstract geometry of the "Rain Bird" design that occurs in ceramics as early as A.D. 1100. (The Zuni *olla* reproduced here is a modern example, traditional in appearance.) In the nineteenth century, the exclusively geometric abstraction of the Pre-contact period occurs alongside bird designs derived from European sources, such as the Pennsylvania Dutch motifs that may have been introduced into New Mexico after it became a U.S. territory in 1848, when trade with the eastern United States expanded. Possibly, the Pueblo artists who painted Europeanized images of birds on ceramics selected these motifs because of the longstanding significance of "Rain Birds" in their native cultural traditions, even if the choice of decoration was (and still is) partly driven by tourism.

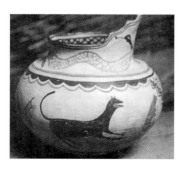

10.c.5. Emma M. Krumrine, *Illuminated Psalm*, inscribed in design "made for M. Schwartz, 1836"; watercolor, colored pencil, and graphite on paper. From *The Index of American Design*, 1939. National Gallery of Art, Washington, D.C. Photo courtesy of the Museum. Thanks to David Snow for this example.

10-10. Arroyo Hondo Carver (active c. 1830–50), *Our Lady of Sorrows,* gesso and water-soluble paint on wood. Museum of International Folk Art (A.78.93-1), Santa Fe, New Mexico. Photo Blair Clark. Although this *bulto* holds a rosary today, she has a hole in her breast where a sword was once placed, identifying her as Our Lady of Sorrows.

10-11. Gobernador polychrome jar, c. 1700–1750. Francis Harlow Collection, Museum of Indian Arts and Culture/Laboratory of Anthropology, Museum of New Mexico (55847/12), Santa Fe. www.miaclab.org. Photo Blair Clark.

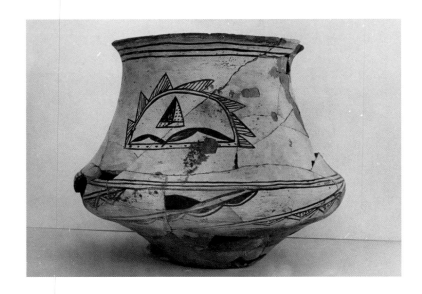

10-12. Sakona polychrome jar, c. 1580–1650. Frances Harlow Collection, Museum of Indian Arts and Culture/Laboratory of Anthropology, Museum of New Mexico (55757/12), Santa Fe. Photo Blair Clark.

10-13. After a Hopi burial vase from Winslow, Arizona. After Fewkes, "Two Summers' Work in Pueblo Ruins," pl. 27.

santo representing Santo Niño de Atocha, patron saint of captive prisoners, shares significant structural features with a Sakona polychrome storage jar from San Ildefonso Pueblo, datable c. 1680, well before any surviving *santos* (Figs. 10-1 and 10-12). If the *retablo* is described as a planar surface embellished with design elements, rather than a visual field organized on optical principles, then the figure of the saint becomes the central, axial element in a vertically oriented rectangle symmetrical around its horizontal and vertical axes. Dark areas frame the light central portion of the panel, creating a repeating pattern of jagged elements (formed by the outline of the draped curtain, to speak in the figurative terms of Western illusionistic painting). The vaguely semicircular core defined by this outline may be compared to the central motif with jagged frame and floating triangle in the illustrated jar from San Ildefonso Pueblo.

In both cases, as in many other *santos* and ceramics that could be cited, the open field around the main figure is treated as a positive shape—in the ceramic design, the relation of the small floating triangle to its immediate framing motif can be characterized in these terms, as can the relationship of this entire motif to its register. Every shape is potentially positive, as is the case with interlocking designs of contrasting color or pattern (M. E. Escher's prints depend heavily on the same device of figure / ground reversibility). The San Ildefonso motif originates in pre-Hispanic times, as is attested by a food bowl from a Hopi burial site near present-day Winslow, Arizona (Fig. 10-13).[19] There are insufficient clues in this geometric design to project an unequivocally optical conception of space onto the surface design. However, other pieces from the early colonial period, like a fourteenth-century bowl from the Mimbres Valley in southern New Mexico (Fig. 10-14), accommodate an optical reading of their pictorial organization very comfortably. But is the spatial construction of this Hopi bowl indebted to European conventions, or can its optical features be explained entirely in relation to Mimbres pottery produced long before first European contact?

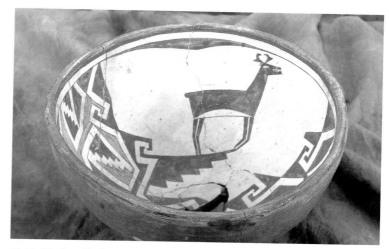

10-14. Mimbres black-on-white bowl, *Antelope in Landscape*, before c. A.D. 1350, 4" x 10" diameter. Grand Junction, Museum of Western Colorado, William Endner collection (G-497). Photo Al Ligrani courtesy of the Museum.

This organization is, moreover, typical of many New Mexican *santos*. A Saint Stephen, attributed to a late nineteenth-century "follower" of the Quill Pen *Santero,* active during the first part of the century, can be described as divided into an upper and a lower register or band, one broad and the other narrow, as can many Pueblo ceramics, including a storage jar of c. 1690 from San Ildefonso Pueblo (see Figs. 10.d.5, 10.d.9, 10.d.10).[20] The bandlike treatment of the shallow stage space or niche in which the saint stands is emphasized by a row of tiny repeating figures, entirely different in scale from the rest of the optical field over which the row seems superimposed. The central, dislocated placement of the saint's pedestal / cloud terrace motif emphasizes the impression that competing systems of pictorial organization are conflated.

A Guardian Angel attributed to the same anonymous *santero* (see pages 174–76, Figs. 10.d.1–10.d.14) exhibits the same cloud terrace motif, parted curtains, frontality of a single image, bilateral symmetry, elaborate framing elements on all sides, strong contrasts of color and patterning, and well-defined horizontal

Yvonne Lange ("In Search of San Acacio," 21) suggests that, since Saint Acacio is practically unknown in Spain and no popular shrine dedicated to him exists in Mexico, it is likely that Germans or Eastern Europeans who settled in Missouri in the nineteenth century introduced the devotion. From Missouri, devotional prints distributed by European firms such as the Benziger Brothers were imported by traders into New Mexico via the Santa Fe Trail. Although the trade route opened in 1821, following Mexican independence, records verifying this mode of transmission do not survive. A note on the reverse of the illustrated *retablo,* acquired by the Taylor Museum in 1963, indicates that it came from the Pueblo of Santa Clara. The depicted drum in the lower left is constructed as a rectangle framed by banding embellished with parallel hatching. The hatching and frame are reminiscent of devices on Pueblo pottery of similar date, and the graphic pattern has precedents predating European contact. The graphic patterns may also derive from the crosshatched or parallel lines that signify shading in European prints of the type, which undoubtedly served as the model for this saint's painted image. Yet the bold graphic lines point to a long-standing tradition of graphic invention native to the cultures of the Southwest, as freehand-drawn examples illustrated here and elsewhere in this volume suggest.

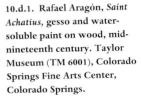

10.d.1. Rafael Aragón, *Saint Achatius,* gesso and water-soluble paint on wood, mid-nineteenth century. Taylor Museum (TM 6001), Colorado Springs Fine Arts Center, Colorado Springs.

10.d.2. Ako Polychrome jar, from Acoma or Zuni Pueblo, c. 1750–1800. Present whereabouts unknown.

10.d.3. a–d. Mesa Verde black-on-white mugs, Anasazi vegetal paint tradition, Mesa Verde province, c. 1200–1300. Museum of New Mexico, Museum of Indian Arts and Culture (8823/II, 19616/II, 19621/II, 19622/II), Santa Fe. www.miaclab.org. Photos Blair Clark.

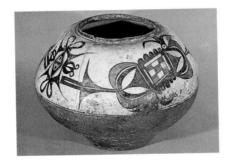

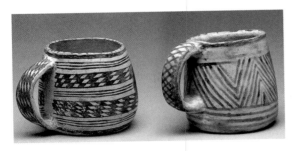

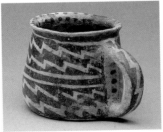

Boyd first suggested that the anonymous Quill Pen *Santero* was of Indian origin. This group of objects depicting "cloud terraces" and "water serpents" shows how motifs can migrate from one context to another, in the process blurring their identity, and suggests that their significance depends on the viewer's orientation. The closer the *style* of the motif remains to another source, the stronger the reminder of this context. For example, the "serpent" motif depicted in the *santos* of the Guardian Angel and the unidentified female saint, a motif that is not customary for either Christian subject, resembles a sketch by Cleo Jurino of Cochiti Pueblo. The graphic style of representation owes something to European drawing conventions, but the snake symbol, a sign used in both cultures, suggests that the motif might also owe something to Pueblo cosmology even in its Christian setting.

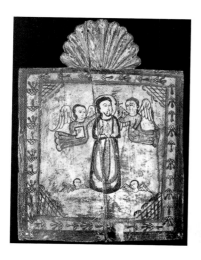

10.d.4. Quill Pen *Santero*, *Saint Peter Nolasco* (?), gesso and water-soluble paint on wood, mid-nineteenth century. Taylor Museum (TM 885), Colorado Springs Fine Arts Center, Colorado Springs.

10.d.5. Follower of Quill Pen *Santero*, *Saint Stephen* (?), gesso and water-soluble paint on wood, c. 1871–80 (bark date 1871). Taylor Museum (TM 902), Colorado Springs Fine Arts Center, Colorado Springs.

10.d.6. Follower of Quill Pen *Santero*, *Guardian Angel*, gesso and water-soluble paint on wood, c. 1871–80 (bark date 1871). Taylor Museum (TM 895), Colorado Springs Fine Arts Center, Colorado Springs. Inscribed on *retablo*, lower left: *el angel de la guardi[a]* [guardian angel].

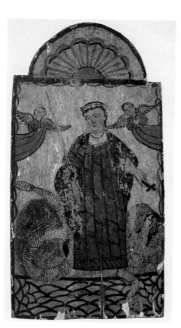

10.d.7. Follower of the Quill Pen *Santero*, *Female Saint*, gesso and water-soluble paint on wood, c. 1871–80 (bark date 1871). Taylor Museum (TM 589), Colorado Springs Fine Arts Center, Colorado Springs.

10.d.8. Cleo Jurino, cosmological drawing made for Aby Warburg at the Palace Hotel, Santa Fe, on January 10, 1896, as noted on the drawing. Warburg's notations on the drawing identify Jurino as the priest of Chipeo Nanutsch, the guardian of the kiva at Cochiti Pueblo, and "painter of the wall paintings" there. Warburg identifies the figure as the water-serpent Ttzitz-chui depicted "with the weather-fetish" (Warburg, *Images from the Region of the Pueblo Indians,* 9). Photo courtesy of the Warburg Institute, London.

The cloud terrace motif that appears on numerous *retablos* is another conventional Pueblo symbol, related to the water serpent, and it resonates in a similar way, even though it is easy to imagine its meaning in strictly European terms as a saint's pedestal. When a closely related motif occurs in the framing border, however, as it does in the painting identified here as *Saint Peter Nolasco*, its Pueblo reference is unmistakable. In every case illustrated, nevertheless, the biculturalism of the motif does not undermine the Christian meaning of the icon. In the *Saint Peter Nolasco*, for example, the Pueblo cloud symbol serves as a decorative device in the framing border, an appropriate motif to include in an image of a Christian saint ascending heavenward accompanied by angels.

Sometimes [mis]identified as "Saint Job" or "El Sto Ecce Homo" [Behold the Man], as in one of the *retablos* pictured here, these two depictions of the Christ of Patience include visual clues suggestive of their original owners' social identities. Was the individual who painted or sought solace, in the painting now owned by Alyce and Larry Frank, of Hopi or other Pueblo origin, as the abstract design of Christ's setting suggests? Was the artist and/or original owner of the variant in the Museum of Spanish Colonial Art of sub-Saharan African origin? The cultural identity of those who originally used these images as instruments of religious devotion may be indicated in such details as the blocklike forms resembling designs on a roughly contemporaneous Pueblo pot, which may be due to the artist's familiarity with certain culturally specific modes of organizing a painted surface. Cowrie shells have sacred associations across wide regions of Africa, where they were initially introduced as an international form of currency (associated with the Portuguese slave trade): their presence here suggests the maker's or owner's deeply personal identification with Christ's plight.

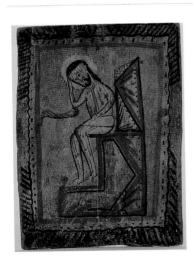

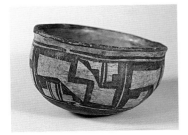

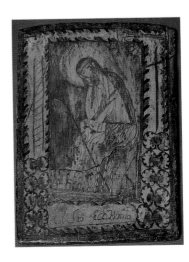

10-15. View looking north to ruins of Abó Pueblo, New Mexico, August 1995. Photo Claire Farago.

banding along the lower edge of the image field. The surfaces of many colonial period Pueblo ceramics are subdivided in the same way. In many cases, there is no attempt to depict a three-dimensional object by modeling and foreshortening. Perhaps in these *santos,* the source may have been a print copied by an artist familiar with the visually homologous but very different pictorial conventions of Pueblo painting.[21]

The Healing Powers of Icons

Good candidates for recovering the possible Native American contribution to polysemic semiotic play in *santos* are plants depicted in the *retablos* that might be associated with the healing powers of the icon—a supplement to its Christian function, perhaps, rather than a rejection of it. As suggested in the description of Aragón's Archangel Gabriel in Chapter 2, healing practices are rooted in both the Spanish and the Pueblo cultures and are conjoined by their shared

geographical setting.[22] However, the plants depicted in the *santos* are usually too stylized to permit positive identification with any actual plant varieties, and pre-contact Pueblo pictorial conventions are generally too abstract to enable any direct comparison.[23] Yet, even if ethnobotanical references cannot be reconstructed, it is difficult to dismiss the landscape as a powerful signifying component of the *santos*. The ruins of Abó Pueblo silhouetted against the midday sky in an open desert field in central New Mexico (Fig. 10-15) suggests, in its graphic contrasts of earth, sky, and vegetation, that the settings of many *retablos* intentionally evoke the actual physical settings in which these images were used.[24]

The innovative landscape settings of New Mexican *santos* are, moreover, among their most distinctive and characteristic features. In an influential, widely disseminated mid-sixteenth century text, the founder of the Jesuit Order, Ignatius Loyola, recommended that the devotee imagine a concrete physical setting for his

mental disciplining. It is easy to imagine that the affective power of these visual aids to religious practice would have pleased the author of the *Spiritual Exercises*.[25] (See Figs. 10.e.1, 10.e.2, 10.e.3, 10.e.4.)

The highly charged word "icon" used throughout this study deserves a brief note of explanation at this juncture. Strictly speaking, an icon is a representation of a saint that has been consecrated in a church ceremony; unconsecrated representations are regarded by the institutionalized Catholic Church merely as "pictures." As Robin Cormack writes, it is only in the charged atmosphere of the church building itself that the devout viewer can achieve close contact with the saints in their icons. However, Cormack also writes that an icon is not simply a physical image, but "an interactive medium between this world and the other."[26] In this broader sense of "icon," Cormack speaks of Coptic Christians as people who live "with

The stylized vegetal imagery on most New Mexican *santos* is too abstract to identify with actual types of plants, but here are two exceptional examples that suggest specific botanical references (see also Chap. 2). The color and shape of the flower "blue curls" are recalled in the intense blue ground and scalloped edge of a *retablo* that can be only tentatively identified as a depiction of the Virgin, because of these and other visual supplements (the three heads identified in the museum records as "the Trinity" recall the Pueblo Storyteller dolls popular with tourists today). Such visual slippages suggest that the plants may refer symbolically to the original owners of private devotional panels. In 1936, Elsie Parsons published a list of women's names in the Tewa-speaking Pueblo of Taos, which included many with plant associations. The English translations of some of these are: good flower, mixed flower, corn flower, playing flower, humming-bird flower, new flower, sun flower, chokeberry flower, cotton, water grass flute, corn grass, elk grass, mint, blue flower, deer grass, spruce—the list goes on. See Parsons, *Taos Pueblo,* 42. Plant names were given only to females, but the collecting of flowers is associated with kiva-society rituals for both genders at Taos.

10.e.1. Anonymous, *Virgin with Trinity* (?), gesso and water-soluble paint on milled wood board, late nineteenth century. Museum of International Folk Art (FA.84.424-1), Santa Fe, New Mexico. Photo Blair Clark.

10.e.2. Blue curls; tea made from this plant, a member of the mint family found in Arizona, New Mexico, and southern California, is used as to stimulate menstruation and to expel the afterbirth. Drawing by Donald Preziosi after Moore, *Medicinal Plants of the Mountain West,* 39.

10.e.3. Anonymous, *Saint Anthony of Padua,* gesso and water-soluble paint on wood, nineteenth century. Museum of International Folk Art (A.9.54-112r), Santa Fe, New Mexico. Photo Blair Clark.

10.e.4. *Añil del Muerto;* this common roadside annual is a type of sunflower that grows to a height of six feet. The powdered plant, made into a paste or a salve, is an anti-inflammatory; taken as a tea, it causes sweating and breaks fevers. Drawing from Moore, *Los Remedios,* 18.

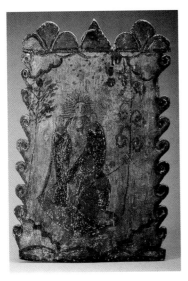

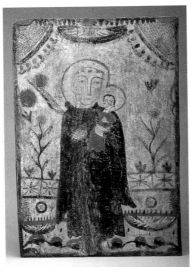

the saints." In New Mexico throughout much of the colonial period, when there were not enough priests to serve the Christian community, many lay Catholics also "lived with the saints." Unconsecrated images of saints must have served the population in the same sense that Byzantine icons served Coptic Christians. Since the present study tries to establish the perspective of Catholic believers who prayed in domestic and community environments outside the sacramental structure of the institutional Church, I use the word "icon" in the broad, but still technically correct, sense that Cormack does.

In the premodern sense of healing as well-being bestowed by divine grace—very different from contemporary notions of healing by medical intervention—the cultural context in which *santos* performed as healing images in New Mexico can be extended to a much wider range of artistic production. The following discussion is concerned, not with ethnobotanic evidence or with medical remedies per se—although these would be subjects worthy of investigation—but with artistic representations. The native inhabitants of the Southwest painted and decorated a wide variety of surfaces, including basketry, stone containers, carvings, textiles, costumes, human bodies, shields, walls, and even stone outcroppings and caves. I turn to this widespread pictorial vocabulary to establish the "healing powers" of images in a cross-cultural context.[27]

There are valid reasons to examine the visual similarities between *santos* and other forms of Pueblo painting besides ceramics. Early records, like the 1630 report on missionization by Benavides, make it clear that the missionaries relied on Pueblo artisans and Pueblo consultants to some extent.[28] It would make little sense to explain in any other way the Pueblo-style decoration that appears on the interior and exterior walls of Catholic churches at some of the pueblos. Corn plants and other motifs grow from painted dados that, as J. J. Brody has noted, recall the formal conventions of mural paintings in kiva interiors since the end of the seventeenth century, and perhaps earlier.

The choice and placement of Pueblo symbols on Catholic churches suggests not so much a rejection of Christianity as an attempt to incorporate Pueblo perspectives into it. After the Pueblo Revolt, such purportedly harmless practices were encouraged by Spanish authorities eager that Native Americans should assimilate Catholicism.[29] Common wall decorations in Catholic churches in the pueblos include friezes of rainbow arcs, cloud terraces, birds, stylized corn plants, sun, moon, and other motifs that are traditional to the vocabulary of Pueblo sacred spaces. For example, in its use of a serpent symbol and handprint, the front post of San Buenaventura Church of Cochiti Pueblo recaslls symbols found at rock art sites in the same region (see page 180, Figs. 10.f.1, 10.f.2, and 10.f. 3).[30] The representations of plants and animals in many Pueblo contexts, such as the meeting room of the Macaw clan at Zuni Pueblo discussed by Brody (reproduced in his fig. 112), are likewise inflected with foreign, in this case European, accents. Brody acknowledges that the subjects painted on church walls, whether taken from Pueblo tradition or European decorative sources, are "secular in character when viewed from a Catholic perspective," or can be interpreted only metaphorically as appropriate in a Catholic context.[31] Nevertheless, he argues, their continued persistence suggests that they were deliberate and symbolically meaningful as "visual prayers," that is, as *general* acts of worship that acknowledged supernatural sanctions" in both Christian and Pueblo architectural spaces (italics mine).

Brody also contends that mural paintings in the native style transformed a Catholic church into a Pueblo ritual space on the order of a kiva or a society house. Yet a mission church is definitely not a kiva. Pueblo paintings functioned within a different cultural setting, as well as a different spatial structure. The images in mission churches were under surveillance by officiating Franciscan friars and later secular priests. Structurally speaking, these Pueblo mission murals occupy the same wall space reserved for religious subjects in Mexican *conventos,* such as Acolman, which

An early twentieth-century photograph records the presence of a handprint and snake symbol on the front posts of the mission church, no longer extant, at Cochiti Pueblo. Similar handprints and serpent symbols are also found at rock art sites in the same region, where they may have been carved as "prayer requests." According to J. J. Brody (*Anasazi and Pueblo Painting*, 148), the murals along the nave walls at the Laguna Pueblo church, probably painted by women of the Pueblo (women traditionally painted the pottery), were in place as early as 1846. (Similar pottery motifs on a jar from nearby Santa Ana Pueblo are illustrated on page 176, Fig. 10.d.9.) Viewed contextually, these visual similarities suggest not a rejection or co-option of Christianity, but rather Pueblo supplements to it.

—Sara Rockwell

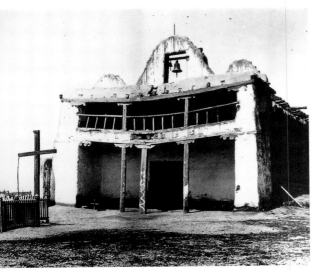

10.f.1. Exterior, San Buenaventura Church, second Cochiti Mission. Photo Carter H. Harrison, c. 1910. Photo courtesy Museum of New Mexico, Santa Fe, neg. no. 2302.

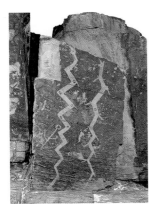

10.f.2. Paired horned and feathered serpents and other petroglyphs, Tompiro district, Torrance County, Rio Grande Valley between Socorro and Albuquerque, fourteenth century (?). Photo Salvatore Mancini.

10.f.3. Interior, San José de Gracia Mission Church, Laguna Pueblo. Photo Charles F. Lummis, 1890. Photo courtesy Southwest Museum, Los Angeles, neg. no. 636.

provides a far more direct precedent for the New Mexican practice.[32]

Given that the mission churches of New Mexico were the immediate context in which these Pueblo-style wall paintings functioned, the context and timing of Pueblo ceremony becomes vitally important to consider whether their presence in a mission church is anything beyond a formal survival, "extinct" in the sense that Kubler defined *tequitqui* ornament. It is significant in this connection, as Sylvia Rodriguez argued recently in a study of contemporary *matachines* dancing in New Mexico, discussed briefly in Chapter 2, that since the seventeenth century, the Pueblos and the Hispano villages have combined indigenous and European ceremonial calendars. Pueblo performances keyed to the agricultural cycle have often been held in conjunction with saints' days and other Catholic observances celebrated in the mission churches and the open spaces around them, as Brenda Romero explains in her contribution to this volume that follows this Chapter.[33]

Any future study of Pueblo Christianity, should the political climate in New Mexico ever enable it in an academic setting, could explore structural similarities in the performative context, just as the preceding discussion has explored structural similarities in the static context of painted "visual signs." The following discussion adapts Brody's intuitive suggestions about Native American motifs painted on New Mexican mission churches to an analysis of devotional panels that survive in museum collections today. Brody discusses an altar made for a Hopi Women's Society called *Oa'qol* (*Owakulti*) in Orayvi (Oraibi), in northeastern Arizona, which may have been begun in Awatovi in the late seventeenth century.[34] This altar consists of eighty-three painted slabs tied to a reed frame, with a painting of the "germination deity" in the center (this identification is, needless to say, in the language of the anthropologist). Offerings of food and many symbolic evocations of well-being and fertility—to use Brody's language again—are laid out in front of the altar. The installation resembles both the

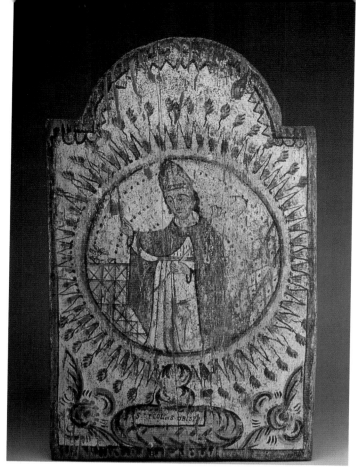

10-16. Anonymous, *Saint Nicholas of Myra,* gesso and water-based paint on wood, nineteenth century. Museum of International Folk Art (A.66.9-2), Santa Fe, New Mexico. Photo Blair Clark.

real landscape and the landscape elements depicted in *santos.* The ritual celebration of fertility and germination is also the general subject of a diorama reconstruction at the Chicago Field Museum of the *Soyal* or winter solstice ceremony from the same Third Mesa Hopi village, recorded at the turn of this century. The painting of the "germination deity" in the installation recalls a *santo* in its formal organization—shared frontality, flatness, isolation of the figure, and landscape setting.[35]

Pueblo paintings of masked *katsina* dancers are suggestive of many *santos* (see Figs. 10.g.1, 10.g.2, and 10.g.3). The similarities include the frontality of the single figure, the representation of attributes, and especially indications of landscape, the planarity of all the figurative elements, outlining of figures filled with flat areas of color, and elaborate framing devices such the cloud terrace and the dado in the examples reproduced here. These visual affinities with Pueblo sacred representations are typically accompanied by subtle transformations of iconography, such as the frequently seen replacement of a water bottle with a gourd, locally used for the same purpose, in depictions of San Rafael carrying a fish, a favorite New Mexican subject. The portrait of Saint Nicholas of Myra reproduced here (Fig. 10-16) is one of the most dramatic innovations: the frame, with small feather or plant motifs, is reminiscent of Pueblo offerings (in which a feather or wind-borne plant seed is accompanied by a wish or request). The frame also recalls the flaming aureole that encir-

Saints and *katsinas* perform similar roles in their respective Christian and Pueblo contexts as guiding spirits that accompany an individual through life. Pueblo paintings of masked *katsina* dancers are suggestive of many *santos* in the formal organization of the visual field: a frontally facing figure holds an object or other attribute that identifies the figure, who stands in a landscape setting. Even the manner of representation, with flat areas of color, closed outlines, arms raised with bent elbows (a praying gesture, according to European convention), is similar. Many New Mexican *santos,* like the "Immaculate Conception" pictured here, are difficult to identify with European iconographic traditions because the saint's attributes are different or absent, there is no narrative context, and the features of the figure are generalized. The significance of these artistic transformations is difficult to assess, beyond attesting to the response of local artists to artistic resources available in the region.

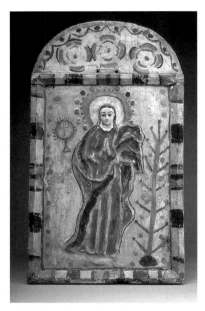

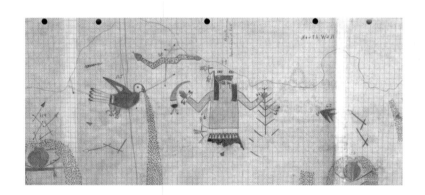

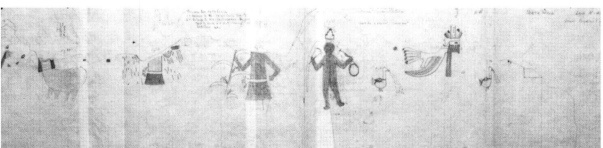

cles the Virgin of Guadalupe in Mexican representations (descended from Germanic representations of the Immaculate Conception and ultimately from Byzantine mandorlas) as well as the circular painted shields made from hide associated with Plains Indians, and known in Pueblo examples as well.[36]

Santos and Katsinas

When Brody's analysis of Pueblo-style paintings on mission church walls is extended to a consideration of the small devotional panels that originally functioned in domestic and community chapel settings, the elements that distinguish New Mexican santos from their counterparts in Mexico, Spain, and elsewhere incorporate recognizably non-European pictorial systems on many levels. Some anthropologists have suggested that images of saints are really katsinas in disguise, or vice versa, that images of katsinas and practices associated with them are indebted to Christianity. The visual similarities between santos and katsinas are in fact so striking that, until indisputably pre-Hispanic murals at Kuaua and other sites were excavated in the 1930s, the anthropologist Elsie Clews Parsons even hypothesized that the katsina cult developed only after the introduction of Christian images of saints.[37] There can now be no doubt that these two forms of material culture developed independently, before contact.

As Frederick Dockstader has convincingly argued in the case of the Hopi and Zuni, the katsina representations are also indebted to European contact, primarily in the form of parodies, though neither side willingly acknowledges its borrowings.[38] Pueblo missions responded to coerced religious conversion (what one writer recently dubbed "ethnocide")[39] by conducting native ceremonies privately, out of view, in this way secretly transmitting what were often already esoteric forms of knowledge. Explanations of visual similarities as evidence of religious syncretism, resistance, or idolatry have been ignored or rejected—above all, by two Pueblo anthropologists. Edward Dozier of

Santa Clara Pueblo and Alfonso Ortiz of Jemez Pueblo, both deeply knowledgeable about Christianity and Native beliefs, prefer explanations of "compartmentalization," as Stoller explains in Chapter 7 of this volume.[40] The historical oppression of Native observances as "idolatrous" no doubt contributes to the refusal of those living in the Pueblo lifestyle today to discuss Pueblo Christianity with outsiders.

How might artistically hybrid images signify differently to different beholders? Consider the "rain-cloud" motifs inserted into several representations of Saint Joseph/Bonaventure, which might be associated with the gifts of the ancestral katsina for some viewers but be merely decorative elements for others. Or consider the pose of a standing saint with the Christ child on his arm, which recalls the iconography of the Virgin and Child, a meaning in keeping with Franciscan representations of regular clergy, in imitation of Christ, as nurturing mothers[41]—but perhaps also in keeping with the sacred status traditionally accorded to self-selected Pueblo males who took on the personae and tasks of women.[42]

In any event, the strictly visual affinities suggest conceptual affinities beyond the formal correspondences discussed so far in this volume. But is it possible to sort these meanings out in historical hindsight? The snake and fishlike creatures pursuing (?) a soul being caught up by the Guardian Angel in a santo mentioned above, are reminiscent of Pueblo water snakes, such as Hopi depictions of the horned water snake (Palulukon), origin of all springs, which causes earthquakes and tries to overturn the floating world (see Figs. 10.f.1–10.f.3 above). Throughout the Pueblo world, snakes are associated with the cloud katsina or Cloud People, humans who lived good lives and serve the living after death by bringing rain and life.[43] Yet the visual narrative suggests that their significance might be different here, in keeping with Christian identifications of serpents with sin, transgression, and damnation. Even within a Pueblo context, snakes are sometimes dangerous to human welfare. Ritual conflict involving them is indicated in a painted cloth curtain from a Hopi

meeting of the Antelope Society, c. 1920 (reproduced by Brody, fig. 134). The drama once performed in front of this screen consisted of snake puppets fighting with human impersonations of *katsinas* over corn plants that the snakes try to destroy.[44] The *katsinas,* who always win, reside in the Hopi village from late December to late July and have the power to bring the rain, fertility, and good fortune that the snakes signify even in opposing them. The Pueblo ritual drama symbolizes the forces of nature in a universe that is not divided morally into good and evil.

Depending on the viewer's cultural orientation, these visual similarities with very different cultural resonances can combine in a variety of different ways: we can sometimes reconstruct the range of meanings an image might have held for a viewer with multiple cultural roots, but it would be impossible—and pointless—to offer a definitive interpretation for an image that embodies such irreducible semiotic equivocations. It is more prudent, perhaps, to ask a more general question, namely what form of Christianity could the Pueblo Indians of the early colonial world have practiced? As noted in Chapter 1, the vast majority of missionaries failed to learn the native languages. Under these circumstances, the teaching of Christian doctrine must have been exceptionally reductive. The limited communication that the Franciscans initially established with the local population may partially explain why there are such extensive formal parallels between later images of saints and Pueblo *katsinas*. If representations of *katsinas* look like icons of saints to us, the similarities may have been equally striking to the missionaries and their coerced converts. After the sobering experience of the 1680 Pueblo Revolt, Franciscans and secular priests apparently encouraged a certain amount of cross-cultural translation.[45] In any case, missionaries in Latin America and elsewhere in Europe's colonies worldwide, even when they acquired linguistic skills, unavoidably transformed Christian concepts into indigenous ideas in the process of translation—because words are inseparable from worldviews.[46] The visual evidence suggests that

a similar process of cultural (mis)translation took place through images in New Mexico.

The Space of Time

There is, perhaps, one significant *difference* between the *katsinas* and the *santos* that can inform our current understanding of the ways in which artistic images transform and are transformed by changing cultural configurations. The cultural traditions to which representations of saints and *katsinas* respectively belong handle the theme of supernatural presence in very different ways. Considering the representation of a single, standing saint as a static object already imposes an ethnocentric, culturally specific frame of reference on images that functioned as religious instruments, not as static works of art meant for secular, aesthetic contemplation. Catholicism stresses incarnation, God-made-flesh, as part of a *chronological* narrative originating in the "moment" of creation.[47] Many Native American traditions, including those of the Pueblo peoples, stress the *immanence* of the supernatural, which is conceived as coeval with human existence (sharing the same space-time).[48] From this perspective, the major difference between Christian and Pueblo constructs of the supernatural is their radically different conceptions of time.

Every Catholic icon signifies the absence of supernatural presence. Religious images, according to Church doctrine established in the eighth century, are temporal mnemonic devices about the nature of eternal truth. As the image is a copy of the subject it portrays, so Christ is a copy of his prototype, God. From the perspective of institutionalized Catholicism, the artistic copy thus refers to another *order* of likeness. From this perspective, the artistic copy provides an instrument through which humans may come into contact with the eternal.

Christianity, to put it briefly, despite its cyclical calendar of feasts and other ceremonial observances, supports what is still our dominant culture's view of time as a linear narrative in which presence is always

marked by the absence of the past and of the future. In Pueblo traditions, by contrast, the sequential nature of events is subordinated to the living presence of the supernatural in the created world. Time appears *successive* only from the mundane perspective of events: from the Pueblo standpoint, we might think of the dominant dimension of time as being suspended in the present. The annual ceremonial calendar conceives of time as cyclical—or, to be more accurate, as distinct locations within a temporal extension, for even the term *cyclical* is tinged with the Western assumption that time's dominant trait is succession. By emphasizing the spatial, Pueblo descriptions of time raise our awareness that our Western indexical notions of time as "naturally" evolutionary/progressive may themselves be a cultural construct.

Is creation a time or a place? Vine Deloria's objections to current scientific worldviews, discussed in Chapter 2, are more relevant to the subject of this book than they initially seem. The son and grandson of Episcopal ministers, a professor emeritus historian at the University of Colorado who graduated from a Lutheran school of theology, Deloria is a veteran activist in Native American civil rights, church politics, and theological debate. In a recent volume of essays about Native American Christianity by Native Americans, James Treat describes Deloria's critical books and essays as "foundational texts in the emergence of native Christian narrative discourse."[49] In other words, in attacking institutional authority, Deloria is not only an outspoken "troublemaker"; he is also a highly respected elder for a pan-Native community, a "survivor" with a long and distinguished track record. And he is a self-professed Christian Native American.

What makes Vine Deloria's views on religion especially relevant to the present discussion is his insistent distinction between two types of thinking about the idea of creation. Christianity has traditionally conceived of creation as a specific event, while Indian tribal religions could be said to consider creation as an ecosystem present in a definable place.[50] Can Deloria's insistence on an immemorial Indian

presence in North America help to explain why references to the land are so important to the visual tradition of New Mexican *santos?* As issues have unfolded in preceding chapters of this book, two radically different constructs of time—one describing experience as linear, chronological time with a past, present, and future; and the other describing experience as the living presence of the supernatural coeval with human existence—emerge along the same axis where Deloria locates his distinction between Christianity and Native American beliefs.

Does the coexistence of such fundamentally different worldviews account for the emphasis on landscape settings in many New Mexican religious images? Significantly, religious images of the Virgin, Christ, and saints function for lay Catholics as a sacred presence—that is, in much the way in which Vine Deloria describes native American religion as functioning. From a Euro-Christian understanding of the world, the setting gives the worshiper concrete, sensual cues that aid an internal process of re-membering, or making the absent present. Perhaps, from an understanding informed by Native American beliefs, the landscape suggests how the supernatural is immanent in the world, coeval with it—that is, how "divine" and "worldly," "human" and "land," are not really separate categories at all.

A Semiotic Account of Style (continued)

Conflicting worldviews simultaneously present in the same visual field need not be synthesized or directly opposed; they can coexist, to be experienced differently by different audiences. Yazzie's diorama, for example, discussed in Chapter 2, is polysemic or at least semiotically open-ended in two respects: as an unorthodox combination of two different subjects and as an image that signifies different things to different people, depending on their cultural and social formation. How, then, can we judge significance in the case of historical objects, like the *santos,* where the historian's knowledge of cultural context is usually far more limited?

Art history, the discipline primarily charged with recovering the significance of works of art, offers two principal kinds of interpretative models, one grounded in the individuality of the artist and the other in the social function of the image. Interpretations of the first kind assume that the object is the unique manifestation of the artist's consciousness. When knowledge of the individual artist is not available—as is the case with the majority of New Mexican *santos*—this path to historical recovery is blocked. Interpretations of the second kind examine the social uses of the art object—in the case of *santos,* their function in the religious contract. Far from stressing the individuality of the work, these interpretations draw upon the popular belief that the efficacy of an icon depends on its likeness to the original.

Both of these accounts are grounded in the same Western philosophical assumption that the consciousness of the "maker" is the "cause" of the work of art, which is transferred to the image. In one case, this consists of the power of the artist/maker, whose inspiration comes from God; in the other case, it consists of the power of the saint or other holy person represented, which also emanates from God. This holy person is the prototype of the image, which is in turn its likeness or copy.

Both types of interpretations are limited, however, in their ability to recover the kind of information that is perhaps most intriguing and significant about New Mexican *santos,* namely, their semiotic openness or polyvalence. Far from being direct evidence of assimilated, fused, syncretistic, or even compartmentalized worldviews, the coexistent palimpsesting of different artistic traditions that is visible in New Mexican Christian icons opens them to constant reinterpretation. The indexical relationship between sign and referent depends on information that the viewer supplies. As far as the interpretative responsibility of the art historian qua art historian is concerned, two significant points emerge from the foregoing analysis: (1) the function of style is explained on strictly historical and material grounds, without positing an a priori, causal position for mental perception; and (2) the semiotic properties of style understood in terms of reception preserve a conceptual relationship between material artifact and the external world. The hand of the artist who constructs such semiotically open-ended compositions is perceptible in the arrangement and choice of recycled elements. Thus, the discussion of style severs its ties with a craft tradition of hand manufacture, enabling a more general discussion—one that encompasses the conditions of "manu-facture" in a mass consumer society with industrialized forms of technology. Chapter 11 will have more to say about the necessity of accounting for the reuse of signs and other materials in a theory of images.

SOUND, IMAGE, AND IDENTITY:
The *Matachines Danza* Across Borders

BRENDA M. ROMERO

The questions and viewpoints discussed in this volume have their counterparts in the performing arts, insofar as various processes of intercultural influence are observable in the *matachines danza* (the term *danza* implying a dance ritual in this instance). Brought by the Spanish, the *matachines* was introduced in the New World in part to aid in converting the Indians to Catholicism. The long history of theatrical productions, sacred and profane, in Spain ensured that the religious play, or *auto,* would be employed in the conversion of the Indians. The *matachines danza,* featuring sacred and profane elements side by side, was a ready-made template for a New World Catholic ritual drama. It is generally known that typical Franciscan psychological tactics to convert the Indians included imposing Spanish Christian ritual formats on important indigenous ceremonial occasions. In Spanish theatricals, they went so far as to portray "Christian saints and Spanish personae, such as . . . Cortés" in aboriginal dress.[1] Evidence that such may have been the case in Picurís Pueblo, New Mexico, is found in native interpretations of the *matachines danza* as a commemoration of the coming of the king, Moctezuma, with his wife, Malinche, on the wings of an eagle.[2] Forms of resistance also included changing and adding "to the European style representations in order to create a piece that was more meaningful to [indigenous actors]."[3] It is highly probable that the importance of the eagle among both Mexicans and Puebloans led to the eagle's incorporation in the Picurís narrative.

Over the course of its long development the *danza* absorbed elements of other music-accompanied rituals, primarily those called *moriscas,* in Spain and in other parts of Europe. There is evidence that the killing of the bull dates back to ancient Rome. While the saints depicted in *retablos* and *bultos* represented men and women martyred for the sake of Christianity, by the time of the conquest the *matachines danza* represented the victory of Christianity over the Moslem infidel. Even today the New World *matachines* "dance symbol" (a term coined by the dance ethnologist Allegra Fuller Snyder) evokes the anachronistic image of a Middle Eastern warrior, but the warrior's sword is replaced by a trident that symbolizes Christianity.[4] Religious plays, like that of Saint George and the Dragon, which featured a maiden in distress, also contributed to the version of the *danza* that eventually arrived in the New World. While it declined in Spain, the *danza* continued to evolve in its new circumstances in the Americas. Over time it became known by other names in other parts of Europe, the most famous example being the English Morris Dance.[5] In modern performances that approximate known features of this and similar Spanish *danzas* at the time of the conquest, the *matachines* are the dancers in double file, around whom the main characters enact a ritual drama of conflict that is resolved through the killing of the bull, which many interpret as the acceptance of Christianity. The *matachines* wear face coverings with fringe over the eyes and tall, arc-shaped crowns with long ribbons that fall from the top over the back and sides. In the Old World, bells around their ankles became iconic of the *matachines,* and in a few New World settings of the *danza,* such as San Juan Pueblo, New Mexico, this custom is still observed. The main characters include the Monarca, or king; the Malinche, or first Christian convert in the Americas (as a child in this instance); the Toro, or bull; and the Abuelo, or grandfather, who, in contemporary New Mexico, typically directs the entire ritual.

The *danza* has a long history of being an occasion for wearing an ornate and elegant dance outfit. In some pueblos of New Mexico, the Malinche changes her clothes for each iteration of the entire 45-minute performance on different days.[6] The *matachines* dancers often change their clothes because of the heavy sweating arising from the vigorous dancing. The music is characterized by a sequence of lively dance melodies (*sones*) played on a violin with guitar accompaniment. The *danza* is enacted outside the homes of important fiscal and spiritual leaders and at the homes of those who dance the parts of the main characters, much as the ancient Spanish versions might have been danced near the fields of prominent individuals to bless them with productivity.

In New Mexico, there are as many as fifteen different towns where the *matachines danza* still thrives, some of which still look very "Spanish," and others where Pueblo influences can be observed. That the *matachines* has survived as the only genre of its type in Hispano towns is perhaps the greatest Pueblo influence on the Hispano versions. At the time of the contact, ritual dance drama with sacred clowns was an ancient and highly developed art among the Pueblos, as it still is today. The clowns have the difficult responsibility of helping to clear the air and bring about the "right heart" required for a ritual to have power; thus their prerogatives are many and varied, including the use of obscenity. In contrast, the Spanish Church considered religious expressions such as the *matachines* profane and even officially censured them because the dancing men appeared effeminately ornamented, and because clownish burlesques could be used to criticize the Church. The question arises whether or not the *danza* would have survived among Hispanos if the Pueblos had not begun to incorporate it into their ritual calendars. The *matachines* looked enough like an indigenous ritual that the Indians easily accommodated it. Just as the Buffalo Dance was accommodated as a means of honoring Plains nations and benefiting from the ritual's inherent power, the *matachines* was the appropriate way of tapping Span-ish and Catholic power. Ramón Gutiérrez has suggested that in many cases Catholic imagery and intent may have had little to do with indigenous interpretations of rituals.[7]

Intent aside, there is little doubt that the *matachines* became more important to Hispanos as more and more of their descendents were *mestizos,* and the society wrestled with contradictory value systems. The *matachines* gave the *mestizos* opportunities to reflect on the spiritual nature of their mixed ethnicities, and this was reinforced by the tandem genesis of the cult of the Virgin of Guadalupe. The dark-skinned, Indian madonna allowed *mestizos* to love her as a symbol of the Indian mother. Today, after 500 years, Hispanos in New Mexico espouse certain indigenous values, such as the concept of the "sacred earth" on which the *danza* takes place. Important reinforcement of this belief is found in the practice, shared by Hispanos and Pueblos, of swallowing a little of the miraculous, healing, sacred earth reputed to replenish itself daily at the Santuario at Chimayo.

While the Pueblo of Jemez recognize the *Matachina* (as they call it) as introduced from Mexico, typically each New Mexican town believes it has the original version of the music and dance. In spite of the relatively short distances between towns, few have ever witnessed neighboring versions of the *danza*. This is partly due to the intimate, meditative nature of the *danza,* which practitioners consider not a spectacle, but an act of prayer as reciprocity for something the dancer has spiritually petitioned. Consequently, each town's version of the *danza* is different in some respects. Presumably, the so-called Spanish version of the *matachines* was introduced in the Pueblos, but over time all of the Pueblos have reinterpreted the Spanish version so that it now looks more Pueblo than Spanish. The Spanish version still seen in most Hispano villages uses violin and guitar, and the men wear dress pants (often black) or a full dress suit, white shirt, and dress shoes or boots (Fig. 3). A certain austere aesthetic has always governed New Mexican Hispanos who observe or have been influenced by Penitente practices. The San Juan Pueblo

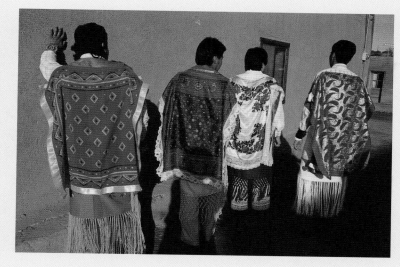

1. and 2. Jemez Pueblo, New Mexico. Four Pueblo of Jemez Turquoise Kiva Matachina dancers don basic Hispano garb, including leather shoes. The captains of each line wear traditional Hispano lace leggings over their trousers. Fringed Pendleton shawls worn over the trousers and brightly designed satin or silk scarves used as capes obscure the Hispano cultural influences, however. The boy in front of the four dancers pictured portrayed the *toro,* albeit wearing a bright shirt underneath. Photos with permission, by Brenda M. Romero, January 1, 1992.

3. Alcalde, New Mexico, the five-year-old Malinche dances between the *Matachines* dancers after Mass at Saint Anne's Church in Alcalde, New Mexico. In this Hispano town, the men wear Western dress suits, and their scarves, worn as capes, often portray Our Lady of Guadalupe or Jesus Christ. The penitential aspects of performing outside in winter weather are clearly seen in this photograph. Photo with permission of Alcalde, by Brenda M. Romero, December 27, 1992.

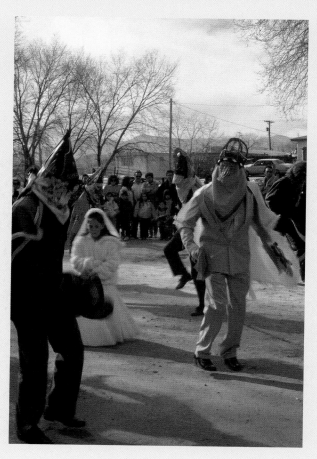

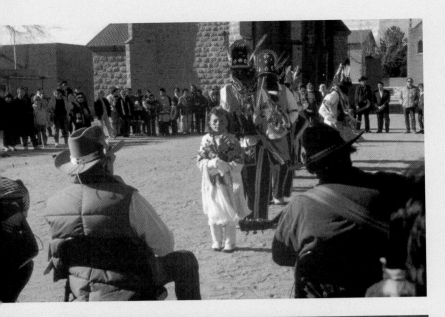

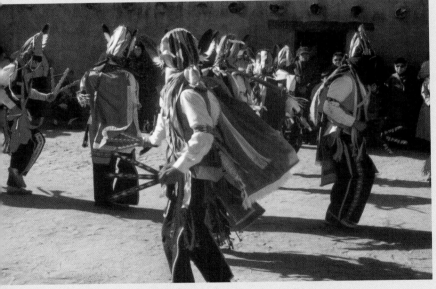

4. and 5. San Juan Pueblo, New Mexico, the young Malinche leads the *Matachines* dancers in San Juan Pueblo, where the *Matachines* ceremonial dress has become more Tewa over time. Now the men no longer wear Western dress pants and shoes, substituting traditional handwoven navy-blue cloth trousers and moccasins, which the Malinche also wears. A clearly indigenous Pueblo aesthetic dominates, with bright, sharply contrasting colors adding an important element to the texture and emotional power of the movement. Photos with permission of San Juan Pueblo, by Brenda M. Romero.

matachines have switched from dress pants and shoes to traditional cotton leggings and vests and moccasins; they also wear ankle bells (Figs. 4 and 5). Here, as in other Pueblos, the tall headdress is heavily adorned with traditional Pueblo jewelry that carries various Pueblo connotations, and the *matachines* dance symbol has become richly bright and colorful (in stark contrast, if not opposition, to the austerity of the Hispanos), incorporating various elements of traditional dress and connotation. In this way, the Pueblo *matachines* resembles Mexican *mestizo* versions. The reverse process is true in Jemez as well, and some *matachines* elements, such as headdresses with falling multicolored ribbons, are now evident in other traditional dances.

Two of the Pueblos, Santa Clara and Jemez, have their own musical versions of the *danza,* accompanied by male chorus and drum, although the choreography is nearly the same as in the Spanish version. Jemez is unusual in performing both a "Drum" version and a Spanish one (Figs. 1 and 2). The Jemez Spanish version is accompanied by violin and guitar, with the basic elements of the Spanish dress (dress clothes and shoes or boots), but with large Pendleton scarves worn over the trousers as kilts and Indian vests and other clothing highly ornamenting the basic dress. The Drum version alternates with the Spanish version throughout the feast day of Our Lady of Guadalupe on December 12, when most Mexican *matachines* are also dancing.

As one goes south toward the Mexican border and beyond, one encounters a proliferation of *Matachines danza* variants. According to the Mexican anthropologist Carlo Bonfiglioli, a system of transformations operates in Mexico, in which the vast number of variants is derived primarily from the combined characters and narrative religious, theatrical elements of four subsystems of transformation: the Passion of Christ, comic-sexual transgression, dances of the Moors and Christians, and the Dances of the Conquest of Mexico.[8] The comic-sexual transgression theme surfaces in Arroyo Seco, New Mexico, as observed by Sylvia Rodriguez:

In Arroyo Seco, the burlesque nativity is present and Indians are alluded to, but the miscegenation motif so central at Taos Pueblo seems offset by other concerns. For example, the Peri-jundia [a man cross-dressed as the Abuelo's wife] is portrayed as an Indian (suggested by the dark braids) who gives birth to a weird-looking child, but like the Abuelo (also a doctor), she is dressed as a cleric. In addition to a riot of other elements, the Abuelos represent the Catholic Church.[9]

In Mexico as in the pueblos, Catholic-derived *danzas* may be balanced with other rituals within traditional ideologies and cosmologies. Because there were no reservations in Mexico, Spanish and indigenous musical elements mix much more there than in New Mexico. This is true among the Yaqui of Arizona as well.

The music of most Mexican indigenous *matachines* may use European instruments like the violin or flute, but the sound of the music often stems from indigenous concepts. The drum often accompanies the violin in much of Mexico, including the *mestizo* villages, even when the guitar is also present. Particular drum rhythms can be ancient and highly connotative, adding yet another layer of semiotics to the complexity of the whole.

In essence, both Hispanos and Pueblos consider the *matachines danza* an act of prayer. Even though the Pueblos are aware that the *danza* was introduced to convert them, traditional Pueblo (and Mexican indigenous) ideas that associated music, ritual, and power with one another allowed them to incorporate the *matachines* without objecting directly to its hegemonic nature. The *danza* became the way best suited to honor those Spanish and Catholic elements selected for preservation and also to honor the new blood that entered the Pueblos through mixed offspring. The process of political resistance is reflected in the *matachines* Drum versions, which seek to obscure the Spanish influence while maintaining the religious association.

In recent history, Hispanos could also be said to perform the *matachines* as a form of political resistance. As Hispanos have themselves felt encroached upon by a mainstream culture that does not respect them, the *danza* reaffirms one's place on the sacred earth, much as dance rituals have for the Pueblos for thousands of years. Most Hispanos who preserve the *danza* see it as a link with the past, here and in the Old World, and see it as providing a sense of historical presence. It remains an affirmation of the continuity of Catholicism, even for Hispanos who no longer hold to all its tenets. It has become for many a common bond with the Pueblos (as it is for me) and a way of affirming one's Indian ancestry in spite of never knowing what that meant. More important, the mystery inherent in the use of the fringe over the eyes, in particular, has stimulated local interest in the dance, and this interest in turn has led to studies that have provided a much greater understanding of the ethnic complexity of Hispanos in the region and in the New World in general. More research needs to be done on the *danza* and its music across borders, which will no doubt continue to shed new light on colonial processes that continue to influence the present.

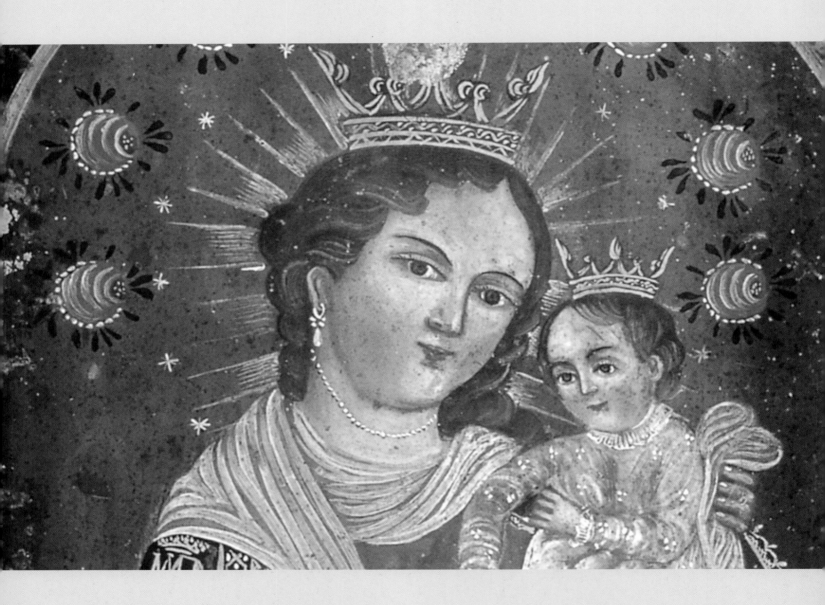

INVENTING MODERN IDENTITIES

11 | COMPETING RELIGIOUS DISCOURSES IN POSTCOLONIAL NEW MEXICO

CLAIRE FARAGO

In the preceding chapters, the writers have collectively emphasized in a variety of ways that New Mexican *santos* are culturally complex products of a heterogeneous society. Given the extensive evidence for this claim, why has the scholarship denied it?

The reduction of a complex cultural heritage to its Spanish sources is due to factors so complex that an entire section of this book, beginning with the present chapter, is addressed to them. The decades following the 1852 acquisition of New Mexico as a U.S. territory ushered in extensive societal changes, including the influx of significant numbers of new settlers who were neither Hispanic nor Catholic, radical shifts in the institutional culture of Catholicism, and the introduction of a mass consumer culture with new technologies ranging from chromolithographs to railroads. In this chapter I argue, against the grain of existing scholarship, that continuities, rather than ruptures, are key to the local religious material culture produced during the second half of the nineteenth century. Assumptions about the value of artful display, inherited from the sixteenth-century reform of the Catholic Church and never brought to bear on this material before, can help explain how new kinds of representational technology participated in longstanding patterns of active reception at the local level.

The present chapter reconsiders a significant question asked in the first sustained study of religious lithographs in New Mexico: *what caused the decline of santo-making in the second half of the nineteenth century?* In 1974, Yvonne Lange argued—and her thesis has been widely accepted in the regional scholarship—that the print technology of the mid- and late nineteenth century generated taste for a new "realism" with which local artists in New Mexico could not compete.[1] While the main lines of her argument are firmly corroborated by material evidence, it is perilously easy to misread that evidence. To put it bluntly, we must consciously resist imposing on Lange's findings a subtext in which the commercial chromolithographs represent a normative artistic ideal (in the "debased" form of mass-produced prints), their popularity with New Mexicans documenting a regrettable lapse from the religious, artistic, and ethnic authenticity of an irrecoverable past.

The concept of "realism" in art is itself a notoriously unstable category. Is the sentimentality of a Murillo, for example, more "realistic" and convincing

11-1. Anonymous, French, *Virgin*, lithograph. Santa Fe Federal Workshop, tinwork frame with painting on glass, c. 1865. Collection Lane Coulter, Santa Fe.

11-2. Title page, *Missae Sanctorum Hispanorum qui generaliter in Hispania Celebrantur* [Masses celebrated in the Spanish Empire], Antwerp: Plantin Press, 1725. Museum of International Folk Art, Santa Fe, New Mexico.

than the style of Zurbarán that it eclipsed in eighteenth-century Spain and Latin America? Similar questions might be raised about the sentimentality of French chromolithographs and the Flemish and Mexican interpretations of Italian and Spanish subjects that they eclipsed (Figs. 11-1 and 11-2). In any case, far from expressing an ethnically pure, "traditional" world untainted by modern commerce, the *santos* themselves were based on prints, which had from the earliest colonial period been complex, internationally distributed, artistically hybrid commercial productions, as Kelly Donahue-Wallace discusses in her contribution to this volume.[2]

Mass culture is generally defined as a sociocultural system that produces and consumes manufactured commodities. Media studies may disagree over the exact moment when mass culture emerged in a given place, but they uniformly insist on its difference from

precedents. The present discussion, while it draws upon the methods and modes of inquiry in media studies, emphasizes continuities that these explanations do not address. Given ecclesiastical attitudes toward religious art following the Council of Trent (discussed below), it is more productive to consider the realism of nineteenth-century prints in the broader context of cultural attitudes toward ornament, broadly defined as any form of artistic embellishment. In agreement that all artistic images are forms of artifice whose purpose is to appeal to the imagination through the senses, and above all the sense of sight, Catholic Reformation writers after 1563 recommended exemplary representations of saints and other holy figures because they provided concrete models to emulate.[3] Ornamental borders helped to set off the sacred image from its surroundings, and locating the saint's image in a tangible setting, like a landscape or room, helped to engage the senses in the service of worship. Art made to these specifications is in keeping with the traditional Catholic belief that the saint acts as an intermediary between the human and the divine realms.

The extent to which the artist's visual interpretation of a subject (established either by Scriptural authority or by institutionally sanctioned tradition) served the clarity and purpose of the religious depiction was a continuing matter of great importance to Church officials. To understand historial (as well contemporary—see below) debates over representation, that is, the value of images, it is essential to take into account the practical ramifications of Church policies from the Catholic Reformation onward. When artists' freedom—their license to invent—was at stake, literati of the fifteenth and sixteenth centuries adapted the terms of their discussion (sometimes by way of medieval writers) from ancient Greek and Roman theories of literary composition, as Leon Battista Alberti's influential treatise on painting, written in 1435, first printed in 1548, and circulating widely in the sixteenth and seventeenth centuries, most famously attests.[4] It was customary for artists, like the ancient orator or medieval writer, to be supplied with a subject by the patron. The artist's freedom (and responsibility) lay in interpreting an assigned subject. Regardless of the actual complexity of relationships among artist, patron, subject, and audience, the finished product was judged according to a tripartite scheme: the fit between the artist's interpretation and the subject in relation to the intended audience for the work.

The historical events so briefly summarized here merit a separate study. The purpose of the foregoing sketch here is partly to indicate, partly to locate historically, enormous differences between the historical notion of artistic freedom and our own contemporary understanding of artistic originality. Only since the decline of the academic system of artistic training and the simultaneous advent of modernist art in the late nineteenth century has the artist's originality been valued above all other criteria inherited by way of Renaissance humanism from Graeco-Roman literary theory. One salient difference between early modern European and contemporary understandings of "art" is the demise of an all-encompassing term to refer to everything made by human art. "Artifice" encompassed everything visible—representational and nonrepresentational elements, modeling of light and shade, color, costume, and setting; in sum, every form of ornament. The 1563 decree on images, and ecclesiastical writings that appeared subsequently as part of the Catholic Reform movement, attempted to redirect artistic license toward an idealized, scientific naturalism presumed comprehensible to a universal audience. One could say that the efforts of ecclesiastic art theorists were so successful in this regard—though they never agreed among themselves—that today we tend to forget that "artifice" applies equally to nonrepresentational strategies and to representational ones. The "rhetoric" of the image is very successful, indeed, if its intended audience takes the artist's construct for the thing itself. And that is exactly what the 1563 decree on images intended: ecclesiastical art theorists from Carlo Borromeo and Gabriele Paleotti forward wanted the religious message, rather than the artist's skill and ingenuity, to dominate the worshiper's experience.[5]

A Brief History of "Artifice"

"Artifice" is an old-fashioned, unfamiliar word today, but it has a long and loaded history in discussions of embellishment that still bears on contemporary discussions of style and representation. Over the course of many centuries, "artifice" evolved into a richly nuanced category that connoted either delightful visual inventions by an artist of elevated imagination or visual ploys that distracted the unwary viewer from the true purpose of a religious instrument of devotion. In the twelfth century Saint Bernard, the Benedictine abbot of Clairvaux, adamantly opposed the use of costly artifice to attract penitents to pilgrimage churches: "Their eyes [the penitents'] are feasted with relics cased in gold, and their purse-strings are loosed. They are shown a most comely image of some saint, whom they think all the more saintly that he is the more gaudily painted. Men run to kiss him, and are invited to give; there is more admiration for his comeliness than veneration for his sanctity. . . . What do you think is the purpose of all this? The compunction of penitents, or the admiration of the beholders?"[6] Four hundred and fifty years later, when ecclesiastics gathered for the Council of Trent to reform corruption within the Church, their tone was different, but the negative attitude of institutionalized Catholicism toward artifice made solely for visual delight had not changed substantially: "in the invocation of the saints, the veneration of relics, and the sacred use of images, all superstition shall be removed, all filthy quest for gain eliminated, and all lasciviousness avoided, so that images shall not be painted and adorned with a seductive charm."[7]

Tridentine doctrine concerning artifice is ultimately (and operatively) traceable to Plato's condemnation of "bad" phantasms (deceiving *mental* images formed by the imagination) and his advocacy of "good" phantasms, defined as those images, like geometric diagrams, that guide the imagination to truth.[8] Plato rejected artistic semblances in the external world, such as imitative poetry and illusionistic painting, for epistemological reasons—not because they

elicited delight per se, but because they intentionally deceived their beholders' judgment.[9] The Church of Rome's 1563 decree on images adapted the epistemological distinction between two different classes of *mental* phantasms to images *external* to the imagination. The distinction was still justified epistemologically, but its purpose now was to regulate *affective* behavior, and it rested on very different artistic grounds. Ecclesiastics were never able to define, much less agree on, issues of style, but—in direct contrast to Plato—they actually favored artifice that effaced its human origins by imitating an idealized, yet also naturalistic, world of natural appearances. The explicit reason was to focus the viewer's attention strictly on the subject matter being presented. This basic point about the relative value of "naturalistic" artifice grounded in knowledge of proportion theory, anatomy, optics, and other scientific arts has already been made in Chapter 1 with regard to sixteenth-century evaluations of the humanness of Native Americans. In the present chapter, I explore how the subject of artifice developed in discussions of art.

Sixteenth- and seventeenth-century artists who called attention to their own artifice—for example, by depicting vertiginous recessions of space and radically foreshortened figures that were often difficult to perceive at first glance, but caused wonder and amazement when the visual "puzzle" was solved—were criticized and sometimes punished for abusing their traditional privilege to interpret the subject matter.[10] The Council of Trent's primary aim was to distinguish between "good" artifice, which arouses the senses to religious devotion, and "bad" artifice, which simply heightens sense experience and leads to the gratification of the senses for their own sake. The Church's contrast is between desire for the good/God and desire for earthly pleasures—in a word, artistic representations thought to be capable of arousing lust in worshipers were rebuked in the Tridentine decree.[11]

The absolute rules of artistic decorum that the Council of Trent tried to articulate in defense of images were never unilaterally imposed by the

Catholic Church, nor were ecclesiastic writers on art able to translate their concerns with religious decorum successfully to the level of artistic practice. Nonetheless, the spirit of the law had enormous, longstanding repercussions for the status of illusionistic art as a form of knowledge—a neoplatonic (and equally neo-Aristotelian) position articulated by Cicero, Vitruvius, Horace, and numerous modern writers who were indebted to influential ancient texts on artistic and literary theory.[12] The crucial issue throughout concerned the status of "artifice" as the outward sign of human judgment—the work of art in this history, as Howard Caygill and John Barrell have concluded in other contexts, functioned as an exemplary embodiment of judgment, a schema that theoretically could and historically did make painting in particular, and "art" in general, a means of educating the general populace and, later, with the birth of the modern nation-state, shaping a shared ancestry for its citizens.[13] In fact, the emergence of the modern category "art" and the modern system of the fine arts is the result of the same historical circumstances.[14] Paleotti was among the first to flesh out the Tridentine decree on images into rules for practicing artists.[15] His 1582 treatise on the abuses of painters reached a wide audience of educated readers, including ecclesiastics in New Spain. In Europe, at the same time, the new art academies emerged in the late sixteenth and early seventeenth centuries. While ecclesiastic writers stressed content, new professional schools taught a representational style for delivering this content in terms that (theoretically) could be universally understood, by teaching perspective, proportion, anatomy, and composition.[16]

Over the course of the three centuries following the Council of Trent (1542–63), the views of ecclesiastic art theorists (both Catholic and Protestant) were adopted by many writers who classified the artistic representations of all cultures according to the same normative standards, regardless of the function of the representation or categories of thought in their culture of origin. These writers and European art schools were based on naïve premises that failed to take into account the symbolic value of images, the mnemonic associations of figures painted in a "naturalistic" style, and other, similar culturally determined aspects of the way images signify. Nonetheless, those who read and wrote the art-critical literature maintained that art was better or worse according to the artist's mastery of idealized optical naturalism.

Ecclesiastics in New Mexico and elsewhere judged portraits of saints and other holy subjects on the basis of the artists' skill, interpreted in generally Tridentine terms to mean their representational competence (judged by European standards of representation, of course).[17] The French-born American Archbishop of Santa Fe Jean Lamy, who arrived in 1851, shortly after the Gadsen Purchase of 1848 made New Mexico a U.S. possession, and the French priests he recruited preferred imported prints over the locally made *santos* for predictable reasons. The chromolithographs that they favored demonstrated the emotional restraint of the Catholicism most familiar to them, as opposed to the effusive and somber Spanish Catholicism of the region. They also favored the new print technology for its representational competence, because it successfully translated the work of academically trained artists into inexpensive and easily portable form.[18]

There is another important factor to consider in assessing religious prints in New Mexico: while central authorities in both Rome and its West Indies extension officially inveighed against all extraneous forms of embellishment, forms of control in the colonial world adapted to local circumstances very different from those in Europe. As Kelly Donahue-Wallace concludes in Chapter 9, the earliest Christian religious art produced in New Mexico—outside any formal institutional setting as far as we know—exercised considerable independence from Inquisition censors in adapting compositions and combining motifs from several visual sources.

Against this historical background, the following analysis aims to identify mechanisms of meaning for-

mation. I argue that, in New Mexico, where "international" and "regional" systems of cultural production were not separate spheres of activity, local inflections given to mass-media prints continued well-established means by which lay Catholics honored sacred personal patrons and sought efficacious contact with the supernatural through images. The ways in which imported lithographs and chromolithographs were displayed in New Mexico suggest that the entire presentation was appreciated for its pleasing visual effect and not only for the vivid color and academic style of the figurative representation, as Lange hypothesized. It would take a comprehensive analysis of all surviving prints, demanding research funding that is currently unavailable from any institution, to document fully this revision of Lange's original argument, but the following sampling of the visual evidence can suggest what is implied for the region as a whole.

Among the appealing technological innovations of late nineteenth-century printing were not only halftones and full color, but also imitations of cut lace and blind embossing, and shot silk threads incorporated into the weave. Unique to New Mexico is the placement of woodcuts, engravings, lithographs, and even the most innovative, appealing chromolithographs in elaborately shaped and painted tin frames made of salvaged materials, in wallpaper surrounds, or arranged in recessed boxes with decorations of flowers, corn, and objects reminiscent of the offerings conventionally placed at domestic shrines, including Pueblo altars (Fig. 11-3).[19]

Entrepreneurship and Piety: Conflicting Registers of Value

Profiteering from the sale of indulgences and other practices associated with popular shrines was one of the chief forms of corruption cited throughout the long history of church reform, as we know best today from the history of the Protestant Reformation.[20] Yet it is seldom asked from a strictly *economic* point of view why ecclesiastics, such as Saint Bernard of Clairvaux in the twelfth century and his numerous modern

11-3. Mora Octagonal Workshop, *nicho,* tin, glass, and polychromed wooden stand, c. 1850. Collection Ford Ruthling, Santa Fe.

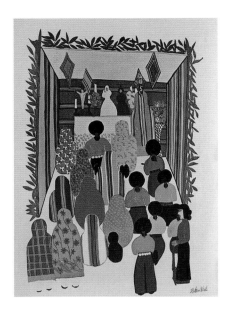

Hundreds of anonymous roadside shrines dot the landscape in the Catholic Southwest, as they do in the western Mediterranean basin, primarily in Italy and Spain, the regions from which many of the settlers emigrated. Even though the exact meaning of the objects positioned on these shrines may never be known to anyone but the maker—and even to the maker, the meaning may be entirely intuitive—such compositions assembled from available materials document "aesthetic" acts of construction and contemplation that transcend the prosaic daily experience of life to communicate with the supernatural. This is the physical act of "ex voto," that which is given according to one's vow or prayer.

11.a.1. **Pablita Velarde (Tse-Tsan), Santa Clara Pueblo,** *Santa Clara Women Before the Altar,* **1936. Present whereabouts unknown.**

11.a.2. *Nicho* **with the Virgin of Guadalupe. Private residence, Santa Fe, New Mexico, 1994. Photo Cara Jaye.**

11.a.3. **Roadside shrine with Madonna and Child, Florence, Italy, 1991. Photo Salvatore Mancini.**

11.a.4. **Urban street shrine with Saint Anthony of Padua and ex-votos, Naples, Italy, 1991. Photo Salvatore Mancini.**

11.a.5. **Temporary altar, festival of Corpus Christi, Ubeda, Spain, 1997. Photo Ken Iwamasa.**

successors condemned elaborate displays of art. Whether the issue is making false claims at popular shrines to attract pilgrims or distracting worshipers with seductive charm, eye-catching artistic embellishments translate into profit. The conflict, baldly stated, is between the religious purpose of art as an instrument for reforming the soul, and the human desire for economic gain.

There is no doubt that the position articulated at the Council of Trent in 1563 influenced the course of artistic production over the following centuries. However, the Roman Catholic Church never fully controlled private enterprise. In New Spain, where the Inquisition apparently did little to regulate commerce in printed images, the few existing records on the control of prints demonstrate that Tridentine ideas about the proper appearance of images were considered applicable, but mostly ignored, especially when it came to prints that might avoid the attention of Church censors by circulating locally or in a relatively limited geographical area.[21] Yet the bare fact that Catholic Reformation criteria for the appearance of images were known and occasionally acted upon by the Council of the West Indies is enough to suggest a whole chain of negotiations between the population and representatives of the Church in the Spanish Americas.

The particular circumstances of production and reception in New Mexico provide an interesting case study of how a profit-driven private industry intersected with official attitudes of the institutionalized Catholic Church toward religious images. There is considerable visual evidence to argue—against the grain of existing scholarship, but in keeping with Lange's insight that the religious prints that appeared in New Mexico circulated in a world network of trade—that the introduction of new print technology to New Mexico around 1820 forms a continuum, rather than a radical break with tradition. A recent study of American holidays titled *Consumer Rites* considers the "process by which [consumer-oriented versions of celebration] have been vested with significant cultural authority and legitimacy."[22] The present study is likewise concerned

with the expressive significance of commodified objects in order to comprehend *both* "the power of market forces and the semiotics of gifts."[23]

Local Perspectives on Global Visual Culture

Since the early contact period of the sixteenth century, missionaries in Mexico had used imported prints as models for the ecclesiastical decoration of their missions, or *conventos*.[24] Relatively few of the thousands of paper images that circulated in the Spanish colonial period and later survive, owing to the ephemeral nature of the medium, but their existence can often be reconstructed indirectly, through painted and sculpted images in widely scattered geographical locations based on the same compositions and pictorial formulas. (For hide paintings, see Kelly Donahue Wallace's and Donna Pierce's contributions to this volume.) How else, asks Yvonne Lange, do we account for common features—despite disparities in terms of historical, socioeconomic, and religious factors—in different geographical areas as widely separated from one another as India, the Philippines, Mexico, and South America?[25]

From the earliest period, prints in the colonial world were complex, hybrid productions. Typically, the composition might have been designed by an Italian painter, translated into a print by a Flemish engraver, published by a Dutch press (the Plantin Press in Antwerp held a monopoly in New Spain), and shipped by a Spanish merchant. In its colonial setting, the same print might have served as a model for a copy published by a Mexican press or might have been used for artistic instruction in or outside an academic setting.

Moreover, prints did not always have ecclesiastical sponsorship; lay individuals and community groups also commissioned prints for commemorative and other purposes, occasionally even to criticize the colonial government.[26] By the eighteenth century, many religious prints were marketed by private merchants for profit.[27] In nineteenth-century New Mex-

ico, French, German, Swiss, and U.S. firms competed for the market in religious images. That market opened up further after the region became a U.S. territory and long-distance transportation improved.[28]

An international market in mass-media religious images precipitated complex local effects in nineteenth-century New Mexico. After mid-century, stylish and affordable prints imported from the eastern United States, Europe, and Mexico were increasingly favored over locally manufactured paintings and sculptures. Rapid change in New Mexico's visual culture was facilitated by a combination of new print technology, political restructuring of the region (New Mexico became a U.S. territory in 1848), and a better transportation system that in a few decades brought more people and goods to Santa Fe, Albuquerque, and the surrounding region than the area had ever known in its long human history. Once the transcontinental railroad system and its local infrastructure were in place around 1880–85, even inhospitable areas like the Hopi mesas received schoolmasters, missionaries, archaeologists, photographers, and tourists, including one adventurous German art historian as early as 1896.[29]

Misinterpretations and reinterpretations of images could, and did, occur at several points in this process. For example, a European print publisher might re-label an image in his inventory for distribution to a new audience. Or an image might be assimilated to a different devotion at the point of reception, perhaps because the two shared some significant feature. Lange has identified an interesting case in Puerto Rico, where these two kinds of changes occurred in conjunction, resulting in an image for the local cult of the Virgin of Hormigueros derived from a mislabeled image of the Virgin of Monserrat.[30] The researches of Robert Farris Thompson and Donald Cosentino suggest that the Puerto Rican devotion may also embody African beliefs, though this possibility requires further study.[31]

Whether the devotion originated in Europe or Latin America, however, economic competition responded to as well as created consumer demand for a certain type of product. To date, the distribution and reception of religious prints in northern Mexico and New Mexico during and after the Spanish colonial period are not well documented, but the anecdotal evidence currently available suggests, among other things, that an international market in religious prints provided models for locally manufactured paintings.[32] Conversely, the appearance of these prints—particularly the saturated colors and other painterly effects of late nineteenth- and early twentieth-century chromolithographs—suggest that European publishing houses also responded to local market demand, not just for certain subjects, but also for specific visual effects. To give an example of this cross-fertilization, the exportation of European chromolithographs since the mid-nineteenth century helps to explain the highly saturated colors and similar compositions of contemporaneous Mexican *laminas* associated with a number of popular northern Mexican devotions. Surviving *laminas* and chromolithographs for such popular devotions as Our Lady the Refuge of Sinners, Our Lady of Light, and Our Lady of Remedies are highly conventionalized images, but they are not exactly alike. The minor variations, and numerous copies of each variation, are significant because they indicate the use of prints as models. This evidence further suggests that European publishing houses and local artists competed for the same mass markets.

A typical case is Our Lady the Refuge of Sinners (Fig. 11-4), patron saint of the city of Zacatecas, whose image originates in an Italian painting brought by Jesuit missionaries to the city in 1719. This "original" is a copy of an eighteenth-century altar in Frascati in north Italy, which is, in turn, closely modeled after the Madonna of Pompeii, still one of the most popular shrines on the Italic peninsula (Figs. 11-5, 11.b.1 & 11.b.2).

What is true of one pilgrimage site in Zacatecas can be claimed for other northern Mexican devotions. The sacred images associated with these shrines were also known farther north, in what is now northeastern and central New Mexico. Painted New Mexican versions of the cult figures for these devotions predate European chromolithographs and Mexican *laminas*.

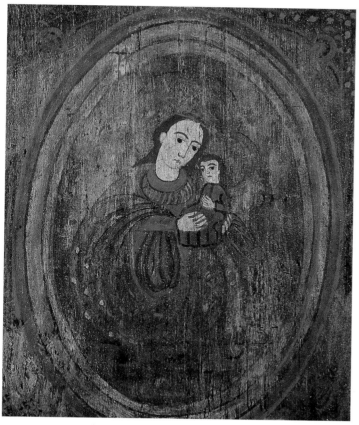

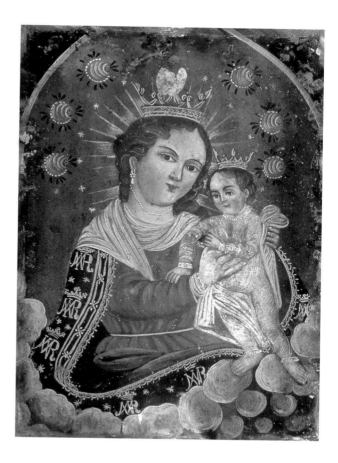

11-4. José Aragón, *Our Lady Refuge of Sinners,* gesso and water-based paint on wood panel, early–mid-nineteenth century. Collection Alyce and Larry Frank.

11-5. Anonymous, Mexican, *Our Lady Refuge of Sinners,* oil on tinplate, late nineteenth century. New Mexico State University Art Gallery (1967.1.2).

Although the manner in which particular images found their way north and became established in New Mexico, sometimes with local dedicated shrines, is undocumented, their sheer numbers point to a familiar pattern of lay practices associated with popular shrines throughout the Catholic world.

Theorizing Catholic Consumer Desire

In its new setting, a devotion translated to Mexico from Europe, such as Our Lady Refuge of Sinners in Zacatecas, acquired local popularity through the establishment of a shrine, the distribution of images, and/or the establishment of confraternities. Prints may have been imported also, but in many cases Mexican presses mass-produced images for popular shrines and devotions.[33] Settlers who emigrated north from northern Mexico to what is now New Mexico brought devotions and images with them. Traveling merchants brought more. In reverse, pilgrims made their way south down the same Camino Real and Chihuahua Trail to pilgrimage sites in Mexico.[34]

These circumstances account for the incidence of the same conventionalized compositions in New Mex-

The model for New Mexican representations of *Our Lady Refuge of Sinners* was a painting in the Baroque style of Guido Reni and Salvator Rosa, which was brought to Mexico in 1719 by a Jesuit missionary and placed in the city of Zacatecas, where this manifestation of the Virgin became the city's patron saint. The direct source of the illustrated *retablo* of *Our Lady Refuge of Sinners* by José Aragón (Fig. 11-4), however, was probably a print commemorating the shrine in Zacatecas, although Aragon's painting predates any surviving print by several decades.

According to Gloria Giffords, *Mexican Folk Retablos,* 62, the "original" image of *Our Lady Refuge of Sinners* is itself a copy of an eighteenth-century altar in Frascati in northern Italy. This is, in turn, very similar to other manifestations of the *Maestà* (the Virgin seated on her celestial throne) holding the Christ Child, such as the Madonna of Pompeii, still one of the most popular shrines on the Italian peninsula. About 25 percent of surviving Mexican paintings on tin, or *laminas,* depict *Our Lady Refuge of Sinners,* an indication of Zacatecas's heavy output of devotional images. The Mexican example illustrated in Figure 11-5 closely resembles the shrine image at Zacatecas. That such faithful copies occur in both Mexico and New Mexico, alongside similar manifestations depicted in a range of styles, indicates the local availability of imported prints derived from a variety of artistic sources (compare page 206, Fig. 11-8, a tin-framed *retablo* created by cutting out an advertisement from a trade catalogue of religious prints in different styles).

ican religious art that were popular in northern Mexico, even though the material objects were fabricated differently from different materials. Among the shared subjects are similar representations of Our Lady Refuge of Sinners, Our Lady of Light, Our Lady of San Juan de los Lagos, Our Lady of Perpetual Help, Our Lady of Mount Carmel, and the Christ Child of Atocha—all of which have major pilgrimage sites in northern Mexico (Fig. 11-6).[35] From the mid-nineteenth century on, imported, mass-produced prints joined the locally produced religious images, including black and white prints published in Mexico that appeared in both regions.[36] But how did the local population deal with the infusion of new visual culture, along with new pressures from the Catholic Church after Archbishop Jean Lamy's arrival in 1851?

Viewed as evidence of the dynamic social function of religious images in local communities, the mass-media images introduced to New Mexico in the nineteenth century take on new significance. Many factors worked "like enzymes" to change the composition of "foreign bodies"—to borrow Stephen Greenblatt's analogy.[37] The visual evidence suggests that the organic process by which imported religious prints acquired local identities, far from erasing the cultural distinctiveness of the region, repeated longstanding patterns of active reception, appropriation, and inflection. The region's predominantly Spanish Catholic religious orientation is built over a cultural base that is not part of the Judaeo-Christian-Islamic tradition. Moreover, New Mexico was a distinct, heterogeneous cultural entity involved in a lengthy process of being incorporated into the United States during the time that the visual culture discussed in this chapter initially circulated among its people. New Mexico was part of New Spain until 1821, was taken over from Mexico by U.S. military forces in 1846, and became a state only in 1912.

What difference does this configuration of Catholicism, strong Native American presence, and territorial status make as far as New Mexico's visual culture is concerned? In the United States, mass-mediated visual culture emerged over the course of the

11.b.1. Prayer card, *Madonna of Pompeii,* **Shrine of the Madonna of Pompeii, Pompeii, Italy, c. 1997. Collection Claire Farago.**

11.b.2. Roadside shrine with printed image of the Madonna enthroned with Christ Child, near Palermo, Sicily, Italy, 1997. Photo Ken Iwamasa.

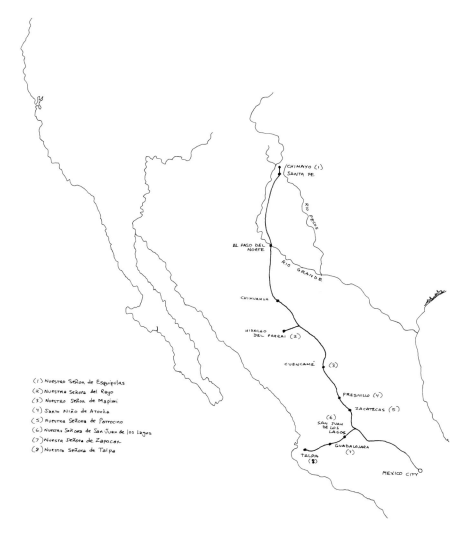

(1) Nuestro Señor de Esquipulas
(2) Nuestra Señora del Rayo
(3) Nuestra Señora de Mapimi
(4) Santo Niño de Atocha
(5) Nuestra Señora de Patrocino
(6) Nuestra Señora de San Juan de los Lagos
(7) Nuestra Señora de Zapocan
(8) Nuestra Señora de Talpa

11-6. **Map of northern Mexican pilgrimage routes. Drawing Donald Preziosi.**

nineteenth century, made possible by a combination of uniform currency, widespread literacy, dependable long-distance transportation, a reliable postal system, and mail-order entrepreneurship. Publishing enterprises flourished in the United States, thanks to a predictable supply of raw materials and the requisite technology, competitive producers, and capital.[38] This so-called market revolution reached New Mexico almost as early as it did the eastern seaboard; that is, the new technology of lithography was already being imported in the 1820s and 1830s, and the most active period of demand, from the 1860s to the early twentieth century, coincides with trends elsewhere on the continent.[39]

In the territory of New Mexico, however, mass-media visual culture was *entirely* imported and, therefore, a relatively scarce (though desired and affordable) presence compared with its counterpart on the east coast.[40] In the regional economy of central and northeastern New Mexico, mass culture did not replace local

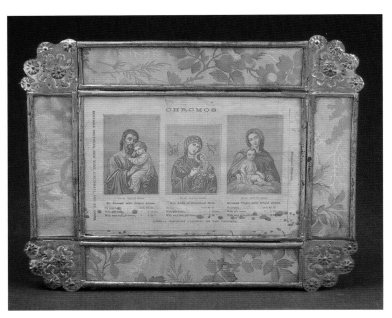

11-7. Benziger Brothers, *Saint Joseph with the Christ Child,* and two images of the *Virgin and Child,* trade catalogue, c. 1890. José Apodaca, tinwork frame with wallpaper inset panels. Collection Museum of New Mexico, International Folk Art Foundation Collections in the Museum of International Folk Art (FA.77.37-1), Santa Fe. Photo Blair Clark.

artistic production but, rather, intersected with it. Just as Native American imagery was common to everyone's daily environment and is, therefore, central to any discussion of New Mexico's artistic culture, manufactured and handmade goods shipped from outside— first from central Mexico and later from the United States—were a significant local presence.[41]

Some of the same publishing houses that supplied the Protestant market elsewhere supplied New Mexicans with Catholic images of the Virgin, Christ, saints, and other holy figures. By the 1840s, manufactured goods made in the eastern United States were made available by Yankee traders to upscale Hispano households in the Santa Fe region.[42] By the 1850s, European and American lithographs were sold locally, and a number of tinworking workshops, each with its own distinctive style, were operating in competition with one another to provide colorful, reflective frames for

the prints.[43] Currier, later Currier and Ives of New York, and Kurz, later Kurz and Allison of Chicago, were two of the largest U.S. firms that competed in the New Mexico market, along with the French firm of Turgis, the Swiss firm of Benziger, and many others less well known.[44] These new firms also participated in longstanding international patterns of print distribution established in the early modern period to serve the Catholic community.[45]

Many surviving nineteenth-century religious prints collected in New Mexico are simultaneously labeled in several languages, suggesting that European publishing houses distributed the same image to different ethnic groups. A survey of 72 (undated) nineteenth-century prints in the collection of the Museum of International Folk Art in Santa Fe produced the following statistics indicative of these international distribution practices: of 64 prints with printed texts, 15 were multilingual, usually in Spanish and English, often with a third language, which might be French, German, Italian, Portuguese, or Latin. Of the images with text in a single language, 3 were in French, 9 in German, 1 in Italian, 13 in Spanish, 19 in English, and 2 in Latin.[46]

Nineteenth- and twentieth-century trade catalogues provide evidence that, in the capitalist process of global distribution, the "style" of representation assumed the new role of attracting consumers. Trade catalogues illustrating images in different styles side by side make it clear that the choice of artistic or cultural identity—Italo-Byzantine, High Renaissance, Murillo, or some other—was up to purchasers, whether individual buyers, peddlers, or suppliers to stationers, religious shops, or popular shrines (Fig. 11-7). The differences are most often indistinguishable from our historical vantage point—and the clients' links with the parent cultures of these styles ranged from direct to nonexistent.

Few studies have been published to date on consumerism in Catholic settings.[47] The following observations, gleaned from regional studies of New Mexican culture focused on other subjects, are intended to suggest useful avenues for further

11-8. Anonymous, French (?), *Christ with a Youth*, chromolithograph, c. 1895, Isleta tinsmith, tinwork frame with glass and paper illustrated with floral motifs in ink and watercolor, c. 1885–1920. Print inscribed in lower border in ink: *Señor San José y el Niño Dio* [Saint Joseph and the Christ Child]. Museum of Spanish Colonial Art, Santa Fe, New Mexico. Photo Jack Parsons.

11-9. Anonymous, French, *Christ with a Youth*, first communion card, chromolithograph, dated 10 June 1909, reproduced after Rosenbaum-Dondaine, *L'Image de Pieté en France*, no. 245.

research. In keeping with dynamic economic conditions and new institutional pressures, local adaptations of mass-mediated images show a complex process of reinterpretation at work. French, Swiss, and German chromolithographs and their American-made imitations introduced many devotions unfamiliar to the Spanish Catholic audience of New Mexico.[48] Some of these images may have been aimed at recent immigrant Catholics, but it is likely that locals associated the new subjects with devotions already familiar to Spanish Catholics in the region. One case that can

be documented, thanks to a handwritten Spanish inscription on the border of the print, misidentifies an image of Christ and a youth that appeared in French announcements of First Communion from the second half of the nineteenth century (Fig. 11-8). Its Spanish-speaking New Mexican owner labeled the image as "Señor San José y el Niño Dios" (Saint Joseph with the Christ Child), even though the "Christ Child" is clearly lacking a halo while "Saint Joseph" has one (Fig. 11-9).[49] It is easy to imagine that many other unfamiliar subjects and new variants of familiar ones,

11-10. **Benziger Brothers,** *Jesus Christ "El Sagrado de Jesús,"* oleograph, c. 1905, Isleta tinsmith, tinwork frame with painting on glass. Collection Lane Coulter, Santa Fe.

like the blond and blue-eyed image of Christ that the Benziger Brothers introduced (Fig. 11-10), were also interpreted by New Mexican audiences on the basis of longstanding local expectations and traditions rooted in Spanish Catholicism.[50]

Recent studies of mass culture stress that supply and demand are driven by resources of time and money to create, satisfy, and renew consumer desire. But what exactly is "consumer desire"? Catholic images circulating in a predominantly Catholic society appear to present an exception to standing accounts of consumer desire that associate it with Max Weber's

concept of disenchantment. Briefly stated, disenchantment is the collapse of the general assumption that independent agents and "spirits" were operative in nature.[51] Weber theorized that consumer desire in a disenchanted society is driven by disillusionment with the material satisfaction of needs. Dissatisfaction continually renews the desire to find material satisfaction.

Consumerism defined in the context of lay Catholicism, however, is not a form of disenchantment, because the worshiper participates in a world where agents or "spirits" *are* considered operative in nature. The religious image and the prayers and material offerings associated with it are the visible symbols of human pleas for divine aid from that world. The cycle that involves mass media religious images in a Catholic society is fueled by expectations that are satisfied often enough (and not too often) to renew human desire.[52]

The cycle of consumption in a Catholic society served by icons and ex-votos corresponds more closely to Colin Campbell's revised Weberian model. Campbell's study of the early days of mass consumerism in late eighteenth-century England concludes that Romanticism was tied to (an expression of) consumers' basic desire "to experience in reality the pleasurable dramas they have already enjoyed in their imagination."[53] By emphasizing the imagination's critical role in the cycle of consumer desire, Campbell's model also describes Catholic justifications of images: in both cases, material representations elicit a desired and renewable emotional response. But there is an important difference: Campbell contends that the imagined experience leads to literal disillusionment with each purchase, while the Catholic iconophile position maintains that the right kind of image elicits the right kind of desiring experience.

Pious Resonance: The Active Reception of Chromolithographs

In foregrounding the basic human activity of making symbolically meaningful worlds out of material objects in the environment, the foregoing sketch

recasts the cycle in which desire operates in a Catholic society in terms of consumerism. The resulting account is less pejorative than Weber envisioned (from his Protestant experience). The difference in turn recasts the fundamental question with which this chapter began: did the introduction of imported chromolithographs contribute to the demise of local *santo* production because they were "better" (more pleasing) images or because they were "worse," in the sense that the religious chromolithographs—contrary to Lamy's expectations—led to disillusionment? The imported lithographs were encouraged by the institutionalized Catholic Church under Lamy and his successors, who strongly disapproved of regionally manufactured paintings and sculptures as unfit for veneration.[54] But the aesthetic attitudes that Lamy and his staff introduced still had to accommodate to local conditions of reception. We do not know how Lamy felt about the tinwork and wallpaper surrounds, but even if he disliked these elaborate settings as much as Saint Bernard of Clairvaux disliked the highly embellished reliquaries of his own day, the religious establishment was unable to prevent private enterprise.

Perhaps the two seemingly irreconcilable processes of consumerism and enchantment were going on at the same time—in the sense, perhaps, that García Canclini writes about different subgroups all seeking their own autonomous goals in a heterogeneous society where modernity and tradition are intersecting, rather than mutually exclusive, processes.[55] If the same description can be applied to different subgroups seeking economic gain and spiritual health in New Mexico—and I argue that it can—what was the outcome?

In the context of religious desire, it matters not whether an image is painted or printed: what matters is its ability to intercede on behalf of the petitioner. Mass-media technology brought artistically sophisticated images to New Mexican worshipers, but the new paper icons also continued the existing cycle of religious desire. At the same time, however, European-made globally marketed lithographs introduced linguistic slippages and other dislocations of meaning into the local Catholic culture. It is difficult to estimate the level of consternation that these new introductions generated. The effect of unfamiliar (but not totally alien) religious imagery cannot be quantified. That linguistic and other cultural barriers introduced communication problems can be inferred, however, from anecdotal evidence, such as the framed page of a Benziger Brothers trade catalogue, c. 1890, already cited (Fig. 11-7). The framed object consists of three images in different styles, with inscriptions below listing the prices of the prints offered. We are fortunate in this case to know that the tinsmith, José María Apodaca, did not read English;[56] his inclusion of the price list is understandable in light of the fact that many imported lithographs and chromolithographs of the period do include real inscriptions, most frequently lines of scripture, in languages other than Spanish.

The Availability of Materials

New Mexican religious material culture is mainly associated with people, like the tinsmith José Apodaca, who created symbolically meaningful worlds out of objects in their daily environments, regardless of what these objects were originally meant to convey. Recycled wallpaper and tinplate could "signify" the Baroque decorations of a sculpted gilt frame; an unfamiliar scene of First Communion could morph into the familiar Saint Joseph and Christ Child. Personalizing a mass-produced religious image is the mid-nineteenth-century equivalent of commissioning a local artist to make a unique version of a conventional religious subject. Both kinds of images are forms of symbolic ordering—"aesthetic construction"—in that communication with the supernatural takes place through the selection and placement of material objects. Whether the materials involved are or are not commercial givens, what matters is that they are available and manipulated for personal pious use.

The foregoing analysis of the visual evidence, though it is but a small sampling of the available data,

suggests that processes of capitalism and Catholicism can both be observed in these images. For example, a frame that emulates a church facade is simultaneously an innovative visual departure from traditional frames and a direct reference to traditional lay Catholic practices of translating a devotion from one sacred place to another—in this case from a church to a domestic setting (Fig. 11-11). This is not to deny that the introduction of mass-produced religious prints added to the social fragmentation of New Mexico's population. Behaviors that have been identified with consumerism, such as imitation, emulation, innovation, manipulation, and status seeking, were undoubtedly operative forces.[57] The rapidly emerging fashion for imported, brightly colored prints of religious subjects, depicted by academically trained artists, elaborately framed in regionally crafted materials, was within reach of the most modest households and appealed to upwardly mobile socioeconomic aspirations as well.

So what can we make of formal visual qualities that span the range of representational technologies from hide paintings to mass-media images in tinwork frames? Is this Catholic material culture really distinctive of the region, as the early *santos* literature tried to demonstrate? If so, what accounts for its distinctive visual characteristics—given the ethnic and cultural heterogeneity of the region? The short answer is that the materials available in the region account for the shared features of the objects. Yet, in addition to the shared use of whatever materials were available, "aesthetic construction" also involves choices that are not determined by materials. In both locally painted and sculpted *santos* and these ensembles of mass-media prints in tinwork frames, artistic embellishments include elaborate framing devices, geometric patterns, and other motifs derived from both indigenous artistic traditions and imported materials (such as Puebla blue-and-white majolica imitations of Chinese export ceramics); prominent landscape settings; and bold graphic compositions, often with exuberant drawing by artists largely untrained in European academic techniques of representation. To put this into more general terms: availability of materials and technology, conditions of reception and use, reproduction of existing prototypes, and traces of the numinous inscribed by the artist or maker in the material record all contribute to a uniquely New Mexican "style."

At this junction of private industry and religious practice, in the middle decades of the nineteenth century, no one attempted to make *santos* into the visible sign of a "Spanish" cultural identity; but the process of defining a cultural heritage began while mass-media images were the predominant form of religious art in the region. When academics and museum professionals joined the ranks of entrepreneurs, they historicized the local production of painted and sculpted *santos* by "re-inventing" it as an "authentic" artistic tradition.[58] At this point, in the opening decades of the twentieth century, the reconfigured cultural identities that are still familiar today were set in place.

To review, I have recast the cycle of religious desire operating in a Catholic society in terms of consumerism, thus setting the stage for the following three chapters. They deal directly with the ways in which religious instruments of devotion were transformed into secularized artifacts associated exclusively with the newly recognized (and to some extent, newly minted) "Spanish" Hispanic cultural heritage of the region. In Chapter 12, Tom Riedel documents the emergence of a regional artistic tradition within a nationalistic framework during the early years of the heritage industry. Riedel studies the rise of two early twentieth-century *santeros,* Juan Sanchez, who worked for the federal government in the WPA era to preserve the region's "Spanish" cultural identity; and Patrociño Barela, who was packaged as a modern "folk artist" for an aggressive new art market driven by private capital and was marketed to the "public" as national culture. In Chapter 13, Robin Farwell Gavin

11-11. **Rio Arriba Painted Workshop,** *nicho,* **tinwork frame with glass and painting on glass, c. 1890. Museum of Spanish Colonial Art, collections of the Spanish Colonial Arts Society, Santa Fe. Photo Jack Parsons.**

further documents a situation that Marianne Stoller introduced in Chapter 7—namely, negative reception of the possibility that Native American artists and their cultural traditions contributed to the local production of religious images. The idea was initially embraced by naively racist amateur historians who delighted in the "primitivism" of the images, and it was then just as hastily denied by professionals operating within the disciplinary framework of art history and museology, in the name of maintaining objective academic standards. Gavin finds that national-culture models of "folk art" overlooked the very existence of artists and workshops operating in the region south of Albuquerque, simply because this geographic zone became a politically liminal region after modern nation-state borders were established. In the final chapter of the section, Dinah Zeiger adds a contemporary twist to the arguments about the construction of cultural tradition in the wake of consumerism. Zeiger focuses on present-day consumers who both appreciate commercially marketed *santos* as "authentic" works of art and use them as exemplary domestic reminders of moral (if not always strictly religious) values. The complex interplay of consumer and religious desire, along with capitalist quest for gain, scholarly investigation, racist thinking, and national patrimony-building through neocolonialist museum acquisitions of exotic material is also the subject of the book's final essay, a rumination on the ethics of scholarship written through the focusing lens of Aby Warburg's trip to the American Southwest in 1895 and 1896, much celebrated today but deeply problematic for that reason.

THOMAS L. RIEDEL

José Benito Ortega (1858–1941), the last documented nineteenth-century *santero* (saint-maker), was still living in Raton, New Mexico, in 1936 when Juan A. Sanchez (1901–69) began making *santos,* or traditional religious images, forty-nine miles away in the town of Colmor.[1] Sanchez's Our Lady of Guadalupe *bulto* (carving in the round) mimics Ortega's "flat figure" style, and the severe countenance features the heavy-lidded and outlined eyes, arched eyebrows, and pointed chin of Ortega's work (Figs. 12-1 and 12-2). Even so, Sanchez was not affiliated with Ortega, who had stopped making *santos* to work as a house-plasterer nearly 30 years earlier.[2] Sanchez's work drew from the traditional visual vocabulary of Ortega and other *santeros,* but the circumstances of its production marked a dramatic shift in the twentieth-century meaning and use of *santos;* while carvings from the eighteenth and nineteenth centuries were commissioned as devotional icons, Sanchez's work was created as "art" under the auspices of the Federal Art Project.[3]

In the opening decades of the twentieth century, Hispanic religious folk art, like other folk art indigenous to the geographic areas of the United States, became collectible, an object of national scrutiny. As *santos* were increasingly removed from churches and amassed by private collectors, the concern that they were disappearing spurred a movement, orchestrated in part by collectors themselves, to keep as many of the icons as possible within the region of their origin and to revitalize the production of traditional Hispanic arts and crafts in general. In the 1930s, government-directed projects such as the *Portfolio of Spanish Colonial Design in New Mexico* and the *Index of American Design* attempted to safeguard the historical record. As the significance of *santos* shifted from devotional icon to collectible object in the twentieth century, a new contemporary style emerged—*santos* as tourist art.

Santos as "American" Folk Art

The interest of early twentieth-century American artists and collectors in native painting, sculpture, and handicrafts became institutionalized in the 1930s under the aegis of the Federal Art Project (FAP), a cultural program of the New Deal.[4]

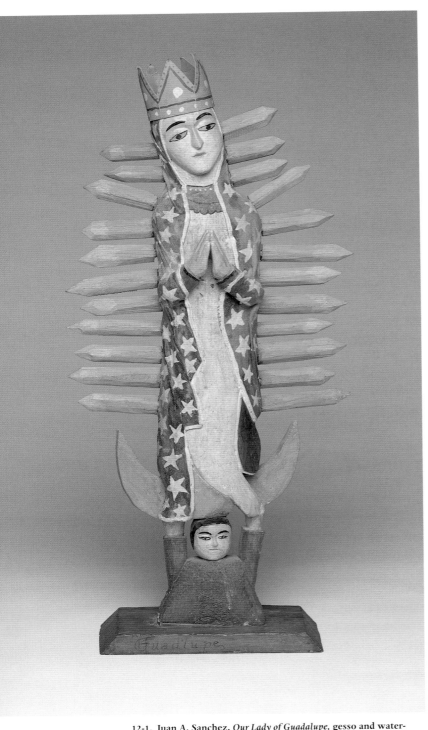

12-1. Juan A. Sanchez, *Our Lady of Guadalupe,* gesso and water-soluble paint on wood, 1937. WPA Project purchase, the Colorado Collection, CU Art Museum, University of Colorado at Boulder.

One of the most extensive FAP undertakings, the *Index of American Design,* made explicit the national merit of the humble and the handmade by putting hundreds of artists to work recording an incredible variety of indigenous designs. *Index* artists were directed to abide by principles of "strict objectivity, accurate drawing, clarity of construction, exact proportions, and faithful rendering of material, color, and textures" as they documented housewares, furniture, toys, and sculpted figures, such as weathervanes, shop signs, and *santos.* In its finished multivolume form, the *Index* was slated to serve not simply as a record of the past but as a source book for contemporary designers.[5]

The diverse objects selected for illustration in the *Index* embodied an inclusive American cultural inheritance, and the fact that this monumental self-examination was initiated in the 1930s reveals the striking preoccupation of Depression-era Americans with their cultural history. It is no surprise that folk art and craft gained national attention during the disastrous times of the Great Depression—handmade objects such as weathervanes and trade signs came to represent a simpler past that provided an antidote to the devastation of the modern, industrialized world. As the critic Henry McBride noted in 1932, it was impossible to regard such objects "without a nostalgic yearning for the beautiful simple life that is no more."[6]

At the same time, folk art's simplified aesthetic appealed to collectors who saw in it an affinity to modern art. By the 1930s, contemporary American artists such as Hamilton Easter Field, Charles Sheeler, and Elie Nadelman had begun collecting folk art along with esteemed collectors such as Abby Aldrich Rockefeller.[7] Folk art further received institutional endorsement when Holger Cahill, who later became National Director of the FAP, curated exhibitions of folk painting and sculpture at the Newark Museum in 1930 and 1931 and "The Art of the Common Man in America" at New York's Museum of Modern Art in 1932. That these exhibitions displayed weathervanes and ships' figureheads along with folk paintings and sculptures in

museum and gallery settings demonstrated that even utilitarian objects held aesthetic merit comparable to that of more established and accepted forms of American art.

Indeed, to Cahill and the collector Edith Gregor Halpert, the similarities between folk art's formal qualities and those of modern art were not serendipitous but demonstrated a previously unrecognized continuity in the American art tradition. On the occasion of the 1931 opening of her American Folk Art Gallery in Greenwich Village, Halpert declared that the objects making up her inventory were selected "not because of antiquity, historical association, utilitarian value, or the fame of their makers, but because of their aesthetic quality and because of their definite relation to vital elements in contemporary American art."[8] Cahill, too, asserted that folk art gave modern art "an ancestry in the American tradition and show[ed] its relation with the work" of the time.[9]

As director of the FAP beginning in 1935, Cahill used the *Index of American Design* as a vehicle to reiterate and codify the linkage between folk and contemporary art. He believed that American folk art provided a uniquely national "usable past" that could influence contemporary creativity from furniture design to art production, and that the *Index* could thus play a role as artifactual bridge from the past to the future. But Cahill made clear that aesthetics alone did not determine the constitution of American tradition in the arts. Although formally, weathervanes and *santos* were reduced to geometric simplicity and exhibited the "indifference to surface realism" that Cahill noted as the primary hallmark of both folk and modern art, objects with origins in Eastern, Protestant, mercantile culture were considered more "American" than *santos,* which represented Hispanic Catholicism.[10]

One of the limiting criteria for inclusion in the *Index of American Design* was that objects demonstrate European lineage, since, according to Cahill, the "peoples of European origin . . . created the material culture of the country."[11] Donald J. Bear, Director of FAP region five (Arizona, New Mexico, Colorado,

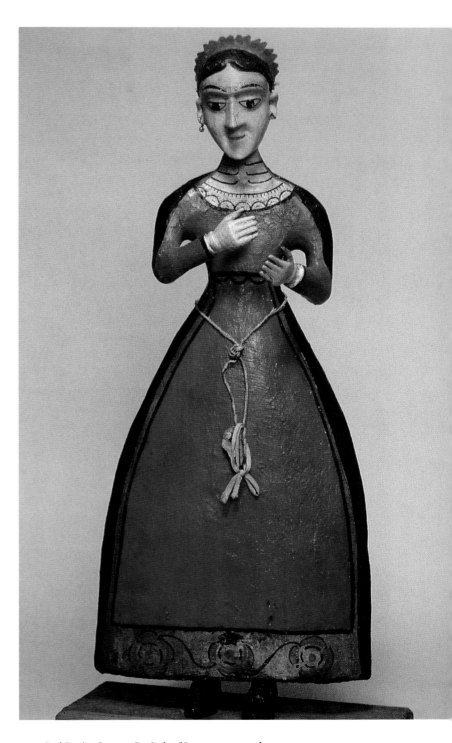

12-2. José Benito Ortega, *Our Lady of Sorrows,* gesso and water-soluble paint on wood, c. 1875–1907. Taylor Museum, the Colorado Springs Fine Arts Center (TM 1595), Colorado Springs.

Wyoming, and Utah), echoed Cahill's Eurocentric conclusion when he stated that "the School of Spanish Colonial Art is even more native to us in tradition than that of the American Indian."[12] While the official, administrative position of the FAP relegated the investigation of Native American arts to separate, ethnological study, it also established cultural categories that New Mexican Hispanic religious art problematically fit, since historical *santo* production was credited by authors at the time to Native American artisans working under the tutelage of Catholic priests.[13] And even if *santos* were of primarily Hispanic origin, contemporary observers correctly noted that many New Mexican Hispanos themselves were "of mixed Indian and Spanish blood."[14] New Mexican Hispanic racial complexity seemed to defy attempts at classification— a 1934 Public Works of Art show, for example, had no "Hispanic" category at all and exhibited the work of the woodcarver José Dolores Lopez as "Indian." And in an attempt to unravel the racial conundrum, the Spanish Arts Shop manager Helen Cramp McCrossen further contributed to the confusion by explaining that the Spanish colonial arts were "not Indian, but Spanish," the work of "the native population that is neither Indian nor American."[15]

For purposes of the *Index of American Design,* the European roots of Spanish colonial art were emphasized over the possible contribution of Native American artisans to its form. Still, even though Cahill noticed "striking interconnections" between seventeenth-century embroidery designs from New England, Shaker inspirationals of the nineteenth century, and New Mexican chest paintings and *santos,* he narrowed the field of what constituted Americanism even further by declaring that the tradition of the early American craftsman was "basically English." He considered Spanish colonial art, on the other hand, more "related to peasant art" and farther away from the center of American tradition.[16]

If the American craft tradition was basically English, so too was the American Protestant view of Roman Catholic art. Protestant thought, especially

the Puritanism that largely shaped the culture of the original American colonies, shunned the religious imagery common to Roman Catholic art in favor of verbal communication in worship. *Santos* stood apart from other American folk art because of their Catholicism and were further tainted in the minds of the American public by their connection to the penitential rituals of the Brotherhood of Our Father Jesus the Nazarene, popularly known as the Penitentes.

In the 1920s and 1930s, the Brotherhood's self-flagellation and especially its Good Friday re-enactment of Christ's Passion, reported to end "in the realistic and sometimes fatal crucifixion of one of their number," captured the imagination of the American public.[17] Brotherhood rituals were even marketed as a tourist attraction: the *Santa Fe Visitors' Guide* of 1931 listed "March—Good Friday—Flagellation of Los Penitentes" in its calendar of recommended Indian dances, and in its travel guide the New Mexico State Highway Commission heralded the "strange rites of the Penitentes" as a "perennial source of interest to tourists as well as local residents."[18] Reports in the press characterized Brotherhood ceremonies as "primitive," "weird," and "macabre," and focused as much on the sport of *observing* rituals, which were off limits to outsiders, as on describing them. For example, Raymond Otis's "Medievalism in America," published in *New Mexico Quarterly* in 1936, hinted at the dangers to interlopers, reported to range from being pelted with stones to risking death:

Annually, during Holy Week, and particularly on Good Friday night, automobiles steal out of the larger New Mexico towns and scatter into the back country beneath the full moon. They are loaded with hushed, expectant people who are convinced of their temerity and the perils of their mission. Often without headlights, if the moon be bright enough, they move into the mountain valleys where the remote and medieval Mexican hamlets are, and carloads of hearts beat a little faster.[19]

Published accounts also detailed the specialized trappings such as *piteros* (flutes), scourges, rattles, and icons employed in Brotherhood rituals. In "Through

Penitente Land with a Leica Camera," published in *Photo Era* in 1929, Willard Morgan related seeing a "beautiful altar of santos" through the window of the *morada* (meeting house) at Las Trampas and eagerly photographed the *carreta de la muerte,* or death cart, as well as the "death-carrier for the Cristus, and other objects for the rituals."[20] In *Brothers of Light,* published in 1937, Alice Corbin Henderson also described a *morada*'s "small and large santos . . . lit by tall candles burning before them and dripping pools of melted tallow at their feet."[21] The author's husband, William Penhallow Henderson, illustrated the book with woodblock prints, making visually explicit the ritualistic role of icons described in the text (Fig. 12-3): "The penitent dragged the *Carreta del Muerto* by a horse-hair rope passed over his shoulders and under his arm-pits, the painful weight of the dragging cart cutting into his naked flesh—a penance as severe as any other, and increased by the fact that the axles of the cart were stationary, and where there was a turn in the path, the entire cart and its inflexible wheels were dragged by main strength."[22] Authors Sheldon Cheney and Martha Candler, writing in *Parnassus* in 1935, connected *santos* even more gruesomely to penitential practice, noting that the *retablos* in the collection of the Hispanic Museum in New York were "originally stained with human blood as a part of frenzied religious rites."[23]

Collecting, Copying, and Transforming Tradition

While the "primitive" nature of penitential rituals seemed foreign if not other-worldly to most Americans, that very primitivism contributed a measure of cachet to *santo*-collecting among more seasoned connoisseurs.[24] Even though *santos* did not generally enjoy popularity with collectors of more "American" forms of folk art, Cheney and Candler reported that the original eighteenth- and nineteenth-century works were nonetheless increasingly difficult to find.[25] Indeed, the Taos doyenne Mabel Dodge Luhan and the Santa Fe artists Frank Applegate, Andrew Dasburg, Cady Wells, and others had already been col-

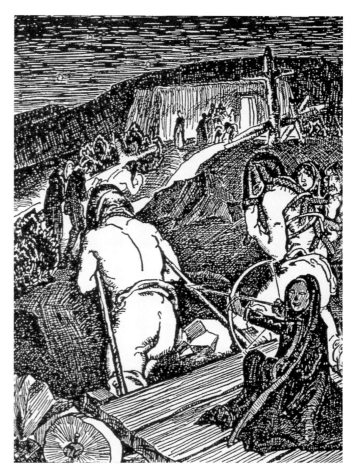

12-3. William Penhallow Henderson, "Penitente and la Carreta del Muerto," woodblock print from Alice Corbin Henderson and William Penhallow Henderson, *Brothers of Light: The Penitentes of the Southwest* (New York: Harcourt, Brace, and Company, 1937), p. 33. Reproduced with permission from Letitia Frank.

lecting *santos,* and the appeal of the icons as collectible art extended beyond the Southwest. Luhan warned the uninitiated that *santos* such as the *Cristo Crucificado* could be "extremely gory," exposing the wounds of crucifixion "lamentably, even shockingly," but credited Dasburg and herself with recognizing the icons as "an authentic primitive art, quite unexploited." "We were, I do believe, the first people who ever bought them from the Mexicans. . . . I was always giving one or two away to friends who took them east where

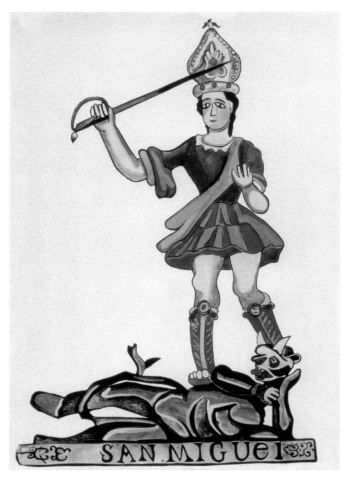

12-4. *Saint Michael Archangel* from *Portfolio of Spanish Colonial Design in New Mexico,* pl. 38, hand-colored linoleum block print. Norlin Library, University of Colorado at Boulder. The original *bulto* is in the Taylor Museum, the Colorado Springs Fine Arts Center (TM1599), Colorado Springs.

Art Project. Before work began on the *Index of American Design* in 1936, Hunter had already initiated efforts to record and preserve Spanish colonial art by directing work on the *Portfolio of Spanish Colonial Design in New Mexico.*[27] Unlike those of the *Index,* which recorded primarily secular objects, nearly forty of the *Portfolio*'s fifty plates illustrated objects used in Roman Catholic worship. The artist E. Boyd wrote the *Portfolio*'s text and made the original watercolor illustrations that served as models for its plates, linoleum-block prints hand-colored by FAP artists.[28] Hunter and Boyd worried about the loss of *santos* not only to unscrupulous collecting, but to disintegration. Boyd explained that many colonial *santos* were long neglected, owing in part to the influence of Archbishop Lamy, who included *santos* in his campaign against idolatry in the 1850s and saw to it that much colonial handiwork was replaced with "French style" pink and gilt plaster models.[29] Thus, many of the icons that had been moved to "barns, storerooms, and junk heaps" were "broken, worm-eaten, and water-rotted" and "further spoiled by poor mending and repainting." Given these circumstances, Boyd noted the importance "from both the historical and aesthetic viewpoint that a definite record be made as soon as possible."[30]

In determining which objects best represented historical Spanish colonial material culture and should therefore be illustrated in the *Portfolio,* Hunter and Boyd scrutinized what remained in northern New Mexican churches as well as items owned by private collectors, historical societies, and museums.[31] Boyd noted that an altar screen in the New Mexico Historical Society collection had originated at the chapel at Llano Quemado near Taos and hinted at her frustration with indiscriminate collecting when she stated that a *bulto* from the town of San Miguel (Fig. 12-4) had been "unfortunately removed from the Church."[32] *Santo*-collecting had indeed become a serious business. As the Denver Art Museum founder and *santo* collector Anne Evans noted in 1925, museums and dealers were already "bidding against each other for every treasure they [could] lay hands on."[33]

they looked forlorn and insignificant in sophisticated houses. People always *thought* they wanted them, though, and soon the stores had a demand for them."[26] Whether or not *santos* were always successfully integrated into private Eastern collections, beginning in the 1920s they were disappearing from rural New Mexican churches at an alarming rate.

Among those concerned that Spanish colonial material culture was in imminent danger of being lost was Russell Vernon Hunter, Director of New Mexico's

Private *santo*-collecting overlapped the organized efforts of the Spanish Colonial Arts Society (SCAS) to preserve colonial artifacts, and the popularity of *santos* as collectible art doubtlessly saved many of them from ruin. After meeting initially in 1925 as the Society for the Revival of Spanish-Colonial Arts, the SCAS formally incorporated in Santa Fe in 1929 to encourage and promote the collection, exhibition, and preservation of Spanish colonial arts, as well as to educate the public. The Society's earliest acquisition was the Llano Quemado altar screen, which had been purchased and restored when the church replaced the original with a contemporary work. In an attempt to stop if not reverse the rampant dispersal of church property, the SCAS also bought the private Santuario at Chimayó in 1929, restored it, and deeded it to the Archdiocese of Santa Fe.[34]

Frank Applegate and the writer Mary Austin provided the moving force behind the SCAS and were concerned not only that antiquities were being taken from the region, but that New Mexican Hispanos were increasingly distanced from their cultural heritage. In a 1931 issue of *Survey Graphic,* both lamented the effect that Anglo influence had had on the production of New Mexican indigenous crafts: Applegate observed that native furniture-making had "practically ceased with the influx of Americans who brought in cheap and ugly machine-made articles," and Austin noticed a "lessened capacity for making things, individual products of the hand and the spirit working coordinately."[35] In fact, the production of traditional furniture, ironwork, weaving, and *colcha* embroidery had waned from the beginning of the American territorial period in the mid-nineteenth century owing, as Applegate noted, to the availability of cheaper, mass-produced items. But if the introduction of mass-produced goods stymied production of Hispanic crafts, it also increased the desirability of colonial objects for collectors such as Applegate, who amassed an impressive personal collection of *santos* in the 1920s.

Although Applegate was primarily interested in original colonial objects for his own collection, he and Austin considered contemporary craft production a practical cultural enterprise that could also economically rehabilitate New Mexico's poor Hispanic population. This rehabilitation, however, was predicated on racist assumptions. Austin considered it her duty "to make the most sympathetic" and "most effective use" of Hispanos and tailored her reforms to her perception of Hispanic inadequacies. She stressed the futility of offering Hispanos a standard education, because "at adolescence the racial inheritance rises to bind them to the patterns of an older habit of thinking." Noting, however, that they had the "capacity to make things requiring a high degree of artisan skill, and to make them beautifully and well," she optimistically declared that "under proper tutelage the despised peon class could become the superior hand-craftsmen of the western world."[36]

By 1931, when Austin and Applegate wrote for *Survey Graphic,* the revitalization of Hispanic crafts was already under way, and it appeared Austin's hopes might come true. The SCAS had arranged the first public exhibition of Hispanic work at the Fine Arts Museum during the 1926 Santa Fe Fiesta and at subsequent Fiestas awarded prizes in a variety of categories such as blanket weaving, handmade furniture, figure carving, tinwork, braided rugs, hooked rugs, and crochet.[37] Complementing the work of the SCAS, federally funded, organized instruction in traditional crafts was initiated in rural communities in 1932, under the direction of Brice H. Sewell of the State Department of Vocational Education.[38]

The SCAS provided a retail outlet for native crafts from 1930 to 1933 at the Spanish Arts Shop in Santa Fe's Sena Plaza, and from 1934 to 1940, the Native Market on Palace Avenue was operated, and often subsidized, by the SCAS member Leonora Curtin.[39] Both the Spanish Arts Shop and the Native Market depended on sales for financial success, and in order for Hispanic crafts to be usable to the largely Anglo market, Hispanic tradition was reconfigured.[40] For example, Native Market chairs and stools, unlike traditional pieces, had padded seats covered with *colcha*

embroidery, handspun and woven fabric, or woven rawhide seats. Tinwork frames were made for mirrors instead of religious prints; and nontraditional tin table lamps, flowerpots, tissue holders, and ashtrays were made in response to customer requests.[41] Curtin emphasized that the traditional crafts had to "leap from the eighteenth and nineteenth century into the twentieth—but without loss of character" in order to make the Native Market a viable business venture, so she discontinued objects that did not sell and introduced those she thought would be more marketable. For example, she encouraged the *santo*-carver Ben Sandoval, who sold few carvings, to make tourist items such as wooden trays and reported that in meeting the demand for such objects "he was able to buy himself a car and a small house in less than a year."[42]

While artisans were encouraged to diversify the types of objects they made, they were also prompted to change the form of *santos* to increase their appeal to Anglo patrons. The anthropologist Charles Briggs explains that the woodcarver José Dolores López, from Córdova, New Mexico, sold brightly polychromed furniture to fellow villagers before he was "discovered" by Frank Applegate, but in response to Applegate's suggestions began leaving his incised and chip-carved work unpainted, a less "gaudy" look that proved more popular with Market patrons. López began making religious images, similarly left unpainted, when prompted to do so by Applegate.[43]

Clearly, the preservation efforts of the SCAS and the collecting activities of connoisseurs such as Applegate, which focused on authentic, antiquarian objects, operated in a separate aesthetic sphere from the market-driven encouragement of tourist art production. But even though José Dolores López was prompted to modify his carvings, other artisans were encouraged to reproduce "old designs." In May 1930, for example, Mrs. Herbert Dunton showed fellow SCAS members a collection of drawings "taken from embroidered bedspreads and other old Spanish textiles," compiled "to assist the native women doing modern hand work." To those selling Hispanic crafts in Santa Fe

and further afield, however, the bottom line was still marketability rather than authenticity. In 1931, Fred Leighton of The Indian Trading Post in Chicago made clear the business nature of his enterprise when he notified the Spanish Arts Shop manager Helen McCrossen that he had been unable to sell the blue blankets she had sent, suggesting he might need to exchange them for "brighter ones" that presumably would be better received by the buying public.[44]

While the Spanish Colonial Arts Society aimed to stimulate craft production as a means to rehabilitate economically the native population, such long-range financial concerns were a less forceful impetus behind federally funded agencies of the Depression such as the FAP, designed to provide immediate work relief. Vernon Hunter's interest in Spanish colonial design largely determined the shape and focus of the New Mexico Art Project, and even though he modified Spanish colonial forms in his own work as a designer, he aimed to preserve the historical record not only through the *Portfolio of Spanish Colonial Design,* but by directing Hispanic artists to reproduce original eighteenth- and nineteenth-century religious objects. In November 1936, the artist Juan Amadeo Sanchez, born at Rio Pueblo near Taos in 1901, began copying *santos* at Hunter's suggestion.[45] Sanchez reproduced as closely as possible the *retablos,* or paintings on panel, and *bultos* from various chapels and *moradas* of northeastern New Mexico. As he explained: "First I study the *bulto* I am about to reproduce in full—its size, colors, proportions, and the materials of which it is made. I measure the head of the *bulto* with a pair of calipers. After choosing the right piece of wood I square it, then start to carve the features and head to an exact likeness of the original." Sanchez made tracings of *retablos* to be reproduced, then gave the new board three or four coats of a powdered gypsum and egg mixture before tracing the outline of the figure over the dried surface.[46]

If we compare an original *retablo* from the School of Rafael Aragón to Sanchez's copy (Figs. 12-5 and 12-6), the figures of Saint Michael and the devils they

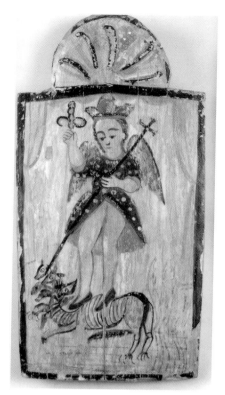

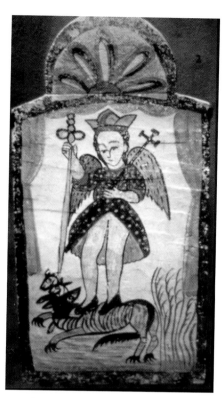

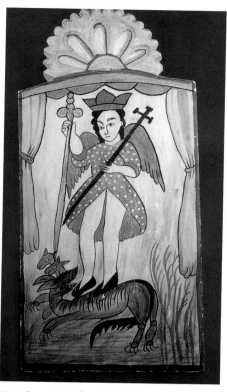

12-5. School of Rafael Aragón, *Saint Michael Archangel,* gesso and water-soluble paint on wood, c. 1840–70. Taylor Museum, the Colorado Springs Fine Arts Center (TM1600), Colorado Springs.

12-6. Juan A. Sanchez, *Saint Michael Archangel,* gesso and water-soluble paint on wood, late 1930s. Museum of International Folk Art, Santa Fe, New Mexico.

12-7. Juan A. Sanchez, *Saint Michael Archangel,* gesso and water-soluble paint on wood, 1942. WPA Project purchase, the Colorado Collection, CU Art Museum, University of Colorado at Boulder.

subdue could almost be superimposed from one *retablo* to the other. In this as in many of his copies, however, Sanchez substituted linear certainty for the original work's painterliness. For instance, Sanchez added a distinct chin line to the saint, while in the original it is only suggested by a dab of red paint. He probably also produced freehand copies, or second-generation copies based on his own earlier work.[47] A *retablo* from 1942 (Fig. 12-7) clearly resembles the earlier works in overall proportion and detail even though it is larger and Sanchez further simplified its color. Sanchez did not always capture the expressive subtleties of colonial masters, but his mimicry is clearly tied to specific styles if not exact prototypes. He convincingly copied the works of a wide range of

santeros, including Molleno, Fresquís, José Rafael Aragón, José Aragón, and José Benito Ortega.

Sanchez also painted plates for the *Portfolio,* although it is impossible to determine which ones.[48] He may even have produced both two-dimensional and three-dimensional copies of the same object, since prototypes for both endeavors were drawn from the same pool (Figs. 12-8 and 12-9). In fact, it would be easy to assume that Sanchez worked from illustrations rather than directly from original objects located in scattered churches, considering that he was severely physically handicapped. At the age of twelve, in the village of Shoemaker, New Mexico, he was the victim of a cruel prank by boys his own age who forced him into a wooden box and nailed down the lid. He was

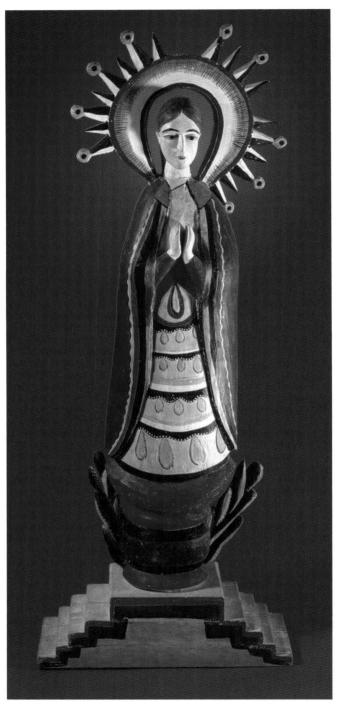

12-8. Juan A. Sanchez, *Nuestra Señora de la Luz* [Our Lady of Light], gesso and water-soluble paint on wood, c. 1939. Santa Fe, collections of the Palace of the Governors, Museum of New Mexico (n. 10752–45).

rescued several hours later, but his cramped position within the box led to rheumatism, with which he was bedridden for nearly three years, and ultimately to paralysis. He was unable to walk, turn his head, bend down, or sit.[49] Yet from 1936 to 1942, he traveled across northern New Mexico sketching, measuring, sometimes photographing, and occasionally even borrowing *bultos* and *retablos* to reproduce. Special accommodations were made so that he could ride in a car driven by his brother, Juan Isidro, who in 1936 was only thirteen years old.[50]

Sanchez's FAP employment stemmed largely from the intervention of Anglo benefactors. As a resident of the town of Colmor in northeastern New Mexico, he gained the attention of the Raton resident Ida (Mrs. W. H.) Atwater and the local landowners Winifred and Mary Grainey. Sanchez's sister Maria Montoya and her son Henry recall that the Graineys often intervened on behalf of the Sanchez family and took a special interest in Juan Amadeo, who in his teens began drawing and carving. Atwater and the Salvation Army sponsored Sanchez for surgery to stabilize his spine in 1929, and the Grainey sisters provided a link between Sanchez and the Native Market, where his carved wooden buttons, and probably other objects such as small carved animals, were sold. It was most likely through the Native Market and Leonora Curtin that Sanchez came to Vernon Hunter's attention.[51]

Soon after Hunter hired Sanchez, the artist set to work preparing "a representative collection of Colonial art objects" for the FAP. Although Hunter emphasized the learning of craft over a given rate of production, Sanchez compiled a significant body of work during his first months on the project.[52] He admitted that his first reproductions were "crude and poorly made" but noted that "with much practice" his work improved.[53] Sanchez not only tried to better his technique but took pride in his efficiency. For example, on the back of the San Miguel *retablo* from 1942 (Fig. 12-7) he wrote "6 hours." He signed his works with a date, location, and the legend "Copied for the W.P.A." (Works Progress Administration, after 1939

Work Projects Administration). His earliest works were made in Colmor, where on at least one occasion (Fig. 12-10), he displayed them for friends and family.[54]

Nine months after the start of Sanchez's FAP employment, his work was exhibited in Las Vegas, New Mexico, at the Saint Francis Community Art Center (Fig. 12-11). According to the *Las Vegas Daily Optic* of August 28, 1937, "the collection aroused such interest in Holger Cahill . . . on his recent visit here from Washington," that he asked for it to be "sent to headquarters for showing in eastern galleries."[55] Community art centers such as the one at Las Vegas were established by the FAP in small towns that had no galleries or art museums and provided rotating exhibitions of painting, drawing, and sculpture, as well as art instruction.[56]

In the late 1930s, more of Sanchez's contemporaries had probably seen his copies than had seen the colonial prototypes. From 1937 to 1939, more than 23,000 people attended traveling exhibitions at New Mexico Community Art Centers in Las Vegas, Roswell, and Melrose.[57] Since objects produced for the FAP were government property, Sanchez's works were accessioned into museum collections after circulating among Art Centers. Among those still in public collections are some that were exhibited in the Las Vegas show (see Fig. 12-11): the Saint Isidore (San Isidro) *bulto* to Sanchez's right is at the Museum of International Folk Art in Santa Fe, the Saint Raphael (San Rafael) and Our Lady of Guadalupe (Nuestra Señora de Guadalupe) *bultos* (fifth and sixth from Sanchez's left) are in the University of Colorado Collection, and the Our Lady of Light (Nuestra Señora de la Luz, eighth from Sanchez's left) is at the Governor's Palace in Santa Fe.

Sanchez's traveling three-dimensional catalog of *santos* helped stimulate contemporary, regional awareness of New Mexican Hispanic material culture in the late 1930s; the *Las Vegas Daily Optic* trumpeted his "remarkably faithful copies" of native folk art and detailed the traditional technique he had used to create them.[58] But the focus on *reproduction* as an artistic

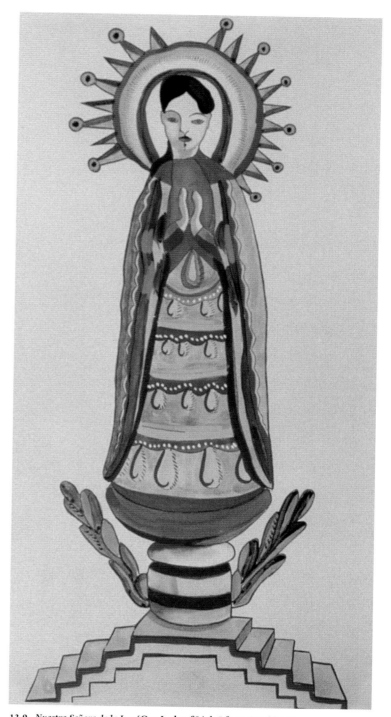

12-9. *Nuestra Señora de la Luz* [Our Lady of Light] from *Portfolio of Spanish Colonial Design,* pl. 34, hand-colored linoleum-block print. Norlin Library, University of Colorado at Boulder. Sanchez's reproduction of the *bulto* is reproduced here as 12–8.

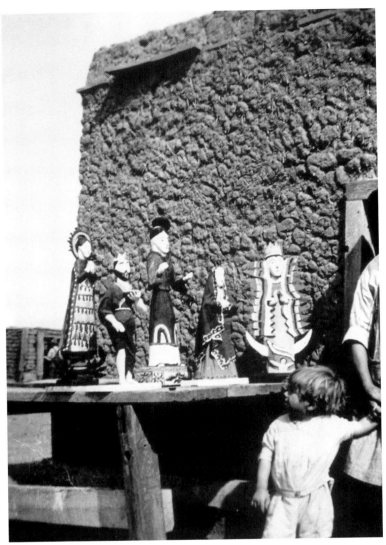

12-10. Early works by Juan A. Sanchez outside his house at Colmor, New Mexico, 1937. Photograph courtesy Mary Ellen Ferreira.

a time when ventures such as the Spanish Arts Shop and the Native Market focused specifically on selling contemporary images, the exhibition of Sanchez's FAP works in gallery settings could only emphasize their aesthetic qualities and bring to mind the popularity of *santos* as collectible art. Even Vernon Hunter hawked the wares of the Native Market, noting that collectors who had failed to acquire "the now rare Santos" could still find "reproductions of the old ones to complete the atmosphere" of their Santa Fe houses in the 1930s.[60]

Sanchez had to be aware of the collectability of *santos*, but he maintained that they held interest for him not only as carvings, but because they were "rich in tradition, history, and culture" and had "much to do with the daily toils and pleasures of the early settlers."[61] He was convinced that his copies would outlive the prototypes and serve a historical purpose. As he explained, "God has granted me the ability to reproduce this old Colonial art, and I live in hopes that my work may be kept for many centuries, so that the future generations may see what Colonial-New Mexican santos once were."[62]

Although Sanchez's works may have been shown in Community Art Centers outside New Mexico, he did not receive national notice in the 1930s. Since he started work on the project in late 1936, he missed a potential opportunity to exhibit at the national show of FAP work titled "New Horizons in American Art," held earlier that year at the Museum of Modern Art in New York City. However, even though illustrations from the *Index of American Design* were included in the "New Horizons" show, the exhibit's sculpture and painting entries demonstrated the tenets of modernism more clearly than they reconstituted the past. One exhibitor, the New Mexican woodcarver Patrociño Barela (c. 1900–1964), was acclaimed for his originality rather than recognized for the traditional cultural roots of his sculpture.[63] Even though works such as *Holy Family* (Fig. 12-12) utilized Christian iconography, Barela carved them from single blocks of wood and left them unpainted, giving them a

enterprise must have also emphasized to viewers that original, colonial *santos* were increasingly rare and valuable objects. The public was certainly aware of the growing popularity of religious items among collectors, as curio dealers in Taos and Santa Fe reportedly plundered the churches and houses of northern New Mexico for marketable goods.[59] Furthermore, at

12-11. Juan A. Sanchez at Saint Francis Community Art Center, Las Vegas, New Mexico, 1937. Photograph E. Boyd files (97215), Museum of International Folk Art, Santa Fe, New Mexico.

12-12. Patrociño Barela, *Holy Family*, c. 1936. Federal Art Project, Photographic Division Collection, 1935–42, Archives of American Art, Smithsonian Institution, Washington, D.C.

sharply different look from the traditional *santos* copied by Sanchez. While Sanchez was assigned to recreate specific colonial examples, Barela carved free-form, often organic abstractions that were dictated by the size, grain, and texture of the wood. As Barela explained, "The idea depends on the piece [of wood]. When I get the piece I decide what I can do."[64] *Holy Family* was one of eight of Barela's works shown at the "New Horizons" exhibit, and on the occasion, *Time* magazine proclaimed him "the Discovery of the Year." Even Holger Cahill declared that Barela's art was the purest he had seen.[65] It seems that Barela succeeded, however naïvely, in conflating the usable past of saint-making and modernist aesthetics.

That Barela's original and creative work met with critical acclaim is not surprising considering the Depression-era quest to establish a link between American folk and modern art. Separate from the modern industrialized world yet capable of producing works with modern appeal, Barela could be seen as a folk artist as well as a modern artist. And since his

12-13. Death carts, right: original from Las Trampas Church, late nineteenth century; left: copy by Juan A. Sanchez, late 1930s. Photograph courtesy Mary Ellen Ferreira.

still found *santos* in rural churches and *moradas* testifies to ongoing devotional use of traditional icons in the 1930s. As Lorin W. Brown of the Federal Writers' Project noted, almost every home in Córdova, one of the towns where Sanchez copied *santos,* had its own *nicho,* or niche, to hold "the home's most precious treasure, the image of some favorite saint, before whom votive candles were ever kept burning."[67] *Santos* were not only venerated, but actively and physically utilized as intercessories. E. Boyd noted in the *Portfolio* that it was still customary for figures in the possession of private families and chapels to be taken outside for processions.[68] And Brown recounted that Guadalupe Martinez (Tía Lupe), a recognized wise woman of Córdova, routinely sliced a fragment from the side of her Santa Bárbara *bulto* during thunderstorms and placed the sliver in the fireplace. She told him, "Santa Bárbara should be prayed to in times of storms, but in the way I have shown you she is more sure protection. For many years I guarded myself and my casita in the way I have shown you."[69]

Juan Sanchez noted that Brotherhood ceremonies with *santos* such as the *Carreta de la Muerte* (Fig. 12-13) he copied at Las Trampas village church in the late 1930s were not performed "with much religious strength or fervor" compared with those of earlier days, but even though changing economic circumstances and social pressures in the first decades of the twentieth century led to the demise of many *moradas,* it was not unusual for Hispanos who had moved to larger towns for economic survival to return to their home villages to participate in religious observances.[70] Indeed, as the historians Thomas J. Steele and Rowena Rivera point out, some Hispanos "clung more tenaciously to the Brotherhood than ever before because everything else in their lives was changing so drastically." But this change in patterns of Hispanic religious worship probably further imbued such religious objects with cultural meaning. If Depression-era Anglos looked to their simpler past with nostalgia, so too, must have many New Mexican Hispanos, for whom traditional *santos* embodied not only the

work diverged iconographically from orthodox Catholicism—Hunter noted that it did not "abide strictly within the precincts of the church," and in fact, the Church fathers could not "define" it—its form could be emphasized over its meaning.[66] By contrast, Sanchez's carvings were parochial and rigidly traditional, repeating the past rather than using it as a catalyst for contemporary creativity. His strict adherence to traditional Hispanic religious form may have held regional interest but ultimately served neither American tradition nor the exigencies of modernism.

Even though Sanchez's FAP work was destined for museum collections, the fact that he and E. Boyd

Roman Catholic faith, but the inseparability of faith from Hispanic culture.[71]

During the course of the FAP, many of the objects recorded for the *Portfolio of Spanish Colonial Design in New Mexico* and the *Index of American Design,* and those reproduced by Sanchez and others, were being acquired by private collectors if not already in private collections.[72] At the same time, three important private collections were donated to museums: Alice Bemis Taylor's to the Taylor Museum in Colorado Springs, Anne Evans's to the Denver Art Museum, and Mabel Dodge Luhan's to the Harwood Foundation in Taos. These donations, along with that of Cady Wells to the Museum of International Folk Art in Santa Fe in 1951, safeguarded the preservation of many original *santos* and kept them, as Luhan noted, from leaving the country "where they were born" even if early twentieth-century collecting in many cases broke the continuum of their devotional use.[73]

Many of Sanchez's prototypes are difficult if not impossible to locate today. Although the body of Sanchez's FAP work may not have fulfilled his expectations by serving as a future substitute for a lost colonial tradition, his copies are now exhibited in the context of the twentieth-century "revival" of Hispanic crafts.[74] They evoke a time of transformation for Hispanic cultural traditions, a time when *santos* were increasingly viewed as art rather than devotional icons, and the compilation of a usable past seemed capable of propelling the nation into a future based on solid historical ground.

Epilogue

In March 1943, after the dissolution of the FAP, Vernon Hunter stated that "only two santeros," Barela and Sanchez, were still working in New Mexico.[75] Although Barela had been nationally celebrated during his years with the FAP, after the project and its regular paycheck ceased he was compelled to spend long stretches of time away from his home in Cañon, near Taos, working as an itinerant farmer to support

his family. He returned to Cañon for good in 1951 and devoted the rest of his life to carving. Barela's biographers note that even though the artist's renown waned after the 1930s, he continued to have a "small but devoted following among collectors in both the Mexican-American and Anglo communities, who recognized him as an important artist."[76] Juan Sanchez continued to make carvings based on the reproduction of traditional objects but expanded his repertoire to include small crucifixes, carved animals, knife and match holders, shelves, cabinets, and other furniture to sell to tourists and collectors.[77] His works were sold on consignment in Santa Fe at the Art Museum Gift Shop, La Conquistadora Gift Shop, and Santa Fe Gift Shop; in Taos at the Blue Door Galleries; and at Ortega's Weaving Shop in Chimayó.[78]

As a copyist for the FAP, Sanchez had worked free from the demands of the market, but producing for a market economy rather than reproducing for the historical record subjected him to suggestions and requests that sometimes challenged his adherence to traditional detail. David Ortega of Ortega's Weaving Shop wrote to Sanchez in 1958, "If you make up Santos like San Gabriel, Santiago and San Rafael and perhaps Santo Niño, I am sure we could sell them in our shop for you." Ortega also suggested that reproducing the old *santos* in Chimayó's Santuario, a pilgrimage church and popular tourist stop, "would be a fine thing to do."[79] While certain objects were targeted for reproduction according to how well they might sell, others were modified according to patron tastes. An entry in Sanchez's record book specifies a "Santiago like at Santuario," twelve inches high with a "round face" and "not too long neck," and notes to try to make the copy look "antique." Another order calls for a crucifix with "not so much blood—especially on head and feet."[80]

Even though Sanchez believed that *santo*-making as a viable cultural enterprise had ended in the nineteenth century, the endeavors of Hispanic craftsmen initiated during the revival of the 1920s and 1930s strengthened the link between colonial craft produc-

tion and the later revival that emanated from a renewed cultural awareness within the Hispanic community in the 1970s. The historian Enrique R. Lamadrid notes that in contrast to the Anglo-initiated revival of the 1920s and 1930s, the Chicano renaissance of the 1970s and 1980s "responded more to the internal needs of the ethnic communities" and that imagery was "reclaimed by native artists and transformed into symbols of cultural identity."[81] Such a reinvestment of cultural symbols was facilitated in part by the efforts of the Spanish Colonial Arts Society and the Federal Art Project earlier in the century, even if those efforts were tainted by the paternalism of reformers who aimed to rehabilitate a people perceived as less industrious and capable than their Anglo counterparts. William Wroth points out that Anglo efforts nonetheless "planted a seed" and that many Hispanic artisans "continued to work after the war, producing work in the medium they had mastered in the 1930s."[82]

Years after the end of the FAP, Virginia Hunter Ewing, Vernon Hunter's widow, succinctly summed up the difference between Sanchez and Barela by designating Sanchez a *"santero"* and Barela a "folk art star."[83] Yet even though Sanchez continued to craft scrupulously his carvings from traditional materials such as cottonwood and pine, join them with wooden pegs and glue, and paint them with tempera colors, he maintained that he was "not a real santero."[84] Although a devout Roman Catholic, he carved works that were appreciated for their artistic qualities and historical associations, in contrast to colonial *santeros* who made carvings strictly for devotional purposes. Sanchez clearly understood that *santos* made during the twentieth century had a meaning and purpose different from those made in the eighteenth and nineteenth centuries and was reluctant to consider himself a *santero*. But if the term *santo* became multivalent in the twentieth century, used to designate devotional objects, collectible artifacts, and contemporary forms adapted to respond to an Anglo market, so too did the term *santero,* which could be applied to any artisan making images of saints and holy persons, regardless of the object's ultimate disposition. Sanchez may not have been a "real" *santero* in historical terms, but was a *santero* in spite of himself.

13 | CURRENT APPROACHES TO PROBLEMS IN ATTRIBUTION

The question of attribution is not unique to the study of New Mexican *santos,* but it presents an unusual case of a Spanish and Catholic-introduced art form occurring in a country where most rigorous academic investigation has been directed toward an Anglo-American and Protestant heritage. Until recently, this resulted in a very small number of serious scholars directing their attention to this material. Fewer still have questioned the attributions put forth in some of the germinal studies on this art, thereby perpetuating certain assumptions that have not been thoroughly documented. As noted in previous chapters, from a strictly statistical point of view, there is significant evidence that many artistic traditions contributed to the *santos'* visual appearance. So why has this not been explored further?

The religious art of New Mexico was transformed into a national cultural heritage within two decades after the state entered the Union in 1912. Early interest in the *santeros,* as Thomas Riedel documents in Chapter 12, coincided with a national wave of interest in American "folk art." Efforts concentrated on defining styles with a broad brush to demonstrate the region's distinctive identity through the "style" of its visual culture. Early scholarship, museum-collecting initiatives, initial attempts to market regional art, and preservation efforts all supported one another in a complex social fabric. It was during this time that these images of religious devotion were transformed into "art" made for aesthetic contemplation. The categories currently in use relating to material culture, such as "Anasazi," "Spanish," and "Pueblo," are the legacy of nineteenth- and early twentieth-century professionals directly engaged in writing about cultural artifacts—art historians, cultural anthropologists, and archaeologists.

This extensive reassessment of regional material culture was based on a variety of unquestioned assumptions. Most damaging in the present context of discussion was the assumption that the historical culture of New Mexico could be separated from that of the geographical region south of U.S. national borders

Portions of this chapter are adapted from my earlier publication "Santeros of the Río Abajo and the Camino Real," in Palmer and Fosberg, *El Camino Real de Tierra Adentro,* 2 (Santa Fe: Bureau of Land Management, 1999), 221–30.

established only in 1848, when the Gadsden Purchase created the current boundary between Mexico and the United States. This chapter presents new evidence for the manufacture of religious images in the region south of Albuquerque, known as the Río Abajo.

The Connoisseurship of Santos Since 1900

Attributions of New Mexican *santos* (apart from those in contemporary historic documents) began with two articles published in 1925 and 1926. The first, by Mabel Dodge Luhan, was published in a popular magazine called *The Arts,* with the title "The Santos of New Mexico." Luhan identified the makers of the *santos* as Spanish New Mexicans, more particularly, members of the Brotherhood of Our Father Jesus the Nazarene. The sensationalism that at that time surrounded New Mexican Catholicism clearly colored her point of view: "They were afraid of themselves and of their own perversion, and their religious symbols are the symbols of this fear. Of course there were a good many men who were not from the society of Penitentes, and these others made pictures of saints who were far less anguished and bloody than those of their whipping brothers. But for the most part suffering and fear are on almost all these hand-hewn boards."[1]

The following year, a catalogue by Elizabeth du Gue Trapier of previously unpublished *retablos* in the collection of the Hispanic Society in New York rejected Luhan's attributions, claiming the works were far too strange and "primitive" to be related to any Spanish tradition, even that of the Brotherhood. The author goes on to credit the Indians of New Mexico with painting the objects in the collection, basing this attribution on Fray Gerónimo de Mendieta's *Historia eclesiastica indiana* (completed 1596), which states that the Indians in colonial Mexico painted religious images under the direction of the friars.[2]

These two articles apparently raised such an outcry from collectors and scholars in New Mexico that they may have been the catalyst for further exploration of the origins of New Mexican *santos*. The following few years saw articles written by Odd Halseth, an archaeologist and historian; Elizabeth deHuff, a writer and wife of a U.S. Indian Agent; and the writer Mary Austin in collaboration with the artist Frank Applegate. In 1934, Austin completed the first draft of a manuscript she had coauthored with Applegate before his death in 1931, titled "The Spanish Colonial Arts" (on deposit today at the University of New Mexico Zimmerman Library).[3] They included the names of currently practicing artists with known works that they thought fell within this tradition (Celso Gallegos and José Dolores López), as well as others about whom they had only heard stories: Juan Flores of Las Colonias, Miguel [Rafael] Aragón of Córdova, Benito Bustos, and the prolific Mol[l]eno, whose distinctive personality was named on the basis of an elusive inscription on the verso of a *retablo* with an image of Saint Francis (owned by the Spanish Colonial Arts Society, Inc.).

Austin and Applegate attributed most of the *santos* to Spanish colonists, but in their unpublished manuscript Austin describes, in glowing terms, work that she and Applegate both believed was executed by a Native American: "The drawing of these pictures is definitely Indian and *on the whole superior to anything achieved by the Colonists*" (emphasis mine).[4] In the next decade, correspondence between the librarian E. Boyd on behalf of the Spanish Colonial Arts Society and various museum curators discussed the different styles and suggested possible names for some of the artists. The attributions that developed from these exchanges were initially presented to the public in Boyd's *Saints and Saintmakers,* 1946.[5] Nearly thirty years later, Boyd's *Popular Arts of Spanish New Mexico* (1974) defined the styles that are the foundation for New Mexican connoisseurship today.[6]

A meticulous and indefatigable scholar, Boyd based her attributions on altar screens in situ and the few signed panels in existence. She assigned the altar screens to six distinct personalities: the anonymous Laguna *Santero* (active around the turn of the eighteenth century), the anonymous Molleno (perhaps a follower of the Laguna *Santero,* active in the first half of

the nineteenth century), Pedro Antonio Fresquís (a.k.a. the Calligraphic *Santero* and the Truchas Master; whose dates have since been tentatively documented as 1781–1832), Rafael Aragón (c. 1796–1862), José Aragón (reputedly, a Spanish-born immigrant active in the mid-nineteenth century), and the late nineteenth-century Mexican itinerant artist José de Gracia González (dates documented by Wroth as c. 1835–1901).[7]

To date, only three Spanish colonial and nineteenth-century artists are known to have signed their work: Rafael Aragón (four signatures), José Aragón (eleven signatures), and José de Gracia González (two signatures). One of these inscriptions appears on a sculpture—a *bulto* "retouched" by José de Gracia González—and the rest are on intact altar screens and individual panels.[8] Boyd also attributed works to other artists on the basis of the distinctive visual characteristics of a single piece or group, and the location where, or time period when, an artist worked. Franciscan Style B, Franciscan Style F, the Eighteenth-Century Novice, the Santo Niño *Santero,* the Quill Pen *Santero,* the A. J. *Santero*, and the Dot-Dash *Santero* were names that Boyd introduced into the literature. She attributed additional works to named artists on the basis of documents, oral histories, and stylistic analyses: Bernardo Miera y Pacheco (c. 1714–85), Fray Andrés García (in New Mexico 1747–79), Miguel Herrera (1835–1905), Juan Ramón Velásquez (c. 1830–1902), and José Benito Ortega (1858–1941). Finally, she mentioned a few artists whom she called "loose ends" because their names are recorded but their work had never been identified: Francisco Vigil of San Luis, Colorado; Monico Villalpando in Ojo Caliente; José Manuel Benavides of Santa Cruz and El Valle; and José Miguel Rodríguez and Patricio Atencio of Taos.[9]

Recuperating the Identities of Anonymous Artists Today

Subsequent scholarship has relied almost exclusively on Boyd's groundwork, despite some provocative suggestions put forth by others such as Wilder and Breitenbach in *Santos: The Religious Folk Art of New Mexico,* and José Espinosa in *Saints in the Valleys.* More recently, some authors have extended the list of identified and unidentified styles,[10] but the tendency to lump all stylistic variations into the small circle of established artists (using the terms "school of" or "workshop of") has obscured the distinct possibility that not all of the thousands of surviving *retablos* and *bultos* dating to the eighteenth and nineteenth centuries are attributable to a handful of artists. It is probable that numerous other artists were active, some professionally and others as occasion demanded within a family, kinship group, or community.

The colonial art of New Mexico, particularly the *santos,* has been associated almost exclusively with the Río Arriba, that is, the region north of Santa Fe in the Río Grande River Valley. But the assumption that religious art was locally produced only in northern New Mexico is problematic. The defining images and styles of the New Mexican aesthetic are due largely to historical accident—the initiatives of early collectors were concentrated where they had settled, in the Río Arriba region. Artists and collectors who were drawn to Santa Fe and Taos in the early twentieth century arrived when proximity to the mountains and to the pueblos—at the end of the historic and romantic Santa Fe Trail—were reasons to relocate from the eastern United States. Artists looking for a certain kind of exotic subject matter and others seeking adventure or simply an alternative lifestyle arrived after the national railroad system made travel relatively comfortable. Others joined Mary Austin and Frank Applegate: Elmer Shupe, a collector and dealer who opened a shop in Taos; H. Cady Wells, an artist and collector who split his time between California and northern New Mexico; and Charles Carroll, who moved to Taos with his mother, Mrs. Mitchell Carroll. This vanguard art colony established the terms of discussion for, as well as the marketability of, New Mexican–made religious images and other locally manufactured items as "folk art."[11] Theirs was a consciously anti-industrial, Arts and Crafts ambience and a fashionable haven for

the social elite. Many of the collections formed in this era were later bequeathed to state museums. Cady Wells's collection is the core of the Museum of New Mexico's holdings. The second-largest public collection of *santos,* at the Taylor Museum in Colorado Springs, was also acquired in northern New Mexico: its core consists of the contents of the Talpa Chapel near Taos and the private collection formed by Alice Bemis Taylor. The founder of the Denver Art Museum, Ann Evans, donated her private collection of *santos* to establish that museum's holdings.

As a result, much of the subsequent scholarly work about New Mexico's *santero* tradition was based on the Río Arriba region of northern New Mexico. Over time, the assumption developed that little or no religious art or other material culture was produced elsewhere in New Mexico. Boyd dedicates only one paragraph in *Popular Arts of Spanish New Mexico* to the *santeros* of the Río Abajo, as the region south of Albuquerque is called:

The identification of *santero* styles from the present border region between Mexico and the United States is complicated by several factors. Among these are the steady migration of Mexican nationals to the north, who brought their family saints with them, and the buying trips made by wagon to the Las Cruces–La Mesilla region early in this century by the Santa Fe trader, John Candelario.... Agents for the Fred Harvey Indian Company also collected in southern New Mexico, and in all cases little or no record was kept of the place of origin of the examples. Santos known to have come from the border region share pronounced characteristics with provincial Mexican folk images in the extensive use of glass eyes, cloth dipped in gesso and modeled to form drapery, feet composed of solid plaster built up on the base instead of being attached to the figure itself, more theatrical poses, and presence of gold leaf or paint.[12]

Wroth also suggests the possibility that religious images were produced in southern New Mexico:

There are two pieces of sculpture in the Taylor Museum collection in the same provincial academic style as those attrib-

uted by E. Boyd to Fray Andrés García. They tend to be somewhat awkward renderings which attempt to replicate Baroque conventions, such as the elaborate robing, naturalism and sentimentality in the faces, and a dynamism in the bodies achieved by gestures and angling of the head and torso. Two other pieces located by the present writer are in private collections. One of them, St. Joseph, was collected in Ciudad Juárez, Chihuahua, which suggests the possibility that this style originates not in northern New Mexico, but further south.[13]

To this day, the production of religious art in the region of New Mexico south of Albuquerque is largely *terra incognita,* despite the fact that every itinerant artist from Mexico, and every New Mexican colonist, would have taken the same path north to Santa Fe. Boyd was exceptional for the extent of her fieldwork, but even she did not venture far from the artistic center defined at the beginning of the twentieth century around Taos and Santa Fe.

Río Abajo Santos: Naming a Family Resemblance

In fact, it appears that quite a large number of *santos* were produced in southern New Mexico, from the Río Abajo south into the Mesilla Valley and El Paso del Norte (present-day Juárez). The provenance of many of these objects is unclear; but an informal survey of dozens of examples in private collections conducted in 1994–95 suggests that certain guidelines were maintained for every piece produced, while the organization of labor was flexible enough to allow artists to develop recognizably individual styles.[14] Similarities in construction techniques, pose, and handling of materials suggest that many of the *santos* in the Río Abajo were produced in a workshop setting.[15] Not all of the traits appear in all pieces, but several of them are shared among a large number of objects, mostly sculptures—enough to allow a tentative association among the artists who produced them. Distinctive features of construction and materials include, as Boyd noted, "cloth dipped in gesso and modeled to form drapery, feet composed of solid plaster built up

on the base instead of being attached to the figure itself [Fig. 13-1], more natural poses [Fig. 13-2], and presence of gold leaf or paint [Fig. 13-4]." The glass eyes that Boyd also mentioned were not common in the survey, and gold leaf was supplemented with silver and copper leaf on a number of images. The use of plaster to form the feet, faces, hands, costume details, and hair is virtually unheard of in the Río Arriba region, but is characteristic of images made in southern New Mexico. In addition, a distinctive gray plaster was found on a number of the surveyed images. Many of the *bultos* have thick pedestals, sometimes constructed in two tiers of wood, reminiscent of sculptures produced in more cosmopolitan areas of Mexico (see Fig. 13-2). Minor features, such as the ears and fingernails, are often indicated by delicate lines, finely drawn with a quill pen or similar tool in red ink.

Moreover, features of technique and composition shared among all the Río Abajo *santos* suggest that the circumstances of their manufacture are somehow related, although different hands can be distinguished. If workshops existed, they were probably based on the guild system of central Mexico that was functional—at some level—throughout the colonial period. The possibility that artists' workshops existed in the Río

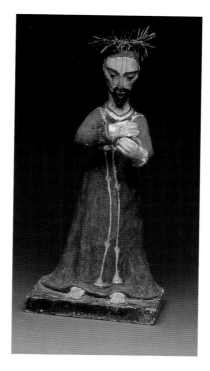
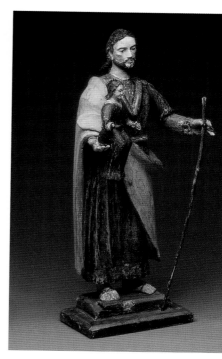
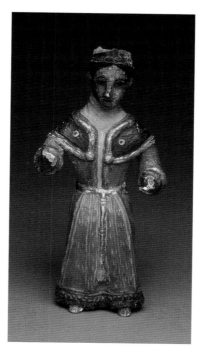
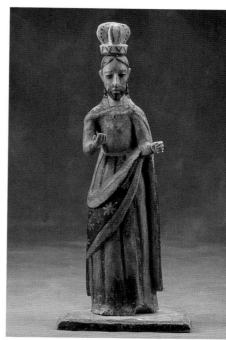

(*clockwise from top left*)

13-1. *Jesus of Nazareth,* Church of San Luis Rey, Chamberino, New Mexico, wood, gesso, cloth, and oil, mid-nineteenth century. Private collection. Photo Blair Clark.

13-2. *Saint Joseph,* Ciudad Juárez, Mexico, wood, oil, and metallic leaf, mid-nineteenth century. Collection J. Paul and Mary Taylor. Photo Blair Clark. This piece, collected in Ciudad Juárez, Mexico, when compared to Fig. 13-3, from northern New Mexico, shows the relative naturalism in the pose and expression of the figure.

13-3. Attributed to Rafael Aragón, *Saint Joseph,* northern New Mexico, wood and water-soluble pigments, early–mid-nineteenth century. Museum of International Folk Art, Santa Fe, New Mexico. Gift of the Historical Society of New Mexico to the Museum of New Mexico. Photo Paul Smutko.

13-4. *The Holy Child,* southern New Mexico, wood, gesso, cloth, oil, and copper leaf, early nineteenth century. Collection of J. Paul and Mary Taylor. Photo Blair Clark.

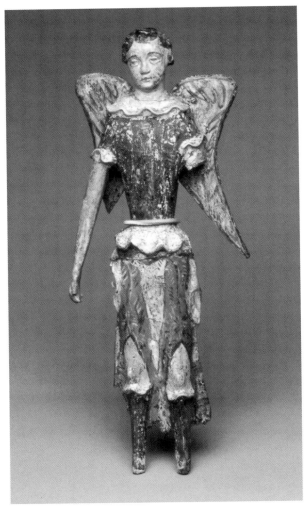

13-5. *Archangel,* Mesilla Valley style, wood, gesso, water-soluble pigments, and metallic leaf, mid-nineteenth century. Museum of Spanish Colonial Art, collections of the Spanish Colonial Arts Society, gift of Mr. and Mrs. John Gaw Meem, Santa Fe. Photo Jack Parsons.

Arriba area north of Santa Fe has been suggested by several authors and is indeed implied whenever the terms "school" and "workshop" are used. Inscriptions on several *retablos* refer to the *esculteria* (workshop) of Don José Aragón, but no other documentation currently known demonstrates that workshops or businesses that manufactured *santos* existed anywhere. Further demonstration of their existence depends on

the physical analysis of the *santos* themselves. Many of the techniques associated with the presumed "school" of the Laguna *Santero,* for example, suggest that this artist operated a business *(taller)* employing assistants and associates.

THE CASE OF THE LAGUNA *SANTERO*

Most of the characteristics of the Río Abajo described above are associated with the work of the anonymous Laguna *Santero* (active c. 1790–1808). The Laguna *Santero* is named for the monumental altar screen in the church of San José at Laguna Pueblo, which was built between 1792 and 1813.[16] Dated examples of his work include altar screens at Santa Cruz (1795), San Miguel (1798), Laguna (1800–1808), and Acoma (1808). An itinerant artist, the Laguna *Santero* was familiar with contemporary artistic trends in the academic centers of Mexico, as the construction techniques, style, and imagery of his altar screens attest.[17]

Is it possible that this same anonymous artist is responsible for the Río Abajo *bultos? Bultos* with known provenances, manufactured in a style that resembles the Laguna *Santero*'s signature altar screens, come from the southern part of the state in the Mesilla Valley area. However, this area was not settled until the late 1840s—more than thirty years after the last known dated piece by the Laguna *Santero.* These circumstances suggest that *bultos* in this style (Fig. 13-5) were manufactured at a much later date than commonly assumed *and* that they were not executed by the Laguna *Santero.* The other possibility is that the *bultos* with Mesilla Valley provenances were made earlier somewhere else—possibly El Paso del Norte—and were brought to the Mesilla Valley by the nineteenth-century settlers.

In any case, the historical record of settlement in the Mesilla Valley suggests that stylistic and technical characteristics of the *santos* long assumed to be indicative of the late eighteenth century are actually common features of the mid-nineteenth century. Some of these figures have also been previously attributed to Fray Andrés García, who was born in Puebla, Mexico,

and was sent to the New Mexico missions in 1747. Others that share these characteristics have been attributed to an anonymous "Master of San José," and still others are categorized as "Provincial Academic Style."[18] Clearly, there has not been enough research to resolve the attributions of those images that do not fit neatly into the Río Arriba stylistic categories.

Río Abajo *Santos:* Physical Evidence for the Existence of Workshops

THE MASTER OF SAN JOSÉ

Fourteen images of San José very similar in their execution are nonetheless difficult to attribute to one artist. Boyd attributed three to Fray Andrés García, an artist named by Fray Atanasio Domínguez in his 1776 inventory, whose style is otherwise conjectural. Several have been attributed to the "Master of San José."[19] Three were collected in or near the Mesilla Valley; one was purchased in Ciudad Juárez, Mexico, and another in Mora, in northern New Mexico. The remaining nine, in private collections, are of unknown provenance.

The similarities shared among these figures in their solidity and monumentality, in the attention to the weight and fold of drapery, in the slight inclination of the heads, all result in a naturalism uncharacteristic of the aesthetic of the Río Arriba region (see Fig. 13-3), but fundamental to provincial Mexican art (Figs. 13-2, 13-6, and 13-7). Their construction also bears comparison with sculpture produced farther south: the figures are large—all but one are between one and two feet high; the figures' capes are wrapped around the bodies so that they are covered either completely or partially with gessoed cloth, which is usually draped over an arm; they all have exposed feet, usually made of plaster, and plaster heads and sometimes hair; they all wear V-necked robes with collars built up of plaster; and the sculptures are usually resting on thick wooden bases. In this group of *bultos,* as well as in the following one, these visual patterns and specific features are present, regardless of the figure's scale.

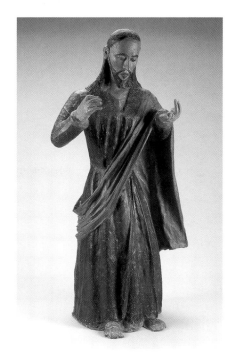
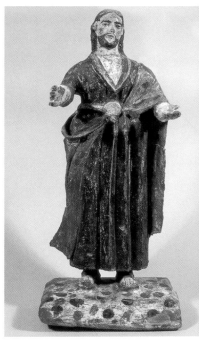

13-6. *Saint Joseph,* Mesilla Valley, New Mexico, wood, gesso, and oil, mid-nineteenth century. Museum of International Folk Art, Santa Fe, New Mexico, gift of Carter Harrison to the Museum of New Mexico. Photo Paul Smutko.

13-7. *Saint Joseph,* southern New Mexico, gesso and water-soluble pigments, mid-nineteenth century. Museum of International Folk Art, Santa Fe, New Mexico, Charles D. Carroll bequest to the Museum of New Mexico, Santa Fe. Photo Blair Clark.

One image bears a technique that clearly points out the relationship of this style with image production in Mexico (Fig. 13-8). The technique used for the decoration of the robe on this image of San José is a punch or stamp similar to that used for decorating *estofado* figures in Mexico.[20] The punch was used to expose the gilding, enhance the design, and help give the decorated wood the effect of a heavy brocade fabric. This technique has never been recorded for images made in northern New Mexico, but points to a clear relationship with images made in Mexico where *estofado* was common.

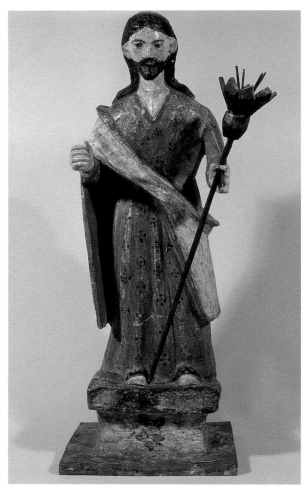

13-8. *Saint Joseph,* southern New Mexico, wood, gesso, and water-soluble pigments, mid-nineteenth century. Museum of International Folk Art, Santa Fe, New Mexico, the Fred Harvey Collection of the International Folk Art Foundation, Santa Fe.

MESILLA VALLEY STYLE

A series of images of various saints and archangels share many characteristics with other works collected in the Mesilla Valley. Before the survey was conducted, many of these images were either unattributed or attributed to the school of the Laguna *Santero.* Once again, they did not fit neatly into the stylistic characteristics of the *santos* of northern New Mexico. Because a number of images in this style have been

located in Mesilla Valley collections, they are referred to here as the work of the Mesilla Valley *Santero.* Shared attributes include plaster faces with eyes with drooping lower lids (see Fig. 13-5); plaster hands, and costume details, such as sashes, ruffles, and trim; the use of metallic leaf; and gessoed cloth garments. Paints appear to be both water-soluble pigments and oils (no definitive tests have been made), with varying tones of blue predominating in the palette. Within this category fall a number of angels associated with the images of San Ysidro discussed below.

THE WORKSHOP OF SAN ISIDRO

Seven San Ysidro figures were documented from the Mesilla Valley, one of which (Fig. 13-9) bears an inscription stating that it was repainted in 1888 in Las Cruces (established c. 1854 and the major settlement in the Mesilla Valley after 1880). Two others were documented as once having been in churches in Chamberino (a small town in the valley south of Mesilla/Las Cruces) and El Paso. These seven works are not by the same artist, but they share techniques and characteristics that suggest there may have been a workshop in southern New Mexico producing *bultos* of San Ysidro.

The largest image of San Ysidro documented during the survey (Fig. 13-10) bears a strong resemblance to the smaller San Ysidro that was retouched in Las Cruces (Fig. 13-9, above). The two figures, although different in scale, are similar in proportions, composition, costume, and gesture. All the figures wear the same costume, consisting of three-quarter length black coat, knee-high breeches, and short boots. They have short arms and legs in relation to their torsos, with the right arm raised and held in front of the chest and the left arm holding a staff. The subordinate figures of an angel and two oxen stand to the saint's right, with the exception of the group from Socorro, where four oxen are placed in front of the saint and one angel stands to either side. The angels are similar in their method of construction and their costume to other figures in the Mesilla Valley style. Their propor-

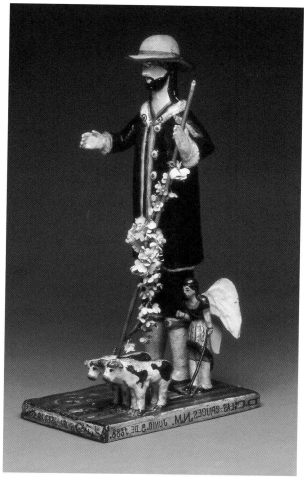

13-9. *Saint Isidore,* Las Cruces, New Mexico, wood, gesso, and oil, mid-eighteenth century (retouched 1888). Collection Letitia E. Frank. Photo Blair Clark. The inscription on the base of this *bulto* reads: *Sr. Sn Isidro / Fue retocado hen la Fecha de / D G Las Cruces. N.M. Junio. 3. DE 1888* [Señor San Isidro was retouched by the hand of D. G., Las Cruces, N.M., June 3, 1888].

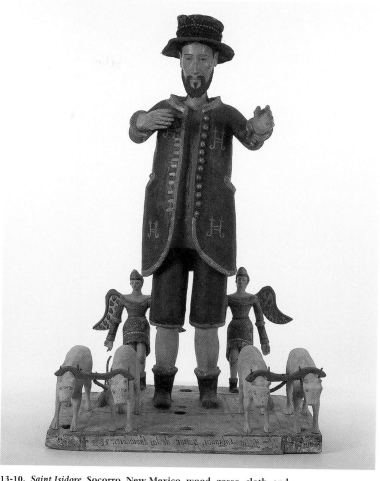

13-10. *Saint Isidore,* Socorro, New Mexico, wood, gesso, cloth, and oil, mid-nineteenth century. Museum of Spanish Colonial Art, Santa Fe, New Mexico. Photo Jack Parsons.

tions are short and squat, with protruding stomachs; they wear short tunics and crowns that come to a single point over the forehead.

THE SOCORRO *SANTERO*

Three sculptures that may have been made in Socorro (about 70 miles south of Albuquerque) are so similar in style that they can be attributed to the same artist (see

Figs. 13-1 and 13-10). The distinctive blue skirts on the angels of the San Ysidro (discussed above; Fig. 13-10) led to the identification of another object made by the same artist, a life-size *Santo Entierro* (Christ Interred). The *Cristo* wears a loincloth with the same palette and design elements as the tunics on the angels. Both the San Ysidro and the *Santo Entierro* were collected in Socorro, the former purchased in the 1930s and the lat-

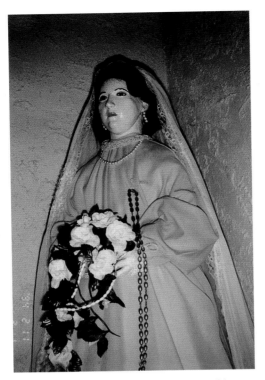

13-11. Attributed to Antonio Silva, *Our Lady of the Rosary,* New Mexico, wood, gesso, and oil paint, mid-nineteenth century. Collection of the Mission of Our Lady of Guadalupe, Peralta. Photo Robin Farwell Gavin.

13-12. Attributed to Antonio Silva, *Immaculate Conception,* New Mexico, wood, gesso, and paint, mid-nineteenth century. Collection of the Immaculate Conception Church, Tomé. Photo Bernardo López.

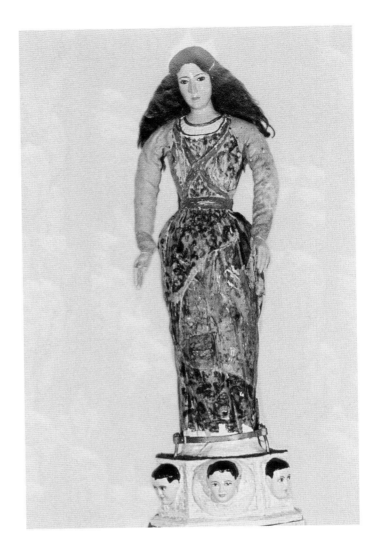

ter part of the collection of the Archdiocese of Santa Fe (housed at the Museum of New Mexico) and once located in the church of Our Lady of Socorro. The third image, the Jesús Nazareno that was once in the church in Chamberino (Fig. 13-1), shares other characteristics with the two Socorro images: hands formed of gray plaster; the use of fine, painted red lines to delineate the nostrils, fingernails, and ears; long, fine, delicate nose; and similarities in the shape of the head, the carving of the cheekbones, and the proportions of the figure. Socorro, a town established in the seventeenth

century and abandoned after the Pueblo Revolt in 1680, was resettled in 1816. This survey produced the first evidence for a *santero* working in the Socorro area in the nineteenth century.

THE TOMÉ WORKSHOP

According to oral history, a *santero* by the name of Antonio Silva was working in the region around Tomé, south of Albuquerque, in the late eighteenth to early nineteenth century. However, the pieces identified through this oral history are not by the same

hand but rather the work of different artists.[21] A survey of a number of pieces from the region did reveal several works that must have been produced by a single artist, but there is no evidence to confirm whether this is the work of Antonio Silva.

Stylistic similarities between the images of the Immaculate Conception at Tomé and Our Lady of the Rosary from Valencia indicate that they were made by the same hand (Figs. 13-11 and 13-12). Works by this artist documented from the Río Abajo include a Saint Anthony in Peralta (Fig. 13-13); an Immaculate Conception in Casa Colorado; two images of the Virgin Mary in Manzano; and another image of the Virgin Mary in Los Chávez. The head and hands of all these figures are uniformly carved, but the body types vary. Some are "candlestick" figures with a carved torso and individual staves or sticks, forming the lower half of the body, covered by a gesso-soaked fabric. Others have bodies carved from wood with varying degrees of finish (see Figs. 13-12 and 13-13). This type of construction is unusual in the Río Arriba and suggests an artistic style more affiliated with workshop sculpture produced in colonial Mexico, where master artists carved the most visible elements of a sculpture while apprentices or even community members produced the parts that were intended to be clothed.[22]

GESSO RELIEF

The use of plaster and/or gesso is one of the consistent characteristics of the images from southern New Mexico. Although gesso relief has been documented on images from northern New Mexico, it is rare and usually used only for minor details, such as collars, cuffs, and occasionally the faces of images on *retablos*. In southern New Mexico, however, gesso or plaster is used on numerous figures, and sometimes full figures are rendered from this material. An example of gesso-relief images on board is illustrated in plate 5 in E. Boyd's *Popular Arts*. A full figure of a Crucified Christ was documented in the Minge collection (now part of the Albuquerque Museum), which was collected in southern New Mexico. These images are formed in a

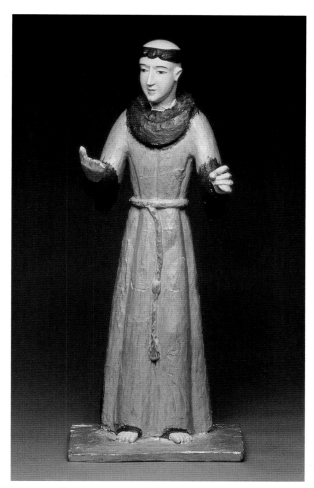

13-13. Attributed to Antonio Silva, *Saint Anthony,* New Mexico, wood, gesso, and oil paint, mid-nineteenth century. Collection of the Mission of Our Lady of Guadalupe, Peralta. Photo Blair Clark.

mold, with some of the finer details carved with a sharp instrument. Similar use of plaster and gesso has been found in images from northern Mexico, in the area around Chihuahua.

Southern New Mexican Religious Images

The data collected during this informal survey indicate that numerous religious images were produced in southern New Mexico in the nineteenth century. Certain stylistic characteristics and techniques of manu-

facture are similar enough to group them into possible workshops and to set them apart from the images produced in northern New Mexico. Techniques that were previously thought to indicate *earlier* manufacture in northern New Mexico, such as the use of gessoed cloth and more naturalistic poses and expressions, are now very possibly characteristics of work produced in the first quarter to the mid-nineteenth century in southern New Mexico. So if these stylistic and technical attributes do not represent a stylistic "evolution" in the production of the *santos* from more Baroque and naturalistic to less academic and more stylized, as many authors have suggested,[23] then how do we account for the different styles of images produced at the same time less than 200 miles apart?

One of the factors that may have contributed to these stylistic differences is proximity to the pueblos of the northern Río Grande. These pueblos, concentrated in the area between Albuquerque and Taos, were founded in the prehistoric period, were occupied throughout the colonial period, and are still occupied today. The area south of Albuquerque along the Río Grande, however, had only one permanent Native American settlement by the late colonial period, Isleta Pueblo, which was abandoned during the Pueblo Revolt and resettled after 1692. The Mesilla Valley was populated intermittently by nomadic groups.

What is defined today as the New Mexico style of imagery from the colonial period is unique to those images that seem to have been produced in the narrow geographic area of the Río Arriba, or the northern Río Grande Valley.

As we have seen from this survey, the *santos* from southern New Mexico and the Río Abajo are distinctly different in both style and construction and suggest a stronger relationship with images produced farther south in present-day Mexico. This suggests that the proximity of the northern Río Grande Pueblos to the northern Río Grande Hispano communities made a real difference to the appearance of the religious images produced in these communities. The foregoing study of Río Abajo sculpture corroborates and hones arguments set forth elsewhere in this volume that Pueblo cultural traditions contributed to the Catholic art produced in the region north of Albuquerque after the mid-eighteenth century. Furthermore, close reading of the material evidence—revealing shared features of technique, composition, and materials—provides the strongest evidence to date that artists in this region were trained in workshops organized at the village level, in this way transmitting styles and educational methods associated with the guild system established in central Mexico at the beginning of the Spanish colonial period.

DINAH ZEIGER

Creator Mundi, which bills itself as "A Gallery of Distinctive Sacred Art," is something of an anomaly in Denver's tony Cherry Creek North shopping district, where chic restaurants and trendy boutiques purvey an upscale lifestyle to well-heeled middle-class consumers (Fig. 14-1). Creator Mundi (literally, creator of the world) sells an eclectic mix of religious objects, everything from crucifixes to menorahs, in a small, sleek space on one of the most-trafficked streets in the sixteen-block shopping area. Celtic crosses and facsimiles of pages of illuminated manuscripts share shelf space with Eastern Orthodox icons of the Virgin and Child. Russian icons of the saints, encased in elaborate metal frames, are displayed beside Jewish menorahs, and Southwestern *santos,* primarily the work of the local *santero* Ronnald Miera, jostle for attention with abstract bronze medals popular with Roman Catholics. The upper floor of the shop contains a small selection of books ranging from slick photograph collections of sacred "art treasures" and images of angels to weighty investigations of the meaning of scripture.

This is not the type of "art" typically found in Cherry Creek North's galleries, which tend more toward pricey art-glass sculptures, prints, and Southwestern objects like hand-woven rugs, pottery, and the ubiquitous howling coyote.[1] The objects in Creator Mundi are not displayed as art, with individual pieces showcased on special stands or dramatically lighted on nearly bare walls or isolated within vitrines. Instead, merchandise is displayed like housewares, cluttered on dozens of open shelves, lining the walls, with a few small or fragile items tucked into glass-fronted counters. No object is singled out for attention or self-consciously displayed as special.

Creator Mundi's German-born owner, Hildegard Ledbetter, opened the Cherry Creek shop in 1997 because of her frustration with "disgusting stuff . . . kitsch and plastic saints" that she routinely saw in people's homes when she worked as a real estate agent.[2] On some deep level, Creator Mundi reflects Ledbetter's desire to proselytize. Her crusade is not on behalf of a particular creed or faith; rather, it stems from a deep-seated idea that belief can be enhanced by beautiful devotional objects. For Ledbetter, the more beautiful the object the deeper the connection to the spiritual. What she strives for in Creator Mundi is to make available sacred objects crafted to the highest standards of

14-1. Creator Mundi, 2910 East Third Avenue, Denver, mixes styles and ritual practices in its retail space in a popular shopping area. Religious books and incense candles share shelf space with hand-carved *bultos* and traditional *retablos,* cast metal sculptures, and pottery. The owner, Hildegard Ledbetter, believes beautiful devotional objects enhance spiritual belief. Photo Dinah Zeiger.

artistic quality. The stock is "ecumenical," and buyers are mainly what she calls "professional clergy," priests, pastors, and nuns. But a growing proportion are casual shoppers, attracted by the objects visible through the store's large display window. Sometimes they only buy a card or stop by to chat with the clerks, who are knowledgeable and patient. Orthodox icons are very popular, as are angels and nativity figures, especially around Christmas. The single biggest sellers, Ledbetter says, are crosses. They range from the simple, familiar shape made from imported hardwoods and cast bronze, to life-sized, often bloody crucifixions suspended from the ceiling. Ledbetter says she thinks the appeal of the cross is that it's a universal symbol, not specifically important to one branch of Christianity. "A lot of people at first were interested in the icons, even non-Orthodox Christians. I was suspicious that they took them because they looked old and somehow they only valued them because of that. Maybe they weren't interested in them for devotion. I don't know," she says. "We've sold a few 'art' pieces, but the majority of buyers are those who have a need themselves or for someone they know."

Creator Mundi straddles a curious middleground between an "art gallery," in some abstract definition with implications about taste, and a kitchen boutique selling household items like funky ceramic dishes and top-of-the-line cookware. In fact, one way of considering Creator Mundi's merchandise may be to think of the pieces as useful objects, necessary to daily life, much the way many contemporary Americans look at religion itself. Looked at from that perspective, these religious objects perhaps reclaim an aspect of their being that is often denied them in postmodern criticism, namely, their power to continue to function as devotional, utilitarian items rather than being merely decorative pieces intended strictly for display.

The notion that making and selling sacred objects somehow corrupts their devotional nature lies at the heart of the current debate over *santos,* painted wooden or tin panels *(retablos* and laminas) or carved statues *(bultos)* of the saints and the Holy Fam-

ily. Perhaps more than almost any other type of sacred art in the marketplace today, *santos* are a site of contested meaning. Some scholars attempt to fix these objects in time and space and to attach specific and exclusive meaning to the images and their uses. The fact that many buyers of *santos* are non-Catholics also raises questions about their purpose. In reality, however, *santos* are a highly constructed category of objects, which since the early 1900s have migrated to museums, galleries, and private collections, where they are hoarded and displayed as precious rather than devotional objects. Embedded in the debate is a suspicion that when devotional objects cross the boundary to become decorative objects they lose their traditional meaning and cease to function as indicators of the sacred.

Laurie Beth Kalb argues in *Crafting Devotions: Tradition in Contemporary New Mexico Santos* that "early Anglo tradition seekers" shifted the meaning of devotional objects by collecting Spanish colonial *santos:*

By removing *santos* from churches and the homes of local parishioners, early collectors stripped the Spanish colonial images of their devotional use. Housing them in their living rooms, the new owners adopted colonial *santos* as foundlings and redefined them as antiques. The carvings became objects from a distant past that once had functional value to a certain community but that now had aesthetic and, perhaps, symbolic import for a culturally removed group of admirers.[3]

Anglo owners might revere their *santos,* Kalb says, but for the wrong reasons: because they are old or fit some vague notion of "beauty," or because they are "authentic." These new owners might even have some notion of their "generalized spirituality," but not their true religious value, which, Kalb says, is not "culturally portable beyond the Hispano-Catholic community."[4] Moreover, contemporary *santeros* flog their wares today at fairs, museum exhibitions, and the prestigious Spanish Market held in Santa Fe each year in July. They promote their *santos* not only to the faithful but also to tourists, simultaneously reposition-

ing and elevating the objects to the status of "art" or degrading them to mere souvenirs.

Implicit in such a reading are various assumptions that fail to address the meanings attached to the *santos* by their makers and their owners and raise questions about devotional objects and viewer response. First is the assumption that *santos* are closed and unmediated images. But who, exactly, has determined the "traditional" meaning of *santos*? Was that meaning ever stable and fixed, or were the images and their uses always adaptable to new circumstances? What is left out of such a critique is how owners and makers of *santos* interpret and negotiate meaning, which is in a constant state of flux, changing in response to changing circumstances. For surely the power of these images is their ability to "tease certain kinds of emotive responses" that are mixed into the cultural baggage of ordinary lives to produce meaning.[5]

Perhaps there are some different questions to be asked. For example, why would someone buy a *santo*? How is it used and where is it placed in the private spaces of the home? Is it possible for a *santo* to be both devotional and aesthetic? Such an investigation might reveal that the desire to fix in time a meaning for *santos* robs them of their true power to continue to multiply meanings and remain useful in a far wider community over time. What these assumptions also fail to recognize is a singular aspect of the American character—namely, a deeply ingrained religiosity that is part of the national myth of America as the New Jerusalem. According to a December 1998 *Life* magazine photo-essay on religious America, 96 percent of Americans say they believe in God (compared with 70 percent of Britons), 79 percent pray to God for help, and 33 percent believe the Bible is the actual word of God.[6] At the same time, American Christianity articulates a profoundly democratic spirit, one that embraces many competing and often contradictory interpretations of the Word of God. Its strength lies in those very contradictions and in the unspoken but understood notion that personal, unmediated interpretations of Scripture are a fundamental right of

every American.[7] A key aspect of this religiosity is the notion that belief is a private matter, endlessly flexible in its practices and expression. Institutional religion certainly has its place and its adherents, but it is on the fringes and in the homes of believers that faith is manifested most uniquely in America. And because belief is private and expression is so flexible, it is impossible to secure a single meaning to objects of devotion.

Consumption of devotional objects is not a contemporary phenomenon. Colleen McDannell in *Material Christianity: Religion and Popular Culture in America* traces the consumption of the material goods of Christianity, whether Protestant or Catholic, to at least the seventeenth century in Europe. While it was forbidden to display statues of saints in Protestant churches, families did hang images depicting Bible stories in their homes. In fact, as McDannell points out, many of the Protestant clergy subscribed to the Roman Catholic belief that appropriate images were instructional and could encourage people to lead a holy life, at the same time teaching them "correct historical scriptural reality."[8] In many Protestant homes, a family Bible was, and is, displayed prominently in a public space, often near a print of Warner Sallman's popular *Head of Christ*.

Catholics have a much longer tradition of using images and objects, whose power is derived only partly from the institutional blessing of the Church, as part of their devotions. In large measure the power of such objects derives from their integration into and use within the day-to-day lives of believers. In many homes, a simple print of the Sacred Heart of Jesus or an inexpensive plaster statue of the Virgin enters the realm of the family, taking its place in the kitchen or on top of the television surrounded by photographs and other personal mementos. Similar home altars are also found in the homes of Protestants, attesting to the familial and personal attachment people feel for the images and objects.

In other words, people have been buying devotional objects for a very long time. As Erika Doss points out, this combination of religious and commer-

cial sensibilities in the American home is nothing new: "In the nineteenth century, Protestants and Catholics alike linked religiosity with domesticity, creating a more sanctified homefront with parlor organs, Bibles, religious pictures, and plaster statues of the Madonna and Child. While this changed somewhat in the twentieth century, many post–World War II Christian homes remained reverential, largely through the widespread consumption of mass-produced images and religio-commercial objects."[9]

The art market—that complex network of cultural insiders who define and assign value to objects as art—is a more recent phenomenon.[10] But assumptions about the power of the art market to drive purchases of *santos* need to be unpacked. David Halle's argument in *Inside Culture: Art and Class in the American Home* supposes that buyers are dependent upon art experts—who understand these things by virtue of education and training—for advice.[11] The presumption is that some people buy *santos* as indicators of status: by possessing such objects their owners somehow signal that they are "in the know" and have acquired the means—economic as well as educational—to grasp the *santos'* value. This might be true occasionally, but Halle's own research doesn't bear out status as the prime factor in most people's decisions to buy particular kinds of objects or works of art.[12] In an informal survey of buyers of *santos,* all of the people I talked to were aware of the "market" aspect of the objects, and, indeed, had purchased them at fairs and outdoor markets.[13] But none said they bought them because they might increase in value or because they were collectors' items. One of those interviewed, Michelle Thomas of Denver, sums up most of the other comments: "First of all, we buy them [*santos*] for their devotional aspects. They're not intended to be 'art,' as such. They may increase in value, but that's not our reason. We have a cross in every bedroom. Some days when I'm not particularly thinking about God in my life, I look up and see them, and I'm thankful and grateful when I see things like this in my house."[14]

The danger in ascribing too much authority to the art market lies in the implication that meaning is a one-way process, handed down from above by a cultural elite of collectors, museum curators, critics, writers, and theologians, who hold the keys to the significance of the object. In reality, the cultural elite rarely holds such power. Pierre Bourdieu, in examining the culture-as-domination theory, posits that the meaning of a work of art is available only to that person "who has the means to appropriate it, or in other words to decipher it."[15] And the deciphering capability is the direct result not only of institutional education, which allows one to master systems of classification like style and attribution, but also of the socialization of the individual within his or her own milieu. Culture really boils down to class, Bourdieu says, available to those who have "the means to acquire the means to appropriate it"—in other words, money and education.[16] Pivotal to this process of appropriation is the requirement that it appear to be natural, to look as if some people are simply *born* cultured, blessed with a kind of inherent merit. This cultivated eye—apparently, born, not made—is thus in a position to pronounce what objects mean. According to this theory, the vast public, which is not so well informed, simply swallows what the cultural elite feeds it.

Such an assumption, however, fails to consider the consumer as an active maker of meaning. Nor does it consider the driving force of faith: the desire to believe and the need for objects that convey or embody such faith. What someone sees when looking at an image may or may not be what the artist intended, for the response is particular and the reaction belongs to the viewer, not to the object.[17] *Santos* are an instance of this exchange. Michelle Thomas said she was attracted to the *santos* she bought because of the familiarity of the images. "I guess they look like me. But I'm also drawn to particular images—saints that are patrons of the home, for instance, and crucifixes." Accessibility is one of the main attractions of the *santos*. The stories behind the images are familiar to Catholics and even appeal to non-Catholics when they can locate a need or use-value within the narrative.

A case in point concerns the nomination of a patron saint of the Internet. Communities generally choose a patron because of a certain talent, interest, or event in a saint's life that overlaps the condition requiring patronage; the impetus is usefulness backed by faith, and official sanction is not required. Internet users wanted a protector, and in 1998 they narrowed the field of contenders to Saint Isidore of Seville, a seventh-century Spanish bishop who compiled the twenty-volume *Etymologiae,* a sort of encyclopedia covering grammar, medicine, law, geography, theology, and even cooking. In early 2002 the Vatican added its weight, forwarding Saint Isidore's name to the Congregation for Divine Worship and the Sacraments, which sets Church liturgy.[18] This selection process is an intriguing example of a cultural transformation tailor-made to meet the needs of new people and new communities.[19] And the Internet is certainly a new community, in many ways comparable to the New World that became the mixing bowl for Spanish and indigenous cultures.

Some argue that such casual use by those outside the faith is a form of cultural appropriation, treading on ground that belongs to a cultural "other," whether that "other" is Catholic devotional practice borrowed and misunderstood by non-Catholics or whether it is Anglos taking possession of a uniquely Hispanic art form. The problem with the appropriation argument is the implication that the "traditional" images were not themselves borrowed from other cultures and altered over time. The earliest extant *santos* made in New Mexico and southern Colorado have been catalogued according to criteria that were constructed to account for form and materials, since next to nothing is known about the makers. The standard descriptions emphasize the isolation of the communities in which the *santos* were made and can evoke a mistaken belief that they were somehow the product of a particular creative genius, untouched by external influences. But *santos* were never the exclusive property of the Hispanic communities of New Mexico.

Marion Oettinger Jr., in a catalogue essay for the

exhibition *El Alma del Pueblo,* stresses the evolving, malleable nature of the images, which have assumed, as he says, "the forms required by time and place."[20] The *santos* share a cultural veneer with their antecedent Spanish Catholic religious images, but they have been refashioned and often dramatically altered "to meet the needs of new people and communities . . . through time and space."[21] The Southwestern *santeros* reflected both the needs of the community and the materials available.[22] San Isidro Labrado (Saint Isidore the Farmer) is patron saint of Madrid and of farmers, and it's no accident that he's one of the most popular *santo* figures in the New World, since most of the area into which he was imported in the sixteenth century was rural and agrarian. What is interesting is how the figure has been adapted: he wears clothes and harvests crops peculiar to each New World community he serves (Fig. 14-2).[23]

Now, it might be argued that clothes don't make the saint, but, in fact, they do to the extent that they help believers identify one from another. The Council of Trent—convened by the Pope in 1545 to reform certain church practices considered corrupt—mandated that religious art be accurate, realistic, and inspirational.[24] The function of religious art was to inspire the faithful to emulate the spiritual lives of sainted people.[25] Therefore, the depictions should emphasize the humanity of the saints and the Holy Family, accentuating the fact that they had been real people who had lived real lives. At the same time, however, the Church needed to retain control over the viewer's interpretation of the behavior to be emulated and therefore over the artist's interpretation of sacred narrative. The result was an emphasis on accurate depictions of the lives of the saints as "officially" recorded. In practice, this translated into an emphasis on iconography: the use of standardized visual symbols as a shorthand narrative that enabled the viewer to identify a realistically depicted moment of action, with its individual human model(s), as a scene from the life of a particular saint. Images of saints and the Holy Family thus emphasized some distinctive characteristic or

symbol that could be quickly and easily recognized. The martyr Saint Sebastian is typically portrayed pierced by arrows. Saint James the Greater, Spain's Santiago, often is shown on horseback riding down the Moors, but he's also sometimes portrayed as a pilgrim, with staff, gourd, and a scallop shell on his hat. Even when he is depicted on horseback, the scallop shell appears on his hat.[26]

What's at work in such images is *recognition,* which David Morgan argues lies at the heart of popular visual piety. These familiar images offer reassurance and reaffirm faith, he says, providing an anchor of stability in tumultuous times.[27] An example among *santos* is Nuestra Senora de Guadalupe (Our Lady, or The Virgin, of Guadalupe), the patron saint of Mexico. In the sixteenth-century image in Mexico City she wears a rose-colored gown and a cloak of greenish blue, hands clasped to her breast, head tilting slightly to her right. She is shown standing on a half-moon held aloft by an angel, her whole body surrounded by the spiked rays of a golden halo. These are her "traditional" attributes, those items with which the Mexican Virgin of Guadalupe is associated and without which she would not be the Virgin of Guadalupe.

But how stable are these attributes? No matter how conservatively intended, iconography lends itself to cultural reinterpretation, as the arguments over the Virgin of Guadalupe demonstrate. Because she is "dark-skinned," like the native people to whom her image has been directed since the sixteenth century, she is now widely regarded as a symbol of native resistance. But Thomas Steele, S.J., says that all the iconography including the "vaguely Semitic face (in Mexico the Virgin is often known as La Morena, literally the Moor)," are European in origin and are not indicative of or derived from indigenous religious iconography.[28] He argues that her image was not "a set of heavenly messages couched in indigenous symbols, in a sort of Aztec code."[29] Jeannette Favrot Peterson, on the other hand, sees the Virgin of Guadalupe as a fusion of the Christian Mother of God with native Aztec mother goddesses. Like the preconquest earth

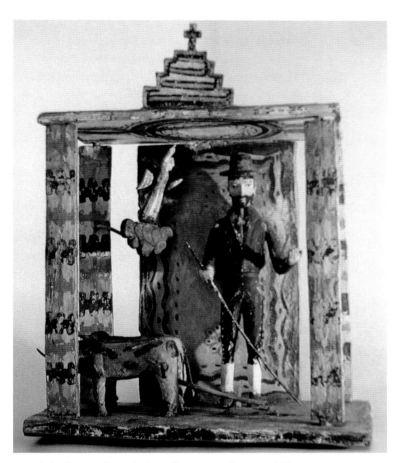

14-2. Pedro Antonio Fresquís, *San Isidro,* gesso and water-soluble paint on wood, late eighteenth–early nineteenth century. Taylor Museum, the Colorado Springs Fine Arts Center (TM 1244), Colorado Springs.

mothers, the Virgin symbolized fertility and protected against disease and natural disasters. The attributes associated with the Virgin of Guadalupe derive from the Apocalyptic Woman described in Revelation 12.1—"a woman clothed with the sun, and the moon under her feet, and upon her head a crown of twelve stars"—which Peterson adds were commonly seen in European representations of the Immaculate Conception. But the symbols themselves transcend cultures for historical reasons.[30] Peterson argues that it was necessary to fuse the Virgin and the Aztec earth mother

because, despite the Catholic Church's "zealous program of evangelization," from the beginning of the Spanish conquest, traditional indigenous religious beliefs and practices persisted. New Christian saints were substituted for old gods, and parallel beliefs and rituals were incorporated into Christian rites.[31] William Wroth recounts several instances of a divine or miraculous appearance by the Virgin at or near a former shrine dedicated to an indigenous goddess:

These events may be interpreted in various ways, but from the point of view of the Christianized Indians, the miraculous appearance of Mary provided a continuation of the divine blessings granted them by the goddesses of the indigenous religion. Mary simply was the goddess appearing in another form. The often-expressed idea that these events were engineered by the Catholic Church to bring more Indians into the fold overlooks the serious consequences and problems which miraculous cults had for the church. To say the least, the miraculous appearances were a two-way street; the Indians utilized them for their own ends, perhaps more effectively than did the clergy.[32]

Changing the worldview of an entire population was no simple matter, as Wroth points out, and European Christianity was decidedly different from indigenous practice in its interpretation of the cosmos. For the native populations, divinity was found within every thing created, every action, every moment. In contrast, the Catholic Reformation Church view emphasized the transcendent aspect of God the Father, downplaying his participation in the everyday world, except through the incarnation of his son in human form as Christ.[33] Such Christocentric emphasis creates ambivalence in Christian attitudes toward miraculous images and places: on the one hand an overemphasis could lead to worship of images; on the other images were useful in educating the faithful and intensifying their devotions.

The foregoing is merely to point out the slipperiness of attempting to ascribe a constant and consistent iconography even to well-known images or to fix a particular meaning to them. As both Halle and Mor-

gan show, meaning is modified and reshaped by individuals, whose response is intuitive as well as intellectual. In the case of the Virgin of Guadalupe, how the image was interpreted depended on whether the beholder was a Spanish cleric or a Christianized native inhabitant. In both cases, believers read into the image what they needed to see. The primary appeal of such images is that they help individuals cope with "an oppressive or indifferent world."[34] They are, above all, useful objects, engaged and functional in people's daily lives.[35] And, to judge from my interviews, they remain so in a variety of ways, whether or not they have been blessed by the parish priest. For some people, their *santos* are gentle reminders of God in their lives; for others they resonate "quiet pleasure." For Andrea Schroeder, whose home contains an eclectic mix of *santos* from Mexico and Central America as well as New Mexico and the Philippines, they evoke an emotional response: "I'm a cradle Catholic, raised in Iowa, and I've only gone to Catholic schools. My religion is a strong daily part of my life. I am surrounded by Catholicism. These images have always had a lot of meaning for me. What I love about *santos* is they are so emotional. The passion of Catholicism is what I love . . . the tears on the Madonna's face. I started loving *santos* because of how they capture the emotionalism of Catholicism."[36]

James Elkins, in his book *The Object Stares Back: On the Nature of Seeing,* says that objects—pictures or things in general—provoke a dialogue with the viewer that engages not only the eyes but the whole body in an anything-but-passive response.[37] Looking, he says, is really hunting, and the objects themselves are a kind of lure, hooking us because we want to be caught. In this game of hunter-and-hunted, it's impossible to be passive or objective: "We are so deeply involved in the world, so desperately dependent on it, that we must pretend that we have some distance. . . . Our 'objective' descriptions are permeated, soaked, with our unspoken, unthought desires. . . . Just beneath the surface there are other forces that can't quite be spoken, twisting their way

through the viewer's thoughts, forcing the eye here and there."[38] For believers, looking at *santos* involves a total engagement, an active beseeching. As Morgan points out, "the body of the believer is explicitly engaged. . . . The transcendence they seek is deliverance from ailment and anguish. . . . Desire is at the heart of this vision; there is nothing 'disinterested' about it."[39]

Both Morgan and Elkins argue that even purely aesthetic contemplation is never entirely "disinterested." The roots of the discourse on aesthetic disinterestedness lie in Protestant theology and ethical reflections on selflessness, "more specifically the abandonment of self-interest in the face of the divine or human other."[40] The theological contemplation of the pure beauty of God and his works was transformed in the eighteenth century into a philosophy of aesthetics, but the language remained largely intact: the enjoyment and contemplation of beauty is an inward, mental state divorced from everyday existence. Attempts to simplify and etherealize *santos* in the name of form remove them from their messy, experiential, original context.[41] To do so requires ignoring the folktales surrounding them and spurns the facts of daily existence from which they arose and in which they still function for many. More important, the idea of aesthetic disinterestedness ignores the possibility that the beholder—including someone who claims to be "disinterested"—is in fact responding to some unspoken need. Although the object itself may be a "hook," the fact remains that someone ultimately *chooses* to buy this one particular thing from among thousands of other possible choices. Then he or she displays it in the private spaces of the home, the locus of identity and the place where one exercises control.

The *why* of the choice is complex and personal. Perhaps, as Morgan suggests, it is because these religious-themed objects provide reassurance and continuity in an impersonal, homogenized modern world. They correspond to systems of belief by offering a means to unstructured, unmediated contemplation. An interesting case in point is provided by *santos*

depicting San Pascual Baylon. Pascual—proclaimed by the Vatican as the saint of the Eucharist and of shepherds—is most commonly shown in his role as patron of cooks and kitchens and is one of the most popular contemporary *santos*. Depictions of this saint are rarely thought of as a "collector's item"; rather, the image has descended into the realm of what some *santeros* characterize as the "mundane collectible" and is often dismissed as tourist art, even though San Pascual existed historically.[42] He was born to a shepherd's family in 1540 in Torre Hermosa on the borders of Castile and Aragon in Spain and became a friar of the Franciscans of Saint Peter of Alcantara when he was about twenty. According to the account in Butler's *Lives of the Saints,* he "schemed to secure special delicacies for the sick [and] the poor," and was invariably good humored. His eucharistic patronage was conferred because of his cheerfulness in prayer and devotion to the Sacrament (the communion of bread and wine). But his distinction as patron of the kitchen probably derives from this apocryphal story: "When Paschal was refectorian and had shut himself in to lay the tables, another friar, peeping through the buttery-hatch, caught sight of the good brother executing an elaborate dance—leaping high and moving rhythmically backwards and forwards before the statue of Our Lady which stood over the refectory door."[43] Today, San Pascual is invoked for cheerfulness, and he is usually depicted in the kitchen, often with a well-fed cat. Sometimes the images show onions or chilies hanging beside a fireplace or a pot over a flame.

Contemporary *santeros* make the image of San Pascual because it *is* popular. "I work to the market," the *santero* Ronn Miera acknowledges.[44] "People like San Pascual shown with bread and the wine, not the Eucharist [the holy wafer]. They [bread and wine] are symbols of the Eucharist but are not so obvious." The *Santera* Catherine Robles-Shaw says she makes "a lot" of San Pascuals. "He's very popular with people who don't know very much about the imagery. But they know San Pascual as patron of the kitchen and food. He's the kitchen saint, to make better meals. It's a

nonthreatening religious image."[45] But several of the *santeros* also believe that when buyers reach a comfort level with San Pascual, they want to know more about other images. So, in a way, the image reverts to one of its traditional uses, as a didactic device, leading people to a deeper understanding of the divine. Both Miera and Robles-Shaw spend a lot of time at fairs and shows talking to people who stop at their booths. As Miera explains:

I approach it [making *santos*] first as education. I put a description on the back of each *santo* I make. It tells who the saint is, the purpose behind them as devotional objects, and I encourage people to use them. I suppose some people do buy them as decorative objects, but they also get interested. I publish a newsletter that I send to people who buy my *santos*. It tells them the stories, and how we make the colors, and what's going on in the *santos* world. But you never know with buyers; maybe they get it home, hang it on the wall, and pass by it daily and it reminds them of the story. All that repetition, maybe it gets to them.

It would be misleading to think that buying such objects as *santos* is primarily a by-product of cultural tourism and souvenir collecting. As Michelle Thomas says, "I can't imagine anyone who would hang a collection of crosses on the wall in their house just to have a collection. With so many things to choose from, why would they choose this?" Why, indeed. As traces of authentic experience, *santos* may answer some deep-seated yearning, some desire to reclaim a romanticized version of a lost world. But they are seldom, if ever, merely souvenirs arising out of "the insatiable demands of nostalgia," as Susan Stewart defines souvenirs in *On Longing*.[46] She locates souvenirs as narrative generators that can only reach behind, into the past, incapable of moving outward toward the future. Yet when buyers move *santos* into their private spaces, the images appear to function as a bridge linking past, present, and future. If used as devotional objects, they are, by definition, about hope, which is always about the future. But their stance is in the pres-

ent, based on a historical past that has established a precedent for how the saint is depicted and how it functions as an intermediary. And the *santeros* are careful to explain to believers that if they wish their *santos* to function as devotional objects they should have them blessed by a priest.[47] Even if *santos* are admired and originally purchased mainly for their aesthetic qualities, there remains the possibility of change through the act of looking, which is, again, a condition that requires a future balanced by the past. As Elkins points out, "*The* beholder is many beholders, and *the* object is many objects, and there is no scene in which a single beholder stands and absorbs facts and forms from an object while remaining impassive. . . . A picture *is* the ways and places it is viewed, and I *am* the result of those various encounters."[48] The owners in my survey, whether they use the objects devotionally or not, admired their *santos* for what they represented rather than for how they looked. The authenticity of the image for beholders, Morgan says, is based on "fit or adequate correspondence." Mixed in with *bultos* depicting Saint Barbara and Saint Gertrude and a large Tree of Life in Joanne Ditmer's house is an unusual *santo,* a *bulto* of Saint Catherine of Siena, made by Malcolm Withers (Fig. 14-3). Ditmer, a "Protestant minister's daughter," commissioned the piece after careful research into the lives of saints, because she "liked the fact that she [Catherine] was wise and Popes came to her for advice."[49] For her, the images are also "symbols that religion can do good things." Maureen Harrington has several *santos* in her bedroom. Their appeal, she says, is in their "messy, handmade look . . . like someone real made them."[50] Andrea Schroeder connects with the tears of the Madonna, the suffering, and for her "the first thing that must appeal to me is that the figures must represent something"; they have to tell a story.[51] Thomas says she wants people "to walk in and see [the *santos*] as an expression of our faith in God and the place faith has in our daily life."

Even in homes where the *santos* are regarded as devotional-religious objects, they can simultaneously

hold other meanings, for example as decoration. In Thomas's home, the *retablos* hang on walls in the family rooms and were deliberately placed in positions guaranteed to attract the attention of visitors.[52] In Schroeder's and Ditmer's homes, the *retablos* and *bultos* are included in a welter of similar objects. The *bultos* in Ditmer's living room share shelf space with carved and cast Buddhist images as well as small Native American sacred objects. Schroeder mixes New Mexico–style *retablos* and *bultos* on the living-room mantel with objects ranging from scapulars to holy cards and plaster saints. *Santos* and other similar images also hang in the family room and kitchen, and she has a small altar in her bedroom. By far the dominant material is wood, in part because her German-born father took up woodcarving after he retired. She knew which among the hundred or so pieces displayed he had made, but who made the others was immaterial to her. That was true of most of the other owners interviewed. Few of the people I talked to were concerned about the materials—or the maker, for that matter. Few could name the *santero* who made the images without turning them over to see if they were signed. "It's not important to me to know who made them," said Ditmer. "I just like the figures."

The issue of authenticity seems of much greater concern to the *santeros* themselves. That's probably because their status in the Southwestern marketplace depends upon their identity as an "authentic" *santero,* that is, a descendant of a Hispano New Mexican family, which is generally a criterion for acceptance as a Spanish Market participant.[53] Entrée is predicated on familial ties and use of traditional materials and techniques. Many *santeros* begin practicing their craft using any materials to hand—acrylic or oil paints, old lumber, and commercial varnishes. Most are self-taught and learn by talking with other *santeros* who have mastered the old materials. Gradually, the "traditional" way of making paints and varnishes and the "traditional" materials, usually cottonwood or piñon pine root, take over. This concern is driven largely by the marketplace, which mythologizes tradition, locat-

14-3. *Retablos* and *bultos,* Buddhist temple bells, Hindu incense burners, and Native American sacred objects share space on wall-mounted shelves in the living room of Joanne Ditmer's house. Photo Dinah Zeiger.

ing authenticity in adherence to earlier forms and hand-mixed, locally gathered materials. But such cultural authenticity is a construction that benefits and is controlled by the market, in particular the influential Spanish Market held in Santa Fe each summer. As Kalb points out, "For Spanish Colonial Arts Society board members, making traditional crafts means adhering to the Spanish colonial style developed by SCAS, that is, replicating nineteenth-century religious and domestic items found in museums, private collections, and some churches, and perpetuating a revival style begun in the 1920s in response to early Anglo patrons."[54] Robles-Shaw says if she didn't show her work at Santa Fe's Winter Market, also sponsored by the SCAS and held annually on the first weekend of December, she wouldn't do as much business. "It's exposure, and it's New Mexico, which is so important (for *santeros)* because people go there to buy and see this kind of stuff." Robles-Shaw, the only Colorado *santera* whose work is shown at Spanish Market, makes a living from her *santos.* Miera, on the other hand, supports himself working as an auditor for Kmart Corp. and makes *santos* in a basement workshop in his spare time.

Authenticity in materials, techniques, and forms is also a strategy by which *santeros* can claim their cultural identity and ethnic heritage. Uncovering the traditional images and ways of making them is a voyage of personal discovery and self-identification. The *santero* Miera, who was born and raised in Brighton, Colorado, said his interest began when he was digging into his family history, which he traced to Don Bernardo Miera y Pacheco, widely recognized as the first *santero* in New Mexico. "He's a seventh great-grandfather," Miera says. "I was curious what a *santero* was and started to read about it." From there, he began making images, painting in acrylics on odd bits of lumber. Attending fairs and marketplaces introduced him to well-known *santeros,* who shared with him techniques and materials. Now, as part of his strategy for recovering his heritage, he makes many of his own pigments and varnishes from materials he col-

lects. Several generations back Miera's family converted to Mormonism and only reconverted to Catholicism two generations ago. His images, he says, are "about tradition, and a lot of the tradition has been lost in the Hispanic community."

Robles-Shaw's family roots lie in Conejos County in southern Colorado's San Luis Valley. Although raised in Denver, she grew up with home altars and images of the saints. "My mother and grandmother both had them, and I bought plaster saints for home altars," she said. She, too, began with acrylics and oils and graduated to traditional pigments as she learned from established *santeros.*

There's a certain irony in the insistence on "traditional" cottonwood panels and handmade pigments, since the earliest locally produced religious images in New Mexico, according to seventeenth-century inventories, were paintings on hides, textiles, and walls.[55] Supply trains from Mexico carried new ideas as well as much-needed consumer items, including religious images, to New Spain's remote colonies. Goods were imported from Mexico, Spain, and even Asia, influencing materials, colors and style, and form and content of images.[56] In northern Mexico cheap tin became a favored material for painted *retablos,* and because they were inexpensive and available from artist/peddlers, who sold them door-to-door or from stands set up around churches during holidays and feast days, they were popular devotional items in the nineteenth century.[57] However, few contemporary *santeros,* if any, produce painted tin *santos* today, although tinwork may be added to *bultos* as halos, or made into decorative frames for *retablos.* For most *santeros* in the Southwest, the "tradition" is based on wood.

The *santeros* see themselves as rescuers and conduits of tradition, but the issue of self-expression is never far from the surface. The *santeros* I talked with believe traditional imagery and materials are integral to what they are making. Robles-Shaw says traditional materials are an important part of making the *santo,* because they are "a spiritual connection." On the other hand, she also delights in creating her own

interpretations, and some of her imagery is drawn not from the lexicon of saints and the Holy Family but from the Old Testament. She also reinterprets traditional figures. For example, she has painted a Saint Joseph—patron of carpenters and fathers, husband of the Virgin Mary, and earthly father of Jesus—in modern dress. Instead of a long robe and flowering staff, in her image he's dressed in jeans and wears a carpenter's tool belt. Robles-Shaw doesn't exhibit this image, which she painted for her husband, who's a carpenter. This is her own private creation. Robles-Shaw modestly accepts the label *artist* and relishes the fact that her work sells but maintains that making *santos* is, for her, a form of devotion, albeit one that sells: "I had a hard life, and a sick child who died. I started visiting churches—it kept calling me after my daughter died. [Making *santos*] is a calling. I feel good about what I do. I'm calm and centered; but it's also good because I'm able to sell it. At first it was just a hobby."

Miera, too, insists on the devotional motivation of his work. He sees his *santos* as "a form of personal prayer, not art. I make them for use, not decoration." Because he doesn't make his living as a *santero,* he shies away from labeling himself an artist, although he says he's "always been a creative person." Even so, his images are self-expressive in the way he manipulates subject matter and style. All of his images, except his crucifixions, look out at the world with a tiny smile on their lips. Miera says he paints his saints "to look like they're in heaven. You show them as they were—real and lived—but also in heaven. That's why they smile. I think they're also more 'user-friendly' that way."

José Raul Esquibel, who won the 1997 Colorado Council on the Arts Heritage Grant, almost dismisses his role as an artist:

To make a *santo* is a charismatic gift. It's instrumentality; it says nothing about the artist's ability. [The *santo*] is a gift for other people . . . to give consolation. It's a surrogate for presence. I don't know if some people buy them because they are beautiful. I try to make them beautiful and real. But beauty is not my motivation—mine are mostly penitential figures. They can be beautiful if you understand that aesthetic; in that you are looking for what's real, direct, and simple. Beauty is very subjective, commonly understood as "like us." If it looks Italian Renaissance there is an assumption of beauty; but I don't notice that it's a big criterion for buyers of my *santos.*[58]

Esquibel's *santos* are plainly religious—his favorite subjects are Saint Joseph and the Crucifixion, and the latter emphasizes suffering. He sells about 200 *santos* a year but doesn't do the exhibition circuit; instead, he teaches in area churches and schools and shows his work in conjunction with his lecture/demonstrations. Much of his work is done as private commissions for *moradas,* monasteries, and churches, as well as for confirmation and baptismal gifts and funeral commemorations. Esquibel says nonreligious people don't have much interest in the *santos* he makes because he makes them for their traditional purposes, as "surrogates for presence, for when they can't be there. People invest emotional and sacred energy in what they buy."

Esquibel's assessment is correct as far as it goes. But people also find other meanings in these objects, as I have argued, which may not be exclusively religious or simply aesthetic. *Santos* are not closed, unmediated images; rather, they appeal across a spectrum of religious practice and belief because of their multivalent meanings. Nor are they static and fixed in time and place. On the contrary, they are endlessly adaptable to the changing needs of different beholders. They remain today, as they were in the past, useful objects. The uses and needs have changed with the times, but *santos* are a sufficiently broad statement of Christian sensibility that a wide variety of people can relate to them. Their popularity isn't based strictly on their aesthetic appeal, although that appeal is certainly present for most people who buy them. Their strength lies in their ability to adapt to religious practices and accommodate a range of personal beliefs, regardless of institutional decree. If *santos* are objectified, it is mainly in museums and galleries and among those patrons who buy them for their monetary value

rather than their use value. For many others, even those outside the Hispano-Catholic tradition, they retain their power to speak words of comfort and offer reassurance. As Esquibel says: "Words like appropriation and consumption, they are problems created by critics and historians, who lack a vocabulary to talk about the sacred. I am not making art for art's sake. [This] art is made for a reason, it's religious and devotional. I think the religious nature of the work makes the nonreligious person place their assumptions into it. They see with blinders on and don't examine their own biases."

Although little is known about actual business practices in New Mexico before the twentieth century, the *santos'* newfound status in the marketplace as commodities is not so very different from the earlier status of religious objects—people have been buying devotional objects for a very long time. Having monetary value does not strip or even compromise their devotional value, for market value is only another in the multiple layers of meaning. Santos are objects for a practical kind of Christianity: supple and adaptable to the needs of a new millennium just as surely as they adapted to a new world nearly five hundred years ago.

CATHOLICISM AND THE PUEBLO MISSIONS OF NEW MEXICO

CARMELLA PADILLA

The solid outlines of three simple wooden crosses rising from a rooftop are among the first things one sees when driving toward Isleta Pueblo, a village on the banks of the Rio Grande where the church of San Agustín de la Isleta was established by Spanish missionaries in 1613. Isleta, Spanish for "little island," is a community of more than 3,000 people located 15 miles south of Albuquerque. As they have since Franciscan friars carried Catholicism to New Mexico more than four hundred years ago, many Isleta tribal members observe Sunday mass. Inside the cool, narrow church nave, Pueblo worshipers practice the same liturgy as Catholics worldwide, kneeling in prayer and singing religious hymns. Statues, paintings, and other images of European saints introduced to the Pueblo peoples by the Spanish are displayed on surrounding walls and upon the altar where the Reverend Nicholas Nirschl, the former parish pastor, celebrates the mass.

Before the mass ends, the Isleta congregation inserts its own "Prayer for Native People" into the liturgy. The prayer is at once a bow to Catholic ritual and a bold statement of native pride in its request for blessings through the intercession of Our Lady of Guadalupe, the patron saint of native peoples, and Blessed Kateri Tekakwitha, a Native American candidate for sainthood (Fig. 2). A statue of Blessed Kateri Tekakwitha is prominently displayed outside the church, where the parish council member Shirley Zuni mingles with fellow parishioners after attending mass.

"This church is a foundation for us," Zuni says. Describing her maternal grandfather as "very Catholic" and her paternal grandfather as a traditional tribal medicine man, Zuni says that she grew up practicing both the Catholic and the native Pueblo religions. Today she is raising her children the same way.

"I was taught to worship God and the Great Spirit because they both come together as one," Zuni says. "We're blessed to have both religions in our lives. I think they make our lives stronger."

According to oral history at Laguna Pueblo, the people of the ancient Laguna tribe were told to emerge from the Fifth World to seek a new home in a place where they encountered the sign of a cross symbolizing the four directions of the Creator and the Holy Spirit. In 1699, nineteen years after the deadly Pueblo Revolt, they were met 45 miles west of present-day Albuquerque by Antonio de Miranda, a Franciscan friar who carried a cross. Welcoming the priest into their community, they established Laguna Pueblo as home and began construction on the mission church of San José de la Gracia. Besides the early-1800s altar screen built by the Laguna *Santero* that stands at the head of the church, the interior nave walls are bordered with Native American murals that symbolize the spirits of their ancestors (see Chap. 7, Fig. 7-1). Though pueblo members participate in non-Catholic denominations ranging from Presbyterian to Baptist to Mormon, some 80 percent of the nearly 8,000 members of the tribe are baptized as Catholic and remain deeply dedicated to their mission as a symbol of their community. The annual September 19 Feast of San José is a combination of Catholic ceremony and tribal performances in honor of the harvest. After mass, images of San José and other saints are removed from the church and carried in procession throughout the Pueblo to a temporary shrine set up in the center of the plaza, where the Harvest, Buffalo, and Eagle dances are performed. A communal celebration featuring native foods continues throughout the day.

"The Catholic ways and the traditional ways work well together at Laguna," says the Reverend

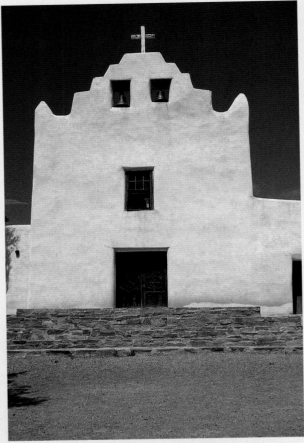

1. **Exterior, San José de la Gracia Mission Church, Laguna Pueblo, c. 1710. Photo Donna Pierce.**

which expressed openness to other spiritual beliefs and traditions besides Catholicism and mandated that mass be spoken in vernacular languages. New Mexico church officials also recognize the importance of the native religion in Pueblo cultures. Ironically, Trujillo says, the harsh suppression of native religions suffered by the Pueblo peoples at the hands of the first Franciscans may have been what kept the native prayers and rituals so strong. And where native faith is strong, Catholic faith is still strong today. "The curse, which at the time was Catholicism, ultimately became the blessing," he says. "Because they were forced to be secretive in their beliefs, they preserved their traditional practices while others lost it. As traditional Pueblo people and as Catholics, they understand that prayer is important. Their sense of God is ever-present."

But Catholicism may be viewed as a more mixed blessing at Acoma Pueblo, fifteen miles west of Laguna Pueblo, where the mission of San Estevan de Acoma, a huge mid-seventeenth-century adobe and stone structure, towers dramatically above the landscape on top of a 400-foot-high mesa. While other pueblos obliterated their churches during the Pueblo Revolt, the Acoma people refused to destroy what they had built and thus considered their own. The Pueblo's feast day, honoring its patron saint, San Estevan (Saint Stephen), is celebrated every September 2 with a mass, religious processions, and traditional dances, as at Laguna. Nonetheless, Acoma Pueblo officials declined to discuss the influence of Catholicism on contemporary Pueblo life. According to the Reverend Trujillo, who formerly served as the pastor of San Estevan mission, their refusal is not necessarily a criticism of Catholicism but a proud statement of the Pueblo's cultural sovereignty. Indeed, he says, for all of the Pueblo peoples, Catholicism today is less about conversion than about accepting the religion on their own terms and adapting it to fit their own spiritual lives. In this way, the Pueblo peoples have taken Catholicism and made it their own.

At the isolated mountain pueblo of Picurís, the state's smallest pueblo, located about 58 miles north

Antonio Trujillo, the former church pastor. Trujillo, who was the first Spanish Franciscan priest to be assigned to Laguna Pueblo since 1840, worked closely with Pueblo members to achieve a balance between the spiritual practices of the Church and those of the Pueblo. In addition to regular weekday and Sunday masses, a special Native American mass featuring drumming and songs in the native Keres language is celebrated once a month. On feast days, the entire mass is recited in Keres.

Trujillo's encouragement of tribal religious practices is in accordance with the dictates of Vatican II,

2. Interior, San Juan parish church, 2000. Permission for this photograph was arranged by John Reyna of Taos Pueblo. Photo Ken Iwamasa.

of Santa Fe, Carl Anthony Tsosie spent ten years heading up a project that he believes is the ultimate symbol of such reconciliation, and a strong statement of the Tiwa-speaking Pueblo's unwavering devotion to Catholicism: the reconstruction of the 1780 mission of San Lorenzo de Picurís. Using all-volunteer labor, donated materials, and other contributions from various sources, Tsosie successfully rebuilt the national historic landmark so that it is again functional for mass and other important sacraments such as baptisms, first communions, confirmations, marriages, and funerals. Now at Christmas, the church pews are

once again cleared out of the whitewashed adobe church for the Pueblo's traditional dance of the *Matachines* (see the Interleaf by Brenda Romero). In an interesting acknowledgment of the past, the dance symbolizes the Spanish Conquest and the assimilation of indigenous peoples in the so-called New World, particularly their conversion to Christianity.

"We would like to think we could have stopped [the Spanish], but we didn't. Now, we've got to move on and show some unity," Tsosie says. "There's no division between the Catholic way and the traditional way, between who came first—Jesus or the Great

Spirit. Our church is just as important as our kivas. We need both."

As at all of the Pueblos, and as in most Catholic communities, a core 10 percent of Picurís members—or about 30 of 300—attend mass regularly, says the Reverend Adam Ortega y Ortiz, the former parish pastor. The numbers are the greatest among elderly tribal members, although the major sacraments draw members of all ages. But perhaps the most fervent expression of the Pueblo's Catholic faith is exhibited in its staunch devotion to Franciscan traditions. "In certain areas, the Pueblo should be considered a model for us Hispanics," Ortega y Ortiz says. Whenever a Pueblo member dies, for instance, the body is taken to the church for a traditional *velorio* (wake) in which the rosary is recited. The church bells calling people to mass are still rung by Pueblo members according to how the Franciscans taught them. The boundaries of the Pueblo are still measured with the Church as the center. The official start of the Pueblo's New Year and its change in tribal government take place on the January 6 Feast of the Three Kings. Two representatives of the Church sit on the tribal council and have an equal vote in all tribal issues. And on the Pueblo's feast days, the saints are carried out of the church to the riverside to watch the traditional Pueblo foot races.

In a strange case of coincidence, Picurís Pueblo's annual August 10 Feast of San Lorenzo falls on the anniversary of the Pueblo Revolt. Instead of viewing the events as separate, the Pueblo commemorates both together as equally important parts of the Pueblo's history. According to the historian Joe Sando, a native of Jémez Pueblo and director emeritus of the Institute for Pueblo Indian Studies and Research in Albuquerque, this is an important example of why the deeply intertwined history of the Hispanic and Pueblo cultures cannot be overlooked. The influence of the Spanish, particularly Catholicism, on modern Pueblo life, Sando says, is here to stay: "Catholicism is at the core of the Pueblo culture today. If not, why would the Pueblo people still be singing Spanish hymns and reciting Spanish prayers? Why would the missions still carry Spanish names?"

EPILOGUE
Re(f)using Art: Aby Warburg and the Ethics of Scholarship

CLAIRE FARAGO

So, you *studied* us, huh? Were we *interesting?*
—Peter Whiteley, *Deliberate Acts: Changing Hopi Culture Through the Oraibi Split,* citing
"an older Hopi man, on learning of my prior research"

Your intention to honor Hopi religion through the historical visit of a famous Ger-
man art historian to the Southwestern United States addresses a similar misconcep-
tion stated in your letter and symbolizes our concern with publications relating to
our cultural and religious life Way. . . . The fact is that when our forefathers became
aware of the publication of the photographs of Warburg and other westerners, they
were indeed thought to be violating secrets . . . those secrets or subjects of privi-
leged information that were violated a century ago continue to be violated today.
—Leigh J. Kuwanwisiwma, director of the Cultural Preservation Office, Hopi Tribe, to
the director of the Warburg Institute, London

The following essay does not deal with New Mexican santos; *rather, it deals with ethi-
cal considerations about scholarly practice that arose while this book was in prepara-
tion. Although other chapters have addressed such fundamental questions as who owns
the past and what determines a good interpretation, there remains the crucial issue of
how scholars reproduce, inadvertently or not, the biases inherent in the categories that
organize their studies, categories that implicitly recognize certain issues and ignore oth-
ers. The ethical scholar must question the categories. This is especially true in metaschol-
arly re-evaluations of past scholarship, where charity—or disciplinary solidarity—may
tempt us to focus exclusively on the most progressive aspects of our predecessors' work, to
the point that we excuse, rather than learn from, their faults.*

My thanks to Kirk Ambrose, Amelia Jones, Nicholas Mann, Matthew Rampley, Donna Pierce,
Donald Preziosi, and Charlotte Schoell-Glass for their critical comments on various drafts of
this chapter. Preliminary versions were presented at the International Congress for the His-
tory of Art (CIHA) in London in September 2001, at Harvard University in March 2002, and at
a colloquium sponsored by the National Science Foundation, entitled "Framing Art History:
Reflections on the Discipline," held at the Edinburgh College of Art in March 2003. The fol-
lowing presentation of the issues has benefited from comments by those learned audiences,
but I alone am responsible for the views presented here.

Staging Art History

Despite its geographical location remote from the east coast, where money and power were concentrated throughout the nineteenth and much of the twentieth century, the Southwest provided two eminent art historians with the formative experiences of their careers. George Kubler's dissertation on Pueblo mission architecture, published in 1940, set the standard for art-historical scholarship in the region. Kubler's conflicted, problematic legacy was assessed in earlier chapters of this study. Equally problematic, though currently much more fashionable, is a study by Aby Warburg (1866–1929), best known for his contributions to the history of Italian Renaissance art and culture. Warburg's significant methodological contributions are widely regarded today as having been fundamentally shaped by his youthful encounter with the American Southwest. His belated article on a Hopi ceremonial dance that he called "the serpent ritual"—a term with literary pretension that suggests his familiarity with popularizing accounts of Indians more than it does his scholarly or professional interests[1]—was based on two brief visits to New Mexico and Arizona in 1895–96, shortly after he completed his dissertation. Fritz Saxl, who prepared his then recently deceased colleague's notes for publication and also wrote his own reminiscence about Warburg's interest in Pueblo culture, claimed that the American experience revolutionized Warburg's approach to Renaissance art.[2] Outside New Mexico, this 1939 article is currently something of an art-historical cult piece, amplified versions of the text having appeared in English, French, German, and Italian within the last decade.[3] Yet it has never been cited by any regional New Mexican scholar as far as I know—and this difference in reception is the catalyst for the following discussion, based in part on my own experiences when writing and editing this book.

In recent years, it has been argued in an international arena that Warburg's ethnographic interest was a sign of remarkable intellectual open-mindedness and precocious multiculturalism. The historian Peter Burke, for example, recommends that we emulate Warburg's strategy today by writing our own "anthropology" of the Renaissance.[4] Warburg continued the legacy of cultural history begun by Jacob Burckhardt, and perhaps the most currently relevant aspect of his writing is his idea that unsynthesized dualities of meaning coexist in a dialogical tension in every society.[5] Warburg specialist Matthew Rampley argues rightly that Warburg's theoretical studies constitute the basis of his lifelong interest in the concrete, culturally determined significance of certain symbols. Yet he was also deeply interested in the ability of certain transhistorical, transcultural visual images, such as the "serpent," to function polysemically, as shifters of meaning. The impossibility of abstracting cultural signs from their specific context of use is still a fundamental tenet of cultural criticism and history across the board, from Frantz Fanon to John Shearman, and Warburg was indisputably one of the first to conceive of symbols in these simultaneously semiotic and culturally specific terms.

Rampley locates the conceptual basis of Warburg's inquiry in late nineteenth-century attempts to revise Kant's notion of space as an a priori form of intuition by proposing (in fact, by reintroducing neo-Aristotelian) physiological explanations of aesthetic judgment. Far less constrained by disciplinary formations than most of his peers, Warburg followed the writings of Hermann Lotze, Friedrich-Theodor Vischer and his son Robert, and others, including authors better known to art historians such as Adolf Hildebrand, Conrad Fiedler, and Alois Riegl, who of course was an art historian himself.

These late nineteenth-century writings on symbolization are indebted to the cultural evolutionism of Hegel, for whom symbolic art constituted the lowest stage of art, when "matter predominated over spirit"; and the mind, in its effort to express its spiritual ideas, resorted to the artifice of the symbol. Here spiritual content (a deity, for instance) was often not consciously distinguished from its symbolic representation (as in Hindu art) or only vaguely so (as in

Egyptian art). Only in the later period of classical art did art transcend its symbolic limitation. In late-nineteenth-century theorizing this notion of cultural progress was conflated with notions of individual psychological maturation from uncontrolled emotion toward rationality. Warburg was especially attracted to theories defining the role that subjective feeling plays in conditioning the perception of form—in short, emotional transference.[6] Friedrich-Theodor Vischer (1807–87) developed Hegelian ideas when he described architecture as a kind of intrinsically human symbolism by which we define our relation to the world, through the symbolic interjection of emotions into objective forms. This basic human behavior manifested itself, Vischer believed, in a pantheistic impulse to merge our spirit with the sensuous world. In the early 1870s, the elder Vischer's son Robert coined new terms for emotional projection, such as *Einfühlung*, in a dissertation that considered the subjective content that viewers bring to aesthetic contemplation.

According to Rampley, Warburg's originality was that he "historicized the phenomenon of empathy," thereby accounting for the function of images in various cultural circumstances without imposing a universal, normative theory onto the concrete data.[7] It is quite unclear, however, what Rampley means when he praises Warburg for "historicizing empathy." Certainly not what he meant when he himself historicized Warburg's ideas about subjectivity by locating their direct and indirect textual sources. Tellingly, Rampley seems not to question Warburg's mapping of progressive stages of "empathy" onto successive epochs of Italian culture—not even when he signals the significance of Warburg's comparisons of symbols from different times and places. But Warburg treats "empathy" as if it had a predetermined trajectory of development like a biological organism. And in doing so, he employs a widespread Hegelian notion of "symbolic art" as the crude early manifestation of a long civilizing process. Warburg wrote sympathetically about "the medieval mindset" as a stage of "symbolic" or metaphorical thinking that the humanist culture of

the "Renaissance" and "Enlightenment" tried to replace with a scientific, rational worldview.[8] For Warburg, building specifically upon Robert Vischer's 1873 dissertation—and following Hegelian trajectories in the writings of many of his contemporaries—a "symbolic" worldview corresponds to an intermediate stage in the life cycle of the human spirit, collectively and transculturally viewed.

Warburg applied the same scheme of cultural evolution to contemporary Hopi culture as he did to premodern European history. Historians today who admire Warburg's application of "empathy theory" in the published essay on Hopi symbolism appear unconcerned that he identified the "primitiveness" of the Hopi with both the "primitive" nature of man at the dawn of Western civilization and the "primitive" core of human emotions transhistorically defined. The instability of "primitive" as a signifier in Warburg's thinking has not been discussed.

We can begin to assess the conflation of biology, psychology, and social Darwinism in Warburg's use of the word "primitive" and its cognates by asking what evidence external to the rhetorical trajectory of his own argument there was for his understanding of medieval art, identified in his writings with "primitive" as opposed to Renaissance forms of empathic projection. In fact there is none whatsoever: Warburg attached the labels "primitive" and "medieval" to the concrete visual evidence to make his case. The central premise of Warburg's "history of empathy" theory suffered from what his intellectual mentor Nietzsche termed *metalepsis*, or chronological reversal, meaning that the object of study *seems* to justify its presence on the basis of a pre-existing historical context—whereas, in fact, "history" is the construction of a context based on the historian's prior understanding of the object's significance. In short, there is no place to ground such a history as Warburg's: it is a self-fulfilling prophecy.[9]

If we follow Rampley's argument one step further, we find that it is strangely inconsistent from a structural point of view. On the one hand, he recognizes the "modernist pattern" of cultural evolutionary

theory in Warburg's study of "Moki serpent ritual." (Parenthetically, one wonders why current European scholars have not troubled to disavow explicitly Warburg's terminology. Certainly the Hopi did not think of snakes as "serpents," and the nineteenth-century label "Moki" has derogatory connotations for the Pueblo people who now call themselves "Hopi," the accepted term in general use.)[10] On the other hand, Rampley ignores the presence of the same objectionable evolutionary scheme in Warburg's account of the "history" of empathy.

The ongoing reception of Warburg's essay by the academic community has recontextualized E. H. Gombrich's foregrounding in 1970 of Warburg's untenable underpinnings in social Darwinism, his dependence on evolutionary theories about cultural development: "A convinced evolutionist, he [Warburg] saw in the Indians of New Mexico a stage of civilization which corresponded to the phase of paganism ancient Greece left behind with the dawn of rationalism. It was this belief which accounts for the importance of the experience of Indian ritual for Warburg."[11]

Contemporary art historians writing about Warburg's study of Hopi symbolism acknowledge his references to the "primitive" mentality of modern Native Americans as untenable but *isolated* occurrences of racial theory in Warburg's thinking. Contemporary writers also atomize Warburg's allegiance to social Darwinism by referring his objectionable thinking to the sources he read. Edgar Wind, for example, criticized Gombrich for overlooking Warburg's specific debts to "empathy theory" when that study first appeared, and this critique has been widely cited and elaborated in the subsequent literature.[12]

In my view, the fundamental lesson of this controversy for historians today is not one about accuracy in source criticism. More basic than this is the responsibility to recognize the undigested racist projections of past generations in our present-day theoretical extensions of Warburg's vision. The current reception of Warburg neglects crucial elements of cultural evolutionary theory present throughout his writings. In the case of his essay on the Hopi, Warburg claimed to have uncovered a developmental parallel to the trajectory of European culture in their worldview, which he locates midway between empathic projection and the self-conscious use of symbols.

Connections between what is still viable and what is no longer tenable in Warburg's theoretical considerations need to be considered fully if his thought is to be truly relevant today. When one recent writer, the historian Michael Steinberg, interpreted Warburg's sympathetic attitude toward the Hopi as an unacknowledged form of identification with his own disavowed social identity as ethnically Jewish, his reading of ethnographic photographs of Jews and Native Americans in Warburg's personal collection was rejected as farfetched; no one wondered whether shared photographic conventions might have played a role, regardless of Warburg's conscious intent.[13] Yet the agency, or actions, of individuals are by no means the only admissible form of evidence in historical interpretation. I will have more to say about the epistemology of visual ethnography below.

The Ideology of Chronology

Can we truly disengage Warburg's "good" relevant ideas from his "bad" untenable ones or disengage *our* institutionally affiliated position from his in the historical continuum? Contemporary European writers who focus their interest in Warburg on the innovative aspects of his methodology *assume* a separation is possible, as if his writing were a textile that could be separated into its component threads. It would take us too far afield here to review the burgeoning literature on Warburg systematically, but I would like to suggest that Warburg's received assumptions about cultural development and his original theoretical formulations about the transformatory power of visual images are inextricable.

Warburg participated in a contemporary German and British academic trend to study the ritual origins of drama. As the Hellenist Vassilis Lambropoulos has

argued, to explain the development of ancient drama, classicists at the beginning of the twentieth century turned to evolutionary anthropological theories that originated in the 1870s and 1880s: "By using the tools of comparative religion, the theorists were in fact able to construct accounts of the worship of Dionysus and the rites traditionally associated with the origins of drama. . . . High art was shown to evolve out of high ritual."[14] Lambropoulos argues that these Ritualists were themselves influenced by biblical historians but, despite the impact of Hebraism on the interpretation of ancient Hellenism, "Dionysiology did not lose its exorcistic character."[15]

Warburg, it is widely recognized, studied the Dionysian myth of Orpheus because it was for him a symbol of ritual sacrifice and violence—and no matter how sympathetic his attitude toward the Hopi became as he entered into direct contact with them, Warburg considered the Hopi symbolic universe from a Hellenist's point of view, as an intermediate stage between the poles of Dionysus and Apollo. Although Lambropoulos does not analyze his predecessor's essay on the American Southwest, Warburg studied the Hopi "serpent ritual" with this larger program in mind. In so-called paganism, to cite Lambropoulos again, Warburg saw a psychological state of surrender to impulses of frenzy and fear. In symbolism, Warburg recognized "an aspect of human culture in which the irrational was still very close to the surface." In keeping with a major goal of contemporary cultural studies, Warburg analyzed history in order to transcend it—Lambropoulos describes this pursuit with Warburg's own term "undemonizing."[16]

The question that the current generation of Warburg scholars raises is whether Warburg saw past the Apollonian-Dionysian antinomy that Nietzsche's *Birth of Tragedy* had introduced into the interpretation of Greek thought, or whether he conformed to the views held by his direct and indirect sources, including the Vischers as well as the Ritualist anthropologists of his day. Wind, Rampley, Raulff, and other specialists claim the former, that Warburg consciously devel-

oped a model of constant oscillation between the rational and the irrational in order to transcend chronology as an ordering device.[17]

To his credit Warburg did seek innovative ways to write history without relying on chronology. Nonetheless, although he was not an imperialist in any directly political manner, Warburg's description of Hopi beliefs makes sense only within the framework of a European understanding of ritual as the formal origin of myth and religious drama—without that framing effect, his description would be nonsensical. Significantly, this context is irrelevant from a Hopi perspective. As Leigh J. Kuwanwisiwma writes in the Hopi Tribe's letter to the Warburg Institute cited at the beginning of this Epilogue:

The Hopi religion not only teaches peace and goodwill, Hopi people must also live it. . . . Most [of the dances] also seek to improve the Hopi people's harmony with nature, thereby enhancing the prospect of its members for good health and a long, happy life. Only members initiated into these societies hold its information and knowledge, which is not written, but rather is passed on orally to society members who participate in the ceremonies. Information about the significance and function of these ceremonies can only be given by those initiated into these societies.[18]

According to the Director of the Hopi Cultural Preservation Office, then, Warburg committed an injustice to Hopi beliefs simply by being a historian.

The Power of Theory

The question for us today is not whether Warburg had alternatives to the views he held, but to what extent our own theoretical projects can follow the alternatives he chose. The current scholarship lauds Warburg's treatment of symbolism as an aspect of social memory, while flatly rejecting his received assumptions about cultural evolution. Yet much current critical writing insufficiently addresses the ways in which sign theory and cultural theory are interrelated in

Warburg's writing, a fact that structurally reproduces the power relations that critical theory seeks to expose. Vanguard academic writing on Warburg's methodology frequently mentions his essay on Hopi beliefs, but conspicuously ignores several decades of writing on colonial and postcolonial identity—in particular both the burgeoning literature on the roots of cultural anthropology in the nineteenth-century science of race and the theoretically rich literature dealing with the circulation of goods made for the tourist market. What is quite extraordinary in the current international climate of opinion about Warburg's brief New Mexican foray is its lack of acknowledgment of historiographical critiques by anthropologists, which are familiar to art-historical audiences.[19]

Nor has any European writer mentioned the contentious nature of identity politics in the Southwest, where Warburg's violations of Hopi privacy are considered far more egregious today than they were in 1896. The present-day political standoff among different cultural factions in New Mexico reproduces a set of oppositions originating in the same neocolonial setting as the subject matter of this book. Even as this manuscript went to press, issues surfaced in a complex interchange between the Hopi Tribal Council and the Warburg Institute, part of the School of Advanced Study of the University of London, regarding the use of documentary photographs of *katsina* ceremonies dating from Warburg's brief—but in art-historical terms momentous—stay with the Hopi in Oraibi, Arizona, in 1896.

My firsthand information comes from the director of the Warburg Institute, Dr. Nicholas Mann, who has shared with me his correspondence with the Hopi Tribal Council since May 1997. The first letter, signed by the Hopi Cultural Preservation Office's legal researcher Yvonne Hoosava, objects to the publication of photographs of Hopi religious ceremonies, considered to be the Tribe's cultural property by a Council resolution. The letter states the Tribe's desire to publish appropriate, accurate, factual information by offering to review any segments concerning the Hopi.

The correspondence between the Hopi Tribal Council and the Warburg Institute includes a copy of the Council's "Protocol for Research, Publications, and Recordings," which opens with the Hopi people's desire to protect their "rights to privacy" and their intellectual property. Their two chief concerns are to avoid commoditization of their intellectual property and to avoid making esoteric knowledge public. A second letter addressed to Mann in December 1998, signed by Kuwanwisiwma, more bluntly states that the Hopi religion is not for sale. Moreover, the letter explains, the photographs and other material contained in the Warburg Institute's new publication, entitled *Photographs at the Frontier: Aby Warburg in America, 1895–1896,* are privileged information, handed down orally through initiation into the *Katsina* society. Kuwanwisiwma reports that Hopi religious leaders were saddened by the book's publication and requested that its printing be stopped.

From these letters, it is clear that the Hopi have developed and are employing a language and institutional infrastructure adequate to addressing the dominant culture on its own terms. Both the Warburg Institute and the Hopi Tribe are familiar with institutional forms of protocol and power, but they did not see eye to eye. The Institute responded almost immediately (in January 1999) to the director of the Hopi Cultural Preservation Office by deferring to the Institute's publishers—as in fact only they were in the position to recall the book, published in 1998 by the London firm of Merrell Holberton in association with the Warburg Institute. Yet it should be noted that had the Warburg Institute acted upon the Hopi Tribe's *first* request to review the manuscript in May 1997, the Hopi religious leaders would undoubtedly have voiced the same objections and the publication (though well advanced by this time) could have been halted.

The Institute, through its director, indicated two reasons why the Council's initial request was found to be uncompelling: first, because the authors and editors of the volume do not actually profit at the expense of the Hopi religion; and second, because the photo-

graphs that have "any direct bearing" on a Hopi religious ceremony are already in the public domain, having been published many years ago. In any case, the Institute emphasized that the book's primary intent was to document Warburg's visit to the Southwest, and the publication attempted to maintain historical accuracy by including an essay on Hopi beliefs written, in its own words, by "the best Western specialist" in order "to honour, not to sell, Hopi religion."[20]

My reason for devoting so much space to Warburg in a study that refrains from studying Pueblo material culture is to suggest how incommensurable worldviews operate in a contemporary international standoff that discourages cultural exchange and reproduces colonial hierarchies of power. The current status of Warburg's ideas about the Hopi is a puzzling omission in a body of scholarship that praises his innovative methodology, and specifically his prescient notion that ethnography can be a useful instrument of analysis for art historians. Even though it may seem anachronistic, it is important to articulate in detail Warburg's complicity in late nineteenth-century racism in order to expose its connections with less obvious twenty-first-century forms of the same animal ("you *studied* us"). The ambiguous phrase "in the public domain" in the Warburg Institute's letter suggests an unstated but crucial connection between the Hopi Tribal Council's two complaints and the Warburg Institute's two answers. In the narrow sense, the dispute played out in the correspondence concerns the control of monetary profit, but it is also clear that this discussion is rooted in a fundamental disagreement over the legitimate use of power. The real sticking point concerns how information about a less powerful subgroup of society is perceived and used by a more powerful one. "In the public domain" could simply mean that the photographs are no longer secret, or the phrase could also be taken to mean that they are no longer covered by copyright and therefore, in the strict capitalist sense, it is no longer possible to make a monetary profit out of them. In either case, the Warburg Institute's defense that it is not

making a profit makes "privacy" rather like virginity—once you've lost it, it's gone forever. (Too bad, but nothing we can do about it now.) The Institute's position depends on viewing time strictly as a linear sequence, an irreversible succession of events: the violation of privacy pertained only to the particular moment and people photographed. The Hopi, on the other hand—and the same is true of every Pueblo group in the Southwest today—conceptualize sacred presentness as transtemporal, so privacy is violated *every* time someone looks at the photographs.

The following statement is taken from the book that the Warburg Institute published on Warburg's 1895–96 trip to the Southwest. Like many other recent accounts that could be cited, it needlessly fails to identify the very complex concerns about the ownership of intellectual property current and pressing not only in southwestern studies but in many places in the world today, one result of which is a tone that is unhappily rather naive. In the words of Benedetta Cestelli Guidi,

Warburg not only violated the tradition that forbade one to look at a bareheaded Kachina: he also wanted to set up a scenario, gathering the dancers' masks and arranging them in a precise order, and placing himself at the centre with the Indian.

There must have been some valid reasons for violating the Indians' customs in this way.[21]

On whose terms can Warburg's violation be considered valid? Ongoing debates about the ownership of cultural property involve not only the physical remains of the past but also very importantly our perceptions of the past and our articulations of these views. With respect to Native American culture, the more familiar context for disagreeing over property rights is that of repatriating sacred objects, including human remains, housed in museum collections. Should images, in this case photographs, be treated any differently than the esoteric objects and events they document? There is in fact a double impropriety to consider: Warburg's original transgressions, which ignored Pueblo attitudes

toward esoteric knowledge and the transgressions of contemporary scholars who promote Warburg's ideas as unproblematic because his views on "primitivism" were more progressive, enlightened, or objective than those of his contemporaries.

In New Mexico, the role of the critical historian has been and to a large extent remains inscribed in a long and complex history of institutional repression of native beliefs and practices. In its series of letters to the Warburg Institute, as we have just seen, the Hopi Tribe's spokespeople framed their position in terms of economic exploitation: they state categorically that the Hopi religion is not for sale. Implicit in this statement are the effects of neocolonial economic exploitation imposed by the market in ethnic art that dates from the time of Warburg's visit. Edwin Wade and others have argued that the popularity of ethnic art— the term itself is deeply problematic—is due partly to the participation of native peoples who commoditize and commercialize their cultural heritage in order to survive in (or otherwise profit from) a capitalist society.[22] This is the compromised position that the Hopi Tribal Council rejects when it mandates that Hopi religion is not for sale.[23]

Yet historians commonly argue that scholarly publications are not driven by profit motives in either theory or fact. When the present study met the same resistance in the process of trying to enlist participation from Pueblo individuals, my initial reaction was the same. From a Hopi perspective, however, it matters not at all whether the profit is going directly into the pockets of publishers or scholars. The Hopi Tribe understands that one effect of the knowledge thus produced is financial profit on something that should be valued for its inherent merit, and another effect is loss of control over the transmission of their own cultural values, with its attendant loss of the values themselves within their own culture and falsification of religious beliefs to all concerned. Gradually and with difficulty I came to recognize that, from the viewpoint of many Native Americans and others whose cultures are commoditized through the manufacture and sale

of "tourist art," "souvenirs," "direct-mail art," and even "scholarly publications," my institutional affiliation could cogently be seen as rendering my critique complicit with the system.

Working Through Amnesia

There is a second sense in which contemporary scholars are compromised by existing political and intellectual frameworks of institutional authority. In our social network, the specialization of scholars discourages (although it does not prevent) reflection on the broad social effects of the information/knowledge we produce. bell hooks addresses the crucial issue of self-reflexivity in words quoted at the beginning of this book. Later in the same critique, addressed to the (then) recently established field of cultural studies, she restates her point in the following way: "Participants in contemporary discussions of culture highlighting difference and otherness who have not interrogated their perspectives, *the location from which they write in a culture of domination*," create "a field of study where old practices are simultaneously critiqued, re-enacted, and sustained" (my emphasis).[24]

Let us consider, then, how the case before us exemplifies the way "old practices" are sustained by the institutional structures that contain and support them. For one thing, to what extent is it our business as scholars to feel responsibility for the manner in which our archives came into possession of their materials? For example, what is the status of the not uncommon claim that, because the photographs of Hopi religious ceremonies have been previously published, they are in the public domain?

At the end of the nineteenth century, archaeologists and other academics supplied European museums with enormous collections of native material culture, in the process depriving those who were practicing indigenous lifestyles of access to this cultural heritage, traditionally preserved through oral, pictorial, and performative modes of transmission interwoven with the practice of daily life. Not only did the

peoples concerned lose the heritage of millennia in a matter of decades, but their cultural productions became inscribed in and subsequently framed by an alien system of values. "Ethnic" artifacts entered museums and collections most often stripped of their original cultural significance and function. Artifacts quickly came to be appreciated for their "aesthetic" form or curiosity value alone. The archaeological expeditions (and free railroad passes) that paved Warburg's way established an efficient chain of contacts enabling him to exchange ideas with leading archaeologists and even to witness *katsina* dances and other esoteric events for the initiated. The same network passed burial remains that archaeologists of Warburg's personal acquaintance had excavated, along with contemporary objects of daily use and trinkets made for the tourist market, into homes and museums. De- and re-contextualized in its new locations, this problematically undifferentiated material culture was transformed into "art"' and "cultural history" for a completely different audience. Warburg contributed *directly* to these activities, donating his own personal collection to the Hamburg Ethnographic Museum, where some of his tourist bric-a-brac, mingled with exhumed burial pots, is still on display, reproduced in the most recent scholarship as anonymous examples of ancient Pueblo culture.[25] And if his entrepreneurial efforts had been more successful, he would have convinced both his Mennonite host at Oraibi, H. R. Voth, and Jesse Fewkes, the leading field archaeologist in the region, to sell their collections of Pueblo objects to the Berlin Museum of Ethnography, in addition to successfully advocating that the same museum acquire five hundred "funerary vases" from the dealer Thomas Keam.[26]

To what extent are these circumstances not our responsibility today? The anthropologist James Clifford doesn't mince words: ethnography has been a form of representation that establishes the ethnographer in a transcendent and transcendental position, "over-seeing" and explaining his subject according to his own categories of signification.[27] Contemporary European scholarship on Warburg has adopted a stance insensitive to—and astonishingly lacking in political understanding of—these historical circumstances and the manner in which they are reproduced in current cultural relations. Warburg's entrepreneurial "bent" is reported with a tone of bemusement, as if he—and consequently, we—were not complicit in the exploitation and expropriation of Hopi culture.[28]

The central issue, as should be clear by now, is not merely ownership of intellectual property, but quality control of intellectual property and the ability to conserve the healthy infrastructure of a society by educating its young in its values. Kuwanwisiwma might have added that the "best Western specialist of Hopi religion," as Mann described him,[29] relied on information, descriptive procedures, and vocabulary (previously published by Voth, Fewkes, and others) that are currently in contention.[30] What do we do with information, including photographs, that was published from the end of the nineteenth century until the 1930s and even later, and that is condemned as inaccurate or inappropriate by current Hopi standards, such as Tribal Council Resolution H-70-94, cited in the letters from the Tribal Council to the Warburg Institute?

The representational conventions that Warburg employed in his photographs of ethnographic subjects provide an untapped and recoverable historical context for his study of Hopi symbolism. Roll-film cameras were a very recent invention when Warburg used a handheld Kodak to document the *Hemis* (growing corn) *katsina* dance. These photographs of sacred and private Hopi ceremonies and of individual Hopi people are currently praised by European writers for the "spontaneity" of their composition.[31] But the modernity of his technology aside, Warburg frequently worked within a long established pictorial genre, originating in sixteenth-century Europe. Images such as the famous shot of Warburg posing with a Hopi *katsina* dancer (Fig. E-1), as casual as they may seem, owe their formal origins to a combination of sources ranging from costume illustration, to illustrated cultural geographies, to anatomical illustrations prepared for students of medicine. One, if not the earliest, proto-

Photographs at the Frontier
ABY WARBURG IN AMERICA 1895–1896

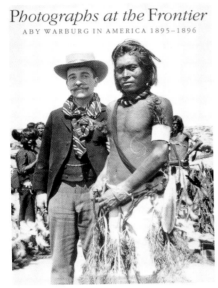

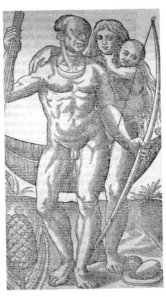

E-1. Book Jacket, *Photographs at the Frontier: Aby Warburg in America, 1895–96,* ed. Benedetta Cestelli Guidi and Nicholas Mann. London: Merrell Holberton with the Warburg Institute, 1998. Based on a photograph of Aby Warburg and unidentified Hopi dancer, Oraibi, Arizona, May 1896. London, University of London, the Warburg Institute.

E-2. Jean de Léry, illustration for chapters 14 and 15 of *Histoire d'un voyage fait en la terre du Brésil autrement dite amerique,* wood engraving, Geneva, 1587. The John Carter Brown Library at Brown University, Providence, Rhode Island. Photo Ken Iwamasa, with permission of the Library.

type is in a text that Michel de Certeau has described as the equivalent of a primal scene in the construction of ethnographic discourse, the set of woodcut engravings in Jean de Léry's *History of a Voyage to the Land of Brazil* (*Histoire d'un voyage faict en la terre du Brésil*), 1578 (Fig. E-2).[32] The ethnocentric assumptions that informed Warburg's ethnographic *images*—in Derridean terms, the "teleology and hierarchy . . . prescribed in the envelope of the question"—have only recently begun to receive much critical attention.[33]

Warburg's photographs suggest obvious parallels between his fascination with Indians and the contemporaneous popularity of the "Wild West" in Germany, where translations of James Fenimore Cooper's

highly romanticized novels such as *The Last of the Mohicans,* painted images by German and American artists, and prints based on them were widely disseminated forms of popular culture. The German novelist Karl May (who adopted the literary form of a first-hand report, even though he never set foot in the American West) promoted his self-fashioned identity as an American cowboy in widely distributed photographic postcards (Fig. E-3). Warburg could not have been unaware of the ongoing German flirtation with the "West" any more than someone living almost anywhere on the planet today could be entirely ignorant of American westerns (Fig. E-4).[34] Some American vaqueros *were* German immigrants, making it difficult then, as now, to separate social realities from fiction. Romanticizing records of cowboys and "noble savages" in the form of illustrated novels, prints, and postcards provide close contemporary parallels to the surviving photographic records of Warburg, the German scholar-turned-tourist, dressed as a cowboy striking a pose with a real Indian (Fig. E-1). Warburg's American diaries vent a typically conservative German middle-class weariness of civilization (*Zivilisationsmüdigkeit*) in the face of rapidly advancing industrialization. A kindred disdain for the bourgeois condition is epitomized in his famous snapshot capturing an anonymous "Uncle Sam" against the backdrop of electric cables on a San Francisco street (Fig. E-5). Warburg, like May's fictional cowboy character "Old Shatterhand," sought shelter from civilization's ills by seeking out the company of unspoiled Indians in the Wild West.[35]

And where does one draw the line between this popular culture and the archaeologists and other professionals whom Warburg read, consulted, and imitated in preparation for his trip to the Southwest? The Columbian World's Exposition of 1893 held in Chicago only three years before Warburg's American journey featured a scale model of the cliff dwellings at Mesa Verde, where Warburg began his own real life adventure (Fig. E-6).[36] The exhibit was designed by the amateur Norwegian archaeologist Gustav Nor-

E-3. Karl May posing as "Old Shatterhand," picture postcard, from a series published by F. E. Fehsenfeld. Hohenstein-Ernstthal, Germany, Karl May Haus Museum.

E-4. Book jacket, Karl May, *The Legacy of the Inca*, Hanoi: Ngoai, 1988. [Author and title in Vietnamese.] Hohenstein-Ernstthal, Germany, Karl May Haus Museum.

E-5. Aby Warburg, photographer. "Uncle Sam," San Francisco, February 1896. London, University of London, the Warburg Institute.

In his lecture of April 21, 1923, published in the *Journal of the Warburg Institute* (1938), Warburg wrote the following description of this image: "The conqueror of the serpent cult and of the fear of lightning, the inheritor of the indigenous people and of the gold seeker who ousted them, is captured in a photograph I took on a street in San Francisco. He is Uncle Sam in a stovepipe hat, strolling in his pride past a Neoclassical rotunda. Above his top hat runs an electric wire. In this copper serpent of Edison's, he has wrested lightning from Nature." (Cited from Warburg, *Images from the Region of the Pueblo Indians*, p. 53.)

E-6. *Model of Southwestern Cliff Dwelling at the World's Columbian Exposition,* photograph, from *Glimpses of the World's Fair: A Selection of Gems of the White City Seen Through a Camera,* Chicago: Laird and Lee, 1893.

denskiöld, whose book Warburg read at the Smithsonian Institution library when he was planning his trip.[37] The privileged network of experts that Warburg assembled through personal contacts in the academic community enabled him to contact and enlist Nordenskiöld's guides in Mesa Verde—none other than the Wetherill brothers, who had only very recently come upon the abandoned thirteenth-century complex during a cattle run. These facts have been noted in the recent European scholarship, where the Wetherills are, however, described as respected amateur archaeologists—not the notorious pot hunters that Southwestern regional scholars consider them to have been.[38]

The scholarship implies that Warburg prepared himself for fieldwork in the manner of a modern ethnographer who interviews informants in their native language, but the evidence suggests that Warburg's interests were primarily directed toward material artifacts. Warburg's study of the Hopi language is

cited widely on the basis of notebooks and texts preserved in his archives, but no one has ever bothered to note that his textbook, John Wesley Powell's *Introduction to the Study of Indian Languages,* is intended for those who needed actually to speak Native languages, while Warburg's preserved wordlists consist almost exclusively of nouns associated with the ceremonial costumes he studied.[39]

In general, the current scholarship paints a theoretically sophisticated, but distorted picture of Warburg's innovative methods, while glossing over other, historically equally significant aspects of his work that have less in common with contemporary progressive values. To wit, Warburg's knowledge of such popular sources as Lt. J. G. Bourke's *The Snake Dance of the Moquis of Arizona* (1884) is cited with reference to their detailed descriptions of costumes and ceremonies, but not with reference to their authors' sensationalizing treatment of and phobic reaction to "demonic" practices they claim to have witnessed firsthand.[40] The snake dance itself, which is the basis for Warburg's term "serpent ritual," was a relatively inconspicuous ceremony in the Pueblo agricultural calendar that became a popular spectacle staged for tourists, partly because snake handling provided a sensational attraction that translated into profit, partly because it was not as esoteric (and therefore private) as many other celebrations, including the *hemis* (or young corn) dance that he photographed.[41] Warburg, as is acknowledged but not otherwise commented upon in the scholarship, never actually saw the snake dance, which is performed in August (while he visited the Pueblos in April and May).

The context of mass entertainment and popular ethnography where the more banal undertones of cultural evolutionism played out gives a different resonance to Warburg's echoing of Robert Vischer's theoretical abstraction that a "dark, prescient projection" of the self into objects accounts for the "pantheistic urge for union with the world" manifest in the symbolic art of societies less advanced than Europe.[42] As far as Warburg's use of anthropological theory is

concerned, the continued presence of dated ideas in popular culture may explain why Warburg relied on James Frazer's cultural evolutionism at a time when he might have been digesting Franz Boas's groundbreaking demolition of scientific racial theory.[43] Perhaps if Warburg had lived to realize the project of returning to the Southwest and working with Boas's student at Columbia University, he would have excised the remnants of racial theory in his own theoretical considerations—notes from the end of his life are suggestive.[44] But defense of the man is not the point, any more than personal indictment is: historical understanding demands nuance beyond praise or blame. As I mentioned above, in Oraibi, Warburg stayed with the Mennonite missionary H. R. Voth, who gained access to *katsina* ceremonies for him and is perhaps the photographer responsible for some of the photographs in Warburg's collection of Southwestern materials. Voth spoke Hopi fluently and became an expert on Hopi culture, knowledge that he exploited for his own financial profit. Peter Whitley has assembled damning evidence that Voth was deeply hated by the Hopi then for gaining their trust while exploiting them. Non-Native presence at Oraibi fueled antagonism between two factions, one hostile to white culture and the other open to it. Twelve years after Warburg's visit, the feuding sides split the community over this issue.[45] Although Warburg may have been unaware of any such friction and his notes record his own disdain for Voth's coarse personality, Warburg was only partly aware of his own subject position in the configuration of institutionally supported power relations, and the same is true of his well-meaning contemporaries. For example, however brief his presence was, however progressive his intentions might have been, by conducting his famous drawing "experiment" at the Keams Canyon school, Warburg participated in a long history of coerced cultural assimilation presented as education for Indian children in government schools.[46] Forced attendance at government schools was one of the key issues that brought the factionalism at Oraibi to a head, leading to the expulsion of the "unfriendlies" in 1906. No clearer case than the Oraibi split could be imagined of the manner in which scholars can inadvertently become complicit in the destruction of their subjects. In the long run, from a Pueblo perspective, the despoliation ushered in by archaeologists and the modern museum age left equally deep scars on their cultural landscape, literally and figuratively.

Poverty, disease, economic depression, coerced participation in the tourist industry, and continued litigation in the courts over land ownership and water rights are ways that colonial power relations are sustained until the present day. The following assertion can only be taken as breathtakingly oblivious to this history and its contemporary repercussions:

> Today, the Pueblo tribes have adapted themselves admirably to contemporary life with modern administrative, educational, and healthcare facilities and services. A number of schools have come under native control in several pueblos, introducing modern curricula as well as programmes focusing on native language and culture. Although the dramatic influx of tourism during the 1960s and 1970s did have adverse effects, it also brought on a veritable renaissance of traditional crafts (as well as new experimental arts) that has had important repercussions for Pueblo efforts to preserve indigenous ceremonial practices.[47]

We need to understand what continues to perpetuate such skewed representations of cultural interaction in the contemporary lenses of respected archaeologists, art historians, and other "experts" insensitive to the colonial and neocolonial oppression that their own practices often unwittingly continue to reproduce in the name of historical accuracy.

It would be a serious short circuit of logic, however, if the current situation as I have described it thus far were simply blamed on *individuals* in a vast network of diffused power/knowledge relations. (Voth lacked integrity by the standards of his own day, but Warburg didn't.) By analyzing connections among individuals *structurally,* we can try to understand the ways in which contemporary discriminatory practices

are grounded in historical circumstances in order to change them, not justify them. We the authors of this collaborative study would not have undertaken this project to theorize cultural interaction if we felt comfortable with the controls that the Hopi Tribal Council and administrative bodies of other Pueblo Nations want to impose on the "outside" world—not because of any disagreement with their aims, but because their isolationist strategies are a form of resistance, born of circumstance, that (in my view, at least) interferes with the realization of their own goals. Not that I wish to discount the value of resistance—its ability to question structures of domination and implement change is indisputable.[48] Nonetheless, the current strategies are only partly successful, as the correspondence between the Hopi Tribe and the Warburg Institute demonstrates: the Warburg Institute is under no legal constriction, and its administrators do not comprehend why they should comply with the Hopis' requests.

From the dominant culture's point of view, the *difference* between trafficking in ritual objects and circulating documentary photographs of rituals is historically significant and quantifiable in museological terms: the monetary value of the objects, their mode of storage, display, attribution, ownership, materials, condition, and so on "preserve" these differences. From the marginalized culture's viewpoint, on the other hand, what counts is controlling the signifying power of the material residue of events: the *commonalities* between purloined artifacts and barred photographs are significant within this frame of reference—the materiality of the material artifact aside from its symbolic value is, in a manner of speaking, immaterial.

One of the key reservations voiced by the Warburg Institute is that the photographs in dispute document the presence of non-Native observers. Why should it matter, in this case, that photographs of events once open to the public (and previously published to boot) are on public view now? The terms of misunderstanding (and miscommunication) hinge on the meaning of "public," or rather, degrees of public-

ness. Warburg and his host Voth photographed non-Native observers who were not in a position *at the time* to impose their own interpretations on the ceremonies they viewed. However, once the photographic documentation entered the discourse of anthropology and of the popular press, the Hopi lost control of the ways in which their ceremonies were interpreted. The behaviorist descriptions typical of anthropological fieldwork may signal "objectivity" from the standpoint of empirical science, but in the same breath, they deny the significance that the Hopi themselves attach to their performances. At this intersection of cultural practices, the notion of "public" means the power to inscribe Hopi belief in an alien system of values and activities. In the act of preservation, historians unavoidably displace the dynamic present into the past for the sake of the future. In sum, an account of an event and the event itself cannot be identical: history is always at least one remove from the "authenticity" it seeks to "preserve." One of the most difficult issues for historians to understand is the inauthenticity of the written word.

Ethnocentric attitudes toward outsiders originate on both sides of the cultural divide, where they operate at the expense of more productive courses of action. Moratoriums and cultural embargoes reinforce existing forms of domination because they do not, by themselves, encourage meaningful contestation and constructive confrontation. Resistance and counterappropriation at the grass roots level, on the other hand, are often effectively embodied in the "tourist art" forms to which Hopi officials object, or so Ruth Phillips among others has recently argued.[49] Whether coerced or not, these transgressive hybrid forms of cultural production are indirect forms of confrontation, limited in the sense that they participate in the capitalist processes of mass consumerism and tourism, but effective in the sense that they can subvert dominant cultural symbols and modes of production.

In the neocolonial gridlock of cultural interaction—whether acknowledged or not—the interdependence of various subgroups seeking autonomous

goals in a heterogeneous society operates globally, as the foregoing discussion of Warburg has tried to suggest.[50] Current dissent over the use of Warburg's photographs simultaneously presents a unique historical circumstance and a typical performance of the idea that culture is anyone's "property." The expanded understanding of scholarly responsibility that my own unanticipated involvement with identity politics in New Mexico encouraged, as I became immersed in the study of its material culture, raises complex, general ethical questions. The individual chapters in the book that eventually resulted from this engagement collaboratively enact an array of responses/accommodations/grapplings with ethical issues.

The point of this Epilogue is *not* that the resulting study was able to avoid chronology in dealing with *santos*. Rather, I have argued that Pueblo and Western constructs of temporality are incommeasurable, yet they appear to coexist in certain *santos*. At most it seems possible to conceive of these images as polysemic signs that engender responses rooted in incommeasurable worldviews. My argument is in no way intended to subsume the many different subject positions assumed by the contributors to this volume. Yet one overriding observation can be made: ongoing struggles for control of cultural "property" arise along the continuing fault lines of colonial power relations. To conclude this book by invoking one of the major arguments made in the Introduction, the troping of "time" is largely unrecognized and thus continues to be inadequately theorized even in vanguard circles. Consider the various ways in which "presentness" and chronological time are used in Western culture.[51] Time defined as constant presentness is often called "cyclical" time (the term itself implies the priority of Western linear time) and is associated primarily with "fantasy," "myth," "vacation," "holidays," and other moments of leisure in the annual calendar. By contrast, "chronological" or "linear" time is considered historical, "real," factual, objective, and also productive and progressive as opposed to static and repetitive. The hierarchical relationship of these two ways of conceiving time is (within a modern Western framework) obvious, but a complex network of socially constructed relationships often masks the actual operations of power involved. For example, the hidden core assumption in the argument that Warburg historicized the notion of "empathy" is that history equals chronology. Chronology engenders, masks, and validates what Derrida condemns as the "Patriarchive."[52] Pueblo conceptions of time as "presentness," in addition to their role within the native lifeway, exhort historians to act on their disenchantment with the cult of historical chronology. The paradigm of "objectivity" has shifted, and in shifting has revealed the arbitrary, imperialistic nature of this framework.

NOTES

Introduction

1. There are records of earlier images made locally, but none survive that can be dated before the mid-eighteenth century, except for a few charred architectural fragments; see Taylor and Bokides, *New Mexican Furniture,* 11, for references and a photograph of an early seventeenth-century beam fragment from Quarai (Las Humanas) Pueblo, now in the collection of the Laboratory of Anthropology, Museum of Indian Arts and Culture, Santa Fe. The first writer to allude to the local manufacture of religious images is Fray Alonso de Benavides, *Memorial, 1630,* and *Revised Memorial, 1634,* who notes five oil paintings and two sculptures in the 34 newly built missions and more than 50 churches constructed with the help of Indian labor; Benavides also describes an Indian mass before an altar containing an image of the Virgin.

2. The makeup of the first groups of settlers in the Resettlement period following 1692 is the subject of Chap. 4, by José Antonio Esquibel, based primarily on his own archival research. For a synthetic overview of the region's early colonial history, see Salinas, *Indians of the Rio Grande;* Hackett, *Revolt of the Pueblo Indians;* J. Manuel Espinosa, *The Pueblo Indian Revolt of 1696;* and Sando, *Pueblo Nations.* In 1715, the viceroy of New Spain finally enforced the abolition of tribute labor known first as the *encomienda* system and later as the *congrega* system.

3. On the two earliest surviving examples, see Pierce, "From New Spain to New Mexico," 64, figs. 50–53, on the main altar screen at Zuni Pueblo (1770s) and the stone altar made for the *castrense,* or military chapel, dedicated to Our Lady of Light on the Santa Fe plaza (1760–61). Pierce attributes both to Captain Bernardo Miera y Pacheco, born near Burgos, Spain, in 1714, and documented in Santa Fe from c. 1754. See Pierce, "Saints in New Mexico," 31–32; and in this volume her Interleaf, "The Life of an Artist . . . Miera y Pacheco". Dating of the majority of paintings and sculptures depends on conservation analysis: the only published systematic study of materials to date, based on a small sampling of 13 *santos,* is Gettens and Turner's "The Materials and Methods"; see also the dendrochronology of William Stallings cited in Boyd, *Popular Arts,* 165, reviewed and updated by Wroth, *Christian Images,* 195–200. Conservation analyses are ongoing at the Museum of International Folk Art in Santa Fe and the Smithsonian Institution in Washington, D.C. See also the evidence reported by Cash, *Santos: Enduring Images,* the analyses of furniture by Taylor and Bokides, *New Mexican Furniture,* and two case studies by Bakker, cited in the consolidated bibliography of the present volume. Also in this volume, see further discussion by Pierce, Chap. 3; Stoller, Chap. 7; and Gavin, Chap. 13.

4. See Boyd, *Saints and Saintmakers* and *Popular Arts;* Cash, *Built of Song and Earth;* Dickey, *New Mexico Village Arts;* Espinosa, *Saints in the Valleys;* Frank, *New Kingdom of the Saints;* Gavin, *Traditional Arts of Spanish New Mexico;* Kubler, *Santos;* Lange, *Santos de Palo;* Mather, *Colonial Frontiers;* Mills, *People of the Saints;* Pierce, "Saints in New Mexico"; Shalkop, *Arroyo Hondo;* Steele, *Santos and Saints;* Wilder and Breitenbach, *Santos;* Wroth, *Christian Images* and *Images of Penance.* The local manufacture of tinwork frames for mass-produced prints is better documented: see Coulter and Dixon, *New Mexican Tinwork.*

5. Pierce, "The Holy Trinity," 29, provides this estimate. A few altar screens can be dated by church documents; see, further, Boyd, *Popular Arts;* Gavin, *Traditional Arts of Spanish New Mexico;* Pierce, "Saints in New Mexico."

6. Many of these small panels were collected from subsistence households during the Depression, by traveling dealers who often did not themselves keep records (personal communication, Robin Gavin, June 1998).

7. See new archival records published in this volume by Esquibel, Chap. 4, and Pierce, Chap. 8.

8. No comparative study has ever been conducted, but see examples reproduced in Bantel and Burke, *Spain and New Spain; Barrocco de la Nueva Granada;* Chorpenning, *Mexican Devotional Retablos; Colonial Art of Peru; Colonial Mexican and Popular Religious Art;* Luque Agraz and Beltrán, *Doñes y Promesas;* Giffords, *Mexican Folk Retablos* and *The Art of Private Devotion; Gloria in Excelsis;* Juárez Frías, *Retablos populares; Retablos;* Oettinger, *Folk Art of Spain and the Americas.*

9. White, "The Fictions of Factual Representation."

10. Spivak, *Critique of Postcolonial Reason,* 66–67.

11. Paraphrasing Derrida, "The Right to Philosophy from a Cosmopolitan Point of View: The Example of an International Institution," in *Ethics, Institutions, and the Right to Philosophy,* 9.

12. Kubler, *The Religious Architecture of New Mexico,* 6: "the

passive resistance of a native race contributed to the formation of the style of architecture under discussion"; and 65–67, noting the use of Pueblo iconography and architectural detail of possible native religious significance.

13. D. Weber, *Myth and History,* levels a similar critique against Turner and the so-called Borderlands School of writing colonial history from the perspective of the dominant culture. See also Limerick, *Legacy of Conquest.*

14. These Spanish terms are twentieth-century appellations not customarily used in Spanish-speaking households, according to Carlos Fresquez, a nationally prominent artist and active member of the Denver Latino community, who is also a direct descendant of Pedro Antonio Fresquís, the prolific eighteenth-century *santero.*

15. Burkhart, *The Slippery Earth,* 39.

16. According to Schroeder, "Rio Grande Ethnohistory," 41–72; see also Gutiérrez, *When Jesus Came,* 166–75. Gutiérrez's figures have been questioned as being too low by David Snow, "So Many Mestizos." The most extensive comparative study is by Tjarks, "Demographic, Ethnic, and Occupational Structure of New Mexico, 1790," who reports (83) the following percentages in 1790: for Santa Fe, 54 percent Spanish, 16 percent Indian, and 28 percent mixed blood; and for Albuquerque, 38 percent *mestizo.* Tjarks (72–74) observes that at the end of the eighteenth century, "the process of ethnic hybridization was proceeding in high gear and the increase in exogamic or interracial marriages contrived to create a more homogeneous population." The terms of classification are also inconsistent: see Bustamante, "The Matter Was Never Resolved," and Chap. 5 in this volume, by Paul Kraemer.

17. Wroth, "The Flowering and Decline of the Art of the New Mexican Santero," 265.

18. At the very beginning of the local artistic tradition, Miera y Pacheco, the anonymous Laguna *Santero,* and Pedro Antonio Fresquís are outstanding examples of cultural mediators: they painted the altar screens in both Pueblo mission churches and Hispano villages. The Laguna *Santero* painted the altar screen at Laguna Mission's Church of San José Gracia. A diminutive copy of its Three-Person Trinity (attributed to Pedro Fresquís) was painted for an altar screen in a small chapel, probably Chamíta (Denver Art Museum), which is in turn closely related to Fresquís' signed and dated altar screen at Trampas chapel. Similarly, Miera y Pacheco is credited with a stone, originally polychromed altar screen for the Military Chapel (La Castrense) in Santa Fe (now in the Church of Cristo Rey, Santa Fe), and a wooden altar screen at Zuni Pueblo: see Pierce, "Saints in New Mexico," "From New Spain to New Mexico," and, in this volume, her Interleaf "The Life of an Artist . . . Miera y Pacheco"; see also in this volume, Chap 9, by Kelly Donahue-Wallace.

19. Steele, *Santos and Saints,* 84–85.

20. Y. Lange, "Lithography, an Agent of Technological Change."

21. Notably Memmi, *The Colonizer and the Colonized;* Fanon, *Wretched of the Earth;* Cesaire, *Return to My Native Land.*

22. Young, *Torn Halves,* 21.

Chapter 1

1. Glick-Schiller, "Introducing Identities"; idem, et al., *Towards a Transnational Perspective on Migration.*

2. Said, *Orientalism.* For critiques in the burgeoning literature, see Parry, "Problems in Current Theories of Colonial Discourse"; Bhabha, *Nation and Narration* and *The Location of Culture;* García Canclini, *Hybrid Cultures;* Papastergiadis, "Tracing Hybridity in Theory"; Young, *Colonial Desire* and *Torn Halves.*

3. Cordell and Yannie, "Ethnicity, Ethnogenesis, and the Individual"; Cordell, *Archaeology of the Southwest;* Lekson, "The Architecture of the Ancient Southwest" and "*Magnus Redivivus.*"

4. For the former view, see Chávez, *Origins of New Mexico Families.* This view was revised by Esquibel, "Mexico City to Santa Fe"; *Remembrance/Recordacíon;* and Chap. 4 in the present volume.

5. On immigration trends, see Craver, *The Impact of Intimacy.* Neulander, "The Crypto-Jewish Canon," presents evidence that many late-nineteenth-century references to Jews are literary tropes because of the New Mexican presence of Protestant millenialism. For the broader context of conversion, diaspora, and survival of Crypto-Jews in the Spanish colonies after the expulsion of Jews from Spain in 1492, see Gitlitz, *Secrecy and Deceit,* and Segal, *Jews of the Amazon.* For a different opinion, see Hordes, "The Sephardic Legacy in New Mexico."

6. Kubler, *The Religious Architecture of New Mexico,* 6, citing Zarate Salmerón, *Relacíon,* c. 1629, who used baptismal registers for his report.

7. Sando, *Pueblo Nations,* 75, citing factionalism among the Pueblos. See also O. Jones, *Pueblo Warriors;* J. Bailey, *Diego de Vargas;* Kessell, *Kiva, Cross, and Crown;* Espinosa, *The Pueblo Indian Revolt of 1696;* and Hackett, *Revolt of the Pueblo Indians.*

8. R. Ortiz, *Roots of Resistance,* 82–89, and DeBuys, *Enchantment and Exploitation.*

9. D. Snow, "Spanish American Pottery Manufacture"; in this volume, see Pierce and Cordelia Snow, Chap. 6.

10. According to Francisco de Vitoria, *Obras,* 723–25, Indians possessed no knowledge of the liberal arts, had no proper agriculture, and produced no true artisans; cited by Pagden, *Spanish Imperialism,* 20, and see, further, *The Fall of Natural Man,* 73–80, 120. According to the Aristotelian-

Thomist position fabricated by Vitoria, Indians were merely ignorant misguided people who had lost the mental habit of *Scientia,* defined as the ability to draw conclusions from stated premises: therefore, it was the responsibility of European missionaries to educate Amerindians in the liberal arts, the sciences, and theology.

11. The most famous of these was Bartholomé de las Casas's defense of the Indians against Juan Gines de Sepulveda, at Valladolid in 1550. See the fundamental studies by Pagden, *The Fall of Natural Man;* Hodgen, *Early Anthropology;* and Hanke, *Aristotle and the American Indians.*

12. See Schaifer, "Greek Theories of Slavery"; Pagden, *Spanish Imperialism,* 16–33, and *The Fall of Natural Man,* 27–56.

13. The operative intellect *(intellectus operativus)* corresponds with Averroes's "particular intellect" or *vis cogitativa,* which is a power of the *sensitive* soul, the sum of human internal sense, the activity of which Aquinas describes as the bringing together and comparing of individual forms—human reason performs analogous operations with universal forms: see Summers, *The Judgment of Sense,* 27–28.

14. *Argumentum apologiae adversus Genesium Sepulvedam theologum cordubensem,* 24r–25r, cited in Pagden, *The Fall of Natural Man,* 136. Las Casas also cited the products manufactured by laborers and artisans as proof of the rationality of Amerindian peoples (*Apologetica historia,* chaps. 61–65). See Kubler, "Aesthetic Recognition," and Hanke, "Pope Paul III," on the Pope's 1537 bull declaring that Indians were human beings whose rights must be respected.

15. See, further, Farago, "Classification of the Visual Arts."

16. Klor de Alva, Nickolson, and Keber, *The Work of Bernardino de Sahagún,* intro. 1–12, on the complexity of institutional forces and the politics involved.

17. Ricard, *The Spiritual Conquest of Mexico,* 50; and Edgerton, *Theaters of Conversion,* emphasizing the coexistence of hundreds of local languages.

18. Ricard, *The Spiritual Conquest of Mexico,* 2–8.

19. G. Bailey, *Art on the Jesuit Missions,* in the first comprehensive overview of the Jesuits' activities outside Europe, emphasizes the important role played by printed books and engraved illustrations in the global dissemination of European ideas and values.

20. See Cordell and Gumerman, "Cultural Interaction in the Prehistoric Southwest," and S. Jones, *The Archaeology of Ethnicity.* Thanks to Maxine McBrinn for these references.

21. On the earliest remains, see Kubler, *The Religious Architecture of New Mexico;* Pierce, "From New Spain to New Mexico," 64–65; and here note 1, Introduction, above.

22. Bolton, "The Mission as a Frontier Institution," discusses the lack of language training and names several key exceptions; pp. 55–56, he cites the 1745 testimony of Father Ortiz that there were more than 200 dialects of twenty distinct languages in the Rio Grande region (present New Mexico and Texas), which prevented missionaries from learning native languages. The bibliography on Valadés is extensive, but see the recent, excellent discussion of the engravings by Edgerton, *Theaters of Conversion,* 114–25, 237–45.

23. Kelly, *Franciscan Missions of New Mexico,* 10, adding that the friars used children as translators because they quickly mastered Spanish. Schaafsma, "Pueblo Ceremonialism from Spanish Documents," 129–36, reviewing documents published since Kelly's article, emphasizes that the influence of the missionaries during the Oñate period (1598–1610) is difficult to gauge and probably insignificant owing to the small number of friars (14). Significant changes took place after 1610, when 12 more missionaries arrived, until about 1639, when the relationship between the Spaniards and the Pueblos gradually began to deteriorate. Schaafsma reviews the documentation for the revival of *katsina* ceremonies until 1661, when Fray Alonzo de Posadas, the commissary of the Holy Office in New Mexico and the chief representative of the Inquisition, arrived in Santa Fe. The documents from the period after Posadas's arrival also indicate that cross-cultural communication was (at least sometimes) controlled by the Pueblo Indians, as in the case of Esteban Clemente, the native governor of the Pueblos of Las Salinas in 1660, who was a "very capable interpreter of six Indian languages of New Mexico." The suppression of the *katsina* ceremonies encouraged some people to seek "exile" outside the converted pueblos in the secluded hills, and these repressive (and well-documented) conditions of the 1660s immediately preceded the Pueblo Revolt of 1680.

24. Artistic embellishments like the treatment of light were especially important to the Franciscans, who emphasized the role of the senses over the intellect in coming to knowledge of God. See Tracy, *Celebrating the Medieval Heritage.* With Catholic reform in the sixteenth century came renewed interest in depictions of saints, especially important to the Franciscans as visual reminders of exemplary lives in imitation of Christ. On Franciscan subject matter in Spain, see Stoichita, *Visionary Experience;* in New Spain, see Sylvest, *Motifs of Franciscan Mission Theory.*

25. See Prodi, *Ricerca sulla teorica.* See further discussion here in Farago, Chap. 11.

26. On lay devotion, see Brown, *Mama Lola;* Orsi, *The Madonna of 115th Street* and *Thank You, St. Jude;* Tweed, *Our Lady of the Exile;* and the extensive writings of William A. Christian Jr. In this context especially, rural Spain offers a significant comparison: see Christian's *Local Religion in Sixteenth-Century Spain* and *Visionaries.* Most surviving locally manufactured New Mexican colonial religious art

portrays individual saints and other holy figures, in keeping with the Catholic Reformation emphasis on exemplary visual material and specifically in tune with Franciscan mysticism, which interpreted Christianity as primarily a spiritual practice based on imitating the lives of Christ, Saint Francis, and other saints. On Catholic Reformation, especially Franciscan, subject matter in Spain, see Stoichita, *Visionary Experience.*

27. In 1776, Fray Domínguez ordered the destruction of images: see Adams and Chávez, *The Missions of New Mexico,* the most complete source of documentation for church furnishings before the nineteenth century; other primary sources are cited in Espinosa, *Saints in the Valleys;* and see further discussion here by Stoller, Chap. 7.

28. See Sullivan, "European Painting and the Art of the New World Colonies," and Peterson, *The Paradise Garden Murals of Malinalco,* 50–57, both with further bibliography.

29. In New Mexico, while there may have been workshops at the village level, little is known about private patronage or artistic instruction and the transmission of artistic skills. See here, Gavin, Chap. 13.

30. The Spanish guild system was established in Mexico City in 1568; rules of proportion used in furniture making suggest that the guild system was brought to New Mexico along with Spanish tools, according to Taylor and Bokides, *New Mexican Furniture,* 1ff. This is indicated by the use of the same units of measurement and the same joining techniques. See also Pierce, "New Mexican Furniture."

31. See Pierce, Chap. 8.

32. Bloom, "A Trade Invoice of 1638."

33. As in note 31 above. In this volume, Marianne Stoller, Chap. 7, reviews the history of scholarship about the ethnic and cultural identity of New Mexican artists; Esquibel, Chap. 4, also publishes newly discovered archival evidence of Indian painters.

34. In this volume, see Gavin, Chap. 13; see Esquibel, Chap. 4, on Miera y Pacheco and Pedro Antonio Fresquís working together.

35. In this volume, see Farago, Chap. 11, and Donahue-Wallace, Chap. 9, on lenient enforcement of Catholic Reformation strictures; and on commercial trade in religious images, including images brought back by pilgrims from northern Mexican shrines, see also Edgerton, *Theaters of Conversion,* especially 129–53, and Peterson, *The Paradise Garden Murals of Malinalco,* 65–77, with further references.

36. Weigle, *Brothers of Light;* Davis, *El Gringo;* Salpointe, *Soldiers of the Cross.* Domínguez, *The Missions of New Mexico, 1776,* mentions seven confraternities without placing special emphasis on Nazarenes or *Penitentes.*

37. Rivalry between church and state, and between secular clergy and missionaries, is well documented: see France V. Scholes, *Church and State in New Mexico* and *Troublous Times in New Mexico;* Adams, *Bishop Tamarón's Visitation.*

38. This is the central argument of P. Brown, *The Cult of the Saints;* see especially his critique of David Hume's "two-tiered" model, 13–22.

39. Spicer, *Cycles of Conquest;* Dozier, *The Pueblo Indians;* A. Ortiz, *The Tewa World.*

40. See Swadesh, *Los Primeros Pobladores,* 31–52, on the use of this term; on racial classifications in general, see Bustamante, "The Matter Was Never Resolved," and Esquibel, Chap. 4, and Kraemer, Chap. 5, in this volume. The genealogical evidence and terminology are far from sorted out. See also discussion in Stoller, Chap. 7.

41. Swadesh, *Los Primeros Pobladores,* 39. Landless emancipated *genízaros* were awarded land grants on the margins of the Kingdom of New Mexico: Belén in 1740, Abiquiu and Ojo Caliente in 1754, and San Miguel del Vado in 1794, to name just a few of the settlements (cited from Gutiérrez, *When Jesus Came,* 305).

42. See Cordell and Yannie, "Ethnicity, Ethnogenesis, and the Individual"; Carrillo, *Hispanic New Mexican Pottery;* Cordova, "Missionization." As late as the 1980s, inhabitants of Abiquiu still called themselves Moquis, a colonial-period term for the Hopi, mentioned in the Epilogue, Chap. 15, note 10 below.

43. Swadesh, *Los Primeros Pobladores,* 41–47.

44. Ortiz, *Roots of Resistance;* see further, Wroth, *Images of Penance.*

45. Ortiz, *Roots of Resistance,* 82; see also DeBuys, *Enchantment and Exploitation,* and Sando, *Pueblo Nations,* 83–165.

46. Boyd, *Popular Arts;* Teresa Archuleta-Sagel, "Textiles," 1:143–64; Taylor and Bokides, *New Mexican Furniture;* Bakker, "Aesthetic and Cultural Considerations"; Kubler, *The Religious Architecture of New Mexico;* Puig and Conforti, *The American Craftsman;* and Fisher, *Spanish Textile Tradition.*

47. Carrillo, *Hispanic New Mexican Pottery,* labels these artifacts "Spanish." While I disagree with the nomenclature because it does not capture the complex cultural heritage that produced this ware, the important point to stress is the reclamation of indigenous contributions to colonial culture. See also D. Snow, "Spanish American Pottery Manufacture" and "Some Economic Considerations."

48. Frank, "From Settler to Citizen" and "The Changing Pueblo Indian Pottery Tradition."

49. Frank, "The Changing Pueblo Indian Pottery Tradition," 312.

50. Frank, "The Changing Pueblo Indian Pottery Tradition," 298.

Chapter 2

1. Bhabha, "DissemiNation," 139–40, citing Hobsbawm, *Nations and Nationalism.* See also Hobsbawm and Ranger, *The Invention of Tradition,* intro.; B. Anderson, *Imagined Communities.*

2. The first three characterizations are too widely dispersed to require attribution, but the last is found in Wroth, *Christian Images,* 25. Thirty years ago, in *Popular Arts,* 155, E. Boyd hypothesized that the anonymous *santero* active at Laguna Mission around 1800 was a transitional figure who had had experience in "some Spanish center" before he came to the Pueblos, where she attributes to him five major altarpieces: San José at Laguna Pueblo; Acoma (overpainted) altar screen; altar screen of San Miguel, Santa Fe; Church of the Assumption, Zia Pueblo; Santa Ana Pueblo (with paintings of Saint Anne and Virgin from New Spain). A panel depicting San José, from the altarpiece in the church of San José at Laguna Pueblo, exhibits many trademarks of the Mexican Baroque. These traits include the voluminous folds of the saint's drapery with its dramatic chiaroscuro, the elaborate framework including carved Solomonic columns, scallop-shell valance in imitation of *estofado* or painted relief, another ornamented border composed of elements vaguely *all'antica,* and the shallow stage space in which the figure stands, with its skewed perspective construction. Boyd classifies the anonymous *santero* Molleno as a prolific follower of the Laguna *Santero,* a painter who turned the Mexican Baroque into "literally shorthand symbols of images" that "reject the three-dimensional plane." These two characteristics are considered key features of the entire *santero* tradition. On the Mexican Baroque, see Romero de Terreros y Vincent, *Las Artes Industriales;* Keleman, *Baroque and Rococo;* Toussaint, *Colonial Art;* and *Mexico: Splendors of Thirty Centuries.*

3. Mayes and Lacy, *Nanise'.* On guardian angels, see Pelikan, *Imago Dei,* 160–75; P. Brown, *Cult of Saints,* 50–68; Aune, *Prophecy;* Corbin, *History of Islamic Philosophy;* and Naar, *Three Muslim Sages.*

4. For this specific argument, see Peterson, "Synthesis and Survival."

5. Edgerton, *Theaters of Conversion,* 211–32. Edgerton's compex argument is too detailed to fully to summarize here, but he makes a convincing case for a calculated, polysemic program at Malinalco that makes extensive use of Nahuatl symbolism. Edgerton argues that the fictive landscape depicts a jungle wilderness, not Paradise, painted as it is on the outermost walls of a cloister atrium with an inner garden. Medallions painted on the same walls as the depicted gardens indicate a processional route and convey a didactic message, "reminding the passing celebrants first of the holy mission of the Augustinian order, then of Jesus' miraculous conception in the sacred womb of Mary . . . and finally of Jesus' sacrifice on the cross as saviour of mankind just before pausing for a further inspirational message at each corner testera" (p. 217). Whether or not the medallions function as Edgerton argues, as an "allegorical boundary" on the order of the actual boundaries of native Indian communities, he extends Peterson's interpretation of the imagery itself into a reading that reinforces the recently acquired Christian religion of the native celebrants with reminders of their preconquest past (p. 224). This is achieved by means of cryptic Nahua calendar references, not only in the frescoes at Malinalco but in a related series of early colonial codices (already signaled by Peterson as produced in the same milieu). Edgerton, p. 231, quite accurately calls these connections "syncretistic." If his reading is valid, and his arguments for the polysemic function of the visual symbolism certainly seem to be, Malinalco provides a rare example of extensive deliberation on the part of Christian missionaries to make two worldviews syncretic. The present study argues throughout that the same semiotic conditions apply to the New Mexican imagery, although far less systemically achieved and therefore less legible, their significance for their original beholders far less recoverable through historical lenses.

6. Peterson, *The Paradise Garden Murals,* 7.

7. Suina, "Pueblo Secrecy," 60. Thanks to Zena Pearlstone for bringing this article to my attention.

8. The most prominent example in the recent past is the negative response by the Native American academics Alison Freese, Joe Sando, and others to Gutiérrrez, *When Jesus Came.*

9. Bhabha, "Editor's Introduction."

10. Here I would like to acknowledge the sensitive support of John Reyna of Taos Pueblo, who believed in this project from the beginning and brought to my attention specific instances of Pueblo Christian imagery that might be considered artistically if not ideologically "hybrid," including some of the contemporary practices and examples cited in this volume. I happily acknowledge the enthusiastic support of Phil Deloria, a member of the academic community himself, who helped me place contemporary political issues into a historiographical context. I am also indebted to Jaune Quick-to-See Smith, who urged me to enlist scholars from the Pueblo community and contacted several potential participants on my behalf. Unfortunately, despite the willingness of these three individuals and the support of my students whose contributions are noted throughout this study, the time for such collaboration has not yet arrived.

11. R. White, "Representing Indians." Thanks to Dana Liebsohn for calling this review to my attention.

12. See Rushing, *Native American Art and the New York Avant-Garde,* for an excellent collection of current positions on Nativism.

13. Thomas, *Colonialism's Culture,* 184.

14. Mauze, *Present Is Past,* intro. 4–5. Thanks to Rebecca Hernández for calling this study to my attention. The critique that might be put forward is *not* that Nativist essentialism is merely appropriating a derivative discourse, but that Nativist appropriation "partakes of a cultural essentialism" that reduces Maoriness to the terms that complement white society's absences: the exhibition's construction of authentic spirituality marginalizes most Maori who must negotiate their identities in (urban) contexts with nontraditional social relations, institutions, jobs, and so on.

15. Mauze, *Present Is Past,* intro., 13.

16. See, for example, E. C. Parsons, *Isleta Paintings,* 16–17, paintings 2 and 3, painted and annotated anonymously by a member of Isleta Pueblo.

17. See, for example, Jaramillo, *Shadows of the Past,* 60, reminiscing about her childhood in the village of Arroyo Hondo, New Mexico: "Sometimes when a saint turns a deaf ear, after prayers and novenas, he is punished by having his picture or statue turned face to the wall, or locked in a trunk, until the request is granted."

18. Among notable exceptions elsewhere in an emerging field of ethnographic study unrecognized as such (apart from some being contributions to American studies), see Halle, *Inside Culture;* McDannell, *Material Christianity;* D. Morgan, *Visual Piety;* and Doss, *Elvis Culture.*

19. Christian, *Local Religion in Sixteenth-Century Spain.*

20. Ginzburg, *The Cheese and the Worms.*

21. On penitential practices of the lay confraternities, whose dramatic reenactments of the Passion of Christ took the place of sacraments in the absence of local officiating priests, see Weigle, *Brothers of Light,* and Wroth, *Images of Penance, Images of Mercy.* More generally, see the excellent anthology of source material in Weigle and White, *The Lore of New Mexico.*

22. See Chap. 9 by Donahue-Wallace in this volume, citing the earlier work of Boyd, Lange, and Wroth.

23. In addition to the studies already cited, for example, see Leibsohn, "Colony and Cartography"; Lockhart, "Sightings"; Adorno, *Guaman Poma;* Baird, "Adaptation and Accommodation"; Clendinnen, *Ambivalent Conquests;* Cummins, "From Lies to Truth"; Dean, "The Renewal of Old World Images"; Klein, "Wild Woman"; MacCormack, "Demons" and *Religion in the Andes;* Peterson, "Synthesis and Survival"; Silverblatt, *Moon, Sun, and Witches;* and López-Baralt, *Icono y Conquista.*

24. Quintilian, *Institutio Oratoria* 8.v.9–134 and 8.vi.37–39. For the self-conscious, historical application of rhetorical theory to the visual arts by early humanists, the foundational study is Baxandall, *Giotto and the Orators.*

25. For an overview, see Bal and Bryson, "Semiotics and Art History"; Bal, "De-disciplining the Eye"; and the critique by Summers, "On the Histories of Artifacts."

26. Coward and Ellis, *Language and Materialism,* 122–52, drawing primarily on the work of Benveniste, Freud, Barthes, and Kristeva. The distinction between condensation and displacement corresponds roughly to the dyadic distinction between metaphor and metonymy in contemporary literary theory.

27. Deloria, *Red Earth, White Lies.*

28. James Owen Dorsey, cited in Mitchell, *The Last Dinosaur Book,* 45.

29. Mitchell, *The Last Dinosaur Book,* 46, citing collaborations between the paleontologist O. C. Marsh and the Sioux, Edward Drinker Cope and the Crow Indians, as well as other period testimony that paleontologists were "usually spoken of as bone- or bug-hunting idiots" (citing James H. Cook).

30. This has been described in terms of the agency of the sign itself by Coward and Ellis, *Language and Materialism.*

31. Some of the earliest art historical discussions of this phenomenon emerged from the revisionist study of Mannerist art in the 1960s and 1970s: see Smyth, *Mannerism;* Shearman, *Mannerism;* and Summers, "Maniera and Movement," "Contrappposto," and *Michelangelo.*

32. A concept fundamentally indebted to Bakhtin: see Young, "Back to Bakhtin." The use of the term *liminal* is widely known from the writings of the anthropologist Victor Turner; see the Interleaf "Sound, Image, and Identity" by Brenda Romero.

33. Babcock, "Introduction," *The Reversible World.*

34. Babcock, "Introduction," 29, citing the work of her contributor James Peacock, distinguishes in this context symbolic reversal from instrumental views of the word, which reduce "all forms to mere means toward the ultimate end."

35. Morgan, *Visual Piety,* 50–51. From the perspective of psychologists such as Mihály Csikszentmihályi and sociologists such as Peter Berger and Thomas Luckman, on whom Morgan draws for his discussion of the maintenance of identity through images, material things assert our identities and maintain them in an "ever present flux of sensation and mental activity." Morgan anchors his argument in Bourdieu's account of the relationship between mental structures and practice in the world of objects: both the mind and the world are constructed according to the same structures. The popular aesthetic of visual culture often merges representation and object in order to experience as real what one has imagined.

36. Csikszentmihályi and Rochberg-Halton, *The Meaning of Things.*

37. Bourdieu, *Outline,* 79; 23, building on the work of Saus-

sure, compares his conception of schemes to Riegl's *Kunst-wollen* and Panofsky's iconology, and treats the sensible properties of the work of art, together with the affective experiences it arouses, as cultural symptoms that yield their full meaning when the viewer is armed with the cultural cipher the artist engaged in his work: the true medium of communication between two subjects is the structure of objective relations making possible both the production and the deciphering of discourse.

38. Bourdieu, "The Historical Genesis of Pure Aesthetic," 205, speaking of the entire set of agents engaged in the field of production (of the object in its materiality). And further, see Bourdieu, *The Rules of Art.*

39. Bourdieu, *Outline,* 163–64.

40. Bourdieu, *Outline,* 164–66.

41. Gombrich, *Art and Illusion.* After his initial formulation of "schema and correction" in 1960 to consider the culturally determined aspects of style, Gombrich's then new emphasis led to sustained debate over which aspects of an artist's process of perception (i.e., "matching") are "natural" (i.e., biological, hardwired) and which are determined by social custom.

42. For subsequent discussion of Gombrich's idea of a "schema," see Carrier, "Perspective as a Convention"; Kemp, "Seeing and Signs"; Summers, "Real Metaphor."

43. Bourdieu, *Outline of a Theory,* 1, 23.

44. Bourdieu, *Outline of a Theory,* 178, part of his discussion of institutionalized "misrecognition."

45. Bourdieu, *Outline of a Theory,* 163ff., part of his discussion of seeing the cultural as natural.

46. Bourdieu, *Outline of a Theory,* 168; I am indebted to Morgan in *Visual Piety,* 4–5, for discussing the possibility of many coexistent forms of visual piety.

47. García Canclini, *Hybrid Cultures.*

48. García Canclini, *Hybrid Cultures,* 204.

49. The movement within the "in-between . . . constitutes a zone of proximity . . . carrying one into the proximity of the other." Bhabha, *Front Lines,* 439, citing Deleuze and Guattari, *A Thousand Plateaus,* 291, 293. Bhabha, 436–37, citing Etienne Balibar, describes the ensuing "process of negotiation between claims" as a "multiple universal" that "leads us to a postontological, performative condition. It is not what minority is, but what minority does, or what is done in its name, that is of political and cultural significance."

50. Bell, *Ritual Theory,* argues that the distinction between theory and practice itself is due to categories we impose on the subject matter of cultural anthropology and, consequently, this framework tells us more about our own mental habits than it does about the cultures it was meant to elucidate.

51. Preziosi, *Semiotics of the Built Environment,* 3.

52. Bal and Bryson, "Semiotics and Art History," 175–76, noting this theoretical advantage with respect to interdisciplinary study.

53. Amin, *Eurocentrism,* especially 85–117. I have discussed this at greater length in Farago, *Reframing the Renaissance,* intro., especially 3–6.

54. See Steele and Rivera, *Penitente Self-Government,* 3–11, citing earlier scholarship by Dorothy Woodward, Marta Weigle, and others. Images are, moreover, central to this history of struggle. Therefore, historians are unjustified in taking up the position of the Church, whether intentionally or only inadvertently, above all because the Church has a vested interest in the outcome of the conflict. In reality, even the Church has never been able to agree on a position.

55. Brown, *The Cult of Saints.*

56. First proposed by Elsie Clews Parsons, who thought that kiva paintings were dependent on saints' images and doubted that masks predated European contact, until indisputably pre-Hispanic kiva paintings were explored at Awatovi, Pottery Mound, and elsewhere. For a current review of the arguments, see Schaafsma, "Pueblo Ceremonialism." Schaafsma begins with the observation that the documents indicate a real break with the past from c. 1610–39, when the pueblos were effectively converted to Catholicism essentially in the manner described by Benavides (1630 and 1634). The Jesuit missions in Sinaloa and Sonora in the eighteenth century used similar conversion techniques (see Hu-DeHart, *Missionaries,* cited by Schaafsma, 132). Also there is evidence for major population dislocations and mixing of Pueblo peoples from c. 1670–1706 (i.e., in the period including the resettlement that is the subject of Esquibel's Chap. 4 here). These changes mean that the Pueblo cultures after c. 1790 may have been significantly different from those existing before 1598 (p. 122; and cf. p. 132). The *katsina* cult strongly suppressed by the Spanish missionaries after c. 1610 was revived in the 1660s (the ceremonies revived at the direction of Governor Don Bernardo López de Mendizábal are well documented: see F. G. Anderson, "The Kachina Cult" and "Early Documentary Material"). *Katsina mitotes* or ceremonies revived during and after the interregnum period of the 1680–96 Pueblo Revolt were certainly altered by these traumatic events, but that does not mean that the *katsina* cults existed because of the introduction of Christianity, as Parsons argued in 1928 and 1930. The documentation that negates Parsons's hypothesis, excerpted by Schaafsma, appears in records of the Inquisition or "Holy Office" between 1660 and 1664, relating to the trials of Governor Mendizábal and the *alcalde mayor* of Las Salinas Pueblo (see Anderson as above; also Hackett, *Historical Docu-*

ments, 152, as cited by Schaafsma, 125). Schaafsma, 136, concludes with the suggestion that the revival of *katsina* ceremonies in the 1660s was made possible by the maintenance of old ceremonies by people living outside the pueblos, some of whom might have left visual evidence at secluded rock art locations near Abo, Tenabó, and Tajique, although this would require further research. See further discussion here in Farago, Chap. 10.

57. Although their methodologies and epistemological assumptions differ from one another and from this study, here I mention a few exemplary scholars whose works are cited in the Consolidated Bibliography: Karen Brown, Robert Orsi, Robert Farris Thompson, and Thomas Tweed,

58. Leroi-Gourhan, cited in Hodder, *Symbolic and Structural Archaeology,* intro., 7.

59. See discussion here in Chap. 10, "Transforming Images."

60. Hodder, "Post-Modernism, Post-Structuralism, and Post-Processual Archaeology," in Hodder, *The Meaning of Things,* 64–78; and Tilley, "Interpreting Material Culture," ibid., 185–94.

61. Rodríguez, *The Matachines Dance;* Ortiz, *The Tewa World.* Ortiz paid dearly for his study—even as an insider he was heavily criticized for revealing esoteric knowledge.

62. Ortiz, *The Tewa World,* 17–28.

63. First the Spanish, later the Mexican, and finally the U.S. government opposed the religious practices of the local population, destroying sacred material artifacts, and later forcing the Pueblos and grassroots *Penitentes* into secrecy. Under U.S. control, the federal government tried to assimilate Native Americans into the cultural mainstream by sending children of the reservations to eastern boarding schools, prohibiting native languages and Spanish in the public schools, and perpetuating other cruel forms of social oppression, such as economic exploitation and substandard health care. For Native American perspectives on New Mexican and U.S. history, see Sando, *Pueblo Nations,* and Deloria, *Custer Died for Your Sins.* While there is nothing new about this argument, most of the evidence is buried in individual case studies; for a synthetic view, argued on the basis of extensive historical data, that does not neglect the centralizing effort of the Church in Rome, see G. Bailey, *Art on the Jesuit Missions.*

64. Foucault, *The Archaeology of Knowledge,* 115: "not the speaking consciousness, not the author of the formulation, but a position that may be filled in certain conditions by various individuals."

65. The following summary is based on Coward and Ellis, *Language and Materialism,* 3–6, who write: "The lesson of this development of structuralism was that man is to be understood as constructed by the symbol and not as the point of origin of symbolism." And this means that the notion of the individual as embodying some ideal pre-given essence is not possible. It follows that an analysis is needed of the process by which fixed relations of predication are produced.

66. Roland Barthes, *S/Z,* cited in Coward and Ellis, *Language and Materialism,* 6.

67. Preziosi, in "The Art of Art History," makes a similar point with respect to the concept of museums, where works of "fine art," individually and collectively, represent entire cultures, epochs, peoples, and so on.

68. Coward and Ellis, *Language and Materialism,* 29, discussing Barthes, *Système de la mode* (1967), as "eventually show[ing] how both denotation and connotation are inseparable in the functioning of the system of fashion."

69. Barthes, *Writing Degree Zero,* is discussed by Coward and Ellis, *Language and Materialism,* 40, in this connection. See also H. White, *The Content of Form* and *The Question of Style.* Anthropologists have spent considerable energy devising methods to take into consideration native formal categories of viewing and making patterns; their studies sensitize us to the cultural specificity of any practice of formal analysis. The issues are relevant but further discussion lies outside the scope of this work, which is devoted to the social construction of the visual image, not the formal construction of patterns. See the excellent historiographical and theoretical overview in Washburn, *Style, Classification and Ethnicity,* 6–16.

Chapter 3

1. While we acknowledge the limitations of these Eurocentric stylistic terms, they are used here merely as convenient labels to discuss the transmission and selection or rejection of motifs. See Wilder and Breitenbach, *Santos;* Shalkop, *Wooden Saints;* Mills, *People of the Saints;* Espinosa, *Saints in the Valleys;* Wroth, *Christian Images* and *Images of Penance;* Steele, *Santos and Saints.* Although she was drawn to New Mexican *santos* originally because of their similarities to Romanesque art, Boyd soon acknowledged, but never explored in detail, their close ties to the Baroque art of Spain and Mexico. See Boyd, *Popular Arts,* and Pierce, foreword to the 1998 reprint of Boyd's *Saints and Saint Makers.* Other authors who acknowledged, but explored only minimally, the connections to the Baroque art of Spain and Mexico include Mather (*Colonial Frontiers*) and Wroth.

2. For some discussions of this, see Peterson, *Paradise Garden Murals;* Reyes-Valerio, *Arte Indocristiano;* Gruzinski, "Images and Cultural *Mestizaje*"; Edgerton, *Theaters of Conversion;* and Mundy, *Mapping of New Spain.*

3. Twitchell, *Spanish Archives of New Mexico.*

4. D. Weber, *Spanish Frontier;* Mather, *Colonial Frontiers;* and Palmer, *El Camino Real I, El Camino Real II.*

5. For a discussion of the bias against the art of Spain by European and American art historians since the Renaissance, see McKim-Smith, "Spanish Polychrome Sculpture."

6. For examples of early overviews in English that focus primarily on architecture but cover painting and sculpture at least minimally, see Kubler and Soria, *Art and Architecture in Spain and Portugal and Their American Dominions;* Kelemen, *Baroque and Rococo in Latin America;* and, for Mexico, Toussaint, *Colonial Art in Mexico,* originally published in Spanish in 1949 and translated into English by Elizabeth Wilder Weismann in 1967.

7. For discussions of this topic throughout, see particularly Hecht, "Creole Identity" and "The Liberation of Viceregal Architecture"; and Burke, "A Mexican Artistic Consciousness" and "Painting: The Eighteenth-Century Mexican School," all in *Mexico: Splendors of Thirty Centuries.* Also see Fane et al., *Converging Cultures,* particularly Umberger, "The Monarchia Indiana," 46–58, for an example of the inclusion of pre-Hispanic imagery in a seventeenth-century Baroque screen. Most recently, see Donna Pierce, Rogelia Ruiz Gomar, and Clara Bargellini, *Painting a New World: Mexican Art and Life, 1521–1821* (Denver: Denver Art Museum, 2004).

8. This style is often referred to as Churrigueresque after the Churriguera brothers of Spain. Since they never traveled to Mexico and used the key elements *(estípite* column, C-scrolls, and so on) of the Mexican version of the style only minimally, I prefer to use the term late Mexican Baroque.

9. E. Adams, *Bishop Tamarón's Visitation.* Also see Adams and Chávez, *Missions of New Mexico in 1776.* For detailed discussions of the colonial architecture of New Mexico see Kubler, *Religious Architecture of New Mexico;* and Kessell, *Missions of New Mexico Since 1776.*

10. For Taxco, see Vargas Lugo, *La iglesia de Santa Prisca de Taxco.* Also see Tovar de Teresa, *México barroco.*

11. For a recent discussion of the style of the Laguna *Santero,* see Kornegay, "Altar Screens of an Anonymous Artist." Also see Bol, "Anonymous Artist of Laguna."

12. J. A. Ceán Bermúdez, *Descripción artística de la catedral de Sevilla* (Seville, 1804), as quoted in Kubler and Soria, *Art and Architecture of Spain and Portugal,* 159.

13. Ruiz Gomar, "Capilla de los reyes."

14. Baird, "Eighteenth-Century Retables," "Ornamental Niche-Pilaster," and "Style in Eighteenth-Century Mexico."

15. See my Interleaf "The Life of an Artist . . . Miera y Pacheco."

16. Pierce and Snow, "A Harp for Playing."

17. Fisher, "Colcha Embroidery." Also see Archuleta-Sagel, "Textiles."

18. Mudge, *Chinese Export Porcelain.*

19. Pierce, "Ceramics," in *Splendors of Mexico,* 457–80; and Pierce, "Ceramics," in Palmer and Pierce, *Cambios,* 132–39.

20. C. Snow, "Brief History of the Palace."

21. Leatham Smith, "Santuario de Guadalupe."

22. For discussions of Baroque painting and sculpture in Mexico see Bantel and Burke, *Spain and New Spain;* Burke, *Pintura y escultura en Nueva España;* Tovar de Teresa, *México barroco; Splendors of Mexico;* Pierce, Ruiz Gomar, and Bargellini, *Paining a New World.*

Interleaf: Possible Political Allusions in Some New Mexican Santos

1. Four of these are in the collection of the Taylor Museum at Colorado Springs (TM 310, 510, 538, 937), with TM 510 reproduced in Wroth, *Christian Images,* pl. 122. Two are in the collection of the Museum of International Folk Art, with one reproduced in Boyd, *Popular Arts,* 400. One is in the Museum of Spanish Colonial Art, collection of the Spanish Colonial Arts Society in Santa Fe (1976–6), and another in the Alfred I. Barton collection, illustrated in Boyd, *Saints and Saint Makers,* 1951, no. 3.

2. Wroth, *Christian Images,* 148.

3. Examples of Spanish ceramics with images of Ferdinand VII can be found in the Museo de Cerámica in Talavera de la Reina, Spain, the Museu de Cerámica in Barcelona, and the Museo de Artes Decorativas in Madrid. Ceramic examples from Mexico with images or references to Fernando VII can be seen in *Talavera Poblana* (Mexico City: Banamex, 1979), pls. 44, 45, 103. The leggings or *botas* are in the collection of the Museum of International Folk Art, (FA.70.37–16). (See the excellent unpublished catalog notes on this piece produced by Patricia E. Sawin in 1986.)

4. These two are Taylor Museum (TM 937) and the one in the Barton collection.

5. For information on this issue see D. Weber, *Spanish Frontier.*

Chapter 4

1. McWilliams, *North from Mexico,* 63; Steele, *Santos and Saints,* 2.

2. One of the best studies is by Frances Swadesh, *Los Primeros Pobladores;* on terminology, see the excellent analysis of inconsistencies by Bustamante, "'The Matter was Never Resolved.'"

3. In this chapter, the term *casta* denotes ethnic categorization as developed and used in the Spanish society of the New World during the colonial era. For additional information specific to eighteenth-century New Mexico, consult Bustamante, "'The Matter Was Never Resolved.'" Bustamante mentions that there are no extant census records of seventeenth-century New Mexico to provide

ethnic identities of the frontier population. However, *casta* designations for the period 1600–1680 can be found in various archival documents, particularly those of the Inquisition. A key source consulted by Bustamante was León, *Las castas de México colonial.* It is important to note that unions between Africans and Indians occurred much more frequently than unions between Spaniards and Africans. In Mexico, the offspring of Africans and Indians were referred to as *mulatos/mulatas,* whereas the term *mulato blanco/mulata blanca* referred to the offspring of Africans and Spaniards. In a letter to King Phillip II dated January 9, 1574, Mexico City, Don Martín Enríquez de Almansa, viceroy of New Spain, wrote the following: *las indias prefieren casar con negros, y estos se hacen para que sus hijos sean libres* [the Indian women prefer to marry with African men, and these men marry as such so that their children will be free]. Martínez, *Pasajeros de Indias,* 205. An example for seventeenth-century New Mexico is found in the testimony of Antonio, identified as *mulato de nacion Piro* [a mulatto of the Piro Indian nation], *Spanish Archives of New Mexico,* Series II (*SANM II),* Roll 3, fr. 262. For an interesting treatment regarding *negros* and *mulatos* in the colonial society of New Spain, as well as for a good bibliography on Africans and their contribution to Spanish society in the Americas, see Martínez, *Pasajeros de Indias,* 193–212.

4. Gutiérrez, *When Jesus Came,* 106.

5. The intention of the Spanish crown to bestow "the privileges of nobles" upon the new settlers of New Mexico is reflected in a statement made by Dr. Juan de Escalante y Mendoza, in his report to the viceroy of New Spain dated November 21, 1692. Escalante y Mendoza wrote, "He [Vargas] will also have proclaimed in Parral, Sonora, Sinaloa, and wherever it seems necessary that all the individuals and families who may want to go to the settlement referred to will, as first settlers, be given the privileges of nobles, and lots and land will be distributed among them, if, by this method, it would be easier for some to go." Kessell and Hendricks, *By Force of Arms,* 470. In addition, when the descendants of the original New Mexico colonizers returned to Santa Fe with Governor Don Diego de Vargas in 1693 after thirteen years of exile, their rights and privileges as hidalgos were reconfirmed. On September 20, 1693, Vargas wrote the following statements as he made preparations for the resettlement of New Mexico: "These settlers originated in and are natives of this kingdom. By virtue of the directive, I summon, demand, and set them a time limit, so that they will obey and fulfill it as his majesty's loyal vassals, going to settle the kingdom. . . . In that kingdom, I shall give them the lands, homesites, and haciendas they had and left at the time of the uprising of

the nations of that kingdom. I shall also declare the privileges, honors, and distinctions that as conquerors his majesty, the king, our lord (may God keep him), has conceded and granted them. In his royal name, I do so declare in addition to their noble status, which they will enjoy as hidalgos, according to the rights and privileges of the king of Castile, of the most serene former kings, and confirmed by the present king, our lord Carlos II." Kessell, Hendricks, and Dodge, *Royal Crown Restored,* 375.

6. *SANM II,* Roll 3, fr, 344, no. 169 (1712 tool distribution at Santa Cruz).

7. Unfortunately, there is not enough documentation about the percentage of the population with family ties in both Spanish and Pueblo Indian communities in seventeenth-century New Mexico. The most valuable records to assist in this determination, those of baptism and marriage, did not survive the Pueblo Revolt of 1680.

8. Kessell, Hendricks, and Dodge, *Royal Crown Restored,* 431, 447, 458, and 529.

9. Kessell, Hendricks, and Dodge, *Royal Crown Restored,* 520, 522, 523, 526–27.

10. Kessell and Hendricks, *By Force of Arms,* 461.

11. Kessell, Hendricks, and Dodge, *Royal Crown Restored,* 109.

12. Kessell and Hendricks, *By Force of Arms,* 474–75; Kessell, Hendricks, and Dodge, *Royal Crown Restored,* 350.

13. Kessell, Hendricks, and Dodge, *Royal Crown Restored,* 356.

14. Kessell, Hendricks, and Dodge, *Royal Crown Restored,* 355.

15. Kessell, Hendricks, and Dodge, *Royal Crown Restored,* 20.

16. Kessell, Hendricks, and Dodge, *Royal Crown Restored,* 122.

17. Espinosa, *Crusaders of the Rio Grande,* 188.

18. Colligan, *Juan Páez Hurtado Expedition,* 14–16.

19. Colligan, *Juan Páez Hurtado Expedition,* 16–17, 24–25.

20. *SANM II,* no. 65, Roll 3, frs. 50–80.

21. The male New Mexican was Diego González, who was married to María de Benavides. Her family had come from the town of Nombre de Dios, Nueva Vizcaya, in 1693. The other 14 couples represent native New Mexican females who married males, mainly soldiers, who originated from outside New Mexico: Ana María Montoya and Captain Diego Arias de Quiros, native of Asiera in Asturias, Spain; Antonia Luján and José de Quintana, native of Mexico City; Ana Romero and Juan de Villalpando, soldier, native of La Villa de León, Spain; María de Hinojos and Carlos de Villavicencio, soldier; Sebastiana Martín Serrano and Pedro López Gallardo, soldier, native of Querétaro, Nueva España; Josefa Tafoya and Juan de Tafoya Altamirano, soldier, native of El Real de Talpujagua, Nueva España; María Martín and Tomás de Bejarano, soldier; Ana María López and Juan Cristóbal de Losada, soldier, native of Córdoba, Spain; Rosa Rodríguez and Juan de Estrada, soldier; Juana Montoya and Don

Francisco Palomino Rendón, soldier, native of Puerto de Santa María, Spain; María de Valencia and José de Contreras, soldier, native of San Luís Potosí, Nueva España; María Baca and José Vasquez de Lara, soldier, native of Villa de los Lagos, Nueva Galicia; Margarita Gómez Robledo and Captain Don Jacinto Peláez, native of Villanueva, Asturias, Spain; and Doña María de Zapata Telles Jirón and Diego de Medina, soldier, native of Durango. *SANM II,* Roll 3, no. 65, frs. 51, 53, 54, 55, 59, 67, 70 and 71, family nos. 1, 16, 19, 20, 25, 26, 37, 94, 160, 162, 163, 166, 169, 185, and 198; Chávez, *Origins of New Mexico Families,* 134, 147, 165, 173, 219, 228, 255, 256, 262, 306, 312, 366, 368.

22. Examples include unions between the progeny of the following pre-Revolt families (listed first) and post-Revolt families: Anaya-Espíndola, Apodaca-Moya, Archuleta-Quintana, Baca-Aragón, Baca-Ortiz, Domínguez-Jirón, Gallegos-Silva, González-Sena, Herrera-Jaramillo Negrete, Luján-Abeyta, Mestas-Cortés del Castillo, Márquez-Valdés, Montoya-Armijo, Quintana-Martín Sánchez-Rodarte, and Trujillo-Archibeque. Chávez, *Origins of New Mexico Families,* 119, 125, 127, 129, 133, 136, 141, 179, 199, 201, 247, 281, and 302.

23. *SANM II,* Roll 3, no. 65, frs. 51, 54, and 67, family nos. 1, 19, 25, 26, and 169.

24. A list of 19 Mexican Indian families who had lived at Santa Fe before the Pueblo Revolt was made under the direction of Governor Vargas in early 1693. Five of these households appear on the list of *pobladores* who received livestock in May 1697: no. 18 Miguel Morán with his wife and son; no. 32 Cristóbal Apodaca with his wife and two children; no. 76 Magdalena de Ogama (a.k.a. Ogano), a widow with two daughters and two granddaughters; no. 82 Josefa de Ortega, a widow with a son and two daughters; and no. 90 Agueda Morón, widow with two sons and two grandchildren. See *SANM II,* Roll 3, no. 65, frs. 54, 55, 59, 60, and 61. In addition, there are two men with the surname of Pasote, father and son, who appear in the list of livestock recipients who were also Mexican Indians: no. 47 Juan de Dios Pasote with his wife, and no. 48 Miguel Pasote with his wife and a daughter. Juan de Dios Pasote was born circa 1644 and was known as Juan de Dios called Pasote. His wife in 1697 was a woman named Juana Jirón. His son, Miguel de la Cruz, was born circa 1668–69, and Miguel's wife in 1697 was a woman named Juana de la Cruz. See *SANM II,* Roll 3, no. 65, fr. 57; and Chávez, *New Mexico Roots, Ltd.,* 1557–58 (DM 1694, February 12, no. 1, Santa Fe).

25. Captain Hernán Martín Serrano, b. c. 1607 San Gabriel, and a resident of Santa Fe for many decades, appears in many records of seventeenth-century New Mexico as a witness in numerous cases. He identified himself as *mestizo,* indicating Spanish and Indian parentage. Archivo General de la Nación (AGN), México, Inquisición, t. 304, fr. 181. Martín Serrano was referred to in 1626 as *el mozo,* the "young one," and was named as Hernán Martín, the son of Doña Inéz, *india mui ladina que se trata como española de nacion tana* [an acculturated Tano Indian woman whom they treat as a Spanish woman]; AGN, México, Inquisición, t. 356, fr. 314, May 29, 1626, Santa Fe. In addition, there was testimony given in 1777 that indicated that Luis Martín Serrano was also called "Tigua" because of his Tigua blood, but at this late date the validity of this statement may very well be inaccurate. Yet in 1696 a son of Captain Luis Martín Serrano, *mestizo,* and Antonia de Miranda, *castiza,* was married at Santa Fe. This son, Antonio Martín Serrano, was identified as *mestizo,* native of New Mexico and widowed of Inés de Ledesma, *mestiza.* Antonio's prospective bride was Josefa Domínguez, born c. 1680, *mestiza,* native of New Mexico, daughter of Domingo Luján and Juana Domínguez, *mestizos,* natives of New Mexico. See Chávez, *New Mexico Roots, Ltd.,* 1094–95, DM 1696 (no. 16), Santa Fe.

26. In November 1662, Captain Juan Lucero de Godoy, secretary of the governor, and his sister Doña Catalina de Zamora were each identified by the caste designation of *castizo,* a term denoting a parentage of *español* (Spaniard) and *mestizo* (mixed Spaniard and Indian). In the same record, their father, Maese de Campo Pedro Lucero de Godoy, was identified as *español.* The conclusion based on this information is that the wife of Pedro Lucero de Godoy, Petronila de Zamora, was a *mestiza.* Petronila de Zamora was a daughter of Bartolomé de Montoya (a native of Cantillana, Spain) and María de Zamora. The inference here is that María de Zamora was an Indian woman. She and Montoya came with their young family to New Mexico in December 1600. AGN, México, Inquisición, t.587, ff. 385 and 387. Chávez, *Origins of New Mexico Families,* 59 and 77.

27. Snow, *New Mexico's First Colonists,* 48–66. See also Hammond and Rey, *Don Juan de Oñate.*

28. Hammond and Rey, *Don Juan de Oñate,* 24.

29. Kessell, *Kiva, Cross, and Crown,* 99.

30. In April 1663, a list of people who had provided testimony in the case of the Inquisition against Governor López de Mendízabal was drawn up. In addition to listing names, the caste designations of these individuals were recorded. The following members of the Anaya Almazán, Griego, de la Cruz, Martín Serrano, and Montoya families were accounted for: Captain Francisco de Anaya (progenitor of the Anaya family of New Mexico), *español,* father of Cristóbal de Anaya, *castizo;* Graciana de la Cruz (Griego),

mestiza; María de la Cruz Alemán (Griego), *mestiza;* Captain Diego González Bernal, *castizo;* Captain Juan Griego, *mestizo;* Captain Andrés López Zambrano, *castizo;* Captain Juan Lucero de Godoy, *castizo;* Captain Hernán Martín, *mestizo;* Doña Catalina de Zamora (Lucero), *castiza.* AGN, México, Inquisición, t.587, ff. 375–89; AGN, Mexico, Inquisición, t. 304, f. 184. AGN, México, Inquisición, Concursos de Peñalosa, leg. 1, no. 9, f. 21, has a reference to *Capitán Juan Griego vecino de Santa Fe y emcomendero.* For intermarriages with *encomendero* families, see Chávez, *Origins of New Mexico Families,* 3–4, 23–24, 40, 41–42, 58–61, 71–73, 77–79.

31. Beatriz de los Ángeles and Juan de la Cruz, *el Catalan,* were the parents of at least two children: Pedro de la Cruz, *mestizo* and *encomendero;* and Juana de la Cruz, *mestiza* and wife of Juan Griego, *mestizo* and *encomendero.* AGN, México, Inquisición, t. 304, ff. 186 and 190; Chávez, *Origins of New Mexico Families,* 23–24.

32. AGN, México, Inquisición, t.587, f. 387.

33. In a testimony by María de Villafuerte at Santa Fe on May 29, 1626, she gave her age as forty (b. c. 1586) and her birthplace as the Pueblo of Guatitlan. She named her husband as Francisco López, *español* and a native of Jérez, who was deceased by the date of her testimony. The daughter of this couple, Juana López, became the wife of Francisco de Anaya Almazán, *encomendero* and *español.* In AGN, México, Inquisición, t. 356, f. 310, and t. 582, exp. 2, f. 309; Chávez, *Origins of New Mexico Families,* 3.

34. AGN, México, Inquisición, t. 304, f. 189, and t. 356, f. 312.

35. AGN, México, Inquisición, t. 587, ff. 375, 386, and 387, t. 593, f. 96; Hackett, *Historical Documents Relating to New Mexico,* 3:272.

36. Francisco "Pancho" Balón, *indio méxicano* (Mexican Indian) and a blacksmith by trade, resided in Santa Fe before his death in 1628. He was married to Inés, *india ladina* (an Indian woman who spoke Spanish well and was acculturated to Spanish customs) and a *criada* (an aide or servant) of Doña Catalina Pérez de Bustillo, the wife of Capitan Alonso de Varela. AGN, México, Inquisición, t. 304, f. 187, t. 372, f. 8, and t. 356, f. 308. Juan Chamiso, *indio méxicano,* with 20 persons (wife, children, and grandchildren, and servants), passed muster at El Paso del Norte on October 2, 1680, as a refugee of New Mexico. AGN, México, Provincias Internas, t. 37, f. 112.

37. See works by Leslie A. White, Jesse Walters Fewkes, and Philip Deloria, as well as those by Alfonso Ortiz, Joe Sando, and Edward Dozier, natives of the Pueblos who became anthropologists and historians.

38. AGN, México, Inquisition, Concurso de Peñalosa, leg. 1, no. 2, f. 233ff.

39. On October 21, 1661, at Santa Fe, Antonio González, acting in his role as *protector de indios,* filed a petition with specific details about the claims of the Indian painters, *pintores,* who were seeking compensation for work done under the direction of Governor Don Diego López de Mendízabal. The petition begins as follows: *Antº Gonzalez en nombre de diez yndios de nacion Teguas y tagnos Pintores . . . hecho que los le pintaron gran cantidiad de antas los qualez de ybierno y Berano Pintaron dhos yndios como dho es en todo su govierno* [referring to the tenure of López de Mendizábal] [Antonio González in the name of ten Indian Painters of the Tewa and Tano nations . . . that they painted a large quantity of elkskins, having been made in the spring and summer, the said Indians painted as is said, in all his time of governing]. González then proceeded to name ten Indian *pintores* and the compensation requested for their work:

> Nicolás of Nambé, *Pintor Mayor,* five pesos in the clothing of the land *(roba de tierra).*
> Antonio Hondoguaque of Cuyamungue, three pesos in the clothing of the land.
> Diego of Nambé, four pesos in the clothing of the land.
> Two Indians from the Pueblo of San Lázaro, Agustín and Miguel, two pesos each in two cotton blankets *(mantas de algadón).*
> Bartolomé and José of Galisteo, two pesos each, both in two cotton blankets and two of wool.
> Juan and Diego of the Pueblo of San Juan, two pesos each, both in two cotton blankets and two of wool.
> Alonso of the Pueblo of Tesuque, two pesos in two cotton blankets and two of wool.

González mentioned in the petition that *siendo asi que en trabajado continuo los dhs yndios en las dhs pinturas . . .* [as such, that the said Indians continued at work with the said paintings . . .]. In his response to this petition, Governor López de Mendizábal declared that *una anta pinta un indio cada dia* [each day one Indian painted one elkskin]. AGN, Tierras, t. 326, f. 418–19.

40. See note 34 above.

41. Hackett, *Historical Documents,* 3:284 (Declaration of Don Pedro Manso, December 10, 1665).

42. Simmons, *Witchcraft in the Southwest,* 19 and 21. For specific examples, see AGN, México, Inquisición, t. 372, f. 14–18, and t. 732, f. 14, regarding Juana de los Reyes and her sister Juana Sánchez, both identified as *mulatas;* and AGN, México, Inquisición, t. 304, ff. 186, 189, regarding Doña Beatris de los Ángeles, *india ladina* (an Indian woman who spoke Spanish well and was acculturated to Spanish customs) and *hechicera* (bewitcher, or someone who prepared potions), and her daughter Juana de la Cruz, *mestiza* and *hechicera.*

43. AGN, México, Inquisición, t. 467, ff. 343–53, San Gabriel, 1606: María de Zamora, *hechicera y bruja* (bewitcher and witch); Ana Ortiz, *hechicera* (bewitcher); and María, *mujer de Francisco López, hechicera* (bewitcher).

44. Kessell, Hendricks, and Dodge, *Royal Crown Restored,* 355.

45. Kessell, Hendricks, and Dodge, *Royal Crown Restored,* 373 and 381.

46. Colligan, "Vargas' 1693 Recruits."

47. Colligan, "Vargas' 1693 Recruits." *Coyote* was an imprecise term used during the Spanish colonial era to describe persons of mixed racial backgrounds who were one-quarter Spanish. These could be persons whose parentage was *meztizo* and *indio* or *mestizo* and *mulato* (African and Indian). *Morisco* most often was the *casta* designation for people who were half Spanish and half *mulato.* Bustamante, "The Matter Was Never Resolved," 144; León, *Las castas de México colonial,* 39–40.

48. The Tarascan Indian was Juana de la Cruz, born c. 1637. She was described as *india tarasca ladina,* a Tarascan Indian woman who spoke Spanish well, and was most likely well acculturated to Spanish customs. Recruited at Sombrerete, she came to New Mexico as a cook for the muleteers. Colligan, "Vargas' 1693 Recruits," 191.

49. *SANM II,* no. 65, fr. 65.

50. Chávez, *Origins of New Mexico Families,* 309–10.

51. Espinosa, *Crusaders of the Río Grande,* 124.

52. The craftsmen recruited at Mexico City who settled New Mexico were Gabriel de Ansures, cartwright, settler of Santa Cruz; Ignacio de Aragón, weaver, settler of Bernalillo and Albuquerque; Andrés de Betanzos, master stonemason and carpenter, settler of Santa Cruz; Diego de Betanzos, stonemason, settler of Santa Cruz; Andrés de Cárdenas, weaver, settler of Santa Cruz; Juan Cortés del Castillo, cobbler, settler of Santa Cruz; Juan Antonio de Esquibel, tailor, settler of Santa Fe; Miguel Garía de la Riva, silk weaver, settler of Santa Fe; Antonio de Isasi y Aguilera, tailor, settler of Santa Fe; José Jaramillo Negrete, brickmason, settler of Santa Cruz; Diego Jirón de Tejeda, weaver, settler of Santa Cruz; Nicolás Jirón de Tejeda, painter, settler of Santa Fe; Tomás Jirón de Tejeda, painter, settler of Santa Fe; Diego Márquez de Ayala, tailor, settler of Santa Fe; José Bernardo de Mascareñas, coppersmith, settler of Santa Fe; Simón de Molina, carpenter/cabinetmaker, settler of Santa Fe; Nicolás Moreno Trujillo, barber, settler of Santa Fe; Antonio de Moya, brickmason, settler of Santa Fe; José Núñez, tailor, settler of Santa Cruz; Nicolás Ortiz Ladrón de Guevara, weaver, settler of Santa Cruz and Santa Fe; Tomás Palomino, stonemason, settler of Santa Cruz; Francisco de Porras, weaver, settler of Santa Cruz; Antonio Rincón de Guemes, weaver, settler of Santa Fe; José Rodríguez, tailor, settler of Santa Fe; Manuel Rodríguez, tailor, settler of Santa Fe; Juan de Dios Sandoval Martínez, tailor, settler of Santa Fe and Santa Cruz; Antonio de Silva, blacksmith, settler of Santa Fe and Albuquerque; Manuel Vallejo González, master blacksmith, settler of Santa Cruz and Albuquerque. Kessell, Hendricks, and Dodge, *Royal Crown Restored,* 245–49, 293–95, 312–14.

53. Kessell, Hendricks, and Dodge, *Royal Crown Restored,* 353.

54. Esquibel and Colligan, *Spanish Recolonization of New Mexico,* 8; Church of Jesus Christ of Latter-day Saints, Genealogical Library, Sacramental Records of Asunción Church, Mexico City, Mexico: Marriages, 1688–1701 (microfilm no. 0035270).

55. Esquibel and Colligan, *Spanish Recolonization of New Mexico,* 10–14.

56. Esquibel and Colligan, *Spanish Recolonization of New Mexico,* 12–13.

57. Married April 5, 1682, Santa Catalina Martir Church, Mexico City, Juan de Gamboa, *castizo,* native of Puebla de los Ángeles, with María de Sepeda, orphan and native of Mexico City. LDS (microfilm no. 0036028).

58. Married August 31, 1670, Santa Vera Cruz Church, Mexico City, Simón de Molina, son of Don Tomás de Molina and Nicolasa de Castro, with Micaela de Medina, *castiza,* native and resident of Mexico city, daughter of Cristóbal Carballo and Ana Romero. LDS (microfilm no. 0035849).

59. Esquibel, *Remembrance/Recordación,* 10–11; Esquibel and Colligan, *Spanish Recolonization of New Mexico,* 14.

60. Espinosa, *Crusaders of the Río Grande,* 226.

61. *SANM II,* Roll 3, no. 65, fr. 62.

62. *SANM I,* no. 1076; Esquibel and Colligan, *Spanish Recolonization of New Mexico,* 134.

63. Colahan and Lomelí, "Miguel de Quintana."

64. The main works of Bartólome de Góngora include *El corrigidor sagaz: Abisos y documentos morales para los que lo fueren; Elogios seráficos,* a book of diverse poetic compositions in honor of Saint Francis; *Temple de la imortalidad,* a historical poem addressing the traditions and history of Spain; *Historia de la casa de Córdoba,* a genealogical dissertation written around 1630; *Selva de apolo,* a collection of miscellaneous sonnets and other poetry; and *Octava miravilla,* a highly regarded work in poetic form relating the history of New Spain. No immediate family connection can be found between Don Bartolomé de Góngora, a resident of Mexico City until his death in September 1659, and the Mexico City sophist of the latter half of the seventeenth century, Don Carlos de Sigüenza y Góngora. Esquibel and Colligan, *Spanish Recolonization of New Mexico,* 213–15.

65. Esquibel and Colligan, *Spanish Recolonization of New Mexico,* 258.

66. Colligan, *Juan Páez Hurtado Expedition,* 29–60.

67. Colligan, *Juan Páez Hurtado Expedition,* 71–76. It is worthwhile to note that the muster roll of the Páez Hurtado colonists recruited at Zacatecas and published by Clevy Lloyd Strout lists a number of fraudulent families, as Colligan so adeptly shows. Strout, "Resettlement of Santa Fe," 261–70.

68. *SANM II,* Roll 3, no. 65, frs. 63–65, family nos. 114–35.

69. *SANM II,* Roll 3, no. 65, frs. 75–80.

70. Colligan, *Juan Páez Hurtado Expedition,* 35, 37, 39–41, and 54.

71. *SANM I,* no. 22.

72. Chávez, *Origins of New Mexico Families,* 136.

73. Chávez, *Origins of New Mexico Families,* 136–38.

74. Esquibel and Colligan, *Spanish Recolonization of New Mexico,* 351–64.

75. Preston, Preston, and Esquibel, *Royal Road,* 155–57.

76. Chávez, *Origins of New Mexico Families,* 229–30; Pierce and Weigle, *Spanish New Mexico,* 1:31–32.

77. The 1790 census of the jurisdiction of Santa Cruz de la Cañada identifies Pedro Antonio Fresquís and his wife Antonia Micaela Medina as *mestizos.* His age was recorded as twenty-eight and her age as twenty-nine. They had five children in their household ranging in age from two to thirteen. Olmsted, *New Mexico Spanish and Mexican Colonial Censuses,* 83.

78. *Archives of the Archdiocese of Santa Fe* (AASF), Diligencias, Roll 70, fr. 45, DM 1824, September 28 (no. 130), Santa Cruz.

Chapter 5

1. Dictionaries consulted: *American Heritage Dictionary* 1997; *Webster's New Universal Unabridged,* 2d ed., 1983.

2. An interesting case of erroneous traditions is described by Hirschkind, "History," 311–42.

3. Hammond and Rey, *Don Juan de Oñate,* 150–68, 289–300, 548–85; on the desertions of 1601, ibid., 672–739, and Simmons, *Last Conquistador,* 164–68.

4. Kamen, *Inquisition and Society,* 1; Garate, *Basque Names,* 77–104; MacLachlan and Rodríguez, *Forging of the Cosmic Race,* 212; Tobias, *History of the Jews,* 7–21; Hordes, "Sephardic Legacy," 82–90; Gitlitz, *Secrecy and Deceit,* 55–58.

5. Hammond and Rey, *Don Juan Oñate,* 560–63; Chávez, *Origins of New Mexico Families,* 82.

6. Hammond and Rey, *Don Juan Oñate,* 623–69; Schroeder, "Querechos," 159–64; "Shifting for Survival," 295–96.

7. MacLachlan and Rodríguez, *Forging of the Cosmic Race,* 215–16; Lafaye, "Caste Society," 81–83; Boyd-Bowman, "Patterns of Spanish Emigration," 580–604.

8. MacLachlan and Rodríguez, *Forging of the Cosmic Race,* 196–97, 202.

9. Stern, "Gente de Color Quebrado," 188–89; Cope, *Limits of Racial Domination,* 9–26.

10. Netanyahu, *Origins of the Inquisition,* 3–216; Gitlitz, *Secrecy and Deceit,* 3–72.

11. Bustamante, in "The Matter Was Never Resolved," 143, cites Nicolás León's list, *Las castas del México colonial,* also published in *Artes de Mexico* 8 (summer 1990): 79; Leonard, *Baroque Times,* 37–52; McAlister, "Social Structure and Social Change," 349–70.

12. Katzew, *New World Orders,* 1–144; Sullivan, "A Visual Phenomenon," 85–86; Sánchez, "La Pintura," 21–88.

13. O'Crouley, *A Description,* 18–19.

14. Katzew, *New World Orders,* 13.

15. O'Crouley, *A Description,* 18–19.

16. Stern, "Gente de Color Quebrado," 185–205.

17. Leonard, *Baroque Times,* 37–52; MacLachlan and Rodríguez, *Forging of the Cosmic Race,* 199–201.

18. MacLachlan and Rodríguez, *Forging of the Cosmic Race,* 196.

19. Stern, "Social Marginality," 1–188, and "Gente de Color Quebrado," 185–205; Cope, *Limits of Racial Domination,* 161–65.

20. Stern, "Social Marginality," 95–188; Jones, *Los Paisanos,* 85, 90.

21. Cramaussel, "Ilegítimos," 405–38.

22. Esteva-Fabregat, *Mestizaje,* 83–110.

23. Powell, *Soldiers, Indians and Silver,* 137–38.

24. Hammond and Rey, *Don Juan Oñate,* 47, and *Rediscovery,* 5; Simmons, *Last Conquistador,* 58–59, 65.

25. Chávez, *Origins of New Mexico Families,* 1–336.

26. Hammond and Rey, *Don Juan Oñate,* 676, 770.

27. Chávez, *Origins of New Mexico Families,* xi.

28. Hammond and Rey, *Don Juan Oñate,* 29–34.

29. C. Snow, "Juan Martinez de Montoya," 5–8.

30. Scholes, "Supply Service," 93–115; Ivey, "Seventeenth-Century Mission Trade," 41–48.

31. Chávez, *Origins of New Mexico Families,* 1–114; Gutiérrez, *When Jesus Came,* 103; Hackett, *Revolt,* 1:94–142 (list of payments made to settlers, El Paso, September 22–October 16, 1681).

32. Benavides, *Memorial,* 22–23.

33. Gutiérrez, *When Jesus Came,* 102.

34. D. Snow, "A Note on Encomienda Economics," 347–57.

35. Simmons, "Tlascalans," 101–10; Gibson, *Tlaxcala in the Sixteenth Century,* 158–96; Sego, "Six Tlaxcalan Colonies"; Powell, *Mexico's Miguel Caldera,* 147–59; Twitchell, *Spanish Archives,* 1:36–37 and *Spanish Archives,* 2:306; Jones, *Pueblo Warriors,* 14–18, 22–23; Kessell, Hendricks, and Dodge, *Royal Crown Restored,* 33, 56–58; Hackett, *Revolt,* 1:138.

36. Kraemer, "Haciendas," 4–8; Hackett, *Historical Documents,* 106–15; Hackett, *Revolt,* 1:125.

37. Scholes, "Troublous Times," 139; Gutiérrez, *When Jesus Came,* 103.

38. Kraemer, "Haciendas," 6; Scholes, "Troublous Times," 140.

39. Hackett, *Revolt,* 1:134–53 and 2:32–86, 94–142, 190–201; Kessell, Hendricks, and Dodge, *Royal Crown Restored,* 426, 525; Espinosa, *Revolt of 1696,* 13; Chávez, "Pohé-Yemo's Representative," 85–126.

40. Leslie Byrd Simpson, in Chevalier, *Land and Society,* vi; Kessell, "Restoring Seventeenth-Century New Mexico," 46–54.

41. Hackett, *Historical Documents,* 299, 328 n.

42. Kessell and Hendricks, *By Force of Arms,* 119 n. 64; Kessell, Hendricks, and Dodge, *Royal Crown Restored,* 32–65; Hughes, *Beginnings of Spanish Settlement,* 303–14; Walz, "History of the El Paso Area."

43. Kessell, Hendricks, and Dodge, *Royal Crown Restored,* 469.

44. Kessell, Hendricks, and Dodge, *Royal Crown Restored,* 223–343; Bustamante, "The Matter Was Never Resolved," 146.

45. Colligan, *Juan Páez Hurtado Expedition,* 59–60. On the use of the term *coyote* in New Mexico, see Morfi, "Account of Disorders," 160 n. 10, and Bustamante, "The Matter Was Never Resolved," 144.

46. Hackett, *Revolt,* vols. 1 and 2; J. M. Espinosa, *Pueblo Indian Revolt of 1696* and *Crusaders,* 351–52.

47. Schroeder, "Pueblos Abandoned," 236–54; Hackett, *Historical Documents,* 372–78, 402–5.

48. Chávez, *Archives of the Archdiocese,* 19; Schroeder, "Shifting for Survival," 246.

49. Thomas, *After Coronado,* 16–22; Schroeder, "Shifting for Survival," 250.

50. Hackett, *Historical Documents,* 391–93.

51. Spicer, *Cycles of Conquest,* 210–14; Brugge, "Navajo Prehistory," 491–95; idem, "Navajo Archaeology," 256–57; Towner and Dean, "Questions and Problems," 4–5; McNitt, *Navajo Wars,* 3–25; Kent, *Navajo Weaving,* 7–10, 23–32; Amsden, *Navajo Weaving,* 125–30; Schroeder, "Querechos," 159–66.

52. Hackett, *Historical Documents,* 372–78.

53. Frank, "From Settler to Citizen," 413–23; Hackett, *Historical Documents,* 396–407; La Fora, *Frontiers of New Spain,* 81–92; Cutter, "Anonymous Statistical Report," 347–52; Jones, *Los Paisanos,* 123.

54. Hackett, *Historical Documents,* 402–6; Olmsted, *Spanish and Mexican Censuses,* 1–97, Rios-Bustamante, "New Mexico," 357–89.

55. Simmons, *Indian and Mission Affairs,* 11.

56. Hackett, *Historical Documents,* 399; Twitchell, *Spanish Archives,* 2:233–34; Swadesh, *Los Primeros Pobladores,* 33–41; Poling-Kempes, *Valley,* 31–52; Noyes, *Los Comanches,* 25.

57. Hackett, *Historical Documents,* 464.

58. Jones, *Pueblo Warriors,* 69–109; Beck, *New Mexico,* 89–100; Hall, *Social Change,* 105–9.

59. John, *Storms,* 226–57, 304–35, 465–86; Brugge, "Navajo Prehistory," 491–94; Kavanagh, *Comanche Political History,* 73–75; Kessell, *Kiva, Cross, and Crown,* 357.

60. Norris, "Breakdown of Franciscan Hegemony," 260; Chávez, *Archives,* 203, 249; Hackett, *Historical Documents,* 41, 391, 414, 422; Swadesh, *Los Primeros Pobladores,* 33–35.

61. Simmons, *Albuquerque,* 91; Candelaria, "Noticias," 274–97.

62. Bustamante, "The Matter Was Never Resolved," 154. Also see note 45 above.

63. Morfi, "Account of Disorders," 147.

64. Adams and Chávez, *Missions,* 255; Weber, *Taos Trappers,* 32–50.

65. Foote and Schackel, "Indian Women," 25–27; Lange, *Cochiti,* 415.

66. Kessell, *Kiva, Cross, and Crown,* 372; a recent detailed analysis of population decline at Pecos Pueblo is Levine and LaBauve, "Examining the Complexity," 75–110.

67. Kessell, *Kiva, Cross, and Crown,* 380.

68. Hackett, *Historical Documents,* 414, 464; Worcester, "Navajo," 114.

69. Schroeder, "Pueblos Abandoned," 236–54; Simmons, "New Mexico's Smallpox Epidemic," 319–26.

70. Candelaria, "Noticias," 280; Chávez, "Genízaros," 198–200. Morfi, "Account of Disorders," 156–59; Gutiérrez, *When Jesus Came,* 155; Cutter, "Anonymous Statistical Report," 350.

71. Chávez, *Origins of New Mexico Families,* 119–314.

72. Frank, "From Settler to Citizen," 166–210; idem, "The Changing Pueblo Pottery Tradition," 282–321.

73. Archibald, "Acculturation and Assimilation," 207–10; Bailey, *Indian Slave Trade;* Jones, "Rescue and Ransom," 129–48.

74. Hackett, *Historical Documents,* 401; Chávez, "Genízaros," 198–99.

75. Hackett, *Historical Documents,* 382; Reeve, "The Navajo-Spanish Peace," 9–40.

76. Brugge, *Navajos in the Church Records,* 17–32.

77. Gutiérrez, *When Jesus Came,* 171; Schroeder, "Rio Grande Ethnohistory," 62.

78. Hackett, *Historical Documents,* 401–2; Adams and Chávez, *Missions of New Mexico,* 126; Stern, "Social Marginality," 58–94; Morfi, "Account of Disorders," 156; Chávez, "Comments Concerning Tomé," 68–74.

79. Chávez, "Genízaros," 198–200; Hackett, *Historical Documents,* 401–2; Kenner, *History of New Mexican–Plains Indian Relations,* 63–64.

80. Adams and Chávez, *Missions of New Mexico,* 259; Twitchell, *Spanish Archives* 2:258, 406, 412, 526.

81. Olmsted, *Spanish and Mexican Censuses;* Cutter, "Anonymous Statistical Report," 347–52; Adams, "Tamarón's Visitation," 205; Archibald, "Cañon de Carnué," 313–28.

82. Cutter, "Anonymous Statistical Report," 347–52. Archibald, "Acculturation," 208.

83. Bustamante, "The Matter Was Never Resolved," 157–58; Kessell, *Kiva, Cross, and Crown,* 416–17.

84. Bustamante, "The Matter Was Never Resolved," 159.

85. Olmsted, *Spanish and Mexican Censuses, 1750, 1790;* Archibald, "Acculturation," 214; Esteva-Fabregat, *Mestizaje,* 7; MacLachlan and Rodríguez, *Forging of the Cosmic Race,* 200–201.

86. Chávez, *Diligencias Matrimoniales,* 1024, 1029; Kessell, "Restoring Seventeenth Century New Mexico," 46; Bustamante, "The Matter Was Never Resolved," 146–47, 162; Kraemer, "Shifting Ethnic Boundaries."

87. Baxter, *Las Carneradas,* 26–31; D. Snow, "Purchased in Chihuahua," 138–44; Ahlborn, "Will of a New Mexico Woman," 319–55.

88. Dozier, *Pueblo Indians,* 133–76, 157–58.

89. Jones, *Los Paisanos,* 136–65; Swadesh, *Los Primeros Pobladores,* 41–47; Dozier, *Pueblo Indians,* 84–86, 88–96; J. P. Sánchez, *Explorers, Traders, and Slavers,* 16, 91–102.

Interleaf: Possible Approaches to Future Research Based on the Human Genome Project

1. Cavalli-Sforza and Cavalli-Sforza, *Great Human Diasporas;* Cavalli-Sforza et al., *History and Geography of Human Genes;* Bertran-Petit and Cavalli-Sforza, "Genetic Reconstruction," 51–67.

2. Cooper, *Human Genome Project;* Marshall, "Playing Chicken over Gene Markers," 2046–48; Gabriel, et al., "Structure of Haplotype Blocks."

Chapter 6

1. Hammond and Rey, *Don Juan de Oñate.*

2. *When Cultures Meet;* Ellis, *San Gabriel del Yunque.*

3. Hammond and Rey, *Don Juan de Oñate,* 1:522–48. On August 22, 1600, Captains Juan de Gordejuela Ybarguen and Juan de Sotelo Cisneros conducted an inspection of reinforcements and supplies being sent to Oñate in San Gabriel. The inventory is quite detailed and contains numerous references to the personal belongings the new colonists brought with them. Cordelia Thomas Snow provides a discussion of material goods imported to New Mexico in "A Headdress of Pearls." Also see Pierce and Snow, "'A Harp for Playing.' "

4. Hammond and Rey, *Don Juan de Oñate,* 1:538–40.

5. C. T. Snow, " Brief History of the Palace."

6. Schurz, *Manila Galleon;* Cruz, *La nao de China;* Martínez del Río de Redo et al., *El galeón de Acapulco.*

7. Mudge, *Chinese Export Porcelain in North America.*

8. Personal communication, Linda Shulsky, Research Associate, Metropolitan Museum of Art, New York, April 1992 and April 1993.

9. Unpublished document, Archivo General de la Nación, Mexico City, Inquisición 593, expediente 1, f. 60.

10. Unpublished documents, Archivo General de la Nación, Tierras 3268, Proceso contra Gómez Robledo, 1662–65.

11. These estate inventories and wills are located in the State Records Center and Archives of Santa Fe, *Spanish Archives of New Mexico (SANM) I and II.* See listing in "Wills and Inventories Consulted," at the end of this chapter. Also see Pierce and Snow, "'A Harp for Playing.'"

12. Ahlborn, "The Will of a New Mexico Woman in 1762"; Chávez, *Origins of New Mexico Families.* However, Fray Angelíco Chávez also notes that a Matías Luján with a daughter Juana was living in Santa Cruz in 1702 (p. 369).

13. *SANM I,* 556, Roll 9, fr. 352–385; Ahlborn, "Will of New Mexico Woman," 1990.

14. Strout, " Resettlement of Santa Fe, 1695"; Colligan, *Juan Páez Hurtado Expedition;* Esquibel and Colligan, *Spanish Recolonization of New Mexico.* Also see Esquibel, Chap. 4, this volume.

15. According to C. Espinosa, *Shawls, Crinolines, Filigree,* 17, these were "kimonos del Japón"; however, the phrase "del Japón" does not appear in the original document. Other wills and inventories also mention "kimonos," but again the country of origin is not specified.

16. Archaeological reports and artifacts are in the collection of the Archeological Records Management Service at the Laboratory of Anthropology, Museum of New Mexico, Santa Fe. Personal communication with archaeologists David Snow, Cordelia Thomas Snow, and Dr. Marianne Stoller, 1992.

17. Carrillo, *Hispanic New Mexican Pottery.*

18. Taylor and Bokides, *New Mexican Furniture,* 9, 18–19, 22, 25, 67, 80–81, 96. Also see Chávez, "The Carpenter Pueblo."

Chapter 7

Italicized notes have been kindly supplied by Robin Farwell Gavin and Cordelia Snow, both of the Museum of New Mexico, to provide some updating for this chapter. I appreciate their efforts.

1. *Reredos is the French word for altar screen;* retablo *is the correct word in Spanish for an altar screen. In the colonial documents from New Mexico, the terms used are* retablo *and* colateral, *both of which are still used in Spain to refer to the main and colateral, or side, altars. Presumably, the French term, which is more commonly, and incorrectly, used in New Mexico today, was brought to the territory by Bishop, later Archbishop, Jean Lamy. That the term* reredos *has continued in use is an example of not only Lamy's but Territorial influences on New Mexico.*

2. The tradition has been kept alive, primarily in the form of

unpainted carvings of birds and animals, as well as saints, by Hispano artisans in the village of Córdova creating mostly for a secular, tourist market. It has also been perpetuated, if one can so dignify the practice, by the producers of fakes, as the collectors' market for old *santos* rose sharply in the past 10 or 15 years. Quite recently an appreciation of the old art has returned to Hispano villagers, and the role of *santero* has been resumed by one or two artisans creating for religious purposes and uses. One *santero* in particular, Horatio Martínez of Dixon, New Mexico, has started painting his carvings and also making *retablos* again. It is interesting to observe that painting was abandoned when the tradition was secularized.

3. Shalkop, *Wooden Saints*, 3.
4. Du Gue Trapier, *Ten Panels Probably Executed by the Indians of New Mexico*.
5. Cheney and Chandler, "Santos—An Enigma."
6. Pach, "New-Found Values."
7. Spinden, "Santos and Katchinas."
8. *American Guide Series: New Mexico*.
9. For example, in "Ten Panels" the paint was identified as oil, while in fact it is tempera, and Cheney and Chandler date the *santos* to the seventeenth century before the Pueblo Revolt, while subsequent tree-ring dating has failed to establish any works as earlier than the late eighteenth century. Spinden's attribution is rather confusing, but it is seemingly to the "Mexican Indians" who mixed with the Spanish, and not to the Southwestern Indians.
10. Wilder and Breitenbach, *Santos: Religious Folk Art of New Mexico*.
11. Kubler, *Santos: An Exhibition*.
12. Mather, "Religious Folk Art," 24.
13. Wilder, *New Mexican Santos*, 2.
14. Espinosa, *Saints in the Valleys*, 4.
15. Espinosa, *Saints in the Valleys*, xii.
16. Boyd, "The Literature of Santos," 137.
17. Boyd, *Popular Arts*, 338–39, 375, respectively.
18. Wroth, "Flowering and Decline," 29. Wroth's statements come much closer to being correct for the "classic" age of *santero* art, 1820–50. The discussion below documents why they are inaccurate for the early or developmental period of the art.

 There are no known contemporary descriptions of the earliest mission churches in New Mexico. However, archaeological evidence indicates that most if not all seventeenth-century mission churches contained murals painted in locally available pigments; presumably the painting was done by Pueblo artists under the direction of the Franciscans at those missions. By the latter part of the 1630s, during the term of Governor Rosas, at least one obraje or workshop was located in Santa Fe, where Indian laborers produced quantities of painted hides to transport to communities elsewhere in New Spain (Pierce and Weigle, Spanish New Mexico, 1:82). Unfortunately, no examples of seventeenth-century hidework are known to exist. However, see Esquibel, Chap. 4, this volume, for the names of several seventeenth-century Pueblo Indian painters. The fact that one of those individuals, Nicolás of Nambé, was identified as a pintor mayor is unprecedented. One cannot help but wonder what guild requirements Nicolás had met in order to be accorded the designation "master," or "mayor."

19. Boyd, *Popular Arts*, 57, 60, 155, 157–58. *In addition, new research has revealed two earlier dated altar screens made in New Mexico: the altar screen made in 1761 for La Castrense, the military chapel in Santa Fe, by Bernardo Miera y Pacheco; and the nave altar screen at the church of Santa Cruz, dated 1795.*
20. Domínguez, *Missions of New Mexico*, 98–99.
21. Domínguez, *Missions of New Mexico*, 126; Boyd, "The Plaza of San Miguel del Vado," 20; Hayes, *The Four Churches of Pecos*, 53.
22. Steele, *Santos and Saints*, 1.
23. Mills, *People of the Saints*, 57.
24. Schroeder, "Rio Grande Ethnohistory," 61, 64.
25. Schroeder, "Rio Grande Ethnohistory," 60.
26. D. Snow, *Some Economic Considerations*, 57.
27. *Probably the most startling difference between some of the remains of the seventeenth-century mission churches and those of the eighteenth and nineteenth centuries is inclusion of the convento kiva as a means of educating Pueblo children in the ways of Christianity before about 1660. James E. Ivey ("Convento Kivas," 121–52) has found that rather than representing a case of "superposition," convento kivas were an integral part of church architecture in the first half of the seventeenth century in New Mexico.*
28. Ortiz, *The Tewa World*.
29. Scully, "Man and Nature."
30. Although the term *genízaro*, as defined by Chávez, referred to Plains and other nomadic Indians who had been taken captive and thoroughly Hispanicized, both Schroeder and Swadesh note the necessity of extending the term to cover Hispanicized Pueblos, too, and Swadesh documents the presence of people from various pueblos in the *genízaro* community of Abiquiu (Chávez, *La Conquistadora*, xiv; Domínguez, *Missions of New Mexico*, 42 n. 72; Schroeder, "Rio Grande Ethnohistory," 63; Swadesh, *Los Primeros Pobladores*, 40).
31. Spicer, "Spanish-Indian Acculturation"; idem, *Cycles of Conquest*.
32. Spicer, "Spanish-Indian Acculturation," 665.
33. Spicer, *Cycles of Conquest*, 508.
34. Dozier, "Comment, on Spanish Acculturation," 681.
 While more research needs to be done to determine presence and treatment of religious art in Pueblo homes, Capt. John Gre-

gory Bourke, U. S. A., kept voluminous field notes and journals during his military career at posts in New Mexico, Arizona, and other places in the West during the latter half of the nineteenth century. Lansing B. Bloom published portions of the Bourke journals in the New Mexico Historical Review over a period of several years in the 1930s. Although Bourke never published his intended treatise on the Southwest, he repeatedly mentioned bultos, retablos, and religious paintings on canvas and hide he saw in the homes of, and on occasion purchased from, individuals from the various pueblos in 1881. For example, while in the house of the governor at Tesuque on April 16, Bourke noted a bulto of San Antonio and "time blackened holy pictures from Mexico." At Pojoaque on July 15 of that year, he purchased an old oil painting, a representation of Santiago that had been "banished" from the church to a private home. While in Picurís on July 19, Bourke noted, "the first building I entered was the church where I found the 'governor' of the Pueblo, Nepomuceno, who with others of his tribe, was engaged in carpentry work, making a new altar and other much needed repairs." During a visit to Laguna on October 30, 1881, Bourke made the cryptic statement "Old saints pictures on wood appear in this Pueblo, the most western of the series of which this fact can be noted."

35. E.g., Nutini, "Syncretism and Acculturation," 313–16.

36. Bunzel, Chichicastenango; Reina, The Law of the Saints.

37. Parsons, Pueblo Indian Religion.

38. Smith, Kiva Mural Decorations; Dutton, Sun Father's Way; Hibben, "Prehispanic Paintings."

39. See Brody, Anasazi and Pueblo Painting; Crotty, "Protohistoric Anasazi Kiva Murals: Variation in Imagery as a Reflection of Differing Social Contexts"; Mauldin, "The Wall Paintings of San Esteban Mission, Acoma Pueblo, New Mexico: A Description and Analysis."

40. Dutton, Sun Father's Way, 49; Hibben, "Prehispanic Paintings," 269.

41. Dutton, Sun Father's Way, 38, 207–8.

42. Smith, "Mural Decorations," 23, 27–29.

43. Smith, "Mural Decorations," 30.

44. Hibben, "Prehispanic Paintings," 269.

45. Smith, "Mural Decorations," 31.

46. Smith, "Mural Decorations," 22.

47. Dutton, Sun Father's Way, 32.

48. Hibben, "Prehispanic Paintings," 269.

49. Through careful experimentation, Boyd and the conservator Alan C. Vedder developed methods for removing overpaint so that the original paint could be determined. See Boyd, "Conservation of New Mexican Santos."

50. Boyd, Popular Arts, 125.

51. This renewal, as viewed by the writer in September 1976, is liable to cause some confusion for future scholars. Boyd attributes the original reredos at Acoma to the Laguna Santero, as mentioned earlier, on the basis of certain stylistic devices and a photograph made by Charles Lummis in 1895. But the inscription in the lowest right-hand panel (as one faces the reredos) credits José Miguel Aragón as Mallor in the year 1802. Don José Manuel Aragón was alcalde mallor (i.e., mayor) of Laguna, Acoma, and other settlements in the area between 1792 and 1813 and was undoubtedly the sponsor—not the painter—at Acoma, as he is known to have been at Laguna (Boyd, Popular Arts, 125, 157). The overpainting strongly resembles the style of José Raphael Aragón. José Raphael Aragón—apparently no relation to the Spaniard José Aragón, also a santero, who arrived in New Mexico in 1820 (Boyd, New Mexican Santero, 13)—was first identified by Frank Applegate as Miguel Aragón (cf. Carroll, "Migual Aragon," 49–64), but Boyd's genealogical research established his name as José Raphael (a few panels are also signed with his name); he lived in northern New Mexico, in Córdova, and his known working dates are 1826–55 (Boyd, Popular Arts, 392–407). Thus, in the present inscription, only the date may be accurate.

52. Gettens and Turner, "Materials and Methods," 9–10.

53. Montgomery, "San Bernardo de Aguatubi," 243.

54. Montgomery, "San Bernardo de Aguatubi," 248.

55. Colton, Hopi Kachina Dolls, 9–10.

56. Gettens and Turner, "Materials and Methods," 10.

57. G. Espinosa, "New Mexican Santos," 187.

58. Gettens and Turner, "Materials and Methods," 10. For further discussion on pigments see Wroth, Christian Images, 196–97, Carrillo in Saints and Saint Makers, 99; see references to Keith Bakker and Barbara Mauldin in the Consolidated Bibliography.

59. Gettens and Turner, "Materials and Methods," 11.

60. Gettens and Turner, "Materials and Methods," 11–16.

61. D. Snow, Some Economic Considerations, 64.

62. Domínguez, Missions of New Mexico, 74, 333.

63. Boyd, Popular Arts, 122–25.

64. J. Espinosa, Saints in the Valley, 98.

65. Some eighteenth-century wood panels were modeled in relief with gesso as well as being painted. Boyd feels that the artist(s) was probably a priest familiar with gesso relief tradition, but some of these panels are also attributed to the santero Molleno (Boyd, New Mexican Santero, 9, 12).

66. Boyd, Popular Arts, 118.

67. Boyd, Popular Arts, 118.

68. Boyd, Popular Arts, 125.

69. Boyd, Popular Arts, 125.

70. Toulouse, Mission of San Gregorio, 10; Stubbs, "'New' Old Churches," 167; F. B. Parsons, Early Seventeenth-Century Missions, 36.

71. Smith, "Mural Decorations," 295–96; idem, Kiva Mural Decorations, 24–25.

72. Brody, *Indian Painters,* 42.

73. E.g., Boyd, "The Literature of Santos."

74. Boyd, *Popular Arts,* 78–95.

75. Kubler, *Religious Architecture of New Mexico,* 5.

76. Kubler, *Santos: An Exhibition,* 8. *Many authors continue to share this opinion that the style of New Mexican* santos *is a primitive throwback to earlier medieval models. See Wroth,* Christian Images; *Steele,* Santos and Saints; *Frank,* New Kingdom of the Saints; *Cash,* Santos: Enduring Images of Northern New Mexican Village Churches. *On the other hand, Pierce and Weigle,* Spanish New Mexico, *Gavin,* Traditional Arts, *and Boyd,* Saints and Saint Makers, *have noted that while the iconography and presentation of New Mexican images are according to Catholic tradition, the style and pigments recognize contemporary artistic developments in Europe and New Spain. Chapters 2, 3, and 10 in this volume address the reasons for the distinctive style of the New Mexican* santos.

77. Boyd notes, however, that "ineptness in drawing human hands" was a characteristic of Mexican artists for three centuries (Boyd, "San Vincent Ferrer," 197).

78. These features are isolated not only from my own observations but also from written descriptions by the authorities cited in this chapter; in fact, it was in the process of turning from one source to another that my attention was caught by the repeated use of certain descriptive terms. Of course it may be argued that this simply points to a certain poverty of descriptive terms for visual representations in the English language; this poverty, on the other hand, may force the observer to perceive and express fundamental similarities.

79. Steele, *Santos and Saints,* 1–27.

80. Shalkop, *Wooden Saints,* 29.

81. The presence of murals in San Miguel in Santa Fe and the chapel at Las Trampas (newly built when Domínguez saw it in 1776) demonstrates that the practice was common and not confined to Pueblo missions alone. However, when wooden altar screens came into widespread use in the next century, the Spanish seem to have completely abandoned the practice of wall murals, although the Pueblos did not and continue it today (e.g., the churches at Taos, Santo Domingo, and Laguna).

82. Domínguez, *Missions of New Mexico,* 191.

83. Boyd wrote (*Popular Arts,* 96), "It was formerly assumed that only the Franciscans of the eighteenth century could have painted or carved ornaments for their missions, but they were not alone in their creative efforts"; her discussion of Fray García, Miera y Pacheco, the "Eighteenth Century Novice Painter," follows.

 Since this chapter was written, several artists have been identified who indeed were not friars. See Pierce, "Saints in New Mexico"; Wroth, The Chapel of Our Lady of Talpa; *Esquibel, Chap. 4, this volume. Testimony from the seventeenth century cites Indian artists (Hackett,* Historical Documents Relating to New Mexico, *225, 264, 370).*

84. Boyd, *Popular Arts,* 96.

85. Domínguez, *Missions of New Mexico,* 74.

86. Boyd, *Popular Arts,* 96–98.

87. See Ricard, *Spiritual Conquest,* 212–15.

88. Domínguez, *Missions of New Mexico,* 160.

89. Boyd, *Popular Arts,* 60.

90. J. Espinosa, *Saints in the Valleys,* 22. *See Pierce, "Saints in New Mexico," on reattribution of this altar screen to Bernardo Miera y Pacheco; also, more recently, Pierce and Mirabal, "The Mystery of the Cristo Rey Altar Screen."*

91. Weigle, *Brothers of Light,* 21.

92. All figures from Weigle, *Brothers of Light,* 21–22.

93. Bloom ("New Mexico Under Mexican Administration," 30) discusses population figures for this period; he reports the 1794 total as 34,256, 1829 as 43,439, and 1839 as 57,026.

94. The Eighteenth Century Novice Painter, mentioned previously, is excluded here because he worked in oils (Boyd, *New Mexican Santero,* 7). The other individual who might be included, Fray Andrés García, has already been discussed.

95. Boyd, *Popular Arts,* 59–60, 103, 159.

96. Archive of the Archdiocese of Santa Fe, Reel 5, Box 17A; see, e.g., nos. 1062 and 1072.

97. For example, at Laguna on June 8, 1775, Fray Andrés García baptized 29 "Naba Jo"; the first three females had María Josepha Cavallero as *madrina,* the next two, Don Juan Pino, etc. (Archive of the Archdiocese of Santa Fe, Reel 5, B 17A: no. 1143).

98. *Cash, in her recent book* Santos, *has identified the Laguna Santero as Fray Ramón Antonio Gonzales (56); however, this identification is problematic for several reasons. First, Cash assumes that the Laguna Santero must have been a friar because his works are so widely separated geographically. But it has been shown in numerous publications that "distance was no obstacle" to the colonial settlers, many of whom traveled many miles every year to trade, hunt, and protect their territories. More specifically, it has been shown that colonial artists traveled widely to fulfill commissions; the Laguna Santero was among the first artists in New Mexico to do so, but not the only one. Cash's identification also depends on her analysis of Fray Ramón's handwriting and on the fact that Fray Ramón was stationed at many of the churches where the Laguna Santero worked. But both of these things might rather suggest that Fray Ramón was an admirer of the Laguna Santero and commissioned him to do a number of works, perhaps helping with the inscriptions, as friars were often among the few literate people in the community. Furthermore, Fray Ramón's tenure at*

Laguna was earlier than the dates proposed for the altar screen, and his tenure at Santa Cruz ended two years before the date of 1795 found on the nave altar screen through infrared photography.

In addition, Paula B. Kornegay, in "Altar Screens of an Anonymous Artist," points out the artist's familiarity with contemporary artistic trends in Mexico, trends that an artist is more likely to have been aware of than a friar who had been stationed in New Mexico for many years. Boyd (Popular Arts), Bol ("Anonymous Artist"), and Wroth (Christian Images) have all pointed out that the Laguna Santero was probably an itinerant artist from Mexico.

 99. Boyd, *Popular Arts,* 337–40; 327–28, 335.
100. Olmsted, *Spanish and Mexican Colonial Censuses,* 83.
101. Olmsted, *Spanish and Mexican Colonial Censuses,* 29.
102. Olmsted, *Spanish and Mexican Colonial Censuses,* 2.
103. Boyd, *Popular Arts,* 329.
104. *See Wroth's comments in* Christian Images *re the PF brand and Pierce's discussion in "Saints in Spanish New Mexico" regarding the identity of this artist.* Cash (Santos, 19) *adds interesting new documentation regarding Fresquís' identity.*
105. Boyd, *New Mexican Santero,* 9.
106. Boyd, *Popular Arts,* 349.
107. Boyd, *Popular Arts,* 349.
108. This list is compiled from the following sources: Olmsted, *Spanish and Mexican Colonial Censuses;* Chávez, "Origins of New Mexico Families"; and *Archives of the Archdiocese of Santa Fe* (AASF) microfilms, Books of Baptism for Isleta Pueblo (B 18: 1720–1776), and Laguna Pueblo (B 17A: 1720–1776). Except for the Book of Marriages, 1776–1846, for Isleta Pueblo, church records for these two pueblos are not microfilmed in the State Records Center and are kept in the diocese of Gallup. Following the leads of names and locations provided by the censuses plus the known locations of their works, a thorough search of church records for the early *santeros* should cover, besides Laguna and Isleta, Picurís, Taos, and San Juan Pueblos.

As noted, the censuses are incomplete in geographical coverage; the Spanish census of 1790 is the most complete, but does not contain the Taos area although Picurís and adjacent settlements are present; the Mexican census of 1823 covers only Santa Fe and the Tesuque area, while the 1845 census records that have survived omit Isleta, Laguna, Albuquerque, Taos, and Picurís. Furthermore, only the 1790 census consistently records ethnic designation. Under the Republic of Mexico's Plan of Iguala, the racial origin of citizens was officially ignored (Schroeder, "Rio Grande Ethnohistory," 65), so while the records do sometimes list ethnic designation, we cannot assume this was done consistently enough to provide reliable data. The church records for the Mexican period do, however,

continue to contain sufficient information on ethnic identity to prove useful.
109. Boyd, *New Mexican Santero,* 12; Shalkop, *Wooden Saints,* 16.
110. Chávez, *Archives of the Archdiocese,* 76.
111. Boyd, *Popular Arts,* 157.
112. Boyd, *Popular Arts,* 61, 62, 170, 253.
113. Boyd, *Popular Arts,* 356.
114. Chávez, *Archives of the Archdiocese,* 207.
115. Boyd, *Popular Arts,* 357.
116. Swadesh, *Los Primeros Pobladores,* 48–52.
117. Spicer, *Cycles of Conquest,* 508, see note 33 above.
118. Stoller, 1986 and 1987.

Interleaf: The Life of an Artist: The Case of Captain Bernardo Miera y Pacheco

 1. Mirabal and Pierce, "The Mystery of the Cristo Rey Altar Screen." Also see Pierce, "Saints in New Mexico," and Pierce, "From New Spain to New Mexico," 64–65.
 2. Domínguez, *The Missions of New Mexico,* xv, 13, 160–61, 268, 288, 304, 307, 323, 345.
 3. Boyd, *Popular Arts,* 100–102. For a discussion of the maps by Miera y Pacheco, see M. F. Weber, "Tierra Incognita."
 4. Domínguez, *The Missions of New Mexico,* 198; Boyd, *Popular Arts,* 100–102; Pierce, "From New Spain to New Mexico," 64–65. The four *estipite* columns survive in the collection of the Brooklyn Museum. In the late nineteenth century two archangel sculptures were taken to the Smithsonian Institution, where one (Saint Gabriel) was destroyed by a fire in 1965; the other (Saint Michael) was repatriated to Zuni Pueblo in 1995. Saint Gabriel is reproduced here (Chap. 3, Fig. 10); both statues are reproduced in Boyd, figs. 86–87.
 5. Carroll and Villasana Haggard, *Three New Mexico Chronicles,* 2:99.
 6. Chemical analysis conducted on the surviving statue of Saint Michael revealed azurite blue paint. Jui-Sun Tsang, unpublished treatment report, Conservation Analytical Laboratory, Smithsonian Institution, 1992.
 7. Gettens and Turner, "Materials and Methods."
 8. Wuthenau, "Spanish Military Chapel." After the destruction of the Castrense chapel in the late nineteenth century, the stone altar screen was stored in a small museum at the Cathedral of Santa Fe until it was installed in the newly constructed Church of Cristo Rey in 1940.
 9. Kelemen, "Stone Retablo of Cristo Rey."
10. Mirabal and Pierce, "The Mystery of the Cristo Rey Altar Screen." Also see Pierce, "From New Spain to New Mexico."
11. Martín González, *El retablo barroco,* 169–70; idem, *Escultura barroca en Espana,* 470–71; idem, *Escultura barroca castellana,* 2:187–88, figs. 272–77; Ballesteros Caballero, "El retablo mayor"; Ayala López, "La capilla de Santa Tecla."

12. For further discussion of this altar screen, see Chap. 3 in this volume.

13. Baird, *Los retablos*, 128–252; Bargellini, *La arquitectura de la plata*.

Chapter 8

1. For examples of inventories listing imported religious images, see Alonso de Benavides, *Revised Memorial of 1634*, 109–24; Scholes and Adams, "Inventories of Church Furnishings"; Ivey, *In the Midst of a Loneliness*; idem, "Seventeenth-Century Mission Trade"; and Pierce, "Heaven on Earth: Church Furnishings."

2. Gerlero, "La pintura mural durante el virreinato"; Toussaint, *Colonial Art in Mexico*; Mauldin, "Wall Paintings of San Estéban Mission, Acoma Pueblo."

3. E. Boyd had located fifty-seven paintings on hide by 1974 (Boyd, *Popular Arts*, 130–54). She did not cite the Segesser paintings or four hide paintings currently in the collection of the Southwest Museum in Los Angeles. All four of the latter are reproduced in *The Cross and the Sword*, figs. 37, 57, 64, 80. Five other hide paintings not listed by Boyd are now in private collections. The painted hide canopies at Laguna and Acoma were not on her list either. In view of the huge quantity of painted hides produced in New Mexico during the seventeenth century, it is interesting that apparently none survives in Mexico or New Mexico. Certainly in New Mexico, most would have been destroyed during the Pueblo Revolt or at least worn out during the succeeding century. To date, I have been unable to locate any surviving examples from either the seventeenth or the eighteenth century in private or public collections in Mexico. Possibly this is attributable to two factors: (1) the paints on hide apparently faded rather rapidly, a problem still encountered by artists recreating the tradition today, and (2) the hides themselves were valuable for many other uses after the colors had faded. In fact, in 1989 I viewed numerous small stools at the Escorial Palace outside Madrid, Spain, which appeared to have been upholstered with fragments of a New Mexican hide painting. Examples of various books, pouches, and other colonial-period artifacts made from cast-off hide paintings can be found in the collections at the Palace of the Governors, the Archdiocese of Santa Fe, and the Museum of International Folk Art in Santa Fe.

4. Because of their sophistication and stylistic similarity to Mexican mural paintings of the sixteenth century, José E. Espinosa believed they were painted in Mexico and shipped to New Mexico with other supplies for the missions (Espinosa, *Saints in the Valleys*, 12, 25, 53). E. Boyd strongly disagreed and considered the paintings to have been executed in New Mexico by Franciscan friars in the style of the mural paintings of Mexico (Boyd, *Popular Arts*, 118–28). In more recent years, scholars have continued to be divided on the issue. William Wroth favored Espinosa's theory of Mexican authorship (Wroth, *Christian Images*, 45–47). Christine Mather and Father Thomas Steele agree with Boyd that the paintings were made in New Mexico by the friars to decorate local churches (Mather, *Colonial Frontiers*, 14–19; and Steele, *Santos and Saints*, 1994, 9).

5. Kessell, *Kiva, Cross, and Crown*, 134–37, 526 n. 54.

6. Domínguez, *Missions of New Mexico*, 88.

7. Unpublished documents in the Archivo General de la Nación (AGN), Mexico City, Inquisición, t.594, expediente 1 (for López de Mendizábal); AGN, Tierras 3268, Proceso contra Gómez Robledo, 1662–65 (for Gómez Robledo). A three-quarter-length buckskin jacket used in New Mexico during the late eighteenth century survives in the collections of the Museo del Ejército in Madrid, Spain. A short buckskin jacket with fringe and long buckskin pants used in the late eighteenth and/or early nineteenth centuries in New Mexico survive in the collections of the Museum of Spanish Colonial Art in Santa Fe. For photographs, see Boyd, *Popular Arts*, figs. 139–40, 185.

8. Benavides, *Memorial of 1630*, 55–56, 152–54.

9. Bakewell, *Miners of the Red Mountain*, 24. Also see Bakewell, *Silver Mining and Society in Colonial Mexico*.

10. AGN, Inquisición, t. 356, f. 302, and AGN, Reales Cédulas y Ordenes, Duplicados, t. 8, ff. 33–34. Also see Scholes, *Church and State*, 73, 95 n. 23.

11. AGN, Inquisición, t. 356, f. 283v. Also see Scholes, *Church and State*, 93 n. 16.

12. AGN, Inquisición, t. 385, exp. 15, 1637–38. Also see Scholes, *Church and State*, 117–19, 143–44 n. 6.

13. Ibid.

14. Bloom, "A Trade Invoice of 1638," 242–48.

15. Boyd-Bowman, "Two Country Stores," 237–51. Boyd-Bowman translates portions of two estate inventories from the archives in Hidalgo de Parral.

16. AGN, Tierras, 3268 and 3283. Also see Scholes, *Troublous Times*, 44–45.

17. Ibid. See also Francisco Gómez Robledo's testimony regarding the goods López de Mendizábal accumulated for export in AGN, Tierras, 3903.

18. AGN, Tierras, 3268; Scholes, *Troublous Times*, 47–49.

19. AGN, Tierras, 3268, 3283, 3286; Scholes, *Troublous Times*, 137–41, 169–71.

20. AGN, Inquisición, t. 594, exp. 1.

21. Ibid., articles 100–108; Scholes, *Troublous Times*, 153.

22. AGN, Inquisición, t. 594, f. 247.

23. AGN, Tierras, 3268, 3283, 3286; AGN, Inquisición, t. 507 (1661–68).

24. AGN, Tierras, 3286; AGN, Inquisición, t. 507 (1661–68); Scholes, *Troublous Times,* 218, 224–25.

25. Fragment Inventory, Santa Ana Mission, Loose Documents, 1697, no. 3, *Archives of the Archdiocese of Santa Fe* (AASF), Reel 51, Frames 317–18. The altar canopy is also mentioned in inventories of 1712 and 1743 in Fragment Inventory, Santa Ana, 1712–53, AASF, Loose Documents, 1712, no. 1.

26. *Spanish Archives of New Mexico (SANM)* in New Mexico State Records Center and Archives, Santa Fe, I, no. 13.

27. Portions of the subsequent discussion were done in collaboration with Kelly Donahue-Wallace. See Foote, "Spanish-Indian Trade," 22–33.

28. See Hotz, *The Segesser Hide Paintings.*

29. Fray Angélico Chávez, "Girón de Tejada Family of Artists," unpublished ms., Palace of the Governors, Santa Fe.

30. Steele, "Francisco Xavier Romero," 4.

31. Donahue, "Odyssey of Images," 14.

32. Domínguez, *Missions of New Mexico,* references throughout; *Spanish Archives of New Mexico (SANM),* Museum of New Mexico, Santa Fe, Archive nos. 1360 and 1993.

33. Domínguez, *Missions of New Mexico,* 15–25, 167.

34. *SANM, I,* no. 26.

35. *SANM, II,* no. 556.

36. Gov. L. Bradford Prince Papers, Ramon Vigil Grant, María Luján Will, New Mexico State Records Center and Archives.

37. *SANM, I,* no. 177. Also see Cassidy, "Santos and Bultos in the Spanish Archives."

38. *SANM, I,* no. 193.

39. *SANM, I,* no. 1231.

40. *SANM, I,* no. 590.

41. *SANM, I,* no. 912.

42. Lugarda Quintana, Santa Cruz, 1749 *(SANM I,* no. 968); María Guadalupe Sánchez, Santa Fe, 1834 *(SANM I,* no. 908); and María Micaela Baca, Santa Fe, 1832 *(SANM, I,* no. 144). 38. *SANM I,* no. 193.

43. Domínguez, *Missions of New Mexico,* 65, 74, 93, 104, 106, 121, 133, 172–73, 177, 184, 191, 198–99, 204, 210.

44. Domínguez, *Missions of New Mexico,* 53, 90.

45. Boyd, *Popular Arts,* 155–69; and Wroth, *Christian Images,* 69–93.

46. The canopy at Acoma was overpainted in the 1920s. The altar screen and canopy at Laguna have survived in good condition in the church but have been recently overpainted with synthetic paints.

47. Acts of the Guevara Visitation of New Mexico, 1817–20, *Archives of the Archdiocese of Santa Fe* (AASF), Accounts, Book LXII, Box 5, Reel 45, Santa Fe, Book 2, 1817; and Boyd, *Popular Arts,* 125–27.

48. Acts of the Agustín Fernández de San Vicente Visitation of New Mexico, 1826, AASF, Accounts Book LXIV, Box 5, Reel 45; and Bishop José Antonio de Zurbiría, 1833–45, AASF, Patentes, Book XI–XV, B1-B72.

49. Boyd, *Popular Arts,* 127, 349–65; and Wroth, *Christian Images,* 93–99. Unlike earlier hide paintings these are at least partially primed with gesso. Two images of Santiago exist, one at the Jocelyn Museum in Omaha and one at the Museum of International Folk Art in Santa Fe; an image of Saint Francis is at the Brooklyn Museum. Another painting in the style of José Aragón is executed over an older hide painting that has been completely gessoed over; this is in a private collection.

Chapter 9

1. "En este caso, la relación concreta con el modelo de un artista tan famoso como Rafael es el mejor argumento que tenemos para demostrar lo imbuido que estaba Pereyns de la estética de su época." Sebastián, "Nuevo grabado," 46. Translation mine.

2. Kubler and Soria, *Art and Architecture,* 303. Elsewhere Kubler and Soria attribute the Mexican sixteenth-century *tequitqui* or Indo-Christian style to German and Flemish Late Gothic woodcuts and the seventeenth-century Cuzco painting style to popular woodcuts that appealed to Indians and uneducated *mestizos.*

3. Jorge Alberto Manrique describes one of the early results of Mexican reliance on print sources as "atemporality" or "temporal confusion," because prints sent from Europe took time to arrive and therefore already represented outdated styles. See Manrique, "La estampa como fuente del arte," 55–60; and Stastny, "Modernidad, ruptura, y arcaismo en el arte colonial."

4. Cash, *Santos,* 12, writes, "These popular prints, which lacked visual perspective and shading, were the *santero's* major source of inspiration for the painting of retablos." Wroth, *Christian Images,* 31, similarly states, "The style of the engravings made not only in Spain but also in the New World was in keeping with their use by the people: simple images with little change in style until the 19th century."

5. Steele, *Santos and Saints,* 35, differentiates the spiritual pursuits of the New Mexican *santeros* from the art for art's sake individualism of European artists.

6. Dean, "Copied Carts," 98. In the New Mexican context, this dynamic relationship is best represented by Larry Frank *(New Kingdom,* 28), who writes, "In producing retablos, the New Mexican *santeros* drew upon the ideas that had made the prints popular and borrowed specific iconographic conventions, but they also added some personal dimensions to their work, translating many characteristics of the prints into their own artistic language."

7. Gauvin Bailey, *Art on the Jesuit Missions,* 30–31.

8. Archivo General de la Nación (AGN), Inquisición, t. 2, f. 27.

9. See Donahue-Wallace, "Prints and Printmakers," 287–91.

10. Leonard, *Books of the Brave,* 337; and Torre Revello, "Obras de arte," 93.

11. See Donahue-Wallace, "Casada imperfecta."

12. Gálvez and Ibarra, "Comercio local," 581–616.

13. Scholes, "Supply Service," 100.

14. See Domínguez, *Missions of New Mexico.*

15. *Archives of the Archdiocese of Santa Fe* (AASF), Acts of the Guevara Visitation, Patentes Book 62, reel 45.

16. Vargas's library is discussed in Adams, "Two Colonial New Mexico Libraries."

17. Ahlborn, "Will of a New Mexico Woman," 347.

18. Pierce and Snow, " 'A Harp for Playing.'"

19. Steele, "Francisco Xavier Romero," n.p.

20. Cash, *Santos,* 12, and Wroth, *Christian Images,* 48.

21. Not until the establishment of the *santero* tradition in the last quarter of the eighteenth century did artists have the large studios employing numerous apprentices common in Europe and Mexico. See Wroth, *Christian Images,* 69.

22. Domínguez, *Missions of New Mexico,* 223 and 226.

23. See AASF, Acts of the Guevara Visitation, Patentes Book 62, reel 45.

24. Boyd, *Popular Arts,* 128.

25. On the Segesser hide paintings, see Hotz, *Indian Skin Paintings.*

26. According to Boyd, *Popular Arts,* 130, this painting was collected at the *morada* at Embudo.

27. This engraving was originally published in 1593 in Jerónimo Nadal's *Evangelicae historiae imagines* and Nadal's 1595 *Adnotationes et meditationes.* While these popular Jesuit illustrated books inspired many artists in Latin America, I suspect that the New Mexican hide painter saw the engraving in the 1722 edition of Sor María de Jesús de Agreda's *Mystica ciudad de Dios,* a copy of which was found by Eleanor Adams in a New Mexican colonial library. See Adams, "Two New Mexican Colonial Libraries," 151.

28. According to Boyd, *Popular Arts,* 122, this painting hung in a *morada* near Taos until 1921.

29. The artist added the date 1608 to the inscription for an as yet unknown reason. It is probably not the date of the painting, since no hides are believed to have survived the Pueblo Indian Revolt of 1680.

30. A similar arch appears over the figure of Saint John the Baptist in a hide painting in the collection of the Archdiocese of Santa Fe.

Chapter 10

1. Oettinger, *El Alma del Pueblo,* especially 28–29. While Oettinger avoids the word "syncretism," several of his contributors use it extensively: for example, María

Concepción García Sáiz, "Constructing a Tradition," 157, and William Wroth, "Miraculous Images and Living Saints in Mexican Folk Catholicism," 164, both in the same volume. Burke, in *Art and Faith in New Mexico.*

2. Religious syncretism appears to be a popular theoretical construct among art historians dealing with multivalent colonial imagery, variously called "visual bilingualism" (Cecelia Klein, "Editor's Statement"); "double mistaken identity" (James Lockhart, "Some Nahua Concepts"); "convergence" (Jeanette Peterson, *The Paradise Garden Murals of Malinalco);* and "taking the signs away from the sign-makers" (Adorno, "On Pictorial Language"). See discussion by Peterson, *Paradise Garden Murals of Malinalco,* 8; and Edgerton, *Theaters of Conversion,* 2–3. Nutini and Bell, *Ritual Kinship,* 291, introduce the term "guided syncretism" to designate a process of intentionally fusing symbolism from different belief systems, as in the case of priests who consciously select polysemic symbols with native resonances in the hopes of converting their charges. Edgerton, *Theaters of Conversion,* argues, against Peterson, that the indigenous references in the Malinalco murals suggest supplements sympathetic to Christianity. He notes, 299 nn. 4–6, that Kubler also avoided the word "syncretism" because it did not take into account local power relationships between colonizer and colonized (on Kubler, see note 4 below).

3. See also the literature review in Burkhart, *The Slippery Earth,* 8–10, where the author emphasizes that current approaches by Nancy Farriss, Dennis Tedlock, and other anthropologists have moved "beyond the syncretic model to view religious change in terms of dialogue and creative synthesis" (citing Burkhart, p. 10). A central issue for the history of art concerns the role of artistic invention and the value of its visible manifestation, which, in the classical tradition and its early modern Humanist revival, is considered to be evidence of the artist's imagination; see my discussion in *Reframing the Renaissance,* 9–12.

4. Kubler, "On the Colonial Extinction of the Motifs of Pre-Columbian Art," proposed five categories (that he considered less problematic than the word "syncretism") to describe the various combinations of motifs and behaviors: (1) "juxtaposition," meaning the coexistence of forms without interaction; (2) "convergence," referring to similar behavioral patterns from unconnected cultural traditions that are allowed by the ruling group; (3) "explants," meaningful portions of native behavior that survive under colonial rule; (4) "transplants," isolated parts of native tradition that survive without change under colonial rule; and (5) "fragments," defined as "isolated pieces of the native tradition [that] are repeated without comprehension, as meaningless but pleasurable acts or forms." The

majority of survivals are type 5, which he considered "extinct beyond recall."

5. See preceding note. Other scholars developed different views on the blending of European and indigenous styles in Mexican colonial architecture, sculpture, and painting, notably Neumeyer, "The Indian Contribution to Architectural Decoration," and Weismann, *Mexico in Sculpture,* two studies that anticipate current trends. Thanks to Cecelia Klein for discussing Kubler's contemporaries with me in spring 1998. Among contemporary scholars, notably Peterson, *The Paradise Garden Murals of Malinalco,* pays tribute to Kubler without relying on his epistemological assumptions; see 6–7 for her discussion of *tequitqui,* and 34ff., where she adopts the vocabulary developed by Kubler's student Donald Robertson to account for what she calls the "syncretism" of the fresco decoration under study.

6. In an essay originally published in *Critical Inquiry* in 1973, Kubler acknowledged his fundamental debt to some of the theoretical aspects of Focillon's essay, above all Focillon's discussion of the "imaginary worlds" of art as something existing in "a relation to cause and effect with history at all points" (see Kubler, *Studies in Ancient American and European Art,* 406).

7. Riegl, *Stilfragen,* 1893; published in English as *Problems of Style.*

8. In this respect, Focillon's language recalls not just Riegl, but also E. B. Tylor's *Primitive Culture,* widely disseminated after its 1871 publication, in claiming that "spiritual progress" encompasses technology and the crafts as well as the fine arts. I have discussed the lingering traces of social Darwinism in texts at the foundation of art history more fully in Farago, "'Vision Itself Has Its History,'" with additional bibliography. See further, the more recent study by Wood, *The Vienna School Reader.*

9. Léon-Portilla, *The Broken Spears;* Neumeyer, "The Indian Contribution to Architectural Decoration in Spanish Colonial America." See note 5 above.

10. Davis, "Response."

11. Pierce, "New Mexican Furniture," 186. This late eighteenth- early nineteenth-century side chair is in the collection of the Museum of New Mexico. The techniques of carving and construction are also discussed by Pierce and by Taylor and Bokides, *New Mexican Furniture,* 98.

12. See Charlene Villaseñor Black on the Cult of Saint Joseph in caption to Fig. 10.a.2.

13. See now Gavin, *Cerámica y Cultura: The Story of Spanish and Mexican Mayólica.*

14. Donahue-Wallace, Chap. 9, and further, the probable visual source, reproduced in Pierce, "Saints in the Hispanic World," 1:18, fig. 25.

15. Wroth, *Christian Images,* 68, 179–80.

16. The mermaid/siren/fish motif has been studied and traced to indigenous symbolism by Gisbert, *Iconografía y mitos indígenas,* 46–49. Thanks to Carol Parenteau for calling this study to my attention.

17. As is the case for *santos* (see note 3, Introduction, above), dating of Pueblo ceramics since 1540 is not yet fully defined; for the state of the issues concerning terminology and sequencing, see D. Snow, review of Chapman, *The Pottery of San Ildefonso Pueblo,* and Batkin, *Pottery of the Pueblos.* I thank both Snow and Batkin for discussing the problems with me.

18. A structuralist semiotic language for describing the field of the visual sign was introduced into art history by Meyer Shapiro, and related techniques have been developed by anthropologists interested in the communicative properties of decorative patterns. Dorothy Washburn has developed an extensive system of diagnostic techniques for analyzing Pueblo pottery. I have borrowed Washburn's description of her own method as follows: "When the decorative output of . . . an interacting community is subjected to a symmetry analysis, the result will be a series of homogenously structured designs specific to that community. Since each group uses distinctive symmetries to compose its designs, the symmetry classes are, in effect, group 'name tags.'" Washburn, *A Symmetry Analysis,* 4–11, where she associates her methods with precedents for analyzing pottery and textile patterns in the work of Joe Ben Wheat, James C. Gifford, and William W. Wasley (1958); George Brainerd (1942); Anna Shepard (1936); H. J. Woods (1935); Arthur Loeb (1971); and others.

19. Fewkes, "Two Summers Work in Pueblo Ruins," pl. 27, whose identification I follow.

20. On the identity of the Quill Pen *Santero,* see Boyd, *Popular Arts,* 388.

21. Dependence on a European artistic model does not necessarily mean that the devotion itself originated in Europe. On the devotion to Saint Achatius presenting a case of "reverse" migration from the Americas to Europe, see Lange, "In Search of San Acacio"; and for a similar case of translation from the "New" to the "Old World," see Nunn, "Santo Niño de Atocha."

22. The choice of borrowings and meaning of resistances can be analyzed in terms of cross-cultural structural analogies—what Edward Sapir calls "patterning" and Hayden White calls "the form of content," as recently discussed by Gruzinski in the context of healing practices farther south: Gruzinski, *The Conquest of Mexico,* "Capturing the Christian Supernatural," 206 and 209. Gruzinksi, 219, writes that "[a]cculturation of the *form of expression* could quite well accommodate itself to a *content* that remained unchanged." Gruzinski argues that different cultural traditions govern conceptions of the body and of sickness—

and the European binomial "pattern" of opposites (form/matter, good/evil, right/wrong, and so on) is fundamentally different from the native belief system; on which, see also the excellent study by Furst, *The Natural History of the Soul in Ancient Mexico.* For a contemporary ethnographic parallel, see the literature on Niño Fidencio Constantino, a lay healer who attracted an enormous following to his isolated home in Espinazo, Texas. Since his death in 1938 at the age of forty, his followers in the border regions of the United States and northern Mexico have kept his cult alive by acting as mediums for his healing powers. Images play an important part in maintaining and spreading his unorthodox practices: in one famous image, the Niño is dressed in white robes, displaying the Sacred Heart of Jesus, surrounded by the aureole of the Virgin of Guadalupe. See Gardner, *Niño Fidencio;* Wroth, "Miraculous Images," 166–68.

23. For example, neither the ethnobotanist William Weber at the University of Colorado nor Richard Ford at the University of Michigan was able to make any positive identifications from the *santos* imagery I showed them. In my own research, I have consulted numerous sources, including Kiev, *Curanderismo;* Simmons, *Witchcraft in the Southwest;* Trotter and Chavira, *Curanderismo;* Roeder, *Chicano Folk Medicine;* Walker, *Witchcraft and Sorcery;* Krueger, *Medicine Women.* I also spoke with the *curandera* Sabinita Herrera and consulted the ethnographic literature: Elmore, *Ethnobotany of the Navajo;* Karen Ford, *Las Yerbas;* Weber, *Rocky Mountain Flora;* Moore, *Medicinal Plants* and *Los Remedios;* Richard I. Ford, *An Ethnobiology Source Book;* and Mayes and Lacy, *Nanise'.* I thank Prof. Salvadore del Pino, now Professor Emeritus, Department of Ethnic Studies, University of Colorado, Boulder, for consulting with me on this subject.

24. As Richard Ford suggests, in correspondence with the author, November 1992.

25. On Ignatius Loyola's *Exercises* and the contemplative imagination of an ideal landscape setting, see, further, Bailey, "The Jesuits and Painting in Italy." More generally, on meditative prayer in this period, see Evenett, *The Spirit of the Counter-Reformation,* 23–66; and McNally, "The Council of Trent."

26. Cormack, *Painting the Soul,* 26 and 31.

27. I follow Brody, *Anasazi and Pueblo Painting,* 147.

28. *The Memorial of Benavides 1630* and *Benavides' Revised Memorial of 1634.* See further in this volume, Introduction, note 2, above. Espinosa, *Saints in the Valleys,* chronicles the training of Indians in workshops and assembles the most extensive record of early criticism of *santos* yet published. Nonetheless, he maintains that Indians never made paintings or sculptures (20, 27). See further discussion by Stoller, Chap. 7, this volume.

29. On the short-lived revival of *katsina* ceremonies in the 1660s; see Schaafsma, "Pueblo Ceremonialism"; for documentation on the revival in the eastern Pueblos following the 1680 Pueblo Revolt, see Adams, *The Pueblo Katsina Cult.*

30. Brody, *Anasazi and Pueblo Painting,* 174.

31. Ibid.

32. See the excellent new documentation of missions in the sixteenth- through eighteenth-century Valley of Mexico and Yucatan peninsula, Edgerton, *Theaters of Conversion.*

33. For a view by a Native American anthropologist, see Dozier, "Spanish-Catholic Influences on Rio Grande Pueblo Religion"; most recently, see the study by Rodríguez, *The Matachines Dance,* discussed in Chap. 2, this volume.

34. The original of the replica altar reproduced here after Brody may date from late seventeenth-century Awatovi. If this women's society is like the one in Walpi that Adams, *The Pueblo Katsina Cult,* discusses, it is a curing society. Brody also reproduces an altar from a meeting of the Antelope Society in a Hopi kiva of c. 1920, in which freestanding figures and a freestanding frame form the altar.

35. Brody, *Anasazi and Pueblo Painting,* pl. 39, and see 98–103. Citing the reports of Hernan Gallegos, a member of the 1581 Chamus Cado-Rodríguez expedition, Gerónimo Marquez, a member of Juan de Oñate's 1598 expedition, and other early testimony, Brody provides us with a history of Pueblo wall painting from the earliest European accounts to the most recent archeological finds.

36. For example, a painted shield depicting a buffalo head, from Tesuque Pueblo, c. 1850, Los Angeles, Southwest Museum, cat. no. 491G 1958.

37. Parsons, "El uso de las máscaras," and "Spanish Elements in the Kachina Cult"; Hawley, "The Role of Pueblo Social Organization."

38. Dockstader, *The Kachina and the White Man,* 42, on precontact presence of *katsinas;* and see 125–30 for an evaluation of Parsons's thesis. For a current review of the evidence that representations of *katsinas* existed before first contact, see Schaafsma, "Pueblo Ceremonialism," rejecting Parsons's thesis completely; and Tedlock, "Stories of Kachinas." On formal borrowings, see Brody, "Kachina Images in American Art."

39. Markowitz, "From Presentation to Representation in Sioux Sun Dance Painting," 160.

40. Stoller, p. 122 in this volume.

41. Bynum, *Jesus as Mother,* 118, citing Bernard of Clairvaux as an important application of twelfth-century Cistercian mothering imagery to describe institutional authority, specifically to soften masculine authority by masking it. See, further, Waddell, "Feminized Santos," especially 34–37.

42. On which, see Williams, *The Spirit and the Flesh;* Roscoe,

The Zuni Man-Woman; Blackwood, "Sexuality and Gender in Certain Native American Tribes." Cf. the homophobic and ethnocentric account by Trexler, *Sex and Conquest.*

43. As encapsulated in Gill and Sullivan, *Dictionary of Native American Mythology,* 49, 148; see, further, Dockstader, *The Kachina and the White Man;* Geertz, *Hopi Indian Altar Iconography,* and for examples of Hopi dance songs that summon cloud *katsinas,* see Geertz and Lomatuway'ma, *Children of Cottonwood,* 106–9.

44. Brody, *Anasazi and Pueblo Painting,* 167.

45. See note 29 above.

46. The active role of indigenous worldviews in the processes of cultural domination is central to current studies of cultural interaction: although the bibliography is now too extensive to cite, my own thinking was initially inspired by studies based in oral and written literature, including numerous studies by Gruzinski, some of which are cited in the consolidated bibliography; MacCormack, "Caldera's *La Aurora en Copacobana*"; Burkhart, "A Nahuatl Religious Drama of c. 1590" and *The Slippery Earth;* and Damrosch, "The Aesthetics of Conquest."

47. Treat, *Native and Christian,* intro. 14, citing Vine Deloria (see below). Wroth, "Miraculous Images," 164–65, has also recently drawn attention to the significant role played by landscape and other natural phenomena in lay Catholic practice, in the context of the curative powers of sacred images.

48. To draw an analogy with Bourdieu's study of Muslim Kabylia, "[t]he over-eager peasant [who] moves ahead of the collective rhythms which assign each act its particular moment in the space of the day, the year, or human life [enters] a race with time [which] threatens to drag the whole group into the escalation of diabolic ambition, *thahraymith,* and thus to turn circular time into linear time, simple reproduction into indefinite accumulation" (*Outline,* 162). There are indisputable resonances between this criticism and Said's foundational critique of Western constructions of the Orient as a body of knowledge to be acquired, mastered, and objectified as irreducible alterity.

49. Treat, *Native and Christian,* intro. 17.

50. Treat, *Native and Christian,* intro. 14–17. In this distinction lies the fundamental problem of whether the reality of human experience is better capable of being described in terms of space or time—"what happened here" or "what happened then."

Interleaf: Sound, Image, and Identity: The *Matachines Danza* Across Borders

1. Breining, *Dramatic and Theatrical Censorship,* 136.

2. See Shipley, *Matachines Dance of New Mexico.*

3. Breining, *Dramatic and Theatrical Censorship,* 136

4. Snyder, "The Dance Symbol."

5. See Forrest, *Morris and Matachin.* I have also discussed this in Romero, "Matachines Music and Dance," and "Old World Origins of the Matachines Dance."

6. Rodríguez, *The Matachines Dance,* 25, 33.

7. See Gutiérrez, *When Jesus Came, the Corn Mothers Went Away,* pt. 1.

8. See Bonfiglioli, *Fariseos y Matachines,* and Seed, *Ceremonies of Possession.*

9. Rodríguez, *Matachines Dance,* 55.

Chapter 11

1. Lange, "Lithography, an Agent of Technological Change."

2. For a good general introduction, see Stoichita, *Visionary Experience.*

3. For recent assessments and an excellent bibliography, see the exhibition catalogue, Mormando, *Saints & Sinners: Caravaggio.* Among classic studies, see Prodi, *Il Cardinale Gabriele Paleotti;* Mâle, *L'Art religieux;* Scavizzi, "La teologica cattolica"; and Zeri, *Pittura e controriforma.*

4. Alberti, *Della pittura,* 1435, is the *locus classicus* for discussions derived from rhetorical theory; see Baxandall, *Giotto and the Orators;* Summers, *Michelangelo and the Language of Art.*

5. Paleotti, *Discorso intorno;* Jones, *Borromeo and the Ambrosiana;* and Worchester, "Trent and Beyond: Arts of Transformation."

6. Saint Bernard of Clairvaux, letter to William, Abbot of Saint-Thierry, cited from Holt, *Documentary History,* 1:20–21.

7. *Canons and Decrees of the Council of Trent,* cited from Holt, *Documentary History,* 2:65.

8. Bundy, *Theories of the Imagination.*

9. See Keuls, *Plato and Greek Painting.*

10. In one famous incident, disputes arose about a sculpted tympanum of the Annunciation planned for the façade of Milan Cathedral. Cardinal (later Archbishop) Carlo Borromeo, a leading ecclesiastical writer who implemented the Council of Trent's 1563 decree on images in a treatise on church architecture composed around 1572 *(Instructionum fabricae ecclesiasticae et superlectilis ecclesiasticae libri duo),* asked the new architect of the Cathedral, the Bolognese illusionistic painter Pellegrino Tibaldi, to compose a design for the relief made from a normative point of view in the interests of greater legibility for the spectator at ground level. The Building Committee's decision of 1569 to accept Tibaldi's design angered certain artists, especially the Milanese architect Martino Bassi, who published his own plan constructed according to the correct diminution of perspective, that is, strongly foreshortened the way "natural things" were seen from below. See Farago,

Leonardo da Vinci's Paragone, 148–54; Kemp, The Science of Art, 73–74.

11. On the issue of lust aroused by certain kinds of images in certain beholders, see, further, Jones, "Art Theory as Ideology" and Federico Borromeo and the Ambrosiana.

12. On the history of these issues, see Summers, Judgment of Sense.

13. Caygill, Art of Judgement; Barrell, Political Theory of Painting.

14. Farago, "Classification of the Visual Arts."

15. Paleotti, Discorso intorno alle imagini sacre e profane.

16. See further, Rosand, "Crisis of the Venetian Renaissance Tradition"; Goldstein, Visual Fact over Verbal Fiction; Bell and Willette, Art History in the Age of Bellori; and the forthcoming study by Farago and Frangenberg, Art as Institution.

17. Domínguez, Missions of New Mexico; and, further, Espinosa, Saints in the Valleys, 21–33, for period testimonies as late as 1881. See further discussion in Stoller, Chap. 7, this volume.

18. The French Catholic clergy tried to eliminate the use of locally made religious images, which they considered unworthy of veneration. Davis, El Gringo, 49, writes that the new priests (who, directed by Lamy, established 18 parishes by 1859) distributed devotional lithographs themselves and discouraged the veneration of handpainted retablos produced locally. From c. 1853/4 to 1856, Davis was the U.S. attorney general for New Mexico and editor of the Santa Fe Weekly Gazette. Cited by Coulter and Dixon, New Mexican Tinwork, 3; 166 n. 13.

19. The example reproduced here is particularly reminiscent of temporary shrines for feast days of patron saints at the Pueblo mission churches, as documented by twentieth-century Pueblo artists such as the printmakers Lilia Torivio and Pablita Velarde in two screen prints, c. 1936, Museum of Indian Arts and Culture of the Museums of New Mexico, Santa Fe (Figs. 2-3 and 11.a.1–11.a.5). Thanks to Joanne Rubino for calling these images to my attention.

20. See Freedberg, The Power of Images, for a synthetic overview.

21. Leyva, "Censura inquisitorial novohispana." See further discussion in Donahue-Wallace, Chap. 9, this volume.

22. Schmidt, Consumer Rites, 7.

23. Schmidt, Consumer Rites, 9.

24. On the training of indigenous artists, see the recent assessment by Peterson, The Paradise Garden Murals of Malinalco, who suggests that itinerant artists trained in Mexico City traveled from convento to convento; see also Edgerton, Theaters of Conversion.

25. Lange, "In Search of San Acacio," 19.

26. In this volume, see Donahue-Wallace, Chap. 9, p. 000.

Pierce and Snow, Chap. 6 in this volume, p. 000, cite the example of Manuela Candia, a woman who commissioned an engraving critical of crown policies, printed in 600 copies, many of which she sent to her cousin in Oaxaca (Archivo General de la Nacíon, Mexico City, v. 1521, exp. 9, 253–90).

27. Donahue-Wallace, Chap. 9, this volume, stresses that prints produced in Mexico circulated alongside European imports. See also Johnson, The Book in the Americas.

28. Coulter and Dixon, New Mexican Tinwork, stress the effects of improved transportation. See, further, note 44 below.

29. That art historian was Aby Warburg: see discussion in the Epilogue of this volume.

30. Lange, Santos de Palo, n. p., figs. 14–17 and accompanying text; idem, "Lithography, An Agent of Technological Change," 59–61; and idem, "In Search of San Acacio," 19.

31. Cosentino, Sacred Arts of Haitian Vodou, 36–37, 56–57, citing Thompson, discusses the multiple origins of the three-horned bull, associated with fertility and protection, in Dahomey, Congo, and Celtic France, as it was transformed and Christianized in Haiti.

32. On locally manufactured paintings in what is now northern Mexico, see Giffords, Mexican Folk Retablos, 13, who notes, p. 62, that láminas were produced in a few areas, such as Zacatecas, and distributed for sale in others. See, further, Giffords et al., The Art of Private Devotion, 40, noting the areas of greatest production.

33. See Donahue-Wallace, Chap. 9, this volume and, "An Odyssey of Images."

34. Merchants participated in annual trade fairs in Chihuahua, Saltillo, San Juan de los Lagos, and Taos; see Galvez and Ibarra, "Comercio local y circulación regional de importaciones," and Frank, "The Changing Pueblo Pottery Tradition."

35. On the location of the main shrines, see La Ruta de los Santuarios en México, and Luque Agraz and Beltrán, eds., Doñes y Promesas. Devotions that do not exist in both regions, such as the originally South Italian devotion to Saint Francis de Paola, to La Mano Poderosa, and to the Anima Sola promoted by the Jesuits, may indicate that they were introduced to Mexico with chromolithographs. Jacinto Quirarte, "Los Cinco Señores and La Mano Poderosa: An Iconographic Study."

36. Lange, "Lithography, an Agent of Technological Change."

37. Greenblatt, Marvelous Possessions, 4.

38. Morgan, Protestants and Prints, 18. See further discussion in ibid., chap. 1, "Media, Millennium, Nationhood," 13–42.

39. For the concept of "market revolution," see Sellers, Mar-

ket Revolution; and Johnson, "Market Revolution." The first printing press arrived in New Mexico in 1844, brought by Josiah Gregg: see Gregg, *Commerce of the Prairies.*

40. Firsthand accounts vividly capture the remoteness of New Mexico—in 1860 and later, the trip necessitated months of uncomfortable travel. For example, Salpointe, in *Soldiers of the Cross,* recounts his initial efforts to reach Santa Fe from the east coast and those of Jean Lamy, the first Archbishop of New Mexico, stationed in Santa Fe in 1851.

41. Palmer and Fosberg, *El Camino Real de Tierra Adentro.* A great deal of valuable information is contained in wills, on which see Bakker, "Aesthetic and Cultural Considerations," 24–38, and Donahue-Wallace, Chap. 9 in this volume; Pierce and Snow, Chap. 6 in this volume.

42. Coulter and Dixon, *New Mexican Tinwork,* ix, write that these goods could have been purchased through trade over the Santa Fe Trail or obtained during expeditions organized by local families for trading in Saint Louis and farther east.

43. Coulter and Dixon, *New Mexican Tinwork,* pp. x, 3, write that these prints, primarily lithographs, created a demand for frames made by tinsmiths; but the print trade itself has never been the subject of a separate full-length study.

44. Coulter and Dixon, *New Mexican Tinwork,* building on Lange's groundwork, stress the effects of improved transportation. From the sixteenth century, French firms played a leading role in the distribution of inexpensive prints of single standing saints. After the invention of lithography in 1798, lithographs of religious subjects were marketed first by French firms, such as the Turgis family, LeMercier, and Boasse Lebel (cited by Coulter and Dixon, 13), who exported devotional prints including single-leaf broadsheets, holy cards, and prayer cards to the United States from the 1820s. Lange ("In Search of San Acacio") has also identified and dated prints published by the Swiss firm of Benziger, still operating in the pilgrimage town of Einsiedeln today, which sold its chromolithographs in Cincinnati beginning in 1838, and became the most important Catholic publishing house in the United States. By 1835, American firms adopted the lithographic process and imitated the style of European productions, notably Currier (joined by Ives in 1857) of New York and Kurz (who founded his firm in the 1860s and was joined by Allison) of Chicago. Coulter and Dixon reproduce prints by these firms and others. By the 1850s, European-born merchants sold European and American prints, primarily lithographs, in Santa Fe and Albuquerque. The firm of Spiegelberg Brothers, established in 1846, was one of the leading wholesale houses in the territory for the duration of the nineteenth century. The Huning Company of Albu-querque even established a branch at Zuni Pueblo. See Fierman, *Spiegelbergs,* 11–20. Subjects of religious prints are catalogued by Farwell, *French Popular Lithographic Imagery,* 1; Peters, *America on Stone; Currier and Ives, A Catalogue Raisonné,* 1. European popular religious prints have been studied recently, notably by Rosenbaum-Dondaine, *L'Image de Pieté en France;* Pieske, *Bilder für Jedermann;* further bibliography in Lange, "In Search of St. Acacia."

45. Notably, Schantz, "Religious Tracts."

46. Yvonne Lange and Christa Pieske conducted a survey of prints in the collection of the Museum of International Folk Art, Santa Fe; see report dated February 28, 1989, from the files of the Museum.

47. McDannell, *Material Christianity,* 17–67, 132–197, which builds on her earlier specialized studies and has an extensive bibliography, takes theories of mass consumption into account. See also Olalquiaga, *Megalopolis.* In a very different context, valuable information is presented in recent literature on the African diaspora; see Thompson, *Face of the Gods;* Cosentino, *Sacred Arts of Haitian Vodou.* Freedberg, *The Power of Images,* is a synthetic study of the early modern period that takes a universalizing approach though it is framed "from below" and treats material culture.

48. The subject cries out for investigation. Thanks to Yvonne Lange, personal communication, November 9, 1998, for the suggestion that American firms imitated the latest European innovations, particularly French prints made accessible when these American firms opened offices in New York. See below, note 54.

49. Rosenbaum-Dondaine, *L'Image de Pieté,* 162–71, discusses the use of these cards for First Communion, celebrated at age twelve, and reproduces three variants of the same iconography (nos. 245, 246, and p. 191).

50. Coulter and Dixon, *New Mexican Tinwork,* reproduce a number of the new introductions, including Virgin labeled "Corazon de miraculado de Maria/pedid por nosostros," chromolithograph, pl. 8; Praying Virgin, French lithograph, 5.5; The Sacred Heart of Mary, lithograph, 5.6; Jesus Christ, French lithograph, 5.12; Saint Vincentius A Poulo, Benziger lithograph, 5.14; Holy Card with Christ and Saint John the Baptist as Children, Benziger lithograph, 5.15; Saint Ann and the Virgin Mary, Benziger lithograph, 5.16; Saint Rupert, German lithograph, 5.29; Scene of Holy Communion, Currier and Ives lithograph, 5.30 and 5.102; Resurrected Christ, French oleograph, 5.38; Sacred Heart of Jesus, German lithograph, 5.42; Souvenir from Our Lady of Lourdes, French lithograph, 5.44; and Saint Louis Contemplating a Crucifix, Benziger oleograph, 5.87.

51. The foundational argument is Max Weber's classic study

of Protestant ethics, with its emphasis on disenchantment and the overall presence of rationalization. Weber, *The Protestant Ethic.*

52. Psychological testing suggests that subjects lose interest when desire is always satisfied. In this case, icons are perfect objects of desire because their response to individual petition is never guaranteed.

53. Campbell, *The Romantic Ethic,* 205, though I do not follow Campbell when he says that the imagined experience still leads, because this account is still based, like Weber's, on the case of Protestantism. Campbell, 9–14, 72, is critical of Weber's and related theories that explain consumer desire either as an inherent character trait (an essentialist explanation) or as the product of external manipulation (a determinist explanation).

54. Coulter and Dixon, *New Mexican Tinwork,* xvii, citing Davis, *El Gringo,* 49. The problems perceived were artistic and religious: the humble execution and graphic Spanish realism of New Mexican *santos* clashed with French sensibilities. Yvonne Lange, personal archives, has an unpublished receipt from Francis Saler, Bookseller, Saint Louis, dated December 30, 1864, for "merchandise" purchased by Bishop Lamy—suggesting the process by which the new print technology entered New Mexico with ecclesiastical endorsement. (Thanks to Dr. Lange for sharing this information with me.) On Lamy's harsh treatment of lay confraternities, see Weigle, *Brothers of Light,* 57–60. On Lamy, see also the account by his successor Salpointe, *Soldiers of the Cross.*

55. García Canclini, *Hybrid Culture,* especially 151–57; 206–22. In the foreword (p. xiii), Renato Rosaldo summarizes the argument in terms that are highly relevant to the present study: "From García Canclini's viewpoint, the modern and high culture correspond to the hegemonic whereas the traditional and popular correspond to the subaltern. In contradictory fashion, he argues, the nation-state ideologically incorporated popular culture into national culture in order to legitimate its domination in the name of the people at the same time it attempted in its policies to eliminate popular culture in the name of ending superstition."

56. Based on firsthand information from his grandson; see Coulter and Dixon, *New Mexican Tinwork,* 91–93.

57. Campbell, *The Romantic Ethic,* 36–57, reviews theories of modern consumerism in these terms.

58. A great deal has been published recently on the "invention of tradition" (the phrase itself derives from Eric Hobsbawm's classic volume by the same name, on the emergence of modern nation-states) in the context of tourism, including studies of the American Southwest in the late nineteenth century. See further discussion in Chap. 2, this volume, and, on the Southwest, see publications by the following cited in the consolidated bibliography: Frederick Dockstader, Jonathan Batkin, Hilary Scothorn, Edwin Wade. See also two recent publications in connection with an exhibition about the Fred Harvey Company: Howard and Pardue, *Inventing the Southwest,* and Marta Weigle and Babcock, *The Great Southwest of the Fred Harvey Company and the Santa Fe Railway.*

Chapter 12

1. *Santero* is a twentieth-century term used by scholars and ultimately adopted by contemporary saint-makers from the 1970s on. Charles Carrillo notes that colonial *santeros* were referred to as *pintores* (painters), *escultores* (sculptors), or *maestros* (masters); Boyd, *Saints and Saint Makers,* 23.

2. Wroth, *Images of Penance,* 64.

3. This essay is based on my master's thesis, "Copied for the W.P.A." Research was supported by two Dean's Small Grant Awards from the University of Colorado Graduate School, and two grants from the University of Wyoming Libraries. I am indebted to Sanchez family members Juan Isidro Sanchez and Maria Sanchez Montoya (brother and sister of Juan Sanchez), Henry and Eusebio Montoya (sons of Maria Montoya), Viola Roaseau and Phil Garcia (daughter and son of Sanchez's sister Amalia), and especially Mary Ellen Ferreira (daughter of Juan Isidro) for providing me with information, recollections, and photographs.

4. For more on the Federal Art Project see McKinzie, *New Deal for Artists.*

5. Cahill, "Introduction," in *Index,* xiv. The most comprehensive *Index* published is in microfiche format as the Federal Art Project, *Index of American Design.* Both Christensen, *Index of American Design,* and Hornung, *Treasury of American Design,* published only selections from the comprehensive *Index.* For more on the *Index,* see Harris, *Federal Art and National Culture,* 85–102.

6. McBride, "New York Criticism," 14.

7. Rumford, "Uncommon Art," 14–15.

8. Halpert, "Folk Art of America," 3.

9. Cahill, "Folk Art," 1.

10. Christensen, *Index of American Design,* 28.

11. Cahill, "Introduction" in *Index,* xii.

12. Federal Art Project, New Mexico, *Portfolio of Spanish Colonial Design,* 10. On use of the term "Spanish colonial" see Wroth, "The Hispanic Craft Revival," 85–86. Although the term gained currency in the 1920s and 1930s, the arts in question were more Mexican than Spanish in derivation, and many dated after 1821, which marked the end of the colonial period.

13. Cheney and Candler, "Santos," 22; Federal Art Project, New Mexico, *Portfolio of Spanish Colonial Design,* 12, 22.

14. Luhan, *Edge of Taos Desert,* 80; Meinig, *Southwest,* 9–16.

15. McCrossen, "Native Crafts in New Mexico," 456; Wroth, *Hispanic Crafts of the Southwest,* 7.

16. Cahill, "Introduction," *New Horizons,* 25; idem, "Introduction," in *Index,* xv, xvi.

17. Austin, "Trail of the Blood," 35.

18. *Santa Fe Visitors' Guide,* 19; New Mexico State Highway Commission, *Roads to Cibola,* 32. Compare the popularity of the "primitive" and "dangerous" Hopi Snake Dance as a tourist attraction in the late nineteenth and early twentieth centuries, Udall, "The Irresistible Other," 43–67.

19. Otis, "Medievalism in America," 83; Weigle, *Brothers of Light,* 75–77. See also Luhan, *Edge of Taos Desert,* 135; *Actual Photographs of Los Penitentes,* [1]; Morgan, "Through Penitente Land," 68.

20. Morgan, "Through Penitente Land," 71.

21. Henderson, *Brothers of Light,* 25.

22. Ibid., 35.

23. Cheney and Candler, "Santos," 22.

24. For example, the well-known collector Dr. Albert Barnes of Philadelphia tried to get Mabel Dodge Luhan to sell him some of her *santos* because, as he told her, they belonged with his other "primitives." *Edge of Taos Desert,* 127–28.

25. Cahill, "Introduction," in *Index,* xii; Cheney and Candler, "Santos," 22.

26. Luhan, "Santos of New Mexico," 128; idem, *Edge of Taos Desert,* 126–27.

27. Even though Constance Rourke, Director of the *Index of American Design,* questioned the legitimacy of the term "Spanish colonial" for the proposed introductory essay in the *Index* for the same reasons pointed out by Wroth (note 10 above), Vernon Hunter argued to preserve the designation for *The Portfolio of Spanish Colonial Design,* Hunter to Cahill, February 16, 1937, and Rourke to Parker, March 10, 1937, Records Group 69, National Archives.

28. Boyd made renderings for the *Portfolio* and the *Index of American Design* concurrently. She was not happy with the translation of her work into hand-colored prints, and referred to the *Portfolio* plates as "a boondoggling job," Notes from E. B. notebook on FAP job, November 6, 1963, E. Boyd Papers.

29. Boyd later revised her statement, citing orders to remove locally made objects given by ecclesiastical inspectors from Durango before Lamy's tenure. No such edict has been credited to Lamy. Boyd, *Saints and Saint Makers,* 23 n. 4.

30. Federal Art Project, New Mexico, *Portfolio of Spanish Colonial Design,* 15, 16.

31. The *Portfolio* credits the Historical Society of New Mexico, the Laboratory of Anthropology, Santa Fe, School of American Research, Museum of New Mexico, and the collectors Paul Horgan, Ruth Laughlin, John Gaw Meem, Sheldon Parsons, James Seligman, B. Sweringen, Carlos Vierra, and Cady Wells.

32. Federal Art Project, New Mexico, *Portfolio of Spanish Colonial Design,* 29.

33. Evans, "Christmas Pilgrimage in the Southwest."

34. Pierce and Weigle, *Spanish Colonial Arts Society Collection,* 94; on the SCAS see Weigle, "Brief History," 26–33.

35. Applegate, "Spanish Colonial Arts," 156; Austin, "Mexicans and New Mexico," 144. Applegate's article appeared posthumously—he had died in February 1931.

36. Austin, "Mexicans and New Mexico," 144, 187, 190.

37. Austin, "Mexicans and New Mexico," 190; Weigle, "First Twenty-Five Years," 183.

38. On the vocational education program, see Wroth, "New Hope in Hard Times," 22–31.

39. On the early years of the Native Market, see Nestor, *Native Market,* 11–34.

40. Brody, in *Indian Painters and White Patrons¸* 59, notes that "the term 'traditional' has been a semantic booby trap" in that it can lead to oversimplified analysis of complex and varied artistic expression. King, in "Tradition in Native American Art," 65, states that tradition is "a highly emotive term, used in many contexts to validate not only art objects but also political and cultural ideas." The use of the term in this chapter, while it bears some cultural and political weight in discussion of formal shifts as the result of outside influences, establishes tradition in Hispanic material culture on the basis of technique, materials, form, function, and meaning; see King, "Tradition in Native American Art," 67–69.

41. Nestor, *Native Market,* 12; Coulter and Dixon, *New Mexican Tinwork,* 141.

42. Nestor, *Native Market,* 12, 33.

43. See Briggs, *Wood Carvers of Córdova,* 53.

44. Minutes, May 19, 1930, "Miscellaneous minutes, reports, & expenses, 1930–1934," Spanish Colonial Arts Society Papers; Leighton to McCrossen, March 12, 1931, SCAS Papers; Wroth, "The Hispanic Craft Revival," 86, notes that while some SCAS members such as Andrew Dasburg believed that contemporary crafts should be "allowed to sink or swim" on their own, others, such as the industrialist Cyrus McCormick Jr., "insisted that revival work be based directly on earlier prototypes."

45. Sanchez, "My Reproductions," 1. Other Hispanic artists who copied colonial works for the New Mexico FAP included Eliseo Rodriguez, Santiago Mata, Ernesto Roybal, Isauro Padilla, Eddie Delgado, and Pedro Cervantez.

46. Sanchez, "My Reproductions," 3.

47. Sanchez may also have created copies from memory. His nephew, Henry Montoya, recalls that Sanchez's

memory was "photographic." Interview with author, April 3, 1992.

48. Sanchez was one of 44 artists credited in the *Portfolio of Spanish Colonial Design*.

49. Eric McCrossen, "Crippled City Man," 1; Dolores Atwater Noell, telephone interview with author, January 22, 1992. Sanchez's niece, Mary Ellen Sanchez Ferreira, was brought up by her uncle Juan Amadeo Sanchez and her grandparents in Raton. She recalls that her uncle told her the "prank" came about in retaliation because Sanchez refused to do the schoolwork of one of the other boys. Telephone interview with author, February 8, 1992.

50. Juan Isidro Sanchez, telephone interview with author, March 23, 1992.

51. Maria Sanchez Montoya, Henry Montoya, and Eusebio Montoya, interview with author, April 3, 1992; "Case of Injured Boy," newspaper clipping hand-dated August 1927 by Juan A. Sanchez, Mary Ellen Ferreira Collection (MEFC); Nestor, *Native Market*, 31. There is no record of Sanchez's carving animals at this early date, although he did make them later. Thomas Burch, interview with author, August 4, 1991; Mary Ellen Ferreira to author, February 25, 1992.

52. Sanchez, "My Reproductions," 1. Eliseo Rodríguez notes that the FAP was a "wonderful thing for people interested in what they were doing" and that artists were not closely supervised; interview with author, August 1, 1991.

53. Sanchez, "My Reproductions," 2. New Mexico History Museum Library records indicate that eight works by Sanchez were discarded in 1953 because they had "disintegrated."

54. Juan Sanchez's niece and nephew, Viola Roaseau and Phil Garcia (daughter and son of Sanchez's sister Amalia), identified this photograph. The child in the lower right corner is Phil Garcia.

55. Vivian, "New Mexican Folk Art," 2.

56. McDonald, *Federal Relief Administration*, 463–74; O'Connor, *Art for the Millions*, 208–27.

57. Cassidy, "Art and Artists of New Mexico," 25.

58. Vivian, "New Mexican Folk Art," 2.

59. Gibson, *Santa Fe and Taos Colonies*, 170. Mabel Dodge Luhan recalled that the artist Andrew Dasburg became a "ruthless and determined" saint-hunter and "bullied the simple Mexicans into selling their saints, sometimes when they didn't want to," *Edge of Taos Desert*, 126.

60. Newspaper clipping, Russell Vernon Hunter Papers, microfilm 3029, frame 102, Archives of American Art.

61. Sanchez, "My Reproductions," 1; Sanchez had a typewritten copy of Gilbert Espinosa's "New Mexican Santos" in his papers, from which he most likely drew some of his observations (MEFC). Sanchez's nephew, Henry Mon-

toya, recalls that his uncle often read "books on the saints"; interview with author, April 3, 1992.

62. Sanchez, "My Reproductions," 4.

63. On this variation of the spelling of Barela's first name, which was most often spelled Patrociño or Patrociño in the press, see Gonzales and Witt, *Spirit Ascendant*, 173 n. 1.

64. Crews, Anderson, and Crews, *Patrocinio Barela*, 9.

65. "Relief Work," 42–43; "Wood Carvings of Former WPA Teamster," 3.

66. Hunter, "Concerning Patrocinio Barela," 98.

67. Brown, *Hispano Folklife of New Mexico*, 138.

68. Federal Art Project, New Mexico, *Portfolio of Spanish Colonial Design*, 16.

69. Brown, *Hispano Folklife of New Mexico*, 135–36.

70. Sanchez, "My Reproductions," 3. Sanchez was himself a member of the Penitente Brotherhood, according to Viola Roaseau; conversation with author, July 27, 1997; Weigle, *Brothers of Light*, 96–97.

71. Steele and Rivera, *Penitente Self-Government*, 50. The sale of religious images to Anglo tourists and collectors resulted in a compromise between two ways of life for Hispanic woodcarvers. Briggs points out that the incursion of Anglo outsiders into remote areas in search of collectible items did not always put woodcarvers in good stead with fellow villagers. The unsavoriness of such Hispano/Anglo interaction was compounded by the fact that Catholic images were sold to Protestants, Briggs, *Wood Carvers of Córdova*, 89; idem, "To Talk in Different Tongues," 49.

72. E. Boyd made the original watercolor rendering of the *Portfolio*'s San Miguel plate (see Fig. 12-4, this volume) in New Mexico, before the *bulto* was accessioned into the Taylor Museum of the Colorado Springs Fine Arts Center in 1938. The San Acacio (Saint Acacius) illustrated in *Portfolio*, pl. 29, was also rendered for the *Index of American Design* after the *bulto* became part of the Taylor Museum collection in 1937. The *Three Archangels retablo* rendered for the *Index* (*New Horizons in American Art* [New York: Museum of Modern Art, 1936], cat no. 340) belonged to Anne Evans and was donated to the Denver Art Museum.

73. Luhan, *Edge of Taos Desert*, 127. Luhan noted in 1937 that she had already given her *santo* collection to the Harwood Foundation, although David Witt, curator at the Harwood, states that the collection was donated in 1940.

74. See, for example, Sanchez works in the Hispanic Heritage wing of the Museum of International Folk Art in Santa Fe. Other Sanchez FAP works traveled with the "Images of Penance, Images of Mercy" exhibition, organized by the Taylor Museum in 1991.

75. Hunter, "Latin-American Art in U.S.A.," 21.

76. Gonzales and Witt, *Spirit Ascendant*, 50.

77. Sanchez also operated a "Complete sharpening service" in Raton (MEFC).

78. *Juan A. Sanchez Labor Records* contains invoices of consignments to these galleries (MEFC).

79. Ortega to Sanchez, May 9, 1958, MEFC. Ortega noted that Brice Sewell made the original suggestion for Sanchez to copy images from the Santuario.

80. The Santiago order, dated May 13, 1967, was commissioned by David Ortega, *Juan A. Sanchez Labor Records,* undated, unpaginated entry, MEFC. The dated invoices and orders are mostly from the 1960s.

81. Lamadrid, "Cultural Resistance in New Mexico," 24–25.

82. Wroth, "Hispanic Craft Revival in New Mexico," 93.

83. Ewing , "Some Memories," 9.

84. Sanchez, "My Reproductions," 2.

Chapter 13

1. Luhan, "The Santos of New Mexico."

2. Du Gue Trapier, "Ten Panels."

3. Austin and Applegate, "The Spanish Colonial Arts." See also Halseth, "Saints of the New World"; idem, "Venerated Women"; DeHuff, "Santos y Bultos," 50–51, 56.

4. Austin and Applegate, "The Spanish Colonial Arts," 160–61.

5. Boyd, *Saints and Saintmakers,* rev. ed. 1998. Before this publication, Wilder and Breitenbach published *Santos: The Religious Folk Art of New Mexico* (1943), which made preliminary stylistic classifications among the *santos* (Santa Cruz Valley style, Flat Figures, Taos style, and Arroyo Hondo style), but concentrated more on tools and techniques in general than on characteristics of particular pieces.

6. E. Boyd, *Popular Arts.* In both these publications, Boyd affirms the "Hispanidad" of the artists, primarily on the basis of visual content, but discussion of the artistic and ethnic origins of the images and their artists continued among colleagues behind the scenes. A 1959 letter from Frank Crabtree, curator at the Nelson Atkins Museum, to E. Boyd states: "Read William Houghland's old exhibition catalog last week . . . he sure is, or was, hopped up on the Indian 'influence' in the style of painting, wasn't he?" Another publication that discusses the *santos* of New Mexico during this time and that was virtually ignored by later authors is José E. Espinosa's *Saints in the Valleys.* Espinosa, a scholar and professor at the University of Detroit, several times cites Indian artists, even including a woman (either artist or donor) from San Juan Pueblo. He goes on to discuss styles in both *retablo* and *bulto* construction, refining the styles identified by Wilder and Breitenbach in 1943 and Boyd in 1946 and introducing new stylistic categories. But elsewhere in the same publication, he states categorically that Indians did not make *santos:* see Farago's Introduction to this volume.

7. Wroth, *Images of Penance,* 101–5.

8. These signed pieces are enumerated in various publications. Boyd, *Saints and Saint Makers* (1998), 50; idem, *Popular Arts,* 367, 369, 373; Wroth, *Christian Images,* 107–8; idem, *Images of Penance,* 101–15; Frank, *New Kingdom of the Saints,* pl. 96; and Museum of International Folk Art accession records for FA.1968.20.5.

9. The work of several more artists who have been named through subsequently discovered documents and folklore remains unidentified. These include Francisco Pachete, an Indian in Santa Fe in 1665 (Hackett, *Historical Documents,* 3:264); Fray Rafael Benavides, in Albuquerque in 1776 (Adams and Chávez, *Missions of New Mexico*); José Antonio Casados, *escultor* in Santa Fe in 1823 (Olmsted, *New Mexico Spanish and Mexican Colonial Censuses);* and Antonio Silva, of Tomé (c. 1800) and La Mesilla (in 1855) (Ellis, "Comment: The Santeros of Tomé"; Gavin, "Santeros of the Río Abajo and the Camino Real").

10. Wroth, *Christian Images* and *Images of Penance;* Pierce and Weigle, *Spanish New Mexico;* Frank, *New Kingdom of the Saints;* Cash, *Santos.* Important unpublished work has also been accomplished by Charles Carrillo and James Córdova, *santeros* and scholars from Santa Fe. Most recently, José Esquibel and Charles Carrillo have identified the work of José Manuel Benandes (see *A Tapestry of Kinship).*

11. Locally made furniture had been a major export item from the region even before the railroad lines were laid in the 1880s. Building on this vernacular style, the architect John Gaw Meem developed a "Spanish Revival" style, which he synthesized from the region's distinctive cultural traditions—his extensive work for private and public patrons, and the signature style of his exterior and interior designs, makes him the New Mexico equivalent to Frank Lloyd Wright.

12. Boyd, *Popular Arts,* 432.

13. Wroth, *Christian Images,* 66.

14. Gavin, "Santeros of the Río Abajo and the Camino Real."

15. Workshops have a long history in Mexico and Spain; see Donahue-Wallace, Chap. 9, this volume; Edgerton, *Theaters of Conversion,* 107–27; Peterson, *Paradise Garden Murals of Malinalco,* 29–83; and, further, Toussaint, *Colonial Art in Mexico;* García Miranda, *Historia del Arte Mexicano;* and Taylor and Bokides, *New Mexican Furniture,* 6–26.

16. According to an inscription, the altar screen was erected during the tenure of Alcalde Mayor Don José Aragón. See Boyd, *Popular Arts,* 157.

17. See Kornegay, "Altar Screens of an Anonymous Artist." Boyd, *Popular Arts,* 96–98.

18. Boyd, *Popular Arts,* 96–98; Wroth, *Christian Images;* Mather, *Colonial Frontiers.*

19. See Domínguez, *Missions of New Mexico;* Mather, *Colonial Frontiers,* 2.

20. *Estofado* is a process by which a wooden sculpture is entirely covered in gold leaf; the gold leaf is then entirely covered in paint, and designs are scratched into the paint to expose the gilding beneath in imitation of brocade fabric. See Alarcón Cedillo and Lutteroth, *Tecnología de la obra de arte,* 59–60.

21. Boyd, *Popular Arts;* Ellis, "Comment: The Santeros of Tomé"; Espinosa, *Saints in the Valleys;* Steele, *Santos and Saints.*

22. See Alarcón Cedillo and Lutteroth, *Tecnología de la obra de arte,* 76–78.

23. Kubler, *Religious Architecture of New Mexico;* Boyd, *Popular Arts;* Wroth, *Christian Images.*

Chapter 14

1. Cherry Creek North, where Creator Mundi moved in 1997, is a high-visibility, high-sales area. Sales by "specialty merchandisers" such as galleries account for roughly 40 percent of sales taxes collected, higher even than those collected by the area's many and expensive restaurants and bars, according to sales tax data supplied by the Cherry Creek North Merchants Association. And religious-themed materials were one of the hottest trends in the late 1990s. According to book industry data by Barna Research Group Ltd., a market-research company in Ventura, Calif., sales in the broad category of religious books (including cards, medals, and so on) totaled $1.3 billion in 1997, a 9 percent increase from 1995; see *Wall Street Journal,* August 11, 1998, B-1.

2. Personal interview, Hildegard Ledbetter, November 3, 1998. All subsequent quotations are from this interview.

3. Kalb, *Crafting Devotions,* 31.

4. Kalb, *Crafting Devotions,* 36. It should be noted that the effect of Protestantism in New Mexico has never been thoroughly studied.

5. Doss, *Elvis Culture,* 29.

6. McCourt, "When You Think of God," 63f.

7. Hatch, *The Democratization of American Christianity,* 5.

8. McDannell, *Material Christianity,* 12.

9. Doss, *Elvis Culture,* 77.

10. Seeing the art market as a social phenomenon has gained popularity in recent years. See, for example, Metcalf, "From Domination to Desire," 215–16. "According to this concept, the meaning of a work of art is not innate to the object itself. Instead, this meaning emerges through the process in which the object serves as a focus for the beliefs, ideas, and interactions of the people and institutions which define and support the object as art. . . . It is the product of a group of people, not an individual. Mean-

ing . . . [is found] in the social and cultural processes that underlie these transactions."

11. Halle, *Inside Culture,* 5–11.

12. Emmer, "Kitsch Against Modernity," 57–58.

13. For this article, I interviewed four owners of *santos* in the Denver area, as well as two area *santeros* and one *santera.* I make no attempt to claim these few as representative of all, but the buyer-owners in particular seemed to bear out the findings of both Halle's research in *Inside Culture* and the extensive surveys undertaken by David Morgan in *Visual Piety: A History and Theory of Popular Religious Images.*

14. Personal interview, Michelle Mahoney Thomas, October 27, 1998. All subsequent quotations are from this interview.

15. Bourdieu, *The Field of Cultural Production,* 220.

16. Bourdieu, *The Field of Cultural Production,* 234.

17. Langer, *Feeling and Form,* 395.

18. Shachtman, "Searchin' for the Surfer's Saint."

19. Oettinger, *Folk Art of Spain and the Americas,* 141.

20. Oettinger, *Folk Art of Spain and the Americas.*

21. Palmer and Pierce, *Cambios,* 105.

22. Oettinger, *Folk Art of Spain and the Americas,* 141.

23. Oettinger, *Folk Art of Spain and the Americas,* 141.

24. Pierce, *Spanish New Mexico,* 19.

25. Pierce, *Spanish New Mexico,* 19.

26. Nolan and Lee, *Christian Pilgrimage,* 187.

27. Morgan, *Visual Piety,* 32.

28. Steele, *Santos and Saints,* 64.

29. Steele offers an extensive reading of the iconography and makes a case for the uniquely "Hispanic" as opposed to *mestizo* culture that he believes demarcates New Mexico from Mexico. He says that however much a given New Mexican Hispanic may have been racially an Indo-Hispanic mixture, he considered himself both culturally Hispanic and racially Iberian. New Mexico's ties to New Spain were strong, but in the late nineteenth and early twentieth centuries its inhabitants, according to Steele, were equally eager to disavow ties to Mexico and immigrant Mexicans. Indeed, Steele says, New Mexicans' self-identification as Spanish and identification of their heritage as "Spanish colonial" date from the period between 1910 and 1920 (see further discussion in this volume by Riedel, Chap. 12, and the editors' introduction to Stoller, Chap. 7). However, Steele appears to undermine the "Hispanic" argument by pointing out that Guadalupe, the patron saint of Mexico, was the second-most-numerous title among Virgin *santos* found in New Mexico. Her popularity there, he notes, was further substantiated by research by T. M. Pearce, who found eight localities in New Mexico identified as Guadalupe, the largest number of place names

honoring the Mother of Christ. See especially Steele, *Santos and Saints,* 67–69.

30. Peterson, "The Virgin of Guadalupe," 40. As opposed to the sense in which a symbol is regarded to be universal to the human psyche; see, for example, Cooper, *An Illustrated Encyclopedia,* 44, who identifies the crescent moon, on which the Virgin stands, as "par excellence" the symbol of the Great Mother: the crescent is the passive, feminine principle and is both the Mother and Celestial Virgin.

31. Peterson, "Virgin of Guadalupe," 40.

32. Wroth, "Miraculous Images," 161.

33. Wroth, "Miraculous Images," 161.

34. Morgan, *Visual Piety,* 23.

35. Morgan, *Visual Piety,* 24.

36. Personal interview, Andrea Schroeder, October 31, 1998. All subsequent quotations are from this interview.

37. Elkins, *The Object Stares Back,* 24.

38. Elkins, *The Object Stares Back,* 33.

39. Morgan, *Visual Piety,* 31.

40. Morgan, *Visual Piety,* 27.

41. Masteller, "Using Brancusi," 50.

42. Kalb, *Crafting Devotions,* 147.

43. Thurston and Attwater, *Butler's Lives of the Saints,* 335.

44. Personal interview, Ronnald Miera, October 27, 1998. All subsequent quotations are from this interview.

45. Personal interview, Catherine Robles-Shaw, October 23, 1998. All subsequent quotations are from this interview.

46. Stewart, *On Longing,* 135.

47. The three *santeros* interviewed all stressed the necessity of a blessing to invoke the image's devotional aspects. Each of Ronn Miera's *santos* comes with a little brochure, which says, "If you are Catholic, your *santo* would be honored to be blessed by a priest."

48. Elkins, *The Object Stares Back,* 43.

49. Personal interview, Joanne Ditmer, October 29, 1998. All subsequent quotations are from this interview. Withers, an Anglo, was a professor at the University of Denver. She made the piece on commission. Ditmer, a friend of Father Tom Steele, a recognized authority on *santos,* said, "Father Steele considers her (Malcolm) one of the finest craftsmen, but acknowledges that among *santeros* she is not considered authentic, one of them, because she is not Hispanic."

50. Personal interview, Maureen Harrington, October 21, 1998.

51. Personal interview, Andrea Schroeder, October 31, 1998.

52. Mahoney interview: her Saint Anthony *retablo* by Arlene Cisneros-Sena hangs on a part of the wall jutting out beside the doors opening to the back deck. "It's one of the most visible spaces in the room. Everyone notices it when they walk in."

53. Kalb, *Crafting Devotions,* 124.

54. Kalb, *Crafting Devotions,* 18.

55. Pierce, *Spanish New Mexico,* 6.

56. Pierce, *Spanish New Mexico,* 4. Spain opened a trade route to China via Mexico after it conquered the Philippines in 1565. See also Pierce, Chap. 3, this volume.

57. Giffords, *Mexican Folk Retablo,* 1. See also Farago, Chap. 10, this volume.

58. Telephone interview, José Raul Esquibel, October 2, 1998. All subsequent quotations are from this interview.

Epilogue

1. Originally published in incomplete translation as Aby Warburg, "A Lecture on Serpent Ritual." This text is neither a reliable nor a complete translation (see note 3 below). Warburg never witnessed the ceremonial dance that he wrote about, but relied on photographs and published accounts, notably by the anthropologist Jesse Fewkes. Her "A Few Summer Ceremonials at the Tusayan Pueblos" is a documented source of Warburg's knowledge of the "snake dance," held in August, whereas Warburg was in Oraibi in April–May 1896 (a handwritten German translation of Fewkes's article, corrected by Warburg himself, is preserved in the Warburg Institute Archive, London, III.46.1.68). See further discussion in note 40 below.

2. Saxl, "Warburgs Besuch in Neu-Mexico," in Wuttke, *Aby M. Warburg-Bibliographie,* 317–26.

3. Warburg, *Images from the Region of the Pueblo Indians,* is the full text of Warburg's 1923 lecture, condensed in the published article of 1939; idem, *Schlangenritual: Ein Reisebericht,* ed. Ulrich Raulff, 1988 (the only edition of the text in its integral state, and therefore the only safe base for discussion); Philippe-Alain Michaud, *Aby Warburg et l'image en movement.* The burgeoning literature on Warburg's interest in the American Southwest is too extensive to cite, but in addition to these references, see in particular the important studies by Forster, "Introduction"; Naber, "Pompeii in Neu-Mexico"; Michaud, "Un Pueblo à Hambourg."

4. As expressed by Forster, "Aby Warburg: His Study of Ritual and Art on Two Continents," 14: "What is still viable in Warburg's model is this idea of an unsynthesized, coexistent duality" that is inherently irresolvable. Comparable ideas are central to the writings of García Canclini, Homi Bhabha, and other contemporary cultural theorists: see further discussion in Chaps. 1 and 2, this volume.

5. Citing P. Burke, "Aby Warburg as Historical Anthropologist," 44. See also Forster, "Aby Warburg: His Study of Ritual and Art on Two Continents."

6. Rampley, "From Symbol to Allegory"; Mallgrave and Ikonomou, *Empathy, Form, and Space,* intro. 18.

7. Rampley, "From Symbol to Allegory," 49. I am grateful to Matthew Rampley for commenting on my response before publication: our dialogue was lively and productively focused on the issues.

8. Rampley, "From Symbol to Allegory," 49–50.

9. F. Nietzsche, *Werke*, 3:804; see the discussion of "context" by Bal and Bryson, "Semiotics and Art History," 86.

10. Ironically, Jesse Fewkes, Warburg's foremost source of expertise on Hopi culture, was responsible for the name Hopi (meaning "good in every respect" in the Third Mesa dialect of Hopi) being adopted by anthropologists. Originally a self-designation, *moqui* [mókwi] offended the Hopi in its ambiguous English pronunciation [mo-ki] because it was homologous with the Hopi word *mo-ki*, meaning "dies, is dead." At Fewkes's urging, the local Bureau of Indian Affairs agency was officially renamed the Hopi Agency, and the term Moqui was dropped from government usage in 1923. Cited from Connelly, "Hopi Social Organization," 551.

11. Gombrich, *Aby Warburg,* 91. A clear statement of Warburg's objectives is the introduction to his lecture, omitted from the 1939 article but recently published by Steinberg, who translates: "In what ways can we perceive essential character traits of primitive pagan humanity?" An early version of the sentence includes the additional phrase, "incapable of life, crippled by a dark superstition," a phrase eliminated as Warburg revised his manuscript. Steinberg draws the conclusion that for Warburg the principle of synchrony *[Nebeneinander]* is a "principle of redeeming ambivalence, through which paganism and rationality are allowed never to be reconciled but to exist in dialogue nonetheless." In another note from 1923, Warburg used the word "primitive" in quotation marks (Steinberg, "Aby Warburg's Kreuzlingen Lecture," 66, 98f.).

12. Wind, "On a Recent Biography of Warburg"; see discussion by Rampley, "From Symbol to Allegory." See, further, the essay by Wind, "Warburg's Begriff der Kulturwissenschaft," especially 26–27, for Warburg's conceptual framework of aesthetic response as he derived it from psychological aesthetics, especially from Friedrich Theodor Vischer's essay, "Das Symbol," 1887, which is an expansion of his Vischer's son's dissertation.

13. Mallgrave and Ikonomou, *Empathy, Form, and Space,* intro. 25, citing Vischer, "On the Optical Sense of Form," in *Empathy, Form, and Space,* 209, for whom this symbolizing activity is based on the pantheistic urge for union with the world. Rampley, "From Symbol to Allegory," 45, states that even for Adorno, "a fundamental level of experience consists of a mimetic passing over into the object."

14. Lambropoulos, *Rise of Eurocentrism,* 176, citing Harry Payne, "Modernizing the Ancients: The Reconstruction of Ritual Drama, 1870–1920," *Proceedings of the American Philosophical Society* 122, no. 3 (1978): 185; and naming William Robertson Smith's *Lectures on the Religion of the Semites,* 1894, as a major source of inspiration for the Ritualists and Freud alike. On the further effects of a primitivist discourse grounded in anthropology shaping disciplinary practices, see Richard Halpern, "Shakespeare in the Tropics," who argues that this anthropological trope is "not a mere curiosity or sidelight but germane to the development of modern literary criticism as a discipline" to the present day (citing Halpern, p. 1).

15. Lambropoulos, *Rise of Eurocentrism,* 177, citing popular works until 1951.

16. Lambropoulos, *Rise of Eurocentrism,* 178.

17. Lambropoulos, *Rise of Eurocentrism,* 178, citing Hans Liebeschütz, "Aby Warburg (1866–1929) as Interpreter of Civilisation," *Leo Baeck Institute Yearbook* 16 (1971): 232; Wind, "Warburg's Begriff der Kulturwissenschaft"; Raulff, "The Seven Skins of the Snake," 74; Rampley, "From Symbol to Allegory," 49.

18. Letter dated January 29, 1999, addressed to Nicholas Mann as Director of the Warburg Institute. My thanks to Dr. Mann for making this correspondence available to me.

19. Among the most prominent writers are George Marcus, George Stocking, James Clifford, Sherry Errington, Donna Haraway, James Boone, Ruth Phillips, Christopher Steiner, and Nicholas Thomas.

20. Nicholas Mann, letter to Leigh J. Kuwanwisiwma, January 12, 1999.

21. Cestelli Guidi, "Retracing Aby Warburg's American Journey Through his Photographs," 28. The text continues: "With this image Warburg meant probably to emphasize the dancer's double identity, as a member of a symbolic world when wearing the mask and as a rational being when not. Warburg takes up this twofold identity the Indians assigned to all human beings, portraying himself as the protagonist of a magical transformation, when he draws a kachina mask over his own head." The question of distinguishing between what is universally human and what is culturally specific is implicit in Warburg's writing—and remains implicit in Cestelli Guidi's account. Can *any* contemporary interest in Warburg's theoretical considerations neglect to mitigate his assumptions about what is universally "human"? Since a full analysis of Cestelli Guidi's essay is beyond the present context of discussion, it must suffice to note that the "twofold identity" of rational/symbolic is irrelevant from a Pueblo perspective. More likely, Warburg adapted Vischer's theory of emotional transference to his "case study."

22. Wade, "The Ethnic Art Market"; Weigle and Babcock, *The Great Southwest of the Fred Harvey Company and the*

Santa Fe Railway; Batkin, "Tourism Is Overrated," a study of mail-order mass consumerism. For a relevant critique of the term "ethnic art," see Araeen, "From Primitivism to Ethnic Arts."

23. The immediate historical context for their refusal is the civil rights movement in the early 1970s, when the American Indian Movement, Indians Against Exploitation, Navajo national chapters, and other groups were formed and began expressing serious objections to the way in which some revivalist activities, such as the Gallup Ceremonial, were rewarding Indians for perpetuating a Hollywood caricature of their traditional life through the public performance of sacred ceremonies. See Wade, "The Ethnic Art Market"; idem, "Economics of Southwest Indian Art Market." Deloria, *Custer Died for Your Sins* (1969), is an excellent introduction to Native American civil rights issues, by a leading and highly respected activist.

24. hooks, *Yearning: Race, Gender, and Cultural Politics,* 125.

25. Warburg tried to negotiate the sale of Hopi objects to German museums. On April 5, 1896, from Arizona, and on October 10, 1896, from Hamburg, he wrote to the anthropologist Jesse Fewkes of the Smithsonian about the interest of the Berlin Ethnographisches Museum in purchasing *katsina* dolls, ceramics, and other ceremonial objects. See Steinberg, "Aby Warburg's Kreuzlingen Lecture," 92–95.

26. Cestelli Guidi, in "Retracing Aby Warburg's American Journey Through his Photographs," 44, uses this classicizing descriptive term and provides further references. In 1902, Warburg donated his own collection of 124 artifacts to the Hamburg Völkerunde Museum, where some items are still on display. Cestelli Guidi, who is currently preparing a detailed study of Warburg's donated collection, reports, 46–47, that he purchased from Thomas Keam, the Wetherill brothers, Voth, and the Santa Fe curio dealers Jake Gold and Abraham Spielberg, and directly from Pueblo villages. The inventory book in the Warburg Archives indicates a mixed collection of exhumed and other ceremonial artifacts along with tourist ware, like the pot reproduced in Cestelli Guidi's article, fig. 33. Compare Batkin, *Pottery of the Pueblos,* 126, identifying a closely comparable jar as a Zia Polychrome water jar *(olla),* c. 1890–1910, with similar naturalistic depictions of animals; and ibid., p. 48, top, reproducing a vessel of similar shape with a similar melange of decorative motifs, identified as a San Ildefonso Polychrome *olla* of "pseudo-ceremonial design, c. 1900." Further unpublished examples are in the Taylor Museum collection, on display in its open storage exhibition. On the complicity of archaeologists, dealers, and Native American artists in the history of excavation, sale, and revival of Pueblo pottery, see Batkin, *Pottery of* the Pueblos, intro. 15–34; and Scothorn, "Pueblo Women."

27. Clifford, *The Predicament of Culture.* See also Clifford's historiographical overview of anthropology in his Introduction to *Writing Culture,* updated in Clifford, *Routes.*

28. Steinberg, "Aby Warburg's Kreuzlingen Lecture," 95, comments only that this activity documents an "otherwise unrevealed entrepreneurial side to Warburg's adventure."

29. Nicholas Mann, letter to Leigh Kuwanwisiwma, dated January 12, 1999.

30. Geertz, *Hopi Indian Altar Iconography.* The contemporary reproduction of many of Geertz's photographs, taken from ethnographical reports by Fewkes and others published around the turn of the twentieth century, is strictly forbidden, not only by the Hopi Tribal Council, but by institutions such as the School for American Research, Santa Fe, which houses *tablitas* and other ceremonial artifacts from the time that Geertz discusses. In all fairness to Geertz, who may justifiably feel caught in an ethical bind manufactured by institutionalized forms of power, in the same year Geertz published another book on Hopi religion coauthored with three Hopi individuals: Geertz and Michael Lomatuway'ma, illustrated by Warren Naminingha and Poul Nørbo, *Children of Cottonwood.* Geertz studied the Hopi language extensively in order to render Hopi texts in English translation, checked by his Hopi colleagues.

31. Compare Cestelli Guidi, "Retracing Aby Warburg's American Journey," 39: "his photographs rarely fell either into the category of the picturesque or into that of documentary evidence"; 41: "the esthetic unconventionality of the photographs might seem surprising." My quarrel is not with those noting the innovativeness of Warburg's photographic compositions, but with those laying stress exclusively on the innovative character of his photographs, disregarding or failing to analyze the inherited formal conventions also embodied in them.

32. de Certeau, *The Writing of History.* De Léry's popular pocket-size travelogue was Montaigne's main source of information for *Des Cannibales,* the famous critique of European society that established the noble savage as a utopian theme in modern thought. See, further, Farago, "Jean de Léry's Anatomy Lesson."

33. The only writer to my knowledge who has given critical attention to Warburg's categories is Koerner, "Paleface and Redskin."

34. Gombrich, *Aby Warburg,* p. x, quotes from Warburg's notes for the Kreuzlinger sanitarium lecture, to the effect that he knew "American Indian novelettes" in his childhood. My thanks to Erhard Schuettpelz for this reference. My thanks to Beeke Sell Tower for sharing her research

on Karl May and nineteenth-century German fascination with the American West, and for providing bibliographical guidance. For an overview of the enduring myth of the Far West in the German imagination, see Tower, *Envisioning America*. Tower, 19, notes that "[t]he philosophical ramblings in [Karl] May's novels reflected the conservative values of the German middle class during the Wilhelmine empire, tempered by an admixture of freewheeling Christian and pacifist thought." See, further, Joshua Taylor, *America as Art*. On the reception of James Fenimore Cooper and the Wild West in Germany, Hans Plischke, *Von Cooper bis Karl May*; Karlheinz Rossbacher, *Lederstrumpf in Deutschland*; Harmut Lutz, '*Indianer*' and '*Native Americans*'; Rick Stewart, Joseph D. Ketner II, and Angela L. Miller, *Carl Wimar: Chronicler of the Missouri River Frontier*, especially 32ff. Cooper's novels were the inspiration for German-born painters like Carl Wimar, who traveled to Missouri as a fifteen-year-old, deriving his paintings from romanticizing, sentimental prints of civilized Europeans confronting primitive wilderness and natural man.

35. On the international distribution of Karl May's novels, see Karl-May-Haus, *Das Begleitbuch zu den Ausstellungen*, from which this illustration is reproduced (p. 73: Karl May, *The Legacy of the Inca*, Hanoi: Ngoai Van, 1988).

36. See Hinsley, "The World as Marketplace." Warburg's preserved collection of American memorabilia includes commercial postcards of cliff dwellings and of display shelves of Pueblo pottery (Warburg Institute Archive, III.47). The author of a letter dated Walpi, February 4, 1893, preserved in the Warburg Institute Archive. III.46.1.3, inscribed at the top margin as being from A[lexander] W. Stephenson, the Scottish archaeologist of Warburg's acquaintance, notes that he has "a picture of the Chicago exhibition tacked up in my quarters," much as Warburg might have done himself. In these close quarters, where does one draw the line between popular culture and professional activity, or make determinations about "authenticity"?

37. Nordenskiöld, *The Cliff Dwellers of the Mesa Verde*, in folio with photographic illustrations, which Warburg described in 1923 as the inspiration for his travels (see Steinberg, "Warburg's Kreuzlingen Lecture," 62, citing lecture notes in the Warburg Archives). For the reconstruction of Warburg's American itinerary, see Naber, "Pompeii in Neu-Mexico."

38. Philippe-Alain Michaud, "Un Pueblo à Hambourg," 46, refers to Richard Wetherill as "one of the best connoisseurs of Mesa Verde." Compare Wade, "The Ethnic Art Market," 175, who refers to Richard and John Wetherill as "premier pothunters," whose "self-taught expertise," though frowned upon academically, was valuable": they

discovered the Mesa Verde ruins on a cattle run in 1888 and soon established a profitable business supplying excavated materials from Mesa Verde, Chaco Canyon, Canyon de Chelly, and other sites to European museums. Warburg instantly became part of a small network of dealers, anthropologists, scholars, and entrepreneurs through contacts initiated by his sister-in-law's brother James Loeb (later publisher of the Loeb Library Classics). On his way west, after studying Southwestern materials and meeting with various experts first at the Peabody Museum, Harvard University, then at the Smithsonian Institution, which housed a library and the Bureau of American Ethnology, Warburg visited John Wetherill at his ranch in Mancos, Colorado. Warburg recorded his presence at the Cliff Palace, Mesa Verde, with Wetherill on December 1, 1895 (Warburg Archives, III.10.1, "The American Diary," 23 verso). Thanks to his business contacts, Warburg carried letters of introduction on his trip west that enabled him to receive preferential treatment (such as bilingual guides) at the eastern Pueblos of Laguna, Acoma, Cochiti, and San Ildefonso. After wintering in San Francisco (1895–96), Warburg returned to the Southwest in March 1896, visiting the western Pueblos at Zuni, the Hopi villages of Walpi and Oraibi, and the settlement at Keams Canyon. The dealer Thomas Keam was the main conduit for passing Hopi materials to American and European museums, along with the Mennonite missionary Voth, who arrived in 1892. These two were Warburg's contacts and hosts in Oraibi. The Stanley McCormick Hopi Expedition collected Hopi material for the Chicago Columbia Field Exposition in 1892–93, which entered the Chicago Field Museum collection in 1897, when George A. Dorsey purchased pottery and artifacts from Nordenskiöld, who had hired the Wetherills as his assistants (Warburg followed Nordenskiöld's itinerary). See Dockstader, *The Kachina and the White Man*, 76–87; Titiev, *Old Oraibi*, 69–95; Whiteley, *Deliberate Acts*, 90–108.

39. Warburg Institute Archive, III.46.2, contains Warburg's copy of the second revised edition of Powell's *Introduction to the Study of Indian Languages* (Washington, 1880), written by a hired military scout (later director of the Bureau of Ethnology and, incidentally, an outspoken critic of land exploitation). Powell made his reputation in the mid-nineteenth century by leading a government-funded survey expedition to map the Far West for commercial and scientific reasons: see Anderson et al., *Thomas Moran*, 54–57, who also note that Powell's *Report on the Lands of the Arid Regions of the United States* was "one of the most farsighted and sobering documents ever issued" by the U.S. government, and *not* the message that railroad promoters and developers wanted to hear. Warburg Institute Archive

III.47.1.13 contains a small unbound notebook labeled "Cochiti" with drawings and wordlists; III.47.1.14 contains similar diagrams of ceremonial bowls, altars, and cosmic maps labeled in English and Keresan; III.46.1.6.3 consists of a vocabulary list of 103 folios, mostly nouns and adjectives comparing Isleta, San Juan, and Santa Clara terms in list form as Powell, *Introduction to the Study of Indian Languages,* 59, 77–228, had recommended, with the significant difference that Warburg largely omitted verbs from consideration—concentrating instead on naming ceremonial masks, *katsinas,* and other cultural data useful for his study of symbols.

40. Warburg's terminology resonates with current accounts written for a general audience, such as the sensationalizing full title—not mentioned by any contemporary writer on Warburg's study of Pueblo culture—of Lt. John Gregory Bourke's 1884 *The Snake Dance of the Moquis of Arizona . . . with a description of The Manners and Customs of this Peculiar People, and especially of the revolting religious rite, The Snake-Dance; to which is added a brief dissertation upon serpent-worship in general with an account of the Tablet Dance of the Pueblo of Santo Domingo, New Mexico, etc.,* reprinted from Scribner's tabloid of the same year.

41. Whiteley, *Deliberate Acts,* xix, notes that his initial interest in Hopi was awakened by watching the Snake Dance in Hotevilla, which, for a "rather typical European 'orientalist'" like himself in search of the exotic, "was not some reinvented, quasi-authentic spectacle, but the 'real stuff.'" Yet, Whiteley continues, p. 93, citing further references, the Hopi Snake Dance, widely publicized by Bourke's 1884 book, had attracted a number of anthropologists, tourists, artists, photographers, and scientists since the 1880s: "Tours to the Snake Dance (with the Grand Canyon thrown in) were advertised in leading Eastern newspapers, especially from the late 1890s, and a few years later became great social events (Theodore Roosevelt visited in 1913), with huge crowds of camera-wielding tourists." See, further, Udall, "The Irresistible Other," 43–67. The Fred Harvey Company cornered much of the market in the early 1900s with its "Indian Detours." Charles E. Burton, superintendent of the Keams Canyon School where Warburg performed his experiment in cultural memory on Hopi schoolchildren, described the effect of some tourists on the Hopi as "very demoralizing," because they encourage the Hopi to "cling[e] to Hopi clothing, customs, and superstition" (cited by Whiteley, 93).

42. On the immediate sources of Vischer's abstractions in Herbart and Albert Scherner, and the contemporary response to Vischer, see Mallgrave and Ikonomou, *Empathy, Form, and Space,* intro. 25–29.

43. The recent scholarship is quick to acknowledge War-

burg's personal acquaintance with Boas from 1895, when they first met in New York, but skims over the fact that Warburg's ideas about race were far behind the cutting-edge ones of his new acquaintance, then and thereafter. See, for example, Michaud, "Un Pueblo a Hambourg," 45, citing without further comment Warburg's own testimony, dated March 17, 1923, about his American acquaintances, including "Franz Boas in New York, the pioneers of ethnological research, who opened my eyes to the universal significance of prehistoric and savage America." On Boas, see Stocking, *Race, Culture, and Evolution.*

44. In fall 1927, Warburg was visited in Hamburg by Franz Boas's student Gladys Reichard of Columbia University, who proposed teaching a joint seminar there on the tradition of antiquity for modern cultures (see Steinberg, "Warburg's Kreuzlingen Lecture," 100). We can only guess how Warburg's thinking about "primitive pagan humanity" might have matured if this collaboration had taken place. On his planned but unrealized second trip to America, against the advice of his doctors and cut short by his death, see Forster, *Aby Warburg,* intro. 40–42; Steinberg, "Warburg's Kreuzlingen Lecture," 106–8.

45. See Whiteley, *Deliberate Acts,* and Titiev, *Old Oraibi,* and idem, *The Hopi Indians of Old Oraibi,* for the most complete accounts of the complexity of issues and events that divided the two factions. Whiteley, p. 74, questions the conventional view that the Oraibi split was solely the result of the division into the "Friendlies" and the "Hostiles," as the government called them. Whiteley favors a more complex view of acculturation and associated pressures. Whiteley, p. 25, cites evidence, in the form of a missionary narrative of 1775 by Father Silvestre de Escalante, that the town was already divided into two parties as early as the 1740s over the issue of missionary intervention. The important point to stress in the present context of discussion is that the Oraibi split of 1906, leading to the establishment of a new village at Bacavi, constitutes a typical Pueblo solution to internal discord, but the discord itself was exacerbated by the aggressive presence of non-natives, primarily religious evangelicals. Whiteley, p. 85, sides with other scholars who think it is a mistake to blame the Mennonites for the discord, but "Voth's influence is, nonetheless, a factor to be reckoned with" because of his public distribution of "esoteric lore"; in other words, the same issues about control of knowledge that fuel present-day antagonisms.

46. The official establishment of the Hopi reservation in 1882 was fueled by increased fear of Mormon and other Protestant missionaries beginning in the 1870s—and above all, the Mennonite mission established at Third Mesa by H. R. Voth in 1893. In 1891, the government put pressure on

Hopis to send their children to the government school at Keams Canyon (where Warburg conducted his drawing experiment on Hopi children's faculties of symbolization in 1896). The faction of Oraibi known as the "Hostiles" refused to comply with the Board of Indian Affairs' policy to send their children to government schools, resulting in their imprisonment, which increased their antipathy, culminating in the Oraibi split in 1906. See Dockstader, *The Kachina and the White Man,* 82–87. Pueblo Indians gained the right to vote only in 1948, following a court ruling (see Deloria, *Custer Died for Your Sins*). Whiteley, *Deliberate Acts,* 74–83, further discusses the issue of schooling as key in the factional division that led to the 1906 split. On Warburg's drawing experiment, see Steinberg, "Aby Warburg's Kreuzlingen Lecture," 64–66.

47. Geertz, "Pueblo Cultural History," 13. Compare the sobering account of contemporary circumstances in a differently narrated historical context, by the Santa Clara Pueblo historian Joe Sando, *Pueblo Nations.* See also Dozier, *The Pueblo Indians of North America.*

48. As discussed in Chap. 2, this volume.

49. Phillips, *Trading Identities,* especially 6–9 (extending arguments first made by Nelson Graburn, *Ethnic and Tourist Arts,* for considerations of "resistance" and specifically following Susan Stewart's theorizing of the souvenir as a site for harmonization of the exterior world with the interior self), argues that aboriginal makers who had to reimagine themselves in terms of consumer conventions of Indianness destabilized indigenous concepts of identity by appropriating European constructs for their own use. Graburn narrates the reception of his ideas in *Trading Identities,* 335–54. Contemporary exploitations of stereotypes include the humorous ironical work of performance artists such as Guillermo Gomez-Peña, Coco Fusco, James Luna, and Jimmy Durham, who offer strident critiques of *all* essentialist discourses centering around questions of ethnographic purity.

50. I follow García Canclini, *Hybrid Cultures;* see especially Chap. 10, this volume. Foucault, "Of Other Spaces," coined the term "heterotopia"; García Canclini has brilliantly analyzed South American art and material culture as a "heterotopic" capitalist network maintained by/as a fictive (in reality, "co-dependent") division between "tradition" and "modernity."

51. Schmidt, *Consumer Rites,* is an insightful recuperation of the significance that the "cyclical" time of holidays has had in American middle-class calendars since the latter part of the nineteenth century.

52. Derrida, *Archive Fever,* 36, on the mechanisms of the "patri-archive" that seek investigation, writes: "The question of the archive is not, we repeat, a question of the past. It is not the question of a concept dealing with the past that might *already* be at our disposal, an *archivable concept of the archive.* It is a question of the future, the question of the future itself, the question of a response, of a promise and of a responsibility for tomorrow." A "spectral messianicity," Derrida continues, is at work in the concept of the archive—and what he says about the archive pertains to all historical enterprise—because the past we construct, whether it justifies the present, undermines it, or relates to it in some other way, is nothing other than a *construction,* an arrangement of evidence, a work of human artifice assembled and displayed for purposes at hand, in the present. And, of course, the present study is no exception.

CONSOLIDATED BIBLIOGRAPHY

Actual Photographs of Los Penitentes. Denver: Cosner Selling Co., 1931.

Adams, E. Charles. *The Origin and Development of the Pueblo Katsina Cult*. Tucson: University of Arizona Press, 1991.

———. *Walpi Archaeological Project: Synthesis and Interpretation*. Flagstaff: Museum of Northern Arizona, 1982.

Adams, Eleanor. "Two Colonial New Mexico Libraries." *New Mexico Historical Review* 19 (1944): 135–67.

Adams, Eleanor B. *Bishop Tamarón's Visitation of New Mexico, 1760*. Albuquerque: Historical Society of New Mexico, 1954.

———, and Fray Angélico Chávez, trans. and annotators. *The Missions of New Mexico in 1776: A Description by Fray Francisco Atanasio Domínguez with Other Contemporary Documents, 1956*. 2d ed.: Albuquerque: University of New Mexico Press, 1976.

———, ed. "Bishop Tamarón's Visitation of New Mexico, 1760," parts 1–4. *New Mexico Historical Review* 28 (April, July, October 1953): 81–114, 192–221, 291–315; and 29 (January 1954): 41–47.

Adorno, Rolena. *Guaman Poma: Writing and Resistance in Colonial Peru*. Austin: University of Texas Press, 1986. 2d rev. ed. 2000.

———. "On Pictorial Language and the Typology of Culture in a New World Chronicle." *Semiotica* 36, nos. 1/2 (1981): 51–106.

Ahlborn, Richard E. "The Will of a New Mexico Woman in 1762." *New Mexico Historical Review* 65 (July 1990): 319–55.

———, and Harry R. Rubenstein. "Smithsonian Santos: Collecting and the Collection." In *Hispanic Arts*, ed. Marta Weigle, 241–79. Santa Fe: Ancient City Press, 1983.

———. "The Will of a New Mexico Woman in 1762." *New Mexico American Antiquity* 29 (1964): 316–27.

Alarcón Cedillo, Roberto, and Armida Alonso Lutteroth. *Tecnología de la obra de arte en la época colonial: Pintura mural y de caballete, escultura y orfebrería*. Mexico City: Universidad Iberoamericana, 1993.

Alberti, Leon Battista. *On Painting*. Trans. Cecil Grayon, intro. Martin Kemp. London: Penguin, 1991.

American Guide Series: New Mexico, 1945.

Amin, Samir. *Eurocentrism*. Trans. R. Moore. New York: Monthly Review Press, 1989.

Amsden, Charles Avery. *Navajo Weaving, Its Technique, and Its History, 1934*. Reprint Glorieta, N.Mex.: Rio Grande Press, 1982.

Anderson, Benedict. *Imagined Communities: Reflections on the Origin and Spread of Nationalism*. Rev. ed. London: Verso, 1991.

Anderson, Frank Gibbs. "Early Documentary Material on the Pueblo Kachina Cult." *Anthropological Quarterly* 29 (1956): 31–44.

———. "The Kachina Cult of the Pueblo Indians." Ph.D. diss., University of New Mexico, Albuquerque, 1951.

Anderson, Nancy K., with Thomas P. Bruhn, Joni L. Kinsey, and Anne Morand. *Thomas Moran*. Exh. cat. Washington, D.C.: National Gallery of Art; New Haven: Yale University Press, 1997.

Applegate, Frank. "Spanish Colonial Arts." *Survey Graphic* 19 (May 1931): 156–57.

Araeen, Rasheed. "From Primitivism to Ethnic Arts." In *The Myth of Primitivism: Perspectives on Art*, ed. Susan Hiller, 158–92. London: Routledge, 1991.

Archibald, Robert. "Acculturation and Assimilation in Colonial New Mexico." *New Mexico Historical Review* 53 (July 1978): 205–15.

———. "Cañon de Carnué: Settlement of a Grant." *New Mexico Historical Review* 51 (October 1976): 313–28.

Archive of the Archdiocese of Santa Fe. *Books of Baptism, 1720–1776*, B-18. Isleta, New Mexico.

———. *Books of Marriages, 1770–1777*, M-12. Laguna, New Mexico.

———. *Ranchos de Taos*. Unclassified documents. Taos, New Mexico.

Archuleta-Sagel, Teresa. "Textiles." In *Spanish New Mexico: The Spanish Colonial Arts Society Collection*, ed. Donna Pierce and Marta Weigle, 144–62. Santa Fe: Museum of New Mexico Press, 1996.

Auerbach, Herbert S. "Father Escalante's Journal." *Utah Historical Quarterly* 2 (1943): 120–22.

Aune, David E. *Prophecy in Early Christianity and the Ancient Mediterranean World*. Grand Rapids: Eerdmans, 1983.

Austin, Mary. "Mexicans and New Mexico." *Survey Graphic* 19 (May 1931): 141–44, 187–90.

———. "The Spanish Colonial Arts." Manuscript on file at the New Mexico State Records Center and Archives, Pearce Collection, Archive Inventory 255, Box 1, Item 10, Folders 1 and 2.

———. "The Trail of the Blood: An Account of the Penitent Brotherhood of New Mexico." *Century* 108 (May 1924): 35–44.

———, and Frank Applegate. "The Spanish Colonial Arts." Unpublished ms., 1934, at the Zimmerman Library, University of New Mexico.

Awalt, Barbe, and Paul Rhetts. *Our Saints Among Us: 400 Years of New Mexican Devotional Art*. Albuquerque: LPD Press, 1998.

Ayala López, Manuel. "La capilla de Santa Tecla en la S.I.C.B.M. de Burgos." *Boletín de la Comisión de Documentos de Burgos* 4 (1934–37): 388–96.

Babcock, Barbara A. "Introduction." In *The Reversible World: Symbolic Inversion in Art and Society,* ed. and intro. Barbara Babcock, 13–38. Ithaca: Cornell University Press, 1972.

Bailey, Gauvin Alexander. *Art on the Jesuit Missions in Asia and Latin America, 1542–1773.* Toronto: University of Toronto Press, 1999.

———. "The Jesuits and Painting in Italy, 1550–1690: The Art of Catholic Reform." In *Saints and Sinners: Caravaggio and the Baroque Image,* ed. Franco Mormando, 151–78. Boston: McMullen Museum of Art, Boston College; distributed by University of Chicago Press, 1999.

Bailey, Jesse P. *Diego de Vargas and the Reconquest of New Mexico.* Albuquerque: University of New Mexico Press, 1940.

Bailey, L. R. *Indian Slave Trade in the Southwest.* Los Angeles: Westernlore Press, 1966.

Baird, Ellen T. "Adaptation and Accommodation: The Transformation of the Pictorial Text in Sahagun's Manuscripts." In *Native Artists and Patrons in Colonial Latin America,* ed. Emily Umberger and Tom Cummins, 36–51. Special issue of *Phoebus* 7 (1995).

Baird, Joseph A., Jr. "Eighteenth-Century Retables of the Bajío, Mexico: The Querétaro Style." *Art Bulletin* 35, no. 3 (1953): 195–216.

———. "The Ornamental Niche-Pilaster in the Hispanic World." *Journal of the Society of Architectural Historians* 15, no. 1 (1956): 5–11.

———. *Los Retablos del Siglo XVIII en el Sur de España, Portugal, y México.* Mexico City: Universidad Nacional Autónoma de México, 1987.

———. "Style in Eighteenth-Century Mexico." *Journal of Inter-American Studies* 1 (1959): 261–76.

Bakewell, Peter J. *Miners of the Red Mountain: Indian Labor in Potosí, 1545–1560.* Albuquerque: University of New Mexico Press, 1984.

———. *Silver Mining and Society in Colonial Mexico, Zacatecas, 1546–1700.* Cambridge: Cambridge University Press, 1971.

Bakker, Keith. "Aesthetic and Cultural Considerations for the Conservation of Hispanic New Mexican Religious Art." Master's thesis, Antioch University, 1994.

———. "A Reassessment of New Mexican Spanish Colonial Furniture." In *Postprints of the Wooden Artifacts Group,* 47–55. Saint Paul: American Institute for Conservation, June 1995.

Bal, Mieke. "De-disciplining the Eye." *Critical Inquiry* 16 (spring 1990): 506–31.

———, and Norman Bryson. "Semiotics and Art History." *Art Bulletin* 73 (June 1991): 174–208.

Ballesteros Caballero, Floriano. "El retablo mayor del antiguo colegio de la Compañía de Jesús de Burgos." *Boletín del Seminario de Estudios de Arte y Arqueología* (Valladolid: University of Valladolid, Facultad de Filosofía de Letras) (1975): 273–86.

Bantel, Linda, and Marcus B. Burke. *Spain and New Spain: Mexican Colonial Arts in Their European Context.* Corpus Christi: Art Museum of South Texas, 1979.

Bargellini, Clara. *La arquitectura de la plata: Iglesias monumentales del centro-norte, 1640–1750.* Mexico City: Universidad Nacional Autónomo de México, 1991.

Barker, Francis, Peter Hulme, and Margaret Iverson, eds. *Colonial Discourse/Postcolonial Theory.* Manchester: Manchester University Press, 1993.

Barrell, John. *The Political Theory of Painting from Reynolds to Hazlitt: 'The Body of the Public.* New Haven: Yale University Press, 1986.

Barroco de la Nueva Granada: Colonial Art from Colombia and Ecuador. New York: Americas Society, 1992.

Barthes, Roland. *Criticism & Truth.* Ed. and trans. Katrine Pilcher Keuneman, intro. Philip Thody. Minneapolis: University of Minneapolis Press, 1987.

———. *The Pleasure of the Text* (1973). Trans. Richard Miller, ed. Richard Howard. New York: Noonday, 1975.

———. *S/Z* (1970). London: Jonathan Cape, 1974.

Batkin, Jonathan. *Pottery of the Pueblos of New Mexico, 1700–1940.* Colorado Springs: Taylor Museum of the Colorado Springs Fine Arts Center, 1987.

———. "Tourism Is Overrated: Pueblo Pottery and the Early Curio Trade, 1800–1910." In *Unpacking Culture: Art and Commodity in Colonial and Postcolonial Worlds,* ed. Ruth B. Phillips and Christopher B. Steiner. Berkeley and Los Angeles: University of California Press, 1999.

Baxandall, Michael. *Giotto and the Orators: Humanist Observers of Painting in Italy and the Discovery of Pictorial Composition.* Oxford: Oxford University Press, 1971.

Baxter, John O. *Las Carneradas: Sheep Trade in New Mexico, 1700–1860.* Albuquerque: University of New Mexico Press, 1987.

Beck, Warren A. *New Mexico: A History of Four Centuries.* Norman: University of Oklahoma Press, 1962.

Bell, Catherine. *Ritual Theory, Ritual Practice.* New York: Oxford University Press, 1992.

Bell, Janis, and Thomas Willette, eds. *Art History in the Age of Bellori: Scholarship and Cultural Politics in Seventeenth-Century Rome.* Cambridge: Cambridge University Press, 2002.

Benavides, Alonso. *The Memorial of Fray Alonso de Benavides.* Trans. Mrs. Edward E. Ayer. Albuquerque: Horn and Wallace, 1965.

Benavides, Alonso de. *Fray Alonso de Benavides; Revised Memorial of 1634.* Ed. and trans. F. W. Hodge, G. P. Hammond, and A. Ray. Albuquerque: University of New Mexico Press, 1945.

———. *The Memorial of Fray Alonso de Benavides, 1630.* Ed. and trans. Frederick W. Hodge and Charles F. Lummis. Chicago: University of Chicago Press, 1966.

Bertranpetit, J., and Luigi Luca Cavalli-Sforza. "A Genetic Reconstruction of the History of the Population of the Iberian Peninsula." *Annals of Human Genetics* 55 (1991): 51–67.

Bhabha, Homi K. "DissemiNation: Time, Narrative, and the Margins of the Modern Nation." In *The Location of Culture*, 139–70. London: Routledge, 1994.

———. "Editor's Introduction: Minority Maneuvers and Unsettled Negotiations." In *Front Lines / Border Posts*, ed. Homi K. Bhabha. Special issue of *Critical Inquiry* 23, no. 3 (1997): 431–59.

———. *The Location of Culture*. London: Routledge, 1994.

———. *Nation and Narration*. London: Routledge, 1990.

Blackwood, Evelyn. "Sexuality and Gender in Certain Native American Tribes: The Case of Cross-Gender Females." *Signs* 10, no. 1 (1984): 27–42.

Bloom, Lansing B. "Bourke on the Southwest." *New Mexico Historical Review* 8, no. 1 (1933); 9, nos. 1, 2, 3, 4 (1934); 10, nos. 1, 4 (1935); 11, nos. 1, 2, 3 (1936); 12, no. 3 (1937); 12, nos. 1, 4 (1938); 13, no. 2 (1939).

———. "New Mexico Under Mexican Administration, 1821–1846." *Old Santa Fe* 1, no. 1 (1913): 10–49.

———. "A Trade Invoice of 1638 for Goods Shipped by Governor Rosas from Santa Fe." *New Mexico Historical Review* 10, no. 3 (1935): 242–48.

Bol, Marsha C. "The Anonymous Artist of Laguna and the New Mexican Colonial Altar Screen." Master's thesis, University of New Mexico, 1980.

Bolton, Herbert E. "The Mission as a Frontier Institution in the Spanish American Colonies." *American Historical Review* 23 (1918): 42–61.

Bonfiglioli, Carlo. *Fariseos y Matachines en la Sierra Tarahumara: Entre la Pasión de Cristo, la Transgresión cómico-sexual, y las Danzas de Conquista*. México City: Instituto Nacional Indigenista, 1995.

Boone, Elizabeth Hill, and Walter D. Mignolo, eds. *Writing Without Words: Alternative Literacies in Mesoamerica and the Andes*. Durham: Duke University Press, 1994.

Borges, Pedro. *Métodos Misionales en la Cristianición de América, Siglo XVI*. Madrid: Consejo Superior de Investigaciones Científicas, Departamento de Misionología Española, 1960.

Borhegyi, Stephen F. *The Miraculous Shrines of Our Lord of Esquípulas in Guatemala and Chimayó, New Mexico*. Santa Fe: Spanish Colonial Arts Society, 1956. (Originally published in *El Palacio*, 60, no. 3 [1953]: 83–111)

Bourdieu, Pierre. *The Field of Cultural Production: Essays on Art and Literature*. Ed. and intro. Randal Johnson. New York: Columbia University Press, 1993.

———. "The Historical Genesis of Pure Aesthetic." *Journal of Aesthetics and Art Criticism* 47 (1987): 201–10.

———. *Outline of a Theory of Practice* (1972). Trans. Richard Nice. Cambridge: Cambridge University Press, 1977.

———. *The Rules of Art: Genesis and Structure of the Literary Field* (1992). Trans. Susan Emanuel. Stanford: Stanford University Press, 1995.

Bourke, Captain John Gregory. *The Snake Dance of the Moquis of Arizona. . . . with a description of The Manners and Customs of this Peculiar People, and especially of the revolting religious rite, The Snake-Dance; to which is added a brief dissertation upon serpent-worship in general with an account of the Tablet Dance of the Pueblo of Santo Domingo, New Mexico, etc.* New York: Charles Scribner's Sons, 1884.

Boyd, E. "The Conservation of New Mexico Santos and Other Painted and Gessoed Objects." *El Palacio* 81, no. 2 (1975): 11–24. (Reprinted from *El Palacio* 74, no. 4 [1967])

———. "The Literature of Santos." *Southwest Review* 35, no. 2 (1950): 128–40.

———. *The New Mexican Santero*. Santa Fe: Museum of New Mexico Press, 1969.

———. "The Plaza of San Miguel del Vado." *El Palacio* 77, no. 4 (1971): 17–27.

———. *Popular Arts of Spanish New Mexico*. Santa Fe: Museum of New Mexico Press, 1974.

———. *Saints and Saint Makers of New Mexico* (1946). Rev. and ed. Robin Farwell Gavin, foreword Donna Pierce, appendix Charles Carillo. Santa Fe: Western Edge Press, 1998.

———. "San Vicente Ferrer, A Rare Santero Subject." *El Palacio* 57, no. 7 (1950): 195–97.

———, Papers. Archives of American Art, Smithsonian Institution Press, Washington, D.C.

Boyd-Bowman, Peter. "Patterns of Spanish Emigration to the Indies Until 1600." *Hispanic American Historical Review* 56, no. 4 (1976): 580–604.

———. "Two Country Stores in Seventeenth-Century Mexico." *The Americas* 28 (1972): 237–51.

Breining, Daniel. *Dramatic and Theatrical Censorship of Sixteenth-Century New Spain*. Lewiston: The Edwin Mellen Press, 2002.

Briggs, Charles L. "To Talk in Different Tongues: The 'Discovery' and 'Encouragement' of Hispano Woodcarvers by Santa Fe Patrons, 1919–1945." In *Hispanic Crafts of the Southwest*, ed. William Wroth, 37–51. Colorado Springs: Taylor Museum of the Colorado Springs Fine Arts Center, 1977.

———. *The Wood Carvers of Córdova, New Mexico: Social Dimensions of an Artistic "Revival."* Knoxville: University of Tennessee Press, 1980; Albuquerque: University of New Mexico Press, 1989.

Brody, J. J. *Anasazi and Pueblo Painting*. Albuquerque: University of New Mexico Press, 1991.

———. *Indian Painters and White Patrons*. Albuquerque: University of New Mexico Press, 1971.

———. "Kachina Images in American Art: The Way of the Doll." In *Kachinas in the Pueblo World*, ed. Polly Schaafsma, 147–60. Albuquerque: University of New Mexico Press, 1994.

———, and Rita Swentzell. *To Touch the Past: The Painted Pottery of the Mimbres People*. Intro. Lyndel King. Exh. cat. New York: Hudson Hills Press in association with Frederick R. Weisman Art Museum at the University of Minnesota, Minneapolis, 1996.

Brown, Karen McCarthy. *Mama Lola: A Voudou Priestess in*

Brooklyn. Berkeley and Los Angeles: University of California Press, 1991.

Brown, Lorin W. *Hispano Folklife of New Mexico.* Ed. Charles L. Briggs and Marta Weigle. Albuquerque: University of New Mexico Press, 1978.

Brown, Peter. *The Cult of the Saints: Its Rise and Function in Latin Christianity.* Chicago: University of Chicago Press, 1981.

Brugge, David M. "Navajo Archaeology—A Promising Past." In *The Archaeology of Navajo Origins,* ed. Ronald H. Towner, 255–71. Salt Lake City: University of Utah Press, 1996.

———. "Navajo Prehistory and History to 1850." In *Handbook of North American Indians,* ed. Alfonso Ortiz, 10:489–501. Washington D.C.: Smithsonian Institution Press, 1983.

———. *Navajos in the Church Records of New Mexico, 1694–1875.* Tsaile, Ariz.: Navajo Community College Press, 1985.

Bundy, M. W. *Theories of the Imagination in Classical and Medieval Thought.* Illinois Studies in Language and Literature 12, nos. 2–3. Urbana: University of Illinois, 1927.

Bunim, Miriam. *Space in Medieval Painting and the Forerunners of Perspective.* New York: Columbia University Press, 1940.

Bunzel, Ruth. *Chichicastenango: A Guatemalan Village.* Americfan Ethnological Society Publications, XXII, 1953.

———. *The Pueblo Potter: A Study of the Creative Imagination in Primitive Art* (1929). Reprint New York: Dover Publications, 1972.

Burke, Marcus B. "A Mexican Artistic Consciousness." In *Mexico: Splendors of Thirty Centuries,* intro. Octavio Paz, 321–23. New York: The Metropolitan Museum of Art and Bullfinch Press, 1990.

———. "Mexican Painting of the Renaissance and Counter-Reformation." In *Mexico: Splendors of Thirty Centuries,* intro. Octavio Paz, 286–314. New York: The Metropolitan Museum of Art and Bullfinch Press, 1990.

———. "On the Spanish Origins of Mexican Retablos." In *Art and Faith in Mexico: The Nineteenth-Century Retablo Tradition,* ed. Elizabeth Zarur and Charles Lovell, 39–45. Albuquerque: University of New Mexico Press, 2001.

———. "Painting: The Eighteenth-Century Mexican School." In *Mexico: Splendors of Thirty Centuries,* intro. Octavio Paz, 360–63. New York: The Metropolitan Museum of Art and Bullfinch Press, 1990.

———. *Pintura y escultura en Nueva España: El barroco, Arte Novo-hispano.* Mexico City: Grupo Azabache, 1992.

———. *Treasures of Mexican Colonial Painting: The Davenport Museum of Art Collection.* Santa Fe: Museum of New Mexico Press, 1998.

Burke, Peter. "Aby Warburg as Historical Anthropologist." In *Aby Warburg: Akten des internationalen Symposions Hamburg, 1990,* ed. H. Bredekamp, M. Diers, and C. Schoell-Glass, 39–44. Weinheim: VCH, 1991.

——— "History and Anthropology in 1900." In *Photographs at the Frontier: Aby Warburg in America, 1895–1896,* ed.

Benedetta Cestelli Guidi and Nicholas Mann, 20–27. London: Merrell Holberton with Warburg Institute, 1998.

Burkhart, Louise. "A Nahuatl Religious Drama of c. 1590." *Latin American Indian Literatures Journal: A Review of American Indian Texts and Studies* 7 (fall 1991): 153–71.

———. *The Slippery Earth: Nahua-Christian Moral Dialogue in Sixteenth-Century Mexico.* Tucson: University of Arizona Press, 1989.

Burkhart, Louise M. *Holy Wednesday: A Nahua Drama from Early Colonial Mexico.* Philadelphia: University of Pennsylvania Press, 1996.

Burns, Kathryn. *Colonial Habits: Convents and the Spiritual Economy of Cuzco, Peru.* Durham: Duke University Press, 1999.

Bustamante, Adrian. "'The Matter Was Never Resolved': The Casta System in Colonial New Mexico, 1693–1823." *New Mexico Historical Review* 66, no. 2 (1991): 143–64.

Bynum, Carolyn Walker. *Jesus as Mother: Studies in the Spirituality of the High Middle Ages.* Berkeley and Los Angeles: University of California Press, 1982.

Cahill, Holger. "Folk Art: Its Place in the American Tradition." *Parnassus* 4 (March 1932): 1–4.

———. "Introduction." In *New Horizons in American Art,* 41. New York: Museum of Modern Art, 1936.

Campbell, Colin. *The Romantic Ethic and the Spirit of Modern Consumerism.* Oxford: Basil Blackwell, 1987.

Candelaria, Juan. "Noticias Que Da Juan Candelaria. . . ." *New Mexico Historical Review* 4 (July 1929): 274–97.

Canons and Decrees of the Council of Trent. Trans. H. J. Schroeder. Saint Louis: B. Herder, 1941.

Carlson, Roy L. *Eighteenth-Century Navajo Fortresses of the Gobernador District.* Series in Anthropology, no. 10. Boulder: University of Colorado Press, 1965.

Carrier, David. "Perspective as a Convention: On the Views of Nelson Goodman and Ernst Gombrich." *Leonardo* 13 (1980): 283–87.

Carrillo, Charles M. "Appendix E: A Saint Maker's Palette." In E. Boyd, *Saints and Saint Makers of New Mexico,* 99–104.

———. *Hispanic New Mexican Pottery: Evidence of Craft Specialization, 1790–1890.* Albuquerque: LPD Press, 1997.

———. "Introduction." In *The Index of American Design,* ed. Erwin O. Christensen, ix–xviii.

Carroll, Charles D. "Miguel Aragón, A Great Santero." *El Palacio* 50, no. 3 (1943): 49–64.

Carroll, H. Bailey, and J. Villasana Haggard, trans. and eds. *Three New Mexico Chronicles: The exposición of don Pedro Bautista Pino, 1812; The Ojeada of Lic. Antonio Barriero, 1832; and the additions by don José Agustín de Escudero, 1849.* Quivira Society Publications, vol. 2. Albuquerque: Quivira Society, 1942.

Cash, Marie Romero. *Built of Song and Earth: Churches of Northern New Mexico.* Photographs Jack Parsons. Santa Fe: Red Crane Press, 1993.

————. *Santos: Enduring Images of Northern New Mexican Village Churches*. Niwot: University Press of Colorado, 1999.

Cassidy, Ina Sizer. "Art and Artists of New Mexico." *New Mexico Magazine* 14, November 1936, 25.

————. "Santos and Bultos in the Spanish Archives." *El Palacio* 59, no. 2 (1952): 51–56.

Cavalli-Sforza, Luigi Luca, and Francesco Cavalli-Sforza. *The Great Human Diasporas*. Reading, Mass.: Addison-Wesley, 1995.

————, Paolo Menozzi, and Alberto Piazza. *The History and Geography of Human Genes*. Princeton: Princeton University Press, 1994.

Caygill, Howard. *Art of Judgement*. Oxford: Basil Blackwell, 1989.

Celebrating the Medieval Heritage: A Colloquy on the Thought of Aquinas and Bonaventure. Ed. David Tracy. Chicago: University of Chicago Press, 1978.

Cesaire, Aimé. *Return to My Native Land*. Trans. Emil Snyder. Paris: Présence africaine 1968.

Cestelli Guidi, Benedetta. "Retracing Aby Warburg's American Journey Through His Photographs." In *Photographs at the Frontier: Aby Warburg in America, 1895–1896,* ed. Benedetta Cestelli Guidi and Nicholas Mann, 28–47. London: Merrell Holberton with Warburg Institute, 1998.

The Chapel of Our Lady of Talpa. Colorado Springs: Taylor Museum of Colorado Springs Fine Arts Center, 1979.

Chapman, Kenneth M. "The Evolution of the Bird in Decorative Art." *Art and Archaeology* 4 (December 1916): 307–16.

Chartier, Roger. *The Cultural Uses of Print in Early Modern France*. Trans. Lydia G. Cochrane. Princeton: Princeton University Press, 1987.

Chávez, Fray Angélico. "The Carpenter Pueblo." *New Mexico Magazine,* September–October 1971, 26–33.

————. "Comments Concerning 'Tomé and Father J.B.R.'" *New Mexico Historical Review* 31 (January 1956): 68–74.

————. *La Conquistadora: The Autobiography of an Ancient Statue*. Paterson, N. J.: Saint Anthony Guild Press, 1954.

————. "Genízaros." In *Handbook of North American Indians,* ed. Alfonso Ortiz, 9:198–200. Washington, D.C.: Smithsonian Institution Press, 1979.

————. "Girón de Tejada Family of Artists." Fray Angélico Chávez Papers, History Library, Palace of the Governors, Museum of New Mexico, Santa Fe, New Mexico.

————. "Pohé-Yemo's Representative and the Pueblo Revolt of 1680." *New Mexico Historical Review* 42 (April 1967): 85–126.

————, O.F.M. *Archives of the Archdiocese of Santa Fe, 1678–1900*. Washington, D.C.: Academy of American Franciscan History, 1957.

————. *New Mexico Roots, Ltd.: A Demographic Perspective from Genealogical Historical and Geographical Data Found in the Diligencias Matrimoniales or Pre-Nuptial Investigations (1678–1869) of the Archives of the Archdiocese of Santa Fe; Multiple data extracted, and here edited in a uniform presentation by years and family surnames*. 11 vols. Santa Fe: n.p., 1982.

————. *Origins of New Mexico Families in the Spanish Colonial Period in Two Parts: The Seventeenth Century (1598–1693), and the Eighteenth Century (1693–1821)*, 1954. Reprint Santa Fe: Museum of New Mexico Press, 1992.

Chávez, Fray Angélico, and the Archdiocese of Santa Fe. *The Lord and New Mexico*. Albuquerque: Starline Creative Printing, 1976.

Chávez, Fray Angélico, ed., trans., and annotator. *Diligencias Matrimoniales (1678–1869) of the Archives of the Archdiocese of Santa Fe*. Santa Fe: New Mexico Roots Ltd, 1982. Microfiche ed., University of New Mexico Special Collections.

Cheney, Sheldon, and M. Candler. "Santos—An Enigma of American Native Art." *Parnassus* 7 (May 1935): 22–24.

Chevalier, François. *Land and Society in Colonial Mexico: The Great Hacienda*. Berkeley and Los Angeles: University of California Press, 1963.

Chorpenning, Joseph F., ed. *Mexican Devotional Retablos from the Peters Collection*. Philadelphia: Saint Joseph's University, 1994.

Chow, Rey. *Ethics After Idealism: Theory-Culture-Ethnicity-Reading*. Bloomington: Indiana University Press, 1998.

Christensen, Erwin O., ed. *The Index of American Design*. Washington, D.C.: National Gallery of Art, 1950.

Christian, William A., Jr. *Local Religion in Sixteenth-Century Spain*. Princeton: Princeton University Press, 1981.

———— *Visionaries: The Spanish Republic and the Reign of Christ*. Berkeley and Los Angeles: University of California Press, 1996.

Church of Jesus Christ of Latter-day Saints, Genealogical Library, Asunción Sagrario, Mexico City, Mexico. Marriages, 1688–1701, microfilm no. 003527.

Clendinnen, Inga. *Ambivalent Conquests: Maya and Spaniard in Yucatan, 1517–1570*. Cambridge: Cambridge University Press, 1987.

Clifford, J., and G. E. Marcus, eds. *Writing Culture: The Poetics and Politics of Ethnography*. Berkeley and Los Angeles: University of California Press, 1986.

Clifford, James. *The Predicament of Culture*. Cambridge: Harvard University Press, 1988.

————. *Routes: Travel and Translation in the Late Twentieth Century*. Cambridge: Harvard University Press, 1998.

Colahan, Clark, and Francisco A. Lomelí. "Miguel de Quintana: An Eighteenth-Century Poet Laureate?" In *Paso por Aquí, Critical Essays on the New Mexican Literary Tradition, 1542–1988,* ed. Erlinda González-Berry. Albuquerque: University of New Mexico Press, 1989.

Colie, Rosalie. *'Paradoxia Epidemica': The Renaissance Tradition of Paradox*. Princeton: Princeton University Press, 1966.

Colligan, John B. *The Juan Páez Hurtado Expedition of 1695: Fraud in Recruiting Colonists for New Mexico*. Albuquerque: University of New Mexico Press, 1995.

————. "Vargas' 1693 Recruits for the Resettlement of New

Mexico." *Genealogical Journal: Society of Historical and Ancestral Research,* ed. Raul J. Guerra, 2 (1995): 169–215.

Colonial Art of Peru: A Selection of Works from the Collection of Marshall B. Coyne. Exh. cat. Washington, D.C.: Museum of Modern Art of Latin America, 1980.

Colonial Mexican and Popular Religious Art: Selections from the Permanent Collection of the Mexican Museum. Exh. cat. San Francisco: Mexican Museum, 1990.

Colton, Harold S. *Hopi Kachina Dolls.* Albuquerque: University of New Mexico Press, 1949.

Connelly, John C. "Hopi Social Organization." In *Handbook of North American Indians: The Southwest,* ed. Alfonso Ortiz, 9:539–53. Washington, D.C. U.S.: Government Printing Office, 1979.

Cooper, J. C. *An Illustrated Encyclopedia of Traditional Symbols.* New York: Thames and Hudson, 1978.

Cooper, Necia Grant, ed. *The Human Genome Project: Deciphering the Blueprint of Heredity.* Mill Valley, Calif.: University Science Books, 1994.

Cope, R. Douglas. *The Limits of Racial Domination.* Madison: University of Wisconsin Press, 1994.

Corbin, Henry. *History of Islamic Philosophy.* Trans. Liadain Sherrard. London: Kegan Paul International, 1993.

Cordell, Linda. *Archaeology of the Southwest.* 2d ed. San Diego: Academic Press, 1997.

Cordell, Linda S., and George J. Gumerman. "Cultural Interaction in the Prehistoric Southwest." In *Dynamics of Southwest Prehistory,* ed. Linda S. Cordell and George J. Gumerman, 1–18. Washington, D.C.: Smithsonian Institution Press, 1989.

———, and Vincent J. Yannie. "Ethnicity, Ethnogenesis, and the Individual: A Processual Approach Toward Dialogue." In *Processual and Postprocessual Archaeologies: Multiple Ways of Knowing the Past,* ed. Robert W. Preucel, 96–107. Center for Archaeological Investigations, Occasional Paper no. 10. Carbondale: Southern Illinois University, 1991.

Cordova, Gilberto Benito. "Missionization and Hispanicization of Santo Thomas Apostol de Abiquiu, 1750–1770." Ph.D. diss., University of New Mexico, 1979.

Cormack, Robin. *Painting the Soul: Icons, Death Masks, and Shrouds.* London: Reaktion Books, 1997.

Cosentino, Donald J., ed. *Sacred Arts of Haitian Vodou.* Exh. cat. Los Angeles: UCLA Fowler Museum of Cultural Anthropology, 1995.

Coulter, Lane, and Maurice Dixon Jr. *New Mexican Tinwork, 1840–1940.* Albuquerque: University of New Mexico Press, 1990.

Coward, Rosalind, and John Ellis. *Language and Materialism: Developments in Semiology and the Theory of the Subject.* London: Routledge & Kegan Paul, 1977.

Cramaussel, Chantal. "Ilegítimos y Abandonados en la Frontera Norte: Parral y San Bartolomé en el siglo XVII." *Colonial Latin American Historical Review* 4 (fall 1995): 405–438.

Craver, Rebecca McDowell. *The Impact of Intimacy: Mexican-Anglo Intermarriage in New Mexico, 1821–1846.* Southwestern Studies, monograph no. 66. El Paso: Texas Western Press, 1982.

Crews, Mildred, Wendell Anderson, and Judson Crews. *Patrocinio Barela: Taos Wood Carver.* 3d ed. Taos: Taos Recordings and Publications, 1976.

The Cross and the Sword [La cruz y la espada], ed. Jean Stern. Exh. cat. San Diego: Fine Arts Gallery, 1976.

Crotty, Helen. "Protohistoric Anasazi Kiva Murals: Variation in Imagery as a Reflection of Differing Social Contexts." *Archaeology, Art, and Anthropology Papers in Honor of J. J. Brody,* ed. M. Duran and D. Kirkpatrick. *Archaeological Society of New Mexico* 18 (1992): 51–61.

Cruz, Francisco Santiago. *La nao de China.* Mexico City: Editorial Jus, 1962.

Csikzentmihályi, Mihályi, and Eugene Rochberg-Halton. *The Meaning of Things: Domestic Symbols and the Self.* New York: Cambridge University Press, 1981.

Cummins, Tom. "From Lies to Truth: Colonial Emphasis and the Act of Crosscultural Translation." In *Reframing the Renaissance: Visual Culture in Europe and Latin America, 1450–1650,* ed. Claire Farago, 152–74. New Haven: Yale University Press, 1995.

Currier and Ives, A Catalogue Raisonné. Vol. 1. Detroit: Gale Research Company, 1984.

Cutter, Donald C. "An Anonymous Statistical Report on New Mexico in 1765." *New Mexico Historical Review* 50 (October 1975): 347–52.

Damrosch, David. "The Aesthetics of Conquest: Aztec Poetry Before and After Cortés." *Representations* 33 (winter 1991): 101–20.

Davidson, Gustav. *A Dictionary of Angels, Including the Fallen Angels.* New York: Free Press, 1967.

Davis, W. W. H. *El Gringo or, New Mexico and Her People* (1857). Chicago: Rio Grande Press, 1962.

Davis, Whitney. Response to David, Sterner, and Gavua, "Why Pots Are Decorated." *American Anthropologist* 29, no. 3 (1988): 380–81.

DeBuys, William. *Enchantment and Exploitation: The Life and Hard Times of a New Mexico Mountain Range.* Albuquerque: University of New Mexico Press, 1985.

de Certeau, Michel. *The Writing of History* (1975). Trans. Tom Conley. New York: Columbia University Press, 1988.

De Huff, Elizabeth. "Santos y Bultos." *Touring Topics* (1930): 50–51, 56.

de la Maza, Francisco. *Las tesis empresas de la Antigua Universidad de México.* Mexico City: Imprenta Universitaria, 1944.

Dean, Carolyn. *Inka Bodies and the Body of Christ: Corpus Christi in Colonial Cuzco, Peru.* Durham: Duke University Press, 1999.

——— "The Renewal of Old World Images and the Creation of Colonial Peruvian Visual Culture." In *Converging Cultures:*

Art and Identity in Spanish America, ed. Diane Fane, 171–82. New York: Brooklyn Museum, 1996.

Dean, Carolyn S. "Copied Carts: Spanish Prints and Colonial Peruvian Paintings." *Art Bulletin* 78, no. 1 (1996): 98–110.

Delen, A. J. J. *Histoire de la gravure dans les anciens Pays-Bas et dans les provinces belges: Des origines jusqu'à la fin du XVIIIe siècle,* pt. 2. Paris: F. de Nobele, 1969.

Deloria, Philip J. *Playing Indian.* New Haven: Yale University Press, 1998.

Deloria, Vine, Jr. *Custer Died for Your Sins: An Indian Manifesto,* 1969. Reprint Norman: University of Oklahoma Press, 1988.

———. *Red Earth, White Lies: Native Americans and the Myth of Scientific Fact.* New York–Singapore: Scribner, 1995.

Derrida, Jacques. *Archive Fever: A Freudian Impression.* Trans. Eric Prenowitz. Chicago: University of Chicago Press, 1996.

———. *Ethics, Institutions, and the Right to Philosophy I.* Trans. and ed. Peter Pericles Triforas. Lanham: Rowman and Littlefield, 1997.

Dickey, Roland. *New Mexico Village Arts,* 1949. Reprint Albuquerque: University of New Mexico Press, 1990.

Dockstader, Frederick J. *The Kachina and the White Man: The Influences of White Culture on the Hopi Kachina Religion.* Rev. ed. Albuquerque: University of New Mexico Press, 1985.

Domínguez, Francisto Atanasio. *The Missions of New Mexico, 1776: A Description by Fray Francisco Atanasio Dominguez with Other Contemporary Documents.* Ed. and trans. Eleanor Adams and Fray Angélico Chávez. Albuquerque: University of New Mexico Press, 1956.

Donahue, Kelly. "An Odyssey of Images: The Flemish, Spanish and New Spanish Print Sources of New Mexican Colonial Hide Paintings." Master's thesis, University of New Mexico, 1994.

Donahue-Wallace, Kelly. "*La casada imperfecta:* A Woman, a Print, and the Mexican Inquisition." *Mexican Studies/Estudios Mexicanos* 18, no. 2 (2002): 231–50.

———. "An Odyssey of Images: The Flemish, Spanish, and New Spanish Print Sources of New Mexican Colonial Hide Paintings." In *The Segesser Hides: An Anthology.* Unpublished ms. Palace of the Governors History Library, Santa Fe.

———. "The Print Sources of New Mexican Colonial Hide Paintings." *Anales del Instituto de Investigaciones Estéticas* 68 (1996): 43–69.

———. "Prints and Printmakers in Viceregal Mexico City, 1600–1800." Ph.D. diss., University of New Mexico, 2000.

Doñes y Promesas: 300 años de arte ofrenda (ex votos mexicanos). Ed. Elin Luque Agraz and Michele Beltrán. Exh. cat. Mexico City: Centro Cultural, Arte Contemporaneo, Fondacíon Cultural Televisa, 1996.

Doss, Erika. *Elvis Culture: Fans, Faith, and Image.* Lawrence: University Press of Kansas, 1999.

Dozier, Edward P. "Comment, On Spanish Acculturation in the Southwest by Edward Spicer." *American Anthropologist* 56, no. 4 (1954): 680–83.

———. *The Pueblo Indians of North America.* New York: Holt, Rinehart and Winston, 1970.

———. "Spanish-Catholic Influences on Rio Grande Pueblo Religion." *American Anthropologist* 60, no. 3 (1958): 441–48.

Du Gue Trapier, Elizabeth. *Ten Panels Probably Executed by the Indians of New Mexico.* Pamphlet printed by the trustees of the Hispanic Society of America. New York, 1926.

Dutton, Bertha P. *Sun Father's Way.* Albuquerque: University of New Mexico Press, 1963.

Eco, Umberto. *The Limits of Interpretation.* Bloomington: Indiana University Press, 1990.

Edgerton, Samuel Y. *Theaters of Conversion: Mendicant Friars and Indian Artists in Sixteenth-Century Mexico.* Photographs Jorge Pérez de Lara. Albuquerque: University of New Mexico Press, 2001.

Elkins, James. *The Object Stares Back: On the Nature of Seeing.* New York: Harcourt, Brace, 1996.

Ellis, Florence Hawley. "Comment: The Santeros of Tomé." *New Mexico Quarterly* 24, no. 3 (1954): 346–53.

———. *San Gabriel del Yunque: Window on the Prespanish Indian World.* Santa Fe: Sunstone Press, 1988.

Ellis, F. H., and J. J. Brody. "Ceramic Stratigraphy and Tribal History of Taos Pueblo." *American Antiquity* 29 (1964): 316–27.

Elmore, Francis. *Ethnobotany of the Navajo.* Monographs of the School of American Research, no. 8. Santa Fe, 1944.

Emmer, C. E. "Kitsch Against Modernity." *Art Criticism* 13, no. 1 (1998): 57–58.

Espinosa, Carmen. *Shawls, Crinolines, Filigree: The Dress and Adornment of the Women of New Mexico, 1739–1900.* El Paso: Texas Western Press, 1970.

Espinosa, Gilbert. "New Mexican Santos." *New Mexico Quarterly Review* 6 (August 1936): 181–89.

Espinosa, J. Manuel. *Crusaders of the Rio Grande: The Story of Don Diego de Vargas and the Reconquest and Refounding of New Mexico.* Chicago: Institute of Jesuit History, 1942.

———. *The Pueblo Indian Revolt of 1696 and the Franciscan Missions in New Mexico: Letters of the Missionaries and Related Documents.* Norman: University of Oklahoma Press, 1988.

Espinosa, José E. *Saints in the Valleys: Christian Sacred Images in the History, Life, and Folk Art of Spanish New Mexico.* Albuquerque: University of New Mexico Press, 1960. Rev. ed. 1967.

Esquibel, José Antonio. "Mexico City to Santa Fe: Spanish Pioneers on the Camino Real, 1693–94." In *Camino Real de la Tierra Adentro,* ed. Gabrielle Palmer and Stephen Fosberg, 55–70. Santa Fe: Bureau of Land Management, Cultural Resources Series no. 13, 1999.

———. *Remembrance/Recordación: The Spanish Colonists That Arrived in Santa Fe, 23 June 1694.* Denver: Genealogical Society of Hispanic America, 1994.

———, and Charles M. Carrillo. *A Tapestry of Kinship: The Web*

of Influence Among Escultores and Carpinteras in the Parish of Santa Fe, 1790–1860. Albuquerque: LPO Press, 2004.

———, and John B. Colligan. The Spanish Recolonization of New Mexico: An Account of the Families Recruited at Mexico City in 1693. Albuquerque: New Mexico Genealogical Research Center, 1999.

Esteva-Fabregat, Claudio. Mestizaje in Ibero-America. Trans. John Wheat. Tucson: University of Arizona Press, 1995.

Evans, Anne. "A Christmas Pilgrimage in the Southwest." Anne Evans Collection, Colorado Historical Society, Denver, Colorado.

Evenett, H. O. The Spirit of the Counter-Reformation, ed. J. Bossy. Notre Dame: University of Notre Dame Press, 1975.

Ewing, Virginia Hunter. "Some Memories Concerning New Mexico's WPA–Federal Art Project." Unpublished manuscript, n.d.

Fabian, Johannes. Time and the Other: How Anthropology Makes Its Object. New York: Columbia University Press, 1983.

Fane, Diana, et al. Converging Cultures: Art and Identity in Spanish America. New York: Brooklyn Museum and Harry Abrams, 1996.

Fanon, Frantz. The Wretched of the Earth. Trans. Constance Farrington, preface Jean-Paul Sartre. New York: Grove Press, 1966.

Farago, Claire. "The Classification of the Visual Arts During the Renaissance." In The Shapes of Knowledge from the Renaissance to the Enlightenment, ed. D. R. Kelley and R. H. Popkin, 25–47. The Netherlands: Kluwer, 1991.

———. "Jean de Léry's Anatomy Lesson: The Persuasive Power of Word and Image in Constructing the Ethnographic Subject." In European Iconography East & West, ed. G. Szöny, 109–27. Leiden: E. J. Brill, 1995.

———. Leonardo da Vinci's Paragone: A Critical Interpretation with a New Edition of the Text in the Codex Urbinas. Leiden: E. J. Brill, 1992.

———. "Prints and the Pauper: Artifice, Religion, and Free Enterprise in Popular Sacred Art." In Art and Faith in New Mexico: The Nineteenth-Century Retablo Tradition, ed. Elizabeth Netto Calil Zarur and Charles Muir Lovell, 47–56. Albuquerque: University of New Mexico Press, 2001.

———. "Silent Moves: Locating the Ethnographic Subject in the Discourse of Art History." In Art History and Its Institutions, ed. Elizabeth Mansfield, 191–214. London: Routledge, 2002.

———. " 'Vision Itself Has Its History': 'Race,' Nation, and Renaissance Art History." In Reframing the Renaissance, ed. and intro. Claire Farago, 67–89. New Haven: Yale University Press, 1995.

———, and Thomas Frangenberg. Art as Institution: Leonardo da Vinci's Abridged Treatise on Painting, 1570–1900: A Study in the History of Reception with a Critical Edition of the Text. Forthcoming.

———, ed. and intro. Reframing the Renaissance: Visual Culture in Europe and Latin America, 1450–1650. New Haven: Yale University Press, 1995.

———, and Robert Zwijnenberg, eds. Compelling Visuality: The Work of Art in and out of History. Minneapolis: University of Minnesota Press, 2003.

Farwell, Beatrice. French Popular Lithographic Imagery, 1815–1870. 12 vols. Chicago: University of Chicago Press, 1981–1997.

Federal Art Project, New Mexico. Portfolio of Spanish Colonial Design in New Mexico. Santa Fe, 1938.

Fermin de Mendinueta, Pedro. Indian and Mission Affairs in New Mexico, 1773. Ed. and trans. Marc Simmons. Santa Fe: Stagecoach Press, 1965.

Fewkes, Jessie Walter. "A Few Summer Ceremonials at the Tusayan Pueblos." Journal of American Ethnology and Archaeology 2 (1892): 1–160.

———. "Two Summers Work in Pueblo Ruins." 22nd Annual Report of the Bureau of American Ethnology, 1900–1901, pt. 1, 1–96. Washington, D.C., 1904.

———. "A Theatrical Performance at Walpi," Washington Academy of Science Proceedings 2 (1900): 80–138.

Fierman, Floyd S. The Spiegelbergs of New Mexico, Merchants and Bankers, 1844–1893. El Paso: Texas Western College Press, 1964.

Fisher, Nora. "Colcha Embroidery." In The Spanish Textile Tradition of New Mexico and Colorado, ed. Nora Fisher, 153–67. Santa Fe: Museum of New Mexico Press, 1979.

———, ed. The Spanish Textile Tradition of New Mexico and Colorado. Santa Fe: Museum of New Mexico Press, 1979.

Foote, Cheryl. "Spanish-Indian Trade along New Mexico's Northern Frontier in the Eighteenth Century." Journal of the West 24 (1985): 22–33.

Foote, Cheryl J., and Sandra K. Schackel. "Indian Women of New Mexico, 1535–1680." In New Mexico Women, Intercultural Perspectives, ed. Joan M. Jensen and Darlis A. Miller, 17–40. Albuquerque: University of New Mexico Press, 1986.

Ford, Karen. Las Yerbas de la Gente. Ann Arbor, 1975.

Ford, Richard I., ed. An Ethnobiology Source Book: The Uses of Plants and Animals by American Indians. Ed. and intro. Richard I. Ford. New York: Garland, 1986.

Forrest, John. Morris and Matachin: A Study in Comparative Choreography. Sheffield, England: CECTAL, 1984.

Forster, Kurt. "Aby Warburg: His Study of Ritual and Art on Two Continents." Trans. David Britt. October 77 (summer 1996): 5–24.

———. "Introduction." In Aby Warburg: The Renewal of Pagan Antiquity: Contributions to the Cultural History of the European Renaissance. Trans. David Britt, 1–75. Los Angeles: Getty Center for the History of Art and the Humanities, 1999.

Foucault, Michel. The Archaeology of Knowledge and the Discourse on Language. Trans. M. Sheridan Smith. New York: Pantheon Books, 1972.

———. "Of Other Spaces." Diacritics 16, no. 1 (1986): 22–28.

Frank, Larry. *New Kingdom of the Saints: Religious Art of New Mexico, 1780–1907.* Santa Fe: Red Crane Press, 1992.

——, and Francis H. Harlow. *Historic Pottery of the Pueblo Indians, 1600–1800.* 2d ed. West Chester: Schiffer, 1990.

Frank, Ross. "The Changing Pueblo Indian Pottery Tradition: The Underside of Economic Development in Late Colonial New Mexico, 1750–1820." *Journal of the Southwest* 33, no. 3 (1991): 282–321.

Frank, Ross Harold. "From Settler to Citizen: Economic Development and Cultural Change in Late Colonial New Mexico, 1750–1820." Ph.D. diss., University of California, 1992.

Freedberg, David. *The Power of Images: Studies in the History and Theory of Response.* Chicago: University of Chicago Press, 1989.

Freese, Alison. Response in "Commentaries on Gutierrez, Ramón, *When Jesus Came, the Corn Mothers Went Away.*" *American Indian Culture and Research Journal* 17, no. 3 (1993).

Furst, Jill Leslie McKeever. *The Natural History of the Soul in Ancient Mexico.* New Haven: Yale University Press, 1995.

Gabriel, Stacey B., et al. "The Structure of Haplotype Blocks in the Human Genome." *Science* 296 (June 21, 2002): 2225–29.

Gálvez, María Angeles, and Antonio Ibarra. "Comercio local y circulación regional de importaciones: la Feria de San Juan de los Lagos en la Nueva España." *Historia Mexicana* 46, no. 3 (1997): 581–616.

Galvin Rivera, Mariano. *Concilio III provincial mexicano, 1585.* Barcelona: Imprenta de Manuel Miro y d. Marsa, 1870.

Garate, Donald T. "Basque Names, Nobility, and Ethnicity on the Spanish Frontier." *Colonial Latin American Historical Review* 2 (winter 1993): 77–104.

García Canclini, Néstor. *Hybrid Cultures: Strategies for Entering and Leaving Modernity.* Trans. C. Chiappari and S. López. Minneapolis: University of Minnesota Press, 1995.

García Miranda, Jorge, ed. *Historia del Arte Mexicano.* Vols. 5, 6, 7, and 8, Arte Colonial I, II, III, and IV. Mexico City: Salvat Mexicana de Edicione, 1982.

Gardner, Dore. *Niño Fidencio: A Heart Thrown Open.* Photographs and interviews Dore Gardner; essay Kay F. Turner. Santa Fe: Museum of New Mexico Press, 1992.

Gavin, Robin Farwell. "Santeros of the Río Abajo and the Camino Real." In *El Camino Real de Tierra Adentro* 2, ed. Gabrielle Palmer and Stephen Fosberg, 221–30. Cultural Resources Series no. 13. Santa Fe: New Mexico Bureau of Land Management, 1999.

——. *Traditional Arts of Spanish New Mexico: The Hispanic Heritage Wing of the Museum of International Folk Art.* Santa Fe: Museum of New Mexico Press, 1994.

——, Donna Pierce, and Alfonso Pleguezuelo, eds. *The Story of Spanish and Mexican Mayólica: Cerámica y Cultura.* Albuquerque: University of New Mexico Press, 2003.

Geertz, Armin W. *Hopi Altar Iconography.* Leiden: E. J. Brill, 1987.

——. "Pueblo Cultural History." In *Photographs at the Frontier: Aby Warburg in America, 1895–1896,* ed. Benedetta Cestelli Guidi and Nicholas Mann, 9–19. London: Merrell Holberton with Warburg Institute, 1998.

——, and Michael Lomatuway'ma. *Children of Cottonwood: Piety and Ceremonialism in Hopi Indian Puppetry.* Lincoln: University of Nebraska Press, 1987.

Gerlero, Elena I. E. "La pintura mural durante el virreinato." In *Historia de Arte Mexicano* 7:1011–27. Mexico City: Salvat, 1982.

Gettens, Rutherford J., and Evan H. Turner. "The Materials and Methods of Some Religious Paintings of Early Nineteenth-Century New Mexico." *El Palacio* 53, no. 1 (1951): 3–16.

Gibson, Arrell Morgan. *The Santa Fe and Taos Colonies.* Norman: University of Oklahoma Press, 1983.

Gibson, Charles. *Tlaxcala in the Sixteenth Century.* New Haven: Yale University Press, 1952.

Giffords, Gloria Fraser. *The Art of Private Devotion: Retablo Painting of Mexico.* Principal essay and catalogue Gloria Fraser Giffords, accompanying essays Yvonne Lange, Virginia Armella de Aspe, and Mercedes Meade. Fort Worth: Intercultura; Dallas: Meadows Museum, Southern Methodist University, 1991.

——. *Mexican Folk Retablos.* Rev. ed. Albuquerque: University of New Mexico Press, 1974.

Gill, Sam D., and Irene F. Sullivan. *Dictionary of Native American Mythology.* New York: Oxford University Press, 1992.

Ginzburg, Carlo. *The Cheese and the Worms: The Cosmos of a Sixteenth-Century Miller.* Trans. John and Ann Tedeschi. Baltimore: Johns Hopkins University Press, 1980.

Gisbert, Teresa. *Iconografía y mitos indígenas en el arte.* 2d ed. La Paz, Bolivia: Linea Editorial, Fundacíon BHN, 1994.

Gitlitz, David M. *Secrecy and Deceit: The Religion of the Crypto-Jews.* Philadelphia: Jewish Publication Society, 1996.

Glick-Schiller, Nina. "Introducing Identities: Global Studies in Culture and Power." *Identities* 1, no. 1 (1994): 1–6.

——, Linda Basch, and Cristina Blanc-Szanton, eds. *Towards a Transnational Perspective on Migration: Race, Class, Ethnicity, and Nationalism Reconsidered.* New York: New York Academy of Sciences, 1992.

Gloria in Excelsis: The Virgin and Angels in Viceregal Painting of Peru and Bolivia. Exh. cat. New York: Center for Inter-American Relations, 1986.

Goldstein, Carl. *Visual Fact over Verbal Fiction: A Study of the Carracci and the Criticism, Theory, and Practice of Art in Renaissance and Baroque Italy.* Cambridge: Cambridge University Press, 1988.

Gombrich, E. H. *Aby Warburg: An Intellectual Biography, with a Memoir on the History of the Library by F. Saxl.* Chicago: University of Chicago Press, 1970.

——. *Art and Illusion: A Study in the Psychology of Pictorial Representation.* Bollingen Series 35, no. 5. Princeton: Princeton University Press, 1960.

Gonzales, Edward, and David L. Witt. *Spirit Ascendant: The Art and Life of Patrociño Barela*. Santa Fe: Red Crane Books, 1996.

Graburn, Nelson H. H., ed. *Ethnic and Tourist Arts: Cultural Expressions from the Fourth World*. Berkeley and Los Angeles: University of California Press, 1976.

Greenblatt, Stephen. *Marvelous Possessions: The Wonder of the New World*. Chicago: University of Chicago Press, 1991.

Gregg, Josiah. *Commerce of the Prairies*. Intro. Archibald Hanna. 2 vols. Philadelphia: Lippincott, 1962.

Gruzinski, Serge. *The Conquest of Mexico*. Cambridge: Polity Press, 1993.

———. "Images and Cultural *Mestizaje* in Colonial Mexico: The Incorporation of Indian Societies into the Western World of the Sixteenth–Eighteenth Centuries." *Poetics Today* 16, no. 1 (1995): 53–77.

Gustaf Nordenskiöld: Mesa Verde, 1891. Text Pirjo Vorjola, trans. Gillian Hökli. Exh. cat. Helsinki: National Board of Antiquities, 1992.

Gutiérrez, Ramón A. *When Jesus Came, the Corn Mothers Went Away: Marriage, Sexuality, and Power in New Mexico, 1500–1846*. Stanford: Stanford University Press, 1991.

Hackett, Charles W., ed. *Revolt of the Pueblo Indians of New Mexico and Otermín's Attempted Reconquest, 1680–1682*. 2 vols. Albuquerque: University of New Mexico Press, 1942.

Hackett, Charles Wilson, ed. and trans. *Historical Documents Relating to New Mexico, Nueva Vizcaya, and Approaches Thereto, to 1773*, vol. 3. Washington, D.C.: Carnegie Institution, 1937.

Hale, Constance, ed. *Wired Style: Principles of English Usage in the Digital Age*. San Francisco: HardWired, 1996.

Hall, Thomas D. *Social Change in the Southwest, 1350–1880*. Lawrence: University Press of Kansas, 1988.

Halle, David. *Inside Culture: Art and Class in the American Home*. Chicago: University of Chicago Press, 1986.

Halpern, Richard. "Shakespeare in the Tropics: From High Modernism to New Historicism." *Representations* 13 (winter 1994): 1–26.

Halpert, Edith Gregor. "Folk Art of America Now Has a Gallery of Its Own." *Art Digest* 6, October 1, 1931, 3.

Halseth, Odd S. "Saints of the New World." *International Studio* 94 (September 1929): 32–38.

———. "Venerated Women in Early American History." *New Mexico Magazine* 12, no. 5, May 1934, 14–15, 42–43.

Hammond, George P., and Agapito Rey. *Don Juan de Oñate, Colonizer of New Mexico, 1595–1628*. 2 vols. Albuquerque: University of New Mexico Press, 1953.

———. *The Rediscovery of New Mexico*. Albuquerque: University of New Mexico Press, 1966.

Hanke, Lewis. *Aristotle and the American Indians: A Study in Race Prejudice in the Modern World*. London: Hollis & Carter, 1959.

———. "Pope Paul III and the American Indians." *Harvard Theological Review* 30 (1937): 65–102.

Harlow, Francis H. *Matte Paint Pottery of the Tewa, Keres, and Zuni Pueblos*. Albuquerque: University of New Mexico Press, 1973.

Harris, Jonathon. *Federal Art and National Culture*. New York: Cambridge University Press, 1995.

Haskett, Robert. "Paper Shields: The Ideology of Coats of Arms in Colonial Mexican Primordial Titles." *Ethnohistory* 46 (1996): 99–126.

Hatch, Nathan. *The Democratization of American Christianity*. New Haven: Yale University Press, 1989.

Hawking, Steven. *A Brief History of Time*. Rev. ed. New York: Bantam Books, 1998.

Hawley, Florence. "The Role of Pueblo Social Organization in the Dissemination of Catholicism." *American Anthropologist* 48 (1946): 407–15.

Hayes, Alden C. *The Four Churches of Pecos*. Albuquerque: University of New Mexico Press, 1974.

Hecht, Johanna. "Creole Identity and the Transmutation of European Forms." In *Mexico: Splendors of Thirty Centuries*, intro Octavio Paz, 315–21. New York: The Metropolitan Museum of Art and Bullfinch Press, 1990.

———. "The Liberation of Viceregal Architecture and Design." In *Mexico: Splendors of Thirty Centuries*, intro. Octavio Paz, 357–60. New York: The Metropolitan Museum of Art and Bullfinch Press, 1990.

Heermann, Christian. *Das Begleitbuch zu den Ausstellungen*. Exh. cat. Hohenstein-Ernstthal: Karl-May-Haus, 1995.

Henderson, Alice Corbin. *Brothers of Light: The Penitentes of the Southwest*. Illus. William Penhallow Henderson. New York: Harcourt, Brace, 1937.

Herrin, Judith. *The Formation of Christendom*. Princeton: Princeton University Press, 1987.

Hibben, Frank C. *Kiva Art of the Anasazi at Pottery Mound*. Las Vegas: K. C. Publications, 1975.

———. "Prehispanic Paintings at Pottery Mound." *Archaeology* 13, no. 4 (1960): 267–74.

Hill, Tom, and Hill, Richard, Sr., eds. *Creation's Journey: Native American Identity and Belief*. Washington, D.C.: Smithsonian Institution Press, 1992.

Hinsley, Curtis M. "The World as Marketplace: Commodification of the Exotic at the World's Columbian Exposition, Chicago, 1893." In *Exhibiting Cultures: The Poetics and Politics of Museum Display*, ed. Ivan Karp and Steven D. Lavine, 344–66. Washington, D.C.: Smithsonian Institution Press, 1991.

Hirschkind, Lynn. "History of the Indian Population of Cañar." *Colonial Latin American Historical Review* 4 (summer 1995): 311–42.

Hobsbawm, Eric. *Nations and Nationalism Since 1780: Programme, Myth, Reality*. Cambridge: Cambridge University Press, 1990.

———, and Terence Ranger, eds. *The Invention of Tradition*. Cambridge: Cambridge University Press, 1983.

Hodder, Ian, ed. *The Meaning of Things.* London: Unwin Hyman, 1989.

———. *Symbolic and Structural Archaeology.* Cambridge: Cambridge University Press, 1982.

Hodgen, Margaret. *Early Anthropology in the Sixteenth and Seventeenth Centuries.* Philadelphia: University of Pennsylvania Press, 1964.

Holly, Michael Ann. "Mourning and Method: The State of Art History." *Art Bulletin* 84, no. 4 (2002): 660–69.

Holt, Elizabeth. *A Documentary History of Art,* vol. 1. Princeton: Princeton University Press, 1947.

hooks, bell. *Yearning: Race, Gender, and Cultural Politics.* Boston: South End Press, 1990.

Hordes, Stanley M. "The Sephardic Legacy in New Mexico: A History of the Crypto-Jews." *Journal of the West* 35 (October 1996): 82–90.

Hornung, Clarence P. *Treasury of American Design.* New York: Harry N. Abrams, n.d.

Hotz, Gottfried. *Indian Skin Paintings from the American Southwest.* Norman: University of Oklahoma Press, 1970.

———. *The Segesser Hide Paintings: Masterpieces Depicting Spanish Colonial New Mexico.* Rev. ed. of *Indian Skin Paintings* (1970), new foreword Thomas E. Chávez. Santa Fe: Museum of New Mexico Press, 1991.

Howard, Kathleen L., and Diana F. Pardue. *Inventing the Southwest: The Fred Harvey Company and Native American Art.* Foreword Martin Sullivan. Flagstaff: Northland and Heard Museum, 1996.

Hu-DeHart, Evelyn. *Missionaries, Miners, and Indians.* Tucson: University of Arizona Press, 1981.

Hughes, Anne E. *The Beginnings of Spanish Settlement in the El Paso District.* Berkeley and Los Angeles: University of California Press, 1914.

Hunter, Russell Vernon. "Concerning Patrocinio Barela." In *Art for the Millions: Essays from the 1930s by Artists and Administrators of the WPA Federal Art Project,* ed. Francis V. O'Connor, 96–99. Boston: New York Graphic Society, 1973.

———. "Latin-American Art in U.S.A." *Design* 44 (March 1943): 20–21.

——— Papers. Archives of American Art, Smithsonian Institution Press, Washington, D.C.

Iversen, Margaret. "Saussure Versus Peirce: Models for a Semiotics of Visual Art." In *The New Art History,* ed. A. L. Rees and Frances Borzello, 82–94. Atlantic Highlands, N.J.: Humanities Press International, 1988.

Ivey, James E. "Convento Kivas in the Missions of New Mexico." *New Mexico Historical Review* 73, no. 2 (1998): 121–52.

———. *In the Midst of a Loneliness: The Architectural History of the Salinas Missions.* Southwest Cultural Resources Center Professional Papers, no. 15. Santa Fe: National Park Service, 1988.

———. "Seventeenth-Century Mission Trade on the Camino Real." In *El Camino Real de Tierra Adentro, 1,* ed. Gabrielle G.

Palmer, 41–68. Cultural Resources Series, no. 11. Santa Fe: Bureau of Land Management, 1993.

Jaramillo, Cleofas M. *Shadows of the Past (sombras del pasado),* 1941. Reprint Santa Fe: Ancient City Press, 1980.

John, Elizabeth A. H. *Storms Brewed in Other Men's Worlds.* Lincoln: University of Nebraska Press, 1975.

Johnson, Julie Greer. *The Book in the Americas: The Role of Books and Printing in the Development of Culture and Society in Colonial Latin America.* Exh. cat. Providence: John Carter Brown Library, 1988.

Johnson, Paul E. "The Market Revolution." In *Encyclopedia of American Social History,* ed. Mary Kupiec Cayton, Elliott J. Gorn, and Peter W. Williams, 1:545–60. New York: Scribner, 1993.

Jones, Oakah L., Jr. *Los Paisanos: Spanish Settlers on the Northern Frontier of New Spain.* Norman: University of Oklahoma Press, 1979.

———. *Pueblo Warriors and Spanish Conquest.* Norman: University of Oklahoma Press, 1966.

———. "Rescue and Ransom of Spanish Captives from the Indios Bárbaros on the Northern Frontier of New Spain." *Colonial Latin American Historical Review* 4 (spring 1995): 129–48.

Jones, Pamela M. "Art Theory as Ideology: Gabriele Paleotti's Hierarchical Notion of Painting's Universality and Reception." In *Reframing the Renaissance: Visual Culture in Europe and Latin America, 1450–1650,* ed. Claire Farago, 127–39. New Haven: Yale University Press, 1995.

———. *Federico Borromeo and the Ambrosiana. Art Patronage and Reform in Seventeenth-Century Milan.* Cambridge: Cambridge University Press, 1993.

Jones, Sian. *The Archaeology of Ethnicity: Constructing Identities in the Past and Present.* New York: Routledge, 1997.

Juárez Frías, Fernando. *Retablos populares mexicanos, iconografía religiosa del siglo XIX.* Mexico City: Espejo de Obsidiana, 1991.

Judson, J. Richard, and Carl. van de Velde. *Book Illustration and Title-Pages: Corpus Rubenianum,* pt. 21, vol. 1. London: Harvey Miller–Heyden & Son, 1978.

Kalb, Laurie Beth. *Crafting Devotions: Tradition in Contemporary New Mexico Santos.* Albuquerque: University of New Mexico Press, 1994.

Kamen, Henry. *Inquisition and Society in Spain in the Sixteenth and Seventeenth Centuries.* Bloomington: Indiana University Press, 1985.

Karl-May Hous. *Das Begleitbuch zu den Ausstellungen.* Commentary Christian Heermann. Hohenstein-Ernstthal: Karl-May Haus, 1995.

Karp, Ivan, and Steven D. Lavine, eds. *Exhibiting Cultures: The Poetics and Politics of Museum Display.* Washington, D.C.: Smithsonian Institution Press, 1991.

Katz, Friedrich. *Situación social y económica durante los siglos XV y XVI.* 1966. Mexico City: Cien de México, 1994.

Katzew, Ilona. *New World Orders: Casta Painting and Colonial*

Latin America. New York: Americas Society Art Gallery, 1996.

Kavanagh, Thomas W. *Comanche Political History.* Lincoln: University of Nebraska Press, 1996.

Kelemen, Pál. *Baroque and Rococo in Latin America,* 1951. 2d ed. 2 vols. New York: Dover Publications, 1967.

———. "The Significance of the Stone Retable of Cristo Rey." *El Palacio* 61 (1954): 243–72.

Kelly, Henry Warren. *Franciscan Missions of New Mexico, 1740–1760.* Albuquerque: University of New Mexico Press, 1941.

Kemp, Martin. *The Science of Art: Optical Themes in Western Art from Brunelleschi to Seurat.* New Haven: Yale University Press, 1990.

———. "Seeing and Signs: E. H. Gombrich in Retrospect." *Art History* 7 (1984): 228–43.

Kenner, Charles L. *A History of New Mexican–Plains Indian Relations.* Norman: University of Oklahoma Press, 1969.

Kent, Kate Peck. *Navajo Weaving: Three Centuries of Change.* Santa Fe: School of American Research Press, 1985.

Kessell, John L. *Kiva, Cross, and Crown: The Pecos Indians and New Mexico, 1540–1840.* Washington, D.C.: U.S. Department of the Interior, U.S. Government Printing Office, 1979.

———. *The Missions of New Mexico Since 1776.* Albuquerque: University of New Mexico Press, 1980.

———. "Restoring Seventeenth-Century New Mexico, Then and Now." *Historical Archaeology* 31 (winter 1997): 46–54.

———, and Rick Hendricks, eds. *By Force of Arms: The Journals of Don Diego de Vargas, New Mexico, 1691–1693.* Albuquerque: University of New Mexico Press, 1992.

———, Rick Hendricks, Meredith D. Dodge, J. Ignacio Avellaneda, Larry D. Miller, and José Antonio Esquibel, eds. *The Royal Crown Restored: The Journals of Don Diego de Vargas, New Mexico, 1692–1694.* Albuquerque: University of New Mexico Press, 1995.

Keuls, Eva. C. *Plato and Greek Painting.* Leiden: E. J. Brill, 1978.

Kidder, A. V. "Ruins of the Historic Period in the Upper San Juan Valley, New Mexico." *American Anthropologist* 22 (1920): 322–29.

Kiev, Ari. *Curanderismo: Mexican-American Folk Psychiatry.* New York, 1968.

King, J. C. H. "Tradition in Native American Art." In *The Arts of the North American Indian: Native Traditions in Evolution,* ed. Edwin L. Wade, 65–92. New York: Hudson Hills Press, 1986.

Klein, Cecelia. "Editor's Statement: Depictions of the Dispossessed." *Art Journal* 49, no. 2 (1990): 106–9.

Klein, Cecelia F. "Wild Woman in Colonial Mexico: An Encounter of European and Aztec Concepts of the Other." In *Reframing the Renaissance: Visual Culture in Europe and Latin America, 1450–1650,* ed. Claire Farago, 245–64. New Haven: Yale University Press, 1995.

Klor de Alva, J. Jorge, H. B. Nicholson, and Eloise Quiñones Keber, eds. *The Work of Bernardino de Sahagún, Pioneer Ethnographer of Sixteenth-Century Aztec Mexico.* Studies on Culture and Society, vol. 2, Institute for Mesoamerican Studies, State University of New York–Albany. Austin: University of Texas Press, 1988.

Klor de Alva, Jorge. "The Postcolonization of the (Latin) American Experience: A Reconsideration of 'Colonialism,' 'Postcolonialism,' and 'Mestizaje.'" In *After Colonialism,* ed. Gyan Prakash, 241–75. Princeton: Princeton University Press, 1995.

Kluckhohn, Clyde. *Anthropology and the Classics.* Providence: Brown University Press, 1961.

Koerner, Joseph Leo. "Paleface and Redskin," review of *Images from the Region of the Pueblo Indians of North America,* by Aby Warburg, trans. and ed. Michael P. Steinberg. *The New Republic,* March 24, 1997, 30–38.

Kornegay, Paula B. "The Altar Screens of an Anonymous Artist in Northern New Spain: The Laguna Santero." *Journal of the Southwest* 38, no. 1 (1996): 63–79.

Kraemer, Paul M. "Haciendas and Hispanic Society in Seventeenth-Century New Mexico." *Compadres: Newsletter of the Friends of the Palace* 2 (March 1993): 4–8.

———. "Shifting Ethnic Boundaries in Colonial New Mexico: Evidence from the *Diligencias Matrimoniales." La Crónica* no. 50 (1999): 2–4.

Kubler, George. "The Aesthetic Recognition of Ancient American Art (1492–1842)." In *World Art: Themes of Unity in Diversity,* ed. Irving Lavin, 1:27–40. Acts of the XXVth International Congress of the History of Art. University Park: The Pennsylvania State University Press, 1989.

———. *The Esthetic Recognition of Ancient Amerindian Art.* New Haven: Yale University Press, 1991.

———. "On the Colonial Extinction of the Motifs of Pre-Columbian Art." In *Essays in Pre-Columbian Art and Archeology,* ed. Samuel K. Lothrop et al., 14–34. Cambridge: Harvard University Press, 1961.

———. *The Religious Architecture of New Mexico in the Colonial Period and Since the American Occupation,* 1940. 4th ed. Albuquerque: University of New Mexico Press, 1974.

———. *The Religious Architecture of New Mexico in the Colonial Period and Since the American Occupation.* Foreword Barbara Anderson. 5th ed. Albuquerque: University of New Mexico Press, 1990.

———. *Santos: An Exhibition of the Religious Folk Art of New Mexico.* Fort Worth: Amon Carter Museum, 1964.

———. *Studies in Ancient American and European Art: The Collected Essays of George Kubler.* Ed. Thomas F. Reese. New Haven: Yale University Press, 1985.

———, and Martin Soria. *Art and Architecture in Spain and Portugal and Their American Dominions, 1500–1800.* Baltimore: Penguin Books, 1959.

Lafaye, Jacques. "Caste Society in New Spain." *Artes de México* 8 (summer 1990): 81–83.

LaFora, Nicolas. *The Frontiers of New Spain.* Ed. Lawrence Kin-

naird. Berkeley: Quivira Society, 1958; New York: Arno Press, 1967.

Lamadrid, Enrique R. "Cultural Resistance in New Mexico: A New Appraisal of a Multi-Cultural Heritage." *Spanish Market* 4 (July 1991): 24–25.

Lambropoulos, Vassilis. *The Rise of Eurocentrism: Anatomy of Interpretation.* Princeton: Princeton University Press, 1993.

Lange, Charles H. *Cochiti: A New Mexico Pueblo, Past and Present.* Albuquerque: University of New Mexico Press, 1959.

Lange, Yvonne. "In Search of San Acacio: The Impact of Industrialization on Santos Worldwide." *El Palacio* 94, no. 1 (1988): 18–24.

———— "Lithography, an Agent of Technological Change in Religious Folk Art: A Thesis." *Western Folklore* 33, no. 1 (1974): 51–64.

———. *Santos de Palo: The Household Saints of Puerto Rico.* New York: Museum of American Folk Art, 1991.

Langer, Susanne K. *Feeling and Form: A Theory of Art.* New York: Scribner's Sons, 1953.

Layva, Edelmira. "La censura inquisitorial novohispana sobre imagines y obetos." *Arte y coerción,* 149–62. Mexico City: UNAM, 1992.

Leatham Smith, Miguel C. "The Santuario de Guadalupe in Santa Fe and the Observations of Fr. Estéban Anticoli, SJ." *New Mexico Studies in the Fine Arts* 10 (1985): 12–16.

Leibsohn, Dana. "Colony and Cartography: Shifting Signs on Indigenous Maps of New Spain." In *Reframing the Renaissance: Visual Culture in Europe and Latin America, 1450–1650,* ed. Claire Farago, 265–83. New Haven: Yale University Press, 1995.

Lekson, Stephen H. "The Architecture of the Ancient Southwest." In *The Ancient Americas: Art from Sacred Landscapes,* ed. Richard F. Townsend, 103–13. Chicago: Art Institute of Chicago, 1992.

———. *The Chaco Meridian: Centers of Political Power in the Ancient Southwest.* Walnut Creek, Calif.: Altamira Press, 1999.

———. "*Mangus Redivivus:* The Dinwiddie Site and Mimbres Unit Pueblos." Ms., July 14, 1995. Department of Anthropology, University of Colorado at Boulder.

Léon, Nicolás. *Las castas de México colonial y Nueva España.* Publicaciones del Departamento de Antropología Anatómica, no. 1. Mexico City: Talleres gráficos del Museo Nacional de Arqueología, Historia y Etnografía, 1924.

Léon-Portilla, Miguel. *The Broken Spears: The Aztec Account of the Conquest of Mexico.* Boston, 1962.

Leonard, Irving A. *Baroque Times in Old Mexico.* Westport: Greenwood Press, 1981.

———. *Books of the Brave: Being an Account of Books and of Men in the Spanish Conquest and Settlement of the Sixteenth-Century New World.* Berkeley and Los Angeles: University of California Press, 1992.

Levine, Frances, and Anna LaBauve. "Examining the Complexity of Historic Population Decline: A Case Study of Pecos Pueblo, New Mexico." *Ethnohistory* 44 (winter 1997): 75–112.

Limerick, Patricia Nelson. *The Legacy of Conquest: The Unbroken Past of the American West.* New York: Norton, 1987.

Lockhart, James. "Sightings: Initial Nahua Reactions to Spanish Culture." In *Implicit Understandings: Observing, Reporting, and Reflecting on the Encounters Between Europeans and Other Peoples in the Early Modern Era,* ed. Stuart B. Schwartz, 218–48. Cambridge: Cambridge University Press, 1994.

———. "Some Nahua Concepts in Postconquest Guise." *History of European Ideas* 6 (1985): 465–82.

López-Baralt, Mercedes. *Icono y Conquista: Guamán Poma de Ayala.* Madrid: Hiperión, 1988.

Lotze, Hermann. *Outlines of Aesthetics.* Trans. and ed. George T. Ladd. Boston: Ginn & Company, 1866.

Luhan, Mabel Dodge. *Edge of Taos Desert: An Escape to Reality.* Albuquerque: University of New Mexico Press, 1987. (Reprint of *Intimate Memories,* vol. 4, New York: Harcourt, Brace, 1937)

———. "The Santos of New Mexico." *The Arts* 7 (March 1925): 127–30.

Lupton, Julia Reinhard. *Afterlives of the Saints: Hagiography, Typology, and Renaissance Literature.* Stanford: Stanford University Press, 1996.

Lutz, Hartmut. *'Indianer' and 'Native Americans': Zur sozial- und literarhistorischen Vermittlung eines Stereotyps.* Hildesheim: Olms, 1985.

MacCormack, Sabine. "Caldera's *La Aurora en Copacobana:* The Conversion of the Incas in Light of Seventeenth-Century Spanish Theology, Culture, and Political Theory." *Journal of Theological Studies* 33 (1982): 448–80.

———. "Demons, Imagination, and the Incas." *Representations* 33 (winter 91): 121–46.

———. *Religion in the Andes: Vision and Imagination in Early Colonial Peru.* Princeton: Princeton University Press, 1991.

MacLachlan, Colin M., and Jaime Rodríguez. *The Forging of the Cosmic Race: A Reinterpretation of Colonial Mexico.* Berkeley and Los Angeles: University of California Press, 1980.

Madsen, William. "Religious Syncretism." In *Handbook of Middle American Indians,* ed. Robert Walpole, 6:369–91. Austin: University of Texas Press, 1967.

Mâle, Emile. *L'Art Religieux après le Concile de Trente. Étude sur l'iconographie de la fin du XVIe Siècle.* Paris: Librairie Armand Cohn, 1932.

Mallgrave, Harry, and Eleftherios Ikonomou, eds. *Empathy, Form, and Space: Problems in German Aesthetics, 1873–1893.* Trans. F. Mallgrave and E. Ikonomou. Santa Monica: Getty Center for the History of Art and the Humanities, 1994.

Manrique, Jorge Alberto. "La estampa como fuente del arte en la Nueva España." *Anales del Instituto de Investigaciones Estéticas* 8, no. 50, pt. 1 (1982): 55–60.

Markowitz, Harvey. "From Presentation to Representation in Sioux Sun Dance Painting." In *The Visual Culture of American*

Religions, ed. David Morgan and Sally M. Promey, 160–75. Berkeley and Los Angeles: University of California Press, 2001.

Marshall, Eliot. "Playing Chicken over Gene Markers." *Science* 278 (19 December 1997): 2046–48.

Martin, François Rene. Review of *Three Warburg Essays: Image in Movement; Souvenirs of a Voyage to Pueblo Country (1923), and Project from a Voyage in America (1927)*, ed. Philippe Alain Michaud. *Cahiers du Musée National d'Arte Moderne* 63 (spring 1998): 113–16.

Martín González, Juan José. *El retablo barroco en España.* Madrid: Editorial Alpuerto, 1993.

———. *Escultura barroca castellana.* 2 vols. Madrid: Lázaro Galdiano, 1959 and 1971.

———. *Escultura barroca en España, 1600–1770.* Madrid: Manuales Arte Catedra, 1983.

Martínez, José Luis. *Pasajeros de Indias: Viajes Transatlánticos en el Siglo XVI.* Mexico City: Alianza Editorial, 1984.

Martínez del Rio de Redo, Marita, et al. *El galeón de Acapulco.* Mexico City: Instituto Nacional de Antropología e Historia, 1988.

Masteller, Richard N. "Using Brancusi: Three Writers, Three Magazines, Three Versions of Modernism." *American Art* (Spring 1997).

Mather, Christine, ed. *Colonial Frontiers: Art and Life in Spanish New Mexico, The Fred Harvey Collection.* Santa Fe: Ancient City Press, 1983.

Mather, Christine R. "Religious Folk Art in New Mexico." In *The Cross and the Sword,* ed. Jean Stern. San Diego: Fine Arts Gallery of San Diego, 1976.

Mauldin, Barbara B. "The Wall Paintings of San Esteban Mission, Acoma Pueblo, New Mexico: A Description and Analysis." Master's thesis, University of New Mexico, 1988.

Mauze, Marie, ed. *Present Is Past: Some Uses of Tradition in Native Societies.* Lanham: University Press of America, 1997.

Mayes, Vernon O., and Barbara Bayless Lacy. *Nanise': A Navajo Herbal. One Hundred Plants from the Navajo Reservation.* Tsaile, Ariz.: Navajo Community College Press, 1989.

McAlister, Lyle N. "Social Structure and Social Change in New Spain." *Hispanic American Historical Review* 43, no. 3 (1963): 349–70.

McAndrew, John. *The Open-Air Churches of Sixteenth-Century Mexico: Atrios, Posaas, Open Chapels, and Other Studies.* Cambridge: Harvard University Press, 1965.

McBride, Henry. "New York Criticism." *Art Digest* 7 (December 1932): 14.

McCourt, Frank. "When You Think of God What Do You See?" *Life,* December 1998, 60–63.

McCrossen, Eric. "Crippled City Man Reproduces Colonial New Mexico Objects." *The Raton Range* 30, November 1962, 1.

McCrossen, Helen Cramp. "Native Crafts in New Mexico." *School Arts Magazine,* March 1931, 456–58.

McDannell, Colleen. *Material Christianity: Religion and Popular Culture in America.* New Haven: Yale University Press, 1995.

McDonald, William F. *Federal Relief Administration and the Arts.* Columbus: Ohio University Press, 1969.

McEvilley, Thomas. *Art & Otherness: Crisis in Cultural Identity.* Kingston, N.Y.: Documentext/McPherson & Co., 1992.

McKim-Smith, Gridley. "Spanish Polychrome Sculpture and Its Critical Misfortunes." In *Spanish Polychrome Sculpture, 1500–1800, in United States Collections,* ed. Suzanne L. Stratton, 13–31. New York: Spanish Institute, 1993.

McKinzie, Richard D. *The New Deal for Artists.* Princeton: Princeton University Press, 1973.

McNally, R. E. "The Council of Trent: The Spiritual Exercises and the Catholic Reform." *Church History* 34 (1955): 36–49.

McNitt, Frank. *Navajo Wars, Military Campaigns, Slave Raids, and Reprisals.* Albuquerque: University of New Mexico Press, 1972.

McWilliams, Carey. *North from Mexico.* New York: Lippincott, 1949.

Medina, José Toribio. *La imprenta en México.* Santiago: Impreso en Casa del Autor, 1909.

Meinig, D. W. *Southwest: Three Peoples in Geographical Change, 1600–1970.* New York: Oxford University Press, 1971.

Memmi, Albert. *The Colonizer and the Colonized.* Trans. Howard Greenfeld, intro. Jean-Paul Sartre. Boston: Beacon Press, 1967.

Metcalf, Eugene W., Jr. "From Domination to Desire: Insiders and Outsider Art." In *The Artist Outsider: Creativity and the Boundaries of Culture,* ed. Michael D. Hall and Eugene W. Metcalf Jr. Washington, D.C.: Smithsonian Institution Press, 2001.

Mexican Folkways 5 (MexicoCity): 152–56.

Mexico: Splendors of Thirty Centuries. Intro. Octavio Paz. New York: The Metropolitan Museum of Art and Bullfinch Press, 1990.

Michaud, P.-A. *Aby Warburg et l'image en mouvement suivi de Aby Warburg: Souvenirs d'un voyage en pays Pueblo (1923) et Projet de voyage en Amérique (1927).* Preface G. Didi-Huberman, trans. Sibylie Muller. Paris: Macula, 1998.

Michaud, Philippe Alain. "Un Pueblo à Hambourg: Le Voyage d'Aby Warburg au Nouveau-Mexique, 1895–1896." *Cahiers du Musée National d'Art Moderne* 52 (summer 1995): 42–73.

Mills, George. *People of the Saints.* Colorado Springs: Taylor Museum of the Colorado Springs Fine Arts Center, n.d.

Mirabal, Felipe, and Donna Pierce. "The Mystery of the Cristo Rey Altar Screen and Don Bernardo de Miera y Pacheco." *Spanish Market Magazine* (Santa Fe) 12, no. 1, 1999, 60–68.

Mitchell, W. J. T. *The Last Dinosaur Book: The Life and Time of a Cultural Icon.* Chicago: Chicago University Press, 1998.

Montgomery, Ross Gordon. "San Bernardo de Aguatubi." In R. G. Montgomery, W. Smith, and J. O. Brew, *Franciscan Awatovi.* Cambridge: Papers of the Peabody Museum of American Archaeology and Ethnology 36 (1949): 109–288.

Moore, Michael. *Medicinal Plants of the Mountain West.* Santa Fe: Museum of New Mexico Press, 1979.

————. *Los Remedios: Traditional Herbal Remedies of the Southwest.* Santa Fe: Red Crane Books, 1990.

Morfi, Father Juan Agustín. "Account of Disorders in New Mexico, 1778." In *Coronado's Land,* trans. Marc Simmons. Albuquerque: University of New Mexico Press, 1991.

Morgan, David. *Protestants and Pictures: Religion, Visual Culture, and the Age of American Mass Production.* New York: Oxford University Press, 1999.

————. *Visual Piety: A History and Theory of Popular Religious Images.* Berkeley and Los Angeles: University of California Press, 1998.

Morgan, Willard D. "Through Penitente Land with a Leica Camera." *Photo-Era* 62, February 1929, 65–73.

Mormando, Franco, ed. *Saints & Sinners: Caravaggio and the Baroque Image.* Exh. cat. McMullen Museum of Art, Boston College, 1999.

Moyssén, Xavier. "Un grabado de J. Sadler y el miniaturista Luis Lagarto." *Boletín del Instituto Nacional de Antropología e Historia* 34 (1968): 2–10.

Mudge, Jean McClure. *Chinese Export Porcelain in North America.* New York: Clarkson N. Potter, 1986.

Mundy, Barbara A. *The Mapping of New Spain: Indigenous Cartography and the Maps of the Relaciones Geograficas.* Chicago: University of Chicago Press, 1996.

Museum of Modern Art. *New Horizons in American Art.* Intro. Holger Cahill. New York, 1936.

Naar, Seyved Hossein. *Three Muslim Sages: Avicenna-Suhrawardi-Ibn 'Arabi.* Cambridge: Harvard University Press, 1964.

Naber, C. "Pompeii in Neu-Mexico: Aby Warburgs amerikanische Reise." *Freibeuter* 38 (1988): 88–97.

Nación de imágenes: la litografía mexicana del siglo XIX. Mexico City: Museo Nacional de Arte, 1994.

Nestor, Sarah. *The Native Market of the Spanish New Mexican Craftsmen: Santa Fe, 1933–1940.* Santa Fe: Colonial New Mexico Historical Foundation, 1978.

Netanyahu, B. *The Origins of the Inquisition in Fifteenth-Century Spain.* New York: Random House, 1995.

Neulander, Judith. "The Crypto-Jewish Canon: Choosing to be 'Chosen' in Millennial Tradition." *Crypto-Jews of the Southwest,* special issue of *Jewish Folklore and Ethnology Review* 18, no. 1–2 (1996): 19–58.

New Mexico State Highway Commission. *Roads to Cibola: What to See in New Mexico and How to Get There.* Santa Fe, 1929.

New Mexico State Records Center and Archives. Unpublished document, 11 June 1779. Spanish Archives of New Mexico 2:21, folio 831.

New Mexico State Records Center E. Boyd Collection. *New Mexico.* American Guide Series. Albuquerque: University of New Mexico Press, 1945.

Neumeyer, Alfred. "The Indian Contribution to Architectural Decoration in Spanish Colonial America." *Art Bulletin* 30 (1948): 104–21.

Nicks, Trudy. "Indian Villages and Entertainments: Setting the Stage for Tourist Souvenir Sales." In *Unpacking Culture: Art and Commodity in Colonial and Postcolonial Worlds,* ed. Ruth B. Phillips and Christopher Steiner, 301–15. Berkeley and Los Angeles: University of California Press, 1999.

Nietzsche, Friedrich Wilhelm. *Werke.* Ed Karl Schlecta. 4 vols. Munich: C. Hanser, 1954–65.

Nolan, Sidney, and Mary Lee. *Christian Pilgrimage in Modern Western Europe.* Chapel Hill: University of North Carolina, 1989.

Nordenskiöld, Gustav. *The Cliff Dwellers of the Mesa Verde, Southwestern Colorado: Their Pottery and Implements.* Trans. D. Lloyd Morgan. Stockholm: P. A. Norstedt, 1893.

Norris, Jimmy D. "The Breakdown of Franciscan Hegemony in the Kingdom of New Mexico, 1692–1752." Ph.D. diss., Tulane University, 1992.

Noyes, Stanley. *Los Comanches: The Horse People, 1751–1845.* Albuquerque: University of New Mexico Press, 1993.

Nunn, Tey Marianna. *Sin Nombre: Hispana and Hispano Artists of the New Deal Era.* Albuquerque: University of New Mexico Press, 2001.

Nutini, Hugo G. "Syncretism and Acculturation: The Historical Development of the Cult of the Patron Saint in Tlaxcala, Mexico, 1519–1670." *Ethnology* 15, no. 3 (1976): 301–21.

————, and Betty Bell. *Ritual Kinship: The Structure and Historical Development of the Compadrazgo System in Rural Tlaxcala.* 2 vols. Princeton: Princeton University Press, 1980.

O'Connor, Francis V., ed. *Art for the Millions: Essays from the 1930's by Artists and Administrators of the WPA Federal Art Project.* Boston: New York Graphic Society, 1973.

O'Crouley, Pedro Alonso. *A Description of the Kingdom of New Spain, 1774.* Trans. and ed. Seán Galvin. Dublin: Allen Figgis, 1972.

Oettinger, Marion, Jr. "The Transformation of Spanish Folk Art in the Americas." In *Folk Art of Spain and the Americas: El Alma del Pueblo,* intro. Marion Oettinger, 140–43. Exh. cat. San Antonio Museum of Art. New York: Abbeville Press, 1997.

Oettinger, Marion, ed. *Folk Art of Spain and the Americas: El Alma del Pueblo.* Intro. Marion Oettinger. Exh. cat. San Antonio Museum of Art. New York: Abbeville Press, 1997.

Olalquiaga, Celeste. *Megalopolis: Contemporary Cultural Sensibilities.* Minneapolis: University of Minnesota Press, 1992.

Olmsted, Virginia L., comp. *New Mexico Spanish and Mexican Colonial Censuses, 1790, 1823, 1845.* Albuquerque: New Mexico Genealogical Society, 1979.

Olmsted, Virginia Langham. *Spanish and Mexican Censuses of New Mexico 1750 to 1830; and 1790, 1823, 1845.* Albuquerque: New Mexico Genealogical Society, 1981.

Orsi, Robert. *The Madonna of 115th Street: Faith and Community in Italian Harlem.* New Haven: Yale University Press, 1985.

————. *Thank You, St. Jude: Women's Devotion to the Patron Saint of Hopeless Causes.* New Haven: Yale University Press, 1996.

Ortiz, Alfonso. *The Tewa World: Space, Time, Being, & Becoming*

in a Pueblo Society. Chicago: University of Chicago Press, 1969.

Ortiz, Roxanne Dunbar. *Roots of Resistance: Land Tenure in New Mexico, 1680–1980.* Los Angeles: Chicano Studies Research Center Publications, UCLA, and American Indian Studies Center, UCLA, 1980.

Otis, Raymond. "Medievalism in America." *New Mexico Quarterly* 6 (May 1936): 83–90.

Owens, Craig. "*Einstein on the Beach:* The Primacy of Metaphor." *October* 4 (fall 1977): 21–32.

Pach, Walter. "New-Found Values in Ancient America." *Parnassus* 7 (December 1935): 7–10.

Pacheco, Francisco. *El arte de la pintura.* (1648). Ed. Bonaventura Bassegoda y Hugas. Madrid: Catedra, 1990.

Pagden, Anthony. *European Encounters with the New World: From Renaissance to Romanticism.* New Haven: Yale University Press, 1993.

——— *The Fall of Natural Man: The Amerindian and the Origins of Comparative Ethnology.* 2d ed. Cambridge: Cambridge University Press, 1986.

———. *Spanish Imperialism and the Political Imagination: Studies in European and Spanish-American Social and Political Theory, 1513–1830.* New Haven: Yale University Press, 1990.

Paleotti, Gabriele. *Discorso intorno alle imagini sacre e profane.* Bologna, 1582. Reprint ed. Paola Barocchi, in *Trattato d'arte del Cinquecento,* 2:117–509. Bari: Giuseppe Laterza e Figli, 1961.

Palmer, Gabrielle, and Donna Pierce. *Cambios: The Spirit of Transformation in Spanish Colonial Art.* Albuquerque: University of New Mexico Press and Santa Barbara Museum of Art, 1992.

———. *El Camino Real de Tierra Adentro I.* Santa Fe: Bureau of Land Management, 1993.

———. and Stephen Fosberg. *El Camino Real de Tierra Adentro 2.* Santa Fe: Bureau of Land Management, 1999.

Papastergiadis, Nikos. "Tracing Hybridity in Theory." In *Debating Cultural Hybridity: Multi-Cultural Identities and the Politics of Anti-Racism,* ed. Pnina Werbner and Tariq Modood, 257–81. London: Zed Books, 1997.

Parry, Benita. "Problems in Current Theories of Colonial Discourse." *Oxford Literary Review* 9 (1987): 27–58.

Parsons, Elsie Clews. *Isleta Paintings.* Ed. and foreword Esther Goldfrank. Rev. ed. Washington, D.C.: Smithsonian Institution Press, 1970.

———. *Pueblo Indian Religion.* 2 vols. Chicago: University of Chicago Press, 1939.

———. "Spanish Elements in the Kachina Cult of the Pueblos." In *Proceedings of the Twenty-Third International Congress of Americanists, 1928,* 582–603. New York: Science Press, 1930.

———. *Taos Pueblo.* Wenasha, Wis.: George Banta, 1936.

———. "El uso de las máscaras en el suroeste de los Estados Unidos." *Mexican Folkways* 5 (1929): 152–56.

Parsons, Francis B. *Early Seventeenth-Century Missions of the Southwest.* Tucson: Dale Stuart King, 1975.

Pelikan, Jaroslav. *Imago Dei: The Byzantine Apologia for Icons.* Bollingen Series 36. Princeton: Princeton University Press, 1960.

Perrone, Bobette, H. Henrietta Stockel, and Victoria Krueger. *Medicine Women, Curanderas, and Women Doctors.* Norman: University of Oklahoma Press, 1989.

Peters, Harry T. *America on Stone: The Other Printmakers to the American People.* Garden City, N.Y.: Doubleday, 1931.

Peterson, Jeanette Favrot. *The Paradise Garden Murals of Malinalco: Utopia and Empire in Sixteenth-Century Mexico.* Austin: University of Texas Press, 1993.

———. "Synthesis and Survival: The Native Presence in Sixteenth-Century Murals of New Spain." In *Native Artists and Patrons in Colonial Latin America,* ed. E. Umberger and Tom Cummins, special issue of *Phoebus* 7 (1995): 36–51.

———. "The Virgin of Guadalupe: Symbol of Conquest or Liberation?" *Art Journal* 51 (winter 1992): 39–47.

Phelan, John Leddy. *The Millennial Kingdom of the Franciscans in the New World: A Study of the Writings of Gerónimo de Mendieta (1523–1604).* Berkeley and Los Angeles: University of California Press, 1956.

Phillips, Ruth B. *Trading Identities: The Souvenir in Native North American Art from the Northeast, 1700–1900.* Seattle: University of Washington Press; Montreal: McGill-Queen's University Press, 1998.

———, and Christopher Steiner, eds. *Unpacking Culture: Art and Commodity in Colonial and Postcolonial Worlds.* Berkeley and Los Angeles: University of California Press, 1999.

Photographs at the Frontier: Aby Warburg in America, 1895–1896, ed. Benedetta Cestelli Guidi and Nicholas Mann. London: Merrell Holberton with Warburg Institute, 1998.

Photographs of Los Penitentes. Denver: Cosner Selling Co., 1931.

Pierce, Donna. "Appendix A: The Spanish Colonial Arts Society Collection: A History." In *Spanish New Mexico: The Spanish Colonial Arts Society Collection,* ed. Donna Pierce and Marta Weigle, 2:94–100. Santa Fe: Museum of New Mexico Press, 1996.

———. "Ceramics." In *Cambios: The Spirit of Transformation in Spanish Colonial Art,* ed. Gabrielle Palmer and Donna Pierce, 132–39. Albuquerque: University of New Mexico Press and Santa Barbara Museum of Art, 1992.

———. "Ceramics." In *Mexico: Splendors of Thirty Centuries,* intro. Octavio Paz, 457–80. New York: The Metropolitan Museum of Art and Bullfinch Press, 1990.

———. "Decorative Arts and Furniture." In *Mexico: Splendors of Thirty Centuries,* intro. Octavio Paz, 363–456. New York: The Metropolitan Museum of Art and Bullfinch Press, 1990.

——. "From New Spain to New Mexico: Art and Culture on the Northern Frontier." In *Converging Cultures: Art & Identity in Spanish America,* ed. Diane Fane, 59–68. New York: Brooklyn Museum and Harry N. Abrams, 1996.

———. "Heaven on Earth: Church Furnishings in Seventeenth-Century New Mexico." In *El Camino Real de Tierra Adentro, 2,* comp. Gabrielle G. Palmer and Stephen L. Fosberg, 197–208. Cultural Resources Series, no. 13. Santa Fe: Bureau of Land Management, 1999.

———. "The Hide Painting Tradition in New Mexico and Its European and Mexican Sources." In *The Segesser Hides: An Anthology.* Unpublished ms. History Library, Palace of the Governors, Santa Fe.

———. "The Holy Trinity in the Art of Rafael Aragón: An Iconographical Study." *New Mexican Studies in the Fine Arts* 33 (1978): 29–33.

———. "New Mexican Furniture and Its Spanish and Mexican Prototypes." In *The American Craftsman and the European Tradition, 1620–1829,* ed. Francis J. Puig and Michael Conforti, 179–201. Exh. cat. Hanover: Minneapolis Institute of Arts, 1989.

———. "New Spain." In Gabrielle Palmer and Donna Pierce, *Cambios: The Spirit of Transformation in Spanish Colonial Art,* 74–83. Albuquerque: University of New Mexico Press and Santa Barbara Museum of Art, 1992.

——— "Saints in the Hispanic World." In *Spanish New Mexico: The Spanish Colonial Arts Society Collection,* ed. Donna Pierce and Marta Weigle, 1:16–28. Santa Fe: Museum of New Mexico Press, 1996.

———. "Saints in New Mexico." In *Spanish New Mexico: The Spanish Colonial Arts Collection,* ed. Donna Pierce and Marta Weigle, 1:29–60. Santa Fe: Museum of New Mexico Press, 1996.

———. "The Sixteenth-Century Nave Frescoes in the Augustinian Mission Church at Ixquilmilpan, Hidalgo, Mexico." Ph.D. dissertation, University of New Mexico, 1987.

———, Rogelio Ruiz Gomar, and Clara Bargellini. *Painting a New World: Mexican Art and Life, 1521–1821.* Denver: Denver Art Museum, 2004.

———, and Felipe Mirabal. "The Mystery of the Cristo Rey Altar Screen and Don Bernardo de Miera y Pacheco." *Spanish Market Magazine* (Santa Fe), 1999, 60–67.

———, and Cordelia T. Snow. "A Harp for Playing: Domestic Goods Transported over the Camino Real." In *El Camino Real de Tierra Adentro, 2,* comp. Gabrielle G. Palmer and Stephen Fosberg, 71–86. Cultural Resources Series no. 13. Santa Fe: Bureau of Land Management, 1999.

———, and Marta Weigle, eds. *Spanish New Mexico: The Spanish Colonial Arts Society Collection.* 2 vols. Santa Fe: Museum of New Mexico Press, 1996.

Pieske, Christa. *Bilder für Jedermann: Wandbild Drucke, 1840–1940.* Exh. cat. Berlin: Staatliche Museen, Museum für Deutsche Volkskunde, 1988.

———, and Yvonne Lange. "Survey of Prints in Tin Frames at Moifa." Unpublished ms. February 28, 1989, Memorandum in the Museum of International Folk Art, 13 pp.

Plischke, Hans. *Von Cooper bis Karl May: Eine Geschichte des völkerkundlichen Reise und Abenteuerromans.* Düsseldorf: Droste, 1951.

Poling–Kemps, Lesley. *Valley of Shining Stone: The Story of Abiquiu.* Tucson: University of Arizona Press, 1997.

Powell, John Wesley. *Introduction to the Study of Indian Languages, with Words, Phrases, and Sentences to Be Collected.* Washington, D.C.: Government Printing Office, 1877.

Powell, Philip Wayne. *Mexico's Miguel Caldera: The Taming of America's First Frontier (1548–1597).* Tucson: University of Arizona Press, 1977.

———. *Soldiers, Indians and Silver.* Berkeley and Los Angeles: University of California Press, 1969.

Preston, Christine, Douglas Preston, and José Antonio Esquibel. *The Royal Road: El Camino Real from Mexico City to Santa Fe.* Albuquerque: University of New Mexico Press, 1998.

Preziosi, Donald. "The Art of Art History." In *The Art of Art History: A Critical Anthology,* ed. D. Preziosi, 509–10. Oxford: Oxford University Press, 1998.

———. "Brain of the Earth's Body: Museums and the Framing of Modernity." In *The Rhetoric of the Frame: Essays on the Boundaries of the Artwork,* ed. Paul Duro, 96–110. Cambridge: Cambridge University Press, 1996.

———. *The Semiotics of the Built Environment: An Introduction to Architectonic Analysis.* Bloomington: Indiana University Press, 1979.

Prodi, Paolo. *Il Cardinale Gabriele Paleotti (1522–1596).* 2 vols. Rome: Edizioni di storia e letteratura, 1959–67.

———. *Ricerca sulla teorica delle arti figurative nella Riforma Cattolica.* Bologna: Nuova Alfa Editoriale, 1984.

Puig, Francis J., and Michael Conforti, eds. *The American Craftsman and the European Tradition, 1620–1820.* Hanover: Minneapolis Institute of Arts, 1989.

The Question of Style in Philosophy and the Arts. Ed. Caroline van Eck, James McAllister, and Renée van de Vall. Cambridge: Cambridge University Press, 1995.

Quintilian. *The Institutio Oratoria of Quintilian.* Trans. H. E. Butler. 4 vols. London: Loeb Library Classics, 1921.

Quirarte, Jacinto. "*Los Cinco Señores* and *La Mano Poderosa:* An Iconographic Study." In *Art and Faith in Mexico: The Nineteenth-Century Retablo Tradition,* ed. Elizabeth Netto Calil Zarur and Charles Muir Lovell, 79–87. Albuquerque: University of New Mexico Press, 2001.

Rabasa, José. *Inventing America: Spanish Historiography and Eurocentrism.* Norman: University of Oklahoma Press, 1993.

———. *Writing and Violence on the Northwestern Frontier.* Durham: Duke University Press, 2000.

Ramirez Leyva, Eldemira. "Censura inquisitorial novohispana sobre imágenes y objetos." In *Arte y coercíon, Comité Mexicano de Historia del Arte,* 149–62. Mexico City: UNAM / IIE, 1992.

Ramirez Vázques, Pedro. *Fray Pedro de Gante: El primero y mas*

grande maestro de la Nueva España. Mexico City: Editorial Porrua, 1995.

Rampley, Matthew. "From Symbol to Allegory: Aby Warburg's Theory of Art." *Art Bulletin* 77 (1995): 41–55.

Raulff, Ulrich. "Image in Movement; Souvenirs of a Voyage to Pueblo Country (1923), and Project from a Voyage in America (1927)." Ed. P.-A. Michaud, *Cahiers du Musée National d'Art Moderne* 63 (spring 1998): 113–66.

———. "The Seven Skins of the Snake: Oraibi, Kreuzlingen and Back: Stations on a Journey into Light." In *Photographs at the Frontier: Aby Warburg in America, 1895–1896,* ed. Benedetta Cestelli Guidi and Nicholas Mann, 64–74. London: Merrell Holberton with Warburg Institute, 1998.

Reeve, Frank D. "The Navajo-Spanish Peace: 1720's–1770's." *New Mexico Historical Review* 34 (January 1959): 9–40.

Reina, Ruben E. *The Law of the Saints.* Indianapolis: Bobbs-Merrill, 1966.

"Relief Work." *Time* 28, September 21, 1936, 42–43.

Retablos: Devotional Images of Mexico. Exh. cat. Mount Vernon, Illinois: Mitchell Museum, 1990.

Reyes-Valerio, Constantino. *Arte indocristiano: Escultura del siglo XVI en Mexico,* 1978. Rev. ed. Mexico City: Instituto Nacional de Antropología e Historia, 2000.

Reynolds, Bryan, and Joseph Fitzpatrick. "The Transversality of Michel de Certeau: Foucault's Panoptic Discourse and the Cartographic Impulse." *Diacritics* 29, no. 3 (1999): 63–80.

Ricard, Robert. *The Spiritual Conquest of Mexico: An Essay on the Apostolate and the Evangelizing Methods of the Mendicant Orders in New Spain: 1523–1572.* Berkeley and Los Angeles: University of California Press, 1966.

Riedel, Thomas L. "'Copied for the W.P.A.' Juan A. Sanchez, American Tradition and the New Deal Politics of Saint-Making." Master's thesis, University of Colorado, 1992.

Riegl, Alois. *Problems of Style: Foundations for a History of Ornament.* Trans. E. Kain, notes and intro. D. Castriota, preface H. Zerner. Princeton: Princeton University Press, 1992.

———. *Stilfragen: Grundlegungen zu einer Geschichte der Ornamentik,* 1893. Facsimile reprint Hildesheim: Georg Olms, 1975.

Ríos-Bustamante, Antonio José. "New Mexico in the Eighteenth Century: Life, Labor, and Trade in the Villa de San Felipe de Albuquerque, 1706–1790." *Aztlan* 7, no. 3 (1978): 357–89.

Rodríguez, Sylvia. *The Matachines Dance: Ritual Symbolism and Interethnic Relations in the Upper Río Grande Valley.* Albuquerque: University of New Mexico Press, 1996.

Roeder, Beatrice. *Chicano Folk Medicine from Los Angeles, California.* University of California Publications, Folklore and Mythology Studies, vol. 34. Berkeley and Los Angeles: University of California Press, 1988.

Romero, Brenda M. "Cultural Interaction in New Mexico as Illustrated in the Matachines Dance." In *Musics of Multicultural America,* ed. Kip Lornell and Anne Rasmussen, 155–85. New York: Schirmer, 1997.

———. "The Matachines Music and Dance in San Juan Pueblo and Alcalde, New Mexico: Context and Meanings." Ph.D. diss., University of California at Los Angeles, 1993.

———. "The Old World Origins of the Matachines Dance of New Mexico." In *Vistas of American Music, Essays and Compositions in Honor of William K. Kearns,* ed. Susan L. Porter and John Graziano, 339–56. Detroit Monographs in Musicology / Studies in Music, no. 25. Detroit: Harmonie Park Press, 1999.

Romero de Terreros, Manuel. *Grabados y grabadores en la Nueva España.* Mexico City: Ediciones Aite Mexicano, 1948.

Romero de Terreros y Vincent, Manuel. *Las artes industriales en la Nueva España.* Mexico City: Librería de P. Robredo, 1923.

Rondet, Henri, S.J. *Saint Joseph.* Trans. Donald Attwater. New York: P. J. Kennedy and Sons, 1956.

Rosand, David. "The Crisis of the Venetian Renaissance Tradition." *L'Arte* 3 (1971): 5–53.

Roscoe, Will. *The Zuni Man-Woman.* Albuquerque: University of New Mexico Press, 1991.

Rosenbaum-Dondaine, Catherine. *L'Image de Pieté en France, 1814–1914.* Paris: Musée-Galerie de la Serita, 1984.

Rossbacher, Karlheinz. *Lederstrumpf in Deutschland: Zur Rezeption James Fenimore Coopers beim Leser der Restaurationszeit.* Munich: W. Fink, 1972.

Ruíz Gomar, Rogelio. "Capilla de los reyes." In *Catedral de México: Patrimonio artístico y cultural,* 16–43. Mexico City: Instituto Nacional de Antropología e Historia, 1986.

———. "Rubens en la pintura novohispana de mediados del siglo XVII." *Anales del Instituto de Investigaciones Estéticas* 8, no. 50 (1982): 87–101.

Rumford, Beatrix T. "Uncommon Art of the Common People: A Review of Trends in the Collecting and Exhibiting of American Folk Art." In *Perspectives on American Folk Art,* ed. Ian M. C. Quimby and Scott T. Swank, 13–53. New York: Norton, 1980.

Rushing, Jackson, ed. *Native American Art in the Twentieth Century: Makers, Meanings, Histories.* London: Routledge Press, 1999.

Rushing, W. Jackson. *Native American Art and the New York Avant-Garde.* Austin: University of Texas Press, 1995.

La ruta de los santuarios en México. Mexico City: Secretaría de Turismo, 1994.

Said, Edward W. *Orientalism.* New York: Random House, 1978.

Salinas, Martin. *Indians of the Rio Grande Delta: Their Role in the History of Southern Texas and Northeastern Mexico.* Austin: University of Texas Press, 1990.

Salpointe, John Baptiste. *Soldiers of the Cross: Notes on the Ecclesiastical History of New Mexico, Arizona, and Colorado.* Albuquerque: Calvin Horn, 1967.

San Carlo Borromeo: Catholic Reform and Ecclesiastical Politics in the Second Half of the Sixteenth Century, ed. John Headley and John Tomaro. Washington, D.C.: Folger Shakespeare Library; London: Associated University Presses, 1988.

Sánchez, Alberto Ruy, ed. "La Pintura de Castas." *Artes de México* 8 (summer 1990): 21–88.

Sánchez, Joseph P. *Explorers, Traders, and Slavers: Forging the Old Spanish Trail, 1678–1859.* Salt Lake City: University of Utah Press, 1997.

Sánchez, Juan A. "My Reproductions of New Mexican Santos." Unpublished manuscript, n.d. Mary Ellen Ferreira collection, Pinole, California.

Sando, Joe S. *Pueblo Nations: Eight Centuries of Pueblo Indian History.* Foreword Regis Pecos. Santa Fe: Clear Light, 1992.

Santa Catalina Martír Church, Mexico City, Mexico. Marriages, 1672–1741, microfilm no. 0036028.

Santa Fe Visitors' Guide. Santa Fe: Ladd Haystead Advertising, 1931.

Santa Vera Cruz Church, Mexico City, Mexico. Marriages, 1666–1704, microfilm no. 0035849.

Santos. Exh. cat. Fort Worth: Amon Carter Museum of Western Art, 1964.

Scavizzi, Giuseppe. "La teologia cattolica e le immagine dirante il XVI secolo." *Storia dell'arte* 21 (1974): 171–213.

Schaafsma, Curtis F. "Pueblo Ceremonialism from the Perspective of Spanish Documents." In *Kachinas in the Pueblo World,* ed. Polly Schaafsma, 121–39. Albuquerque: University of New Mexico Press, 1994.

Schachtman, Noah. "Searchin' for the Surfer's Saint." In *Wired News Online* [cited January 25, 2002]. Available at http://www.wired.com/news; INTERNET.

Schaifer, Robert. "Greek Theories of Slavery from Homer to Aristotle." *Harvard Studies in Classical Philology* 47 (1936): 165–204.

Schantz, Mark S. "Religious Tracts, Evangelical Reform, and the Market Revolution in Antebellum America." *Journal of the Early Republic* 17 (fall 1997): 425–66.

Schiller, Nina Glick, Linda Basch, and Cristina Blanc-Szanton, eds. *Towards a Transnational Perspective on Migration: Race, Class, Ethnicity, and Nationalism Reconsidered.* New York: New York Academy of Sciences, 1992.

Schmidt, Leigh Eric. *Consumer Rites: The Buying and Selling of American Holidays.* Princeton: Princeton University Press, 1995.

Schoell-Glass, Charlotte. "An Episode of Cultural Politics During the Weimar Republic: Aby Warburg and Thomas Mann Exchange a Letter Each." *Art History* 21, no. 1 (1998): 107–28.

Scholes, France V. *Church and State in New Mexico, 1610–1650.* Albuquerque: University of New Mexico Press, 1937.

———. "The Supply Service of the New Mexican Missions in the Seventeenth Century," pts. 1–3. *New Mexico Historical Review* 5 (January 1930): 93–115; (April 1930): 186–210; (October 1930): 386–404.

———. "Troublous Times in New Mexico, 1659–1670." *New Mexico Historical Review* 12 (April 1937): 134–74.

———. *Troublous Times in New Mexico, 1659–1670.* Albuquerque: University of New Mexico Press, 1942.

———, and Eleanor B. Adams. "Inventories of Church Furnishings in Some of the New Mexico Missions, 1672." In *Dargan Historical Essays,* ed. William M. Dabney and Josiah C. Russell, 27–38. University of New Mexico Publications in History, no. 4. Albuquerque: University of New Mexico Press, 1952.

Schroeder, Albert H. "Pueblos Abandoned in Historic Times." In *Handbook of North American Indians,* ed. Alfonso Ortiz, 9:236–54. Washington, D.C.: Smithsonian Institution Press, 1979.

———. "Querechos, Vaqueros, Cocoyes, and Apaches." In *Collected Papers in Honor of Charlie R. Steen,* ed. Nancy L. Fox, 159–66. Albuquerque: Archeological Society of New Mexico Press, 1983.

———. "Rio Grande Ethnohistory." In *New Perspectives on the Pueblos,* ed. Alfonso Ortiz, 41–70. Albuquerque: University of New Mexico Press, 1972.

———. "Shifting for Survival in the Spanish Southwest." *New Mexico Historical Review* 43 (October 1968): 291–310.

Schurz, William Lytle, *The Manila Galleon.* New York: Dutton, 1939.

Scothorn, Hillary L. "Pueblo Women, Colonial Settlement, and Creative Endeavors: Power and Appropriation in Native American Ceramics." In *Dimensions of Native America: The Contact Zone,* ed. Jehanne Teilhet-Fisk and Robin Nigh, 18–23. Exh. cat. Museum of Fine Arts, Florida State University, Tallahassee, 1998.

Scully, Vincent. "Man and Nature." In *American Indian Art: Form and Tradition.* Minneapolis: Walker Art Center, 1972.

Sebastián, Santiago. "Nuevo grabado en la obra de Pereyns." *Anales del Instituto de Investigaciones Estéticas* 9, no. 35 (1966): 45–46.

Seed, Patricia. *Ceremonies of Possession in Europe's Conquest of the New World, 1492–1640.* Cambridge: Cambridge University Press, 1995.

Segal, Ariel. *Jews of the Amazon: Self-Exile in Paradise.* Philadelphia: Jewish Publication Society, 1999.

Sego, Eugene B. "Six Tlaxcalan Colonies on New Spain's Northern Frontier: A Comparison of Success and Failure." Ph.D. diss., Indiana University, 1990.

Sellers, Charles. *The Market Revolution: Jacksonian America, 1815–1846.* New York: Oxford University Press, 1991.

Shalkop, Robert L. *Arroyo Hondo: The Folk Art of a New Mexican Village.* Colorado Springs: Taylor Museum of the Colorado Springs Fine Arts Center, 1969.

———. *Wooden Saints: The Santos of New Mexico.* Colorado Springs: Taylor Museum of the Colorado Springs Fine Arts Center, 1967.

Shaw, Rosalind, and Charles Stewart. "Introduction: Problematizing Syncretism." In *Syncretism/Anti-Syncretism: The Politics of Religious Synthesis,* ed. R. C. Stewart and R. Shaw, 1–26. London: Routledge, 1994.

Shearman, John. *Mannerism*. Baltimore: Johns Hopkins University Press, 1967.

Shipley, Charles. "The Matachines Dance of New Mexico." 50-minute television documentary. CBS, Channel 13, in Albuquerque, New Mexico, 1986.

Silverblatt, Irene. *Moon, Sun, and Witches: Gender Ideologies and Class in Inca and Colonial Peru*. Princeton: Princeton University Press, 1987.

Simmons, Marc. *Albuquerque, A Narrative History*. Albuquerque: University of New Mexico Press, 1982.

———. *The Last Conquistador*. Norman: University of Oklahoma Press, 1991.

———. "New Mexico's Smallpox Epidemic of 1780–81." *New Mexico Historical Review* 41 (October 1966): 319–26.

———. "Tlascalans in the Spanish Borderlands." *New Mexico Historical Review* 39 (April 1964): 101–10.

——— *Witchcraft in the Southwest: Spanish and Indian Supernaturalism on the Rio Grande*. Lincoln: University of Nebraska Press, 1974.

———, ed. and trans. *Indian and Mission Affairs in New Mexico, 1773*. Santa Fe.: Stagecoach Press, 1965.

Simpson, J. H. *Journal of a Military Reconnaissance from Santa Fé, New Mexico, to the Navajo Country: Made with the Troops Under Command of Brevet Lieutenant Colonel John M. Washington . . . Governor of New Mexico, in 1849*. Philadelphia: Lippincott, Grambo, and Co, 1852.

Simpson, M. G. *Making Representations: Museums in the Post-Colonial Era*. London: Routledge, 1996.

Smith, Watson. *Kiva Mural Decorations at Awatovi and Kawaika-a*. Papers of the Peabody Museum of American Archaeology and Ethnology, 37. Cambridge: Harvard University Press, 1952.

———. "Mural Decorations of San Bernardo de Aguatubi." In *Franciscan Awatovi*, ed. R. G. Montgomery, W. Smith, and J. O. Brew, 289–339. Papers of the Peabody Museum of American Archaeology and Ethnology, 36. Cambridge: Harvard University Press, 1949.

Smyth, Craig Hugh. *Mannerism and Maniera, 1963*. Intro. Elizabeth Cropper. 2d ed. Vienna: IRSA, 1992.

Snow, Cordelia Thomas. "A Brief History of the Palace of the Governors and a Preliminary Report on the 1974 Excavation." *El Palacio* 80, no. 3 (1974): 1–22.

———. "A Headdress of Pearls: Luxury Goods Imported over the Camino Real During the Seventeenth Century." In *El Camino Real de Tierra Adentro, 1*, ed. Gabrielle G. Palmer, 69–76. Cultural Resources Series, no. 11. Santa Fe: Bureau of Land Management, 1993.

———. "Juan Martinez de Montoya: The Reluctant Governor." *Compadres: Newsletter of the Friends of the Palace* 3 (October 1994): 5–8.

———, and Donna Pierce. "Material Culture in Colonial New Mexico: The Seventeenth Century." Unpublished ms. Cordelia Snow, Sites Archeologist, Laboratory of Anthropology, Museum of New Mexico, Santa Fe. Donna Pierce, Curator of Spanish Colonial Art, Denver Art Museum.

Snow, David. *New Mexico's First Colonists*. Albuquerque: Hispanic Genealogical Research Center of New Mexico, 1998.

———. "So Many Mestizos, Mulatos, and Zambohijos: Colonial New Mexico People Without History." Paper presented at the Western Historical Association, Denver, 1995.

Snow, David H. "A Note on Encomienda Economics in Seventeenth-Century New Mexico." In *Hispanic Arts and Ethnohistory in the Southwest*, ed. Marta Weigle, 347–58. Santa Fe: Ancient City Press, 1983.

———. "Purchased in Chihuahua for Feasts." In *El Camino Real de Tierra Adentro, 1*, ed. Gabrielle G. Palmer, 133–46. Cultural Resources Series, no. 11. Santa Fe: Bureau of Land Management, 1993.

———. Review of *The Pottery of San Ildefonso Pueblo*, by Kenneth Chapman. *El Palacio* 78, no. 2 (1972): 45–47.

———. "Spanish American Pottery Manufacture in New Mexico: A Critical Review." *Ethnohistory* 31, no. 2 (1984): 93–113.

Snyder, Allegra Fuller. "The Dance Symbol." In *New Dimensions in Dance Research: Anthropology and Dance: The American Indian*, ed. Tamara Comstock. Proceedings of the Third Conference on Research in Dance, March 26–April 2, 1972, University of Arizona, Tucson, Arizona, and the Yaqui villages of Tucson. New York: Committee on Research in Dance, 1974.

Snyder, James. *Northern Renaissance Art: Painting, Sculpture, the Graphic Arts from 1350 to 1575*. Englewood Cliffs, N.J.: Pretnice-Hall; New Yor: Harry N. Abrams, 1985.

Spanish Colonial Arts Society Papers. New Mexico State Records and Archives. Santa Fe: Red Crane Books, 1992.

Spicer, Edward H. *Cycles of Conquest: The Impact of Spain, Mexico, and the United States on the Indians of the Southwest, 1533–1960*. Tucson: University of Arizona Press, 1962.

———. "Spanish-Indian Acculturation in the Southwest." *American Anthropologist* 56, no. 4 (1954): 663–78.

Spinden Herbert J. "Santos and Katchinas." *Brooklyn Museum Bulletin*, 1, no. 5 (1940): 1.

Spivak, Gayatri Chakravorty. *A Critique of Postcolonial Reason: Toward a History of the Vanishing Present*. Cambridge: Harvard University Press, 1999.

Splendors of Mexico: The Art of Thirty Centuries. Exh. cat. New York: The Metropolitan Museum of Art, 1990.

Stafford, Barbara Maria. *Visual Analogy: Consciousness as the Art of Connecting*. Cambridge: MIT Press, 1999.

Stanley, H. *Being Ourselves for You: The Global Display of Culture*. London: Middlesex University Press, 1998.

Stastny, Francisco. "Modernidad, ruptura, y arcaísmo en el arte colonial." In *Arte, historia, e identidad en América: Visiones comparativas, XVII Coloquio Internacional de Historia del Arte*, ed. Gustavo Curiel, Renato González Mello, and Juana Gutiérrez Haces, 3:939–54. Mexico City: Universidad

Nacional Autónoma de Mèxico Instituto de Investigaciones Estèticas, 1993.

Steele, Thomas J., S.J. "Francisco Xavier Romero: A Hitherto-Unknown Santero." In *The Segesser Hides: An Anthology.* Unpublished ms. History Library, Palace of the Governors, Santa Fe, N. M.

———. *Santos and Saints: The Religious Folk Art of Hispanic New Mexico.* 3d ed. Santa Fe: Ancient City Press, 1974. 4th ed. 1994.

———, and Rowena A. Rivera. *Penitente Self-Government: Brotherhoods and Councils, 1797–1947.* Santa Fe: Ancient City Press, 1985.

Steinberg, Michael. "Aby Warburg's Kreuzlingen Lecture: A Reading." In *Aby Warburg, Images from the Region of the Pueblo Indians of North America,* intro. and trans. M. P. Steinberg, 59–114. Ithaca: Cornell University Press, 1995.

Stern, Peter. "Gente de Color Quebrado: Africans and Afro-mestizos in Colonial Mexico." *Colonial Latin American Historical Review* 3 (spring 1994): 185–205.

Stern, Peter Alan. "Social Marginality and Acculturation on the Northern Frontier of New Spain." Ph.D. diss., University of California, 1984.

Stewart, Rick, Joseph D. Ketner II, and Angela L. Miller. *Carl Wimar: Chronicler of the Missouri River Frontier.* Fort Worth: Amon Carter Museum; New York: Harry N. Abrams, 1991.

Stewart, Susan. *On Longing: Narratives of the Miniature, the Gigantic, the Souvenir, the Collection.* Baltimore: Johns Hopkins University Press, 1984.

Stocking, George W. *Race, Culture, and Evolution: Essays in the History of Anthropology.* New York: Free Press, 1968.

Stocking, George W., Jr., ed. *Objects and Others: Essays on Museums and Material Culture.* Madison: University of Wisconsin Press, 1985.

Stoichita, Victor I. *Visionary Experience in the Golden Age of Spanish Art.* London: Reaktion Books, 1995.

Stoller, Marianne. "The Hispanic Women Artists of New Mexico: Present and Past." *El Palacio* 92, no. 1 (1986): 21–25.

———. "Peregrinas with Many Visions / Hispanic Women Artists of New Mexico, Southern Colorado, and Texas." In *The Desert Is No Lady,* ed. Vera Norwood and Janice Monk, 125–145. New Haven: Yale University Press, 1987.

———. "A Study of Nineteenth-Century Hispanic Arts and Crafts in the American Southwest: Appearances and Processes." Ph.D. diss., University of Pennsylvania, 1979.

———, and José B. Hernandex, eds. *Diary of the Jesuit Residence of Our Lady of Guadalupe Parish, Conejos, Colorado, December 1891–December 1895.* Colorado College Studies, no. 19. Colorado Springs; Colorado College, 1982.

Stratton, Suzanne L., ed. *Spanish Polychrome Sculpture, 1500–1800, in United States Collections.* New York: Spanish Institute, 1993.

Strout, Clevy Lloyd. "The Resettlement of Santa Fe, 1695: The Newly Found Muster Roll." *New Mexico Historical Review* 53 (July 1978): 261–70.

Stubbs, Stanley A. "'New' Old Churches Found at Quarai and Tabira." *El Palacio* 66, no. 5 (1959): 162–69.

Suina, Joseph. "Pueblo Secrecy Result of Intrusions." *New Mexico Magazine* 70, no. 1, January 1991, 60–63.

Sullivan, Edward J. "European Painting and the Art of the New World Colonies." In *Converging Cultures: Art & Identity in Spanish America,* ed. Diane Fane, 28–41. New York: Brooklyn Museum and Harry N. Abrams, 1996.

———. "A Visual Phenomenon of the Americas." *Artes de Mexico* 8 (summer 1990): 85–86.

Summers, David. "*Contrapposto:* Style and Meaning in Renaissance Art." *Art Bulletin* 59 (1977): 336–61.

———. *The Judgment of Sense: Renaissance Naturalism and the Rise of Aesthetics.* Cambridge: Cambridge University Press, 1987.

———. "*Maniera* and Movement: The *Figura Serpentinata.*" *Art Quarterly* 35 (1972): 269–301.

———. *Michelangelo and the Language of Art.* Princeton: Princeton University Press, 1981.

———. "On the Histories of Artifacts." *Art Bulletin* 76, no. 4 (1994): 590–92.

——— "Real Metaphor: Towards a Redefinition of the 'Conceptual' Image." In *Visual Theory: Painting and Interpretation,* ed. Norman Bryson, Michael Ann Holly, and Keith Moxey, 231–59. New York: HarperCollins, 1991.

Swadesh, Frances Leon. *Los Primeros Pobladores: Hispanic Americans on the Ute Frontier.* Notre Dame: University of Notre Dame Press, 1974.

Sylvest, Edwin Edward, Jr. *Motifs of Franciscan Mission Theory in Sixteenth-Century New Spain, Provenance of the Holy Gospel.* Washington, D.C.: Academy of American Franciscan History, 1975.

Talavera Poblana. Mexico City: Pinacoteca Marqués del Jaral de Barrio and Fomento Cultural Banamex, 1979.

Taylor, Joshua. *America as Art.* Washington, D.C.: Smithsonian Institution Press, 1976.

Taylor, Lonn, and Dessa Bokides. *New Mexican Furniture, 1600–1940: The Origins, Survival, and Revival of Furniture Making in the Hispanic Southwest.* Santa Fe: Museum of New Mexico Press, 1987.

Tedlock, Dennis. "Stories of Kachinas and the Dance of Life and Death." In *Kachinas in the Pueblo World,* ed. Polly Schaafsma, 147–60. Albuquerque: University of New Mexico Press, 1994.

Thomas, Alfred Barnaby. *After Coronado: Spanish Exploration Northeast of New Mexico, 1696–1727.* Norman: University of Oklahoma Press, 1935.

Thomas, Nicholas. *Colonialism's Culture: Anthropology, Travel, and Government.* Princeton: Princeton University Press, 1994.

Thompson, Robert Farris. *Face of the Gods: Art and Altars of Africa and the African Americas.* Exh. cat. New York: Museum for African Art, 1993.

Thurston, Robert, S.J., and Donald Attwater. *Butler's Lives of the Saints.* Rev. ed. New York: P. J. Kennedy & Sons, 1956.

Titiev, Mischa. *The Hopi Indians of Old Oraibi: Change and Continuity.* Ann Arbor: University of Michigan Press, 1972.

———. *Old Oraibi: A Study of the Hopi Indians of Third Mesa.* Papers of the Peabody Museum of American Archaeology and Ethnology, Harvard University, vol. 22, no. 1. Cambridge: Peabody Museum, 1944.

Tjarks, Alicia. "Demographic, Ethnic, and Occupational Structure of New Mexico, 1790." *Americas* 35, no. 1 (July 1978): 45–88.

Tobias, Henry J. *A History of the Jews in New Mexico.* Albuquerque: University of New Mexico Press, 1991.

Torre Revelo, José. *El libro, la imprenta, y el periodismo en América durante la dominación española.* Buenos Aires: Talleres S.A. Casa Jacobo Peuser, 1940.

———. "Obras de arte enviadas al nuevo mundo en los siglos XVI y XVII." *Anales del Instituto de Arte Americano e Investigaciones Estéticas* 1 (1948): 87–96.

Toulouse, Joseph H., Jr. *The Mission of San Gregorio de Abó.* Monographs of the School of American Research, no. 13. Albuquerque: University of New Mexico Press, 1949.

Toussaint, Manuel. *Colonial Art in Mexico.* Trans. Elizabeth Wilder Weismann. Austin: University of Texas Press, 1967. (Originally published as *Arte Colonial de Mexico* [Mexico, 1949])

———. *Pintura colonial en México.* 3d ed. Mexico City: Universidad Nacional Autónoma de México / Instituto de Investigaciones Estéticas, 1990.

Tovar de Teresa, Guillermo. *México barroco.* Mexico City: SAHOP, 1981.

———. *Pintura y escultura en Nueva España (1557–1640).* Arte novohispano, n. 4. Mexico City: Grupo Azabache, 1992.

———. *Renacimiento en México: Artistas y retablos.* Mexico City: Instituto Nacional de Antropología e Historia, 1979.

Tower, Beeke Sell. "Asphaltcowboys and Stadtindianer: Imagining the Far West." In *Envisioning America: Prints, Drawings, and Photographs by George Grosz and his Contemporaries, 1915–1933,* ed. Beeke Sell Tower, essay John Czaplicka, 17–36. Exh. cat. Cambridge: Busch-Reisinger Museum, Harvard University, 1990.

Towner, Ronald H., and Jeffrey S. Dean. "Questions and Problems in Pre-Fort Sumner Navajo Archaeology." In *The Archeology of Navajo Origins,* ed. Ronald H. Towner. Salt Lake City: University of Utah Press, 1996.

Tracy, David, ed. *Celebrating the Medieval Heritage: A Colloquy on the Thought of Aquinas and Bonaventure.* Chicago: University of Chicago Press, 1978.

Treat, James, ed. *Native and Christian: Indigenous Voices on Religious Identity in the United States and Canada.* New York: Routledge, 1996.

Trexler, Richard C. *Sex and Conquest: Gendered Violence, Political Order, and the European Conquest of the Americas.* Ithaca: Cornell University Press, 1995.

Trotter, Robert, II, and Juan Antonio Chavira. *Curanderismo: Mexican-American Folk Healing.* Athens: University of Georgia Press, 1981.

Tunn, Marianna Tey. "Santo Niño de Atocha: Development, Dispersal, and Devotion of a New World Image." Master's thesis, University of New Mexico, Albuquerque, 1993.

———. *Sin Nombre i Hispana and Hispano Artists of the New Deal Era.* Albuquerque: University of New Mexico Press, 2001.

Tweed, Thomas. *Our Lady of the Exile: Diasporic Religion at a Cuban Catholic Shrine in Miami.* Oxford: Oxford University Press, 1997.

Twitchell, Ralph Emerson. *The Spanish Archives of New Mexico.* 2 vols. Cedar Rapids, Iowa: Torch Press, 1914.

Tylor, Sir Edward Burnett. *Primitive Culture: Researches into the Development of Mythology, Philosophy, Religion, Language, Art, and Custom.* London: J. Murray, 1871.

Udall, Sharyn R. "The Irresistible Other: Hopi Ritual Drama and Euro-American Audiences." In *Contested Terrain: Myth and Meanings in Southwest Art.* Albuquerque: University of New Mexico Press, 1996.

Valadés, Diego. *Rhetorica christiana.* Perugia, 1579. Spanish trans. *Rétorica cristiana.* Mexico City: Universidad Nacional Autónoma de Mexico, Fondo de Cultura Económica, 1989.

Vargas Lugo, Elisa. *La iglesia de Santa Prisca de Taxco.* Mexico City: Instituto de Investigaciones Estéticas. Universidad Nacional Autónoma de México, 1974.

Vischer, Friedrich-Theodor. "Das Symbol." In *Philosophische Aufsatze. Eduard Zeller su seinem fünfzigjährigen Doctor-Jubiläaum gewidmet,* 152–93. Leipzig Zentral-Antiquariat der Deutschen Demokratischen Republik: Fues's Verlag, 1887.

Vivian, Delma. "New Mexican Folk Art on Display at Center." *Las Vegas Daily Optic,* August 28, 1937.

Waddell, Shanna. "Feminized Santos: An Investigation into the Sources and the Establishment of the Style." Master's thesis, University of Colorado, Boulder, 1996.

Wade, Edwin. "Economics of Southwest Indian Art Market." Ph.D. diss., University of Washington, 1976.

———. "The Ethnic Art Market." In *The Great Southwest of the Fred Harvey Company and the Santa Fe Railway,* ed. Marta Weigle and Barbara A. Babcock. Phoenix: Heard Museum; Tucson: University of Arizona Press, 1996.

———. "The Ethnic Art Market in the American Southwest, 1880–1980." In *Objects and Others: Essays on Museums and Material Culture,* ed. George Stocking, 167–91. History of Anthropology, 3. Madison: University of Wisconsin Press, 1986.

Walker, Deward, ed. *Witchcraft and Sorcery of the American Native Peoples.* Preface David Carrasco. Moscow, Idaho: University of Idaho Press, 1989.

Walsh, K. *The Representation of the Past: Museums and Heritage in the Post-Modern World.* London: Routledge, 1992.

Walz, Vina. "History of the El Paso Area, 1680–1692." Ph.D. diss., University of New Mexico, 1951.

Warburg, Aby. "A Lecture on Serpent Ritual." *Journal of the Warburg Institute* 2 (1938/39): 277–92.

———. *Il rituale del serpent*. Milan: Adelphi, 1998.

———. *Schlangenritual: Ein Reisebericht*. Ed. U. Raulff. Berlin: K. Wagenbach, 1988.

———. *Images from the Region of the Pueblo Indians of North America*. Trans. and ed. Michael P. Steinberg. Ithaca: Cornell University Press, 1995.

Washburn, Dorothy. *Style, Classification, and Ethnicity: Design Categories on Bakuba Raffia Cloth*. Philadelphia: American Philosophical Society, 1990.

Washburn, Dorothy K. *A Symmetry Analysis of Upper Gila Area Ceramic Design*. Papers of the Peabody Museum of Archaeology and Ethnology, Harvard University, 68. Cambridge: Cambridge University Press, 1977.

Weber, David. *The Spanish Frontier in North America*. New Haven: Yale University Press, 1992

Weber, David J. *Myth and the History of the Hispanic Southwest*. Albuquerque: University of New Mexico Press, 1988.

———. *The Taos Trappers*. Norman: University of Oklahoma Press, 1970.

———, ed. *Foreigners in Their Native Land: Historical Roots of the Mexican Americans*. Albuquerque: University of New Mexico Press, 1973.

Weber, Max. *The Protestant Ethic and the Spirit of Capitalism*. Trans. Talcott Parsons. London: University Books, 1930.

Weber, Michael Frederick. "Tierra Incognita: The Spanish Cartography of the American Southwest, 1540–1803." Ph.D. diss., University of New Mexico, 1986.

Weber, William. *Rocky Mountain Flora*. Boulder: Colorado Associated University Press, 1976.

Weigle, Marta. "A Brief History of the Spanish Colonial Arts Society." In *Spanish New Mexico: The Spanish Colonial Arts Society Collection,* ed. Donna Pierce and Marta Weigle, 2:26–35. Santa Fe: Museum of New Mexico Press, 1996.

———. *Brothers of Light, Brothers of Blood: The Penitentes of the Southwest*. Albuquerque: University of New Mexico Press, 1976.

———. "The First Twenty-five Years of the Spanish Colonial Arts Society." In *Hispanic Arts and Ethnohistory in the Southwest,* ed. Marta Weigle, Claudia Larcombe, and Samuel Larcombe, 181–204. Santa Fe: Ancient City Press, 1983.

———, and Barbara A. Babcock, eds. *The Great Southwest of the Fred Harvey Company and the Santa Fe Railway*. Phoenix: Heard Museum; Tucson: University of Arizona Press, 1996.

———, and Peter White. *The Lore of New Mexico*. Albuquerque: University of New Mexico Press, 1988.

Weismann, Elizabeth. *Art and Time In Mexico*. New York: Harper & Row, 1985.

———. *Mexico in Sculpture, 1521–1821*. Cambridge: Harvard University Press, 1950.

When Cultures Meet: Remembering San Gabriel del Yunge Oweenge.

Papers from the October 20, 1984, conference held at San Juan Pueblo, New Mexico. Santa Fe: Sunstone Press, 1970.

White, Hayden. *The Content of Form: Narrative Discourse and Historical Representation*. Baltimore: Johns Hopkins University Press, 1987.

———. "The Fictions of Factual Representation." In *Tropics of Discourse: Essays in Cultural Criticism*. Baltimore: Johns Hopkins University Press, 1978.

White, Leslie A. *The Pueblo of Santa Ana*. Memoirs of the American Anthropological Association, no. 60. Menasha: American Anthropological Association, 1942.

———. *The Pueblo of Santo Domingo*. Memoirs of the American Anthropological Association, no. 43. Menasha: American Anthropological Association, 1935.

White, Richard. "Representing Indians." *New Republic,* April 27, 1997, 28–34.

Whiteley, Peter M. *Deliberate Acts: Changing Hopi Culture Through the Oraibi Split*. Tucson: University of Arizona Press, 1988.

Wilder, Mitchell A., and Edgar Breitenbach. *Santos: The Religious Folk Art of New Mexico*. Colorado Springs: Taylor Museum of the Colorado Springs Fine Arts Center, 1943.

Williams, Walter L. *The Spirit and the Flesh: Sexual Diversity in American Indian Culture*. Boston: Beacon Press, 1986.

Wind, Edgar. Review of *Aby Warburg,* by E. H. Gombrich. *Times Literary Supplement,* June 25, 1971, 735–36. Reprinted with additional references as "On a Recent Biography of Warburg." In *The Eloquence of Symbols: Studies in Humanist Art,* ed. Jaynie Anderson, 106–13. Oxford: Clarendon Press, 1983.

———. "Warburgs Begriff der Kulturwissenschaft und sein Bedeutung für Ästhetik." *Zeitschrift für Ästhetik und allgemein Kunstwisssenschaft* 25 (1931): 163–79.

"Wood Carvings of Former WPA Teamster Gain Attention." *Press Digest,* November 9, 1936, sec. 1–15, p. 3. Records Group 69, National Archives, Washington, D.C.

Wood, Christopher S., ed. *The Vienna School Reader: Politics and Art Historical Method in the 1930s*. New York: Zone Books. 2000.

Worcester, Donald E. "The Navajo During the Spanish Regime in New Mexico." *New Mexico Historical Review* 26 (April 1951): 101–18.

Worchester, Thomas. "Trent and Beyond: Arts of Transformation." In *Saints & Sinners: Caravaggio and the Baroque Image,* ed. Franco Moramando, 87–106. Exh. cat. McMullen Museum of Art, Boston College, 1999.

Wright, B., ed. *Hopi Material Culture: Artefacts Gathered by H. R. Voth in the Fred Harvey Collection*. Flagstaff: Northland, 1979.

Wroth, William. *The Chapel of Our Lady of Talpa*. Colorado Springs: Taylor Museum of the Colorado Springs Fine Arts Center, 1979.

———. *Christian Images in Hispanic New Mexico: Taylor Museum Collection of "Santos."* Colorado Springs: Taylor Museum of the Colorado Springs Fine Arts Center, 1982.

———. "The Flowering and Decline of the Art of the New Mexican Santero, 1780–1900." In *The Cross and the Sword*. San Diego: Fine Arts Gallery of San Diego, 1976.

———. "The Flowering and Decline of the New Mexican *Santero: 1780–1900*." In *New Spain's Far Northern Frontier: Essays on Spain in the American West, 1540–1821,* ed. David J. Weber, 273–82. Albuquerque: University of New Mexico Press, 1979.

———. "The Hispanic Craft Revival in New Mexico." In *Revivals! Diverse Traditions, 1920–1945: The History of Twentieth-Century American Craft,* ed. Janet Kardon, 84–93. Exh. cat. New York: Harry N. Abrams, in association with the American Craft Museum, 1994.

———. *Hispanic Crafts of the Southwest.* Colorado Springs: Taylor Museum, 1977.

———. *Images of Penance, Images of Mercy: Southwestern Santos in the Late Nineteenth Century.* Norman: University of Oklahoma Press, 1991.

———. "Miraculous Images and Living Saints in Mexican Folk Catholicism." In *Folk Art of Spain and the Americas: El Alma del Pueblo,* ed. Marion Oettinger, 158–68. Exh. cat. San Antonio Museum of Art. New York: Abbeville Press, 1997.

———. "New Hope in Hard Times." *El Palacio* 89 (summer 1983): 22–31.

Wuthenau, Alexander von. "The Spanish Military Chapels in Santa Fe and the Reredos of Our Lady of Light." *New Mexico Historical Review* 10, no. 3 (1935): 175–94.

Wuttke, Dieter, ed. *Aby M. Warburg-Bibliographie 1866 bis 1995: Werk und Wirkung: mit Annotationen.* Baden-Baden: V. Koerner, 1998.

———. *Aby M. Warburg: Ausgewählte Schriften und Wurdigungen.* Baden-Baden: V. Koerner, 1980.

Young, Robert. J. C. "Back to Bakhtin." In *Torn Halves: Political Conflict in Literary and Cultural Theory, 33–66.* Manchester, England: Manchester University Press, 1996.

———. *Colonial Desire: Hybridity in Theory, Culture, and Race.* London: Routledge, 1995.

———. *Torn Halves: Political Conflict in Literary and Cultural Theory.* Manchester. England: Manchester University Press, 1996.

———. *White Mythologies: Writing History and the West.* London: Routledge, 1990.

Zarate Salmerón, G. de. *Relación.* Trans. C. F. Lummis. *Land of Sunshine,* 9, no. 5. Los Angeles: Land of Sunshine Publishing Company, 1898, 336–46.

Zarur, Elizabeth Netto Calil, and Charles Muir Lovell, eds. *Art and Faith in Mexico: The Nineteenth-Century Retablo Tradition.* Albuquerque: University of New Mexico Press, 2001.

Zeri, Federico. *Pittura e controriforma. L'arte senza tempo di Scipione da Gaeta.* Turin: Einaudi, 1970.

KELLY DONAHUE-WALLACE earned her Ph.D. in Latin American colonial art history from the University of New Mexico in 2000. She is now Assistant Professor at the University of North Texas, where she teaches Latin American and European Renaissance and Baroque art history. Her current research addresses woodcuts and engravings produced in viceregal Mexico City between 1600 and 1800. Her work on this topic is published in *Mexican Studies / Estudios Mexicanos, Anales del Instituto de Investigaciones Estéticas,* and *Colonial Latin American Review.*

JOSÉ ANTONIO ESQUIBEL is a genealogical researcher. He is the author of more than seventy articles, including "New Light on the Jewish-Converso Ancestry of Don Juan de Oñate: A Research Note," *Colonial Latin American Historical Review* 7 / 2 (1998); and "Sacramental Records and the Preservation of New Mexico Family Genealogies from the Colonial Era to the Present," in *Seeds of Struggle, Harvest of Faith: Papers of the Catholic Cuarto Centennial Historical Conference* (Albuquerque: LPD Press, 1998). Esquibel has coauthored *The Royal Road: El Camino Real from Mexico City to Santa Fe* (Albuquerque: University of New Mexico Press, 1998), *The Spanish Recolonization of New Mexico: An Account of the Families Recruited at Mexico City in 1693* (Albuquerque: Hispanic Genealogical Research Center, 2000), and with Charles M. Carrillo, *A Tapestry of Kingship: The Web of Influence Among Escultores and Carpinteros in the Parish of Santa Fe, 1790–1850* (Albuquerque: LPD Press, 2004).

CLAIRE FARAGO is Professor of Renaissance art, theory, and criticism at the University of Colorado at Boulder. She holds a Ph.D. in art history from the University of Virginia. She has published widely on art theory and historiography and is a leading authority on the manuscripts of Leonardo da Vinci. Her publications include *Leonardo da Vinci's Paragone: A Critical Interpretation* (Leiden: E. J. Brill, 1992) and five edited volumes on Leonardo da Vinci; *Reframing the Renaissance: Visual Culture in Europe and Latin America, 1450 to 1650* (New Haven: Yale University Press, 1995); with Robert Zwijnenberg, *Compelling Visuality: The Work of Art in and out of History* (Minneapolis: University of Minnesota Press, 2003); with Donald Preziosi, *Grasping the World: The Idea of the Museum* (London: Ashgate Press, 2004). She conceived the idea of *Transforming Images,* and this is her first book-length contribution to postcolonial studies.

ROBIN FARWELL GAVIN is Curator of the Museum of Spanish Colonial Art in Santa Fe. She holds a B.A. in archaeology and an M.A. in art history from the University of New Mexico. She has spent twenty-five years studying the history and art of New Mexico, first as a field archaeologist and later as an art historian. Gavin has curated various exhibitions on Spanish colonial art, published numerous articles, and contributed to various publications. She authored *Traditional Arts of Spanish New Mexico: The Hispanic Heritage Wing at the Museum of International Folk Art* (Santa Fe: Museum of New Mexico Press, 1994) and edited and annotated the revised edition of E. Boyd, *Saints and Saint Makers of New Mexico* (Santa Fe: Western Edge Press, 1998). Gavin recently edited the exhibition catalogue *The Story of Spanish and Mexican Mayolica: Cerámica y Cultura* (Albuquerque: University of New Mexico Press, 2005).

PAUL KRAEMER is a microbiologist retired from the Los Alamos National Laboratory, where one of his areas of research included the Human Genome Project. He has applied his scientific knowledge to the history of New Mexico and researched the ethnography, epidemiology, and miscegenation of the people of New Mexico. He has published more than ninety-five articles in the field of microbiology and epidemiology and in the history of New Mexico. He holds doctoral degrees in microbiology (Ph.D., University of Pennsylvania) and epidemiology (Dr. P.H., Tulane University).

NANCY MANN is a senior instructor and editor at the Program for Writing and Rhetoric, University of Colorado at Boulder, where she edits manuscripts for faculty and also for scholars elsewhere in the United States and abroad. She is a former editor of *Frontiers: A Journal of Women Studies* and holds a Ph.D. in English from Stanford University. Her current research centers on style; her most recent publication is "Point Counterpoint: Teaching Punctuation as Information Management," *College Composition and Communication* 54:3.

CARMELLA PADILLA is an award-winning journalist and author who has written extensively about the art and culture of New Mexico. Her work has appeared in the *Wall Street Journal, Dallas Morning News, Latina, Vista, Travel Holiday,* and *New Mexico Magazine,* among others. Padilla is the author of *The Chile Chronicles: Tales of a New Mexico Harvest* (Santa Fe: Museum of New Mexico Press, 1997); *Low 'n Slow: Lowriding in New Mexico* (Santa Fe: Museum of New Mexico Press, 1999); and *Eliseo Rodriguez: El Sexto Pintor* (Santa Fe: Museum of New Mexico Press, 2001). She is a contributor to *Spanish New Mexico: The*

Spanish Colonial Arts Society Collection (Santa Fe: Museum of New Mexico Press, 1996) and co-author, with Donna Pierce, of *Conexiones: Connections in Spanish Colonial Art* (Santa Fe: Museum of Spanish Colonial Art, 2002).

DONNA PIERCE is Frederick and Jan Mayer Curator of Spanish Colonial Art at the Denver Art Museum. She received her Ph.D. in art history from the University of New Mexico. She has contributed to exhibitions and catalogs at various institutions, including The Metropolitan Museum of Art, the Brooklyn Museum, the Minneapolis Institute of Art, the Museum of Spanish Colonial Art, Santa Fe, and the Santa Barbara Museum of Art. She has contributed to numerous publications, including *Mexican Churches* and *Mexican Celebrations* (Albuquerque: University of New Mexico Press, 1987 and 1990); *Mexico: Splendors of Thirty Centuries* (New York: The Metropolitan Museum of Art and Bullfinch Press, 1990); and *Converging Cultures* (New York: Abrams, 1996). She has coauthored publications, including *Cambios: The Spirit of Transformation in Spanish Colonial Art* (Albuquerque: University of New Mexico Press, 1992) with Gabrielle Palmer, *Spanish New Mexico: The Spanish Colonial Arts Society Collection* (Santa Fe: Museum of New Mexico Press, 1996) with Marta Weigle, and *Painting a New World: Mexican Art and Life, 1521–1821* (Denver: Denver Art Museum, 2004).

BRENDA M. ROMERO is an Associate Professor of Ethnomusicology and Chair of Musicology at the University of Colorado in Boulder, where she has been on the faculty since 1988. She holds a Ph.D. in Ethnomusicology from the University of California in Los Angeles, and received her Bachelors and Masters degrees in Music Theory and Composition from the University of New Mexico. She has worked extensively on the pantomimed Matachines music and dance and other New Mexican folk genres that reflect both Spanish and Indian origins, and has published various articles that focus on how the music reflects cultural interaction. She frequently gives local and regional lecture / recitals on the older folk music of New Mexico and southern Colorado. In 2000 she was awarded a Fulbright Research Scholarship to conduct field research on the Matachines music and dance in Mexico. She is the 2004 recipient of the Society for American Music's "Sight and Sound" award, a subvention that will be applied to the production of a forthcoming CD, *Caniones de mis patrias: Songs of My Homelands, Early New Mexican Folk Songs*.

TOM RIEDEL is Associate Professor of Information Science (Distance Services Librarian) at Regis University in Denver, Colorado. He received his M.A. in art history from the University of Colorado and a master's degree in Library and Information Science from the University of Texas at Austin. Riedel assists Thomas J. Steele, S.J., in maintaining the Regis University collection of *santos,* which numbers more than 700 objects.

CORDELIA THOMAS SNOW is a historic sites archaeologist with the Laboratory of Anthropology at the Museum of New Mexico. She has more than twenty-five years of experience in fieldwork and archival research on colonial sites and on the history of the Southwest. Formerly a curator at the Palace of the Governors in Santa Fe, she co-curated the exhibition "Another Mexico: Spanish Life on the Rio Grande" there in 1992. She has published various articles and field reports, including "A Brief History of the Palace of the Governors and a Preliminary Report on the 1974 Excavation," *El Palacio* 80, 3 (1974) and "A Headdress of Pearls: Luxury Goods Imported over the Camino Real During the Seventeenth Century," in *El Camino Real de Tierra Adentro* (Santa Fe: Bureau of Land Management, 1993).

MARIANNE L. STOLLER, a cultural anthropologist and ethnohistorian, holds a Ph.D. from the University of Pennsylvania. She is Professor Emerita of Anthropology at The Colorado College in Colorado Springs and a past president of the American Society of Ethnohistory. She has written various articles and contributed to publications on the Hispanic Southwest, including "Three Church Inventories from Hispanic Frontier Communities," in *Hispanic Arts and Ethnohistory in the Southwest* (Santa Fe: Ancient City Press, 1983) and "Traditional Hispanic Arts and Crafts in the San Luis Valley of Colorado," in *Hispanic Crafts of the Southwest* (Colorado Springs: Taylor Museum, 1977). She co-edited *Diary of the Jesuit Residence of Our Lady of Guadalupe Parish, Conejos, Colorado, December 1871–December 1875* (Colorado College Studies, no. 19; Colorado Springs: Colorado College, 1982). For ten summers, Stoller also directed the archaeological excavation of a major seventeenth-century Spanish homesite in La Cienega, New Mexico.

CHARLENE VILLASENOR-BLACK is Assistant Professor in the Department of Art History at the University of California at Los Angeles, having received her Ph.D. in Art History from the University of Michigan. She has published in *Speaking Chicana: Voice, Power, and Identity* (Tucson, 1999); *The Material Culture of Sex, Procreation and Marriage* (New York, 2002), *Colonial Saints: Discovering the Holy in the Americas* (New York, 2003) and numerous journals. She has received awards from the Fulbright Foundation, the Woodrow Wilson National Fellowship Foundation, the Andrew W. Mellon Foundation, the National Endowment for the Humanities; and the Millard Meiss Foundation to support the publication of the forthcoming book, *Constructing the Cult of St. Joseph: Art and Gender in the Spanish Empire* (Princeton University Press), an investigation of the use of religious imagery in the colonial encounter and the encoding of new gender discourses.

DINAH ZEIGER is a Ph.D. candidate in the School of Journalism & Mass Communications at the University of Colorado–Boulder with an emphasis in visual culture. She is also the author of numerous articles and catalogue essays, including "Expanded Visions: Four Women Print the West," for the Women of the West Museum, and contributions to *Journeys Home: Revealing a Zuni-Appalachia Collaboration,* 2002, published by A:shiwi Press, a bilingual book documenting the sixteen-year collaboration between artists from Appalachia and the Zuni Pueblo in New Mexico.

INDEX

McDannell, Colleen, 244
meaning
 artists and, 38–43
 audience and, 14, 29–31, 38–43, 183–84,
 248–49
 Catholicism and, 41, 42
 collection and, 241–54
 conflict in, 3
 consumers and, 241–54
 contemporary, 241–54
 cultural interaction and, 41–42
 culture and, 3–5, 29–31, 159–61, 183–84,
 185–86, 245, 260–63
 devotion and, 241–54
 Eurocentrism and, 4–5, 28
 evolution and, 260–63
 hybridization and, 38–43
 identity and, 3–5
 images and, 198–99
 inversions and, 37, 40
 language and, 42–43
 naturalism and, 26–28
 objectivity and, 38–40
 overlapping, 3
 performative context of, 33
 power and, 31
 practices and, 39
 santos and, 40–43
 semiosis and, 38–43
 signs and, 26–31, 40, 42–43
 style and, 159–61, 185–86
 subjectivity and, 38–43, 260–61
 substitutions and, 37
 symbolism and, 42–43, 260–63
 time and, 250
 tourism and, 243–44, 249–50
 unity and, 2
 variety in, 11
mechanical arts, 20
Medina, Antonia Micaela, 130, 288
 n. 77
Meem, John Gaw, 306 n. 11
Memmi, Albert, 8
Menchero, Father, 89, 90
Mendieta, Fray Gerónimo de, 230
Mendinueta, Governor, 96
Mera, Harry, 170
merchants, 72. See also trade
Mesilla Valley, 232, 234–35, 240
Mesilla Valley Santero, 236
mestizos
 definition of, 82
 in eighteenth century, 92
 Fresquís, Pedro Antonio, as, 130
 hide paintings and, 141
 identity and, 6, 28, 116
 matachines dances and, 188
 Pueblo Revolt and, 66

in Resettlement period, 66–67, 69, 71
in settlement period, 72, 81
Metcalf, Eugene W., Jr., 307 n. 10
Mexican Baroque, 279 n. 2
Mexican Indians, 70, 72, 84–85, 87, 247–48
Mexico
 Ferdinand VII and, 59
 hide paintings in, 138
 matachines dances and, 190–91
 New Mexico and, generally, 45
 pilgrimage routes in, 205
 print sources in, 146–48
 in Resettlement period, 67–70, 74–77
 shrines in, 202–4
 Spain and, 59–61
 style, influence on, 44–57, 235, 239, 252
Mexico City, 68–70, 74–76, 83–84, 87–88
Michael, Archangel
 of Aragón, Rafael, 55–56, 56, 294 nn. 4, 6
 Saint Michael (anonymous), 108
 Saint Michael (Aragón), 55–56, 56
 Saint Michael Archangel (Portfolio of Spanish
 Colonial Design in New Mexico), 218
 Saint Michael Archangel (Sanchez late-
 1930s), 220–21, 221
 Saint Michael Archangel (Sanchez 1942), 221,
 221, 222
 Saint Michael Archangel (School of Rafael
 Aragón), 220–21, 221
Middle Ages, 126–27
Miera, Joaquín, 79
Miera, Ronnald, 241, 249–50, 252, 253, 308
 n. 47
Miera y Pacheco, Bernardo
 Altar of the Kings and, 136–37
 altar screens of, 128, 134, 135, 135–37, 276
 n. 18, 291 n. 19
 ancestry of, 78–79
 Archangel Gabriel, 12, 55, 55
 attribution to, 3, 134, 231
 biography of, 134–37
 estípite columns of, 135–37, 294 n. 4
 Fresquís, Pedro Antonio, and, 79
 Miera, Ronnald, descended from, 252
 pigments and, 134–35
 style of, 54, 55, 134–37
 technique of, 134–35
Miera y Pacheco, Manuel, 79
military, 86
Military Chapel. See La Castrense
Mimbres Valley bowl, 173, 173
Miranda, Antonio de, 255
Missae Sanctorum Hispanorum qui generaliter in
 Hispania Celebrantur, 195
missionaries. See Franciscans; Jesuits
Mitchell, W. J. T., 36
Model of Southwestern Cliff Dwelling, 270
modernism, 224–26, 261–62

Molleno
 altar screens of, 292 n. 65
 attribution to, 230–31
 ethnicity of, 130–32
 hide paintings of, 125, 144, 149
 identification of, 119, 130–32
 Laguna Santero and, 131–32, 279 n. 2
 Pereyro, Fray José Benito, and, 132
 Saint Anthony, 53
 Saint James the Moorslayer, 132
 style of, 53, 55, 149, 150, 279 n. 2
Montaigne, Michel de, 310 n. 32
Montero, Mateo (master), 81
Montero, Mateo (slave), 81
Montes Vigil, Juan, 112
Montoya, Henry, 222, 305 nn. 47, 61
Montoya, María, 222
Mora Octagonal Workshop, 199
Morgan, David, 37–38, 247, 248, 249, 250
Morgan, Willard, 217
morisco, 82, 287 n. 47
mothering, 183
motifs, 19, 51–57, 109, 161–84. See also signs;
 symbolism
Mountain/Tree Painter, 149, 151–53, 154
mugs, 174
mulatos
 definition of, 82
 in eighteenth century, 92, 96–97
 in Resettlement period, 66, 69, 72
 in settlement period, 81, 284 n. 3
Munier, Pedro, 88
museological process, 33
Museum of International Folk Art, 206, 227,
 305 n. 74
Museum of Modern Art, 224–25
Museum of New Mexico, 232
music, 190–91
Mystica ciudad de Dios (Jesús de Agreda), 297
 n. 27

Nadal, Jerónimo, 297 n. 27
Nahuatl, 20, 279 n. 5
Nambé, Nicolás of, 291 n. 18
Nambé Pueblo, 130
names, 130, 131. See also kinship groups
Namingha, Warren, 310 n. 30
Napoleon, 58–59
Native Americans. See also Mexican Indians;
 Pueblo Indians; specific tribes
 Africans and, 284 n. 3
 civilization of, 19–20
 cultural interaction and, 5
 disease and, 81, 88, 94
 humanity of, 19–20
 language of, 270
 population of, 81, 89–90
 rationality of, 19–20, 261–62